Praise for *Matrilineal Dissent*

"This absorbing collection shows how everything changes when Jewish women are given a place at the center, not the margins, of Jewish literary tradition. Writing itself becomes a radical act, opening new cultural perspectives. This is a book to be savored and admired; it will surely have wide influence in the field."

—Joyce Antler, author of *Jewish Radical Feminism: Voices from the Women's Liberation Movement*

"This inspiring and groundbreaking collection of essays transforms our understanding of American Jewish literature by tracing women's impact from the early part of the twentieth century to the present. *Matrilineal Dissent* reveals the crucial role women played in creating and sustaining a literary community. A literary feast, the volume highlights women's contributions to a wide range of genres from poetry, fiction, plays, autobiography, to graphic literature. Rather than focusing on the same few writers found in earlier collections and anthologies, here the focus is on authors we are less likely to know and yet should know. A must-read for anyone teaching Jewish American literature or who wants to know more about Jewish women's contributions to literary history."

—Laura Leibman, William R. Kenan Professor of English and Humanities, Reed College, and president of the Association for Jewish Studies

"*Matrilineal Dissent* is an extraordinarily smart collection, from the brilliant title all the way through the capacious essays. It will be an asset to scholars and lovers of all types of art alike."

—Jennifer Caplan, associate professor and Jewish Foundation of Cincinnati Chair in Judaic Studies, University of Cincinnati

MATRILINEAL DISSENT

MATRILINEAL DISSENT

Women Writers and Jewish American
Literary History

EDITED BY ANNIE ATURA BUSHNELL,

LORI HARRISON-KAHAN, AND ASHLEY WALTERS

Wayne State University Press
Detroit

© 2024 by Wayne State University Press, Detroit, Michigan 48201. All rights reserved. No part of this book may be reproduced without formal permission.

ISBN 9780814349854 (paperback)
ISBN 9780814349861 (hardcover)
ISBN 9780814349847 (e-book)

Library of Congress Control Number: 2023941257

On cover: Illustration of Lilith by Liana Finck, from *Let There Be Light* (Random House, 2021). Used by permission of the artist. Cover design by Elke Barter.

Publication of this book was made possible through the generosity of the Bertha M. and Hyman Herman Endowed Memorial Fund.

Wayne State University Press rests on Waawiyaataanong, also referred to as Detroit, the ancestral and contemporary homeland of the Three Fires Confederacy. These sovereign lands were granted by the Ojibwe, Odawa, Potawatomi, and Wyandot Nations, in 1807, through the Treaty of Detroit. Wayne State University Press affirms Indigenous sovereignty and honors all tribes with a connection to Detroit. With our Native neighbors, the press works to advance educational equity and promote a better future for the earth and all people.

Wayne State University Press
Leonard N. Simons Building
4809 Woodward Avenue
Detroit, Michigan 48201-1309

Visit us online at wsupress.wayne.edu.

CONTENTS

Acknowledgments vii

Introduction 1
Annie Atura Bushnell, Lori Harrison-Kahan, and Ashley Walters

1. Women Who Wouldn't: Early Twentieth-Century Jewish Women's Proletarian Literature and Ethnoracial Displacement 29
Ashley Walters

2. Where the Shoe Pinches: Appropriation and Allyship in Annie Nathan Meyer's Anti-Lynching Literature 71
Lori Harrison-Kahan

3. The Making of a White Sophisticate: Marian Spitzer and Middlebrow Self-Presentation 111
Jessica Kirzane

4. "Oyb me zukht gefint men": Translating Yiddish Literature Hiding in Plain Sight 147
Rachel Rubinstein

5. The Poetics of Conversation: Adrienne Rich's and Audre Lorde's Uses of Voice 185
Alex Ullman

6. Reception after #MeToo: The Cases of Susan Taubes and Erica Jong 227
Josh Lambert

7. "Kike Art": Chris Kraus's Bad Jewishness and
 Artworld Hustles 251
 Annie Atura Bushnell

8. The Mother-Golem: Jewish, Queer, Feminist Writing
 about Disability 295
 Jennifer Glaser

9. Interconnected Losses: Grief Made Visible in Roz Chast's
 Can't We Talk about Something More Pleasant? 325
 Tahneer Oksman

10. Mizrahi Jewish Women Writers in America: A Conversation 355
 Karen E. H. Skinazi

Contributors 375
Index 379

ACKNOWLEDGMENTS

This collection originated in a seminar on Women and Literary Politics in the United States at the 2020 Association for Jewish Studies (AJS) conference, which took place virtually. We would like to thank the other participants in those sessions—Sandra Chiritescu, Jessica Kirzane, Josh Lambert, Tahneer Oksman, and Shoshana Olidort, as well as the AJS members in attendance—for the generative conversations that led to this volume.

Our gratitude also goes to Sandra Korn, Marie Sweetman, Stephanie Williams, Carrie Teefey, Kelsey Giffin, Emily Gauronskas, Traci Cothran, Jude Grant, and all of the staff at Wayne State University Press for their long-standing support of scholarship on Jewish women writers. Thanks, too, to Rachel Lyons for indexing; to Annie Martin, who acquired this manuscript for Wayne State University Press and shepherded us through the early stages; and to two anonymous reviewers for their feedback and enthusiasm.

The Yaschik/Arnold Jewish Studies Program at the College of Charleston offered crucial financial support for indexing. Erin Dooling and Christine Lenahan provided research and editorial assistance during their time as Undergraduate Research Fellows at Boston College. Roz Chast and Riva Lehrer graciously granted permission to reprint their artwork inside the book. Finally, we extend our deep appreciation to Liana Finck for permission to use her arresting drawing of Lilith on the cover.

INTRODUCTION

Annie Atura Bushnell, Lori Harrison-Kahan,
and Ashley Walters

Midway through Anya Ulinich's 2014 graphic novel, *Lena Finkle's Magic Barrel*, the eponymous protagonist—who, like Ulinich herself, is an American novelist and Soviet émigré—dreams that she is sitting beside Philip Roth on a bus. Lena's gushy fangirl response ("Oh my god, Philip Roth, is this really you? . . . Listen, I love your books! You and I are so much alike!") meets with hostility from the famous Jewish American writer. "You're nothing like me!" Roth replies. "First, you're a **woman**, and not even a pretty one! Second, you're an **immigrant**!" Ulinich's visual rendering of the characters suggests that, indeed, the two authors *are* different: an aged and scraggy Roth is drawn with rough, sketch-like strokes, while Lena appears in a vivid contrast of black and white, as if drawn in permanent marker. Lena quickly retaliates by announcing that she "hated [Roth's 2007 novel] *Exit Ghost* so much [she] threw it in a subway trash can!" Before Roth himself exits the text—for soon we turn the page and the dream is over—he tells Lena, "Don't read me, Finkle. Read Malamud. Read '**The Magic Barrel**.'"[1] This reference to Bernard Malamud's magical realist fable featuring rabbinical student Leo Finkle circles back to the title of Ulinich's graphic novel. In the end, Lena does not need Roth's guidance. This dream Roth is *her* Roth, and Lena, like Ulinich, has already laid claim to the magic barrel, emptying it of the one-dimensional images of women that pervade Jewish American men's fiction of the so-called golden age and repurposing it as a container for agentic self-representations.

Ulinich is one of many contemporary Jewish American woman writers who position their work as an intertextual response to male-dominated, masculinist literary traditions and imagine a space in which Jewish women's texts, voices, and experiences are made central to literary history. We see such allusive gestures in a number of twenty-first-century novels by Jewish women, including Meg Wolitzer's *The Wife* (2003), Nicole Krauss's *The History of Love* (2005), Dara Horn's *The World to Come* (2006), Rachel Kadish's *The Weight of Ink* (2017), Taffy Brodesser-Akner's *Fleishman Is in Trouble* (2019), and, most recently, Melissa Broder's *Milk Fed* (2021), which is discussed in chapter 8 of this volume. For decades, creative works of feminist exegesis have played with masculinist intertexts. From E. M. Broner's *A Weave of Women* (1985) and Anita Diamant's *The Red Tent* (1997) to Anna Solomon's *The Book of V* (2020) and Liana Finck's *Let There Be Light: The Real Story of Her Creation* (2022), Jewish American women authors have rewritten familiar biblical stories from fresh, female perspectives. We see similar moves, too, in pop-cultural texts. In the 2017 "American B***h" episode of Lena Dunham's *Girls*, for example, the protagonist, Hannah Horvath, embraces and then casts aside a signed copy of *When She Was Good* (1967), Philip Roth's sole attempt to narrate a novel from a female character's point of view. The book is gifted to Hannah during a coercive encounter with a fictional male author facing allegations of sexual misconduct from undergraduate women. At the climax of the episode, Hannah rejects, albeit ambivalently, the dubious gift of a masculinist literary tradition alongside the freighted desire for male approbation and sponsorship, which, she realizes, would come at the price of her own exploitation and the betrayal of her feminist ideals.[2]

By invoking masculinist intertexts and then tossing them in the metaphorical subway trash can, these women writers present us with a conundrum. The very act of pushing literary patriarchs aside in an effort to center women has the unintended consequence of reifying cultural reverence for the canonical male luminaries of Jewish American literature. The subversion narrative runs the risk of positioning women's writings as derivative and ancillary, suggesting that the only way to achieve recognition is through men—their books, their institutions, their aesthetics. The love-hate relationship with misogynistic patriarchs replays time and again, perhaps most predictably in debates about Philip Roth. To cite a recent example, the 2021 virtual panel "Rethinking American Jewish Literary Studies in the

#MeToo Era (or: Enough with Philip Roth)," sponsored by the Alan D. Leve Center for Jewish Studies at UCLA, focused almost entirely on Roth (and the controversy over Blake Bailey's biography), with panelists arguing, contra the parenthetical in the title, that Roth's work should continue to be taught and studied. Despite the fact that the panel signaled an interest in moving away from the suppressive logics of the canon, going so far as to invoke #MeToo's ethical imperative to amplify women's voices and take their stories seriously, women writers were rarely mentioned.[3] Given the major roles Jewish women writers have played in every facet and phase of Jewish American literary history, there are, of course, plenty of authors who could have been cited and discussed—so many, in fact, that this volume has space to address only a tiny fraction of them.

Matrilineal Dissent: Women Writers and Jewish American Literary History rethinks Jewish American literary studies by examining Jewish women writers' wide-ranging contributions to American literary culture from the early twentieth century through the present. As writers, editors, and readers, women have consistently been at the forefront of Jewish American literature. While remaining attentive to gendered constraints on production, consumption, and reception, this book's reframing of Jewish American literary history shows women to be dominant players working within mainstream cultural institutions and creating institutions of their own. The perception that women are marginalized outsiders, relegated to the fringes of Jewish literary production in the United States and in need of reparative critical attention, is due in large part to the way that literary history has been told: through the distorting lenses of patriarchy and misogyny.

By tracing alternative lineages of Jewish American writing, the essays in this volume examine how women authors systematically write against reflexive and monolithic understandings of Jewishness in America and toward new modes of belonging to heterogeneous and emergent communities. This book's very form—a collection of essays that grew out of conversations at a national conference, coedited by three scholars with different areas of disciplinary expertise—attests to one of its driving premises: the crucial role played by communities, literary and otherwise, in sustaining women's writing and the power of literature to develop, nurture, and reimagine communities in turn.

Rather than taking the contemporary period as a starting point, as other anthologies have done, this book traces Jewish women's writing in

the United States back to the turn of the twentieth century.[4] In situating literary works as products of their historical moment while also locating enduring concerns that connect Jewish American women's literature across time and place, this collection foregrounds relationality as a hermeneutic practice as well as a strategy of survival. As the contributors to this volume explore various political projects that grow out of and through women's writing, Jewish American texts, canonical and lesser known, emerge as tools and living practices. They become companions in ongoing efforts to challenge and disrupt essentializing representations of Jewish life, culture, religion, and identity in American literary studies—a process that bears significant implications for the timely project of decolonizing Jewish studies.

Comprising nine critical assessments by established and emerging scholars and a moderated conversation featuring Mizrahi women writers, *Matrilineal Dissent* showcases critical and scholarly approaches that have redefined feminist literary study, from intersectional feminism and the #MeToo movement to queer theory and disability studies. The essays situate Jewish American women's writing as products of communal and commercial networks that shape literary production, dissemination, marketing, and reception. Several of the contributions offer important reassessments of literature from the early and mid-twentieth century, highlighting middlebrow, Progressive Era, Yiddish, and second-wave feminist works that present alternatives to familiar assimilation narratives. Others engage with twenty-first-century texts, accounting for innovations in contemporary literary form and genre by considering, for example, the recent popularity of autofiction and graphic narratives. The impact of both is evident in our editorial framing: this introduction opens with Ulinich's semiautobiographical graphic narrative, while our cover, as we later discuss, features an image of Lilith from cartoonist Liana Finck's irreverent adaptation of the book of Genesis. The fact that this collection incorporates so many genres—including novels, periodical fiction, plays, poetry, autobiography, literary biography, and even screenwriting—testifies to how influential Jewish women writers have been in every facet of literary culture.

As several essays in this collection make clear, the misconception that Jewish women writers are secondary to the towering male figures of Jewish literary history is reinforced by a particular breakthrough narrative.

This narrative revolves around a "golden age" of Jewish American literature, and especially fiction, in which second-generation Ashkenazi writers—almost all men, plus one or two token women—burst onto the literary scene in the post–World War II period and redefined what it meant to be Jewish, American, and Jewish American.[5] This inaccurate version of Jewish literary history, which places Ashkenazi men at the center, has exerted tremendous power and influence, holding sway not just in scholarship but even in much of contemporary Jewish women's literary culture, as our opening examples of critical intertextuality suggest. *Lena Finkle's Magic Barrel* registers the danger of this hegemonic narrative when Roth's dismissiveness forces Ulinich's protagonist into alternating positions of fawning supplication and explosive rebellion. More critical and expansive considerations of the canon offer generative possibilities for writers and scholars alike, bringing into focus alternative worlds of writing—worlds that the pieces in this collection describe, theorize, and even help build.

Part of the project of recognizing literature outside of the golden handcuffs of institutional value entails challenging, too, the story of Jewishness in America that undergirds the breakthrough narrative. While establishing a canon built on literary celebrity has had political utility for Jewish studies as a field, the valorization of white Jewish cis-het male authors in the postwar period tends to reinforce a narrative of assimilation and secularization in which immigrants and religious observance are relegated to a nostalgic past. This process of canonization elides, for example, the extensive body of literature by Soviet and Mizrahi immigrant women writers as well as by Orthodox women and those grounded in spiritual and devotional traditions. When literary historians advance a teleological narrative of American Jewishness that moves from immigration to assimilation and then to a contemporary moment of triumphant diversification and inclusion, they reinforce the idea that a flourishing world of letters was made possible only by the coherence and solidity of a white, upwardly mobile, patriarchal Jewish identity to which we are all indebted. By diving back into Jewish women's literary history and foregrounding innovative literary contributions in the contemporary moment, we find a wealth of authors and frameworks that not only challenge but sometimes operate beyond the confines of masculinist institutions.

Matrilineage as Dissent

While our title invokes the halachic notion that Jewishness is passed down through the biological mother, this collection challenges problematic and essentializing notions of kinship, gender, and inheritance tied exclusively and primarily to genetics. In titling this collection *Matrilineal Dissent*, we aim to animate the multiple and sometimes contradictory modes of Jewish women's resistance in US literary history.

The long-standing association between Jewish women and rebellion has come to occupy a kind of mythical status in Jewish American memory, especially among left-leaning Jews from the early twentieth century onward. This popular historical imagination fixates on the fearlessness of Jewish women activists, from the young women who joined Progressive Era picket lines and those who went south during the civil rights movement to the radical firebrands of women's liberation. Icons of progressive politics extend from the biblical matriarchs, who have been reclaimed as symbols of enlightened egalitarianism, to unapologetically Jewy "Jewesses," who have become a mainstay of twenty-first-century television. Nowhere is the veneration for Jewish women's resistance more apparent than in the millennial fixation on Justice Ruth Bader Ginsburg as an iron-pumping icon of liberal discontent—the queen of dissent.[6] While the importance of each of these figures and movements is undeniable, the easy equivalence drawn between radically different political projects and historical moments flattens nuances and masks complex internal dynamics. And while positive, empowering representations of Jewish women trailblazers have proliferated, antisemitic tropes have also coalesced around Jewish women's iconoclasm, feeding into broader fears of Jews as unruly and threatening.

While this volume participates in the tradition of recognizing that Jewish women offer voices of dissent, it also seeks to complicate easy conflations of Jewish womanhood with leftist politics. We resist reading Jewish women's writing as inherently feminist or necessarily aligned with contemporaneous feminist "waves." On the contrary, Jewish women writers' political allegiances ran the gamut. This collection juxtaposes the oft-studied writer Adrienne Rich, who was well known for her feminist leadership, with the understudied Annie Nathan Meyer, an antiracist activist who was also one of the early twentieth-century's most provocative antisuffragists. Other authors, such as Marian Spitzer and Roz Chast, are less explicit

in their political projects, but their writing confronts social and cultural problems—including gender discrimination in the workforce and the invisibilization of care work—that feminism seeks to redress.

Our reframing of Jewish American literary history as matrilineal is intended as an act of dissent from readers and critics who continue to describe women's contributions as mere commentaries on and correctives to a canon that (they imagine) has always belonged to men. At the same time, we are careful not to romanticize dissent as Jewish women's birthright, troubling the politics of inheritance, continuity, and lineage to emphasize the ways that literary traditions—like Jewishness and gender—are mutually constitutive and continually in flux.

While the essays in this collection address twentieth- and twenty-first century Jewish women's writing, it is important to acknowledge how the reevaluation and recovery of nineteenth-century literary predecessors has dramatically reshaped our understanding of Jewish American literary history, demonstrating the pivotal role played by women writers as well as their audiences in building literary communities. When a Jewish American poetic tradition began to emerge in the decades immediately following the Civil War, it was dominated by the work of women such as Emma Lazarus, Penina Moïse, Minna Cohen Kleeberg, and Adah Isaacs Menken, some of whom descend from prominent Sephardic and/or southern families. These early figures disrupt the Ashkenormative assumption that Jewish American literary history began with the influx of Eastern European immigration in the late nineteenth century; so, too, do they disrupt the tendency to regard New York as the epicenter of Jewish diasporic culture. As evidenced by Broadview Press's cultural editions of Lazarus's and Menken's writings, as well as Esther Schor's 2006 biography of Lazarus, nineteenth-century poetry by Jewish American women is increasingly viewed as integral to the study and teaching of Jewish American literature and American literature more broadly.[7] Lazarus provides a high-profile example of the impact of nineteenth-century Jewish women writers on American culture; the words of her most famous poem, "The New Colossus" (1883), continue to fuel ideological debates about immigration, lifted from the plaque on which they are engraved at the base of the Statue of Liberty to appear on protest signs and in the tweets of Kamala Harris.[8]

Recovery efforts surrounding nineteenth-century Jewish American women's fiction have gained traction over the past decade as well. San

Francisco writer Emma Wolf has been the subject of several recent studies that build on earlier efforts to recognize her influence as one of the earliest Jewish American novelists. Focusing on her Jewish-themed domestic novels, *Other Things Being Equal* (1892) and *Heirs of Yesterday* (1900), this scholarship examines Wolf's treatment of topics such as intermarriage and Reform Judaism and demonstrates how late nineteenth-century fiction operated as a contested site for Jewish identity that was carefully policed by the male gatekeepers of the Jewish publishing industry.[9] And while Wolf was once hailed as "the mother of American Jewish fiction," the recent discovery of *Cosella Wayne* (1860), a serialized coming-of-age novel by Cora Wilburn, has altered the field once again, pointing to periodical culture as an often untapped resource for piecing together a more comprehensive genealogy of Jewish American women's writing.[10]

This collection makes no claims to provide exhaustive coverage of the long tradition of Jewish women's writing in the United States, aiming instead to showcase a variety of topics and methodological approaches. It builds on previous scholarly efforts to illuminate a matrilineal tradition of nineteenth- and twentieth-century Jewish American women's literature. In the 1990s, reference books such as *Jewish American Women Writers: A Bio-Bibliographical and Critical Sourcebook*, edited by Ann Shapiro, and monographs by scholars such as Diane Lichtenstein, Janet Burstein, Ellen Serlen Uffen, and S. Lillian Kremer laid the groundwork for future scholarship on Jewish American women's writing.[11] In 2007, Evelyn Avery edited *Modern Jewish Women Writers in America*, the first (and only other to date) anthology of essays about Jewish women writers spanning the early twentieth century to the present. While scholars have already identified a few of the twentieth-century figures covered in our volume (Erica Jong and Adrienne Rich, for example) with the tradition of Jewish American writing, the majority of writers discussed herein have received little, if any, acknowledgment in Jewish American literary scholarship.

Despite the promise of foundational efforts to build a canon of Jewish American women writers, we are mindful of the limitations of this early work. The tendency to celebrate obscured literary traditions sometimes had the effect of diluting complexity and resisting critique. This was especially evident when it came to scholarly considerations of race, class, and queerness—and the lack of consideration given to white privilege. In contrast to other minority literatures, Jewish American women's writing has never

truly blossomed as a subfield of academic inquiry, even as the literary tradition experienced extraordinary expansion and growth in the first decades of the twenty-first century, with new generations of writers experimenting with form and genre and taking on diverse themes including spirituality, disability, queerness, and race. Bolstered by institutions such as the Yiddish Book Center and the journal *In geveb: A Journal of Yiddish Studies*, Yiddish women's writing in the United States has coalesced around a community of feminist scholars, as Rachel Rubinstein discusses in her contribution to this volume. Academic research on Jewish American women's writing in English has not continuously thrived with the same sense of field-building, communal energy.

The relative stagnation of this subfield may be due to several factors, including the contested place of Jewishness in race and ethnic studies; the ways in which literary scholarship on Jewish femininity has sometimes been entrenched in white liberal feminism, with its tendencies toward celebratory narratives of reclamation and empowerment; and institutional funding structures that are beholden to the intersecting demands of academia and Jewish philanthropy. As Jessica Lang points out, the "urgency" that motivated early scholarship on Jewish American women's writing has "largely subsided" in part because, she argues, "feminism and discussions of gender have become more mainstream and built-in to critical analyses where once they were held apart or ignored." She warns, however, that "silent inclusion can be understood as in some ways regressive because it makes possible a re-inscription of the practice of marginalization."[12] In her essay in the collection, Annie Atura Bushnell offers another explanation for the lack of attention given to Jewish American women's writing, suggesting that Jewish explorations of femme abjection have worked at cross-purposes with liberal projects of literary recuperation. The languishing of Jewish American women's writing as an academic subfield is connected to the precarious positioning of its umbrella field: Jewish American literature is rarely valued as an academic focus, especially within English departments, due to its uneasy relationship both to the dominant American canon *and* to decolonial projects that disrupt that canon.[13]

Despite the uncertain status of the field of Jewish American literature, the past decade has seen the publication of a number of reference works and anthologies that point to vibrant new developments. These include,

for example, two anthologies published by Cambridge University Press, *The Cambridge History of Jewish American Literature* (2016), edited by Hana Wirth-Nesher, and *The New Jewish American Literary Studies* (2019), edited by Victoria Aarons. These volumes embed considerations of gender and women's writing in ways that recognize their centrality to the field and include surveys—most notably Lang's "Gender and Feminism in Contemporary Jewish American Writing"—that delineate Jewish American women's writing as a distinct subfield. Recent monographs published on Jewish American literature typically offer case studies of texts by women, even when their primary argument does not turn on questions of gender.[14] And a handful of twenty-first-century scholarly monographs have explicitly addressed the literary and cultural productions of Jewish women, taking up questions of gender in relation to racial appropriation, Orthodox Judaism, modernism, comics, and the Yiddish press.[15] These developments, as well as the missed opportunities and continued fortification of a male-dominated canon, indicate that the time is ripe for a renewed focus on alternative lineages of Jewish American writing.

Reframing Jewish American Literary History

Chapters in this collection illuminate a varied and complex tradition of Jewish American women's writing that spans more than a century. Roughly organized in chronological order, they allow us to trace developments across historical periods, from the early twentieth century to second-wave feminism and our contemporary moment. This chronological arrangement illuminates how Jewish women writers internalized and responded to the literary, communal, and national politics of the particular eras in which they wrote. At the same time, many of the themes that emerge in Jewish women's writing speak to recurring political concerns that connect Jewish women's experiences and literary production across time and place.

The first four essays explore writing that predates the male-dominated "golden age" of Jewish American literature. While immigrant narratives by Anzia Yezierska and Mary Antin remain the best-known literary texts by Jewish American women from this period—likely because they fit neatly into early ethnic studies narratives about assimilation—the initial essays in this collection avoid retreading familiar ground. Going beyond the setting

of the ghetto and the theme of Americanization, they document a much fuller tradition of Jewish American women's writing, from the proletarian and antiracist protest literature discussed by Ashley Walters and Lori Harrison-Kahan to the magazine fiction discussed by Jessica Kirzane.[16] Rachel Rubinstein's chapter explicitly draws a connection between the early twentieth century and our current moment by providing an overview of the robust tradition of Yiddish women's writing, which is currently experiencing a renaissance due to the translation efforts of feminist scholars. These chapters share an investment in recovery projects as a means of expanding our understanding of literary history, taking care to consider the cultural production of women whose work was rendered marginal or invisible by the academy.

Heated debates over race, immigration, and labor prevailed during the tumultuous first half of the twentieth century, and early Jewish women writers weighed in on these disputes. This volume demonstrates that Jewish women's writing was not solely preoccupied with the feminine trifecta of marriage, domesticity, and motherhood. Jewish women writers were interested in "women's issues," to be sure, and their writing consistently valorized the political importance of care work, but they also expressed outrage toward the American racial caste system, called attention to growing anti-immigration sentiments that were closely tied to antisemitism, and agitated on behalf of the working class, of which many of them were a member or product. They weighed in on intracommunal Jewish conflicts; decried sexual violence; and lamented the devaluation of human lives in a capitalistic, misogynistic, and white supremacist country. As the initial chapters of this volume show, the literary strategies and genres that Jewish women employed to explore and advance political commitments range from ethnoracial displacement and ventriloquism to fictionalized diaries and social protest drama.

Central to the feminist project of recuperation is a denaturalization of the aesthetic criteria applied to literary genres and a critical reevaluation of dismissive terms such as "middlebrow" and "sentimental." As Jessica Kirzane notes in her chapter, these categories serve as a pretext for marginalizing women's writing—especially works produced for mass entertainment markets, from popular magazines to Hollywood cinema—by marking it as trivial, lacking in complexity, and artistically and socially conservative.[17] While gender bias has shaped the reception and criticism

of women's texts across the board, the middlebrow designation has special resonance for Jewish women writers. Beginning in the early twentieth century, critics of mass culture increasingly associated the production of literature for popular audiences with Jewish authors and publishers. This problematic identification of Jews not only with industry gatekeeping and financial success but also with mediocrity and pandering to the masses lent credence to antisemitic conspiracies about Jewish artists and entrepreneurs corrupting high art, an accusation that gained traction on both sides of the Atlantic during the interwar period.[18] Jewishness, femininity, and the middlebrow became inextricably intertwined in the popular imagination. From best-selling early twentieth-century authors such as Edna Ferber and Fannie Hurst to popular contemporary writers such as Dara Horn and Jennifer Weiner, Jewish women writers have been accused of producing literature that is aesthetically inferior, and their work is often treated dismissively by critics and within the academy.[19]

Widespread criticism of the middlebrow in the early twentieth century helped pave the way for a male-dominated "golden age" of Jewish American writing. Essays in the latter half of this volume consider Jewish women's writing in the context of second-wave feminism and beyond, attending to the power dynamics that led to the breakthrough narrative of Jewish American literature. This narrative, and its lionization of a small pantheon of cultural producers, continues to silence women writers and circumscribe the reception of their work. The writers discussed by Josh Lambert and Alex Ullman have, to some extent, enjoyed more visibility among American audiences and in the field of literary studies than those addressed in the first half of the book. Lambert's exploration of Erica Jong—alongside the lesser-known novelist Susan Taubes—reconsiders a once enormously popular text, *Fear of Flying* (1973), in the era of #MeToo, while Ullman's chapter explores how Adrienne Rich and Audre Lorde's joint poetry readings conjured feminist counterpublics, spaces in which women writers could engage in conversation with one another and their audiences about race, religion, sexuality, and gender.

The second-wave feminist texts addressed in these essays provide an important vantage point from which to reevaluate the established canon of Jewish American literature. The essays in this volume refuse to treat misogyny as a pillar that cannot be moved or a sacrifice that must be made at the altar of literary greatness. They testify to the ubiquity and historical

consistency of sexual harassment and violence against women, as well as the ongoing struggle to render that violence visible in fiction, memoir, and poetry. From Harrison-Kahan's discussion of anti-lynching literature and Kirzane's exploration of Marian Spitzer's writings to Rubinstein's analysis of recent Yiddish translation projects and Lambert's treatment of Jong and Taubes, these essays encourage us to think about the implications of reading, translating, and teaching narratives of assault and the critical conversations they can foster among varied audiences.

While Jewish women were leaders and direct beneficiaries of white feminist activism in the 1960s and '70s, later political generations grew increasingly vocal about the limitations of feminist politics, sometimes contesting the perceived antisemitism of the women's movement and at other times challenging its narrowness, straightness, whiteness, and/or liberalism. Annie Atura Bushnell's exploration of Chris Kraus, author of the sleeper hit *I Love Dick* and a self-professed "bad feminist," captures how Jewish women writers in the 1990s rejected the liberal politics of second-wave feminism, embracing queer theory and experimenting with ethnic and sexual abjection in an era of feminist backlash.

Atura Bushnell's chapter on Kraus's 1997 work of autofiction and 2017 biography of Jewish punk heroine Kathy Acker serves as a bridge from the twentieth century to the twenty-first. The final three chapters of this volume explore new directions in Jewish women's writing by examining innovative contemporary texts that challenge conventional forms, genres, and identities. Building on her previous work on Jewish women cartoonists such as Aline Kominsky Crumb, Vanessa Davis, Miriam Libicki, and Liana Finck, Tahneer Oksman explores the connective nature of loss through a graphic narrative by Roz Chast and considers whether there is a particularly Jewish way to grieve. Oksman's attention to relationality echoes important contemporary scholarship that argues for more expansive and less hierarchical frameworks of religion (that is, building community through shared meaning-making) and the crucial role played by loss and nostalgia in contemporary American Jewish life.[20] Jennifer Glaser similarly turns to a multimodal text, highlighting how visual artist Riva Lehrer's *Golem Girl* (2020) mobilizes disabled and queer Jewish identities. Glaser charts how texts including Lehrer's memoir and Melissa Broder's comic novel *Milk Fed* reimagine the ancient mystical legend of the golem as a distinctly feminist, queer, and disabled conceit.

Like their early twentieth-century counterparts, contemporary women writers are aesthetic innovators who have diversified and critiqued representation along the lines of gender, class, sexuality, ability, and race. They have been important players in advancing intersectional approaches that challenge the hegemony of Ashkenazi identities and cultural heritage in the United States. While the emphasis on Ashkenazi writers in this collection reflects the historical reality that Eastern European immigrants and their descendants made up the majority of the US Jewish population in the twentieth century, Harrison-Kahan's essay on race in the work of Annie Nathan Meyer, who traces her Sephardi American heritage back to the nation's founding, opens a crucial conversation about Ashkenormativity and its exclusionary effects. The topic finds fuller elaboration in a conversation Karen Skinazi hosts with three Mizrahi writers: Jessica Soffer, Dalia Sofer, and Joyce Zonana.

Although this conversation concludes our volume, we view it not as a terminal point but as an invitation. Our hope is that reflection on the persistent Ashkenormativity of the field will lead to further scholarship on writers from diverse backgrounds, including Jewish writers of color, who have been neglected in academic research despite their undeniable impact on Jewish literary culture, politics, and communal life. Black Jewish memoirs, for example, have found a broad readership since the 1960s; like work by Asian American, Latina, Chicana, and Native American Jewish authors, these explorations of intersectional identity merit scholarship that refrains from tokenization and does more than celebrate their existence as an intervention into Ashkenormative spaces.[21] Similarly, we hope that Rachel Rubinstein's contribution will lead to further scholarship on the multilingualism of American women's writing expressed in languages such as Hebrew, Spanish, and Ladino as well as in English and Yiddish. Other areas deserving of more scholarly attention include Jewish women writers who have made trailblazing contributions to children's and young adult literature, from Sydney Taylor, Judy Blume, and Jane Yolen to Lesléa Newman, Carolivia Herron, and Veera Hiranandani.

The popularity of recent television series featuring Jewish protagonists such as *Transparent*, *Crazy Ex-Girlfriend*, *Unorthodox*, *My Unorthodox Life*, *Broad City*, *The Marvelous Mrs. Maisel*, and *Fleishman Is in Trouble*, as well as Tiffany Haddish's Netflix special *Black Mitzvah*, has drawn attention from scholars interested in Jewishness and gender in popular culture

and media.²² These shows reflect growing mainstream recognition of trans and nonbinary Jewish identities, transnational Jewish experiences, women in Haredi communities, and intergenerational trauma. The cultural preoccupation with on-screen representations of self-aware, postfeminist Jewish milieus and protagonists may help to invigorate literary scholarship on Jewish women's cultural production; the diverse archive of Jewish women's writing provides us with opportunities to explore these very topics with even greater depth and complexity than is captured in mainstream media alone.²³

Despite its continued undervaluation in the academy, Jewish women's literature—like the hit shows listed above—enjoys a wide and enthusiastic audience. We can find evidence of broad popular interest in Jewish American women's writing in the Jewish Women's Archive's virtual Book Talks, which began during Covid lockdown, as well as in long-standing programs such as the Hadassah-Brandeis Institute's Conversations Series and in publications such as *Lilith* magazine. These national literary institutions reflect the vibrancy of community-led discussions about Jewish American women's fiction, memoir, and poetry that take place online and in a variety of local settings around the country, including synagogue sisterhoods and Jewish community reading groups. Academic-adjacent projects such as the Jewish Women's Archive's recently updated *The Shalvi/Hyman Encyclopedia of Jewish Women*, which is easily accessible online and reaches an international audience, further exemplify this widespread interest in Jewish women's cultural production while providing important resources to fuel scholarly research. Academia does not have a monopoly on canonization, and scholars would do well to consider what the canons being built and reimagined by communities of lay readers tell us about gender politics and the cultural meanings of Jewishness.

In the recent graphic narrative *Let There Be Light: The Real Story of Her Creation*, cartoonist Liana Finck offers a retelling of the book of Genesis in which God is depicted as a woman. Finck's God may have lost the gray beard, but her embodiment is still self-consciously specific: lounging in the clouds, she wields a star-shaped wand and wears a tiny crown suggestive of girl-power princess fantasies. The author's note at the end of the book informs us that this playful vision of God emerged from Finck's own girlhood: "Studying the Torah at Hebrew Day School, I thought of it mostly as a

portrait of one childlike (and therefore relatable) character full of feelings and desires: God. . . . This book is an attempt to draw out that character as I saw her (since I started writing this book, it hurts to call God 'him') when I was young. Giving God a new gender—my own—was my first step toward reclaiming this work of literature for myself."[24] The childishness of Finck's portrayal—together with the book's epigraph from Jamaica Kincaid, in which she describes Genesis as "a book for children"—suggests that we must complicate narratives of feminist subversion as surely as Finck's God must outgrow her princess crown. The reappropriation of God as a woman is just the "first step" toward more radical reconfigurations of identity that disrupt gender binaries and patriarchal systems.

Finck takes a page out of the 1970s feminist playbook by recasting Lilith as a Miltonian hero. *Let There Be Light* depicts Lilith as a shadowy figure with a long, straight body and two thin ear-horn-antennae, somewhere between a snail's and a cat's. Finck's Lilith reads as a genderless shape-shifter, more creature than human. When God invites Adam to name the creatures of Eden, Lilith refuses Adam's name: "For your information, I am not named 'woman,'" Lilith insists. "I am **Lilith**, monster of the night!" While Finck's God lies to Adam about her true identity to protect Adam's fragile ego—God assures Adam, "I am an old man with a beard. You were right about everything"—Lilith absents themself from the scene rather than accept Adam's false image of them.[25] When Lilith next appears, they are offering Eve the apple from the Tree of Knowledge in a frame that recalls Michelangelo's "Creation of Adam." The tuft of hair we glimpse springing from Lilith's armpit as they hand the apple down to Eve is a winking feminist promise: this, too, is a real, fleshy body, one that the reader can inhabit regardless of their gender.

God is the grand mover of Finck's Genesis, the charismatic artist who struggles with loneliness, self-doubt, and tempestuous emotion. But she is also an enabler who seems overly concerned with men's opinions of her. "We twist ourselves into knots in our desire to be liked by men," declares a frame in the epilogue placed over an image of God lying prone on a cloud, looking down on her beloved patriarchs like a pining, lovesick teen. But if Finck's God may disappoint some feminist readers by pandering to men, Finck's Lilith offers other possibilities, becoming a redemptive creator in their own right. At the end of the narrative, Lilith is transformed from a serpent back into their original "monster" shape, and the closing

frame—featured on the cover of this book—shows Lilith's newly restored hands tenderly holding a lump of clay they have scooped directly from the earth.[26] While the Lilith of second-wave Jewish feminism was an icon of women's autonomy and self-determination, Finck's Lilith challenges the category of "woman" itself—an intervention made possible, not incidentally, by the groundbreaking work of Jewish queer and trans writers such as Leslie Feinberg, Kate Bornstein, and Judith Butler.

The chapters in this collection think with Jewish American women writers who offer multiple, often contradictory ways to grapple with gender and Jewishness. Some of these writers work within and redefine established identity categories, while others move us toward more radical acts of dissent, invention, and self-naming, rejecting not only masculinist traditions but also well-worn feminist narratives of women's liberation. In devoting these pages to them—and inviting more pages to come—we embrace women writers' world-making endeavors, exchanging the magic barrel for the unformed lump of clay.

Notes

Thank you to Josh Lambert for crucial feedback on an early draft of this introduction.

1. Anya Ulinich, *Lena Finkle's Magic Barrel: A Graphic Novel* (New York: Penguin, 2014), 182–83.
2. Similarly, a Philip Roth novel makes a cameo appearance in the 2022 television adaptation of *Fleishman Is in Trouble*. The copy of *Portnoy's Complaint* on Toby Fleishman's nightstand pays tribute to one of Brodesser-Akner's literary influences, even as the series mounts a narratological critique of the misogynistic solipsism that animates Roth's 1969 novel. Both Brodesser-Akner's novel and its adaptation reverse and subvert conventional gender dynamics by filtering a man's perspective on marriage and divorce through a woman narrator who appropriates his story—before further flipping the narrative to center women's experiences *and* points of view with the revelation that the "Fleishman" of the title is actually Rachel, a character who had been previously demonized as Toby's shrewish ex-wife.
3. The one exception was Lisa Halliday, the non-Jewish author of *Asymmetry* (2018), a Rothian novel in which a main male character, Ezra Blazer, is

unquestionably modeled on Philip Roth. See, for example, Karen Heller, "A Former Lover of Philip Roth Has Published a Novel about a Writer like Philip Roth," *Washington Post*, February 22, 2018; Alexandra Alter, "Lisa Halliday's Debut Novel Is Drawing Comparisons to Philip Roth. Though Not for the Reasons You Might Think," *New York Times*, February 2, 2018; and Debra Shostak, "My Philip Roth," *Philip Roth Studies* 15, no. 1 (2019): 135–41. On Blake Bailey's biography of Roth, see, for example, "Publisher Pauses Promotion of Best-Selling Roth Biography over Sexual Assault Claims," *Washington Post*, April 22, 2021; Alexandra Alter and Jennifer Schuessler, "What Happens to Philip Roth's Legacy Now?," *New York Times*, June 4, 2021; Andrew Anthony, "Philip Roth, Blake Bailey, and Publishing in the post–#MeToo Era," *Guardian*, June 27, 2021; and Alexandra Schwartz, "Blake Bailey, Philip Roth, and the Biography that Blew Up," *New Yorker*, April 23, 2021. Roth's death in 2018 also generated a feminist reckoning with his legacy; see, for example, Helene Meyers, "Why Did I Cry for Philip Roth?," *Lilith*, May 24, 2018; and Dara Horn, "What Philip Roth Didn't Know about Women Could Fill a Book," *New York Times*, May 25, 2018.

4 Collections of scholarly essays that focus on contemporary Jewish American women's writing include Lois Rubin, ed., *Connections and Collisions: Identities in Contemporary Jewish-American Women's Writing* (Newark: University of Delaware Press, 2005); and Jay L. Halio and Ben Siegel, ed., *Daughters of Valor: Contemporary Jewish American Women Writers* (Newark: University of Delaware Press, 1997).

5 For more on the ascendancy of the "golden age" narrative in Jewish American literary studies and critiques thereof, see Benjamin Schreier, *The Rise and Fall of Jewish American Literature: Ethnic Studies and the Challenge of Identity* (Philadelphia: University of Pennsylvania Press, 2020).

6 Annie Atura Bushnell, "The Weight of RBG's Crown: Jewish Feminism and Its Appropriations," *Studies in American Jewish Literature* 41, no. 2 (2022): 119–43.

7 Gregory Eiselein, ed., *Emma Lazarus: Selected Poems and Other Writings* (Broadview, 2002); Gregory Eiselein, ed., *Infelicia and Other Writings* by Adah Isaacs Menken (Broadview, 2002); and Esther Schor, *Emma Lazarus* (New York: Nextbook/Schocken, 2006).

8 That Jewish American women poets continue to exert significant influence on literary culture today is exemplified by the awarding of the 2020 Nobel Prize in Literature to Louise Glück.

9 On Wolf, see, for example, Barbara Cantalupo and Lori Harrison-Kahan, introduction to *Heirs of Yesterday*, by Emma Wolf, ed. Barbara Cantalupo

and Lori Harrison-Kahan (Detroit: Wayne State University Press, 2020), 1–79; Lori Harrison-Kahan, "'A Grave Experiment': Emma Wolf's Marriage Plots and the Deghettoization of American Jewish Fiction," *American Jewish History* 101, no. 1 (January 2017): 5–34; Jessica Kirzane, "Women, Love, and the Reform Jewish Mission: Jewish-Christian Marriage in Emma Wolf's *Other Things Being Equal* and Its Literary Successors," *American Jewish History* 104, no. 2/3 (April/July 2020): 289–322; and Josh Lambert, "The Jewish Jane Austen Whose Novels Were Almost Forgotten," *Lilith* 46, no. 1 (Spring 2021): 23–25. For an earlier consideration of Wolf alongside other nineteenth-century Jewish American women writers, see Diane Lichtenstein, *Writing Their Nations: The Tradition of Nineteenth-Century American Jewish Women Writers* (Indianapolis: Indiana University Press, 1992).

10 D. J. Myers, "Emma Wolf's Stories," dgmyers.blogspot.com/2010/05/emma-wolfs-stories.html. On *Cosella Wayne*, see Jonathan Sarna, "The Forgetting of Cora Wilburn: Historical Amnesia and *The Cambridge History of Jewish American Literature*," *Studies in American Jewish Literature* 37, no. 1 (Spring 2018): 73–87.

11 See Lichtenstein, *Writing Their Nations*; Janet Burstein, *Writing Mothers, Writing Daughters: Tracing the Maternal in Stories by American Jewish Women* (Urbana: University of Illinois Press, 1996); Ellen Serlen Uffen, *Strands of the Cable: The Place of the Past in Jewish American Women's Writing* (New York: Peter Lang, 1992); and S. Lillian Kremer, *Women's Holocaust Writing: Memory and Imagination* (Lincoln: University of Nebraska Press, 1999).

12 Jessica Lang, "Gender and Feminism in Contemporary Jewish American Writing," in *The New Jewish American Literary Studies*, ed. Victoria Aarons (Cambridge University Press, 2019), 91.

13 On the lack of value accorded to Jewish American literature within English departments, see, for example, Lori Harrison-Kahan and Josh Lambert, "Guest Editors' Introduction. Finding Home: The Future of Jewish American Literary Studies," *MELUS* 37, no. 2 (Summer 2012): 5–18. On Jewish literature's relationship to ethnic studies, see, for example, Jonathan Freedman, "Do American and Ethnic American Studies Have a Jewish Problem; or, When Is an Ethnic Not an Ethnic and What Should We Do about It?" *MELUS* 37, no. 2 (Summer 2012): 19–40.

14 Examples by contributors to this volume include Josh Lambert, *Unclean Lips: Obscenity, Jews, and American Culture* (New York: New York University Press, 2013); Rachel Rubinstein, *Members of the Tribe: Native America in the Jewish Imagination* (Detroit: Wayne State University Press, 2010);

and Jennifer Glaser, *Borrowed Voices: Writing and Racial Ventriloquism in the Jewish American Imagination* (New Brunswick, NJ: Rutgers University Press, 2016).

15 See Lori Harrison-Kahan, *The White Negress: Literature, Minstrelsy, and the Black-Jewish Imaginary* (New Brunswick, NJ: Rutgers University Press, 2011); Karen E. H. Skinazi, *Women of Valor: Orthodox Jewish Troll Fighters, Crime Writers, and Rock Stars in Contemporary Literature and Culture* (New Brunswick, NJ: Rutgers University Press, 2018); Amy Feinstein, *Gertrude Stein and the Making of Jewish Modernism* (Gainesville: University of Florida Press, 202); Tahneer Oksman, *"How Come Boys Get to Keep Their Noses?": Women and Jewish American Identity in Contemporary Graphic Memoirs* (New York: Columbia University Press, 2016); and Ayelet Brinn, *A Revolution in Type: Gender and the Making of the American Yiddish Press* (New York: New York University Press, 2023). For additional examples of scholarship focusing on Yiddish women writers, see chapter 4 in this volume by Rachel Rubinstein. Several journal special issues have also been devoted to Jewish American women writers; for a recent example, see the special issue "The Modern Jewess: Image and Text," *Shofar* 39, no. 3 (Winter 2021), guest edited by Keren Hammerschlag.

16 Early twentieth-century Jewish women writers, including Emma Wolf, Miriam Michelson, and Thyra Samter Winslow, were, like Spitzer, frequent contributors to the *Smart Set* and other popular magazines. For selections of this magazine fiction, which usually did not address Jewish themes explicitly, see Barbara Cantalupo, ed., *Emma Wolf's Short Stories in the Smart Set* (New York: AMS Press, 2010); and Lori Harrison-Kahan, ed., *The Superwoman and Other Writings by Miriam Michelson* (Detroit: Wayne State University Press, 2019).

17 Coined in the 1920s, the term "middlebrow" was used to cast aspersions on the mass culture, and especially the literary culture, of the middle class. On the history of the middlebrow in the United States, see Lisa Botshon and Meredith Goldsmith, introduction to *Middlebrow Moderns: Popular American Women Writers of the 1920s*, ed. Lisa Botshon and Meredith Goldsmith (Boston: Northeastern University Press, 2003), 3–21. On the connection between middlebrow writing and Hollywood cinema, see Hilary Hallet, *Go West, Young Women! The Rise of Early Hollywood* (Berkeley: University of California Press, 2013); Karen Mahar, *Women Filmmakers in Early Hollywood* (Baltimore: Johns Hopkins University Press, 2006); Rosanne Welch, *When Women Wrote Hollywood: Essays on Female Screenwriters in the Early Film Industry* (Jefferson, NC: McFarland, 2018); and

Cari Beauchamp, *Without Lying Down: Frances Marion and the Powerful Women of Early Hollywood* (Berkeley: University of California Press, 1998). Sonya Levien provides an interesting parallel to Marian Spitzer. On Levien, see Larry Ceplair, *A Great Lady: A Life of the Screenwriter Sonya Levien* (London: Scarecrow Press, 1996).

18 On the history of the American publishing industry and Jews, see Josh Lambert, *The Literary Mafia: Jews, Publishing, and Postwar American Literature* (New Haven, CT: Yale University Press, 2022). On antisemitic associations between Jews and mass culture, see Jonathan Freedman, *The Temple of Culture: Assimilation and Anti-Semitism in Literary Anglo-America* (Oxford: Oxford University Press, 2000).

19 On Ferber, Hurst, and the middlebrow, see Harrison-Kahan, *White Negress*, 73–75. Regarding debates over Dara Horn's 2021 book, *Why People Love Dead Jews*, and accusations about its middlebrow appeal, see Shaul Magid, "Savoring the Haterade: Why Jews Love Dara Horn's 'People Love Dead Jews,'" *Religion Dispatches*, October 20, 2021. On Weiner, see, for example, Rebecca Mead, "Written Off: Jennifer Weiner's Quest for Literary Respect," *New Yorker*, January 5, 2014; and Constance Grady, "How a Twitter War in 2010 Helped Change the Way We Talk about Women's Writing," Vox, December 15, 2019, www.vox.com/culture/2019/12/15/20991839/jennifer-weiner-jonathan-franzen-vida-count-2010.

20 On new frameworks of communal meaning-making in contemporary Judaism, see Rachel Gross, *Beyond the Synagogue: Jewish Nostalgia as Religious Practice* (New York: New York University Press, 2021).

21 The most politically influential memoir by a Black Jewish woman may be Rebecca Walker's memoir *Black, White, and Jewish: Autobiography of a Shifting Self* (New York: Riverhead Books, 2001); other Black Jewish memoirs include Lisa Jones's *Bulletproof Diva: Tales of Race, Sex, and Hair* (New York: Doubleday, 1994), Rain Pryor's *Jokes My Father Never Taught Me: Life, Love, and Loss with Richard Pryor* (New York: Regan, 2006); and Marra B. Gad's *The Color of Love: A Story of a Mixed-Race Jewish Girl* (Chicago: Bolden, 2019). Asian American Jewish women writers include Gabrielle Zevin, Carmit Delman, Helen Kiyong Kim, and Veera Hiranandani. Influential Latina Jewish and Chicana Jewish writers include Ruth Behar, Marjorie Agosín, and Aurora Levins Morales. For a recent example of Native American Jewish writing, see Emily Bowen Cohen's graphic novel, *Two Tribes* (New York: HarperCollins, 2023). Memoirs by women writers, including Mira Jacob, Hettie Jones, and Rosario Morales, explore interracial partnerships between white Jews and non-Jewish people of color.

22 See Hannah Schwadron, *The Case of the Sexy Jewess: Dance, Gender, and Jewish Joke-Work in US Pop Culture* (New York: Oxford University Press, 2018); Shaina Hammerman, *Silver Screen, Hasidic Jews: The Story of an Image* (Bloomington: Indiana University Press, 2018); Steven J. Ross and Vincent Brook, eds., *From Shtetl to Stardom: Jews and Hollywood* (West Lafayette, IN: Purdue University Press, 2017); Ari Brostoff, *Missing Time: Essays* (Brooklyn, NY: n + 1 Books, 2022); Samantha Pickette, *Peak TV's Unapologetic Jewish Woman: Exploring Jewish Female Representation in Contemporary Television Comedy* (Lanham, MD: Lexington, 2022); Samantha Pickette, "In Hulu's 'Fleishman Is in Trouble,' Jewish Women Defy Their Stereotypes," *Hey Alma*, January 11, 2023, www.heyalma.com/in-hulus-fleishman-is-in-trouble-jewish-women-defy-their-stereotype; Jonathan Branfman, "Jewy/Screwy Leading Lady: *Crazy Ex-Girlfriend* and the Critique of Rom-Com Femininity," *Journal of Modern Jewish Studies* 19, no. 1 (2020): 71–92; Jonathan Branfman, "'Plow Him Like a Queen!': Jewish Female Masculinity, Queer Glamor, and Racial Commentary in *Broad City*," *Television and New Media* 21, no. 8 (2020): 842–60; and Hilene Flanzbaum, ed., "Jewish Women in Popular Culture," special issue, *Studies in American Jewish Literature* 41, no. 2 (2022).

23 The recent anthology *Off the Derech: Leaving Orthodox Judaism* (Albany: State University of New York Press, 2020), edited by Ezra Cappell and Jessica Lang, considers women's literary contributions to the genre of "off the derech" narrative, as does Skinazi's *Women of Valor*. It is also worth noting that one of the few areas in which Jewish women writers have been reliably considered is in terms of their contributions to Holocaust literature; writers such as Cynthia Ozick, Alicia Ostriker, and Marge Piercy often receive attention because their work is representative of both women's and Holocaust literature, and they thus "check two boxes." Indeed, the selective institutional preservation and amplification of women's Holocaust literature is worth exploring, especially as books like Gross's *Beyond the Synagogue* encourage us to understand nostalgia as a form of religious praxis.

24 Liana Finck, *Let There Be Light: The Real Story of Her Creation* (New York: Random House, 2022), 328.

25 Finck, 23, 26.

26 Finck, 322.

Bibliography

Aarons, Victoria, ed. *The New Jewish American Literary Studies*. Cambridge: Cambridge University Press, 2019.

Alter, Alexandra. "Lisa Halliday's Debut Novel Is Drawing Comparisons to Philip Roth. Though Not for the Reasons You Might Think." *New York Times*, February 2, 2018. www.nytimes.com/2018/02/02/books/in-lisa-hallidays-debut-novel-philip-roth.html.

Anthony, Andrew. "Philip Roth, Blake Bailey and Publishing in the Post-#MeToo Era." *Guardian*, June 27, 2012. www.theguardian.com/books/2021/jun/27/philip-roth-blake-bailey-publishing-metoo-ww-norton.

Atura Bushnell, Annie. "The Weight of RBG's Crown: Jewish Feminism and Its Appropriations." *Studies in American Jewish Literature* 41, no. 2 (2022): 119–43.

Avery, Evelyn, ed. *Modern Jewish Women Writers in America*. New York: Palgrave Macmillan, 2007.

Beauchamp, Cari. *Without Lying Down: Frances Marion and the Powerful Women of Early Hollywood*. Berkeley: University of California Press, 1998.

Botshon, Lisa, and Meredith Goldsmith. Introduction to *Middlebrow Moderns: Popular American Women Writers of the 1920s*, edited by Lisa Botshon and Meredith Goldsmith, 3–21. Boston: Northeastern University Press, 2003.

Bowen Cohen, Emily. *Two Tribes*. New York: HarperCollins, 2023.

Branfman, Jonathan. "Jewy/Screwy Leading Lady: *Crazy Ex-Girlfriend* and the Critique of Rom-Com Femininity." *Journal of Modern Jewish Studies* 19, no. 1 (2020): 71–92.

———. "Plow Him Like a Queen!': Jewish Female Masculinity, Queer Glamor, and Racial Commentary in Broad City." *Television and New Media* 21, no. 8 (2020): 842–60.

Brinn, Ayelet. *A Revolution in Type: Gender and the Making of the American Yiddish Press*. New York: New York University Press, 2023.

Brook, Vincent, Michael Renov, Lisa Ansell, and Steven J. Ross, eds. *From Shtetl to Stardom: Jews and Hollywood*. West Lafayette, IN: Purdue University Press, 2017.

Brostoff, Ari M. *Missing Time: Essays*. Brooklyn, NY: n+1 Books, 2022.

Burstein, Janet. *Writing Mothers, Writing Daughters: Tracing the Maternal in Stories by American Jewish Women*. University of Illinois Press, 1996.

Cantalupo, Barbara, ed. *Emma Wolf's Short Stories in the Smart Set*. New York: AMS Press, 2010.

Cantalupo, Barbara, and Lori Harrison-Kahan. Introduction to *Heirs of Yesterday*, by Emma Wolf, 1–79. Edited by Barbara Cantalupo and Lori Harrison-Kahan. Detroit: Wayne State University Press, 2020.

Cappell, Ezra, and Jessica Lang, eds. *Off the Derech: Leaving Orthodox Judaism*. Albany: State University of New York Press, 2020.

Ceplair, Larry. *A Great Lady: A Life of the Screenwriter Sonya Levien*. London: Scarecrow Press, 1996.

Feinstein, Amy. *Gertrude Stein and the Making of Jewish Modernism*. Gainesville: University Press of Florida, 2020.

Finck, Liana. *Let There Be Light: The Real Story of Her Creation*. New York: Random House, 2022.

Flanzbaum, Hilene, ed. "Jews, Women, and Popular Culture." Special issue, *Studies in American Jewish Literature*, 41, no. 2 (2022).

Freedman, Jonathan. "Do American and Ethnic American Studies Have a Jewish Problem; or, When Is an Ethnic Not an Ethnic and What Should We Do About It?" *MELUS* 37, no. 2 (Summer 2012): 19–40.

———. *The Temple of Culture: Assimilation and Anti-Semitism in Literary Anglo-America*. Oxford University Press, 2000.

Gad, Marra B. *The Color of Love: A Story of a Mixed-Race Jewish Girl*. Chicago: Bolden, 2019.

Glaser, Jennifer. *Borrowed Voices: Writing and Racial Ventriloquism in the Jewish American Imagination*. New Brunswick, NJ: Rutgers University Press, 2016.

Grady, Constance. "How a Twitter War in 2010 Helped Change the Way We Talk about Women's Writing." Vox, December 15, 2019. www.vox.com/culture/2019/12/15/20991839/jennifer-weiner-jonathan-franzen-vida-count-2010.

Gross, Rachel B. *Beyond the Synagogue: Jewish Nostalgia as Religious Practice*. New York: New York University Press, 2021.

Halio, Jay L., and Ben Siegel, eds. *Daughters of Valor: Contemporary Jewish American Women Writers*. Newark: University of Delaware Press, 1997.

Hallett, Hilary. *Go West, Young Women! The Rise of Early Hollywood*. Berkeley: University of California Press, 2013.

Hammerman, Shaina. *Silver Screen, Hasidic Jews: The Story of an Image*. Bloomington: Indiana University Press, 2018.

Hammerschlag, Keren, ed. "The Modern Jewess: Image and Text." Special issue, *Shofar* 39, no. 3 (Winter 2021).

Harrison-Kahan, Lori. "A Grave Experiment: Emma Wolf's Marriage Plots and the Deghettoization of American Jewish Fiction." *American Jewish History* 101, no. 1 (January 2017): 5–34.

———. *The White Negress: Literature, Minstrelsy, and the Black-Jewish Imaginary*. New Brunswick, NJ: Rutgers University Press, 2011.

Harrison-Kahan, Lori, and Josh Lambert. "Guest Editors' Introduction. Finding Home: The Future of Jewish American Literary Studies." *MELUS* 37, no. 2 (Summer 2012): 5–18.

Heller, Karen. "Review Asymmetry by Lisa Halliday." *Washington Post*, February 22, 2018. www.washingtonpost.com/entertainment/books/a-former-lover-of-philip-roth-has-published-a-novel-about-a-writer-like-philip-roth/2018/02/22/94261fe8-17e6-11e8-b681-2d4d462a1921_story.html.

Horn, Dara. "What Philip Roth Didn't Know about Women Could Fill a Book." *New York Times*, May 25, 2018. www.nytimes.com/2018/05/25/opinion/sunday/philip-roth-jewish-women-new-jersey.html.

Jones, Lisa. *Bulletproof Diva: Tales of Race, Sex, and Hair*. New York: Doubleday, 1994.

Kirzane, Jessica. "Women, Love, and the Reform Jewish Mission: Jewish-Christian Marriage in Emma Wolf's *Other Things Being Equal* and Its Literary Successors." *American Jewish History* 104, no. 2/3 (April/July 2020): 289–322.

Kremer, S. L. *Women's Holocaust Writing: Memory and Imagination*. Lincoln: University of Nebraska Press, 1999.

Lambert, Josh. "The Jewish Jane Austen Whose Novels Were Almost Forgotten." *Lilith*, April 26, 2021. lilith.org/articles/emma-wolf/.

———. *The Literary Mafia: Jews, Publishing, and Postwar American Literature*. New Haven, CT: Yale University Press, 2022.

———. *Unclean Lips: Obscenity, Jews, and American Culture*. New York: New York University Press, 2013.

Lang, Jessica. "Gender and Feminism in Contemporary Jewish American Writing." In *The New Jewish American Literary Studies*, ed. Victoria Aarons, 98–108. Cambridge: Cambridge University Press, 2019.

Lazarus, Emma. *Emma Lazarus: Selected Poems and Other Writings*. Edited by Gregory Eiselein. Peterborough, ON: Broadview Press, 2002.

Lichtenstein, Diane. *Writing Their Nations: The Tradition of Nineteenth-Century American Jewish Women Writers*. Indianapolis: Indiana University Press, 1992.

Magid, Shaul. "Savoring the Haterade: Why Jews Love Dara Horn's 'People Love Dead Jews.'" *Religion Dispatches*, October 20, 2021. religiondispatches.org/savoring-the-haterade-why-jews-love-dara-horns-people-love-dead-jews/.

Mahar, Karen W. *Women Filmmakers in Early Hollywood*. Baltimore: Johns Hopkins University Press, 2006.

Mead, Rebecca. "Jennifer Weiner vs. the Literary Media." *New Yorker*, January 5, 2014. www.newyorker.com/magazine/2014/01/13/written-off.

Menken, Adah I. *Infelicia and Other Writings*. Edited by Gregory Eiselein. Peterborough, ON: Broadview Press, 2002.

Meyers, Helene. "Why Did I Cry for Philip Roth?" *Lilith*, May 24, 2018. lilith.org/2018/05/why-did-i-cry-for-philip-roth/.

Michelson, Miriam. *The Superwoman and Other Writings by Miriam Michelson*. Edited by Lori Harrison-Kahan. Detroit: Wayne State University Press, 2019.

Myers, D. G. "Emma Wolf's Stories." *A Commonplace Blog*, May 30, 2010. dgmyers.blogspot.com/2010/05/emma-wolfs-stories.html.

Oksman, Tahneer. *"How Come Boys Get to Keep Their Noses?": Women and Jewish American Identity in Contemporary Graphic Memoirs*. New York: Columbia University Press, 2016.

Pickette, Samantha. "In Hulu's 'Fleishman Is in Trouble,' Jewish Women Defy Their Stereotypes." *Hey Alma*, January 11, 2023. www.heyalma.com/in-hulus-fleishman-is-in-trouble-jewish-women-defy-their-stereotype.

———. *Peak TV's Unapologetic Jewish Woman: Exploring Jewish Female Representation in Contemporary Television Comedy*. Lanham, MD: Lexington Books, 2022.

Pryor, Rain. *Jokes My Father Never Taught Me: Life, Love, and Loss with Richard Pryor*. New York: Regan, 2006.

Rubin, Lois E., ed. *Connections and Collisions: Identities in Contemporary Jewish-American Women's Writing*. Newark: University of Delaware Press, 2005.

Rubinstein, Rachel. *Members of the Tribe: Native America in the Jewish Imagination*. Detroit: Wayne State University Press, 2010.

Sarna, Jonathan. "The Forgetting of Cora Wilburn: Historical Amnesia and *The Cambridge History of Jewish American Literature*." *Studies in American Jewish Literature* 37, no. 1 (Spring 2018): 73–87.

Schor, Esther. *Emma Lazarus*. New York: Nextbook/Schocken, 2006.

Shostak, Debra. "My Philip Roth." *Philip Roth Studies* 15, no. 1 (2019): 135–41.

Schreier, Benjamin. *The Rise and Fall of Jewish American Literature: Ethnic Studies and the Challenge of Identity*. Philadelphia: University of Pennsylvania Press, 2020.

Schuessler, Jennifer, and Alexandra Alter. "What Happens to Philip Roth's Legacy Now?" *New York Times*, June 4, 2021. www.nytimes.com/2021/06/04/books/philip-roth-biography-blake-bailey.html.

Schwadron, Hannah. *The Case of the Sexy Jewess: Dance, Gender, and Jewish Joke-Work in US Pop Culture*. New York: Oxford University Press, 2018.

Schwartz, Alexandra. "Blake Bailey, Philip Roth, and the Biography That Blew Up." *New Yorker*, April 23, 2021. www.newyorker.com/culture/cultural-comment/blake-bailey-philip-roth-and-the-biography-that-backfired.

Shapiro, Ann, ed. *Jewish American Women Writers: A Bio-Bibliographical and Critical Sourcebook*. Westport, CT: Greenwood Press, 1994.

Shepherd, Katie. "'Philip Roth' Biographer Blake Bailey Loses Agent, Publisher Support following Sexual Assault Allegations." *Washington Post*, April 22, 2021. www.washingtonpost.com/nation/2021/04/22/blake-bailey-sexual-assault-allegations/.

Skinazi, Karen E. H. *Women of Valor: Orthodox Jewish Troll Fighters, Crime Writers, and Rock Stars in Contemporary Literature and Culture*. New Brunswick, NJ: Rutgers University Press, 2018.

Uffen, Ellen S. *Strands of the Cable: The Place of the Past in Jewish American Women's Writing*. New York: Peter Lang, 1992.

Ulinich, Anya. *Lena Finkle's Magic Barrel: A Graphic Novel*. New York: Penguin, 2014.

Walker, Rebecca. *Black, White, and Jewish: Autobiography of a Shifting Self*. New York: Riverhead, 2001.

Welch, Rosanne, ed. *When Women Wrote Hollywood: Essays on Female Screenwriters in the Early Film Industry*. Jefferson, NC: McFarland, 2018.

Wirth-Nesher, Hana, ed. *The Cambridge History of Jewish American Literature*. New York: Cambridge University Press, 2016.

1

WOMEN WHO WOULDN'T

Early Twentieth-Century Jewish Women's Proletarian Literature and Ethnoracial Displacement

Ashley Walters

On November 22, 1909, in a packed hall at Cooper Union in New York City, nearly three thousand garment workers—mostly young Jewish women from Eastern Europe—decided to go on strike. After union leaders had subjected the agitated audience to hours of cautious speeches, a young worker named Clara Lemlich climbed the platform and delivered a rousing call in Yiddish for an immediate general strike.[1] Within days, twenty thousand to thirty thousand garment workers left their benches in the factories and sweatshops to agitate for better pay, shorter hours, safer working conditions, and union recognition in what would become the largest strike of women workers in the United States to date.[2]

Labor activist and author Theresa Serber Malkiel captured the spirit of the 1909 New York Shirtwaist Strike, also known as the "Uprising of 20,000," from the perspective of a young woman in a semifictional account titled *The Diary of a Shirtwaist Striker* (1910). Written as a first-person narrative from the perspective of Mary, an American-born Christian garment worker of Anglo-Saxon descent, the *Diary* retells the historical events of the strike as a coming-of-age story. Mary's ethnoracial and religious identity is not representative of the Shirtwaist Strikers generally—90 percent of the strikers were Jewish—and neither is the fact that she *chooses* to work outside the home. Mary enjoys the independence that her modest income affords her, while other garment workers, who primarily hail from Eastern

Europe, work out of dire necessity.[3] When a strike is formally declared, Mary finds herself a reluctant participant, but in a matter of days—hours even—she undergoes a remarkable transformation and begins to recognize her own privilege as an American-born worker. She quickly warms to the girls on the picket line, especially the Jewish ones, and lauds them for their exceptional resolve and tenacity, all the while decrying the injustices of the factory owners, the police, and the American legal system. To Mary, the Eastern European Jewish strikers and their politics, formerly distant and unintelligible, are recast into a new ideal. Following the lead of the Jewish strikers, Mary is converted from an indifferent bystander to a socialist and budding feminist, and when the strike ends in early 1910, Mary is still standing on the picket line.[4]

The *Diary* belongs to a small and understudied body of Jewish women's proletariat fiction that emerged during the early 1900s in response to the early labor movement's hostility toward women workers and the public's unsympathetic view of working-class women. A number of Eastern European Jewish women on the radical Left turned to writing fiction in hopes of bringing uninitiated women workers into the movement. In part, this literature was intended to serve as a how-to guide for young women and girls by modeling women workers' consciousness raising and activism. Their work showcased political heroines' agency through uplifting stories of rebellion and aimed to foster a new sense of sisterhood that would—at least theoretically—transcend ethnoracial and religious boundaries. Literature by Jewish women writers and activists in the American labor and socialist movements offers a window into how Jewish women radicals understood their agency as protesters and as members of a newly coalescing radical community.[5] This literature also highlights the strategies Jewish women writers deployed to combat growing antisemitism and nativist politics during the early 1900s.

Although the *Diary* was written by an Eastern European Jewish immigrant who played an important role in organizing the Shirtwaist Strike, its protagonist is conspicuously unlike its author. Malkiel's choice to center a white Christian girl of Anglo-Saxon descent is noteworthy given that the vast majority of strikers were Jewish. Indeed, the strike put Jewish women workers on the map as a key demographic for labor organizing.[6] In Malkiel's rendering, a white Anglo-Saxon Christian worker becomes the poster girl for a largely Jewish movement, raising important questions

about privilege and the perceived legitimacy of Jewish women's voices during this time.

It was not unusual for proletarian fiction in the late nineteenth and early twentieth centuries to displace Eastern European Jewish identities. The genre typically featured white Anglo-Saxon Christian characters rather than centering the immigrant communities who frequently served as real-life models for fictionalized treatments of working-class realities. As committed socialists and savvy consumers of literature, these authors sought to reach non-Jewish audiences in order to communicate the objectives and principles of the movement in their fiction. Focalizing the narrative through unmarked white Christian characters allowed both non-Jewish and Jewish authors to write radical interethnic communities into existence by presenting the struggle for labor through a so-called universalist lens. That universalism was most compelling to white Christian audiences when it was packaged as white and Christian.[7] Women labor activists and socialist writers, like Malkiel and Rose Pastor Stokes, likely feared that ethnoracial specificity might detract from class-based labor politics and women's issues. As a result, they privileged class and gender solidarity above all other distinctions.

This chapter explores the striking degree of ethnoracial displacement within Jewish women's proletariat fiction through an analysis of two texts: Malkiel's *The Diary of a Shirtwaist Striker* (1910) and Stokes's play *The Woman Who Wouldn't* (1916). There is a certain irony to Jewish women authors displacing Jewishness (if not erasing it altogether) in order to render immigrant working-class struggles more visible, especially given the popularity of ghetto fiction by Jewish authors during the early twentieth century.[8] The racial instability of Eastern European Jewish identities in a country riddled by debates over immigration, eugenics, and the future "character" of the country—not to mention the contested state of the labor movement and socialism in the United States—led Jewish women writers to speak in their literature from the position of unambiguously white people in order to bestow a greater sense of legitimacy on their radical politics and reach a broader audience.[9] The literary and political strategy of ethnoracial displacement certainly raises important questions about the narrative's believability (girls like Mary certainly existed in real life, but they were not typical among garment workers at the time). By downplaying the ethnoracial specificity of the radical Left and working-class politics during the

Progressive Era, these writers also, I argue, contributed to a centering of whiteness in depictions of the labor movement and in American proletarian literature well into the 1920s.[10]

The literary choices made by authors like Malkiel and Stokes convey a wealth of information about the positionality of Jewish immigrant women who spurned established gender norms in the early twentieth century and offered an alternative model of immigrant femininity for American audiences. By depicting working-class women rejecting American social norms, Malkiel and Stokes wrote new frameworks of radical femininity into existence. The young women who populated their fiction enjoyed intellectual independence, explored alternative models of family and romantic partnership, and found their place in communities grounded in equality. Jewish women proletarian authors sought to generate broader acceptance of this new womanhood by modeling virtuous radicalism for a young female readership and a reading public who may or may not have been predisposed to leftist politics. History has not been kind to these works, which remain largely forgotten and either unpublished or out of print.[11] The muted reception of women's labor literature at the time echoes the unfavorable response women and girl strikers received on the picket line. In a symbolic economy in which men are imagined as workers/producers/writers and women as domestics/mothers/consumers, literature by women about women's struggle for visibility in working-class politics sits uneasily within the wider genre of proletariat fiction, which privileged men's experiences.

The depiction of young working-class women rebelling against class and gender discrimination helped pave the way for a new generation of Jewish women writers who emerged in the 1920s. These later authors explicitly depicted ethnoracial otherness in their writing about the working class. The ghetto tale that had once been the purview of Jewish men writers expanded to include a new generation of Jewish women writers, most notably Anzia Yezierska, who disregarded the leftist politics of an earlier generation of activist writers. While Malkiel and Stokes were willing to displace Jewishness for the sake of political expediency and universalist principles, Jewish women writers like Yezierska channeled the unapologetic voices of Jewish women in the early 1900s who emphatically rejected assimilation. Yezierska's writing critiqued the United States and capitalism by targeting efforts to "Americanize" immigrants. Like their Jewish women

protagonists, a new cohort of Jewish women writers embraced their ethnoreligious identities and were less likely to seek acceptance through ethnoracial displacement. They not only found literary success in their time but also became the basis of a Jewish feminist literary canon that began to emerge in the 1970s with the recovery of Yezierska's work.[12] In what follows, I demonstrate that Yezierska's predecessors are equally worthy of study; Malkiel's and Stokes's class- and gender-based politics and literature add complexity and nuance to preexisting normative frameworks of Jewish American political and literary history by introducing readers to early instances of Jewish working-class women's rage, their emphatic rejection of patriarchal and capitalist structures within their adopted country, and their use to ethnoracial displacement as a political and literary strategy.

A Question of Representation: Universalizing Jewish Women's Labor Struggles

Jewish immigrants found departure from friends and family in Eastern Europe to be a difficult experience compounded by the many challenges they faced once they arrived in the United States. The substitution of intimate communities and close-knit families with anonymity in urban settings was often traumatic and exacerbated by the precarious material circumstances in which Eastern European Jewish immigrant families found themselves. Many Jewish immigrants were children when they arrived and were forced to enter sweatshops and factories at very young ages. Annie Polland and Daniel Soyer explain that children's labor accounted for 30.7 percent of household income for Eastern European Jews in the United States during the early twentieth century, the highest percentage of any immigrant group.[13] For many Jewish adolescents, departure from Eastern Europe marked the end of their childhoods. Upon entering workshops, including large factories and smaller tenement-based operations, immigrant Jews found dirty, cramped, and poorly lit spaces that presented serious dangers to workers. Pay was low, hours were long, and seasons were irregular; moreover, many employers implemented a system of fines that squeezed already meager salaries. Women and girl workers were subjected to additional indignities, including yet lower pay and sexual harassment. While working conditions were often better in

larger factories, it was difficult for new immigrants to secure these coveted jobs without the proper connections. Even then, work in larger factories did not prevent terrible tragedies from occurring, such as the deadly Triangle Shirtwaist Factory fire in 1911.

The contrast between young immigrants' hopes for America and the realities they encountered when they arrived led to a deep-seated frustration. While an introduction to revolutionary thought in Eastern Europe may have planted early seeds of discontent, encounters with American capitalism compelled a sizable percentage of Jewish immigrants to join the burgeoning labor and socialist movements. Tony Michels explains that Jews were especially overrepresented among immigrant groups on the Left because of the enormous and growing Jewish working class fueled by mass immigration. The concentration of Jewish immigrants in the garment industry provided labor organizers with a large body of workers to mobilize, and a rise in the magnitude and scope of class conflict offered a fertile environment for the spread of socialist ideas. Crucially, Michels notes, the confluence of an earlier generation of German revolutionaries and a new cohort of Russian-speaking Jewish intellectuals on the Lower East Side led to a political exchange that provided the foundations for the Jewish radical Left.[14]

Many Eastern European Jewish men and women embraced the liberal promise of their adopted country by participating in American labor politics and agitating on behalf of socialism or anarchism. Historian Jonathan Frankel argues that revolutionary politics provided an opportunity for Jewish immigrants to express cosmopolitan identities rooted in a pluralist vision of the United States. Marxist values of universalism, rationalism, and scientific truth went hand in hand with immigrant desires to acclimate to a country that, they believed, shared those values.[15] As a result, an abiding disdain for American capitalism could and often did coexist with a genuine appreciation for the professed values of the early twentieth-century United States.

Among immigrant women in the opening years of the twentieth century, Eastern European Jewish women were the most politically engaged, and historians have long debated the origins of their activism. Susan Glenn argues that Jewish women were uniquely positioned to stake a public claim in the labor and socialist movements by virtue of their unique economic role as breadwinners within Eastern European Jewish families.[16] Alice

Kessler-Harris similarly notes that while Jewish women were encouraged to marry, they were also expected to be economically self-sufficient. Self-sufficiency coupled with a well-developed ethic of social justice produced "extraordinary militancy."[17] Annelise Orleck demonstrates how similar life trajectories and shared cultural and social backgrounds underpinned Eastern European Jewish women's radicalism, which she describes as a heady "combination of Isaiah, Marx, and strong maternal examples."[18] The breakdown of traditional Jewish society in Eastern Europe toward the end of the nineteenth century afforded Jewish women the opportunity to question patriarchal norms and imagine alternative possibilities for themselves. Many Jewish women had been introduced to revolutionary thought by friends and family members prior to immigration and already possessed a radical lens through which they could view their new country. In American labor and socialist movements, these women discovered a cosmopolitan milieu and universalist ideologies that afforded them a sense of community, purpose, and hope.

Regardless of their optimism and commitments, labor activists faced unique obstacles to organizing women workers—most notably the changing nature of industry at the turn of the century and widely held misogynistic views toward women's work. Factory mechanization increasingly allowed employers to pursue cheaper forms of unskilled labor (that is, women and children), undermining the security and masculine identity of the working class. The nineteenth-century "cult of domesticity" led many to view women workers as impermanent and their wages as supplemental—the perceived objective for women and girl workers being marriage, domesticity, and maternity. As a result, Kessler-Harris writes, "[a]ppeals to morality and the duties of motherhood obscured the economic issues involved."[19] The assumed priorities of marriage and motherhood for women workers hampered their ability to be taken seriously by employers, labor leaders, and even one another. The prevailing opinion was that women's financial independence presented a direct challenge to men's authority and control. Working-class women were caught in a liminal space between a trade union movement—dominated by men who were hostile to economic competition by women—and a women's movement whose leadership was primarily middle and upper class. The question of who was best suited to define the issues for working-class women—let alone advocate for them—remained unclear.[20]

The 1909 Shirtwaist Strike represented a culmination of these tensions (as well as three years of assiduous organizing) and marked a turning point for women's labor. Malkiel describes what motivated the 1909 strike in the socialist daily, the *New York Call*: "It was not a woman's fancy that drove them to it, but an eruption of a long smoldering volcano, an overflow of suffering, abuse, and exhaustion."[21] The young immigrant women who participated in the strike—likely their first—found the experience catalytic and were thrilled by their newfound ability to upend a gargantuan industry while withstanding the hardships of unemployment.[22] The press, the American public, and industry leaders, on the other hand, were unsympathetic to the women's cause. Newspaper coverage of strikers generally ranged from critical to hostile and focused neither on the demands of the strikers nor on the workplace conditions they were protesting. Instead, journalists reported on the unconventional comportment and appearance of the young strikers, casting them as illegitimate workers with illegitimate concerns and as young women and girls behaving badly. The press and general public viewed women's employment in urban industrial settings and the independence it afforded them as an affront to Victorian standards of decorum and modesty.[23] Depictions of young women protesting on street corners and fabricated reports of girls violently attacking the police and strikebreakers unnerved a nation already in the midst of a gender revolution. It was not until prominent middle- and upper-class reformers and society women became involved in the strike that the tone of the press coverage began to soften. Even then, public sympathy for the strikers was in short supply.[24]

The central challenge for labor organizers and socialist writers alike was how to portray women's militancy and the values that underpinned it in a positive light for broader American audiences. The solution they embraced was to universalize—that is, to whiten—the proletarian struggle. This strategy did not originate with Jewish women writers but with the development of American naturalism. Decades before this new literary movement took hold in the United States, Rebecca Harding Davis introduced readers to white working-class realities in her 1861 short story, "Life in the Iron-Mills."[25] As literary realism and naturalism grew in popularity during the late nineteenth century, notable American writers such as Stephen Crane, Theodor Dreiser, Jack London, Frank Norris, and Upton Sinclair rejected the romanticism and sentimentality of a previous

generation and turned to the factory floor, marketplace, and working-class urban neighborhoods as topics worthy of literary consideration. These authors sought to convey the brutality of daily life among American workers tethered to industry.[26] Following in their footsteps and armed with patrician entitlement and diplomas from top universities, a new generation of aspiring writers and journalists, including Ernest Poole, Arthur Bullard, Kellogg Durland, William English Walling, and Leroy Scott took to the Lower East Side with three objectives: to study working-class life and culture, advocate for meaningful legislative reform, and render the humanity of the working class legible to middle- and upper-class audiences. Few were card-carrying socialists by this point, but they all would be within a couple of years.[27]

Central to the success of these authors' political mission was the question of how to represent undesirable subjectivities to audiences in a sympathetic light. There were certainly literary representations of Jewish life that sold well within the early twentieth-century American literary marketplace. Intimate exposés by journalists Jacob Riis's *How the Other Half Lives* (1890) and Hutchins Hapgood's *The Spirit of the Ghetto* (1902) were a product of and catalyst for mass reform movements targeting America's urban neighborhoods.[28] The enormously successful "ghetto fiction" penned by Jewish authors, including Israel Zangwill, Abraham Cahan, and Anzia Yezierska would become, as Lori Harrison-Kahan explains, "Jewish writers' best known contribution to the broader movement of American literary realism."[29] Additionally, popular Jewish memoirs charting immigrant success reaffirmed foundational myths about the United States for American audiences—with Mary Antin's *The Promised Land* being the most prominent example.[30]

Josh Lambert highlights the paucity of Jews in the early twentieth-century publishing industry and argues that Jews were "literarily disenfranchised"—that is, they were "denied, on the basis of their collective identities, opportunities to participate in the literary system as individuals."[31] Ironically, even the Jewish publishing industry (most notably the Jewish Publication Society) often refused to publish certain kinds of representations of Jews, leading some Jewish writers to purge their work of Jewish content in order to publish with secular presses.[32] This would change over the coming decades when Jews would enter the publishing industry and the academy in sizable numbers, but their exclusion during

the first half of the twentieth century impacted authors' capacity to publish diverse representations of specifically Jewish working-class experiences.[33]

One might expect that the systematic erasure of Jewish subjectivities in working-class fiction would compel emerging Jewish authors to render their ethnoracial experiences all the more visible, but this was not the case. Jewish women writers and socialist activists internalized the universalism of the Left by defaulting to white Christian protagonists in the hope of rendering all working-class struggles legible and sympathetic. Yet Jewish characters did not completely vanish from these imagined worlds. White Christian protagonists frequently mediated between a white Christian Anglo-reading public and minor Jewish characters representing the Jewish immigrant working class and the growing Jewish radical Left.

Mediating the Jewish Left:
The Diary of a Shirtwaist Striker

The Diary of a Shirtwaist Striker by Theresa Serber Malkiel aims to capture history in motion, rendering seemingly foreign politics and characters intelligible and even laudable to mainstream American audiences. An epistolary novel that combines sensationalized journalistic literature, bildungsroman, and memoir (undoubtedly capturing some of Malkiel's firsthand experience of the strike), the *Diary* explores early twentieth-century labor organizing, socialism, and women's rights through the story of the 1909 Shirtwaist Strike.[34] Narrated from the perspective of a young American-born Christian garment worker named Mary, the novel traces her political evolution from an apathetic wage earner to a dedicated labor activist, feminist, and budding socialist.

Theresa Serber is today a little-remembered leader of the early twentieth-century Jewish women's labor movement. Born in 1874 in the small town of Bar, approximately 150 miles from Kiev in the Ukrainian region of the Russian Empire, her family joined the mass exodus of Jews leaving Eastern Europe between 1881 and 1924. Arriving in New York City in 1891, she, like many Jewish immigrant girls her age, went to work in a garment factory. Within a year, she joined the burgeoning labor movement and the Socialist Party of America (SP). She proved to be tremendously effective as a shop unionizer, a talent that would propel her to various

leadership roles in labor organizations and the SP. In 1900, she married fellow immigrant and socialist Leon A. Malkiel, a successful lawyer. While Malkiel's marriage and the birth of a daughter removed her from the factory floor, it also afforded her the time, independence, and financial support necessary to focus on her activism, and she quickly became a key player in the labor movement. She occupied a position on the executive board of the Women's Trade Union League, and when the SP formed the Women's National Committee in 1908 in response to women workers' widespread frustration with the lack of representation and attention to women's issues, Malkiel was elected as one of five representatives to the committee. When the 1909 strike erupted, Malkiel worked tirelessly to organize and publicize the strike in socialist newspapers. In 1910, she published a lengthy pamphlet to commemorate the strike, in addition to the fictionalized *Diary*.[35]

Like many women active in labor and socialist politics, Malkiel advocated for women's equality. She was a vocal critic of the "double burden" shouldered by working-class women and decried the domestic drudgery, unpaid labor, and sexual availability expected of women in marriage. She also criticized women for their perpetual dependence on men, encouraging them to reclaim their independence through a potent combination of suffrage, unionization, and socialism. Initially, Malkiel believed that socialism would provide a holistic solution, but it remained unclear how a Marxist revolution would reshape women's domestic lives. Over time, Malkiel became more active in woman's suffrage movements, motivated perhaps by the mounting hostility toward the Women's National Committee within the SP. Just as Malkiel took issue with the SP's disregard for women's issues, she found its approach to immigrant workers lacking. Minority groups were underrepresented among the leadership, and she believed that outreach efforts to foreign-language socialist organizations were insufficient. She encouraged party organizers to go into immigrant neighborhoods and speak to workers in their native Russian, Yiddish, Finnish, and German in hopes of drawing the various independent workers' organizations into the SP. She also wrote a women's column in the *Jewish Daily Forward*.[36]

The opening pages of the *Diary* introduce Mary as a politically naive young woman. As an American-born worker content with her lot, she marvels at the novelty of participating in a labor strike and confesses that peer pressure compelled her to join the strike. The *Diary* begins: "Ha, ha,

ha! that's a joke. By Jove, it is. I'm a striker . . . I must say I really don't know why I became one—I went down just because everybody else in the workroom did." Despite her dismissive tone, Mary is intrigued by the newfound sense of agency the strike affords her, noting, "And yet, it's a good thing, this strike is; it makes you feel like a real grown-up person."[37] Although she is unable to comprehend the purpose of the strike and fails to see any merit in the labor union, within twenty-four hours Mary's views begin to change. True to the actual events of the 1909 strike, the *Diary* recounts how shop and factory owners hired thugs to violently attack the girls and women on the picket lines. When the police finally intervene, they arrest the peaceful strikers instead of the perpetrators. These scenes of violence and glaring injustice mark a turning point for Mary, who confesses, "Only a little while ago I would have laughed had somebody told me that I would take this strike in earnest, but this afternoon, listening to the stories of assault upon the girls, watching the poor, miserable creatures that don't earn enough to keep body and soul together, I believe I was as much excited as the rest of them" (84). Mary is outraged by the injustice, and equally importantly, she begins to recognize her privilege as an American-born worker. She notices that the violent tactics employed by shop owners and the state are only directed toward the immigrant strikers. Mary's quick recognition of the triple oppression experienced by foreign-born working-class women changes her perspective, and in a matter of days she becomes a dedicated striker and ready ally.

While Mary quickly warms to the strike, her parents and fiancé, Jim, firmly oppose her newfound politics, and she finds herself on a collision path with her support system. While her mother recedes into the background, her father emerges as an overbearing patriarch. A union man himself, he tells Mary that he does not object to striking on principle. His main objection is that she is behaving in public in a manner that is unsuitable for a woman. "I don't think it's a woman's place to be hangin' around street corners, fighting with rowdies and be taken to jail," he tells her. "Union is all good and well by itself, but it was never meant for the women" (91–2). Central to her father's concern is the possibility that Mary might alienate her intended and ruin her younger sister's marriage prospects as well. When Mary disregards his wishes and continues with the strike, her father makes her an offer: if she quits the strike, he will support her until she and Jim are ready to marry. She refuses, bristling at the implication that

she is merely "baggage" to be passed from one man to another (100). After a fight with her father turns physical, Mary leaves home for good, seeking refuge with one of the Jewish strikers and her family.

If Mary's father encapsulates the tyrannical patriarchy of past generations, her mother—the least developed character in the novel—provides a cautionary tale of passive womanhood. When Mary's mother fails to stand up for her daughter, Mary seethes: "I just told ma that I didn't know who would be to blame if I should go wrong [turn to sex work], for she never gave us girls a thought since we were big enough to be out and about" (130). While Mary's criticism initially reads as a personal grievance as opposed to a wholesale attack on patriarchy, she later attributes her mother's unwavering obedience to her father's tyranny and the domestic drudgery her mother endures day in and day out as the cause of her withdrawn and quiescent nature. When Mary complains about her mother to Jim, he expresses shock that she would criticize a woman's domestic life, warning her that she will "rue the day [she] mixed [herself] up with those darn anarchists" (122). (Neither Jim nor Mary seem to know what anarchism is, and Malkiel is sure to distance the protagonists from it.) With a lack of love and support at home and no prospect of Jim coming around to her point of view, Mary begins to reconstitute a chosen family through a newly coalescing "sisterhood" of strikers.

Throughout much of the novel, it appears that Jim will follow the same course as Mary's father. Jim has never been entirely opposed to the strike. He, too, is a union man, and he recognizes the benefits of the strike for immigrant laborers, including immigrant women. Jim is opposed to *Mary's* participation, viewing the public spectacle of the strike and the coarseness of the street violence, courtrooms, jails, and workhouses as unsuitable for a girl of her standing (that is, American born) (86). When Jim finally recognizes the value and necessity of the strike—on Christmas Day no less, a veritable Christmas miracle—he offers to support Mary emotionally and financially in her fight against the factory owners. He promises her that on the day that the strike ends, they will wed. While seemingly antithetical to Mary's rebellion against traditional family structures, Jim's return is crucial to the story. His conversion to socialism, like Mary's, showcases the potential for younger generations of American-born workers (widely regarded as the most difficult demographic of workers to organize) to embrace the labor movement and women's equality. The reconstitution

of the happy couple also spares Mary from the dreaded spinsterhood that many believed awaited girls who joined the picket lines.

While Jim and Mary's split stems from her participation in the strike and growing radicalism, another central conflict of the story concerns gender inequality. These dual narrative threads demonstrate the interconnection of women's labor activism and gendered power dynamics in the factory and the home. The couple's reconciliation is predicated not only on Jim's support for labor but also, and more importantly, on Mary's ability to think and operate as an autonomous agent, even after she is married. While prestrike Mary seems thrilled by the prospect of a traditional marriage, her newfound militancy alters her views toward the institution. After a particularly heated exchange between Mary and her father, she wonders to herself whether a married woman becomes dead to all other concerns, whether she herself might "become dead" to the injustices endured by others less fortunate than her once she is married (93). Evoking Sojourner Truth's "Ain't I a Woman?" speech (1851), she pleads for recognition of the universal nature of humanity's wants, needs, and desires: "Ain't I of the same flesh and bone as a man? I, too, was carried under a mother's heart. And since I was born I've suffered from almost the same diseases and was healed by exactly the same medicines. I walk under the same sky and tread the same earth as men do. I, too, have senses, moods and reasons, am old enough to judge for myself; but they didn't seem to think so" (100).[38] By appropriating Truth's message for her own politics, Mary erases the racial inequality at the heart of the original message and proclaims white working-class women's concerns universal.

With Jim's awakening and his support for women's labor, a new power dynamic emerges between the two. Mary shares socialist literature with Jim and instructs him on the passages he cannot comprehend. Jim in turn joins Mary on the picket line and provides physical defense for the women and girl strikers facing harassment and assault on the streets. Jim, like Mary, is initially shocked by the treatment the young women and girl strikers endure, even going so far as to declare, "In the South they put a noose about a man's neck for insulting a woman. Here we've grown so callous and cold-blooded that we take it as a joke" (164). Assuming that Jim is referring to the widespread practice of white men lynching Black men in the American South under the pretense of threatening white womanhood, this tacit acceptance of American racism echoes other Jewish American

writing from the era, most notably Joseph Opatoshu's Yiddish story "A Lynching" (1924). Both Opatoshu's story and the *Diary* participate in American racism by reproducing well-known tropes of Black Americans by presuming the guilt of the lynch mob's victims. The two texts diverge, however, where Opatoshu criticizes the extrajudicial nature of justice in the South, while Malkiel upholds a violent white supremacist model of southern manhood as something to emulate.[39] As such, Jim's statement in the *Diary* serves as another instance in which whiteness is brought to the fore by alluding to a problematic "other"—in this case, the Black victim of the southern lynch mob.[40]

As Jim's worldview is transformed by socialist literature and activism, he also begins to see women in a new light. He tells Mary that men and women "can't live without one another, there can't be no man's nor woman's world . . . there must be a human world," articulating a vision of society unmarred by gender inequality (191). Mary shares Jim's view, inflecting it with spiritual possibilities: "Lord! If men and women would only know how sweet it is to sit and talk and reason and hope together. Yes, I'm positive that if people only knew what it means there wouldn't be half as many divorces as there are nowadays" (197). Mary and Jim's newly constituted partnership echoes emerging concepts of modern love and companionate marriage that became increasingly popular during the Progressive Era, while solving yet another alleged crisis of modernity: divorce.[41] Mary later exclaims, "I'm the happiest of all the brides I met yesterday at the City Hall. Our union will be tied by a double knot. Now since Jim, too, is converted to my way of thinking, we shall be one in spirit as well as body" (199)—a distinctly Christian conceit.

While the *Diary* provides a template for political awakening and allyship in a multiethnoracial sphere, Malkiel is clear that those who enjoy the most privilege (white Christian native-born Americans) have the most work to do. Part of the labor she demands of her readership is to jettison biases and recognize the potential of a working-class fellowship that transcends ethnoracial, religious, and national differences. At the same time, Malkiel is eager to meet white Christian readers where they are at by portraying the Protestant church as an important ally in the fight to liberate the working class, a calculated move that allowed her to interlace Protestantism (and whiteness) with a political tradition widely perceived to be foreign.

Historian Paul Harvey explores the co-constitution of race and religion throughout American history and demonstrates how Protestantism and whiteness have enjoyed a privileged coupling from the colonial era to the present day.[42] With the arrival of more than twenty million immigrants in the late nineteenth and early twentieth centuries—many of whom were neither Protestant nor considered white—"concepts of race, religion, and citizenship were contested, reformulated, and shaken up."[43] While earlier generations of Jewish immigrants who hailed from Western European countries were accepted as racial insiders but religious outsiders, Jewish arrivals from Eastern Europe increasingly found themselves the target of racial nativists who emphatically opposed Jewish immigration to the United States. In their quest to cast Jews as unfit for American citizenship, white supremacists began to renounce the historical ties between Judaism and Christianity, including distancing Jesus from his "semitic" origins. According to Harvey, nativist thinkers like Madison Grant reasoned that the "greatest moral teacher in world history—Jesus—must have been white, not Jewish."[44] Pluralist leftists, however, maintained a direct lineage between Judaism and Christianity and emphasized the alleged universality of both traditions' ethics. In the *Diary*, Mary, whose name and youth evoke the virginal mother of Jesus, dutifully reminds her readers that Jesus was a Jew after all, noting, "No wonder that Christ had sacrificed himself for all mankind; it seems to run in the Jewish blood, this spirit of self-sacrifice" (109).

Malkiel's strategic coupling of Protestant values with socialism and feminism is most apparent when, at the height of the strike, Mary attends services at the Church of Ascension and is delighted to discover that the minister's sermon is rooted in a universal message of social justice that is also specifically attuned to women's issues. Mary recounts her visit: "The minister spoke of the army of unemployed who stand for hours in line in order to get a cup of coffee and a bit of bread, and of the unfortunate women who are compelled to barter their very flesh for a bit of bread . . . and of the mothers who can't get any bread for their suffering children and welcome the latter's death as a relief from suffering" (136–37). The day has come for women to rise in rebellion, he declares. During the service, Mary feels herself transported to another time and place: "As I sat there listening to those words of wisdom I suddenly saw myself in another world where the working people have thrown off all the fetters that have kept them

bound to their bosses, and were themselves enjoying the fruit of their labor instead of feeding an army of idlers. I felt as though I was sitting in the people's church after they had come into their own . . . I was eager to embrace and join hands with God's children—man, woman, Jew, Gentile, dark and white alike" (137).

As Mary enters the world of Eastern European Jewish leftist politics, she becomes a mediator between immigrant strikers and Anglo-American readers who hold conflicting views on immigration, leftist politics, urban poverty, and crime, all of which were readily associated with Jewish immigrants and drove anti-immigration and antisemitic politics at the time.[45] By relegating Jewishness and Jewish values to minor characters who are mediated through a native-born narrator, Malkiel attempts to forestall knee-jerk reactions toward Jewish immigrants and socialism. By depicting the poverty and suffering of working-class women and girls, the systemic injustices endured by immigrant workers, and the "Americanness" of their work ethic and sense of justice, the *Diary* renders Jewish immigrants visible, perceptible to broader audiences and well suited for the United States. Initially, Mary finds the Eastern European Jewish immigrant girls and women unintelligible culturally, politically, and linguistically. The Jewish labor leaders look "silly" with their "long bushy hair" and scream from the podium, presumably in Yiddish, which Mary cannot understand and finds off-putting (81). Yet, just as she awakens to working-class women's issues, she learns to appreciate the Jewish working class as a political model to emulate: "One would never think that there's so much pride in these little Jew girls. They always stand on their dignity as if they were still God's chosen people" (90–1). Not only are the "Jew girls" validated in their political work, but their culture is valorized as exceptional in its bravery and unwavering ethics. Mary's adulation of the Jewish strikers is intended to offer a favorable lens through which to view Jewish immigrants and labor organizing, but it also has the effect of flattening the richness of Jewish life, culture, and politics for the sake of accessibility—a trade-off that reflects the growing popularity of ethnoracial consumption and intellectual tourism among American progressives in the early 1900s.[46]

Mary's favorable view of Jewish workers stands in striking contrast to her disparaging remarks about the Italian immigrant workers who are criticized for crossing the picket line and serving as strikebreakers. Of her Italian counterparts, Mary complains, "The Italian girls are like a lot of wild

ducks let loose. I ain't a bit surprised that our bosses are so anxious to replace us girls by Italians—they're good workers and bad thinkers. . . . To tell the truth, I don't know as these simple souls can be blamed much—their thinking machines were never set in working order" (141). In addition to suggesting that Italians are less intelligent and capable than the Jewish workers, Mary also levels a feminist critique: "I think that of all the people I know the Italians treat their women the worst—they grow old before they've a chance to be young. What a world of difference between them and the Jew girls" (141)—the implication being that Italian immigrants are less suited for modern America because of their gender politics. Why exactly Malkiel felt the need to contrast Jewish and Italian workers remains unclear, but by singling out the Italian workers, she offers a common enemy for Eastern European Jewish and American-born audiences. Black workers who were also employed as strikebreakers in 1909 are conspicuously absent from Mary's *Diary*.

Critics of the *Diary* dismissed it as sentimental and propagandistic.[47] Yet the focus on women's emotions in the *Diary*—the anger and frustration that led women workers to go on strike in the first place, the outrage the strikers felt when their struggle was met with violence and injustice at the hands of the authorities, their elation as they bent a gargantuan industry to their will, and the sense of camaraderie in the community they built—is precisely what makes the novel so powerful. Decades passed before historians would begin to take women's contributions to the labor movement seriously and recover women striker's voices.[48] Sadly, tragedy overshadowed the triumphs of the strike. On March 25, 1911—one year after Malkiel penned her semifictional account—fire consumed the Triangle Shirtwaist Factory, which occupied the upper floors of the Asch Building near Washington Square Park. Jewish and Italian women and girls—many of whom had stood on the picket lines during the 1909 strike—jumped or were pushed to their death from the ninth story of the building. One hundred forty-six workers lost their lives.[49] Strike leaders were devastated, noting that the potential for mass tragedy and the cheapness of immigrant life was what had compelled workers to strike in 1909.[50] Only in death did these young women and girls finally garner widespread sympathy from the press and public (the very sympathy Malkiel sought to elicit by writing the *Diary*)—and begin to secure the government regulations necessary to protect workers.

Mother Mary: Rose Pastor Stokes and *The Woman Who Wouldn't*

On April 6, 1905, American newspapers announced millionaire James Graham Phelps Stokes's engagement to a twenty-five-year-old former factory worker and Jewish immigrant named Rose Pastor. Journalists recounted in detail the unlikely origins of Phelps Stokes's intended—a working-class Jew from the Polish region of the Russian Empire—and waxed poetic about the couple's shared mission to ameliorate the plight of the immigrant working class. At a time when the United States was undergoing immense social and economic dislocation and being torn apart by heated debates about inequality, immigration, and the future character of the country, the story of a kindly aristocrat falling in love with an immigrant factory worker was one that the American public was eager to consume.

Born in Augustowa, a shtetl in Polish Russia (under tsarist control), Rose Pastor spent eight years living in extreme poverty in London's East End before she and her family immigrated to Cleveland. At the age of eleven, she went to work in the first of several cigar factories, where she spent twelve years supporting her mother, an alcoholic stepfather, and six siblings. Chance and her literary talents took her to New York, where the editor of the English Department of the *Jewish Daily News* offered her a job as a journalist. He assigned her to investigate rumors of turmoil at the University Settlement on the Lower East Side. There she met the settlement's most prominent resident worker, the fabulously wealthy Phelps Stokes. In July 1905, the two wed at the Phelps Stokes family estate in Connecticut in the presence of guests hailing from the upper crust of Madison Avenue and the tenements of the Lower East Side.[51]

Rose Pastor Stokes's marriage to an American aristocrat immediately became the stuff of legend—a veritable Cinderella story recalling the romantic plots of the cheap dime novels factory girls and women would have read—catapulting the two to instant celebrity status. Shortly after their wedding, Stokes and her husband joined the SP and quickly became two of its most popular speakers. They dedicated the next decade to traversing the country speaking about the injustices of capitalism and the promises of socialism. She also played an important and visible role in a number of high-profile strikes, including the Shirtwaist Strike of 1909.[52] They even established a socialist retreat on a private island off the coast of

Stamford, Connecticut, where they hosted an illustrious array of socialist intellectuals, writers, and artists, many of whom encouraged Stokes to pursue literary ventures depicting working-class struggles in print and on stage. When not on the road or resting at their island retreat, the Stokeses resided in a townhome on Grove Street in Greenwich Village, the heart of New York's leftist literary scene.[53]

By the mid-1910s, Stokes was becoming increasingly interested in the birth control movement. For many labor leaders and socialists, access to information about contraception lay at the heart of the proletarian woman's struggle. The vast majority of intellectuals on the Left supported the burgeoning pseudoscience of eugenics, which sought to bolster the health of the nation by curtailing the number of unwanted pregnancies among low-income segments of the American population.[54] While the history of eugenics is fraught, especially given decades-long sterilization campaigns targeting women of color that continued into the 1970s, many Progressive Era and interwar activists believed that access to birth control for the working class was paramount for women's self-determination.[55] Birth control advocates argued that children suffered the most from unwanted pregnancies, and Stokes's own wasted childhood in the factories supporting a large and growing family was a perfect case in point. In a moving speech at Carnegie Hall, Stokes explained the personal nature of her crusade:

> For twenty-three years, Capitalist Society has done its worst to me. It gave me an underfed childhood, hemmed me in on all sides by the stone walls of No Opportunity, and, when I was hardly old enough to bear the burden, it began to turn my very heart's blood into gold for others.... Whole seasons at a time it worked me not only the long day but also far into the night, giving me in return semi-starvation ... a few indecent rags, no schooling, frequently the hard floor for a bed, and the weight of an unnameable nightmare.[56]

Few understood better than Stokes how the ability to control a woman's fertility was vital to working-class women's liberation. After her speech, she accidentally incited a mob when she offered to distribute information about contraception to those in attendance.[57]

The same year Stokes spoke at Carnegie Hall, she also published a play titled *The Woman Who Wouldn't* (1916), which was never staged.

The play blends themes of an unplanned pregnancy with working-class poverty as well as Progressive Era ideals of companionate marriage.[58] It tells the story of a family—likely Irish but not explicitly so—living in a mill town somewhere in Pennsylvania. The family patriarch (John Lacey) is on strike, and the mother (Katherine Lacey), who is ill, supplements the family's meager income by taking in the mill owner's laundry. The Laceys have five children: Nineteen-year-old Mary works as a flower-maker and cares for her sick infant brother, Bennie. Katie is nine and attends the factory town's school. The eldest daughter, Jennie, is married and raises Nellie, her eleven-year-old sister, whom the Laceys cannot afford to feed. Everyone in the family is starving and there is no prospect of relief in sight. The central protagonist, Mary, is engaged and has been for a number of years to one of the strike's leaders, Joe, but they have not married on account of his father's poor health and Joe's wandering eye. Mary is also secretly pregnant with his child. She carries the pregnancy in silence, refusing to tell anyone, including Joe; only her older sister, Jennie, is aware.

The sexual agency of working-class women like Mary was considered highly suspect and required careful messaging for the general public. Puritanical judgments about sexuality were especially harsh for working-class women, who many believed lacked the ability to control sexual impulses. Fears about lower-class sexual licentiousness were especially strong because women's and girls' employment in urban industries had removed them from the control of fathers and husbands.[59] Self-righteous public officials and opponents of birth control believed access to contraception would only exacerbate the situation by freeing unmarried women from the fear of unwanted pregnancies and the stigma that would surely follow. While physicians made contraceptives readily available to middle- and upper-class women, the working class had little to no access to information about birth control and risked arrest for seeking it out.[60] The mob Stokes incited at Carnegie Hall, like the hundreds of letters she received from individuals seeking information about contraception, attests to the desperation of working-class women and men.[61]

Mary adores children, and she would like to keep the baby, but she knows that if she does, she and her family will be ostracized by the rest of the townspeople. She pleads with the local doctor for an abortion, but he refuses on religious and legal grounds. When Mary threatens to commit suicide, the doctor cruelly warns that her family will surely starve without

her—an impossible dilemma. During the course of Mary's conversation with the doctor, the reader discovers that Mary feels compelled to seek an abortion not because of her poverty—how exactly she will feed the baby while she and everyone else are slowly starving to death remains unclear—but because she knows her family's reputation will be ruined. She explains to the doctor, "everybody'll . . . They'll jes' murder me an' m' baby every day. They'll murder us every hour in th' day. Shall it be killin' all at once, or killin' every morning,' noon an' night?—My baby! . . . Murder! Murder! An' they send us t' prison fer this—Who sends us—the 'respectable' folk that goes t' church on Sundays an' robs us on Mondays, so's they c'n live in fine houses an' wear find clo's—an' be educated fine, an' keep their looks, an'—" (57). When her parents finally discover Mary's secret, the scene turns violent. To them, the solution is simple: she should marry her fiancé, the father of the child. Mary refuses. During the course of their two-year engagement, Joe's interest in Mary has waned, and while she still loves him, she worries that an unhappy marriage will result in an unhappy childhood for their baby. In the end, Mary chooses her and her child's happiness over respectability and leaves home to find her own way (105–28).

In Mary's absence, her family's situation deteriorates even further: her mother dies from a heart attack while washing the mill owner's laundry; her father is injured in the mill and hobbles around on crutches; care for Mary's disabled father has fallen to her eldest sister and brother-in-law; Nellie works in a factory in Pittsburgh; Katie ran away from home when her father would not allow her to marry the man she loved; and baby Bennie is dead (134–51). Only Mary, the liberated daughter who left home, has managed to escape the vicious cycle of working-class poverty. In a dramatic final act, she returns to her hometown, which is in the midst of another strike. Mary is no longer the demure girl who vanished eight years ago, nor is she the prodigal daughter one might expect of a working-class single mother who fled town. On the contrary, she has become a widely regarded "mother" figure on the socialist circuit. Audiences discover that Mary kept her pregnancy and is a proud mother to a radiant and healthy daughter, "Joey" (Josephine) (140–47). Mary's newfound agency and confidence present a stark contrast to her father and former fiancé, who are chastened by their misfortunes over the past eight years. Their reunion affords everyone a sense of closure, though the struggle against capitalism

continues, this time with "Mother" Mary leading the way. The play ends with remaining members of the Lacey family and Joey's father gathered around the table for dinner as a family reconstituted to face their uncertain fate together.

The theme of companionate marriage comes full circle in the final act. Mary's former fiancé, Joe, who lost his first wife in childbirth, confesses that he is still in love with Mary. By this point, Mary is no longer interested in him and tells him as much: "I must belong to myself—be mistress of my own body and soul. I couldn't marry the man who didn't love me even though I loved him and his child lay under my heart" (180). Such a concession, she argues, would be no different than prostitution. Stokes makes the case for romantic, companionate marriage while bearing the happiness of future progeny in mind. While Malkiel's vision of modern marriage is largely rooted in the principles of equality, Stokes was likely influenced by her own mother's loveless arranged marriage, as well as by the bohemian intellectuals with whom she socialized.[62] Writing about the avant-garde that populated early Greenwich Village, Stansell explains that young intellectuals on the Left like Stokes and her husband not only sought psychological and sexual fulfillment in their intimate lives but also desired to undertake meaningful work as equal partners. Shared artistic or political endeavors became a crucial feature of many romantic relationships on the radical Left.[63] Historian Leon Fink explains, "[D]ecades before the feminist aphorism 'the personal is political' gained currency, American intellectuals willfully attached political significance to their private lives and relationships."[64] For the young Marys of Malkiel's and Stokes's stories, a marriage founded on love and shared political views became a new imperative.

Stokes is an exceptional character on the American Left: her marriage to an American aristocrat overshadowed her Eastern European Jewish roots and socialist politics, allowing her to address sensitive topics in public spaces with little fear of retaliation. Yet the political dynamics of modern marriage and unwanted pregnancies required deft handling even for her, and it is possible that she, similar to Malkiel, sought to temper controversial subjects by distancing them from the Jewish working class. The first and last names of the characters (Lacey and McCarthy), the iconography that hangs on the Lacey family's walls, and Mary's dialect all imply that Mary is either an Irish immigrant or the child of Irish

immigrants. Jewish writers have long given voice to subjectivities that are not their own, and literary scholars have addressed how Jewish writers explored marginalized identities through forms of ethnoracial ventriloquism.[65] George Bornstein and Stephen Watt highlight frequent evocations of Irish identities in Jewish American writing, which they attribute to the many parallels between Irish and Jewish diasporic identities; collective memories and traumas; and shared immigrant experiences of poverty, urban neighborhoods, and employment in the sweated industries. To the list of similarities between Jewish and Irish history and culture in the United States, one might add a widespread rejection of religious orthodoxy. Common pasts and a shared present inspired an interethnic recognition, if not sympathy, between Jewish and Irish cultural producers of music, literature, theater, and early Hollywood film.[66] Stokes participates in this tradition of interethnic cross-identification as she works to present a sympathetic picture of working-class women's issues for broad audiences.

It is unclear whether Stokes chose to depict an Irish American woman's experience of poverty and unplanned pregnancy because she was grasping for a stabler, whiter immigrant identity—as Malkiel does with Mary in the *Diary*—or if she intended to use Irish experiences to address what she understood to be a particularly potent combination of working-class poverty and providentialism. Early in their relationship, Stokes appears to have shared in her husband's openness to different faith traditions (the latter maintained close ties to his Episcopalian roots, was an active member of the Vedanta Society, and published two books on the topic of world religions later in life), but over time she became a vocal critic of religion.[67] While Malkiel depicted Christian values and the church as a source of spiritual sustenance, moral guidance, and refuge for striking workers, Stokes viewed religion as detrimental to workers' agency and a central obstacle to mobilizing workers, a central theme of the play. For example, the Laceys' home is sparsely furnished, but a portrait of Madonna and Child hangs on the wall—similar to the portrait of Tsar Alexander II that graced the wall of Pastor's grandparents' impoverished home in imperial Russia.[68] As the Lacey children slowly starve (the baby actually dies from illness and malnourishment), the family matriarch, Katherine Lacey, puts her faith in God. Katherine reassures her daughter: "Everybody's got their troubles—but the greatest trouble of all is when we aint' [sic] got enough

faith. What'd I do without faith ... with Father on strike fer two months an' you workin' s' extra hard, an' me only the mill-owner's wife t' wash fer, an' Bennie sick an' the doctor bills to pay—why, I'd worry me head off if I didn't b'lieve in the good Lord!" She then begins to chant to herself: "[T]he Lord will provide ... the Lord will provide." A spasm of rheumatic pain finally cuts her off (9–10). She dies shortly thereafter while washing the mill owner's laundry.

The betrothed couple—Mary and Joseph—is certainly a nod to the story of Jesus, but while Joe, unlike the biblical Joseph, plays a biological role in Mary's conception, Mary's youth, maternity, and wholesomeness evoke the mother of God in the New Testament and also underscore the hypocrisy of modern America. The maternity of a young woman (the Virgin Mary) can pass for divine in Christian doctrine, but it is a sin in a puritanical nation that values abstention, unwavering obedience, and economic output from its daughters. In this perilous setting, only socialism, Stokes suggests, has the power to redeem worthy daughters from such hypocrisy. When "Mother" Mary returns to her hometown in act 3, she is no longer the shunned daughter of the working class but a prophetess of the labor movement. Within this liberated sphere, Mary is celebrated for her maternity not only on account of her beautiful and thriving daughter (the promise of a socialist future) but also for her spiritual guidance delivering workers from capitalist oppression. Stokes's Mary finds her salvation not in the Catholic faith of her ancestors but in the new messianism of labor, a movement at least theoretically grounded in "universalist" principles.

Conclusion

As important leaders and voices in American socialism, Jewish women writers like Malkiel and Stokes harbored a vision of a future in which not only class and gender but national and racial divisions would disappear. They wrote socialist feminist communities into existence and, in the process, displaced the radical subjectivities of the Jewish immigrant women who sustained the movement. By focalizing working-class struggles through white Christian protagonists, in a way these authors claimed whiteness for themselves and disputed prevailing notions that Jewish

immigrants could *not* pass as white and the immigrant Left could *not* pass as fully American.

In either case, these women wrote at a particularly propitious moment for the radical Left in the United States. America's entry into World War I marked a turning point for the United States and its willingness to tolerate radicalism within its borders. The SP split between prowar and antiwar factions over the question of American intervention. Historian Christopher Lasch distinguishes between the two camps, explaining that one side understood the war to be a battle between democracy and autocracy—a "war to end war" so to speak—while the other side perceived the struggle to be a conflict between competing capitalist powers.[69] Americans spanning the far Right to prowar socialists supported legislative efforts that curtailed leftist agitation against America's involvement in the conflict. When Bolshevik leadership threatened to withdraw Russia—the United States' most important ally against the Axis powers—from the war, the urge to suppress leftist dissent in the United States became more pronounced. Repressive legislation, arrests, and trials soon followed, including the high-profile arrest and trial of Stokes in 1918 for violating the Espionage Act.[70] The end of the war failed to restore calm, and a mass hysteria known as the Red Scare took hold of the American government. After government officials arrested and deported a number of immigrant radicals (Emma Goldman being the best known), labor legislation from the previous decade was rolled back and the American Left struggled to regain its footing. Throughout the 1920s, many leading figures of working-class politics, including Malkiel and Stokes, retreated from their public roles in leftist movements. While the labor and socialist movements they had helped build continued to boast an important Jewish presence, interwar labor organizing evolved to target the growing communities of Black and Hispanic migrants who replaced the immigrant workers of an earlier generation.

The legacy of proletarian Jewish writers like Malkiel and Stokes is not solely political, and the ties between them and a new vanguard of emerging Jewish women writers are revealing. Scholars, for example, have suggested that Anzia Yezierska's first novel, *Salome of the Tenements* (1923), is loosely based on Stokes's interclass and interracial marriage to a wealthy reformer. (The novel was also inspired by Yezierska's own unhappy love affair with Columbia University professor John Dewey.[71])

I Am a Woman—and a Jew (1924) by Elizabeth Stern, whose Jewish identity is contested by family members and scholars alike, also revolves around an intermarriage between a Jewish immigrant and a patrician intellectual and explicitly references the Pastor-Stokes marriage.[72] Neither of these novels are preoccupied with labor politics or socialism. Instead, they focus on Americanization as a fraught process of assimilation and materialist consumption—a bargain that is met with reluctance by the Jewish heroines of these novels. Yezierska's and Stern's literary treatments of Jewish women rejecting American demands of immigrants to assimilate and thereby erase their ethnoracial specificity mark a departure from Malkiel's and Stokes's leftist portraits of a universal ideal. Yet, similar to their predecessors, Jewish women authors in the 1920s remained in dialogue with contemporary political currents—most notably growing nativism which challenged the idea that certain immigrant groups could ever truly belong in the United States.[73] As a result, Yezierska and Stern join writers like Malkiel and Stokes in offering rebellious political portraits of Jewish women's agency, providing the foundations for an emerging Jewish American literary canon.

Notes

A special thank you to Annie Atura Bushnell, Lori Harrison-Kahan, Ayelet Brinn, Susan Breitzer, Ronnie Grinberg, and Jessica Kirzane. My interest in this topic benefited from early conversations with Josh Lambert, Tony Michels, and Steven Zipperstein.

1 Chris Weinstein, "Heroine of Cooper Union: Clara Lemlich Dead at 96," *Justice*, September 1982, 12–13. See Clara Lemlich Papers, Tamiment Library and Robert F. Wagner Labor Archives, New York University. See also Annelise Orleck, *Common Sense and a Little Fire: Women and Working-Class Politics in the United States, 1900–1965* (Chapel Hill: University of North Carolina Press, 1995), 57–60.
2 Statistics are taken from Tony Michels, "Uprising of 20,000 (1909)," Jewish Women's Archive, December 13, 1999, jwa.org/encyclopedia/article/uprising-of-20000-1909#:~:text=On%20November%2023%2C%201909%2C%20more,to%20date%20in%20American%20history. For information about the strike, see Ann Schofield, "The Uprising of 20,000: The

Making of a Labor Legend," in *A Needle, a Bobbin, a Strike: Women Needleworkers in America*, ed. Joan M. Jensen and Sue Davidson (Philadelphia: Temple University Press, 1984), 167–82. Annelise Orleck estimates that as many as forty thousand workers participated in the strike. See Orleck, *Common Sense*, 53–55.

3 Meredith Tax writes that more than 90 percent of strikers were Jewish, 6 percent were Italian women, and only 3 percent were American born. See Tax, *The Rising of the Women: Feminist Solidarity and Class Conflict, 1880–1917* (New York: Verso Books, 2022).

4 Theresa Serber Malkiel, *The Diary of a Shirtwaist Striker* (Ithaca, NY: Cornell University Press, 1990).

5 In addition to Malkiel's *Diary*, this chapter also explores Rose Pastor Stokes, *The Woman Who Wouldn't* (New York: G. P. Putnam's Sons, 1916). Stokes wrote several other plays that deal with working-class women's realities, including *The Saving of Martin Greer*, *In April*, *Squaring the Triangle*, and *On the Day*, which are housed at the Library of Congress (MSS3249). Stokes also garnered wide acclaim for her translations of Morris Rosenfeld's poems. See Rosenfeld, *Songs of Labor and Other Poems*, trans. Rose Pastor Stokes (Boston: R. G. Badger, 1914). Labor leader Fannia M. Cohn wrote plays with Irwin Swerdlow on topics related to the labor movement, mainly for workers' education. See Fannia M. Cohn Papers at the New York Public Library (MssCol 588). Anna Strunsky Walling wrote about a working-class girl coming of age in Paris. See Walling, *Violette of Père Lachaise* (New York: Fredrick A. Stokes, 1915). For memoirs by Eastern European Jewish women authors, see Rose Gallup Cohen, *Out of the Shadow* (New York: George H. Doran, 1918); Emma Goldman, *Living My Life* (New York: Alfred A. Knopf, 1934); Lucy Robins Lang, *Tomorrow Is Beautiful* (New York: Macmillan, 1948); P. M. Newman (Pauline Newman), "Letters to Michael and Hugh" (unpublished memoir) 1951, Box 1, Folder 3, Pauline Newman Papers, Arthur and Elizabeth Schlesinger Library, Harvard University; Rose Pesotta, *Bread upon the Waters* (New York: Dodd, Mead, 1944); Rose Pesotta, *Days of Our Lives* (Boston: Excelsior, 1958); Rose Pastor Stokes, *I Belong to the Working Class* (Athens: University of Georgia Press, 1992); Rose Schneiderman, *All for One* (New York: Paul S. Eriksson, 1967); Bella Spewack, *Streets: A Memoir of the Lower East Side* (New York: Feminist Press at CUNY, 1995).

6 Tax, *Rising*.

7 On racial politics and representations of immigrants in American culture, see David R. Roediger, *Working toward Whiteness: How America's*

Immigrants Became White: The Strange Journey from Ellis Island to the Suburbs (New York: Basic Books, 2018); Matthew Frye Jacobson, *Barbarian Virtues: The United States Encounters Foreign Peoples at Home and Abroad, 1876–1917* (New York: Hill & Wang, 2000); and Matthew Frye Jacobson, *Whiteness of a Different Color: European Immigrants and the Alchemy of Race* (Cambridge, MA: Harvard University Press, 1998). On nativism in the Progressive Era, see John Higham, *Strangers in the Land: Patterns of American Nativism* (New Brunswick, NJ: Rutgers University Press, 2002).

8 On the popularity of ghetto fiction at the turn of the century, see Lori Harrison-Kahan, "'Truth-Telling Should Be an Author's Religion': Jewish Fiction and American Literary Realism," in *"Yearning to Breathe Free": Jews in Gilded Age America*, ed. Adam D. Mendelsohn and Jonathan D. Sarna (Princeton, NJ: Princeton University Press, 2023), 189–216.

9 On Jews and whiteness during the late nineteenth and early twentieth centuries, see Eric L. Goldstein, *Price of Whiteness: Jews, Race, and American Identity* (Princeton, NJ: Princeton University Press, 2006).

10 In rare moments when Eastern European Jewish characters appeared in this literature or in the Jewish women's labor movement, Jewish radicalism was upheld as the ideal. As a result, frameworks of a gendered Ashkenormativity were reified in the labor movement and American culture, further contributing to the erasure of growing Mizrahi and Sephardi Jewish working classes in America's industrial centers. In addition to the literature discussed in this chapter, Elias Tobenkin's *The Road* (New York: Harcourt, 1922) and Scholem Asch's *East River* (New York: G. P. Putnam's Sons, 1946) also feature white Anglo-Saxon Christian characters active on the radical Left.

11 At a time when many scholars are reconsidering women's labor organizing and early twentieth-century Jewish women's writing, in addition to race and the American radical Left, proletarian fiction and ethnoracial displacement remain unseen. Eastern European Jewish women authors writing about working-class women were and still are at a triple disadvantage. As early twentieth-century men authors embraced a new masculine ideal rooted in working-class culture, they brought working-class protagonists and issues to the fore of their literature. Attacking the Victorian values of a previous generation and identifying with working-class men was not purely an aesthetic endeavor but also a way for male intellectuals to foreground their own masculine identity in literary culture. If identifying with the working class was supposed to serve as an expression of one's masculine identity, where did that leave women authors writing

about working-class women's experiences? See James Penner, *Pinks, Pansies, and Punks: The Rhetoric of Masculinity in American Literary Culture* (Bloomington: Indiana University Press, 2011), 3. On the evolution of masculinity in early twentieth-century America, see Gail Bederman, *Manliness & Civilization: A Cultural History of Gender and Race in the United States, 1880–1917* (Chicago: University of Chicago Press, 1995).

12 Alice Kessler-Harris, introduction to *Bread Givers: A Novel*, by Anzia Yezierska (New York: Doubleday, 1975), xxi–xxxvi.

13 Annie Polland and Daniel Soyer, *Emerging Metropolis: New York Jews in the Age of Immigration, 1840–1920* (New York: New York University Press, 2012), 122.

14 Tony Michels, *A Fire in Their Hearts: Yiddish Socialists in New York* (Cambridge, MA: Harvard University Press, 2005), 4–20.

15 Jonathan Frankel, *Prophecy and Politics: Socialism, Nationalism, & the Russian Jews, 1862–1917* (Cambridge: Cambridge University Press: 1981), 454.

16 Susan Glenn, *Daughters of the Shtetl: Life and Labor in the Immigrant Generation* (Ithaca, NY: Cornell University Press, 1991).

17 Alice Kessler-Harris, *Gendering Labor History* (Urbana: University of Illinois Press, 2007), 41.

18 Orleck, *Common Sense*, 5–25.

19 Kessler-Harris, *Gendering*, 30–31.

20 Kessler-Harris, 103–4.

21 Theresa Serber Malkiel, *New York Call*, cited in Orleck, *Common Sense*, 53.

22 On the emotional response of strikers, see Orleck, *Common Sense*. For an unpublished memoir about women's labor organizing as a catalytic experience, see Newman, "Letters."

23 Deirdre Clemente, "Striking Ensembles: The Importance of Clothing on the Picket Line," *Labor Studies Journal* 30, no. 4 (Winter 2006): 1–15. See also Nan Enstad, *Ladies of Labor, Girls of Adventure: Working Women, Popular Culture, and Labor Politics at the Turn of the Twentieth Century* (New York: Columbia University Press, 1999).

24 Schofield, *Uprising*, 167–68.

25 Rebecca Harding Davis, "Life in the Iron Mills," *Atlantic Monthly*, April 1861.

26 On literary realism and naturalism, see Malcolm Cowley, "Naturalism in American Literature," in *American Naturalism*, ed. Harold Bloom (Philadelphia: Chelsea House, 2004), 49–79; Donald Pizer, *Realism and Naturalism in Nineteenth-Century American Literature*, rev. ed. (Carbondale: Southern Illinois University Press, 1984); Donna M. Campbell, *Resisting*

Regionalism: Gender and Naturalism in American Fiction, 1885–1915 (Athens: Ohio University Press, 1997); Jan Cohn, "Women as Superfluous Characters in American Realism and Naturalism," *Studies in American Fiction* 1, no. 2 (Autumn 1973), 154–62; and John Dudley, *A Man's Game: Masculinity and the Anti-Aesthetics of American Literary Naturalism* (Tuscaloosa: University of Alabama Press, 2004).

27 On patrician reforms and their literary endeavors, see Leon Fink, *Progressive Intellectuals and the Dilemmas of Democratic Commitment* (Cambridge, MA: Harvard University Press, 1997); Robert Dwight Reynolds, Jr. "The Millionaire Socialists: J. G. Phelps Stokes and His Circle of Friends" (PhD diss, University of South Carolina, 1974); and Ashley Walters, "Intimate Radicals and Radical Intimacies: East European Jewish Women in the Early Twentieth Century Anglo-American Imaginary" (PhD diss., Stanford University, 2020).

28 Jacob Riis, *How the Other Half Lives* (New York: Charles Scribner's Sons, 1890); and Hutchins Hapgood, *The Spirit of the Ghetto* (New York: Funk & Wagnalls, 1902).

29 Harrison-Kahan, "Truth-Telling Should Be an Author's Religion."

30 Mary Antin, *The Promised Land* (London: Penguin, 1997).

31 Josh Lambert, *The Literary Mafia: Jews, Publishing, and Postwar American Literature* (New Haven, CT: Yale University Press, 2022), 7–8.

32 On Emma Wolf's challenges with Jewish publishers, see Barbara Cantalupo and Lori Harrison-Kahan, introduction to *Heirs of Yesterday*, by Emma Wolf, ed. Barbara Cantalupo and Lori Harrison-Kahan (Detroit: Wayne State University Press, 2020), 1–79.

33 Lambert, *Literary Mafia*, 7–8. In addition to challenges in publishing, the rehabilitation of American letters as a masculine endeavor by early twentieth-century writers echoed widespread anxieties about changing gender roles in industrial America. See Bederman, *Manliness & Civilization*. Dudley explains how men authors simultaneously rejected the sentimental subject matter of Victorian popular fiction and the perceived effeminacy of European aesthetes and in doing so the image of the writer as patrician intellectual gave way to the more masculine image of a journalist, who also incidentally laid claim to a "real" and "true" representation of things. Unsurprisingly, many authors who would contribute to literary realism began their writing careers as journalists reporting on working-class neighborhoods. See Dudley, *Man's Game*, 6–7.

34 See Rachel Rubenstein's discussion of diaries as an accepted form of Jewish women's writing in chapter 4 of this volume.

35 Françoise Basch, "The Shirtwaist Strike in History and Myth," in *The Diary of a Shirtwaist Striker*, by Theresa Serber Malkiel (Ithaca, NY: Cornell University Press, 1998), 58.
36 Basch, 56–61.
37 Malkiel, *Diary*, 81. Further page citations from this work appear parenthetically in the text.
38 Sojourner Truth, "Ain't I a Woman?," Akron, OH, 1851.
39 Jessica Kirzane, trans., introduction to "A Lynching," by Joseph Opatoshu, *In geveb* (June 2016), 2–3.
40 Theresa Serber Malkiel's and Joseph Opatoshu's treatment of lynching in their writing diverge significantly from the antiracist strategies Annie Nathan Meyer employed in her writing, which is explored by Lori Harrison-Kahan in chapter 2.
41 On new understandings of love and companionate marriage in the Progressive Era, see Christine Stansell, *American Moderns: Bohemian New York and the Creation of a New Century* (New York: Metropolitan Books, 2000); Christina Simmons, *Making Marriage Modern: Women's Sexuality from the Progressive Era to World War II* (Oxford: Oxford University Press, 2011); and John D'Emilio and Estelle B. Freedman, *Intimate Matters: A History of Sexuality in America*, 3rd ed. (Chicago: University of Chicago Press, 2012).
42 See Paul Harvey, *Bounds of Their Habitation: Race and Religion in American History* (Lanham, MD: Rowman & Littlefield, 2017).
43 Harvey, 131–33.
44 Harvey, 135.
45 On anti-immigration policy and antisemitism, see Goldstein, Price of Whiteness; John Higham, *Strangers in the Land: Patterns of American Nativism*; Margot Canaday, *The Straight State: Sexuality and Citizenship in Twentieth-Century America* (Princeton: Princeton University Press, 2009); and Katherine Benton-Cohen, *Inventing the Immigration Problem: The Dillingham Commission and Its Legacy* (Cambridge, MA: Harvard University Press, 2018).
46 See Tony Michels, "The Lower East Side Meets Greenwich Village: Immigrant Jews, Yiddish, and the New York Intellectual Scene," in *Choosing Yiddish: New Frontiers of Language and Culture*, ed. Lara Rabinovitch, Shiri Goren, and Hannah S. Pressman (Detroit: Wayne State University Press, 2012), 69–85. See also Stansell, *American Moderns*.
47 See Basch, "Shirtwaist Strike."
48 See Orleck, *Common Sense*; and Newman, "Letters."

49 "Remembering the 1911 Triangle Factory Fire," School of Industrial and Labor Relations, Cornell University, Ithaca, NY, accessed May 3, 2023, trianglefire.ilr.cornell.edu/story/introduction.html.

50 Rose Schneiderman's April 2, 1911, speech can be found in Leon Stein, ed., *Out of the Sweatshop: The Struggle for Industrial Democracy* (New York: Quadrangle / New York Times Book Co., 1977), 196–97.

51 Stokes, *I Belong*.

52 Extensive collections of newspaper clippings about Stokes's participation in these strikes can be found in the Rose Pastor Stokes Papers, Tamiment Library and Robert F. Wagner Labor Archives, New York University. Malkiel lauds Stokes's activism in the *Diary*, noting, "They say that the little Jew girl who married one of them millionaires, the lucky dog—well, she's a Socialist, and she's certainly been good to her kind, especially to us girls during the strike" (116).

53 On the Pastor-Stokes marriage, see Arthur Zipser and Pearl Zipser, *Fire and Grace: The Life of Rose Pastor Stokes* (Athens: University of Georgia Press, 1990); Adam Hochschild, *Rebel Cinderella: From Rags to Riches to Radical, the Journey of Rose Pastor Stokes* (New York: Mariner Books, 2020); and Walters, "Intimate Radicals."

54 On the history of eugenics, see Daniel J. Kevles, *Genetics and the Uses of Human History* (Cambridge, MA: Harvard University Press, 1995); Edwin Black, *War against the Weak: Eugenics and America's Campaign to Create a Master Race* (New York: Four Walls Eight Windows, 2003); and Jean H. Baker, *Margaret Sanger: A Life of Passion* (New York: Hill & Wang, 2011).

55 Dorothy Roberts, *Killing the Black Body: Race, Reproduction, and the Meaning of Liberty* (New York: Vintage Books, 1997).

56 Rose Pastor Stokes, "Carnegie Hall Speech," May 5, 1916, Box 6, Folder 22, Rose Pastor Stokes Papers, Sterling Library, Yale University.

57 On the Carnegie Hall rally, see "Women Riot in Meeting On Birth Control," Box 2, Folder 7, Rose Pastor Stokes Papers, Tamiment Library and Robert F. Wagner Labor Archives, New York University. On the controversy over whether Pastor would be arrested or not, see Rose Pastor Stokes, "Letter to Ansen Phelps Stokes," May 29, 1916, Box 4, Folder 140, Rose Pastor Stokes Papers, Sterling Library, Yale University.

58 Stokes, *Woman Who Wouldn't*. Page citations from this work appear parenthetically in the text. Regarding the six to eight plays Stokes wrote, see Zipser and Zipser, *Fire and Grace*, 153–55.

59 On the desire to control working-class girls, see Mary E. Odem, *Delinquent Daughters: Protecting and Policing Adolescent Female Sexuality in the*

United States, 1885–1920 (Chapel Hill: University of North Carolina Press, 1995).

60 Baker, *Margaret Sanger*. Emma Goldman also writes about the class dynamics of access to birth control in her memoir.

61 Rose Pastor Stokes received hundreds of letters from working-class women and men asking for information about birth control. Those letters are available in the Rose Pastor Stokes Papers, Sterling Library, Yale University.

62 Stokes, *I Belong*, 3–8.

63 Stansell, *American Moderns*, 250. See also Simmons, *Making Marriage Modern*; and D'Emilio and Freedman, *Intimate Matters*.

64 Fink, *Progressive Intellectuals*, 147.

65 On racial ventriloquism in Jewish American literature, see Lori Harrison-Kahan, *The White Negress: Literature, Minstrelsy, and the Black-Jewish Imaginary* (New Brunswick, NJ: Rutgers University Press, 2010); and Jennifer Glaser, *Borrowed Voices: Writing and Racial Ventriloquism in the Jewish American Imagination* (Brunswick, NJ: Rutgers University Press, 2016).

66 Stephen Watt, *"Something Dreadful and Grand": American Jewish Literature and the Irish-Jewish Unconscious* (Oxford: Oxford University Press, 2015); and George Bornstein, *The Colors of Zion: Blacks, Jews, and Irish from 1845 to 1945* (Cambridge, MA: Harvard University Press, 2011).

67 See Robert D. Reynolds Jr., "Millionaire Socialist and Omnist Episcopalian: J. G. Phelps Stokes's Political and Spiritual Search for the 'All,'" in *Socialism and Christianity in Early 20th Century America*, ed. Jacob H. Dorn (Westport, CT: Greenwood Press, 1998), 199–216.

68 Stokes, *I Belong*, 7.

69 Christopher Lasch, *The American Liberals and the Russian Revolution* (New York: Columbia University Press, 1962), ix. On American socialists and World War I, see John A. Thompson, *Reformers and War: American Progressive Publicists and the First World War* (Cambridge: Cambridge University Press, 1987).

70 On Stokes's arrest, see Zipser and Zipser, *Fire and Grace*.

71 Anzia Yezierska, *Salome of the Tenements* (New York: Boni & Liveright, 1923). For speculations about *Salome* and who the story is based on, see Anzia Yezierska, *Red Ribbon on a White Horse* (New York: Persa Books, 1987); Louise Levitas Henriksen, *Anzia Yezierska: A Writer's Life* (New Brunswick, NJ: Rutgers University Press, 1988); Mary V. Dearborn, *Love in the Promised Land: The Story of Anzia Yezierska and John Dewey* (New York: The Free Press, 1988); and Alan Robert Ginsberg, *The Salome Ensemble: Rose Pastor Stokes, Anzia Yezierska, Sonya Levien, and Jetta Goudal* (Syracuse, NY: Syracuse University Press, 2016).

72 The Jewish Women's Archive article by Kirsten Wasson explains that Elizabeth Gertrude Levin was born in Poland and immigrated to Pittsburgh at the age of three. Her father was a rabbi. See Kirsten Wasson, "Elizabeth Stern," *The Shalvi/Hyman Encyclopedia of Jewish Women*, Jewish Women's Archive, December 31, 1999, jwa.org/encyclopedia/article/stern-elizabeth-gertrude-levin. Laura Browder contends that Stern was born to German Lutheran and Welsh Baptist parents in the United States. From the age of seven to seventeen, Stern lived with a Jewish foster family. She appears to have taken their last name "Levin" as her own. Throughout the rest of her life, Stern and her husband, who was also born to a non-Jewish family but raised by Jewish foster parents, claimed alternating Jewish and non-Jewish identities. In the late 1980s, Stern's son wrote an unpublished memoir that revealed the extent of his parents' lies. See Browder, *Slippery Characters: Ethnic Impersonators and American Identities* (Chapel Hill: University of North Carolina Press, 2003), 165–70.

73 On Jewish literary responses to the 1920s and anti-immigration politics, see Browder, 154–55.

Bibliography

Antin, Mary. *The Promised Land*. London: Penguin, 1997.

Asch, Scholem. *East River*. New York: G. P. Putnam's Sons, 1946.

Baker, Jean H. *Margaret Sanger: A Life of Passion*. New York: Hill & Wang, 2011.

Basch, Françoise. "The Shirtwaist Strike in History and Myth." In *The Diary of a Shirtwaist Striker*, by Theresa Serber Malkiel, 3–77. Ithaca, NY: ILR Press, 1998.

Bederman, Gail. *Manliness & Civilization: A Cultural History of Gender and Race in the United States, 1880–1917*. Chicago: University of Chicago Press, 1995.

Benton-Cohen, Katherine. *Inventing the Immigration Problem: The Dillingham Commission and Its Legacy*. Cambridge, MA: Harvard University Press, 2018.

Black, Edwin. *War against the Weak: Eugenics and America's Campaign to Create a Master Race*. New York: Four Walls Eight Windows, 2003.

Bloom, Harold, ed. *American Naturalism*. Philadelphia: Chelsea House, 2004.

Bornstein, George. *The Colors of Zion: Blacks, Jews, and Irish from 1845 to 1945*. Cambridge, MA: Harvard University Press, 2011.

Browder, Laura. *Slippery Characters: Ethnic Impersonators and American Identities*. Chapel Hill: University of North Carolina Press, 2003.

Campbell, Donna M. *Resisting Regionalism: Gender and Naturalism in American Fiction, 1885–1915*. Athens: Ohio University Press, 1997.

Canaday, Margot. *The Straight State: Sexuality and Citizenship in Twentieth-Century America*. Princeton, NJ: Princeton University Press, 2009.

Cantalupo, Barbara, and Lori Harrison-Kahan. Introduction to *Heirs of Yesterday*, by Emma Wolf, 1–79. Edited by Barbara Cantalupo and Lori Harrison-Kahan. Detroit: Wayne State University Press, 2020.

Clemente, Deirdre. "Striking Ensembles: The Importance of Clothing on the Picket Line." *Labor Studies Journal* 30, no. 4 (Winter 2006): 1–15.

Cohen, Rose Gallup. *Out of the Shadow*. New York: George H. Doran, 1918.

Cohn, Jan. "Women as Superfluous Characters in American Realism and Naturalism." *Studies in American Fiction* 1, no. 2 (Autumn 1973): 154–62.

Cott, Nancy F. *The Grounding of Modern Feminism*. New Haven, CT: Yale University Press, 1987.

Cowley, Malcolm. "Naturalism in American Literature." In *American Naturalism*, edited by Harold Bloom, 49–79. Philadelphia: Chelsea House, 2004.

Davis, Rebecca Harding. "Life in the Iron Mills." *Atlantic Monthly*, April 1861.

Dearborn, Mary V. *Love in the Promised Land: The Story of Anzia Yezierska and John Dewey*. New York: The Free Press, 1988.

D'Emilio, John, and Estelle B. Freedman. *Intimate Matters: A History of Sexuality in America*. 3rd ed. Chicago: University of Chicago Press, 2012.

Dorn, Jacob H., ed. *Socialism and Christianity in Early 20th Century America*. Westport, CT: Greenwood Press, 1998.

Dudley, John. *A Man's Game: Masculinity and the Anti-Aesthetics of American Literary Naturalism*. Tuscaloosa: University of Alabama Press, 2004.

Enstad, Nan. *Ladies of Labor, Girls of Adventure: Working Women, Popular Culture, and Labor Politics at the Turn of the Twentieth Century*. New York: Columbia University Press, 1999.

Fink, Leon. *Progressive Intellectuals and the Dilemmas of Democratic Commitment*. Cambridge, MA: Harvard University Press, 1997.

Frankel, Jonathan. *Prophecy and Politics: Socialism, Nationalism, & the Russian Jews, 1862–1917*. Cambridge: Cambridge University Press: 1981.

Ginsberg, Alan Robert. *The Salome Ensemble: Rose Pastor Stokes, Anzia Yezierska, Sonya Levien, and Jetta Goudal*. Syracuse, NY: Syracuse University Press, 2016.

Glaser, Jennifer. *Borrowed Voices: Writing and Racial Ventriloquism in the Jewish American Imagination.* Brunswick, NJ: Rutgers University Press, 2016.

Glenn, Susan. *Daughters of the Shtetl: Life and Labor in the Immigrant Generation.* Ithaca, NY: Cornell University Press, 1991.

Goldman, Emma. *Living My Life.* New York: Alfred A. Knopf, 1934.

Goldstein, Eric L. *Price of Whiteness: Jews, Race, and American Identity.* Princeton, NJ: Princeton University Press, 2006.

Hapgood, Hutchins. *The Spirit of the Ghetto.* New York: Funk & Wagnalls, 1902.

Harrison-Kahan, Lori. "'Truth-Telling Should Be an Author's Religion': Jewish Fiction and American Literary Realism." In *"Yearning to Breathe Free": Jews in Gilded Age America*, edited by Adam D. Mendelsohn and Jonathan D. Sarna, 189–216. Princeton, NJ: Princeton University Press, 2023.

———. *The White Negress: Literature, Minstrelsy, and the Black-Jewish Imaginary.* New Brunswick, NJ: Rutgers University Press, 2010.

Harvey, Paul. *Bounds of Their Habitation: Race and Religion in American History.* Lanham, MD: Rowman & Littlefield, 2017.

Henriksen, Louise Levitas. *Anzia Yezierska: A Writer's Life.* New Brunswick, NJ: Rutgers University Press, 1988.

Higham, John. *Strangers in the Land: Patterns of American Nativism.* New Brunswick, NJ: Rutgers University Press, 2002.

Hochschild, Adam. *Rebel Cinderella: From Rags to Riches to Radical, the Journey of Rose Pastor Stokes.* New York: Mariner Books, 2020.

Jacobson, Matthew Frye. *Barbarian Virtues: The United States Encounters Foreign Peoples at Home and Abroad, 1876–1917.* New York: Hill & Wang, 2000.

———. *Whiteness of a Different Color: European Immigrants and the Alchemy of Race.* Cambridge, MA: Harvard University Press, 1998.

Jensen, Joan M., and Sue Davidson, eds. *A Needle, a Bobbin, a Strike: Women Needleworkers in America.* Philadelphia: Temple University Press, 1984.

Kessler-Harris, Alice. *Gendering Labor History.* Urbana: University of Illinois Press, 2007.

———. Introduction to *Bread Givers: A Novel*, by Anzia Yezierska, xxi–xxxvi. New York: Doubleday, 1975.

Kevles, Daniel J. *Genetics and the Uses of Human History.* Cambridge, MA: Harvard University Press, 1995.

Kirzane, Jessica, trans. Introduction to "A Lynching." By Joseph Opatoshu. *In geveb: A Journal of Yiddish Studies* (June 2016). ingeveb.org/texts-and-translations/a-lynching.

Lambert, Josh. *Literary Mafia: Jews, Publishing, and Postwar American Literature*. New Haven, CT: Yale University Press, 2022.

Lang, Lucy Robins. *Tomorrow Is Beautiful*. New York: Macmillan, 1948.

Lasch, Christopher. *The American Liberals and the Russian Revolution*. New York: Columbia University Press, 1962.

Malkiel, Theresa Serber. *The Diary of a Shirtwaist Striker*. Ithaca, NY: Cornell University Press, 1990.

Mendelsohn, Adam D. and Jonathan D. Sarna, eds. *"Yearning to Breathe Free": Jews in Gilded Age America*. Princeton, NJ: Princeton University Press, 2023.

Michels, Tony. "The Lower East Side Meets Greenwich Village: Immigrant Jews, Yiddish, and the New York Intellectual Scene." In *Choosing Yiddish: New Frontiers of Language and Culture*, edited by Lara Rabinovitch, Shiri Goren, and Hannah S. Pressman, 69–85. Detroit: Wayne State University Press, 2012.

———. *A Fire in Their Hearts: Yiddish Socialists in New York*. Cambridge, MA: Harvard University Press, 2005.

———. "Uprising of 20,000 (1909)." Jewish Women's Archive, December 13, 1999. jwa.org/encyclopedia/article/uprising-of-20000-1909#:~:text=On%20November%2023%2C%201909%2C%20more,to%20date%20in%20American%20history.

Morton, Leah (Elizabeth Stern). *I Am a Woman—and a Jew*. New York: Markus Wiener Publishing, 1986.

Odem, Mary E. *Delinquent Daughters: Protecting and Policing Adolescent Female Sexuality in the United States, 1885–1920*. Chapel Hill, NC: University of North Carolina Press, 1995.

Opatoshu, Joseph. "A Lynching." Translated by Jessica Kirzane. *In geveb: A Journal of Yiddish Studies* (June 2016). ingeveb.org/texts-and-translations/a-lynching.

Orleck, Annelise. *Common Sense and a Little Fire: Women and Working-Class Politics in the United States, 1900–1965*. Chapel Hill: University of North Carolina Press, 1995.

Penner, James. *Pinks, Pansies, and Punks: The Rhetoric of Masculinity in American Literary Culture*. Bloomington: Indiana University Press, 2011.

Pesotta, Rose. *Bread upon the Waters*. New York: Dodd, Mead, 1944.

———. *Days of Our Lives*. Boston: Excelsior, 1958.

Pizer, Donald. *Realism and Naturalism in Nineteenth-Century American Literature*. Rev. ed. Carbondale: Southern Illinois University Press, 1984.

Polland, Annie, and Daniel Soyer. *Emerging Metropolis: New York Jews in the Age of Immigration, 1840–1920*. New York: New York University Press, 2012.

"Remembering the 1911 Triangle Factory Fire." School of Industrial and Labor Relations. Cornell University, Ithaca, NY. Accessed May 3, 2023. trianglefire.ilr.cornell.edu/story/introduction.html.

Reynolds, Robert D., Jr. "Millionaire Socialist and Omnist Episcopalian: J. G. Phelps Stokes's Political and Spiritual Search for the 'All.'" In *Socialism and Christianity in Early 20th Century America*, edited by Jacob H. Dorn, 199–216. Westport, CT: Greenwood Press, 1998.

———. "The Millionaire Socialists: J. G. Phelps Stokes and His Circle of Friends." PhD diss., University of South Carolina, 1974.

Riis, Jacob. *How the Other Half Lives*. New York: Charles Scribner's Sons, 1890.

Roberts, Dorothy. *Killing the Black Body: Race, Reproduction, and the Meaning of Liberty*. New York: Vintage Books, 1997.

Roediger, David R. *Working toward Whiteness: How America's Immigrants Became White: The Strange Journey from Ellis Island to the Suburbs*. New York: Basic Books, 2018.

Rosenfeld, Morris. *Songs of Labor and Other Poems*. Translated by Rose Pastor Stokes. Boston: R. G. Badger, 1914.

Schneiderman, Rose. *All for One*. New York: Paul S. Eriksson, 1967.

Schofield, Ann. "The Uprising of 20,000: The Making of a Labor Legend." In *A Needle, a Bobbin, a Strike: Women Needleworkers in America*, edited by Joan M. Jensen and Sue Davidson, 167–82. Philadelphia: Temple University Press, 1984.

Simmons, Christina. *Making Marriage Modern: Women's Sexuality from the Progressive Era to World War II*. Oxford: Oxford University Press, 2011.

Spewack, Bella. *Streets: A Memoir of the Lower East Side*. New York: Feminist Press at CUNY, 1995.

Stansell, Christine. *American Moderns: Bohemian New York and the Creation of a New Century*. New York: Metropolitan Books, 2000.

Stein, Leon, ed. *Out of the Sweatshop: The Struggle for Industrial Democracy*. New York: Quadrangle / New York Times Book Co., 1977.

Stokes, Rose Pastor. *I Belong to the Working Class*. Athens: University of Georgia Press, 1992.
———. *In April*. MSS3249, Library of Congress.
———. *On the Day*. MSS3249, Library of Congress.
———. *The Saving of Martin Greer*, MSS3249, Library of Congress.
———. *Squaring the Triangle*, MSS3249, Library of Congress.
———. *The Woman Who Wouldn't*. New York: G. P. Putnam's Sons, 1916.
Tax, Meredith. *The Rising of the Women: Feminist Solidarity and Class Conflict, 1880–1917*. New York: Verso, 2022.
Thompson, John A. *Reformers and War: American Progressive Publicists and the First World War*. Cambridge: Cambridge University Press, 1987.
Tobenkin, Elias. *The Road*. New York: Harcourt, 1922.
Truth, Sojourner. "Ain't I a Woman?" Akron, OH, 1851.
Walling, Anna Strunsky. *Violette of Père Lachaise*. New York: Fredrick A. Stokes, 1915.
Walters, Ashley. "Intimate Radicals and Radical Intimacies: East European Jewish Women in the Early Twentieth Century Anglo-American Imaginary." PhD diss., Stanford University, 2020.
Wasson, Kirsten. "Elizabeth Stern." *The Shalvi/Hyman Encyclopedia of Jewish Women*. Jewish Women's Archive, December 31, 1999. jwa.org/encyclopedia/article/stern-elizabeth-gertrude-levin.
Watt, Stephen. *"Something Dreadful and Grand": American Jewish Literature and the Irish-Jewish Unconscious*. Oxford: Oxford University Press, 2015.
Weinstein, Chris. "Heroine of Cooper Union: Clara Lemlich Dead at 96." *Justice*, September 1982.
Yezierska, Anzia. *The Breadgivers: A Novel*. New York: Doubleday, 1975.
———. *Red Ribbon on a White Horse*. New York: Persa Books, 1987.
———. *Salome of the Tenements*. New York: Boni & Liveright, 1923.
Zipser, Arthur, and Pearl Zipser. *Fire and Grace: The Life of Rose Pastor Stokes*. Athens: University of Georgia Press, 1990.

Archival Collections

Fannia M. Cohn Papers, New York Public Library.
Clara Lemlich Papers, Tamiment Library and Robert F. Wagner Labor Archives, New York University.

Pauline Newman Papers, Arthur and Elizabeth Schlesinger Library, Harvard University.
Rose Pastor Stokes Papers, Library of Congress.
Rose Pastor Stokes Papers, Sterling Library, Yale University.
Rose Pastor Stokes Papers, Tamiment Library and Robert F. Wagner Labor Archives, New York University.

2

WHERE THE SHOE PINCHES

Appropriation and Allyship in Annie Nathan Meyer's
Anti-Lynching Literature

Lori Harrison-Kahan

In 2016, Lionel Shriver gave a controversial keynote address on fiction and identity politics at the Brisbane Writers Festival in Australia. Describing the novelist as "the appropriator par excellence," Shriver posed a series of questions about fiction writers intended to demonstrate that their art, by definition, involves borrowing the identities and voices of others: "Who assumes other people's voices, accents, patois, and distinctive idioms? Who literally puts words into the mouths of people different from themselves? Who dares to get inside the heads of strangers, who has the chutzpah to project thoughts and feelings into the minds of others, who steals their very souls?"[1] In an era of "sensitivity readers," workshops for writers with titles like "Writing the Other," and social media hashtags prescribing that novelists "stay in [their] lane" and write only from their own identity position, Shriver's deliberately provocative defense of cultural appropriation became a lightning rod for debates about racial politics in the publishing industry. The controversy over whether novelists should be granted license to write about "people different from themselves"—and specifically, people of different racial backgrounds—was further heightened in early 2020 with the publication of *American Dirt*, a best-selling novel about Mexican migrants that earned its white author, Jeanine Cummins, a seven-figure advance. In "The Lives of Others," an essay published in *Harper's Magazine* later that year, novelist Richard Russo entered the fray, raising questions

similar to Shriver's, albeit in a less contrarian manner. "But why constrain the imagination, the very thing that helps us get over ourselves?" he asks. "Are artists really supposed to stay in their lanes?" While cautioning white writers to think more critically about the effects of representing other racial groups, Russo also urges readers to consider why authors might feel compelled to tell stories about "the lives of others."[2]

Scholars of Jewish American culture have long been asking questions about the art and politics of racial appropriation, motivated in part by the early twentieth-century phenomenon of Jewish blackface performers eternalized in the 1927 film *The Jazz Singer*. (Russo takes Al Jolson's performance in *The Jazz Singer* as one of his central analogies, pointing out that most white writers, like the film's star, do not "really stop . . . to consider . . . how underrepresented communities are harmed by inauthentic representations.")[3] As literary scholars Jennifer Glaser and Jonathan Freedman have shown, cross-racial identifications are ubiquitous in Jewish-authored texts, which participate in a broader American cultural tradition of appropriative performance that includes forms of masquerade, ventriloquism, and passing.[4] Representations of racial others in Jewish American literature offer opportunities to interrogate complex processes of comparative racialization that have simultaneously aligned Jewishness with a dominant whiteness and constructed Jews in terms of minoritarian difference. As I explored in *The White Negress: Literature, Minstrelsy, and the Black-Jewish Imaginary*, Jewish women writers such as Edna Ferber and Fannie Hurst made careers out of not staying in their lanes. Two of the most popular writers of the early twentieth century, they have since fallen out of favor. Both have been accused of profiting from flagrant racial appropriation and charged with perpetuating egregious minstrel stereotypes on the basis of their best-known novels, Ferber's *Show Boat* (1926) and Hurst's *Imitation of Life* (1933). However, by reading their fiction closely in its historical context, and considering gender as a complicating factor, I demonstrated that such racial appropriations do not simply reify white privilege; instead, the incorporation of Black characters and narratives of racial passing expose the limitations of the what Freedman calls "the-Jew-as-white-person model" and offer a site for a feminist critique of whiteness.[5]

In this chapter, I expand on my previous claims by turning to the example of Annie Nathan Meyer, an understudied writer of Sephardic

descent. Meyer is best known today for her philanthropic efforts on behalf of women and African Americans, which included founding Barnard College in 1889 and serving as one of Zora Neale Hurston's patrons during the Harlem Renaissance. In the 1920s and 1930s, Meyer also produced works of protest literature in which she represented people of color and addressed questions of racial justice. Building on Carla Kaplan's analysis of Meyer's anti-lynching play, *Black Souls*, I show that Meyer's autobiographical writings and overlooked short fiction—notably a 1935 short story titled "The Shoe Pinches Mr. Samuels," which was published in an NAACP journal (the *Crisis*) and a Chicago Jewish journal (the *Sentinel*)—provide further insight into one Jewish woman writer's personal and political investments in fictionalizing the lives of others. Rather than dismissing Meyer's writings as crude cultural appropriations, this chapter operates from the premise that it is more productive to examine her racial blind spots and to consider why such representations would have been considered radical for their time. I argue that Meyer's work needs to be taken seriously as part of American literary and cultural histories in which women writers from various Jewish backgrounds have spoken for, and through, people of other races. As I demonstrate, such representations of racial otherness offer a space to interrogate both the coupling and uncoupling of Jewishness with whiteness.

Black Souls and the Yankee Jewess

In 1932, Meyer's play *Black Souls* premiered at the Provincetown Playhouse in New York. Running for only two weeks, the six-scene drama by a minor white playwright seemed destined for obscurity, despite the fact that some reviewers recognized the power of its antiracist message. In 1998, *Black Souls*'s status as a significant work in the tradition of anti-lynching dramas was secured when the play was republished in the anthology *Strange Fruit: Plays on Lynching by American Women*. The book's editors, Kathy A. Perkins and Judith L. Stephens, note that the play's "inclusion" in the collection "suggests a new consideration of what has traditionally been called 'feminist drama' for the historical period."[6] Traditional early twentieth-century feminist dramas authored by white playwrights featured white women struggling against patriarchal forces.

In contrast, Meyer's main characters are African American, her setting is a Black college in the South, and the play's conflict centers on anti-Black violence. In writing the lives of others, Meyer was driven by an activist impulse and sought inspiration, as well as direct input, from Black writers and intellectuals who viewed literary production as a pathway to racial justice. Especially when read in relation to her autobiographical treatment of Jewishness, *Black Souls* elucidates a complex web of identifications and cross-identifications underlying Meyer's acts of racial appropriation and allyship.

Hewing closely to the playbook established by Ida B. Wells and other anti-lynching crusaders, *Black Souls* stages a multipronged attack on white supremacist violence.[7] Meyer's play demonstrates that white mobs' justifications for lynching are based on false narratives about Black male sexuality and white womanhood that elide historical evidence of sexual violence against Black women in addition to denigrating Black men. The play debunks the myth of the Black male rapist by depicting a white woman's desire for the Black male protagonist, David Lewis, a poet, professor, and US military veteran. In the penultimate scene, a lynch mob murders David after he is found alone with a state senator's daughter, Luella Verne, who amorously pursued the poet to the secluded cabin where he writes his verses. The play's tragedies are multiple and layered, as traumas of the past intertwine with violence in the present. In a climactic moment, the audience learns that David and his sister, Phyllis, are childhood survivors of a lynching, having barely escaped a brutal attack that killed the rest of their family; the lynching was motivated by their father's attempt to protect a Black girl from "drunken white beasts."[8] Lynching and the sexual exploitation of Black women are portrayed as ongoing generational traumas. In the final scene, Phyllis's realization of her brother's murder occurs concurrently with her painful disclosure of a long-held secret: she reveals to her husband, principal of the Magnolia School for Colored People, that she had been raped as a teenager by Senator Verne, whose fundraising visit in support of the college gave him the opportunity to renew his sexual threats against Phyllis—and brought Luella into David's orbit. In casting the white senator and his daughter as the play's antagonists and sexual aggressors, *Black Souls* makes clear its indictment of the state's institutional complicity. Not only has the law failed to safeguard Black lives, but in addition the state itself is exposed as a perpetrator of anti-Black violence.

In explaining their rationale for including the play in *Strange Fruit*, Perkins and Stephens extend the definition of "feminist" to include activism that allies white women with Black women and their causes—a definition that today is often denoted via the adjective "intersectional" as a means of drawing a distinction from *white* feminism. But Meyer's status as a proto-intersectional feminist, with the implication that her commitment to racial justice is aligned with commitments to gender equality, is more complicated than it first appears. In fact, Meyer herself would have resisted such a label. On the one hand, she was a high-profile advocate for women's education and status in the professions: she founded Barnard College; published *Helen Brent, M.D.* (1892), a New Woman novel about a female physician; and edited a book titled *Woman's Work in America* (1891). On the other hand, as an outspoken anti-suffragist and contributing editor to the *Woman Patriot*, the organ of the National Association Opposed to Woman Suffrage, Meyer campaigned against women's enfranchisement, arguing that politics had nothing to gain from women voters and officeholders. In her writings and speeches, she separated herself from feminists like her own sister, Maud Nathan, a national leader in the suffrage movement. Meyer's most notorious antisuffrage tract, "Woman's Assumption of Sex Superiority" (1904), ruthlessly disproved suffragists' arguments that women were morally superior to men.[9]

Yet when it came to religious and class background, Meyer believed that her Sephardic heritage and membership in an elite New York family conferred superiority. Like her relationship to feminism, Meyer's relationship to Jewishness is rife with contradictions that complicate interpretations of her work's appropriative politics. These contradictions seem even messier from a twenty-first-century perspective, when we consider Sephardic studies' tenuous space within the broader scholarly field of Jewish studies and, in particular, how Sephardic identity challenges understandings of Jewish racial formation that have privileged an Ashkenazi sociohistorical narrative in which American Jews assimilated into whiteness over time.[10] In drawing attention to the exclusion of non-Ashkenazi experiences within Jewish studies, scholars such as Aviva Ben-Ur note that Sephardic American Jews, as a "minority within a minority," "plunge precipitously off the page into the abyss of historical oblivion."[11] As a result of the field's tendency to use Jews of Eastern European descent as a stand in for Jewish identity writ large (a tendency that has been termed

"Ashkenormativity"), writers of Sephardic descent like Meyer have been largely relegated to the margins of Jewish American literary history.[12]

In such contemporary constructions, privilege and minority status often stand in opposition to one another. From the standpoint of late nineteenth-century American culture, however, western Sephardim (Jews who traced their ancestry to Spain and Portugal) were often portrayed as a "superior class" rather than a "minority within a minority," and Meyer positioned herself as part of an elite and noble line.[13] Born in New York in 1867, Meyer was the daughter of Robert Weeks and Annie Augusta (Florance) Nathan, American-born citizens whose ancestors arrived on the continent of North America in the seventeenth and eighteenth centuries. Meyer's parents maintained a strong Jewish identity, observing the Sabbath and other religious holidays and practicing Sephardic customs (as indicated by the fact that Meyer was named for her mother, unlike Ashkenazim who typically refrained from naming children after living relatives). Yet their religion did not present a significant social barrier. Meyer's affluent extended family was well integrated into Old New York society and boasted illustrious members. Her cousins included poet Emma Lazarus, whose 1883 poem "The New Colossus" was posthumously engraved on a plaque at the base of the Statue of Liberty, and Judge Benjamin Cardozo, who was appointed to the Supreme Court in 1932. An 1895 profile of Meyer in *The American Jewess* labeled her "a Yankee Jewess" to mark her "distinguished" lineage as a third-generation American whose great-grandfathers supported the American Revolution rather than "pledg[ing] themselves to the cause of the crown."[14]

In her autobiography *It's Been Fun*, which was published in 1951, the year of her death, Meyer expresses great pride in her Sephardic heritage. This pride rests on her ancestors' identities as American patriots dating back to colonial times. She introduces her family's ethnoreligious background via an anecdote intended to correct audience misconceptions about the relationship between Jewishness and Americanness. Praising her hostess's "beautiful English" while a guest in Meyer's home, a "well-known society leader" asks, "How long is it since your parents came to America?" In response, Meyer displays photographs, letters, and other family artifacts as visual and material evidence of her long-standing American lineage. On her mother's side, she informs her guest, she was descended from Rabbi Gershom Mendes Seixas. As spiritual leader of New York's

Shearith Israel, the first Jewish congregation established in the United States, Rabbi Seixas closed his synagogue rather than pray for George III and later was one of three clergymen to participate in the inauguration of George Washington. On her father's side, she was also descended from the Seixas family. Gershom's sister, Grace Seixas, was married to her paternal great-grandfather, Simon Nathan, who arrived in New York from England in 1777 on "the day the British took possession of Philadelphia" and whose name is listed "in the first Directory of New York, a slender volume published in 1786."[15] Meyer continually emphasizes her family's connection to the country's origins, from a grandfather who signed the constitution of the New York Stock Exchange to a great-grandmother who resembles Martha Washington.

Meyer not only presents her Sephardic ancestors as integral to the nation's founding story, but she also uses photographs and daguerreotypes as visual proof of their physical resemblance to the founding mothers and fathers. The visual evidence accomplishes something her storytelling alone cannot, disabusing her guest of assumptions about ethnoracial difference to further erode distinctions between "Jewish" and "American." However, by framing her genealogy with the society woman's question and assembling a material archive to authenticate her pedigree, Meyer acknowledges that Jews' claims to American identity are often suspect. Aware that the audience of her autobiography likely harbors similar misconceptions, she offers a history lesson: "It will probably surprise most of my readers, as it did my guest whom I had given just a glimpse into the early history of the Jews in America, to learn that only thirty-four years after the Pilgrims landed from the Mayflower, a small band of twenty-three Jews landed in New Amsterdam." In making visible this colonial history, Meyer ironically portrays the Sephardim as part of an American aristocracy, declaring them "the nearest approach to royalty in the United States" and claiming her membership in this "superior class."[16]

While Meyer's recitation of her family history stakes a patrician claim to American superiority grounded in an ideology of exceptionalism and entitlement, her discussion of her mother's southern roots allows her to distance herself—at least rhetorically—from white supremacy, exposing a more ambivalent narrative of ethnoracial identification in which whiteness is conditional. Meyer's maternal ancestors were among the earliest settlers in the colony of South Carolina, where they helped to establish a Jewish

community in Charleston in the eighteenth century. Meyer's mother, Annie Augusta Florance, was born in 1842, after the family's migration to New Orleans. The autobiography's first reference to slavery occurs when Meyer states of her mother's southern upbringing: "Being well-to-do and surrounded by slaves, she knew nothing of the household arts."[17] Whereas Meyer embraced her northern ancestors' colonial roots and patriotic resistance against the Crown, she rejects the legacy of southern rebellion as part of her inheritance. She informs her reader that she and her three siblings were cut out of Grandfather Florance's will because he chose to leave his "considerable fortune . . . to those who had sympathized with the South," adding, with a touch of righteousness, that she "can realistically say that we four suffered for our country's sake."[18] Meyer once again asserts her Americanness by invoking patriotic sacrifice ("suffer[ing] for [her] country's sake"), albeit this time she does so by distancing herself from her Confederate grandfather—a politically prudent move at the time she penned her autobiography, enabling her to shore up her reputation as a antiracist reformer.

This familial rift is further evident in another story that Meyer tells about her Grandfather Florance that explicitly addresses race:

> I was very dark. My grandfather used to amuse himself by threatening to take me down South and sell me as a slave. (Slavery was over but that didn't spoil the joke for him. In fact he loved to speak, as did so many Southerners, as if Appomattox had never been.)
> "It's lucky for you child," he used to say, "that you're not living in the South. You'd find yourself sold down the river in no time!"
> This used to infuriate me.[19]

Given the association of Sephardic ancestry with darker complexions, Meyer's grandfather's "joke" reads as an example of colorism—one that depends on a deliberate misidentification of his granddaughter as Black. The episode underscores the relationality and conditionality of whiteness, illustrating how Jews (of both Sephardic and Ashkenazi descent) have benefited from the United States' racial caste system. It also invokes the historical linkages between Blackness and Jewishness that can be traced back to the early modern world. As Jonathan Schorsch observed in an essay about seventeenth-century Sephardim, "Writing as outsiders, as 'Jews,' many

Sephardic authors sense a need to distance themselves and their people from Blacks, this other whose perceived proximity, even kinship, threatens Jewish entry into the elite circle of Whites."[20] By owning and selling those with darker skin, including hypothetically his own progeny, Grandfather Florance establishes his place at the top of the racial hierarchy. His threat to sell his granddaughter into slavery is not entirely empty, as Meyer's acknowledgment of her southern family's slaveholding past makes clear. Speaking as if the South had not lost the Civil War allows Meyer's grandfather to retain his full investment in the powers and privileges of whiteness. Both his words and the act of disinheriting his grandchildren exemplify the steep "price of whiteness," as the grandfather sacrifices his own kin to secure his racial status.[21]

In light of Meyer's autobiographical treatment of her southern ancestry, the label "Yankee Jewess" takes on additional meaning. Rather than interrogating her own complicity in a white supremacist system, Meyer reinforces a regional binary between North and South that allows her to identify with a northern benevolent whiteness and distance herself from southern white racism. In her retrospective account of her childhood, Meyer's memories of her southern grandfather come to function as a primal scene of racial awareness. Her use of a broad pronoun reference—"*This* used to infuriate me"—creates uncertainty about what aspect of her grandfather's "joke" enraged her: Is she angered by the personal slight, by her grandfather's cruelty in threatening to sell her into slavery and willfully misidentifying her with abjected Blackness? Or, is her anger a response to the universal cruelty of racism and her grandfather's participation in this unjust system of oppression?

As a child, Meyer acquiesces to and internalizes the creed of colorism, confessing her "secret passion for blondes" and the self-loathing caused by "being brunette." Retroactively, however, the anecdote operates as a source of dawning social consciousness about both race and gender. Meyer goes on to observe, "All the innocent, sinned-against heroines in *Godey's Magazine* [a popular woman's magazine] were always blonde. The double-faced villainess was always dark and mysterious looking."[22] As an adult, Meyer turns the fury caused by her deviation from the ideals of white womanhood outward, transforming it into a broader critique of racialization in American culture. Her own writing offered opportunities to reverse the racialized dichotomies circumscribing representations of women. In

Black Souls, Black women and girls are "innocent" and "sinned-against," while the white woman, Luella, strays far from archetypal chaste southern femininity and closer to the role of "double-faced villainess." It is equally important, however, that Meyer sets her indictment of white supremacy in the South, enacting a regional voyeurism that allowed her to express outrage at the South's racial violence and travesties of justice from the perspective of the righteous North.

As a northerner who spent little time in the South, Meyer did not have firsthand knowledge of lynching, and *Black Souls* is indebted to a tradition of Black-authored anti-lynching literature—in particular to the germinal work of Black women writers such as Angelina Weld Grimké, Alice Dunbar-Nelson, and Mary Powell Burrill. Reflecting on the lukewarm response to *Black Souls* in *It's Been Fun*, Meyer uses the play as a prime example of her autobiography's thesis: "[I]t is no more use to be ahead of your time than behind it." While Meyer viewed her drama as "ahead of its day" in its advocacy for racial justice and its depiction of educated, refined, and well-spoken Black characters who defied minstrel stereotypes, *Black Souls* was also very much a product of its time.[23] Beginning in 1916 with the NAACP's controversial production of Grimké's *Rachel*, considered the first anti-lynching play, Black playwrights turned to dramatic form to protest racial violence and explore questions of African American citizenship.[24]

Meyer's characterization of lynching victim David Lewis as a veteran who has recently returned from serving in World War I, for example, echoes elements of Black social protest dramas. In her scholarship on lynching plays, Koritha Mitchell identifies the Black soldier as a "representative figure" who "personified African Americans' admirable character and valid claim to full citizenship."[25] The figure of the Black soldier made an early appearance in the genre with Dunbar-Nelson's 1918 one-act *Mine Eyes Have Seen*, which was printed in the *Crisis*, a periodical to which Meyer subscribed and in which she would later publish a lynching narrative of her own. *Mine Eyes Have Seen* centers on a Black man, Chris, who is drafted into the military. Driven out of the South after his father was lynched by a white mob who believed that "niggers had no business having such a decent home," Chris lives in northern poverty with his traumatized family.[26] The play poses a dilemma about whether African Americans are obligated to serve in the US military, given the racial trauma they have

endured at the hands of fellow American citizens. Interestingly, Dunbar-Nelson introduces a Jewish character named Jake, Chris's tenement neighbor, who is described as "a slight, pale youth, Hebraic, thin-lipped, eager-eyed." Jake argues that it is Chris's patriotic duty to serve, drawing a parallel to the Jewish experience: "Have any people had more horrible persecutions [than the Jewish race]—and yet—we're loyal always to the country where we live."[27] As Mitchell points out, Jake's attempt to analogize the history of Black and Jewish persecutions "overlooks the specific experience of African Americans in the United States and Chris's personal lynching-inspired reasons for not feeling obligated to Uncle Sam."[28]

For Meyer and many of her Black contemporaries, the greater issue was not Black loyalty to the United States but whether the nation was loyal to its African American soldiers, many of whom continued to face discrimination and racial violence despite their military service. Mary Powell Burrill's 1919 one-act *Aftermath*, which was published in the leftist periodical the *Liberator*, features a Black soldier, John, who returns from World War I to learn that his father has been lynched in his absence. The ending of *Aftermath* implies that the soldier may be destined for a similar fate, as he leaves home, gun in hand, seeking revenge for his father's murder. The play's final stage direction indicates that John "disappears in the gathering darkness."[29] While Burrill's play leaves the fate of the Black soldier open ended, Meyer's *Black Souls* dramatizes the lynching of a Black man who served his country and can thus be read as an extension of her predecessor's themes.

Meyer's turn to African American themes also needs to be understood in the context of what Langston Hughes termed "the vogue in things Negro."[30] At the time Meyer began working on *Black Souls* in the 1920s, the Harlem Renaissance was under way, generating unprecedented white interest in Black art and culture and new markets for stories of Black lives. Wealthy, acculturated Jews expressed their commitment to racial justice by supporting civil rights organizations like the NAACP and the work of Black artists and intellectuals. Although the formative years of Meyer's youth were spent in reduced circumstances, with the Panic of 1873 forcing her family's temporary relocation to Wisconsin, her marriage to New York physician Alfred Meyer in 1887 brought financial and social stability, providing her with the resources to pursue her writing as well as a variety of philanthropic causes, many of which fell under the purview of civil rights.

She was drawn in particular to talented Black women like singer Marian Anderson and writer Zora Neale Hurston, activating her extensive social network to help them jump-start their careers in the face of racial barriers.

During the 1920s, Black and white people mingled at interracial cultural events, like the 1925 awards dinner for *Opportunity: A Journal of Negro Life*, where Meyer first met Hurston, a recipient of one of the magazine's literary honors. That serendipitous meeting led to the desegregation of Barnard College. From the college's founding in 1889, Meyer ensured that New York's first institution of higher education for women would reflect pluralistic principles; the board of trustees that she assembled, for example, displayed an ecumenism unusual for its times, including Sephardic and German Jews as well as members who were Catholic, Baptist, and Unitarian.[31] Impressed by Hurston, Meyer saw another opportunity to make her mark on Barnard's history by integrating the college. Meyer arranged for Hurston's admission as a transfer student from the historically Black Howard University and assisted her in securing tuition funds—in part, by appealing to another Jewish American woman writer, the novelist Fannie Hurst, who agreed to employ Hurston as a secretary.[32] Hurston became Barnard's first Black student.

In her book *Miss Anne in Harlem: The White Women of the Black Renaissance*, Carla Kaplan shows that the racial appropriations of white women such as Meyer and Hurst are rarely taken seriously by scholars. Instead, the artistic productions generated by their involvement with Black art and politics tend to be dismissed as misguided and culturally insensitive. The white women are derided as "Miss Annes," a slang term that connotes an overbearing and self-aggrandizing personality, someone who interacts with Black people in a condescending manner and who meddles where she does not belong by venturing into Black social worlds. Such women are often accused of seeking out Black difference, projecting their tastes for exoticism and primitivism, and suffering from white savior syndrome.

Demonstrating the greater complexity underlying many of these white women's engagements with Blackness, Kaplan identifies *Black Souls* as a radical departure from other white-authored texts. Although the workmanlike social protest play is not avant-garde from an aesthetic point of view, Kaplan claims that Meyer's anti-lynching drama was "entirely unlike anything ever written before."[33] This bold claim is not quite accurate. The

play is certainly not as radical as it seems when read against a tradition of African American literature and Black women's writing; in that context, it is clearly derivative. The title itself is a reference to W. E. B. Du Bois's *The Souls of Black Folk* (1903), and the play borrows elements of anti-lynching dramas by Black women playwrights, as I have discussed. By refusing sympathy for white characters and demanding autonomy for Black characters, it follows the "blueprint for the genre" established by writers such as Grimké, Dunbar-Nelson, and Burrill.[34] As Kaplan delineates, however, the play innovates the genre by "depicting female desire" (including interracial desire); "eschewing dialect"; "concentrating on the middle class"; and avoiding "folk elements . . . that were selling so well in . . . Broadway revues about black life," but that, especially in the hands of white cultural producers, flattened Black characterization and reproduced exotic and primitive stereotypes.[35]

These innovations inevitably became a source of tension, and for many years theaters declined to produce the play, despite Meyer's persistent lobbying and strategizing. Concerned about producers' resistance to staging scenes in which a white woman expresses desire for a Black man, Meyer wondered whether casting might alleviate fears; in a reversal of the blackface theatrical tradition, she proposed to one director that a "a very light mulatto" could play the role of Luella, the white senator's daughter, "if it is desired to save the feelings of white audiences."[36] But in other ways, Meyer stuck to her guns. In response to white reviewers' criticism of her dialogue as unrealistic, she stood by her decision not to render Black speech in dialect, aware that pandering to white audiences and their expectations would not only offend Black audiences but also perpetuate harmful caricatures of the very people her play sought to defend. *Black Souls* may have been motivated by Meyer's desire to participate in, and capitalize on, "the vogue in things Negro," but the resulting play offers a compassionate depiction of a middle-class Black family devastated by racial violence and a harsh indictment of white supremacy.

Meyer's ability to steer clear of many of the pitfalls that derailed other white authors may have been due to her willingness to solicit input from Black writers. By the time of the fateful *Opportunity* dinner in 1925, Meyer had already begun working on *Black Souls*, and she shared an early draft of the play with Hurston. Their correspondence suggests that Hurston felt comfortable offering her honest assessment to Meyer and that Meyer

listened carefully to Hurston's critique, which included suggestions for restructuring the plot. "Clever is not a good word for *Black Souls*," Hurston wrote in one letter. "It is immensely moving. It is accurate, it is very, very brave without bathos. There are some mighty fine literary passages too. Once or twice I noted a trite figure."[37] Although Hurston clearly harbored reservations about Meyer's work in progress, the two women began collaborating on a novelization of *Black Souls*, which would in turn shape Meyer's play. By October 1927, however, Hurston's doubts about the project had grown, especially as she undertook anthropological fieldwork in the South. "The more I see of the South," she wrote to Meyer, "the more am I convinced that it would strike a terribly false note."[38]

Despite pulling out of the plan to collaborate on a novelization, Hurston made important contributions to *Black Souls*'s evolution as a work of performance. Most significantly, she suggested incorporating four spirituals—"Steal Away," "Holy unto the Lord," "Every Time I Feel the Spirit," and "Your Soul and Mine"—which lent authenticity by grounding the play in a Black oral tradition. During the play's brief New York run in 1932, Hurston herself directed the spirituals, which were performed by her folk-based choral group, and spoke alongside Meyer when the Barnard College Club hosted a discussion of the play. By that time, Meyer's revisions were significant enough to allay some of Hurston's earlier concerns about "false notes." Advertisements for the play featured an endorsement from Hurston that read: "Never before have I read anything by a white person dealing with 'inside' colored life that did not have a sprinkling of false notes." As I discuss in *The White Negress*, Hurston's public endorsement is carefully worded, using the negative to imply cagily that *Black Souls* may *not* be an exception to her previous assessment of white-authored depictions of black life.[39]

Other Black writers, too, signed off on *Black Souls*—although they, like Hurston, likely felt obligated to do so, given Meyer's status as a white benefactor. In addition to seeking feedback from Hurston, Meyer hired James Weldon Johnson to conduct what today we would call a "sensitivity read" of the manuscript. Along with other NAACP leaders such as Mary White Ovington and Roy Wilkins, Meyer and Johnson had worked together to raise funds for Black college students. Like Hurston, who had attended Howard University for two years, Johnson, a graduate of Atlanta University in Georgia, the first historically Black university in the South,

had firsthand knowledge of southern Black college life and was thus particularly well suited to comment on Meyer's academic setting and erudite characters. As a poet, Johnson may have also supplied some inspiration for Meyer's protagonist, David Lewis. Meyer asked Johnson to "go through the play with a fine-toothed comb for any expression that was not completely in character" and "gave him carte blanche" to make edits. While Meyer's autobiography states that Johnson made only a grammatical suggestion to change "one preposition for another," a letter from Johnson to Meyer indicates otherwise.[40] In it, Johnson approved the changes that Meyer made in "accordance with [his] suggestions," singling out the interracial encounter between David and Luella in the woods and the play's denouement. He further advised that the manuscript may benefit from a more "radical" alteration to its structure, even if he is "not absolutely sure" that a wholesale revision would "make it a better play."[41] With the play set for its premiere in 1932, Meyer continued to seek the approval of Black intellectuals. In a letter inviting Du Bois to the opening night performance, for instance, she signed off with the "hope [that] you will find I have written a beautiful play and a poignant one—of its sincerity there can be no doubt."[42]

Despite the fact that Meyer was a seasoned playwright who had previously written a number of controversial dramas dealing with women's issues, reviews of *Black Souls* suggest that audiences did not find it effective as a work of performance. A reviewer for the *New York Herald Tribune* harshly criticized the play, declaring that it "fails to become either an exciting bit of theater or a convincing treatise."[43] In the *New York Daily News*, John Chapman described it as "uneven . . . with more sympathy than dramatic fire."[44] Such opinions were not restricted to the white press. Expressing little surprise that the play closed in two weeks, the *Crisis* summed up its critique thus: "Overladen with racial propaganda, awkward, unimpressive."[45] Other Black reviewers credited the play for at least being well intentioned. In an *Opportunity* retrospective of Black art for the year 1932, for example, Alain Locke offered the assessment that *Black Souls* was weak as a piece of art but "laudable" in its attempt to convey an important social message.[46]

Determined that her message reach a broader audience, Meyer followed the play's short theatrical run with a print edition. The vexed nature of her allyship is illustrated by various paratextual elements. The back flap of the book jacket features endorsements by Black and white NAACP

86 Lori Harrison-Kahan

luminaries, including Walter White, James Weldon Johnson, Mary White Ovington, and Oswald Garrison Villard. Under the heading "What They Say of Black Souls," the blurbs contain pro forma praise. Villard calls *Black Souls* a "fine thing . . . dramatic and deeply stirring," while Johnson commends Meyer for having "gone beneath surface aspects and done one of the most powerful and penetrating plays yet written on the race question."[47] Joining Black and white activists with the pronoun "They," the back flap markets *Black Souls* as an exemplary product of interracial alliance, forecasting Perkins and Stephens's rationale for including the play in *Strange Fruit*.[48] Yet the rest of the book jacket betrays more troubling dynamics underlying Meyer's allyship. The description on the front book flap begins:

> Why did the dramatic reviewers distort the message or ignore its originality, pretending it was the same old black and white stuff? Was it because the courageous author dared to write of the great American Taboo?
>
> The truth is, never before has a playwright dared to utter certain truths that have been known for years by all serious students of the problems of the Afro-Americans.

Highlighting Meyer's "originality" and courage, the text centers the white playwright rather than the anti-lynching cause. It also exposes the contradiction at the heart of the claim to originality, admitting that the play's "truths have been known for years by all serious students of the problems of Afro-Americans." Absent here is an acknowledgment that the horrors of anti-Black violence were made widely known by Black writers—playwrights included—for whom the stakes were much higher than the curtailment of a theatrical run. Black anti-lynching activists put their lives at risk in their efforts to "right wrongs" by "turn[ing] the light of truth upon them," in Ida B. Wells's famous words.[49]

Much as Meyer's autobiographical treatment of race aligned her with a benevolent North and failed to take into account her own complicity in white supremacy, the design on the cover of the book jacket extricates the author from the racist systems she seeks to ameliorate. The ominous black-and-white image depicts a spider web with the words *BLACK SOULS* entangled in its strands, signaling a narrative of victimhood. Meyer's name and that of John Haynes Holmes, the white Unitarian minister who

Where the Shoe Pinches 87

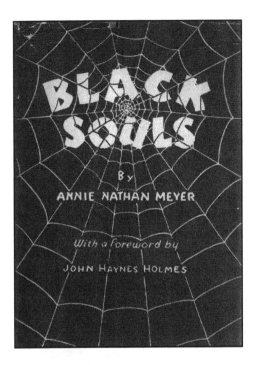

Figure 2.1. Cover of *Black Souls* by Annie Nathan Meyer (New Bedford, MA: Reynolds, 1932).

wrote the edition's laudatory foreword, appear below the title, superimposed on the web, but noticeably free of its threads.[50] The design implies that, as white activists, Meyer and Holmes exist in a space apart from the victims (the "Black souls" of the title) and the victimizers (represented by the fatally entrapping web of white supremacy). Later, Meyer would offer a more nuanced consideration of such dynamics; "The Shoe Pinches Mr. Samuels" not only explores Jews' identification with Black victims of racial violence but also demonstrates how Jews of European descent are complicit with white supremacy through silence as well as through active participation in the racial economy of the South. But the print edition of *Black Souls* exposes Meyer's attempt to install herself as a courageous trailblazer in the anti-lynching movement—even as the play contained between the covers refuses sympathy and heroism for its white characters.

The lackluster reception of *Black Souls* was a grave disappointment for Meyer, who believed deeply in the value of her play and had devoted almost a decade to ensuring that her words would come to life on the stage. Meyer found consolation in the irony that Black audiences responded more favorably to her work than white audiences did, contrary to expectations for a

white-authored play. Responses to the print edition suggest that *Black Souls* may be more effective on the page than it was on the stage. Reviewing the print edition in *Opportunity*, Montgomery Gregory called it "an important social document and a dramatic tour de force." Praising its authenticity as an account of "Negro life," he, like Hurston, noted the rarity of reading a white-authored work in which Black people are portrayed as "human being[s]" rather than as minstrel stereotypes and sources of "revelry."[51] In her autobiography, Meyer exaggerates the extent of such accolades, viewing, for example, "the remarkable fact that *one and all* the Negroes thought well of it" as evidence that she had passed the authenticity test (italics mine).[52] As further proof that her experiment in racial ventriloquism was a success, Meyer noted that unwitting readers and audiences assumed that she herself was Black based on her authorship of the play. "When persons didn't know who I was, they always assumed it was written by a Negro," she wrote in *It's Been Fun*, seemingly pleased by the misrecognition.[53] This self-congratulatory statement stands in contrast to the childhood anger and shame she experienced when her grandfather purposefully misidentified her as Black and threatened to sell her "down the river." Thanks to the "vogue in things Negro," Blackness had become a more aspirational identity for Meyer—if, of course, a temporary identification, one she could claim when it suited her.

By donning temporary identities as "voluntary Negroes," white women often ended up reentrenching the racial status quo with its Black-white binary, as Kaplan and other scholars studying racial appropriation have argued.[54] For Jewish women, racial ventriloquism had additional effects, allowing them to elide or downplay their ethnoreligious difference and insert themselves into a white majority. In her chapter on Meyer, Kaplan explains that Jews "might become 'white' people in Harlem when many had never before experienced themselves as 'whites' in the larger American culture." At the same time, she notes that "being white in Harlem but Jewish (and hence not fully white) elsewhere provided special insights into the relative nature of all social identities."[55] For readers and scholars today, Meyer's Sephardic ancestry may complicate familiar paradigms of Jewish American racialization; in Meyer's time, however, the process of writing and producing *Black Souls* did, in many ways, underscore her position as a white writer. Among his stack of notecards listing authors and their publications, Du Bois kept one on Meyer and *Black Souls*, describing the

playwright as "a white author of a play on Negro life"; with no mention of her Jewish background, Du Bois's notation clearly positions Meyer on the white side of a racial binary.[56] Two years after the play's failed run, Meyer's anti-lynching story "The Shoe Pinches Mr. Samuels" appeared in the *Crisis*, the NAACP organ founded and edited by Du Bois. Lending further weight to Kaplan's claim about the "relative nature of . . . social identities," the story indicates how Meyer's engagement with Black culture led to a greater understanding of the relationality and conditionality of Jewish whiteness.

Skin in the Game

One of Meyer's few fictional works to explicitly take up Jewish identity, "The Shoe Pinches Mr. Samuels" deploys a lynching narrative to complicate the racialization of Jews of European descent as white. Speaking to multiple audiences, the story appeared both in an anti-lynching issue of the *Crisis*, the journal of the NAACP, in January 1935, and (in slightly abridged form) in the *Sentinel*, a Chicago Jewish periodical, in November 1934. Like *Black Souls*, the short story contains a direct and potent antiracist message, arguing that Jews are responsible for combating anti-Blackness and warning that they, too, will find themselves victims of racial hatred and violence if they refuse to act.[57] This message offers insight into Meyer's long-term commitment to *Black Souls* and her inclination to focus on the experiences of middle-class, educated African Americans. When *Black Souls* is studied alone, Meyer's authorship might be interpreted primarily in the context of racial formations that couple Jewishness with whiteness. Reading the play alongside "The Shoe Pinches Mr. Samuels" demonstrates how Meyer's lynching texts also address the *un*coupling of Jewishness and whiteness. The story dramatizes the precarity of Jews' acculturation and the ways in which white social and economic privilege fails to shield Jews from the violence of white supremacy.

Like *Black Souls*, "The Shoe Pinches Mr. Samuels" takes place in the South. The story is set during the Great Depression in an unspecified location described as "one of the more bustling, industrial towns." Its main characters are part of a wealthy and well-established southern Jewish community whose members worship together at the synagogue Petach Shamayim

(Gates of Heaven). The arrival of a young rabbi from the North surfaces underlying tensions. Although Rabbi David Uhlmann revitalizes and modernizes Jewish life in the community, including by raising money for a luxurious new synagogue building, some of his congregants take issue with his refusal to "confin[e] himself to the reading of the Law—the Torah—and its exegesis—the Talmud." Instead, he uses his sermons as an opportunity to address current events, especially race relations in the South. The tension is heightened due to a conflict between the rabbi and the synagogue president, the Hon. Josiah Samuels, whose "pretty and highly cultivated" daughter, Judy, has formed a romantic attachment with Rabbi Uhlmann. Samuels opposes his daughter's marriage to the "notoriety-seeking" rabbi, ostensibly because it would represent a union between South and North.[58] Because his own efforts at fundraising had failed, Samuels further resents the rabbi for his instrumental role in building the new house of worship. Using the political and theological debate about whether or not the rabbi's sermons overstep their bounds as a cover for his more personal animosities, Samuels conspires to have his rival ousted from the synagogue.

The occasion to do so arises when Uhlmann gives a fiery, controversial two-part sermon on racial intolerance following the "lynching of a particularly *decent and self-respecting* Negro in their own town" (italics mine).[59] While these adjectives imply that the outrage was due to the victim's respectability (and not the fact alone of an extralegal, racially motivated killing), Meyer's characterization is intended to demonstrate how Black people's efforts to advance economically made them targets of racial violence. From journalist Ida B. Wells to playwrights Grimké and Dunbar-Nelson, Black anti-lynching activists had corrected the erroneous white record to show that lynch mobs were largely incited by Black success and land ownership, not by sexual assault.[60] The circumstances of the Black man's murder in "The Shoe Pinches Mr. Samuels" convey an understanding of lynching as a weapon of social and economic repression, a theme Meyer had previously explored in *Black Souls*, in which the protagonists are committed to the education of future generations.[61]

Similarly, in the short story, the Black lynching victim, who remains somewhat problematically unnamed, was singled out by the white mob because of "his ambition to better himself" and his family.[62] He purchased a plot of land in a white area and built a home on it "in perfect taste, both inside and out."[63] Intimating that Black desire for upward mobility through

property ownership may follow a trajectory modeled by the successful acculturation of Jewish Americans, the building of this tasteful home finds a parallel in the beautifully appointed new synagogue. A public symbol of the Jewish community's deep roots in the American landscape and its prosperity despite the ongoing economic crisis, the synagogue rouses the ire of the town's Christians, who resent the fact that Jews had built "the finest place of worship in the South."[64] This connection between the upwardly mobile trajectories of African Americans and Jews is solidified by the personal acquaintanceship between the lynching victim and the rabbi, who was drawn to the "quiet dignity and persistence" with which the Black man sought to improve his lot.[65]

Influenced by the rhetoric of Black anti-lynching activists and writers, Meyer adopts their analysis and arguments to craft a narrative about racial violence that counters stories told in the mainstream press and the dominant white culture. Significantly, the short story's plot divorces itself entirely from the discourse of "lynching-for-rape" by revealing the myth of the Black male rapist to be a farce.[66] When a senator argues that the Black man's murder was justified because southern "women, the loveliest and purest on God's earth, must and shall be protected," the third-person narrator interjects to observe that "no one . . . took the trouble" to expose his "empty gestures[,] seeing that this particular lynching had had nothing whatever to do with rape, or indeed with any woman, unless one counts the Negro's own wife whom he was endeavoring to protect."[67] Tinged with irony, the observation speaks to the exclusion of Black women from the category of southern womanhood, a topic Meyer had previously explored by reversing the archetypal characterization of Black and white female characters in *Black Souls*.

In the face of the community's silence, including that of the Christian ministers, the rabbi takes to his pulpit. His sermon is notable not only for his willingness to speak out against the horrific practice of lynching, but for its bravery in implicating the town's "leading citizens." Taking aim at individuals who had participated directly in the ritualized violence, as well as those complicit through their silence, Rabbi Uhlmann "denounce[s] in flaming words the men and women of their own town—the people they met daily on the streets—the people whom they sometimes, *though infrequently*, met in their own homes" (italics mine).[68] The insertion of the adverbial phrase "though infrequently" hints at the turn the story will take,

limning, in just two words, the precarious position occupied by the town's Jews, who are not fully accepted by their white, non-Jewish neighbors. Despite threats to his life after he delivers the first half of his sermon, and the pleas of his beloved Judy, who parrots her father's insistence that "no one who is not born in the South can understand," Rabbi Uhlmann remains unwavering in his ethical obligation. He persists in delivering the second part of his sermon, uttering the words that will be echoed and proven in the story's ending: "For I say unto you, Intolerance begets only Intolerance. And the seeds of Hatred bring forth only Hatred. And from the planting and watering of Contempt can spring forth only Contempt."[69] The synagogue's congregants do not take heed. Instead, they allow their president to orchestrate the termination of the rabbi's contract, leaving David Uhlmann without a congregation and exiled from the South.

"The Shoe Pinches Mr. Samuels" is itself a two-part sermon in the form of short fiction, with the second half breaking from the rabbi's story to focus on the fate of the Hon. Josiah Samuels, the synagogue president. Predictably perhaps, Samuels soon finds himself the victim of a lynch mob.[70] Antisemitism unmistakably drives the attack, which is conceived as retribution for Samuels's accumulation of wealth and power. Starting out as owner of what became "the largest drygoods store in the state," Samuels rose to the position of bank president and translated his financial capital into political currency as a civic leader. Most recently, his election to Congress had earned him his honorific title. Among his attackers, Samuels recognizes constituents who believe he has wronged them in some way: "a man whom he had denied a loan," another "whom he had dismissed from his store," "the contractor who had failed to get the bid for the building of the Temple," and so on.[71] In the mob's antisemitic jeers ("We're going to keep you dirty Jews in your place!") reverberates the verbal assault on the Black victim ("We ain't goin' to let a lot of damned niggers run this town"). Subjecting Samuels to the kind of physical and discursive violence habitually directed at African Americans, the lynch mob links Jews and Blacks as perceived threats to white dominance. The racializing epithet "dirty Jew" skews the alignment between Jewishness and whiteness—in spite of the color of Samuels's skin, which is described, unflatteringly, as "always chalky."[72] The chalkiness of Samuels's skin further speaks to the impermanence of whiteness, suggesting that his skin privilege can be easily erased.

Whereas Meyer's texts depict Black lynching victims with compassion, Samuels, even in his suffering, is portrayed unsympathetically. Meyer's characterization of him as shrewd in business and corpulent in physique skirts close to antisemitic stereotypes depicting Jews as money and power hungry. Samuels may be an innocent victim of intolerance, unjustly punished by lynch law, but the story finds him guilty of hubris—the arrogance to believe that his social status and economic privilege would provide full protection from white supremacist violence. Although the story conjoins bigotries directed at Blacks and Jews, sending a clear message that "Intolerance begets only Intolerance," Meyer refrains from *equating* anti-Black racism with antisemitism. The story remains attentive to differences that allowed many Jews to become beneficiaries of white privilege. In contrast to the Black character's humble attempt to make a comfortable home for his family, for instance, Samuels—not unlike Meyer's southern grandfather—is shown profiting from the racial caste system, which enables his own ability to elevate himself. Poignantly, the fates of the story's two lynching victims are not identical. While the Black man "paid to the last gasp of his agony" and his house was left "a blackened ruin," the story ends with Mr. Samuels, "a cowed and whimpering travesty of a man," making his way back in the dark to "his magnificent home."[73] Not only has he survived the lynching, but his property remains intact. Meyer's Black characters, in this story and in *Black Souls*, are not as fortunate.

Supplying historical context for the fictional lynching of Josiah Samuels, Meyer refers to events of her time such as the rise of Hitler in Germany and the revival of the Ku Klux Klan in the United States. Two other, unmentioned historical events haunt her story as well: the 1915 lynching of Leo Frank in Georgia and the Scottsboro trial of the early 1930s. In 1913, Leo Frank, a Jewish American man of German descent who worked as a superintendent in a pencil factory, was convicted for the murder of a young southern white factory worker, Mary Phagan. Born in Texas and raised in New York, Frank had moved to Atlanta for work and was a prominent member of the city's Jewish community, serving as president of its B'nai B'rith chapter. Sentenced to life imprisonment in what historians today concur was a wrongful conviction, Frank met his death at the hands of a lynch mob in 1915. As Jeffrey Melnick has shown, the case was a formative moment for Black-Jewish relations with complex implications. While the press's and prosecution's antisemitic rhetoric turned public opinion

against Frank, painted him as sexually deviant, and incited his lynching, his defense attorneys used blatant anti-Black stereotypes in an attempt to implicate another main murder suspect, Jim Conley, an African American janitor employed by the factory. The trial created divisiveness for the two minority groups involved, but Frank's lynching also awakened many American Jews to the violent turn antisemitism could take and led to increased Jewish activism on behalf of racial justice.[74]

This Jewish commitment to racial justice was on display during the Scottsboro case, which gripped the nation at the same time that Meyer's *Black Souls* premiered. In 1931, nine Black youths were falsely accused of raping two white woman on a train traveling through Alabama. Historian Hasia Diner has detailed the Jewish press's extensive coverage of the case, with editorials univocally supporting the defendants; the subtext of this coverage was that anti-Black racism "carried with it the seeds of anti-Jewish activity."[75] Evidence for such a linkage could be found in the trial itself. Samuel Liebowitz, the Jewish American defense attorney, was repeatedly threatened with lynching, and his grilling of the men's female accusers on the stand was viewed as an affront to southern white womanhood. An interesting sidebar in the Scottsboro case appears to have caught Meyer's attention. In 1931 and 1932, Rabbi Benjamin Goldstein of Temple Beth-Or, a Reform congregation in Montgomery, Alabama, gave impassioned Yom Kippur sermons in support of the defendants and helped organize a Birmingham rally on their behalf. As a result, he was forced to resign by the synagogue's president.[76]

Bearing traces of both the Frank and Scottsboro cases and deeply influenced by the groundbreaking work of Black activists and writers, "The Shoe Pinches Mr. Samuels," like *Black Souls*, contributes to the tradition of anti-lynching literature by virtue of being authored by a white, Jewish woman. A call for cross-racial, interminority empathy and action, Meyer's story is a cautionary tale about the dangers of staying in your lane. The story's title refers to the idiomatic saying "Only the wearer knows where the shoe pinches." The aphorism may apply to the character of Josiah Samuels, but it need not hold for the story's reader. That Meyer's civil rights activism took the form of protest drama and fiction indicates her faith in literature as a vehicle for understanding the struggles and sufferings of others, a means of stepping into another's shoe in order to experience where it pinches.

In contrast to *Black Souls*, which saw renewed interest following its publication in Perkins and Stephens' *Strange Fruit*, "The Shoe Pinches Mr. Samuels" remains an obscure text, unknown to most scholars of Jewish American literature. The story—and the difficulties of Meyer's allyship—gain relevance today in the wake of recent events, among them: the massacres at Emanuel African Methodist Episcopal Church in Charleston in 2015 and the Tree of Life synagogue in Pittsburgh in 2018; the cries of "Jews will not replace us!" heard in Charlottesville, Virginia, in August 2017 at the Unite the Right rally incited by the removal of a Confederate statue; and the January 6, 2021, insurrection in Washington, DC, which was infused with anti-Blackness and antisemitism.[77] Revisiting Meyer's prescient story now reminds us of the ways Jewish Americans had, and still have, "skin in the game," as Erik K. Ward titles his essay on the centrality of antisemitism to contemporary white nationalist ideology—even if, for many of them, that skin appears white.[78]

In considering Meyer's anti-lynching literature as part of this edited volume, my aim is twofold: first, to exhibit the extraordinary range of Jewish women's writing in the early twentieth-century United States with the goal of opening up new avenues beyond the familiar works of Eastern European immigrant writers that have dominated the study of Jewish American literature from this period; and second, to argue that racially appropriative texts need not be categorically dismissed because they are offensive and out of sync with our times. Rather, when read closely in their historical context, Meyer's writings—blind spots and all—have much to tell us about the varied effects of literature that transcends the lane of its author, illuminating the complex dynamics of cross-racial representation in Jewish American women's writing.

Notes

Thank you to Annie Atura Bushnell, Kimberly Chabot Davis, and Ashley Walters for their feedback on drafts of this essay and to Jessica Kirzane for sharing her knowledge of Yiddish lynching narratives.

1 For a full transcript of Shriver's speech, "Fiction and Identity Politics," see Lionel Shriver, "I hope the concept of cultural appropriation is a passing

fad," *Guardian*, September 13, 2016. For the essay that drew attention to Shriver's speech, see Yassmin Abdel-Magied, "As Lionel Shriver Made Light of Identity, I Had No Choice but to Walk Out on Her," *Guardian*, September 10, 2016. For other responses to Shriver, see Francine Prose, "The Trouble with Sombreros," *New York Review of Books*, September 19, 2016; and Jonathan Foreman, "Lionel Shriver Is Out of Line—and Thank God," *Commentary*, December 2016.

2 Richard Russo, "The Lives of Others," *Harper's Magazine*, June 2020, harpers.org/archive/2020/06/the-lives-of-others-when-does-imagination-become-appropriation/.

3 Russo. On Jewish blackface performance in *The Jazz Singer*, see Michael Rogin, *Blackface, White Noise: Jewish Immigrants in the Hollywood Melting Pot* (Berkeley: University of California Press, 1996). Rogin's book raised provocative questions that were subsequently taken up by other scholars; see, for example, Michael Alexander, *Jazz Age Jews* (Princeton, NJ: Princeton University Press, 2003).

4 See Jonathan Freedman, *Klezmer America: Jewishness, Ethnicity, Modernity* (New York: Columbia University Press, 2007); and Jennifer Glaser, *Borrowed Voices: Writing and Racial Ventriloquism in the Jewish American Imagination* (New Brunswick, NJ: Rutgers University Press, 2016).

5 Freedman, *Klezmer America*, 197.

6 Kathy A. Perkins and Judith L. Stephens, eds., *Strange Fruit: Plays on Lynching by American Women* (Bloomington: Indiana University Press, 1998), 136. For an interesting interpretation of *Black Souls* and other antilynching theater in the context of women-led movements for reproductive justice, see Stephanie Peebles Tavera, *(P)rescription Narratives: Feminist Medical Fiction and the Failure of Censorship* (Edinburgh: Edinburgh University Press, 2022), 178–96.

7 For a comprehensive overview of Wells's contributions to anti-lynching activism and literature, see Ida B. Wells, *The Light of Truth: Writings of an Anti-Lynching Crusader*, ed. Mia Bay and Henry L. Gates (New York: Penguin, 2008).

8 Annie Nathan Meyer, *Black Souls*, in Perkins and Stephens, *Strange Fruit*, 156.

9 Annie Nathan Meyer, "Woman's Assumption of Sex Superiority," *North American Review* 178, no. 566 (January 1904): 103–9.

10 See, for example, Melanie Kaye/Kantrowitz, *The Colors of Jews: Racial Politics and Radical Diasporism* (Bloomington: Indiana University Press, 2007); Sarah Phillips Casteel, *Calypso Jews: Jewishness in the Caribbean Literary Imagination* (New York: Columbia University Press, 2016); Dalia

Kandiyoti, *The Converso's Return: Conversion and Sephardi History in Contemporary Literature and Culture* (Stanford, CA: Stanford University Press, 2020); and Yael Halevi-Wise, ed., *Sephardism: Spanish Jewish History and the Modern Literary Imagination* (Stanford, CA: Stanford University Press, 2012). For a recent example of scholarship on Sephardim that demonstrates the fluidity of race, see Laura Arnold Leibman, *Once We Were Slaves: The Extraordinary Journey of a Multiracial Jewish Family* (Oxford: Oxford University Press, 2021).

11 Aviva Ben-Ur, *Sephardic Jews in America: A Diasporic History* (New York: New York University Press, 2009), 2. The term *minority within a minority* is used by many scholars of Sephardic studies as a way of denoting the group's marginal status. For early uses of the term, see, for example, Abraham D. Lavendar, "The Sephardic Revival in the United States: A Case of Ethnic Revival in a Minority-within-a-Minority," *Journal of Ethnic Studies* 3, no. 3 (1976): 21–31; and Abraham D. Lavendar, "The Minority within a Minority," *Human Behavior* (June 1976): 62.

12 For a consideration of these questions in relation to contemporary writers of Mizrahi descent, see Karen Skinazi's contribution to this volume, chapter 10. Even Meyer's cousin, Emma Lazarus, now one of the best-known Sephardic Jewish writers, has only been reclaimed as an important Jewish American writer in the past two decades. In 1999, noting that most treatments of Jewish American literature "predictably focused on" Ashkenazi male writers like Henry Roth, Saul Bellow, and Philip Roth, Norman Roth asked, "We may recall that Emma Lazarus was a Sephardic Jew, but aside from the memorable verses on the Statue of Liberty, what does anyone know her work?" (260). Norman Roth, "What Constitutes Sephardic Literature?," in *From Iberia to Diaspora: Studies in Sephardic History and Culture*, edited by Yedida K. Stillman and Norman A. Stillman (Boston: Brill 1999), 246–63. That has clearly changed today with Esther Schor's 2006 biography of Emma Lazarus and collections like Lazarus's *Emma Lazarus: Selected Poems and Other Writings*, ed. Gregory Eiselein (Peterborough, ON: Broadview Press, 2002).

13 See Isidore Singer and Meyer Kayserling's entry "Sephardim," *Jewish Encyclopedia*, accessed August 11, 2023, jewishencyclopedia.com/articles/13430-sephardim. The terms *Western Sephardim*, *traditional Sephardim*, *colonial Sephardim*, and *Old Sephardim* have been used by scholars to differentiate Sephardic Jews who arrived in the United States in the seventeenth and eighteenth centuries and traced their lineage to Spain and Portugal from Sephardic Jews who arrived in the United States in the late nineteenth and early twentieth centuries from the Ottoman Empire. The latter group was

also historically identified as "Levantine" or "Oriental" Jews. For more on the differences between these two groups of Sephardim, see, for example, Devin E. Naar, "From the 'Jerusalem of the Balkans' to the *Goldene Medina*: Jewish Immigration from Salonika to the United States," *American Jewish History* 93, no. 4 (December 2007): 435–73; and Devin E. Naar, "'Impostors': Levantine Jews and the Limits of Jewish New York," in *The Jewish Metropolis: New York City from the 17th to the 21st Century*, ed. Daniel Soyer (Brookline, MA: Academic Studies Press, 2021), 115–46.

14 "Annie Nathan Meyer," *American Jewess* 2, no. 1 (October 1895): 20.
15 Annie Nathan Meyer, *It's Been Fun: An Autobiography* (New York: Henry Schuman, 1951), 9. Exiled from Spain during the Inquisition, many Sephardim, like Meyer's ancestors, followed a diasporic path to Holland and England before settling in the New World.
16 Meyer, 10–11. Meyer quotes an entry from the *Jewish Encyclopedia*, which states that Sephardim "Considered themselves a superior class—the nobility of Jewry" (11).
17 Meyer, 40.
18 Meyer, 45–46.
19 Meyer, 58.
20 Jonathan Schorsch, "Blacks, Jews, and the Racial Imagination in the Writings of Sephardim in the Long Seventeenth Century," *Jewish History* 19 (2005): 128–29.
21 See Eric L. Goldstein, *The Price of Whiteness: Jews, Race, and American Identity* (Princeton, NJ: Princeton University Press, 2006).
22 Meyer, *It's Been Fun*, 58–9.
23 Meyer, 3, 266. It is worth noting that, as Perkins and Stephens observe in *Strange Fruit*, anti-lynching plays in general were rarely well-received theatrical hits.
24 On the tradition of Black anti-lynching performance, see Perkins and Stephens, *Strange Fruit*; Koritha Mitchell, *Living with Lynching: African American Lynching Plays, Performance, and Citizenship, 1890–1930* (Chicago: University of Illinois Press, 2011); Koritha Mitchell, "Antilynching Plays: Angelina Weld Grimké, Alice Dunbar-Nelson, and the Evolution of African American Drama," *Post-Bellum, Pre-Harlem: African American Literature and Culture, 1877–1919*, ed. Barbara McCaskill and Caroline Gebhard (New York: New York University Press, 2006), 210–30; Patricia A. Young, *African American Women Playwrights Confront Violence: A Critical Study of Nine Dramatists* (Jefferson, NC: McFarland, 2012); Maisha S. Akbar, *Preaching the Blues: Black Feminist Performance in Lynching Plays* (New York: Routledge, 2020). For examples of cultural studies of lynching

that extend beyond drama to other forms of literature, see Sandy Alexandre, *The Properties of Violence: Claims to Ownership in Representations of Lynching* (Jackson: University Press of Mississippi, 2012); Jacqueline Goldsby, *A Spectacular Secret: Lynching in American Life and Literature* (Chicago: University of Chicago Press, 2006); Sandra Gunning, *Race, Rape, and Lynching: The Red Record of American Literature, 1890–1912* (New York: Oxford University Press, 1996); and Trudier Harris, *Exorcising Blackness: Historical and Literary Lynching and Burning Rituals* (Bloomington: Indiana University Press, 1984).

Meyer's work can also be fruitfully situated within a tradition of Jewish-authored lynching narratives, which includes Waldo Frank's novel *Holiday* (1923) as well as poetry and fiction by Yiddish writers. Both *Black Souls* and "The Shoe Pinches Mr. Samuels," which I will discuss in the following section, bear significant similarities to and differences from Joseph Opatoshu's Yiddish short story "Lintsheray" ("A Lynching"), which was published in a 1923 collection of his writings—although it is unlikely Meyer had read the story, which has only recently been translated into English by Jessica Kirzane (ingeveb.org/texts-and-translations/a-lynching). On "Lintsheray," see Jessica Kirzane, "'This is How a Generation Grows': Lynching As a Site of Ethical Loss in Opatoshu's 'Lintsheray,'" *Zutot* 9 (2012): 59–71; and Marc Caplan, "Yiddish Exceptionalism: Lynching, Race, and Racism in Opatoshu's 'Lintsheray,'" in Sabine Koller, ed., *Joseph Opatoshu: A Yiddish Writer between Europe and America* (New York: Oxford University Press, 2013), 184–98; thanks to Ashley Walters for pointing out this connection. For discussions of lynching in Yiddish poetry, see Merle L. Bachman, *Recovering "Yiddishland": Threshold Moments in American Literature* (Syracuse, NY: Syracuse University Press, 2008), chapter 4; and Amelia Glaser, *Songs in Dark Times: Yiddish Poetry of Struggle from Scottsboro to Palestine* (Harvard University Press, 2020), chapter 3.

25 Mitchell, *Living with Lynching*, 103, 82.
26 Alice Dunbar-Nelson, "Mine Eyes Have Seen," *Crisis*, April 1918, 271, 274.
27 Dunbar-Nelson, 272, 274.
28 Mitchell, *Living with Lynching*, 89.
29 Mary Powell Burrill, *Aftermath*, in Perkins and Stephens, *Strange Fruit*, 91.
30 Langston Hughes, "The Negro Artist and the Racial Mountain," in *The Portable Harlem Renaissance Reader*, ed. David Levering Lewis (New York: Penguin, 1994), 93.
31 See Robert McCaughey, *A College of Her Own: The History of Barnard* (New York: Columbia University Press, 2020), 21.

32. On the relationship between Hurst and Hurston, see Lori Harrison-Kahan, *The White Negress: Literature, Minstrelsy, and the Black-Jewish Imaginary*. New Brunswick, NJ: Rutgers University Press, 2011, chaps. 3 and 4.
33. Carla Kaplan, *Miss Anne in Harlem: The White Women of the Black Renaissance* (New York: HarperCollins, 2013), 170.
34. Mitchell, "Antilynching Plays," 213.
35. Kaplan, *Miss Anne in Harlem*, 184.
36. Annie Nathan Meyer to Frank Shay, Director of the Barnstormers' Theatre, Provincetown, Massachusetts, March 5, 1926, Box 6, Folder 1, Annie Nathan Meyer Papers, Jacob Rader Marcus Center of the American Jewish Archives, Cincinnati.
37. Hurston to Meyer, January 15, [1926,] in Carla Kaplan, ed., *Zora Neale Hurston: A Life in Letters* (New York: Doubleday, 2002), 78.
38. Hurston to Meyer, October 7, 1927, in Kaplan, 108.
39. See Harrison-Kahan, *White Negress*, 155.
40. Meyer, *It's Been Fun*, 268.
41. James Weldon Johnson to Annie Nathan Meyer, June 2, [1932?], Box 6, Folder 2, Annie Nathan Meyer Papers, Jacob Rader Marcus Center of the American Jewish Archives, Cincinnati.
42. Annie Nathan Meyer to W. E. B. Du Bois, March 16, 1932, W. E. B. Du Bois Papers (MS 312). Special Collections and University Archives, University of Massachusetts Amherst Libraries, credo.library.umass.edu/view/full/mums312-b063-i044.
43. Howard Barnes, "Black Souls," *New York Herald Tribune*, March 31, 1932, 12.
44. John Chapman, "Black Man's Burden, White Dominance at Provincetown," *Daily News*, March 31, 1932.
45. "Theatre," *Crisis*, May 1932, 163. *Crisis* editor W. E. B. Du Bois apologized for the fact that the review "offended" Meyer after she wrote to him to complain. See W. E. B. Du Bois to Annie Nathan Meyer, May 27, 1932, Box 6, Folder 1, Annie Nathan Meyer Papers, Jacob Rader Marcus Center of the American Jewish Archives, Cincinnati.
46. Alain Locke, "Black Truth and Black Beauty," *Opportunity: A Journal of Negro Life*, January 1933, 18.
47. Book jacket for Annie Nathan Meyer's *Black Souls: A Play in Six Scenes* (New Bedford, MA: Reynolds, 1932).
48. The title of Perkins and Stephens's collection is interesting in this regard. The title refers most directly to white playwright Lillian Smith's play (adapted from her 1944 novel, also titled *Strange Fruit*), which is included

in the collection. Smith, of course, took, her title from Billie Holiday's anti-lynching song, "Strange Fruit." The song was written in 1937 by a white Jewish American teacher and poet Abel Meeropol, who published under the pen name Lewis Allan. Thanks to Holiday's unforgettable musical rendition, "Strange Fruit" became the best-known cultural text of the anti-lynching tradition and one of the most famous protest songs of all time. Thus, in its various cultural iterations, *Strange Fruit* is the extraordinary product of interracial collaboration.

49 "A Lecture," an advertisement for one of Wells's speeches, *Washington Bee*, October 22, 1892, cited in Mia Bay's introduction to Wells, *Light of Truth*, xix.

50 Meyer had initially hoped that W. E. B. Du Bois or James Weldon Johnson would pen the foreword "in order to give the play the right position as an actually truthful and not exaggerated piece of work." While it is unclear why those plans never came to fruition, the fact that she ultimately turned to a white public figure may indicate reluctance on the part of Black intellectuals to lend their unqualified imprimaturs to the project. See Annie Nathan Meyer to Montgomery Belgion, Harcourt, Brace & Co., February 1, 1926, Box 6, Folder 1, Annie Nathan Meyer Papers, Jacob Rader Marcus Center of the American Jewish Archives, Cincinnati.

51 Montgomery Gregory, Review of *Black Souls*, *Opportunity: A Journal of Negro Life*, May 1933, 155–56.

52 Meyer, *It's Been Fun*, 268. Evidence suggests that Black reception of the play varied, as indicated by the initial negative review in the *Crisis*. In another example, Black playwright Abram Hill, director of the American Negro Theater, did not hold back in a letter to Meyer in which he declined to perform the play with his theater company, explaining that *Black Souls* "was not very well-written, though the theme is necessary and important." Abram Hill to Annie Nathan Meyer, December 26, 1944, Box 6, Folder 2, Annie Nathan Meyer Papers, Jacob Rader Marcus Center of the American Jewish Archives, Cincinnati.

53 Meyer, *It's Been Fun*, 268. A letter from Mabel Carney, a white educator at Columbia Teachers College, to Meyer confirms that such misrecognitions took place. Carney apologizes for not recognizing Meyer at a Negro Education Club Meeting, explaining, "Having read your play I was expecting a colored woman." Mabel Carney to Annie Nathan Meyer, October 24, 1932, Box 6, Folder 2, Annie Nathan Meyer Papers, Jacob Rader Marcus Center of the American Jewish Archives, Cincinnati.

54 Kaplan, *Miss Anne in Harlem*, xx.

55 Kaplan, 178.

56 Authors and Their Publications, ca. 1931. W. E. B. Du Bois Papers (MS 312). Special Collections and University Archives, University of Massachusetts Amherst Libraries, credo.library.umass.edu/view/full/mums312-b190-i111.

57 Joseph Opatoshu's Yiddish short story "Lintsheray" ("A Lynching") makes a similar argument when a Jewish father warns his son, "[Y]ou can be sure that today they will lynch a Negro and tomorrow it will be a Jew!" Like the Jewish congregants in Meyer's story, the son does not take heed. However, while the Jews in Meyer's story are complicit through silence and inaction, the son in Opatoshu's story actively joins the white lynchers. See Joseph Opatoshu, "A Lynching," trans. Jessica Kirzane, *In geveb: A Journal of Yiddish Studies* (June 2016), ingeveb.org/texts-and-translations/a-lynching.

58 Annie Nathan Meyer, "The Shoe Pinches Mr. Samuels," *Crisis*, January 1935, 8. The dynamic interestingly echoes that between Meyer's northern father and her southern maternal grandfather, who could not abide by his son-in-law's loyalty to the Union cause.

59 Meyer, 8.

60 For more on this topic, see Mitchell, *Living with Lynching*; and Alexandre, *Properties of Violence*.

61 On lynching as a weapon of social and economic repression, see, for example, Hazel Carby, "'On the Threshold of the Woman's Era': Lynching, Empire, and Sexuality in Black Feminist Theory," *"Race," Writing, and Difference*, ed. Henry Louis Gates Jr. (Chicago: University of Chicago Press, 1985), 301–16.

62 Meyer, "Shoe," 8. While the character's namelessness fails to differentiate him as an individual, I write "somewhat problematically" because the lack of a name simultaneously expresses the ubiquity of Black lynching in the United States.

63 Meyer, 8.

64 Meyer, 25.

65 Meyer, 8.

66 Here, the politics of Meyer's story differ significantly from those of Opatoshu's "A Lynching," in which the Black lynching victim was, in fact, guilty of raping a white woman; the assault was conceived as an act of revenge after the Black man's teenage sister was sexually assaulted by a white man, a rape that went unadjudicated. In both *Black Souls* and "The Shoe Pinches Mrs. Samuels," in contrast, only white men are depicted as rapists. On the discourse of lynching for rape, see Ashraf Rushdy, *The End of American Lynching* (New Brunswick, NJ: Rutgers University Press, 2012). For an important consideration of the racialization of rape and lynching, see

Estelle Freedman, *Redefining Rape: Sexual Violence in the Era of Suffrage and Segregation* (Cambridge, MA: Harvard University Press, 2015), especially chapters 5 and 12.

67 Meyer, "Shoe," 24. While most Black playwrights exposed the falsity of the lynching-for-rape narrative, Georgia Douglas Johnson was, like Meyer, explicit about undercutting this dangerous association. In *A Sunday Morning in the South* (1925), for instance, a character states, "They lynch you bout anything too, not jest women" (105). This line is echoed in *Safe* (ca. 1929) when a character, after hearing about a lynching, asks, "'Twant no woman mixed up in it, was it?" (111). See Johnson, *A Sunday Morning in the South*, in Perkins and Stephens, *Strange Fruit*, 103–9; and Johnson, *Safe*, in Perkins and Stephens, *Strange Fruit*, 110–15.

68 Meyer, "Shoe," 8. The rabbi's indictment of seemingly upstanding white Christian citizens echoes a theme present in lynching texts by Black women. In Grimké's *Rachel*, for instance, the character of Mrs. Loving reveals to her surviving children that their father and brother were lynched by "church members in good standing—the best people" (40). See Grimké, *Rachel*, in Perkins and Stephens, *Strange Fruit*, 27–78.

69 Meyer, "Shoe," 24.

70 While both the short story and *Black Souls* avoid graphic scenes of anti-Black violence, the Jewish man's brutal torture is described in explicit detail from Samuels's perspective. Perkins and Stephens suggest that Hurston or another Black interlocutor may have encouraged Meyer to eliminate such scenes in *Black Souls*; as evidence, they produce an excerpt from an earlier draft, which included more detailed stage directions for the scene of David's lynching

71 Meyer, "Shoe," 25.

72 Meyer, 25.

73 Meyer, 8, 25.

74 See Jeffrey Melnick, *Black-Jewish Relations on Trial: Leo Frank and Jim Conley in the New South* (Jackson: University Press of Mississippi, 2000). David Levering Lewis similarly locates the Leo Frank case as a turning point in Black-Jewish relations, arguing that in 1915 Black and Jewish American elites saw their interests aligned due to the threat of white supremacy; see Levering Lewis, "Parallels and Divergences: Assimilationist Strategies of Black and Jewish Elites from 1910 to the Early 1930s," *Journal of American History* 71, no. 3 (December 1984): 543–64.

75 Hasia Diner, *In the Almost Promised Land: American Jews and Blacks, 1915–1935* (Baltimore: Johns Hopkins University Press, 1977), 99.

76 See Stephen Whitfield, "The Ordeal of Scottsboro," *AJS Perspectives* (Spring 2021): 66–68; Herman Pollak, "A Forgotten Fighter for Social Justice," *Jewish Currents* 30 (June 1976): 14–18; and Goldstein, *Price of Whiteness*, 159. On other Jewish writers' responses to Scottsboro, see Amelia Glaser, *Songs in Dark Times: Yiddish Poetry of Struggle from Scottsboro to Palestine* (Cambridge, MA: Harvard University Press, 2020), 107–38.

77 This anti-Blackness and antisemitism of the January 6, 2021, Capitol insurrection were displayed visually, for instance, in two widely circulated media images: one in which a white man traipses through the Capitol building wielding a Confederate flag and the other in which a rioter proudly wears a "Camp Auschwitz" sweatshirt.

78 Erik K. Ward, "Skin in the Game: How Antisemitism Animates White Nationalism," Political Research Associates, June 29, 2017, politicalresearch.org/2017/06/29/skin-in-the-game-how-antisemitism-animates-white-nationalism#sthash.he8C5b5R.dpbs. See also Zack Graham's article on Spike Lee's 2018 film *BlacKKKlansman*, which is also titled "Skin in the Game," *Jewish Currents*, October 19, 2018, jewishcurrents.org/skin-in-the-game.

Bibliography

Abdel, Yassmin. "As Lionel Shriver Made Light of Identity, I Had No Choice but to Walk Out on Her." *Guardian*, September 10, 2016. www.theguardian.com/commentisfree/2016/sep/10/as-lionel-shriver-made-light-of-identity-i-had-no-choice-but-to-walk-out-on-her.

Akbar, Maisha S. *Preaching the Blues: Black Feminist Performance in Lynching Plays*. New York: Routledge, 2020.

Alexander, Michael. *Jazz Age Jews*. Princeton, NJ: Princeton University Press, 2003.

Alexandre, Sandy. *The Properties of Violence: Claims to Ownership in Representations of Lynching*. Jackson: University Press of Mississippi, 2012.

"Annie Nathan Meyer." *American Jewess* 2, no. 1 (October 1895): 20.

Authors and Their Publications. W. E. B. Du Bois Papers. Special Collections and University Archives, University of Massachusetts Amherst Libraries, credo.library.umass.edu/view/full/mums312-b190-i111.

Bachman, Merle L. *Recovering "Yiddishland": Threshold Moments in American Literature*. Syracuse, NY: Syracuse University Press, 2008.

Barnes, Howard. "Black Souls." *New York Herald Tribune*, March 31, 1932.
Ben-Ur, Aviva. *Sephardic Jews in America: A Diasporic History*. New York: New York University Press, 2012.
Burrill, Mary Powell. *Aftermath*. In Perkins and Stephens, *Strange Fruit*, 82–91.
Caplan, Marc. "Yiddish Exceptionalism: Lynching, Race, and Racism in Opatoshu's 'Lintsheray.'" In *Joseph Opatoshu: A Yiddish Writer between Europe and America*, edited by Sabine Koller, 184–98. New York: Oxford University Press, 2013.
Carby, Hazel. 1986. "'On the Threshold of the Woman's Era': Lynching, Empire, and Sexuality in Black Feminist Theory." In *"Race," Writing, and Difference*, edited by Henry L. Gates Jr., 301–16. Chicago: University of Chicago Press, 1986.
Carney, Mabel, to Annie Nathan Meyer, October 24, 1932, Box 6, Folder 2, Annie Nathan Meyer Papers, Jacob Rader Marcus Center of the American Jewish Archives, Cincinnati.
Casteel, Sarah Phillips. *Calypso Jews: Jewishness in the Caribbean Literary Imagination*. New York: Columbia University Press, 2016.
Chapman, John. "Black Man's Burden, White Dominance at Provincetown." *Daily News*, March 31, 1932.
Diner, Hasia R. *In the Almost Promised Land: American Jews and Blacks, 1915–1935*. Baltimore: Johns Hopkins University Press, 1995.
Du Bois, W. E. B., to Annie Nathan Meyer, May 27, 1932, Box 6, Folder 1, Annie Nathan Meyer Papers, Jacob Rader Marcus Center of the American Jewish Archives, Cincinnati.
Dunbar-Nelson, Alice. "Mine Eyes Have Seen." *Crisis* 271 (April 1918): 274.
Foreman, Jonathan. "Lionel Shriver Is Out of Line—and Thank God." *Commentary*, December 2016. www.commentary.org/articles/jonathan-foreman/lionel-shriver-line/.
Freedman, Estelle B. *Redefining Rape: Sexual Violence in the Era of Suffrage and Segregation*. Cambridge, MA: Harvard University Press, 2015.
Freedman, Jonathan. *Klezmer America: Jewishness, Ethnicity, Modernity*. New York: Columbia University Press, 2009.
Glaser, Amelia. *Songs in Dark Times: Yiddish Poetry of Struggle from Scottsboro to Palestine*. Cambridge, MA: Harvard University Press, 2020.
Glaser, Jennifer. *Borrowed Voices: Writing and Racial Ventriloquism in the Jewish American Imagination*. New Brunswick, NJ: Rutgers University Press, 2016.

Goldsby, Jacqueline. *A Spectacular Secret: Lynching in American Life and Literature*. Chicago: University of Chicago Press, 2006.

Goldstein, Eric L. *The Price of Whiteness: Jews, Race, and American Identity*. Princeton, NJ: Princeton University Press, 2008.

Graham, Zack. "Skin in the Game." *Jewish Currents*, October 19, 2018. jewishcurrents.org/skin-in-the-game.

Gregory, Montgomery. Review of *Black Souls*. *Opportunity: A Journal of Negro Life*, May 1933.

Grimké, Angelina Weld. *Rachel*. In Perkins and Stephens, *Strange Fruit*, 27–78.

Gunning, Sandra. *Race, Rape, and Lynching: The Red Record of American Literature, 1890–1912*. New York: Oxford University Press, 1996.

Halevi-Wise, Yael, ed. *Sephardism: Spanish Jewish History and the Modern Literary Imagination*. Stanford, CA: Stanford University Press, 2012.

Harris, Trudier. *Exorcising Blackness: Historical and Literary Lynching and Burning Rituals*. Bloomington: Indiana University Press, 1984.

Harrison-Kahan, Lori. *The White Negress: Literature, Minstrelsy, and the Black-Jewish Imaginary*. New Brunswick, NJ: Rutgers University Press, 2011.

Hill, Abram, to Annie Nathan Meyer, December 26, 1944, Box 6, Folder 2, Annie Nathan Meyer Papers, Jacob Rader Marcus Center of the American Jewish Archives, Cincinnati.

Hughes, Langston. "The Negro Artist and the Racial Mountain" [1926]. In *The Portable Harlem Renaissance Reader*, edited by David Levering Lewis, 91–95. New York: Penguin, 1994.

"Hurston to Meyer, January 15, [1926]." In Kaplan, *Zora Neale Hurston*, 78.

Johnson, Georgia D. *Safe*. In Perkins and Stephens, *Strange Fruit*, 110–15.

———. *A Sunday Morning in the South*. In Perkins and Stephens, *Strange Fruit*, 103–9.

Johnson, James Weldon, to Annie Nathan Meyer, June 2, [1932?]. Box 6, Folder 2, Annie Nathan Meyer Papers, Jacob Rader Marcus Center of the American Jewish Archives, Cincinnati.

Kandiyoti, Dalia. *The Converso's Return: Conversion and Sephardi History in Contemporary Literature and Culture*. Stanford, CA: Stanford University Press, 2020.

Kaplan, Carla. *Miss Anne in Harlem: The White Women of the Black Renaissance*. New York: HarperCollins, 2013.

———, ed. *Zora Neale Hurston: A Life in Letters*. New York: Doubleday, 2002.

Kaye/Kantrowitz, Melanie. *The Colors of Jews: Racial Politics and Radical Diasporism*. Bloomington: Indiana University Press, 2007.

Kirzane, Jessica. "'This Is How a Generation Grows': Lynching As a Site of Ethical Loss in Opatosu's 'Lintsheray.'" *Zutot* 9 (2012): 59–71.

Lavendar, Abraham D. "The Minority within a Minority." *Human Behavior* (June 1976): 62.

———. "The Sephardic Revival in the United States: A Case of Ethnic Revival in a Minority-within-a-Minority." *Journal of Ethnic Studies* 3, no. 3 (1976): 21–31.

Lazarus, Emma. *Emma Lazarus: Selected Poems and Other Writings*. Edited by Gregory Eiselein. Peterborough, ON: Broadview Press, 2002.

Leibman, Laura A. *Once We Were Slaves: The Extraordinary Journey of a Multiracial Jewish Family*. New York: Oxford University Press, 2021.

Levering Lewis, David. "Parallels and Divergences: Assimilationist Strategies of Black and Jewish Elites from 1910 to the Early 1930s." *Journal of American History* 71, no. 3 (December 1984): 543–64.

Locke, Alain. "Black Truth and Black Beauty." *Opportunity: A Journal of Negro Life*, January 1933.

McCaughey, Robert. *A College of Her Own: The History of Barnard*. New York: Columbia University Press, 2020.

Melnick, Jeffrey. *Black-Jewish Relations on Trial: Leo Frank and Jim Conley in the New South*. Jackson: University Press of Mississippi, 2000.

Meyer, Annie Nathan. *Black Souls: A Play in Six Scenes*. New Bedford, MA: Reynolds Press, 1932.

———. *It's Been Fun: An Autobiography*. New York: Henry Schuman, 1951.

———. "The Shoe Pinches Mr. Samuels." *Crisis*, January 1935.

———. "Woman's Assumption of Sex Superiority." *North American Review* 178, no. 566 (January 1904): 103–9.

Meyer, Annie Nathan, to Frank Shay, Director of the Barnstormers' Theatre, Provincetown, Massachusetts, March 5, 1926, Box 6, Folder 1, Annie Nathan Meyer Papers, Jacob Rader Marcus Center of the American Jewish Archives, Cincinnati.

Meyer, Annie Nathan, to Montgomery Belgion, Harcourt, Brace & Co., February 1, 1926, Box 6, Folder 1, Annie Nathan Meyer Papers, Jacob Rader Marcus Center of the American Jewish Archives, Cincinnati.

Meyer, Annie Nathan, to W. E. B. Du Bois, March 16, 1932. Special Collections and University Archives, University of Massachusetts Amherst Libraries. credo.library.umass.edu/view/full/mums312-b063-i044.

Mitchell, Koritha. "Anti-lynching Plays: Angelina Weld Grimké, Alice Dunbar-Nelson, and the Evolution of African American Drama." In *Post-Bellum, Pre-Harlem: African American Literature and Culture, 1877–1919*, edited by Barbara McCaskill and Caroline Gebhard, 210–30. New York: New York University Press, 2006.

———. *Living with Lynching: African American Lynching Plays, Performance, and Citizenship, 1890–1930*. Chicago: University of Illinois Press, 2012.

Naar, Devin E. "From the 'Jerusalem of the Balkans' to the Goldene Medina: Jewish Immigration from Salonika to the United States." *American Jewish History* 93, no. 4 (December 2007): 435–73.

———. "'Impostors': Levantine Jews and the Limits of Jewish New York." In Soyer, *Jewish Metropolis*, 115–46.

Opatoshu, Joseph. "A Lynching." Translated by Jessica Kirzane. *In geveb: A Journal of Yiddish Studies* (June 2016). ingeveb.org/texts-and-translations/a-lynching.

Perkins, Kathy A., and Judith L. Stephens, eds. *Strange Fruit: Plays on Lynching by American Women*. Bloomington: Indiana University Press, 1998.

Pollak, Herman. "A Forgotten Fighter for Social Justice." *Jewish Currents* 30 (June 1976): 14–18.

Prose, Francine. "The Trouble with Sombreros." *New York Review of Books*, September 19, 2016. www.nybooks.com/online/2016/09/19/the-trouble-with-sombreros-shriver-cultural-appropriation/.

Rogin, Michael. *Blackface, White Noise: Jewish Immigrants in the Hollywood Melting Pot*. Berkeley: University of California Press, 1998.

Roth, Norman. "What Constitutes Sephardic Literature?" In *From Iberia to Diaspora: Studies in Sephardic History and Culture*, edited by Yedida K. Stillman and Norman A. Stillman, 246–62. Boston: Brill, 1999.

Rushdy, Ashraf H. A. *The End of American Lynching*. New Brunswick, NJ: Rutgers University Press, 2012.

Russo, Richard. "The Lives of Others." *Harper's Magazine*, June 2020. harpers.org/archive/2020/06/the-lives-of-others-when-does-imagination-become-appropriation/.

Schorsch, Jonathan. "Blacks, Jews, and the Racial Imagination in the Writings of Sephardim in the Long Seventeenth Century." *Jewish History* 19 (2005): 109–35.

Shriver, Lionel. "Lionel Shriver's Full Speech: 'I Hope the Concept of Cultural Appropriation Is a Passing Fad.'" *Guardian*, September 13, 2016. www.theguardian.com/commentisfree/2016/sep/13/lionel-shrivers-full-speech-i-hope-the-concept-of-cultural-appropriation-is-a-passing-fad.

Singer, Isidore, and Meyer Kayserling. "Sephardim." *Jewish Encyclopedia*. Accessed August 11, 2023. jewishencyclopedia.com/articles/13430-sephardim.

Soyer, Daniel, ed. *The Jewish Metropolis: New York City from the 17th to the 21st Century*. Brookline, MA: Academic Studies Press, 2021.

Stephens, Judith L., and Kathy A. Perkins, eds. *Strange Fruit: Plays on Lynching by American Women*. Bloomington: Indiana University Press, 1998.

Tavera, Stephanie Peebles. *(P)rescription Narratives: Feminist Medical Fiction and the Failure of Censorship*. Edinburgh: Edinburgh University Press, 2022.

"Theatre." *Crisis*, May 1932.

Ward, Erik K. "Skin in the Game: How Antisemitism Animates White Nationalism." Political Research Associates. June 29, 2017. politicalresearch.org/2017/06/29/skin-in-the-game-how-antisemitism-animates-white-nationalism#sthash.he8C5b5R.dpbs.

Wells, Ida B. *The Light of Truth: Writings of an Anti-Lynching Crusader*. Edited by Mia Bay and Henry L. Gates. New York: Penguin, 2008.

Whitfield, Stephen. "The Ordeal of Scottsboro." *AJS Perspectives* (Spring 2021): 66–68.

Young, Patricia A. *African American Women Playwrights Confront Violence: A Critical Study of Nine Dramatists*. Jefferson, NC: McFarland, 2012.

3

THE MAKING OF A WHITE SOPHISTICATE

Marian Spitzer and Middlebrow Self-Presentation

Jessica Kirzane

A drawing of cub entertainment journalist Marian Spitzer interviewing the famously misanthropic comic actor W. C. Fields backstage at the Palace Theatre in New York depicts her seated uncomfortably close to her subject, who stands akimbo, pointing his cigar at her accusatorially. In this image, Spitzer sits adjacent to fame, both in the form of W. C. Fields and the stage door itself. Her face is composed, and she maintains a professional demeanor, taking notes for her article as though unfazed by the imposing figure in the foreground. While the drawing demonstrates the vulnerable and subordinate position she finds herself in as a woman writer in a male-dominated field (seated below Fields and at the mercy of his stern gaze), it also depicts her as an object of beauty and admiration for her ability to write in such circumstances. W. C. Fields is the subject of the interview, but Spitzer takes up roughly equal room in the image, competing with him for the limelight by her mere presence as a professional woman and highlighting the "battle of the sexes" that was a frequent topic of early twentieth-century magazine culture.[1] Neatly coiffed and professionally dressed, her face upturned, she cuts an eager figure, making room for herself—and for a particular kind of sophisticated, working womanhood—in the space of theatrical entertainment. The drawing captures Spitzer's cultivated poise and her role as a modern woman writer within the early twentieth-century entertainment industry.

Figure 3.1. Marian Spitzer interviewing W. C. Fields, an illustration accompanying a review of *The Palace* (1969), an account of Spitzer's early years as a journalist and publicist for the Palace Theatre. From Roberta Roesch, "Big-Time Writing Stint Books Palace Theatre," *Tyrone (PA) Daily Herald*, August 13, 1969, 12.

As a young woman, Spitzer aspired to make herself over into a sophisticate—a role that would distinguish her from what she understood to be the more homebound expectations for women of her mother's generation. Raised in a Jewish family on New York's Upper West Side, in what she later dismissed as the "prosaic purlieus of Washington Heights,"[2] known at the time to be a fashionable middle- and upper-class neighborhood with a large Jewish population, Marian Spitzer (1899–1983) had the privileges of modest wealth and education. Spitzer's later rebellion against what she perceived as the conservative society life of uptown and embrace of the more lively downtown was connected for her with a rebellion against this well-heeled Jewish upbringing. She asserted herself as a modern woman and a rebel by flaunting the social constraints and expectations of her family's ethnoreligious and class enclave. For Spitzer, her career as a writer came to represent a separation from her parents' Jewishness that was crucial in establishing her independence as a woman.

Spitzer began her career writing for the *Brooklyn Times*, and later the *Evening Globe*, while studying journalism at New York University, from which she graduated in 1920.[3] Due to her background in entertainment journalism, Spitzer landed a position on the publicity staff of the Palace Theatre, where she interviewed vaudeville stars for press releases and moved in and out of rehearsal rooms and offices.[4] As was the trend among middlebrow writers of her day, Spitzer navigated between the popular culture of vaudeville and mass-market magazines, on the one hand, and a more literary-minded readership, on the other. In her writing, she not only observed and reported on the entertainment world but also observed and satirized those who aspired to acquire sophistication as a consumable object, mediating between high and low and pulling both toward a capacious Jazz Age middle ground that she—among others—posited as uniquely fresh and new.[5]

Decades later, nostalgically recalling her life in New York in the 1920s, Spitzer bubbled over with enthusiasm: "It was great to be alive and in New York those years. Everything was wonderful fun especially at the Palace, where that same cornucopia of money and talent was spilling its treasures on the broad stage for all . . . to see."[6] Spitzer recalls a moment that Faye Hammill has termed the "Age of Sophistication."[7] As Catherine Keyser explains in her work on women writers and early twentieth-century magazine culture, Manhattan was imagined as the center of the cosmopolitan ideal, in which "chic commodities and lifestyles could be easily obtained, and small town identity and constrictions could be abandoned."[8] Writers like Spitzer performed the desirability of such glamorous lifestyles through their self-presentation, fashioning themselves as part of the glossy world sold by middlebrow magazines to a captivated reading public. In her catalog of what made those years a delight, Spitzer includes not only the theatrical culture about which she wrote but also the print culture in which she took part.[9] Spitzer's name appears among lists of literati who dined together in notable locales like the Algonquin Hotel. She breakfasted with literary critic Burton Rascoe and kicked a hole in his new straw hat at a raucous "intellectual evening."[10] These appearances were chronicled in the press, gaining her a reputation as a member of the star-studded literary class. Spitzer developed a reputation for having a sharp-tongued, droll wit that would

become a signature feature of both her writing and her persona in the social scene.[11]

In 1924, Spitzer penned her first novel, *Who Would Be Free*. After marrying reporter and future film producer Harlan Thompson in 1925, she moved to Hollywood, where she maintained a career as a novelist, short story writer, gossip writer, memoirist, socialite, and script writer, as well as, briefly, an actor. In addition to writing several Hollywood screenplays, she went on to write five novels and memoirs about career women and show business.[12]

Spitzer's body of work expresses a highly stylized relationship to femininity and modern rebellious womanhood, in which she positioned herself above ordinary femininity as exceptionally suave—an exemplar of modernity. Like many of the trendy New York magazine writers of her era, Spitzer's writing is characterized by fast-paced, understated wit, and an unrelenting criticism of hypocrisy and of women's displays of silliness or weakness around romantic affairs. Just as Spitzer's writing tended to poke fun at women she described as uncultured and ordinary, so too did her depiction of Jewish figures critique what she represented as the kind of parochialism that a young sophisticate would have to disavow in order to be fully modern and liberated. In Spitzer's writing there is a throughline between her self-positioning as liberated from mundane womanhood and her self-presentation as emerging from Jewish ethnicity into American whiteness. Hammill has demonstrated that in the 1920s, sophistication, long associated with class distinction and breeding, was paradoxically also marketed as something that could be learned and attained through participation in bohemian culture and consumption of its cultural products. Spitzer thus exemplifies how the attainment of such sophistication necessitated a performance of elitism and whiteness. Spitzer's self-presentation as a sophisticate, and her use of sophistication to chart a trajectory from prosaic to chic, illustrates the way the concept of sophistication itself has "played a crucial role in the ongoing project of dismantling traditional categories of gender, sexuality and class," allowing a certain kind of social mobility for those who are able to master and perform it.[13]

As an American-born Jewish writer of upper middle-class central European, German-speaking extraction, Spitzer was able to present her Jewishness as an ethnic background that she could surmount in order to achieve American whiteness. Her story contrasts with Eastern European Jewish

narratives—such as those by her contemporary Anzia Yezierska—in which women's Jewish backgrounds precluded the achievement of American whiteness, an achievement that many of Yezierska's protagonists (and Yezierska herself) ultimately conclude is undesirable.[14] Spitzer's literary career can also be compared to that of her more famous friend Dorothy Parker, whose satirical approach to romance Spitzer shared and who was also raised on the Upper West Side and experienced a literary career trajectory from Greenwich Village to Hollywood. What distinguishes Spitzer from Parker is Spitzer's early thematizing of her Jewish background, a topic Parker—whose father was Jewish—tended to avoid.[15] Spitzer's work thus allows us to track how Jewishness could be deployed as part of the project of magazine culture to both critique and reinforce social norms, especially as they pertain to class and gender.[16] An examination of Spitzer's literary output also reveals the limits of Jewishness as an angle into middlebrow magazine culture, which tended to naturalize whiteness as a key feature of new American womanhood.[17] Spitzer's writing thereby illustrates how racial and gender ideologies of exceptionalism operated in concert to produce a popular American image of the modern white sophisticate.

Rejecting Parochial Jewishness: Spitzer's Early Magazine Fiction

Spitzer's early magazine fiction focused on the class and intergenerational conflicts of German Jews in New York. It tends to glibly disparage Jewish religious custom and family life and poke fun at young women Jewish characters reminiscent of the author herself. By invoking misogynistic and antisemitic tropes at her own expense, Spitzer not only participates in fashionable ideologies about race, class, and gender but also writes herself an entry ticket for the socially elite literary and entertainment worlds that she hoped to fully inhabit. Her early short stories situate the narrator as a judgmental observer, knowledgeable about but skeptical of a German Jewish community aspiring to American whiteness but lacking the cultural sophistication to achieve it.

Spitzer wrote regularly for popular middlebrow bohemian outlets, such as the *Smart Set* and *American Mercury*.[18] These magazines appealed to a wide commercial readership while posturing an attitude

of elitism, expressing and catering to the cultural anxieties of a growing professional-managerial middle class intent on educating themselves in matters of taste.[19] (The *Smart Set*, for instance, touted itself as a "magazine of cleverness.") In these magazines, Spitzer represented the Upper West Side Reform Jews among whom she had grown up with criticism and disdain, performing the sophisticated "snobbishness tinged with knowing humor" for which these magazines were known.[20] Adopting attitudes toward Jews circulating in patrician American culture, Spitzer depicts her Jewish figures as vulgar insofar as their desire for fashionability is tied up with their interest in commerce and their ascendancy into the commercial middle class.[21]

A comparison between Spitzer's early magazine fiction and Thyra Samter Winslow's "A Cycle of Manhattan," which appeared in the *Smart Set* in 1919, is helpful in unraveling Spitzer's attitude toward her Jewish characters. Winslow's cycle traces a Jewish family from their Atlantic crossing and settlement in a crowded immigrant neighborhood to their bejeweled middle-class existence of Americanized names, Ivy League education, and economic success.[22] While Winslow's depiction of the Lithuanian, Yiddish-speaking Rosenheim family sympathetically narrativizes the upward striving of Jewish immigrants, who can now look back on their former selves with nostalgia, Spitzer depicts German-speaking second-generation families already comfortable in upper middle-class homes and thus approaches their desire for status with the revulsion and disdain of teenage rebellion and disavowal. Spitzer does not offer a sense of transformation from poverty to wealth, but one of stasis within the uncouth middle—and it is this stasis that bears the brunt of Spitzer's critique. In Winslow's "Cycle of Manhattan," the desire for upward mobility through consumerism is shared by the entire family—parents and children—all of whom achieve wealth that ultimately leaves them nostalgic for the authenticity of "those old days" before they had experienced "middle-class fripperies."[23] Spitzer, on the other hand, pits the generations of her German Jewish families against each another: the parents are content to perpetuate and shore up their middle-class identities, while the younger generation is itching for a change.[24]

The parents in Spitzer's stories have no qualms about their middle-class lifestyles or what Spitzer represents as their false and incomplete sophistication. They make pretentious choices, such as naming their child "Thérèse,

with an accent over both e's, because they thought it looked nicer than Tressa, the more utilitarian name," and are forever trying too hard for sophistication, dressing their daughters in ribbons "a quarter of a yard longer" than those of their schoolmates in order to "show the Jew haters that only a certain class of Jew was objectionable."[25] Mining her ethnic background for the social "types" that middlebrow writers delighted in mocking, Spitzer asserts herself as urbane against the backdrop of her recent context; she caricatures Jews as uptown bores unable to hold a candle to their fashionable, metropolitan downtown counterparts.[26] As Hammill explains, it was common for authors of middlebrow texts of this period to poke fun at those who conformed to social "types" in order to establish their own nonconformity.[27] At the turn of the twentieth century, as Martha Bantha explains, "image-making and image-reading had become a major cultural activity in America," and social differences tended to be mapped onto fixed visual stereotypes that had the seeming permanence of biological traits. Defining minority groups reductively in the way of "social types" fueled the assertion that the magazine's readership was fundamentally different from such easily identifiable others.[28] Therefore, in Spitzer's descriptions, Jewish parental figures are not fully fleshed out characters, but reductive representations of coarse individuals whose aspirations are for economic and social, rather than intellectual, status. Spitzer does not offer sympathy toward such strivings; rather her criticism of them allows her to distinguish her own voice and establish her ability to see through the tawdriness of middle-class dross aspiring to pass itself as gold. In one story, for example, a parent would prefer her daughter not go to college because if you "give your children an education and they know more than you" you lose control of them and they "run around with Gentile fellows."[29] These parents' insularity in marital practices is a proxy for their intellectual narrow mindedness and cultural backwardness.

Spitzer's critique centered largely on the marriage practices of the Reform Jewish community. She depicts their insistence on endogamous marriage as the hypocritical result of prejudice, following similar, earlier American literary aspersions, such as Henry Harland (pseud. Sidney Luska)'s novel *Mrs. Peixada* (1886) in which Jewish parents' concern about intermarriage is deemed "prejudice pure and simple, the offspring of superstition."[30] In the case of Spitzer's writing, parental reasoning against such marriage lacks logic and is as simple as "It's wrong. No good ever comes of

it"—an argument that the younger generation finds "silly."[31] These stories participate in a popular discourse around intermarriage in which romance served as a vehicle for liberalism by "us[ing] sympathetic couples as a way for audiences to test and evaluate traditional hierarchies and outmoded values," in particular calling on audiences to reject the undemocratic values represented by the older generation opposing the romance and to celebrate the liberal ideologies embodied by young lovers from different backgrounds.[32] Several of Spitzer's stories follow teenage Jewish women from an upper middle-class, Reform Jewish, New York background who pursue love and marriage while grappling with their parents' expectations. The struggles that her characters face may be somewhat autobiographical, reflecting her relationship to her parents in light of her budding romance with the non-Jewish playwright Harlan Thompson.[33] As one contemporary reviewer suggested, Spitzer "reveals a good deal more than most young women would care to put on paper," plumbing her own rebellious experiences to entertain her readers.[34]

In the stories, Spitzer skewers uptown Jewish bourgeois culture of parents seeking out favorable marriages for their daughters in order to protect and perpetuate upper middle-class lifestyles. These unions are commodities desired by, and procured by, consumers of a marriage market; Spitzer depicts young women as victims bought and sold under the false promises of that market. In Spitzer's short story "The Six Greatest Moments" (1922), Teddy Baer—whose name represents her as childlike, a plaything on which her parents enact their ambitions and desires—is infatuated with an ideal of bourgeois marriage. In particular, she builds her ambitions on popular illustrator Harrison Fisher's postcard series *The Six Greatest Moments in a Girl's Life*, which Teddy's parents bought for her when she was a child. The postcard series offers an idealized version of a woman's life trajectory, from girlhood through young womanhood to courtship, marriage, and children. Spitzer writes, "In the secret recesses of her [Teddy's] mind she . . . considered herself the heroine of the pictures, and was sure that some day, rather soon, too, all those thrilling things would happen to her."[35] Teddy compares her own life to these unreachable ideals and models herself on the appearance of happiness they convey, refusing to see the way that she and her life fall short of this standard. Spitzer casts a contemptuous gaze on Teddy for her aspirations to be so strictly conventional—in this case combining the conservative conventions of

bourgeois marriage with the conservative conventions of her own Jewish social circles that demand endogamy. With her parents' encouragement, eighteen-year-old Teddy marries a wealthy forty-year-old Jewish man. Her single-minded belief in the perfection of marriage distracts her from the failures of her own married life, especially her husband's infidelity. Instead, Teddy insists to herself: "Here she was, eighteen, engaged to a wonderful, good-looking man, one of the best catches in New York. If any thrills of romantic love were absent, they weren't missed. The thrill of triumph was sufficiently potent to be mistaken for the other. Anyway, Teddy was very happy."[36] As her marital situation becomes increasingly untenable, the narrator repeats "She was very happy" as though to block out the story's blatant undermining of this delusional message. The story ends with Teddy's sighing that again "she was very happy" and feeling a proud sense of accomplishment while watching her husband purportedly admire their baby, even as he is actually thinking about the "swell red-headed girl" who works as their nanny.[37]

Throughout the story, Spitzer insists that bourgeois marriage is a trap that promises young women the illusion of success and happiness. Teddy's upwardly aspiring parents are complicit in her self-delusion and place her in circumstances in which it will be impossible for her to achieve real happiness, privileging status and money over their daughter's feelings and relationship. Their inept imitations of the true happiness promised by the Harrison Fisher pictures reveal not only the failed promise of conventional bourgeois marriage but the even greater moral failure of the middle-class, social-climbing "type" who are more interested in achieving the appearance of happiness than happiness itself. Teddy herself is an ideal product of her parents' efforts, blind to the fact that her "happiness" is based on the false premise of her apparently perfect marriage and foolishly believing that such a marriage should be the most desirable future for a young woman such as herself.

This excoriation of bourgeois marriage is compounded by the failure of endogamy to protect the daughter from an unhappy married life. The notion that finding a Jewish spouse will produce a happier marriage—a supposed truism that parents in Spitzer's stories frequently proclaim—is demonstrated to be as much of an illusion as the notion of a happy conventional marriage more broadly. Another of Spitzer's stories foregrounds this argument more explicitly. In "The Best Husbands" (1923), the protagonist's parents

insist that "Jews make the best husbands." They persuade their daughter Roslyn to marry an abusive Jewish man rather than following her own inclinations and dating a non-Jewish newspaper reporter—reminiscent of Spitzer's own non-Jewish suitor, Harlan Thompson.[38] The parents' close-minded preferences for endogamy blind them to their own child's best interest.

In "The Rise and Fall of Florrie Weissman" (1922), Spitzer once again skewers the false sincerity of her characters, offering another angle on interethnic romance by depicting an intermarriage that is not premised on upward mobility (a Jewish woman desiring a white Protestant partner) but instead on downward mobility (a Jewish woman considering an Irish working-class partner). The protagonist, Florrie Weissman, does not follow her parents' pressure and advice about finding an appropriate marriage partner, nor does she easily submit to popular illusions and ideals of womanhood and marriage. Yet as she deploys romance as a tool for social attention and teenage rebellion, she also fails to achieve happiness, sacrificing personal fulfillment for the sake of a scandalous marriage that functions as a public performance of independence and audacity. A Jewish heiress, Florrie was once among the most popular and sought-after girls in her high school, but as she delays marriage, reveling in the attention of young men, she slowly finds that she loses social clout. Florrie asserts herself as modern and freewheeling when she drops out of high school to attend art school and starts socializing with a non-Jewish bohemian crowd, dating a non-Jewish theater press agent against her mother's wishes ("[W]hat would my friends say?" her mother worries).[39] When she fails to marry into her social set and regain her popularity, she becomes fearful that she will end up an "old maid," and "anything was better than that."[40] She agrees to marry her family's Irish chauffeur because "it would be easy enough to get a divorce after a while. And so many society girls were marrying their chauffeurs and grooms and other servants, it was really quite chic."[41] She looks forward to the scandal: "Everybody would be talking about her . . . secretly admiring her for her daring. Risking everything for the man she loved. That would sound very romantic."[42] Spitzer lambasts Florrie's self-presentation as a romantic sacrificing her family's desires for the sake of love when in reality she does not love, or even really notice, the chauffeur. Florrie is a quintessential target for the ironic gaze of the

middlebrow modern: an uncultured individual with pretensions of sophistication, against which the truly sophisticated narrator—and perhaps, by extension, author—can distinguish herself. Thus, both bourgeois Jewish marriages and unsophisticated teenage rebellion against such marriages become targets of Spitzer's wry, caustic pen. Spitzer's Jewish characters are false sophisticates who try too hard while ultimately failing to achieve the effortless, modern *je ne sais quoi* of the narrative voice that depicts them.

Jewish and Feminist Rebellion in *Who Would Be Free* (1924)

Spitzer's writing about the hypocrisies of middle-class Jewish life culminated in her novel *Who Would Be Free* (1924), an exploration of a young Jewish woman coming of age as a modern working woman.[43] The novel contains cultural practices specific to the Reform Jewish world, such as an opening scene that takes place at a confirmation ceremony, adding a local color element. Like many exemplars of bohemian Greenwich Village womanhood in middlebrow women's fiction of the period, the protagonist, Eleanor Hoffman, navigates obstacles in professional and domestic life as she struggles to free herself from the confines of traditional women's roles. She does so through a series of romantic relationships that take her further away from her Reform Jewish parents' expectations. She gains financial and physical independence by pursuing a career in theater publicity and renting her own studio apartment in Greenwich Village. Although she admits that "she wasn't altogether sure what she meant by freedom," she knows it has to do with escaping both "the religion," the intellectual and faith component of her Jewishness, and "the Sunday school crowd," the social aspect of her confining Jewish life.[44] Eleanor expresses intellectual doubts about the faith in which she is raised, internally questioning the ideas she recites at her own confirmation ceremony as she performs them: "'Life and good, death and evil.' It wasn't always like that, either, Eleanor felt sure."[45] But far more significant than her intellectual misgivings is her decision to leave her family and social milieu to become one of the "girls who live in apartments alone" whom her mother despises.[46]

Eleanor's rebellion is somewhat reminiscent of the trajectory of Jewish heroines of contemporaneous Jewish women's bildungsroman, such as Sara Smolinsky of Yezierska's *Bread Givers* (1925), insofar as Eleanor's realization of what she understands to be the hypocrisy of her religion and culture opens up the possibility of a full rebellion against her family and ethnic background.[47] But unlike Sara, Eleanor is not an academically motivated daughter escaping a father who denies her access to education because of his devotion to religious gender hierarchies. Although she does leave home for art school, Eleanor's thirst is more for independence itself than for education, and her quarrel is largely with her mother. In placing the intergenerational conflict in the feminine sphere entirely, Spitzer centers the story not on a conflict between patriarchal tradition and assimilation but one between uptown vulgarity and downtown vivacity. She depicts the escape not as a matter of intellectual urgency but one of taste—Eleanor wants to leave her parents' home because she simply *does not like it*. Her journey is less earnest than the up-from-poverty narratives of Yezierska; it is not a journey of escape by way of striving for self-improvement. Rather, Eleanor understands her superiority to already have been achieved through the act of leaving itself, which demonstrates her bohemianism and snubs her parents' mores.

Eleanor leaves because she cannot meet and does not respect the expectations her parents—especially her mother—have for her: "Funny, Elly thought, how everything her mother did was all right for others to do, but anything she didn't happen to do was all wrong and immoral."[48] Eleanor is particularly upset about the hypocrisy of her mother's pride in not looking Jewish—her mother brags: "We could get into the swellest hotels without being suspected." She also disdains her mother's insistence on maintaining social separation from non-Jews—her mother insists: "I don't care for Gentiles, as a matter of fact. My own kind are good enough for me."[49] Eleanor's mother seems to be interested in preserving German Jewish identity for its own sake, for the consolidation of wealth and clout and the perpetuation of cliquishness. Indeed, Eleanor's mother reveals the hypocrisies of her class and race biases most shockingly when she disparages Eleanor's Russian Jewish suitor, Ted Levine, who comes from a newly wealthy family. Eleanor's mother perceives them to be homing in on the exclusive German Jewish community: "'Isn't there any place in the world where we can be free from those kikes?' she'd asked her husband. 'You'd think they'd have sense enough

not to come to a nice German Jewish place, where they're not wanted.'"⁵⁰ Eleanor's mother's prejudice echoes sentiments expressed in Spitzer's earlier stories, in which classist German Jewish characters speak with disdain about Eastern European Jewish immigrants. In "The Six Great Moments," members of the Baer family are hypocritical in their Jewish identity insofar as they want to "show the Jew haters that only a certain class of Jews was objectionable" and to differentiate themselves from the "kikes" who "make it hard for real refined Jews" and who are only "ignormanuses" who "can't stay in Hester street where they come from."⁵¹ In this story, the racist, classist approach to Eastern European Jewish immigrants illustrates how the Baers are unaware of their own hypocrisy and desperate to participate in the trappings of American bourgeois life.

In direct response to her mother's rejection of Ted, Eleanor resolves that she "simply *mustn't* give way" to her parents, who believe that her desire to leave home and go to art school is his idea.⁵² Recognizing the repugnance and hypocrisy of her mother's prejudices, Eleanor desires to leave behind her German Jewish enclave and get out from under her parents' authority. To do so, she plans to use her skills to become an artist and be "much freer—freedom was a most desirable thing."⁵³

The novel situates the protagonist's development squarely within the Reform Jewish world, which is represented as insular at best. Speaking to a literary critic about the book, Spitzer explained that she believed the German Jews among whom she was raised to be "stolid; they make a fetish of system; fond of money, contemptuous of all Jews that did not originally come from Germany, lack the human touch, despise ideals, are without the spark of genius, and are prepared to grovel in the dust before any Gentile."⁵⁴ In casting her German Jewish characters as having distinct—and undesirable—ethnic traits, especially in contrast to Russian Jewish Ted Levine, whom she depicts as more educated, open to new ideas, and worldly, Spitzer goes against the grain of the "ghetto realism" of her day that tended to exoticize Eastern European Jews as parochial relics of an older world. Spitzer herself had criticized "ghetto fiction" for its repetitive descriptions of hordes of "Longing Louies and Yearning Yettas with their sniffling outbursts."⁵⁵ Yet here she writes her own reductive and repetitive ethnic caricatures, targeting instead her own community. She inscribes her upper-class Jewish community with visual and linguistic cues as a recognizable ethnic other that her readers can

observe and against which her readers—and she herself—can distinguish themselves. Meanwhile, she casts the character of Russian Jewish Ted Levine as an entry point into the forbidden modern bohemian life that Eleanor desires: Ted is Eleanor's first forbidden romance and her first foray into teenage rebellion. Russian Jewish immigrants, for Eleanor, are adjacent to bohemianism, an attitude shared by many American-born intellectuals who saw Yiddish speakers as having "a more diverse, more broadly based emotional and intellectual existence" they craved and tried to create for themselves.[56]

Who Would Be Free follows two distinct, though related, tracks of the protagonist's liberation: a break from Jewish background and a rebellion against bourgeois gender norms. Reviews of the novel demonstrate how these tracks caught the attention of different audiences. The text caused some controversy within the Reform Jewish world. In response to the novel, Rabbi Jacob Singer of Temple Mizpah in Chicago delivered a sermon on the subject, "The Blessings of Parents," presumably chiding readers sympathetic to the narrator's rejections of her parents' faith and Jewish community.[57] Rabbi Louis Newman of Temple Emanu-El in San Francisco argued, "Whatever merit her book possesses, lies in the stimulus she gives Jewish mothers and daughters to analyze their relationship in an endeavor to understand and enrich it." He goes on to criticize Jewish mothers and daughters alike for not attending to their relationships to one another.[58] Focusing on the first half of the book, in which the protagonist breaks free from her parental home and ethnic environment, these readers saw—and sought to disavow—a punishing portrayal of an overbearing Jewish mother stereotype, as well as a cautionary tale of an intergenerational rift in need of repair.

In the second half of *Who Would Be Free*, Spitzer turns away from local color writing about Reform Jewish characters and toward a detailed description of the professional and social life of a Greenwich Village working girl. Eleanor pursues a career in theater advertising, working for a boss, Morgan Princely, based on Spitzer's own boss, Walter Kingsley of the Palace. Spitzer gives her readers a behind-the-scenes look at some of the day-to-day workings of the entertainment industry.[59] She thus writes her protagonist into a trajectory that was becoming her own: increasing acceptance within what Nina Miller describes as the "slick utopian sameness" of

mass-mediated American popular culture that Greenwich Village sophisticates produced.[60] As Miller observes, the Village "implicitly defined itself" against the immigrant population that it exoticized and admired from a carefully constructed distance.[61] To participate as a bohemian writer, then, Spitzer—like her protagonist—must enact a transformation by eschewing ethnic roots in favor of urbane modernity.

Because Spitzer's local color writing was not grounded in the exotic, impoverished world of the "ghetto" but instead in the upwardly mobile Reform Jewish uptown, it—like its author—was more easily read as universally relevant to a white American audience. As one critic described her, Eleanor Hoffman is "just a girl tainted by modernism and tortured by the vague but cutting impressions of adolescence."[62] This reading of Spitzer's narrative deemphasizes the role of ethnicity, focusing instead on the ways in which the author captures one of the primary preoccupations of American magazine fiction in general in the early twentieth century: "the subject of women's proper place as a site of dynamic change and redefinition of the self."[63] As Eleanor becomes a typical Broadway bohemian, she models that lifestyle for potential readers and consumers. Diana Warwick, writing for *Life* magazine, flippantly observed that *Who Would Be Free* "has probably had a greater influence on my life than any book I ever read, because . . . [I] went out and had my hair bobbed" after reading the novel.[64] As Spitzer herself wrote in an article about women's hair fashion, "bobbed hair is . . . a tangible symbol of woman's recently acquired independence," as well as an important component fueling the "new industry in motion" of hair care and commercialized beauty.[65] Thus, despite its local color Reform Jewish content, *Who Would Be Free*, with its specific references to popular modern fashion, can also be read as a mainstream (that is, not ethnic) novel of bohemianism. The novel appears to have much more in common with the work of the writers of the Algonquin Roundtable, who saw themselves as "articulators of modernity for the modern mass," than with ghetto tales purporting to offer realistic representations of working-class, Yiddish-accented Jews living hardscrabble lives on the Lower East Side.[66] Hoffman's performative rejection of her ethnic origins over the course of the novel lends the character and its author entry into the social and commercial spheres in which sophisticated white modern womanhood was being produced.

In her later work as a screenwriter, Spitzer would repeat this pattern in which a protagonist's ethnic origins are represented and eschewed while a debate about women's roles in work and marriage comes to the foreground. In the screenplay she cowrote with John Francis Larkin for the 1945 biopic *The Dolly Sisters*, Jenny and Rosie Dolly, played by blonde American-born actresses Betty Grable and June Haver, rise from performing with kerchiefs on their heads in front of immigrant audiences in Little Hungary to international acclaim. The presence of their Hungarian-accented uncle Latsy, played by Jewish Hungarian actor S. Z. Sakall, serves as a reminder of their ethnic background. As they gain fame, the sisters' ethnic origins become increasingly irrelevant, and the narrative comes to focus on the women's struggles with their decisions to pursue their acting careers at the expense of their romantic relationships.[67] The similarities between Spitzer's representation of her Jewish protagonist in *Who Would Be Free* and her Hungarian protagonists in *The Dolly Sisters* suggest that a trajectory *away* from ethnic specificity is more central than the grounding of the narrative in any one ethnicity in particular.

Who Would Be Free was Spitzer's last significant work about explicitly Jewish characters. Having exhausted the bildungsroman narrative of the Jewish girl breaking from her parents' tradition, Spitzer continued to write about potentially Jewish characters within a community that included many Jewish cultural producers, but without naming her characters as Jewish. In universalizing her characters as modern women navigating modern love, she also whitened them.[68]

Spitzer's mobilization of the up-from-ethnicity narrative stands in stark contrast to the work of her contemporary Yezierska, who, like Spitzer, was a middlebrow modernist affiliated with the Greenwich Village set and who similarly crossed over into Hollywood. Yezierska's identity as an immigrant Jew was essential to her writing and to her public image. As Lisa Botshon has shown, Yezierska "recognized the marketability" of her work describing impoverished Yiddish-accented Jewish immigrants striving for upward mobility, and her ethnic identity was an asset in creating her literary celebrity.[69] While Spitzer wrote her way out of ethnicity into urbane sophistication, Yezierska peddled an ingenue persona, emphasizing a contrast between her "starving artist–immigrant lifestyle" and the Hollywood glamour that she entered when film companies vied for the rights to her short story collection *Hungry Hearts*

(1920).⁷⁰ Botshon notes that Yezierska's "success at self-promotion was ultimately self-destructive" because her success "meant that her persona as an impoverished immigrant was destabilized."⁷¹ The casting of the film version of *Hungry Hearts* (1922) speaks to the way Yezierska and her work were treated as the unassimilable counterpart to the assimilation narratives that writers like Spitzer popularized. The producers of *Hungry Hearts* wanted to cast actors "who would convey . . . understandable Jewish traits," while *The Dolly Sisters* featured two leading actresses who were icons of American whiteness, despite the fact that Rosie and Jenny Dolly were Hungarian immigrants.⁷² The difference in the treatment of Spitzer's and Yezierska's texts likely arises from the contrast between Spitzer's status as an American-born woman of German Jewish origins and Yezierska's status as an immigrant from Eastern Europe, and the writers themselves drew on their origin stories in their efforts to market their own literary celebrity. As Leslie Fishbein explains, although Yezierska was "a highly idiosyncratic woman" who did not always fit within "her culturally prescribed roles," she successfully harnessed a public hunger for the pathos of ghetto life and "invented a self that won her public acclaim."⁷³ In writing herself out of ethnicity, Spitzer engaged in a similar process of self-invention, exercising agency in the performance of her public identity in the marketplace of literary celebrity. While some scholars have located a temporal shift in American popular literary representations of Jews, from the "proletarian novels" of the 1930s to the "embourgeoisification narratives" of the 1950s,⁷⁴ an examination of Spitzer together with Yezierska allows for an understanding of both of these representations of Jewishness as present simultaneously within early twentieth-century American popular culture. This scholarly narrative tends to conflate Jewishness with Eastern European Jewish immigrants, leaving out writers like Spitzer who came from a central European Jewish background.

Spitzer's assimilability into urbane whiteness relies on the existence of figures like Yezierska, who represents the impossibility of assimilation for some. The contrast enables Spitzer to demonstrate her successful performance of American whiteness. As Spitzer writes of Eleanor, "There was a certain quality she could get into her voice that subtly suggested whiteness, purity."⁷⁵ This quality, with which she performs the Floral Offering at her confirmation in the novel's opening, contrasts with other girls in Eleanor's confirmation class from "important families" who gave large sums

of money to the Reform temple or who recite the Closing Prayer before the Ark with dramatic flair learned from private elocution lessons: their performance is gauche and studied, while Eleanor's is "subtle" and natural sounding, even if she has to work "to get it into her voice." Eleanor's vocal performance differentiates her from other Jewish characters and sets the stage for her trajectory out of the temple and into refined whiteness. Contrastingly, Yezierska uses her protagonists' voices, especially their dialect, to signal their unassimilable difference and call attention to their continued immigrant consciousness.[76] Spitzer's and Yezierska's writing accorded with cultural paradigms of assimilable and unassimilable Jewishness that coexist and rely on one another in order to be fully legible.

A Hungry Young Lady (1930): The Unsuccessful Vamp

Even as she went on to focus on less overtly Jewish themes, Spitzer's fiction continued to thematize her rejection of the unsophisticated bourgeois uptown life, though its Jewish valences became more muted in favor of universalized representations. In her novel *A Hungry Young Lady* (1930), Spitzer expresses a blithe attitude toward a career-desiring woman who is represented as a posturing, social-climbing, unsophisticated counterpoint to Spitzer's own more elevated position. With this novel, Spitzer performs what Michael Kramer has described as the "achievement" of Jewish American literary texts representing assimilation, the "imaginative success" of creating and asserting a narrative in which Jews and non-Jews appear to be interchangeable.[77] The protagonist's parochial community echoes the background of Eleanor Hoffman in *Who Would Be Free*, but in this case, Jewishness is never explicitly mentioned.

Like *Who Would Be Free*, *A Hungry Young Lady* is a narrative of rebellion against the prosaic uptown crowd, but here Spitzer leaves out a description of ethnic specificity. The novel's sympathetic but exasperatingly un-self-reflective protagonist, Juliet Hays, wields her feminine attractiveness to earn bit parts on the stage while attributing her meager successes to talent. As one reviewer describes it, the novel is "told in crisp language, flecked with the satire that is one of the author's chief gifts of expression," and is a "modern, sophisticated yarn" poking fun of a "selfish young wife."[78]

In the novel, Juliet Hays "always felt it was foolish . . . just to stay home and be a housewife" and is convinced of her potential as a performer. She scoffs at the gender conventions she encounters both in her husband's world of banking, where her role is to stay contentedly at home and supervise the preparation of dinners, and of the world of theater, in which even famous producers casually remark that "my wife gave up a very promising career when she married me and I've never heard her say she regretted it."[79]

Juliet rebelliously—if self-centeredly—decides to pursue a career as a chorus girl on Broadway, a role for which she is not qualified. In chasing after this work, she also hotly pursues several industry men, hoping that flirtations will help her to achieve her glamorous goal of becoming an actress. As she pompously explains to her husband, "I'm going to dinner with Tony Waring . . . He's got a tremendous amount of influence and knows simply everybody, and he can do an awful lot for a person if he wants to. So when he asked me to dinner, I thought I'd better accept."[80] Juliet's self-admiration does not, however, match her skills or potential as a performer. When she is dismissed from an understudy role—"You're simply not ready to handle that much of a part yet"—she refuses to believe the explanation.[81] She makes a fool of herself, throwing herself at powerful industry men in the hopes of finding career success, until she finally comes to understand the harsh realities of the work: "Four shows a day, and five on Saturdays and Sundays. Ten o'clock rehearsals from Wednesday on. Lessons three times a week. All for forty dollars. It was downright cruelty . . . She shook her head and decided it was not for her."[82] Juliet ultimately returns to amateur theatricals and to staying home to "be Mrs. Myron Hays" at her husband's request, demurring, "If you really want me to, I must." Her turn toward housewifely duties feebly masks her failures as an actress.[83]

Juliet is characterized by ambition equal only to her self-delusion—a pattern familiar in Spitzer's earlier writing, such as in her story "The Six Greatest Moments" in which the protagonist insists that she is happy even when it is clear that this is far from the truth. Much of this novel is taken up with Juliet's pursuit of Tony Waring, the editor of the fan magazine *The Passing Show*, whom Juliet early on identifies as "an important person" who might be able to further her career.[84] Although she strategizes to attract his attention, she constantly denies that she is deploying sexuality for her own gain, even to herself. She plays the role of the vamp or seductress, trying

to sexually interest powerful men, but she insists on her naivete rather than owning this more sophisticated role. When Tony ignores her, Spitzer writes that "Juliet felt unaccountably bitter and wretched," as though she were fully unaware of the cause of her discontent.[85] Spitzer describes Juliet as flaunting her body in front of Tony—when they are alone in a taxi together "she . . . leaned back, her slim, mesh covered legs out before her, the beautifully shod feet resting on the edge of the opposite seat"—yet when Tony mentions her "very nice, if you don't mind me saying it, pair of what is known as limbs," Juliet pretends not to understand the nature of his interest. She comments that she'd like to pose for stocking ads, suggesting that they share a goal of furthering her career rather than having a romantic liaison.[86] When she learns that Tony is married, she "wondered a little why the intelligence had been so painful" and remarks to herself that "it wouldn't make any difference in their friendship," disavowing that their relationship is based on sexual attraction.[87] At every turn, Spitzer accuses Juliet of leading Waring along, tempting him and provoking him, pretending to be a vamp without intending to carry out a sexual liaison. When they consummate their relationship—to Juliet's protests: "I want you to. But not now, not like this!"—Juliet is portrayed as both victim and culprit in her own victimization. Spitzer seems to blame the assault on Juliet's self-deception about her own purity of motive, and indeed to focus on Juliet's culpability rather than on Waring and his "old familiar violence."[88]

Despite the tone of witty (and misogynistic) dramatic irony at its protagonist's expense, *A Hungry Young Lady* fiercely upbraids the gender conditions that limit Juliet's success, regardless of her potential talent or lack thereof. As Spitzer depicts it, the theater world rewards women who grant sexual favors to men in power and punishes those who are "prudish."[89] Participating in the professional world requires a kind of seductiveness, a willingness to sexualize oneself and be sexualized that women can harness but that can also be quite dangerous for them.[90] One such scene cuts through the mocking wit of the narration and exposes Juliet as at times a victim worthy of pity in at least equal measure to the reproach she receives elsewhere through the author's ironic tone. During a screen test, a casting director walks in on her while she is changing into a bathing suit: "He put his hand out, and much in the manner of a farmer making sure of an expensive head of cattle, ran his hand expertly over her, lingering with evident enjoyment over the small swelling of her breasts . . . 'Don't be so

touchy,' he said. 'It's all in a day's work.'"[91] Through this forthright excoriation of the misogynist basis of the theatrical profession, the novel seems to weigh in supportively for women working in the industry and argue that women's professional roles should not be determined by positioning women as sexual objects, even as it wryly suggests that this particular woman might do best to content herself as a housewife. With Tony Waring, Juliet is positioned as complicit, playing with fire by throwing herself at him and constantly looking for opportunities to be alone with him. However, in the casting scenario, sexual harassment is neither expected nor invited. The casting director's ironic language, subjecting Juliet to unwanted touch while chiding her for being "touchy," further highlights the outrageous treatment of women in the workplace. Juliet was naive enough to believe that in this less intimate, more professional environment, her body would be respected as the vehicle for her work and not seen as a plaything for male pleasure. The abruptness of this scene, Juliet's embarrassment and revulsion, and her utter lack of recourse suggest that this moment is markedly different from the others, a pointed critique directed at a corrupt Hollywood in which sexual harassment is "the usual thing"[92] and not only an indictment of a pretentious protagonist.

The passages in which Tony and Juliet engage in nonconsensual sexual activity for which Juliet is implicitly at least partly blamed, and the passage above, which Spitzer presents as more straightforwardly oppressive, work to titillate audiences with sexually taboo topics, feeding their curiosity about and desire for a taste of the scandal of the entertainment world. They confirm the audience's belief that Hollywood is suitable only for the kind of woman who can stomach rampant immorality in the workplace, inscribing women in popular entertainment as a distinct type of woman, set apart from the housewife who is the imagined consumer of middlebrow work. Even as Spitzer criticizes the ways women are vulnerable to abuse in the entertainment industry, she sells a moment of sexual lasciviousness to her readers as an adventure they can enjoy from home and grows her own reputation as a writer daring enough to tackle the most shocking topics.

In *A Hungry Young Lady*, Spitzer establishes a distinction between women, like Juliet Hays, who should be audiences—reading about or watching entertainers and desiring them as commodities—and the chic industry women, like Spitzer herself, who deserve celebrity. As one review

explains, the novel "divides the population into two classes," placing Juliet on one side of the divide and the narrator on the other.[93] In this way, Spitzer's looking down on unsophisticated women mirrors her earlier stance on Jewish characters lacking the worldliness to achieve whiteness. Juliet appears to be among the class of women that one unsavory character ruefully refers to as "career-chasing debs who are Tired of It All," women who self-aggrandizingly believe themselves to be cultural producers when they are little more than fans.[94] Juliet's inauthentic sophistication is in part due to her lack of sexual liberation; she ultimately proves herself to be a faithful wife and not a vamp experimenting in sexuality outside of conventional monogamy—at a time when such sexual experimentation was the subject of fascination. When it comes to being a modern woman, therefore, Juliet is only pretending. In her portrayal of the housewife's botched, laughable chicness, Spitzer joins better known authors such as Dorothy Parker and Anita Loos, who mock those who attempt to participate in bohemian sophistication but cannot quite cut it. Through the act of mockery, the author demonstrates her ability to discriminate between those aspiring to sophistication and those achieving it, and therefore lays claim to belonging in the latter category.[95]

Conclusion

In 1991, Alison Light noted that middlebrow writing received relatively little scholarly attention because its "apparent artlessness and insistence on its own ordinariness has made it particularly resistant to analysis."[96] Although middlebrow authors have lately been subject to significant scholarly interest,[97] work remains to be done in regards to Jewishness—and especially the ways that middlebrow literature supplies an ideological middle ground that gave women writers space to navigate among unstable class, gender, and ethnic differences. The term "middlebrow" has been deployed as an insult, built on the supposition that culture can be organized according to its objective worth and deeming certain subjects, habits of writing, and publication outlets as less valuable because they target the tastes and buying habits of middle-class consumers.[98] Yet such writing was central to American literary and cultural production, mediating between multiple discourses at a time of shifting cultural values—such as the changing

nature of American womanhood and American whiteness—that were the subject of Spitzer's work. If highbrow modern writing is characterized by a rejection of literary convention and a call for literary experimentation that would establish new literary hierarchies exulting the avant-garde, we might think of middlebrow modernism as a rejection of social convention and a call for social experimentation that would establish new social hierarchies exulting the chic. In drawing connections, and distinctions, between Jewishness and the urbane, Spitzer's work highlights the performance of sophistication as a means of social mobility in early twentieth-century literary culture.

Attention to middlebrow writing such as Spitzer's allows for a greater understanding of an era when the American middle class came into prominence as an arbiter of taste with significant purchasing power. Spitzer's work marked major shifts in thinking about gender, women's work, and American whiteness and the role of ethnicity within it. Her ambivalent relationship to women's independence, which she fiercely insisted on for herself (and her semiautobiographical character Eleanor Hoffman of *Who Would Be Free*) while suggesting that it was not appropriate for all women (such as the gauche Juliet Hays of *A Hungry Young Lady*), resists labels of radicalism and conservatism and demonstrates the dynamic relationship a cultural figure can have to the discourse in which she participates. Likewise, her writing about Jewishness exposes a similar kind of gatekeeping in middlebrow popular culture: some Jews, like Eleanor Hoffman, can exceed their background by claiming whiteness, while others, like her more conventional parents and sister, remain in their ethnic enclave. The contrast between Spitzer and Yezierska demonstrates how Jewish women writers themselves employed divergent strategies to navigate American literary culture—a range of approaches too often obscured by the valorization and tokenization of Yezierska as the representative Jewish woman writer of her era.

Spitzer's use, and rejection, of her Jewishness as a springboard for the cultivated poise and sophistication of modern American whiteness is part of a broader story of Jewish women's participation in the elite magazine culture of the early twentieth century. This story includes writers such as Dorothy Parker, Edna Ferber, and Thyra Samter Winslow, who were pivotal in creating and critiquing American whiteness from their vantage points in the publishing and film industries. Like Spitzer in the

illustration at the beginning of this chapter, they took up space within, and wrote into being, a middlebrow culture that made room for their talents, though often in ways that were not overtly Jewish. Ferber, for instance, wrote about characters from a diverse array of ethnic backgrounds and classes, sometimes sidelining her own Jewish background to showcase a variety of strong professional women challenging gender roles amid sweeping historical dramas that sought to characterize the nature of America itself. As Eliza McGraw notes, Ferber's "use, exploration, and sometimes explosion" of ethnic stereotypes add "intriguing points of pressure" into the American literary middlebrow.[99] Examining the role of Jewishness in each of these writers' work allows us to pinpoint and better understand moments of ethnic and social mobility and unease in the development of American whiteness. Spitzer's writing calls us to think, especially, about ethnic components of the ironic gaze of the literary middlebrow, which created a particular model of American women's whiteness.

Spitzer's literary career does not align well with expectations for Jewish American writing of this period, which has been dominated by the ghetto genre. Immigrant ghetto realism and upward striving have become synonymous with early twentieth-century American Jewish fiction through the canonization of figures like Yezierska, who doubled down on ethnic difference.[100] An examination of Spitzer's trajectory as a writer uncovers a blind spot within American Jewish history, literary scholarship, and historiography. If a writer such as Yezierska was pigeonholed as an ethnic fictionist who ultimately embraced and marketed her Jewish specificity, Spitzer represents something of her opposite: a writer who employed irony and wit to distance herself from her Jewish background and transform herself into a white sophisticate.

Notes

Many thanks to Jeremy Dauber and Rachel Beth Gross, as well as the editors of this volume, for offering editorial feedback on drafts of this chapter.

1 For a discussion of the role of women writers in magazine culture and gender competition and gender anxiety in their writing, see Catherine Keyser, *Playing Smart: New York Women Writers and Modern Magazine Culture*

(New Brunswick, NJ: Rutgers University Press, 2010), particularly chapter 1, "Thoroughly Modern Millay and her Middlebrow Masquerades."
2. Marian Spitzer, *The Palace* (New York: Atheneum, 1969), ix.
3. "NY Reporter to Talk," *University Daily Kansan*, May 20, 1920, 1.
4. Spitzer, *Palace*, xiv. As Antonia Lant notes, entertainment journalism was often the best available route into industry work for women in this period. Lant, *Red Velvet Seat: Women's Writings on the First Fifty Years of Cinema*, ed. Antonia Lant, with Ingrid Periz (London: Verso, 2006).
5. For a discussion of this mediating role of middlebrow writing, see Nicola Humble, *The Feminine Middlebrow Novel, 1920s to 1950s: Class, Domesticity, and Bohemianism* (Oxford: Oxford University Press, 2004), 11–12.
6. Spitzer, *Palace*, 109.
7. Faye Hammill, *Sophistication: A Literary and Cultural History* (Liverpool: Liverpool University Press, 2010).
8. Keyser, *Playing Smart*, 16.
9. Spitzer, *Palace*, 109.
10. Burton Rascoe, "A Bookman's Day Book," *New York Tribune*, June 25, 1922.
11. See, for instance, "Cannot Be Stupid and Cut Figure in Chorus," *Comstock (NE) News*, December 25, 1924, 2; Mary Rennels, "Marian Spitzer Says Her Husband Must Be Good Conversationalist," *Buffalo Sunday Times*, April 22, 1923, 38; and Allene Summer, "The Woman's Day," *Selma Times-Journal*, March 16, 1926, 2, citing an article by Spitzer that appeared in *Pictorial Review*.
12. Spitzer's books include *Who Would Be Free* (1924); *A Hungry Young Lady* (1930); *I Took It Lying Down* (1951); and *The Palace* (1969). Her screenwriting credits include *The Dolly Sisters* (1945); *Look for the Silver Lining* (1949), *Shake Hands with the Devil* (1959), and several television episodes of the *Loretta Young Show* and radio episodes of *Big Story*. In addition, she holds credits for the exhibition and catalog *Stars of the New York Stage: 1870–1970, A Special Exhibition*, Museum of the City of New York, 1970. Her short articles and stories appeared in several magazines, including the *Smart Set*, *McCall's*, *Cosmopolitan*, *Redbook Magazine*, the *Saturday Evening Post*, the *Pictorial Review*, the *American Mercury*, and *Good Housekeeping*. Spitzer was also an anti-Nazi activist, serving as vice chair of the Hollywood Anti-Nazi League (formed in 1936); she was called on to defend the organization against inquiries by the House Un-American Activities Committee and blacklisted.
13. Hammill, *Sophistication*, 210.
14. One memorable instance of Anzia Yezierska's rejection of whiteness as a desirable aim is in her 1923 novel *Salome of the Tenements*, in which a Jewish woman leaves an intermarriage to pursue a romance with a Jewish

partner who "understands me as I am." Yezierska, *Salome of the Tenements* (Urbana: University of Illinois Press, 1995), 182. See also Ljiljana Coklin, "Between the Orient and the Ghetto: A Modern Immigrant Woman in Anzia Yezierska's *Salome of the Tenements*." *Frontiers: A Journal of Women Studies* 27, no. 2 (2006): 136–61; and Jessica Kirzane, "The Melting Plot: Interethnic Romance in Jewish American Fiction in the Early Twentieth Century" (PhD diss., Columbia University, 2017).

15 Barry Day, *Dorothy Parker: In Her Own Words* (Boulder, CO: Taylor Trade, 2004), 3.

16 For a discussion of Dorothy Parker's approach to this project, see Angela Weaver, "'Such a Congenial Little Circle': Dorothy Parker and the Early-Twentieth-Century Magazine Market," *Women's Studies Quarterly* 38, no. 3/4 (2010): 25–41, JSTOR, www.jstor.org/stable/20799362.

17 Martha H. Patterson, *Beyond the Gibson Girl: Reimagining the American New Woman, 1895–1915*. Urbana: University of Illinois Press, 2005, 19.

18 Her stories for the *Smart Set* included "The Six Greatest Moments" 68, no. 1 (May 1922): 47–59; "The Rise and Fall of Florrie Weissman: A Complete Novelette," 68, no. 3 (July 1922): 5–30; and "The Best Husbands," 70, no. 4 (April 1923): 87–104. For the *American Mercury*, she wrote "Morals in the Two-a-Day," *American Mercury*, September 1924, 35–39. One article about Spitzer notes that she had the "unique distinction" of having articles appear in the *American Mercury* and the *Saturday Evening Post* simultaneously. "Girl Writer Claims Unique Distinction," *Times-Dispatch* (Richmond, VA), February 1, 1925, 57. See also Marian Spitzer, "Thicker than Water," *Live Stories*, 40, no. 2 (September 28, 1923): 39–54.

19 Sharon Hamilton, "'Intellectual in Its Looser Sense': Reading Mencken's *Smart Set*," in *Middlebrow Literary Cultures: The Battle of the Brows, 1920–1960*, ed. Erica Brown and Mary Grover (London: Palgrave Macmillan, 2011), 130–47; see also Keyser, *Playing Smart*.

20 Hamilton, "'Intellectual in Its Looser Sense,'" 139.

21 See, for instance, Louis Harap, *The Image of the Jew in American Literature*, 2nd ed. (Syracuse, NY: Syracuse University Press, 2003), 364. Edith Wharton's work, for instance, exemplifies the antisemitic attitudes held by genteel realists of the era. See, for instance Irene Goldman-Price, "The Perfect Jew and 'The House of Mirth': A Study in Point of View." *Edith Wharton Review* 16, no. 1 (2000): 1–9.

22 Thyra Samter Winslow, "A Cycle of Manhattan," *Smart Set* 58, no. 3 (March 1919): 3–35, with gratitude to Lori Harrison-Kahan for introducing me to this source.

23 Winslow, 34.

24 It may also be worth noting, in this brief comparison, that Spitzer is writing with the intimacy and friction of depicting the community she was raised in, while Winslow, though Jewish, was born and raised in Arkansas, and did not directly experience the stereotypical rise from ghetto poverty to new wealth that she depicts in her "Cycle of Manhattan." Joan Moelis Rappaport, "Thyra Samter Winslow," *The Shalvi/Hyman Encyclopedia of Jewish Women*, Jewish Women's Archive, December 31, 1999, jwa.org/encyclopedia/article/winslow-thyra-samter.

25 Spitzer, "Six Greatest Moments," 47.

26 Regarding uptown, Dorothy Parker once quipped, "[I]f I go above 72nd Street, I get a nosebleed!" as quoted in Day, *Dorothy Parker*, 3.

27 Faye Hammill, *Women, Celebrity, and Literary Culture between the Wars* (Austin: University of Texas Press, 2007), 8.

28 See Martha Bantha, *Imagining American Women: Idea and Ideals in Cultural History* (New York: Columbia University Press, 1987), 104; and Ardis Cameron, *Looking for America: The Visual Production of a Nation and People* (Oxford: Wiley Blackwell, 2005).

29 Spitzer, "Rise and Fall of Florrie Weissman," 88.

30 Sidney Luska [Henry Harland], Mrs. Peixada (New York, 1886), 104, quoted in Harap, *Image of the Jew*, 461.

31 Spitzer, "Rise and Fall of Florrie Weissman," 88.

32 Holly A. Pearse, "But Where Will They Build Their Nest? Liberalism and Communitarian Resistance in American Cinematic Portrayals of Jewish-Gentile Romances" (PhD diss., Wilfrid Laurier University, 2010), 16. For further discussion of discourses of intermarriage in this period, see Kirzane, "Melting Plot," 2017.

33 Spitzer met her future husband, then playwright Harlan Thompson, a former World War I pilot and newspaperman from Hannibal, Missouri, while she was a reporter for the *Globe*. Thompson was not Jewish, and one might read between the lines, as her writing about romantic liaisons between Jews and non-Jews was largely published around the time of their courtship, that she may have been working through a conflict with her parents over the relationship in her fictional writing. When Spitzer first met Thompson he was married, and the couple's somewhat scandalous and secretive affair lost Spitzer the job, as she was often skipping assignments to "go riding on the Staten Island ferry with the object of [her] affections." Telephone conversation with Jenn Thompson, September 2, 2021; Martin Golde, "Gossip and News of Jewish Personalities," *Sentinel*, March 21, 1930; and Spitzer, *Palace*, 64.

34 "The Reading Lamp," *Times Union* (Brooklyn, NY), October 19, 1924, 6.

35 Spitzer, "Six Greatest Moments," 50. Harrison Fisher, a popular illustrator of the period, painted this series of six postcards, *The Greatest Moments in a Girl's Life*, around 1911. They charted a narrative for the ideal life of an American Beauty, tying feminine beauty to love, marriage, and motherhood. The six moments in the series were "The Proposal," "The Trousseau," "The Wedding," "The Honeymoon," "The First Evening in Their Own Home," and "Their New Love" (which depicts the couple admiring a baby). See Melissa Speed, "Harrison Fisher and the American Beauty" (term paper, University of North Texas, 1999); and Naomi Welch, *The Complete Works of Harrison Fisher, Illustrator* (La Selva Beach, CA: Images of the Past, 1999).
36 Spitzer, "Six Greatest Moments," 52.
37 Spitzer, 59.
38 Spitzer, "Best Husbands," 93.
39 Spitzer, "Rise and Fall of Florrie Weissman," 11.
40 Spitzer, 28.
41 Spitzer, 28.
42 Spitzer, 28.
43 Spitzer, *Who Would Be Free* (New York: Boni & Liveright, 1924).
44 Spitzer, 55.
45 Spitzer, 15.
46 Spitzer, 87.
47 Anzia Yezierska, *Bread Givers* (Garden City, NY: Doubleday, Page, 1925); and Leah Morton, *I Am a Woman—and a Jew* (New York: J. H. Sears, 1926.)
48 Spitzer, *Who Would Be Free*, 42, 55.
49 Spitzer, 43.
50 Spitzer, 45.
51 Spitzer, "Six Greatest Moments," 47.
52 Spitzer, *Who Would Be Free*, 60.
53 Spitzer, 55.
54 Nathaniel Zalowitz, "We Call Them Yahudim; They Call Us Kikes," *Forward*, November 23, 1924, 3 [The English Page].
55 Marian Spitzer, "The Ghetto in a Fine Story" (a review of *Haunch, Paunch, and Jowl*), *Brooklyn Daily Eagle*, October 27, 1923, 24.
56 David A. Hollinger, "Ethnic Diversity, Cosmopolitanism and the Emergence of the American Liberal Intelligentsia," *American Quarterly* 27, no. 2 (1975): 133–51, 138. See also Tony Michels, "The Lower East Side Meets Greenwich Village: Immigrant Jews, Yiddish, and the New York Intellectual Scene," in *Choosing Yiddish: New Frontiers of Language and Culture*, ed. Lara Rabinovitch, Shiri Goren, and Hannah S. Pressman (Detroit: Wayne State University Press, 2013), 69–86.

57 "Chicago News," *Sentinel*, January 23, 1925, 15.
58 Louis I. Newman, "Those Women Who Would Be Free," *B'nai B'rith Messenger*, December 5, 1924, 1.
59 Flora Merrill, "Walter Kingsley, 'King of Broadway' and Godfather to Struggling Actresses," *Brooklyn Daily Eagle*, October 26, 1924, 89.
60 Nina Miller, *Making Love Modern: The Intimate Worlds of New York's Literary Women* (New York: Oxford University Press, 1999), 91.
61 Miller, 25.
62 "The Reading Lamp," *Times Union* (Brooklyn, NY), October 19, 1924, p. 6.
63 Maureen Honey, "Feminist New Woman Fiction in Periodicals of the 1920s," in *Middlebrow Moderns: Popular American Women Writers of the 1920s*, ed. Linda Botshon and Meredith Goldsmith (Boston: Northeastern University Press, 2003), 87.
64 Diana Warwick, "Life and Letters," *Life*, October 16, 1924, 30.
65 Marian Spitzer, "The Erstwhile Crowning Glory," *The Saturday Evening Post*, June 27, 1925. Spitzer explained that her own hair was not bobbed because "if it were bobbed I wouldn't be able to let it down. And besides, I think I look better with it unbobbed." Nunnally Johnson, "One Word After Another," *The Brooklyn Daily Eagle*, September 22, 1924, p. 22.
66 Miller, *Making Love Modern*, 147; for more on the "ghetto tale" as a genre, see Lori Harrison-Kahan, "Ghetto Realism—and Beyond" in *The Oxford Handbook of American Literary Realisms*, ed. Keith Newlin (Oxford: Oxford University Press, 2019), 200–218.
67 *The Dolly Sisters*, directed by Irving Cummings, screenplay by John Francis Larkin and Marian Spitzer, performances by Betty Grable, John Payne, and June Haver, Twentieth Century Fox, 1945.
68 See Miller, *Making Love Modern*, 108, for a description of Modern Love discourse in the Algonquin Round Table literary circles.
69 Lisa Botshon, "Anzia Yezierska and the Marketing of the Jewish Immigrant in 1920s Hollywood," *Journal of Narrative Theory* 30, no. 3 (Fall 2000): 290. See also chapter 1 in this volume, by Ashley Walters, in which she describes Yezierska's writing as prioritizing "unapologetic voices of Jewish women," in ways that were explicit in their depiction of ethnoracial otherness.
70 Botshon, 292.
71 Botshon, 292.
72 Botshon, 301.
73 Leslie Fishbein, "Anzia Yezierska: The Sweatshop Cinderella and the Invented Life," *Studies in American Jewish Literature* 17 (1998): 137.
74 Gordon Hutner, *What America Read: Taste, Class, and the Novel, 1920–1960* (Chapel Hill: University of North Carolina Press, 2011), 249.

75 Spitzer, *Who Would Be Free*, 12.
76 As Brooks E. Hefner writes, Yezierska "uses this aesthetic to demonstrate the self-conscious project of linguistic Americanization." See Hefner, "'Slipping Back into the Vernacular': Anzia Yezierska's Vernacular Modernism," *MELUS* 36, no. 3 (2011): 187–211.
77 Michael Kramer, "The Art of Assimilation: Ironies, Ambiguities, Aesthetics," in *Modern Jewish Literatures: Intersections and Boundaries*, ed. Sheila Jelen, Michael Kramer, and Scott Lerner (Philadelphia: University of Pennsylvania Press, 2011), 305.
78 Burton Rascoe, "Hungry Young Lady Craves Stage Fame in Marian Spitzer's Book," *Times Union* (Brooklyn, NY), March 2, 1930, 22.
79 Spitzer, *Hungry Young Lady* (New York: Horace Liveright, 1930), 19.
80 Spitzer, 139.
81 Spitzer, 203.
82 Spitzer, 309.
83 Spitzer, 314.
84 Spitzer, 98.
85 Spitzer, 126.
86 Spitzer, 146. Spitzer recycles this scene in her script for *The Dolly Sisters*. Early in the film, the sister performers find themselves seated on a train opposite Harry Fox (played by John Payne), and in their attempts to impress the actor, who they believe has connections to influential theater people in New York, Jenny Dolly stands on her seat to fetch something from an overhead compartment, pausing alluringly to allow the actor, her future husband, to ogle her legs.
87 Spitzer, *Hungry Young Lady*, 167.
88 Spitzer, 260. Perhaps at the time of its publication, readers might not have seen this scene as one of rape, since the author blames Juliet for flaunting herself and making herself sexually available to Waring. Today, however, in an era in which the #MeToo movement has "disrupted the routine minimization of sexual violence," readers would be more attuned to the power imbalance and lack of consent that are essential to my reading of this scene. See Leigh Gilmore, *The #MeToo Effect: What Happens When We Believe Women* (New York: Columbia University Press, 2023). See also chapter 6 in this volume, in which Josh Lambert discusses how the #MeToo movement alters reception of novels by Susan Taubes and Erica Jong.
89 Spitzer, *Hungry Young Lady*, 296.
90 For further conversation about a "smart" magazine writer's self-awareness about the sexualized role of the celebrity female professional, see Keyser,

Playing Smart, particularly chapter 1, "Thoroughly Modern Millay and her Middlebrow Masquerades."
91 Spitzer, *Hungry Young Lady*, 295.
92 Spitzer, 295.
93 Sally Knox, review of *A Hungry Young Lady* in the *Birmingham (MI) Eccentric*, February 27, 1930, 4.
94 Spitzer, *Hungry Young Lady*, 131.
95 Hammill, *Women, Celebrity, and Literary Culture*, 8.
96 Allison Light, *Forever England: Femininity, Literature and Conservatism between the Wars* (London: Routledge, 1991), 11.
97 To name just a few titles of many: Humble, *Feminine Middlebrow Novel* (2004); Joan Shelley Rubin, *The Making of Middlebrow Culture* (Chapel Hill: University of North Carolina Press, 2000); Jaime Harker, *America the Middlebrow: Women's Novels, Progressivism, and Middlebrow Authorship between the Wars* (Amherst: University of Massachusetts Press, 2007); Christoph Ehland and Cornelia Wächter, eds., *Middlebrow and Gender, 1890–1945* (Leiden: Brill, 2016); and Keyser, *Playing Smart*, 2010.
98 Rachel Tanner, "Negotiating the Brows: Value, Identity, and the Formation of Middlebrow Culture" (PhD. diss., University of Oregon, 2020), 6–7.
99 Eliza McGraw, *Edna Ferber's America* (Baton Rouge: Louisiana State University Press, 2014), 8.
100 This latter narrative has held particular fascination for scholars of American Jewish literature, who have gravitated toward authors like Anzia Yezierska, a contemporary of Marian Spitzer's whose working-class Yiddish-speaking immigrant characters more readily fit into the category of "ethnic literature" than someone like Marian Spitzer. As Lori Harrison-Kahan has noted in reference to other understudied Reform Jewish woman writers such as Emma Wolf, "Jews with money rarely qualify as 'ethnic'" and are therefore less likely to be examined within a framework of ethnic American Jewish literature. Harrison-Kahan, "This Is (Not) What a Jewish Feminist Looks Like: San Francisco Women's Clubs and Jewish Literary History," *The HBI Blog*, April 7, 2016, blogs.brandeis.edu/freshideasfromhbi/this-is-not-what-a-jewish-feminist-looks-like-san-francisco-womens-clubs-and-jewish-literary-history/.

Bibliography

Antler, Joyce. *You Never Call! You Never Write!: A History of the Jewish Mother*. New York: Oxford University Press, 2008.

Applegate, Debby. *Madam: The Biography of Polly Adler, Icon of the Jazz Age*. New York: Doubleday, 2021.

Bantha, Martha. *Imagining American Women: Idea and Ideals in Cultural History*. New York: Columbia University Press, 1987.

Botshon, Lisa. "Anzia Yezierska and the Marketing of the Jewish Immigrant in 1920s Hollywood." *Journal of Narrative Theory* 30, no. 3 (Fall 2000): 287–312.

Botshon, Lisa, and Meredith Goldsmith, eds. *Middlebrow Moderns: Popular American Women Writers of the 1920s* (Boston: Northeastern University Press, 2003), xiv.

Cameron, Ardis. "Sleuthing towards America: Visual Detection in Everyday Life." In *Looking for America: The Visual Production of a Nation and People*, edited by Cameron Ardis. Oxford: Wiley Blackwell, 2005.

"Cannot Be Stupid and Cut Figure in Chorus." *Comstock (NE) News*, December 25, 1924.

Coklin, Ljiljana. "Between the Orient and the Ghetto: A Modern Immigrant Woman in Anzia Yezierska's *Salome of the Tenements*." *Frontiers: A Journal of Women Studies* 27, no. 2 (2006): 136–61.

Cummings, Irving, dir. *The Dolly Sisters*. John Larkin and Marian Spitzer Thompson, screenwriters. 20th Century Fox, 1945.

Day, Barry. *Dorothy Parker: In Her Own Words*. Boulder, CO: Taylor Trade, 2004.

The Dolly Sisters. Directed by Irving Cummings, screenplay by John Francis Larkin and Marian Spitzer, performances by Betty Grable, John Payne, and June Haver. Twentieth Century Fox, 1945.

Ehland, Christoph, and Cornelia Wächter, eds. *Middlebrow and Gender, 1890–1945*. Leiden: Brill Rodopi, 2016.

Fishbein, Leslie. "Anzia Yezierska: The Sweatshop Cinderella and the Invented Life." *Studies in American Jewish Literature* 17 (1998): 137–41.

Gilmore, Leigh. *The #MeToo Effect: What Happens When We Believe Women*. New York: Columbia University Press, 2023.

Golde, Martin. "Gossip and News of Jewish Personalities." *Sentinel*, March 21, 1930.

"Girl Writer Claims Unique Distinction." *Times-Dispatch* (Richmond, VA), February 1, 1925.

Goldman-Price, Irene. "The Perfect Jew and 'The House of Mirth': A Study in Point of View." *Edith Wharton Review* 16, no. 1 (2000): 1–9.

Hamilton, Sharon. "'Intellectual in Its Looser Sense': Reading Mencken's *Smart Set*." In *Middlebrow Literary Cultures: The Battle of the Brows, 1920–1960*, edited by Erica Brown and Mary Grover, 130–47. London: Palgrave Macmillan, 2011.

Hammill, Faye. *Sophistication: A Literary and Cultural History*. Liverpool: Liverpool University Press, 2010.

———. *Women, Celebrity, and Literary Culture between the Wars*. Austin: University of Texas Press, 2007.

Harap, Louis. *The Image of the Jew in American Literature*, 2nd ed. Syracuse, NY: Syracuse University Press, 2003.

Harker, Jaime. *America the Middlebrow: Women's Novels, Progressivism, and Middlebrow Authorship between the Wars*. Amherst: University of Massachusetts Press, 2007.

Harrison-Kahan, Lori. "Ghetto Realism—and Beyond." In *The Oxford Handbook of American Literary Realisms*, edited by Keith Newlin, 200–218. Oxford: Oxford University Press, 2019.

———. "This Is (Not) What a Jewish Feminist Looks Like: San Francisco Women's Clubs and Jewish Literary History." *The HBI Blog*, April 7, 2016. blogs.brandeis.edu/freshideasfromhbi/this-is-not-what-a-jewish-feminist-looks-like-san-francisco-womens-clubs-and-jewish-literary-history/.

Hefner, Brooks E. "'Slipping Back into the Vernacular': Anzia Yezierska's Vernacular Modernism." *MELUS* 36, no. 3 (2011): 187–211.

Hollinger, David A. "Ethnic Diversity, Cosmopolitanism and the Emergence of the American Liberal Intelligentsia." *American Quarterly* 27, no. 2 (1975): 133–51.

Honey, Maureen. "Feminist New Woman Fiction in Periodicals of the 1920s." In Botshon and Goldsmith, *Middlebrow Moderns*, 87–109. Boston: Northeastern University Press, 2003.

Hopper, E. Mason, dir. *Hungry Hearts*. Based on the book by Anzia Yezierska. The Samuel Goldwyn Company, 1922.

Humble, Nicola. *The Feminine Middlebrow Novel, 1920s to 1950s: Class, Domesticity, and Bohemianism*. Oxford: Oxford University Press, 2004.

Hutner, Gordon. *What America Read: Taste, Class, and the Novel, 1920–1960*. Chapel Hill: University of North Carolina Press, 2011.

Johnson, Nunnally. "One Word after Another." *Brooklyn Daily Eagle*, September 22, 1924.

Kirzane, Jessica. "The Melting Plot: Interethnic Romance in Jewish American Fiction in the Early Twentieth Century." PhD diss., Columbia University, 2017.

Keyser, Catherine. *Playing Smart: New York Women Writers and Modern Magazine Culture*. New Brunswick, NJ: Rutgers University Press, 2010.

Knox, Sally. Review of *A Hungry Young Lady* by Marian Spitzer. *Birmingham (MI) Eccentric*, February 27, 1930.

Kramer, Michael. "The Art of Assimilation: Ironies, Ambiguities, Aesthetics." In *Modern Jewish Literatures: Intersections and Boundaries*, edited by Sheila Jelen, Michael Kramer, and Scott Lerner, 303–26. Philadelphia: University of Pennsylvania Press, 2011.

Lant, Antonia, ed., with Ingrid Periz. *Red Velvet Seat: Women's Writings on the First Fifty Years of Cinema*. London: Verso, 2006.

Light, Allison. *Forever England: Femininity, Literature and Conservatism between the Wars*. London: Routledge, 1991.

Luska, Sidney (Henry Harland). *Mrs. Peixada*. New York: Cassell and Company, 1886. Project Gutenberg: https://www.gutenberg.org/files/52702/52702-h/52702-h.htm.

McGraw, Eliza. *Edna Ferber's America*. Baton Rouge: Louisiana State University Press, 2014.

Meade, Marion. *Dorothy Parker: What Fresh Hell Is This?* New York: Penguin, 1989.

Merrill, Flora. "Walter Kingsley, 'King of Broadway' and Godfather to Struggling Actresses," *Brooklyn Daily Eagle*, October 26, 1924.

Michels, Tony. "The Lower East Side Meets Greenwich Village: Immigrant Jews, Yiddish, and the New York Intellectual Scene." In *Choosing Yiddish: New Frontiers of Language and Culture*, edited by Lara Rabinovitch, Shiri Goren, and Hannah S. Pressman, 69–86. Detroit: Wayne State University Press, 2013.

Miller, Nina. *Making Love Modern: The Intimate Worlds of New York's Literary Women*. New York: Oxford University Press, 1999.

Morton, Leah. *I Am a Woman—and a Jew*. New York: J. H. Sears, 1926.

Newman, Louis I. "Those Women Who Would Be Free." *B'nai B'rith Messenger*, December 5, 1924.

"NY Reporter to Talk." *University Daily Kansan*, May 20 1920.

Patterson, Martha H. *Beyond the Gibson Girl: Reimagining the American New Woman, 1895–1915*. Urbana: University of Illinois Press, 2005.

Pearse, Holly A. "But Where Will They Build Their Nest? Liberalism and Communitarian Resistance in American Cinematic Portrayals of Jewish-Gentile Romances." PhD diss., Wilfrid Laurier University, 2010.

Rappaport, Joan Moelis. "Thyra Samter Winslow." *The Shalvi/Hyman Encyclopedia of Jewish Women*. Jewish Women's Archive, December 31, 1999. jwa.org/encyclopedia/article/winslow-thyra-samter.

Rascoe, Burton. "A Bookman's Day Book," *New York Tribune*, June 25, 1922.

———. "Hungry Young Lady Craves Stage Fame in Marian Spitzer's Book." *Times Union* (Brooklyn, NY), March 2, 1930.

"The Reading Lamp." *Times Union* (Brooklyn, NY), October 19, 1924.

Rennels, Mary. "Marian Spitzer Says Her Husband Must Be Good Conversationalist." *Buffalo Sunday Times*, April 22, 1923.

Roesch, Roberta. "Big-Time Writing Stint Books Palace Theatre." *Tyrone (PA) Daily Herald*, August 13, 1969, 12.

Rubin, Joan Shelley. *The Making of Middlebrow Culture*. Chapel Hill: University of North Carolina Press, 2000.

Speed, Melissa. "Harrison Fisher and the American Beauty." Term paper, University of North Texas, 1999. https://freepages.rootsweb.com/~mspeed/misc/fisher.html.

Spitzer, Marian. "The Best Husbands." *Smart Set* 70, no. 4 (April 1923): 87–104.

———. "The Erstwhile Crowning Glory." *Saturday Evening Post*, June 27, 1925.

———. "The Ghetto in a Fine Story." Review of *Haunch, Paunch, and Jowl*. *Brooklyn Daily Eagle*, October 27, 1923.

———. *A Hungry Young Lady*. New York: Horace Liveright, 1930.

———. Spitzer, Marian. *I Took It Lying Down*. New York: Random House, 1951.

———. "Morals in the Two-a-Day." *American Mercury*, September 1924.

———. *The Palace*. New York: Atheneum, 1969.

———. "The Rise and Fall of Florrie Weissman: A Complete Novelette." *Smart Set* 68, no. 3 (July 1922): 5–30.

———. "The Six Greatest Moments." *Smart Set* 68, no. 1 (May 1922): 47–59.

———. "Thicker than Water." *Live Stories* 40, no. 2 (September 28, 1923): 39–54.

---. *Who Would Be Free*. New York: Boni & Liveright, 1924.
Stansell, Christine. *American Moderns: Bohemian New York and the Creation of a New Century*. New York: Henry Holt, 2000.
Summer, Allene. "The Woman's Day." *Selma Times-Journal*, March 16, 1926.
Tanner, Rachel. "Negotiating the Brows: Value, Identity, and the Formation of Middlebrow Culture." PhD diss., University of Oregon, 2020.
Warwick, Diane. "Life and Letters." *Life*, October 16, 1924.
Weaver, Angela. "'Such a Congenial Little Circle': Dorothy Parker and the Early-Twentieth-Century Magazine Market." *Women's Studies Quarterly* 38, no. 3/4 (2010): 25–41. JSTOR. www.jstor.org/stable/20799362.
Welch, Naomi. *The Complete Works of Harrison Fisher, Illustrator*. (La Selva Beach, CA: Images of the Past, 1999).
Williams, Deborah Lindsay. "The Cosmopolitan Regionalism of Zona Gale's Friendship Village." In Botshon and Goldsmith, *Middlebrow Moderns*, 46–63.
Winslow, Thyra Samter. "A Cycle of Manhattan." *Smart Set* 58, no. 3 (March 1919).
Yezierska, Anzia. *Bread Givers*. Garden City, NY: Doubleday, Page, 1925.
---. Yezierska, Anzia. *Hungry Hearts*. Cambridge, Massachussets: The Riverside Press, 1920. Project Gutenberg: https://www.gutenberg.org/ebooks/41232.
---. *Salome of the Tenements*. Urbana: University of Illinois Press, 1995. Originally published 1923.
Zalowitz, Nathaniel. "We Call Them Yahudim; They Call Us Kikes." *Forward*, November 23, 1924, 3 [English supplement].

4

"OYB ME ZUKHT GEFINT MEN"

Translating Yiddish Literature Hiding in Plain Sight[1]

Rachel Rubinstein

"What do we mean," asked Anita Norich in Yiddish in a 2021 talk at the YIVO Institute for Jewish Research, "by *canon*? Who decides? When? With what criteria? . . . What is a *literary tradition*? What is a *history of Yiddish literature*? When does it begin? . . . Who decides, and why, who is the better, or more important, writer?"[2] One might imagine, in a contemporary literary-critical context thoroughly transformed by several decades of revisionist work, that these questions are unnecessary, even old fashioned. That Norich still needs to ask them reveals something about the ongoing assumptions, anxieties, and preoccupations that continue to shape Yiddish literary scholarship.

Indeed, in the summer of 2021, Norich and her YIVO copresenter, Karolina Szymaniak, were participating in a debate rippling across the somewhat rarefied world of Yiddish literary studies, spurred by two lectures by Avrom Novershtern, a senior scholar in the field, on the topic of Yiddish women writers and delivered in Yiddish to the students in YIVO's summer program. Explicitly framing his arguments as "controversial" and intended as an intervention into "feminist" Yiddish scholarship, Novershtern argued broadly that there was no historical discrimination against Yiddish women writers within Yiddish literary culture and that women writers were in fact mentored, celebrated, and published by the male editorial establishment. At the same time, he noted, the expectations of male literary gatekeepers of what Yiddish women's writing ought to look

like shaped women's literary production thematically and stylistically, as women intuited that they were writing for men.[3]

The reaction in the Yiddish world was swift and stern, evidenced by Norich and Szymaniak's lecture, streamed just a few days later, also through YIVO. Novershtern's arguments, assumptions, and exclusions in his lectures—about which writers or genres were important, about what constituted authentic Yiddish writing, and about the broader politics of gender in the early twentieth century—were understood by his interlocutors to be uncritical repetitions of the positions of the male literary establishment that constituted both his subject and his sources rather than women writers themselves. This was particularly surprising and dismaying coming on the heels of such events as a high-profile panel at the December 2020 Association of Jewish Studies conference celebrating twenty-five years since the landmark *Froyen* conference in New York on women in Yiddish culture and the robust number of virtual seminars, lectures, and discussions throughout the spring of 2021 on queerness, feminism, gender, and authorship in Yiddish culture. These events were spurred by the recent publication of a number of feminist translations of Yiddish women authors and works of feminist and queer Yiddish literary scholarship—none of which were cited or acknowledged by Novershtern.[4] Because participants in the YIVO summer program are predominantly students and young scholars entering the field of Yiddish studies, nothing less than the future of Yiddish literary scholarship felt at stake. Indeed, as the participants in the feminist Yiddish podcast *Vaybertaytsh* episode of July 19, 2021 reflected, Novershtern's lectures had to be read as a reaction to and against this palpable turn in Yiddish literary and cultural studies in recent years.[5]

These debates concerning canonicity in Yiddish literature, though they took place almost entirely in Yiddish, are deeply entangled with the task of translation. Indeed, it is notable that Norich and Szymaniak, both practitioners as well as scholars of translation, concluded their lecture with a statement about the conjoined need to search for lost Yiddish women writers and translate them into majority languages, foregrounding the gendered politics still vested in Yiddish translation. After all, as Norich has observed elsewhere, "[f]or most of the late twentieth century, and certainly in our own day, Yiddish texts have unquestionably been more familiar to more people in English translation than in their original. That

fact is not likely to change anytime soon, and it makes translation an increasingly urgent project."[6] But translation, as a Jewish political project, is inherently gendered and historically deeply masculine. As Faith Jones has observed, "[T]ranslation is a Jewish feminist problem." A decade ago, Yiddish women writers were "simply not making it through the semipermeable membrane of language with anything like the frequency of men writers."[7] Now, through the meticulous recovery and reconstruction work by contemporary feminist scholars, a portrait of a robust Yiddish literary landscape is emerging, one in which Yiddish women writers wrote to and about one another, reviewed one another's work, and produced a diverse and innovative body of writing.

In this chapter, I offer a historical overview of literary translation of Yiddish women writers into English in the United States in order to unearth the relationship of this translation history with American and Jewish American canon formation. I then describe the recent wave of feminist literary translations, mostly but not entirely undertaken by women, and the potential of these projects to rewrite Yiddish literary history—a history that has always been unsettled, despite the early efforts of many Yiddish writers to invent and fix a Yiddish literary canon. Through close readings of Jessica Kirzane's translation of Miriam Karpilove's novel *Diary of a Lonely Girl, or The Battle against Free Love* and Anita Norich's translation of Kadya Molodowsky's novel *A Jewish Refugee in New York*, I demonstrate how these recoveries defy the received hierarchies and narratives of genre, geography, and gender and allow critics to write alternative genealogies.

Women in/as Yiddish Literature

Before focusing on the recovery and translation of American Yiddish women writers into English, it is helpful to summarize the ways in which the roles of women as writers and as readers of Yiddish literature were imagined *within* Yiddish literary culture, from its premodern origins through the emergence of modern secular Yiddish literature. These representations established the critical frameworks for gender and women's authorship that exercise powerful authority even today.

Most traditional diasporic Jewish communities were multi- and interlingual, constantly negotiating between Hebrew and Aramaic, the sacred

languages of scripture, prayer, and Talmudic study; a Jewish vernacular or creole language that was reserved for day-to-day internal interactions; and the co-territorial, non-Jewish languages of the populations with whom Jews sustained economic or political relationships. In Europe, Yiddish was adapted from the Middle High German of the communities among whom Jews had settled in the tenth and eleventh centuries, written with Hebrew characters and infused with Hebrew and Aramaic vocabulary, and structurally so absorptive that as Jewish populations migrated across Europe, elements of Slavic languages entered Yiddish as well.[8]

The earliest Yiddish published texts were often translations of Hebrew scripture and popular European romances. Old Yiddish literature included translations of prayer books, translations and adaptations of the Bible, as well as original prayers, *tkhines*, written specifically for women and designed for rituals that were imagined to be their special province. The readers of these texts were often imagined to be women and men "who were like women"—Jews, that is to say, who were not educated in Hebrew.[9] This devotional literature, written in part by women, existed alongside, as Kathryn Hellerstein writes, "a rich and varied body of other writings in Yiddish, including drama, secular and religious epic poems, morality texts, fables, guides to customs and conversations, debates, satires, tales, and travel guides, written and published over four centuries and across a broad geographical area."[10]

The emergence of modern, secular Yiddish and Hebrew literatures in nineteenth-century Europe was predicated, Naomi Seidman has argued, on the gendering of both of these Jewish languages.[11] Yiddish was *mame-loshn* (mother-tongue) and *vayber-taytsh* (wives'-German); Hebrew, in opposition, was constructed as masculine. After all, women only sometimes attended traditional Jewish elementary schools (*kheyder*) and were barred from attending yeshivas, the more rigorous institutes of higher Jewish learning. Women were the imagined consumers of mass Yiddish cultural production, dubbed *shund* (trash). As eighteenth- and nineteenth-century European Jewish communities grappled with modernization and secularization, however, Jewish women of a certain class could and did attend gymnasium, where they learned German, Polish, or Russian and read the great works of European literature. Indeed, many Yiddish women writers, not unlike their male counterparts, began writing in Russian, Polish, or German and only later adopted Yiddish for literary production.[12]

The Haskalah, an internal movement of Jewish reform that was in dialogue with the Enlightenment in the eighteenth and nineteenth centuries, thus variously cast Jewish women as the unenlightened and parochial guardians of antiquated traditions or as "improperly" enlightened, seduced by European libertinism and especially susceptible to conversion.[13] There was no feminine equivalent, in Irena Klepfisz's oft-repeated observation, for a maskil (an adherent of the Haskalah).[14]

Thus, in late nineteenth-century Eastern Europe, anxieties about the feminization of Yiddish—what Seidman and others have termed the "myth of Yiddish femininity"[15]—shaped the emergence of a self-consciously modern Yiddish literary movement. Sholom Aleichem dubbed Mendele Moykher Sforim the "grandfather" of Yiddish literature and himself its "grandson," thus creating a genealogy for modern Yiddish letters that was distinctly patrilineal. While male Yiddish writers, editors, and publishers publicly, if not always privately, encouraged women writers in order to establish their progressive and even radical credentials, they emphasized the "domestic" and "emotional" themes of women's writing in their reviews and other critical assessments. The resulting ambivalent dynamic was, and continues to be, one in which female authorship could be promoted, domesticated, and disciplined all at the same time.[16]

Published in New York, Ezra Korman's 1928 anthology *Yidishe dikhterins: Antologye* (Yiddish women poets: An anthology) was the first, and is still the only, anthology in Yiddish devoted entirely to women writers. Korman collected poems by sixty-nine women poets (and one apparently male writer "masking as a female")[17] published between 1586 and 1927. Korman's three-hundred-page anthology, argues Kathryn Hellerstein, can be read as a response to three earlier anthologies, all edited and published in New York between 1917 and 1920, that featured very few women writers, despite their undeniable presence in the American Yiddish literary world.[18]

Korman's anthology, as Hellerstein observes, was thoroughly annotated and featured substantive biographical and bibliographical sections, informing the recovery efforts of Yiddish literary scholars to this day. His bibliography reveals that women poets were contributing prolifically to periodicals and journals, even as they were less able to publish book collections of their poetry. (This dynamic, as we shall see, was mirrored in prose publication as well.) His correspondence with several authors from

whom he solicited poems reveals the ways in which women poets were self-conscious as women writers and saw themselves as part of a broader, protofeminist network.[19]

Hinde Burstin observes that Korman's anthology in many ways marked the "height" of Yiddish women's poetic publication, emerging in a decade during which a "considerable number" of women poets published collections of their poetry,[20] and Yiddish women's journals were even published in Warsaw and Vilna. Yet surveying the broader landscape of Yiddish publishing, Burstin notes the underrepresentation of women writers in journals and book presses even during this golden age.[21] The wealth of primary and critical source material provided by Korman demonstrates how much has been lost in translation, even as it is clear that Yiddish women writers struggled to achieve representation and equity in the Yiddish presses. The multivolume *Leksikon fun der nayer yidisher literatur* (Lexicon of new Yiddish literature), published in 1956 and edited by Shmuel Charney and Jacob Shatsky, contains entries for more than three hundred women,[22] providing further evidence of how Yiddish women writers across genres worked to overcome the barriers they encountered in the Yiddish publishing world.

Despite the interventionist purpose of Korman's anthology, the arguments that animate his introduction, according to Hellerstein, reproduce many of the assumptions of earlier, male-authored critical efforts to define and delimit women's literary production as devotional, domestic, and peripheral.[23] Shmuel Charney's (pen name Sh. Niger) 1913 essay "Di yidishe literature un di lezerin" (Yiddish literature and the woman reader) and A. Leyeles's 1915 essay "Kultur un di froy" (Culture and woman) are frequently cited as critical touchstones in the history of the reception of Yiddish women writers.[24] Charney's 1913 essay is an ambivalent and contradictory account of modern Yiddish literature's origins in, and necessary rebellion against, the "feminine" devotional literature of old Yiddish. Leyeles's essay, in similarly ambivalent fashion, celebrates the "intuitive," eroticized creativity of women but only insofar as it might energize male writers: "*Woman must be what she is!* Then she will be able to be great, to create a new world for us, and become a blessing for us men."[25]

Hellerstein writes that Korman's anthology ultimately received "more scorn than praise" by Yiddish male critics, who were "unable to accept the possibility that women could hold a legitimate place in a Yiddish poetic

tradition."[26] Indeed, Hellerstein argues that this "serious compilation" failed in its efforts to "make women a major part of Yiddish poetry."[27] But as Norich notes, Yiddish literary critics did return to the question of women writers in the postwar period, at the same time that anthologies of Yiddish literature in English translation were crafting a version of Yiddish literary history that excluded women. For example, volume 29 (1966) of Shmuel Rozhansky's *Musterverk fun der yidisher literatur*, a "monumental project of canon formation," was devoted to "Di froy in der yidisher literatur" (the woman in Yiddish literature) and featured 136 poets, one-third of whom were women.[28] In 1973, Ber Grin published a series of articles in *Yidishe kultur*, titled, like Korman's anthology, "Yidishe dikhterins," which presented biographical and bibliographical information about twenty-four women poets. While on the one hand these publications may be read as corrective, inclusive efforts, on the other they reinforced the focus on Yiddish women writers as poets only and on women's poetry as depoliticized and exclusively focused on the self and therefore, as Irena Klepfisz later observed, outside of history.

The Jewish American Manthology[29]

These early efforts to imagine a Yiddish literary past and present shaped the translation and reception of Yiddish writing in English. While several anthologies, novels, and memoirs in English translation were published in the early twentieth century, arguably the most influential translation event was Irving Howe's and Eliezer Greenberg's *A Treasury of Yiddish Stories*. Published in 1953, the collection was received by a postwar American and American Jewish audience primed to reconsider Yiddish, and the "old world" civilization it represented, in relation to their own contemporary religious and national identities.[30] The immediate postwar period, as Steven Zipperstein has observed, saw a "cascade" of books that "enveloped the Eastern European Jewish past in nostalgic amber."[31] The 1940s and 1950s thus produced Maurice Samuel's *The World of Sholom Aleichem* (1943), Roman Vishniac's book of photography *Polish Jews* (1947), Bella Chagall's translated Yiddish memoir *Burning Lights* (1946), Abraham Joshua Heschel's memoir/elegy *The Earth Is the Lord's* (1950), and Mark Zborowski's ethnography of Eastern European Jewish shtetl life, *Life Is with People*

(1952), which along with Vishniac's photographs, influenced the creators of the Broadway musical *Fiddler on the Roof* (1964).[32]

Howe and Greenberg framed their anthology as a corrective to the "sentimentality" that infused earlier efforts, often produced by, in their understanding, "non-literary" people.[33] With its robust introductory critical-historical essay, the anthology demarcated an arc of Yiddish literary history that begins with what the anthology terms the "Fathers" (the three *klasikers*: Mendele Mocher Sforim, Sholom Aleichem, and I. L. Peretz), continues through the crises of modernity in Europe ("Breakup"), and culminates in the ambivalent and moribund nostalgia of the United States ("New Worlds"). It is "a final tragic irony," the editors write, "that a literature which began with the most fluent intimacy between author and audience should survive as the property of isolated circles of authors and readers, who cling to a language which for them is not only history but the answer to history."[34]

Howe and Greenberg's anthology did not center on American Yiddish writing, to be sure, but it served as the first significant effort in America, in English, to produce a sense of a Yiddish prose tradition and a Yiddish literary "all-but-closed canon" that excluded women completely.[35] A second major postwar Yiddish translation effort was in Joseph Leftwich's 1961 anthology, *The Golden Peacock: A Worldwide Treasury of Yiddish Poetry*, featuring 140 Yiddish poets.[36] Leftwich included twelve women authors: "the largest English representation of Yiddish women's poetry [in an anthology] before or since."[37] But in a volume organized by countries of origin, Leftwich collected these twelve poets into one section of "Women Poets," thus, Klepfisz argues, "wrenching women writers from their roots and from the geography and collective history of Ashkenazi Jews."[38] Klepfisz describes the contradiction that infuses this and subsequent translation and anthologization efforts: "[T]he existence of women writers is acknowledged, while their place *within* Jewish literary history is denied. The women writers are anomalies, the male writers the norm."[39] At the same time, in the 1950s and '60s, anthologies of English-language Jewish American writing consistently underrepresented women writers, a practice that in Wendy Zierler's account reached its "apex" in Meyer Levin and Charles Angoff's thousand-page *The Rise of American Jewish Literature: An Anthology of Selections from the Major Novels* (1970), which did not include a single contribution by a woman.[40]

"The question of what constitutes the Yiddish literary canon—in Yiddish or in English translation—remains no less vexed than the question of the American Jewish or the American literary canon," writes Norich in her essay "The Poetics and Politics of Translation."[41] She states that as Yiddish's "most prolific" translators and anthologizers, Howe and Greenberg "became the standard by which other anthologies are measured."[42] Howe and Greenberg's efforts must be read in the context of a postwar critical canonization project in the newly emergent field of American literary studies that was shaped by Cold War politics. The monumental multivolume *Literary History of the United States* (1948) edited by Robert Ernest Spiller, for instance, established an American canon that featured the relatively new additions of Walt Whitman and Herman Melville but included just one woman, Emily Dickinson, and no writers of color.[43] Early critical texts such as F. O. Matthiessen's *American Renaissance: Art and Expression in the Age of Emerson and Whitman* (1941), Lionel Trilling's *The Liberal Imagination* (1950), and R. W. B. Lewis's *American Adam: Innocence, Tragedy and Tradition in the Nineteenth Century* (1955) contributed to a coalescing sense of a distinctly "American"—that is, white, enterprising, masculine, and Protestant—literary past and present that could be deployed to regulate and subdue radical challenges from within or without the polity. That many of these critical efforts were led by Jewish American male literary scholars, like Lionel Trilling, Daniel Aaron, Harry Levin, and Leo Marx, underscores the ways in which the masculinization of literature and literary studies post–World War II worked for Jewish men as a vehicle of acceptance into American academic and literary culture.[44]

As Dovid Katz observes of the Cold War politics of Yiddish translation, "Yiddish came out of the closet in America just as the McCarthy era was peaking."[45] As a result, the literary activity of radical, "hard left" Yiddish writers, who could be read as "disloyal" or "un-American," posed a challenge to "the entire enterprise of winning acceptability for Yiddish in America."[46] "And so it came to pass," Katz concludes, "that the canon of American Yiddish literature that thrives to this day was a creation, in part, of 1950s American political conformity."[47] And further, Katz argues, this continues to shape the "current situation in Yiddish literary studies, in which the same handful of authors get translated, anthologized, taught at universities, and endlessly analyzed in dissertations and conferences, while many *hundreds* of writers, many of them women, remain untouched and

undiscovered, not in desert papyruses or manuscripts lost in war, but in printed journals and books that are easily found in major Yiddish collections."[48] For decades, observe Allison Schachter and Jordan Finkin, "almost no women writers could penetrate this masculine translation culture."[49]

Howe and Greenberg, as male Jewish postwar critics operating across American and Yiddish literary cultures, thus labored under a double pressure. Yiddish male writers, as we have seen, managed their anxiety about writing in a feminized language through an aggressive containment project that recast gender as a discursive and literary category, so that women writers could be sidelined not for being women but for writing "feminine" and therefore minor literature. Jewish American male writers, confronted with a Euro-American culture that feminized and racialized Jewish men, in turn grappled with their own anxieties and desires about masculinity, whiteness, and Americanness in large part by refashioning Jewish literary history as a masculine tradition.[50] Thus, the marginalization of Yiddish women writers in and through English translation was reinforced by the earliest literary critical efforts in English to describe American Yiddish literary history.

The literary scholarship of Howe, Greenberg, Leftwich, and others naturalized and enshrined intertwined hierarchies of genre and gender, mirroring trends in postwar American literary criticism that, for instance, elevated Emily Dickinson as an exceptional and singular woman poet while obscuring women who wrote popular prose fiction. Howe and Greenberg established in their *Treasury* what then became the ascendant narrative: while "important Yiddish novelists such as Asch, Singer, Opatoshu, and Schneour have spent part of their time in America, it is in poetry that recent Yiddish literature in America has excelled."[51] Howe was also instrumental in promoting the narrative of Yiddish poetic "generations," adopted from Sholem Aleichem's grandfather/grandson metaphor of Yiddish literary origins and transposed to America. Howe and Greenberg outline an exclusively male generational development of Yiddish poetry from poets focused on the plight of the worker (Morris Rosenfeld), to those experimenting thematically with Jewishness and "the personal" (Yehoash), to the first modernists in *Di yunge* (Halpern, Mani Leib, Leivick), and finally to the Introspectivists in the 1920s (Glatshteyn, Leyeles, and Minkoff) and a new "proletarian tendency" in the 1930s. After this, the editors imply, the poetic Yiddish tradition dies in America.

Howe elaborates and expands on his generational narrative in his 1976 history *World of Our Fathers*, in which he names these poetic generations: "Sweatshop Writers," "Poets of Yiddishkeit," "Di Yunge," "In Zikh," and "Khurbn." Revisiting his earlier evaluation of American Yiddish fiction, Howe argues that Yiddish prose fiction in America comes "into its own after the First World War," with a "generation" of novelists "remarkable for its sheer energy, and for its readiness to expend that energy in a passionate struggle with the tradition that had formed it."[52] Howe's narrative repeats the Haskalah trajectory of Europeanization and modernization centering men's experiences. This "energy," exemplified for Howe by Asch, I. J. Singer, Schneour, and Opatoshu, introduced a "wider range" of subject matter into Yiddish prose fiction, including urban life, the underworld, and the erotic. Finally, he takes the "generation" of Yiddish post-Holocaust writers to be exemplified by Glatshteyn and Isaac Bashevis Singer, the former a poet "hardly known outside the Yiddish perimeter," and the latter the "one living Yiddish writer whose work caught the imagination of the American literary public."[53]

As one might infer from Howe's title, his account of Yiddish generations in America is strongly patriarchal and features only one woman writer: Kadya Molodowsky, a *khurbn* poet whose poem "God of Mercy" Howe briefly quotes, thus reinforcing the association Charney, Glantz, Leyeles, and Korman make between women and the devotional tradition.[54] The valorization of American Yiddish poetry over prose and the naturalization of the "generational" narrative have been repeated through multiple critical accounts in English of American Yiddish literary history,[55] most lately in Avrom Novershtern's essay "Yiddish American Poetry" in *The Cambridge History of Jewish American Literature*.[56] Novershtern describes the "continuity" of American Yiddish poetry as each of its "four to five generations" self-consciously built on or challenged its predecessor. Novershtern posits that the disorientation brought on by mass migration, modernization, and an American discourse of individualism "all conspired to give poetry a primary role in American Yiddish literature." On the other hand, American Yiddish prose, he writes, was more "conservative" and had to appeal to the mass readership of the popular press, unlike Yiddish poetry, whose readership was more "elitist." Novershtern thus tacitly invokes the postwar Americanist, gendered association among popular prose, "common" readership, and feminization.[57]

Translation's New Wave

Since popular prose fiction was not considered worthy of translation, Rosemary Horowitz observes that "until 1980, readers of English-language anthologies of Yiddish language translations might have concluded that the alignment between Yiddish women and poetry was unassailable and that women only wrote poems."[58] Judging from English translations of Yiddish from the 1950s through the 1980s and the critical assessments that accompanied them, one might conclude that Yiddish women authors in the United States wrote some poetry, albeit outside of the major movements, even less prose fiction, and were totally absent as editors or as authors of memoir, essays, and literary criticism. It is therefore unsurprising that initial efforts to recover and translate Yiddish women writers focused on poetry, with book-length English translations of Rokhl Korn, Malka Heifetz Tussman, and Rukhl Fishman emerging in the 1980s and early 1990s. These decades witnessed improved representation of women poets in translated anthologies, culminating in the important collection *Norton Anthology of Jewish American Literature* (2001).[59]

The 1990s thus marked a shift in the politics of translation, as the project of translating Yiddish women writers converged with the ascendance of feminist and Jewish feminist literary scholarship.[60] With the creation of such alternative presses as Second Story Press, the Feminist Press, and Exile Editions and the Jewish feminist journal *Bridges*, there was also an expanding marketplace for such translation efforts. *Found Treasures: Stories by Yiddish Women Writers* (1994) was a significant event in introducing English readers to such writers as Lili Berger, Rokhl Brokhes, Shira Gorshman, Sarah Hamer-Jacklyn, Blume Lempl, Ida Maze, Rikudah Potash, Miriam Raskin, Yente Serdatsky, and Chava Rosenfarb. It also featured prose by writers who had previously been translated only as poets: Celia Dropkin, Rokhl Korn, Kadya Molodowsky, and Fradl Shtok. Over the next decades, two more prose anthologies followed: *Arguing with the Storm: Stories by Yiddish Women Writers* (2007) and *The Exile Book of Yiddish Women Writers* (2013). Book-length translations of poets Kadya Molodowsky, Anna Margolin, and Celia Dropkin emerged as well.[61]

Now, translations and critical reevaluations of Yiddish women writers are accelerating with astonishing intensity, contributing to a sense among translators and scholars of these texts that we are in a new and remarkable

moment. Madeline Cohen, scholar and director of Translation and Collection Initiatives at the Yiddish Book Center, notes that in the last decade, there have been at least ten volumes of work by Yiddish women writers published in English, nine of which have appeared in just the last seven years.[62] Challenging received notions of period, geography, genre and theme, she writes, these translations "offer English readers a rich sampling of writing that stretches from the 17th century to the 21st, following Yiddish from its origins in Germany to its heartlands in Eastern Europe, then into exile in Siberia, and, finally, to its refuges in Israel, Canada, and the United States."

What is more, Cohen notes the translations' implicit challenges to the reflexive association of Yiddish women writers with poetry and the personal: "The works are essays, memoir, short stories, and serialized novels. Each in various ways foregrounds women's experience, often explicitly. But just as often the fact of the woman author recedes as the writing explores the experiences of war, survival, immigration, and generational conflict in ways that speak across the centuries, across nation, and beyond gender."[63]

Yiddish prose fiction, especially the novel, had been imagined by the aforementioned male critics—and even by many women scholars—to be the province of male writers. As Anita Norich, now deeply engaged in the work of unearthing and translating "scores" of novels by Yiddish women, recollects, "I had read and heard and, I am now embarrassed to say, once accepted the 'fact' that women wrote poetry in Yiddish, and some wrote short stories, but very few wrote novels. And if they did write novels, they were about domestic life, or they were autobiographical."[64] The latest wave of feminist translation explicitly contests this assumption. There is a difference, observes Faith Jones, between the *inclusion* of women's literary production in accounts or anthologies of Yiddish literature, and the *centering* of women.[65] The recentering of women's Yiddish literary production in the US context reveals that the model of poetic "generations" is a fiction that does not account for the long and varied careers of American Yiddish women poets or that women wrote American Yiddish prose that was diverse and wide ranging in its genres, themes, and subject matter.

This explosion of new translations is attributable to two institutional developments in the mid-2010s: first, the launch of the Yiddish Book Center's Translation Fellowship in 2013 and, in 2015, the launch of *In geveb: A*

Journal of Yiddish Studies, a dynamic and multimedia online Yiddish scholarly journal that aimed, in the words of its founding editors, to present "the diversity of what Yiddish Studies might be."[66] Cohen, who currently directs the Yiddish Book Center's Translation Fellowship, is a former editor of *In geveb* and the current president of its board of directors. Kirzane, the current editor in chief of *In geveb*, was a translation fellow, as were Cassedy, Taub, Finkin, and Schachter. The Yiddish Book Center's translation fellowship has incubated an extraordinary number of new Yiddish translations: nineteen in the last five years, reflecting the center's new focus on digitizing Yiddish texts and making them broadly available to an English-reading public.[67]

In geveb, in turn, has published translation excerpts and reviews of new translations by Yiddish women authors alongside Yiddish literary and cultural scholarship that foregrounds not only gender but also race, class, and geography in its efforts to "catalyze" the "next generation of Yiddish scholarship" through rereadings of the Yiddish past.[68] Just as Howe and others absorbed and mirrored the masculine, nationalist critical project of postwar American studies, so too does *In geveb* respond to the latest academic and cultural shifts and expansions that bring Yiddish studies into dialogue with race and ethnic studies, queer studies, gender and sexuality studies, postcolonial and decolonial studies, producing new, intersectional critical approaches.

New York Lonely Girls

I turn now to two texts of feminist recuperative translation mediated and facilitated by these institutional transformations: Jessica Kirzane's translation of Miriam Karpilove's *Diary of a Lonely Girl, or The Battle against Free Love* and Anita Norich's translation of Kadya Molodowsky's *A Jewish Refugee in New York*. Both were the results of extraordinary detective work, and both offer the opportunity to reflect on how the recovery of these texts and their availability to an English-reading audience alters the landscape of American, Yiddish, and American Jewish literary history.[69]

Both *Tage-bukh fun an elende meydel* (1918), translated by Jessica Kirzane as *Diary of a Lonely Girl*, and *Fun Lublin biz Nyu-York* (1942), translated by Anita Norich as *A Jewish Refugee in New York: Rivke Zilberg's Journal*, are epistolary novels masquerading as diaries that describe the

dislocation and struggle of young immigrant women alone in New York. Formally, both engage with a Yiddish literary tradition of women's life-writing that begins with Glikl of Hameln's memoirs, titled *Zikhroynes*, first published in Yiddish in 1896 by David Kaufman after having been preserved in manuscript form by Glikl's descendants.[70] Yet even as Karpilove's and Molodowsky's fictional diaries invoke Glikl, they can also be read as defiant and satirical challenges to the expectation that Yiddish-speaking women only wrote autobiographically.

Glikl's memoirs were introduced to non-Yiddish readers in 1910 with their translation into German by Glikl's descendant Bertha Pappenheim, well known as an Austrian Jewish feminist but also as the patient "Anna O." in Freud's and Breuer's case studies of hysteria in the late nineteenth century. Not unlike Anna O., the narrators of both novels are limited in the ways they are permitted to assert anger or agency within highly regulated class and gender roles. The narrators describe being silent and compliant in public but "privately" confess their inner turmoil and social alienation to their diaries, and in doing so offer sharp critiques of American and American Jewish culture in gendered terms. Like many Yiddish novels authored by women, both novels were serialized in the Yiddish press, though unlike many of these forgotten works, both were published in book form after their serialization. They were nevertheless still lost to literary history until their recent reclamation and translation.

Kirzane recounts in her introduction how she accidentally encountered the novel in the course of her doctoral dissertation research, when she typed the phrase *fraye libe* (free love) into the Yiddish Book Center's digital archives search engine.[71] As she discovered, Miriam Karpilove was one of the few Yiddish women writers in the United States in the early part of the century to make a living from her writing, albeit a precarious one. Karpilove was well known in the Yiddish press, a prolific author of plays, novels, short stories, and belletristic fiction. She also served as a staff writer at the *Forverts*. Yet her work has not been collected or translated until very recently, and there is much work that remains to be done.[72]

Serialized in 1916–18 and published in book form in 1918, Karpilove's novel is, all at once, a sophisticated critique of the politics of gender relations, a parody of male critics' expectations of women's writing, and a challenge to twenty-first-century readers' expectations of immigrant Jewish fiction. Alongside the Yiddish feminine diaristic tradition of Glikl,

the novel also mimics the Western literary conventions of the epistolary novel, including the use of diary entries to improbably record events as they are happening. Through her multilingual, sophisticated, and well-educated narrator, Karpilove invokes Nietzsche, Goethe, Jack London, and other canonical Western intertexts. In one prescient scene, the narrator even seems to comment on the future of Yiddish literary translation, as she reads Tolstoy's *War and Peace* at the public library, because "I'd read it long ago in Russian and I wanted to know how it sounded in English translation" (122).

The novel chronicles a young, immigrant, working-class, single Jewish woman's travails in New York as she is courted by a series of men who attempt to seduce her in the name of political idealism—that is, free love. "His method of convincing me to live," writes the narrator of one typical exchange, "was propagandizing to me about free love. It is necessary to love freely, he explained, supporting his argument with facts from life. He claimed that everything he said was theoretically grounded and factually supported. Only a great ignoramus could disparage or deny the facts he'd collected" (189). Called A., B., C., D., and E. (thus highlighting their "interchangeability," as Faith Jones observes in her review of the translated novel),[73] these suitors' verbose, self-aggrandizing mansplaining and gaslighting[74] is met with our clever narrator's drily comical "economy of words,"[75] a verbal parrying that nevertheless reveals the undertow of corporeal danger, precarity, and threat that meet the protagonist's efforts at economic and social independence. As Kirzane notes in her introduction, although the novel "rarely directly mentions the war, Karpilove fills her discussion of love with metaphors of war, insisting on the urgency and relevance of women's disempowerment in sexual relationships, even in a time when men are dying by the thousands on battlefields."[76] Kirzane's translation, attentive to the political dimensions of Karpilove's linguistic choices, recovers and conveys the critical and satirical energy of Karpilove's text, which she reads as in dialogue with such English-language writers as Edna Ferber, Dorothy Parker, and Anzia Yezierska, who "lodged similar complaints about the unstable and vulnerable place of women in the changing sexual norms of urban American life."[77]

Yiddish literary critics emphasized the domestic, devotional, romantic, and erotic themes of women's literary production; therefore this is the novel's self-conscious, ironic, and relentless focus, its action unfolding

almost exclusively in the narrator's small rented room as she fends off, sometimes physically, the advances of her suitors. To these men, as well as to a series of intrusive landladies, the narrator sometimes strategically justifies her resistance to free love as a vestige of her traditional upbringing. Indeed, in one mournful passage the narrator longs for the *shabes* of her childhood: "How beautifully we would welcome *shabes*! My strict father would become gentle as *shabes* approached. My quiet mother would grow calm and soulful. Everyone in our house looked refreshed, especially my *bobe*, my grandmother . . . *Shabes*—that was the loveliest, best, greatest, most beloved day of the week!" (37–38). Her nostalgia is fueled by grief and loss: "My *zeyde* is no more, my *bobe* is no more. My parents are somewhere far away, old and weak, and my sisters and brothers are scattered far and wide. The Friday evening joy no longer exists, all that remains is the loneliness and sadness of *shabes* night" (39). Later, when she lies to suitor E. that she is the "orthodox" daughter of "freethinking" parents, he responds: "How remarkable! How wonderful! This must be your grandfather's doing?" She corrects him: "It is because of my grandmother, my *bobe*" (290). The Yiddish feminine devotional tradition, in the hands of Karpilove, is reclaimed as a gesture of resistance.

But the narrator cannot escape the oppressive weight of the patriarchy, as imagined in one strikingly violent scene: "I felt C's hand pressing down on me, though he wasn't there. It was pushing me down to the ground. It was trying to force me to debase myself. To fulfill the desires of a man I don't love, who only loves me as much as his economic, ethical, psychological, and physical ideologies dictate. I'm nothing more to him than a thing to spend time with" (193). It is difficult not to read the imagined weight of C's hand pushing down on the narrator, his objectification of her, and her debasement, as a metaphor for Karpilove's struggles as a professional writer in a masculine industry.

"This is America," characters in the novel periodically declare, which serves as a shorthand that equates "America" with profit-minded self-interest and the free market (108). We know nothing of where the narrator works, why or when she arrived in America, or what has become of her parents and siblings.[78] The one genuine relationship in the narrator's life is with her friend Rae, who often sleeps over in her room and who in the novel's conclusion the narrator joins to move together to a new city to "live like sisters," and "start a new life . . . so much better than our life

here" (303). In its final chapter, *Diary of a Lonely Girl* valorizes the found family networks usually imagined as the province of queer literature. In its circumvention of the marriage plot, as Jones notes, the "aggressive straightness" of the novel in fact gives way to "transgressive gender and sexual nonconformity."[79] *Diary of a Lonely Girl* thus challenges contemporary American readers' expectations of pre–World War II Jewish immigrant fiction, often imagined as a narrative of urban labor, upward mobility and secularization, and finally triumphant Americanization, which for female protagonists is often achieved through a successful marriage. In the *Diary*'s expanded notions of self, Jewishness, womanhood, and sexuality, what Karpilove offers her readers is in fact a deeply political and philosophical novel of ideas, masquerading as the kind of "women's fiction" that male editors imagined sold papers.

Kadya Molodowsky, unlike Miriam Karpilove, was one of the few Yiddish women writers to penetrate Jewish American translation culture, thanks in large part to Howe's translation and inclusion of her 1944 poem "El Khanun" ("God of Mercy") in both his anthology *Treasury of Yiddish Poetry* (1969), coedited with Greenberg, and in his discussion of the *khurbn* poetic "generation" in *World of Our Fathers* (1976). Molodowsky began her prolific literary career in Warsaw in the 1920s, and she immigrated to the United States in 1935, where her husband joined her shortly thereafter. She is, as Norich notes in her introduction, probably the best-known woman writer in Yiddish literature.[80] But it wasn't until 1999 that a book-length collection of her poetry, translated and edited by Kathryn Hellerstein, was published, and her considerable body of prose work has yet to be thoroughly mined. In the course of her research, Norich discovered two more novels by Molodowsky that were serialized in the Yiddish press but never published in book form.[81] Moreover, while Molodowsky was also well known in Yiddish as a playwright, her plays have yet to be translated and a critical evaluation of her theatrical work—not to mention her legacy as an editor and essayist—has only just begun.[82]

Norich's translation of Kadya Molodowsky's *Fun Lublin biz Nyu-York*, serialized in 1941 and published as a book in 1942, emerges from her broader project of excavation and translation of lost Yiddish prose fiction by women. Currently, Norich is working on translating a novel, serialized in the *Forverts* in 1934, by Celia Dropkin, another woman writer primarily known as a Yiddish poet. This literature has been "hiding in plain sight,"

according to Norich. "If you've always heard that women didn't write novels in Yiddish, why go looking for it?"[83]

Like *Diary of a Lonely Girl*, *A Jewish Refugee in New York* takes place as war rages across Europe. As we learn in the first chapter or diary entry, dated December 15, 1939, Rivke arrives in New York grieving her dead mother and unsure of the fates of her father, brothers, boyfriend, or home in Lublin. She is taken in by her mother's sister and her family, but her relationship with her cousins is vexed by a language barrier and by jealousy, when her cousin's boyfriend and then his friend both pursue her. The older generation nostalgically share their own stories of migration, refusing to recognize that Rivke is not an immigrant but a refugee, a word that Rivke herself pauses to consider in one of the novel's most remarked-on passages: "What a horrible word: refugee. The word is a curse. It probably comes from refuse, garbage. A refugee is truly cursed, discarded, and worthless."[84]

English in the Yiddish novel is rendered as transliterated and untranslated; in Norich's translation, she presents these English phrases in dialect, such as *gud bay un gud luk* (81), defamiliarizing the language so that English readers stumble through it in much the same way Rivke herself does:

> Selma said something in English, and Eddie threw in something too. All I could make out was *hyuman, hyumanitee*. Somebody said something about the *bend*. I saw that Selma was becoming furious and again talked about *human* and *humanity*. I had no idea that they were arguing because of me, but still, the whole thing made me very sad. Later, Mrs. Shore said, "Rivke, you know, Eddie was mad at Selma because she hadn't wanted to take you along to hear the band, and it was only because Red came that you were able to go. He said that there's a bit of Haman in everybody, and that's why there are Hamans all over the world." (64)

Rivke's limited ability to understand English ends up revealing another level of meaning to a trivial exchange about who can and cannot join the outing to a musical concert, which evolves into a conversation about humanity's capacity for evil, referenced through the character of Haman from the biblical book of Esther who, like the novel's present-day Hitler, plots the destruction of the Jews.

In their continual minimization of the war, as suggested in the passage above, the Americanized and American-born Jews of the novel are the targets of Molodowsky's most trenchant satire. The older characters sentimentalize the "old country" and the younger characters reject it entirely; all are enchanted with an empty American material culture and cannot fully comprehend the tragedy unfolding in Europe. Eventually, Rivke is forced to move out of her aunt's home, and she finds work in the needle trades as she studies and becomes more proficient in English. One of her suitors, "Red," is successful in his overtures and the novel ends as Rivke, now known as "Ray," is engaged. But in this ironic variant of the archetypal Jewish immigrant story, Rivke/Ray's Americanizing trajectory is complicated by the war in Europe and the scattering of her Lublin friends and family. Unlike *Diary of a Lonely Girl*, *A Jewish Refugee in New York* ends ambivalently with an impending heteronormative marriage that marks the narrator's dissolution of self. At the novel's end, Rivke/Ray no longer quite knows who she is:

> Red is very good to me. He doesn't let me worry about anything. "Don't think so much," he says. I wear the engagement ring, and I think that Rivke Zilberg no longer exists. In New York, someone named Ray Levitt will soon be walking around. Rivke Zilberg remained in Lublin. Someone in Palestine is waiting for Rivke Zilberg. And Ray Levitt lives in New York.
>
> Can it be that everyone in the world lives like this? Who knows? (172)

As I have written elsewhere, Rivke/Ray's embattled identity reflects the novel's major preoccupation with language, and specifically the transition from Yiddish to English.[85] The complex ways in which these linguistic shifts are represented in the Yiddish text and in Norich's translation can in fact be read as broadly symbolic of the silencing of Yiddish American women writers in the postwar passage from Yiddish literary production to English translation by a male-dominated publishing and translation industry. Rather than gaining another voice via English, Rivke Zilberg loses her original tongue, unable to express her grief and rage in the face of Red's American innocence and ignorance, which is as oppressive as C's hand pressing down on Karpilove's narrator.

Despite their chronological distance from each other and from us, both novels represent the gendered dynamics of silencing and suppression across Yiddish, Jewish American, and American literary cultures. But their narrators' anger, confessed to their "diaries"—a form of sanctioned women's writing—anticipates the defiant energy propelling an ever-increasing number of translations challenging long-held notions of genre and gender, and prompting scholarly reevaluations of normative Jewish and Jewish American literary history. After all, as Alison Schachter writes, we "cannot simply recover [women writers'] voices and imagine that those narratives [of Jewish minority life] will change." The project of translation is not "additive" but "generative," and should "reorient the very grounds of our understanding of modernity."[86]

Scholars and translators Allison Schachter and Zohar Weiman-Kelman offer recent examples of the alternative literary genealogies made possible by centering women's writing via translation. In *Queer Expectations: A Genealogy of Jewish Women's Poetry*, Weiman-Kelman contends that in order to become writers, Jewish women have had to "undo" the social imperatives that delimited their roles, as well as the "normative history structured by that imperative." This "undoing," in turn, demands a "reclaiming and inventing" of new histories, and the "generating" of "alternative modes of queer history and temporality alike."[87] Queer history, Weiman-Kelman explains, disrupts and undermines notions of history as linear, teleological, and progressive, exposing the constructedness of historical narratives taken as natural or inevitable. Thus, through drawing together English, Hebrew, and Yiddish-language poets Adrienne Rich, Kadya Molodowsky, Emma Lazarus, Leah Goldberg, Anna Margolin, and Irena Klepfisz in poetic dialogue across language, time, and space, Weiman-Kelman exposes heretofore unacknowledged and unseen genealogies of influence, repetition, and conversation.

Schachter's study of the Yiddish, Hebrew, and English prose fiction of Fradl Shtok, Dvora Baron, Leah Goldberg, Elisheva Bikhovksy, Debora Vogel, and Grace Paley similarly challenges received models of Jewish history through a recentering of literary modernity on women's writing and women's experiences, which were shaped by distinct familial, social, political, economic, and educational forces. For example, Schachter notes, Jewish women did not generally experience the secularizing journey 'from the study house to the coffee house,' a masculine experience that has often

168 Rachel Rubinstein

shaped scholarly accounts of Jewish modernity.[88] Throughout her study, Schachter powerfully demonstrates how to "rewrite the narratives of Jewish modernity from [women's] perspectives and rethink modern Jewish experience through their eyes,"[89] a project made possible by the increasing accessibility of their work in translation. Yiddish and Jewish American literary histories that do not recognize the gendered dimensions of Jewish and American experience, and therefore the "radical new Jewish literary forms" and "feminist and democratic aesthetic"[90] produced by Jewish women authors are thus by definition incomplete histories. Feminist scholars and translators have been arguing this for decades, but in the overwhelming face of a rapidly accumulating body of translation and recovered works, such blind spots have become indefensible. The wave has become a surge: churning, furious, scrupulously researched, and with unimpeachable footnotes.

Notes

I am grateful to Jessica Kirzane, Madeline Cohen, Anita Norich, and Faith Jones for illuminating conversations and suggestions for this chapter, the editors of this volume for their thoughtful and thorough readings of earlier drafts, and for all the scholars who have been working in this field for decades, on whose shoulders we stand.

1. A Yiddish translation of the biblical aphorism "seek and ye shall find," this line was delivered by Anita Norich in her YIVO remarks about recovering Yiddish literature by women, reimagined and represented visually by graduate student Alona Bach as a needlepoint and shared with the author by Jessica Kirzane.
2. "Women Writers in Yiddish Literature with Anita Norich and Karolina Szymaniak (in Yiddish)" YIVO Institute for Jewish Research, Yiddish Civilization Lecture Series, YouTube, July 22, 2021, www.youtube.com/watch?v=p2p_gt0EBIQ; author's translation.
3. Avrom Novershtern, "Yiddish Women Writers (Part 1)," YIVO Institute for Jewish Research Yiddish Civilization Lecture Series, YouTube, July 12, 2021, www.youtube.com/watch?v=3wl81swZO2A; and "Yiddish Women Writers (Part 2)," YIVO Institute for Jewish Research Yiddish Civilization Lecture Series, YouTube, July 19, 2021, www.youtube.com/watch?v=66iydt6dzg0. To be sure, the continuing reverberations of Novershtern's

lectures could not have been possible without the digital presence of Zoomed—live-streamed and recorded—YouTube-posted scholarly events characteristic of academic life in the pandemic age. Norich and Szymaniak do not mention Novershtern by name but systematically dismantle each of his arguments, often using the same textual evidence.

4 Such events included "Why We Translate Women Writers," a panel featuring Anita Norich, Ellen Cassedy, and Jessica Kirzane, moderated by Madeline Cohen (43rd Annual Conference of the American Literary Translators Association, virtual, October 13, 2020); the celebratory panel "'*Froyen*: Women and Yiddish,' 25+ Years since the Landmark Conference," featuring Sandra Chiritescu, Irena Klepfisz, Anita Norich, Eve Jochnowitz, and Agnieszka Legutko (Association for Jewish Studies Conference, Chicago, December 19, 2020); a Yiddish Book center virtual event with Faith Jones, "Bringing to Light Yiddish Women Writers" (March 25, 2021); and a lecture series featuring Anita Norich in conversation with Jessica Kirzane at the University of Chicago titled "Women Writing in Yiddish: Gender, Politics, Recovery, and Translation" (April 22 and 23, 2021). Also see the Yiddish Book Center's repository of resources, www.yiddishbookcenter.org/language-literature-culture/yiddish-literature/celebrating-yiddish-women-writers, as well as the New York Public Library's August 2020 article and resource page, www.nypl.org/blog/2020/08/17/other-words-yiddish-women-translation-month.

5 *Vaybertaytsh*, episode 54, hosted by Sosye (Sandra) Fox and featuring Faith Jones, Jessica Kirzane, and Ayelet Brinn, July 19, 2021, www.vaybertaytsh.com/episodes/2021/7/18/episode-54-re-yiddish-women-writers-hjhes.

6 Anita Norich, *Writing in Tongues: Translating Yiddish in the Twentieth Century* (Seattle: University of Washington Press), 5.

7 Faith Jones, "The Bridge of Translation," *Bridges: A Jewish Feminist Journal* 14, no. 2 (Autumn 2009): 1.

8 For a foundational cultural and linguistic history of Yiddish that explains this "polylinguistic system," see Benjamin Harshav, *The Meaning of Yiddish* (Stanford, CA: Stanford University Press), 1999.

9 Naomi Seidman describes the "common" dedication page in premodern literature to "women and uneducated men," quoting Moses Altshuler's introduction to *Brantshpigl* (Burning mirror), a 1596 homiletic work: "The book was written in Yiddish for women and men who are like women in not being able to learn much." Seidman, *A Marriage Made in Heaven: The Sexual Politics of Hebrew and Yiddish* (Berkeley: University of California Press, 1997), 16.

10 Kathryn Hellerstein, *A Question of Tradition: Women Poets in Yiddish, 1586–1987* (Stanford, CA: Stanford University Press, 2014), 45.
11 Seidman, *Marriage Made in Heaven*.
12 One point of feminist reinterpretation is that whereas the Yiddishist old guard considered Jewish women's secular education evidence that they were not really writing within an authentically Yiddish tradition, feminist scholars contend that this alternative linguistic context broadened and innovated Yiddish literary discourse. Also see Irena Klepfisz, "Queens of Contradiction: A Feminist Introduction to Yiddish Women Writers," in *Found Treasures: Stories by Yiddish Women Writers*, ed. Frieda Forman, Ethel Raicus, Sarah Silberstein Swartz, and Margie Wolfe (Toronto: Second Story Press, 1994), 45.
13 For an example of this dynamic, see, for instance, Aaron Halle Wolfssohn's 1796 play *Laykhtsin und fremelay* (Silliness and sanctimony), a maskilic Yiddish rewriting of *Tartuffe* in which, as Nancy Sinkoff writes, Jewish women "are the leading culprits in a headlong rush into excessive and ruinous modernization" (Sinkoff, "The World of Sara Levy," Digital Yiddish Theatre Project, April 2019, https://web.uwm.edu/yiddish-stage/saralevy).
14 Klepfisz, "Queens of Contradiction," 49.
15 Seidman, *Marriage Made in Heaven*, 5–6.
16 For an elegant and succinct account of this dynamic, also see Justin Cammy's introduction to *The Canvas and Other Stories*, by Salomea Perl, trans. Ruth Murphy (Teaneck, NJ: Ben Yehuda Press, 2021), xi–xxiii.
17 Hinda Ena Burstin, "Still Waiting for Tomorrow: Lily Bes and Her Contemporaries in the 1920s," in *Women Writers of Yiddish Literature: Critical Essays*, ed. Rosemary Horowitz (Jefferson, NC: McFarland, 2015), 30.
18 Morris Bassin's *Antologye: Finf hundert yor yidishe poezye* (500 years of Yiddish poetry), published in New York in 1917, included only eight women poets out of ninety-five contributors. Zishe Landau's *Antologye di yidishe dikhtung in amerike biz yor 1919* (Anthology: Yiddish poetry in America until the year 1919), published in New York in 1919, included only three poems by two women, totaling 3 of the 172 pages in the collection. Finally, in 1920, Yankev Glatshteyn, A. Leyeles, and Nokhem-Borekh Minkoff, three poets affiliated with New York's "Inzikh" modernist movement, published *In zikh: A zamlung introspective lider* (In the self: A collection of introspectivist poems), which featured no women at all, though poet Celia Dropkin was a known affiliate of the group and was the only woman to publish in their journal. See Hellerstein, *Question of Tradition*, 15–18. For Hellerstein's discussion of Korman's anthology and its formative effect on

Yiddish literary history, see the chapter titled "The Idea of Literary Tradition," 15–42.

19 Korman describes manuscripts and works in progress that have informed contemporary recovery efforts; he cites, for instance, completed manuscripts by Miriam Ulinover and Rosa Yakubovitsh that were never published. They then vanished during the Nazi occupation of Poland. See Hellerstein, 21, and "Appendix: Letters from Women Poets to Ezra Korman, 1926–27," 401–7.

20 These poets included Leah Hoffman, Miriam Ulinover, Anna Bloch, Ida Glasser-Andrews, Khane Leye Kheydanski, Yudika, Sarah Reisen, Rosa Yakubivitsh, Rosa Gutman, Rashel Veprinski, Pesi Hershfeld, Kadya Molodowsky, Khane Vurtsel, Rokhl Korn, and Esther Segal. Burstin, "Still Waiting for Tomorrow," 30. Of these, arguably only Miriam Ulinover, Kadya Molodowky, and Rokhl Korn are well known via English translation.

21 In 1927, for instance, of the 77 books published by the *Kletskin Farlag*, only one was by a woman, Kadya Molodowky's poetry collection *Kheshvandike nekht* (Kheshvan nights). In 1928, *Literarishe bleter*, the most prestigious literary journal of its day, published sixty pages of poetry; only nine pages "contained *some* writing by a woman." Burstin, 30–31.

22 Sh. Niger [Shmuel Charney] and Jacob Shatsky, eds. *Leksikon fun der nayer yidisher literatur* (New York: Alveltlekhn yidishn kultur-kongres, 1956).

23 See Hellerstein, *Question of Tradition*, 22.

24 Sh. Niger [Shmuel Charney], "Di yidishe literatur un di lezerin" (Vilna: Drukeray vilner farlag, 1919); and A. Glantz (A. Leyeles), "Kultur un di froy," *Di fraye arbiter shtime*, October 30, 1915, 4–5.

25 Cited and translated by Hellerstein, *Question of Tradition*, 30. She also notes Leyeles's hypocrisy: "When he actually encountered them, Glanz famously discouraged the original contributions of women, as suggested by his harsh review in *Der tog* of Fradl Shtok's 1919 volume of short stories. The review, all but silenced her" (31).

26 Hellerstein, 33 and 41.

27 Hellerstein, 41.

28 Anita Norich, Introduction to *A Jewish Refugee in New York: Rivke Zilberg's Journal*, by Kadya Molodowsky, trans. Anita Norich (Bloomington: Indiana University Press, 2019), xxiin19.

29 "Manthology" was a term coined by Jewish feminist scholar Mara Benjamin to describe collections that actively or passively exclude women contributors. See her blog post for *Feminist Studies in Religion*, "On the Uses of Academic Privilege (@theTable: 'Manthologies')," www.fsrinc.org/on-the-uses-of-academic-privilege-thetable-manthologies/.

30 In the 1920s, for example, Isaac Goldberg introduced many Yiddish texts in translation through the inexpensive Little Blue Book publishing series. Leo Schwarz published the anthology *The Jewish Caravan*, which included Yiddish translations, in 1935. Yiddish novelist Sholem Asch had, throughout the 1930s, enjoyed a greater audience in English translation than in Yiddish.

31 Steven Zipperstein, "Underground Man: The Curious Case of Zborowski and the Writing of a Modern Jewish Classic," *Jewish Review of Books* (Summer 2010), jewishreviewofbooks.com/articles/275/underground-man-the-curious-case-of-mark-zborowski-and-the-writing-of-a-modern-jewish-classic/.

32 Also see Sheila Jelen's *Salvage Poetics: Post-Holocaust American Jewish Folk Ethnographies* (Detroit: Wayne State University Press, 2020). For another critical account of *Life Is with People*, see Barbara Kirschenblatt-Gimblett's introduction to its 1995 republication, *Life Is with People: The Culture of the Shtetl*, by Mark Zborowski and Elizabeth Herzog (New York: Schocken Books, 1995), ix–xlviii.

33 Irving Howe and Eliezer Greenberg, *A Treasury of Yiddish Stories* (New York: Penguin, 1953), 1.

34 Howe and Greenberg, 71.

35 Jeffrey Shandler, "Anthologizing the Vernacular: Collections of Yiddish Literature in English Translation," in David Stern, ed. *The Anthology in Jewish Literature* (New York: Oxford University Press, 2004), 313. Norich reports that in addition to women writers, English anthologies of Yiddish writing also excluded writers "not from the United States or Eastern Europe." Norich, "The Poetics and Politics of Translation," in Hana Wirth-Nesher, ed. *The Cambridge History of Jewish American Literature* (Cambridge University Press, 2016), 499.

36 Leftwich's anthology was in fact a revision of his earlier 1939 *Golden Peacock*, which included even more poets—279—but the same organizational structure, relegating women poets to their own section, unmoored from history or geography.

37 Klepfisz, "Queens of Contradiction," 43. Also see Klepfisz's footnote listing the "statistics on the representation of women in popular and scholarly English collections," 57n1.

38 Klepfisz, 43.

39 Klepfisz, 43.

40 Wendy I. Zierler, "The Caravan Returns: Jewish American Literary Anthologies 1935–2010," in Wirth-Nesher, *Cambridge History*, 478.

41 Norich, "Poetics and Politics," 499.

42 Norich, 499.
43 The three-volume essay anthology featured such writers as Jonathan Edwards, Benjamin Franklin, Washington Irving, James Fenimore Cooper, Edgar Allan Poe, Ralph Waldo Emerson, Henry David Thoreau, Nathaniel Hawthorne, Herman Melville, and Walt Whitman, with Emily Dickinson as the lone woman poet—but excluded, for instance, Harriet Beecher Stowe, Harriet Jacobs, and Frederick Douglass, subjects for later generations of Black and feminist scholars. Robert Ernest Spiller, Willard Thorpe, Thomas Herbert Johnson, et al., eds., *The Literary History of the United States* (New York: Macmillan, 1948).
44 See, for instance, Suzanne Klingenstein, *Enlarging America: The Cultural Work of Jewish Literary Scholars, 1930–1990* (Syracuse, NY: Syracuse University Press, 1998); and Leah Garrett, *Young Lions: How Jewish Americans Reinvented the American War Novel* (Evanston, IL: Northwestern University Press), 2015.
45 Dovid Katz, "Introduction: The Days of Proletpen in American Yiddish Poetry," in *Proletpen: America's Rebel Yiddish Poets*, ed. Amelia Glaser and David Weintraub (Madison: University of Wisconsin Press, 2005), 3–4.
46 Katz, 13.
47 Katz, 14.
48 Katz, 14.
49 Jordan Finkin and Allison Schachter, Introduction to Fradl Shtok, *From the Jewish Provinces: Selected Stories*, trans. Jordan Finkin and Allison Schachter (Evanston, IL: Northwestern University Press, 2022), xii.
50 For instance, Riv-Ellen Prell describes the stereotypes Jewish men projected onto Jewish women as pushy mothers or ghetto girls. See Prell, *Fighting to Become Americans: Assimilation and the Trouble between Jewish Women and Jewish Men* (New York: Beacon Press, 2000). Sarah Imhoff describes the ways in which Jewish American men fashioned alternative forms of masculinity in reaction to white Protestant athleticism. See Imhoff, *Masculinity and the Making of American Judaism* (Bloomington: Indiana University Press, 2017). Also see Ronnie Grinberg, "Neither 'Sissy' Boy nor Patrician Man: New York Intellectuals and the Construction of American Jewish Masculinity," *American Jewish History* 98, no. 3 (2014): 127–51, in which Grinberg likewise describes the New York intellectuals' alternative Jewish American masculinity that valorized a "combative" intellectualism (128).
51 Howe and Greenberg, *Treasury*, 70.
52 Irving Howe, *World of Our Fathers* (New York: Schocken Books, 1976), 446.

53 Howe, 454 and 456. Might Howe's juxtaposition of these two postwar Yiddish writers have been influenced by Cynthia Ozick's fictionalization of their competitive relationship and the politics of translation in her short story "Envy, Or Yiddish in America," *Commentary* November 1969, www.commentary.org/articles/cynthia-ozick/envy-or-yiddish-in-america-a-novella/?

54 Howe's translation: "O God of Mercy / For the time being / Choose another people. / We are tired to death, tired of corpses, / We have no more prayers. / For the time being / Choose another people" (453). This is probably Molodowsky's most famous and frequently translated and anthologized poem.

55 See also Benjamin Harshav and Barbara Harshav's monumental bilingual anthology, *American Yiddish Poetry: A Bilingual Anthology* (Berkeley: University of California Press, 1986), another landmark translation event in the field, which features only one woman, Malka Heifetz-Tussman. Their introduction repeats Howe's generations (32–44), and the entire volume builds an argument for the Inzikhistn as producing the crowning modernist achievements of American-Yiddish poetry. Interestingly, the introduction features a photograph of the Inzikh group, which includes Celia Dropkin (36), but she is not included in the discussions or translations of the poetry.

56 Novershtern discusses only Anna Margolin very briefly in what he calls a "collective biography" of American Yiddish poets (215). See Avrom Novershtern, "Yiddish American Poetry," in Wirth-Nesher, *Cambridge History*, 202–22.

57 Such an association, for instance, kept Harriet Beecher Stowe out of the American literary canon for decades. Mikhail Krutikov, also in *The Cambridge History of Jewish American Literature*, notes in his essay that "America opened new opportunities for women writers, who by the early twentieth century began to occupy a significant place in Yiddish letters. Newspaper editors of different ideological persuasions welcomed women as contributors of short topical fiction that attracted female readers. The fiction was modern in themes and concerns but not modernist in form and style." (Krutikov, "New York in American Yiddish Prose," in Wirth-Nesher, ed. *Cambridge History*, 403). Yet in the very next paragraph, Krutikov mentions the "innovative" work of Karpilove, the "subtle psychological portraits" of Yenta Serdatsky, and the "most original and now completely forgotten" writer Rachel Luria (403).

58 Rosemary Horowitz, "A Review of Yiddish Women Writers in English-Language Anthologies," in Horowitz, *Women Writers*, 17.

59 See Hellerstein, *Question of Tradition*, 5. Also see Rosemary Horowitz, "English-Language Anthologies," in Horowitz, *Women Writers*, 21. The *Norton Anthology of Jewish American Literature* was coedited by Hellerstein, one of the most prolific feminist translators and scholars of American Yiddish women's poetry.

60 See, for instance, Naomi B. Sokoloff, Anne Lapidus Lerner, and Anita Norich, *Gender and Text in Modern Hebrew and Yiddish Literature* (New York: Jewish Theological Seminary of America, 1992); and Judith R. Baskin, ed. *Women of the Word: Jewish Women and Jewish Writing* (Detroit: Wayne State University Press, 1994). Baskin's essay collection includes a translation of Shmuel Charney (Niger), "Di yidishe literatur un di lezerin." The *Froyen* conference of 1995 was a culminating event of these efforts in the mid-1990s.

61 Kathryn Hellerstein, *Paper Bridges: Selected Poems of Kadya Molodowsky* (Detroit: Wayne State University Press, 1999); Shirley Kumove, *Drunk from the Bitter Truth: The Poems of Anna Margolin* (Albany: State University of New York Press, 2005); and Faith Jones, Jennifer Kronovet, and Samuel Solomon, trans. and eds., *The Acrobat: Selected Poems of Celia Dropkin* (Berkeley, CA: Small Press Distribution, 2014). These translators and editors still battled resistant gatekeepers, however. It took more than a decade, for instance, to find a press willing to publish *The Acrobat* (Jones in conversation with the author, October 20, 2021).

62 As Joseph Berger writes, this is "more than the number of translations in the previous two decades." Berger, "How Yiddish Scholars are Rescuing Women's Novels from Obscurity," *New York Times*, February 6, 2022, www.nytimes.com/2022/02/06/books/yiddish-women-novels-fiction.html.

63 Madeline Cohen, "The Feminine Ending: On Women's Writing in Yiddish, Now Available in English," *Los Angeles Review of Books*, April 10, 2020, lareviewofbooks.org/article/the-feminine-ending-on-womens-writing-in-yiddish-now-available-in-english/. Recent translations include Ellen Cassedy and Yermiyahu Taub's *Oedipus in Brooklyn and Other Stories by Blume Lempl* (2016); Ellen Cassedy's *On the Landing: Stories by Yenta Mash* (2018); *Confessions of a Yiddish Writer and Other Essays*, by Chava Rosenfarb, trans. Goldie Morgentaler (2019); Chava Turniansky's and Sara Friedman's annotated English edition of *Glikl: Memoirs 1691–1719* (2019); Anita Norich's translation of Kadya Molodowsky's novel *A Jewish Refugee in New York: Rivke Zilberg's Journal* (2019); Ruth Murphy's *The Canvas and Other Stories by Salomea Perl* (2020); Jessica Kirzane's translation of Miriam Karpilove's *Diary of a Lonely Girl, or The Battle against Free Love* (2020); Jordan Finkin and Allison Schachter's translation of Fradl Shtok, *From the*

Jewish Provinces: Selected Stories (2022); and Anita Norich's translation of Chana Blankshteyn, *Fear and Other Stories* (2022).

64 Anita Norich, "Translating and Teaching Yiddish Prose by Women," *In geveb: A Journal of Yiddish Studies*, April 2020, ingeveb.org/blog/translating-and-teaching-yiddish-prose-by-women.

65 Conversation with author, October 20, 2021. For an example of the alternative genealogies made possible by centering women writers, see Zohar Weiman-Kelman, *Queer Expectations: A Genealogy of Jewish Women's Poetry* (Albany: State University of New York Press, 2018).

66 Eitan Kensky and Saul Noam Zaritt, "A Peacock's Dream: Introducing *In geveb*." *In geveb: A Journal of Yiddish Studies*, August 2015, ingeveb.org/blog/introducing-in-geveb-a-journal-of-yiddish-studies.

67 See Recent Publications, Awards, and Fellowships, Yiddish Book Center, accessed February 2, 2023, www.yiddishbookcenter.org/translation-fellowship/recent-publications-awards-and-fellowships.

68 See *In geveb*'s mission statement, https://ingeveb.org/about. *In geveb* published translations of Karpilove, Blume Lempl, Chava Blankshteyn, and Fradl Shtok in advance of book publication and has published reviews of Karpilove, Molodowsky, Mash, and more.

69 Norich writes:

> The fact that there are more of these novels than we knew about is equally significant. Everyone who has ever read, researched, or written about Yiddish literature knows that there are a disheartening number of authors and texts published in the pages of Yiddish periodicals but now largely unknown. The only way to find them is by searching in archives and by turning the pages (or scrolling through the microfilm) of scores of periodicals. It is a frustrating, tedious, and incredibly exciting task, where you feel like a combination of sleuth, explorer, archaeologist, and obsessive. Finds like these demonstrate the vital importance of archival and bibliographical research and the importance of translation projects. (Norich, "Kadya Molodovsky: A Woman Novelist Rediscovered," *Pakntreger*, no. 76 [Winter 2017], www.yiddishbookcenter.org/language-literature-culture/pakn-treger/kadya-molodovsky-woman-novelist-rediscovered).

Norich has now begun cataloguing and translating more serialized Yiddish novels by women, reintroducing such fascinating figures as Beyle Friedberg, Mordkhe Spektor's first wife, who wrote about Eastern European

Jewry in the 1880s and '90s under the name "Izabella," lived for a time in Constantinople and became a Baha'i follower. See Norich, "Translating and Teaching Yiddish Prose by Women." Also see Finkin and Schachter, xii.

70 Cohen notes this as well in "Feminine Ending."
71 Miriam Karpilove, *Diary of a Lonely Girl, or The Battle against Free Love*, trans. and with an introduction by Jessica Kirzane (Syracuse, NY: Syracuse University Press, 2020), xii. Further page citations to this work appear parenthetically in the text.
72 In addition to Karpilove's *Diary*, Kirzane has also translated Miriam Karpilove's *Judith: A Tale of Love and Woe* (Tours, France: Farlag Press, 2022); and Miriam Karpolove's *A Provincial Newspaper and Other Stories* (Syracuse, NY: Syracuse University Press, 2023). For more information on Karpilove, including a bibliography, see Ellen Kellman, "Miriam Karpilove," *The Shalvi/Hyman Encyclopedia of Jewish Women*, Jewish Women's Archive, June 23, 2021, jwa.org/encyclopedia/article/karpilove-miriam.
73 Faith Jones, "*Diary of a Lonely Girl*: A Queer Reading." *In geveb: A Journal of Yiddish Studies*, October 2020: ingeveb.org/articles/diary-of-a-lonely-girl-a-queer-reading.
74 Mansplaining, the act of explaining "something to a woman in a condescending way that assumes she has no knowledge of the topic" (from the *Merriam-Webster* online), and gaslighting, *Merriam-Webster*'s 2022 word of the year, feel appropriate to describe the novel's surprisingly contemporary resonance.
75 Jessica Kirzane, introduction to *Diary of a Lonely Girl, or The Battle against Free Love*, by Miriam Karpilove, trans. Jessica Kirzane (Syracuse, NY: Syracuse University Press), xiii.
76 Kirzane, 16.
77 Kirzane, 12.
78 In its deliberate erasure of the narrator's life as a worker, usually understood to be the centerpiece of immigrant fiction, *Diary of a Lonely Girl* serves as a provocative counterpoint to the *The Diary of a Shirtwaist Striker*, discussed by Ashley Walters in chapter 1 of this volume.
79 Jones, "A Queer Reading."
80 For more information, see Kathryn Hellerstein, "Kadya Molodowsky." *The Shalvi/Hyman Encyclopedia of Jewish Women*, Jewish Women's Archive, December 31, 1999, jwa.org/encyclopedia/article/molodowsky-kadya.
81 Norich, "Kadya Molodovsky."
82 See Debra Caplan, "Forgotten Playwright: Kadya Molodowsky and the Yiddish Theater," in Horowitz, *Women Writers*, 180–94. Molodowsky served as the editor of the literary journals *Der Heym* (Israel) and *Svive* (New

York). Her work in translation includes Kathryn Hellerstein, *Paper Bridges: Selected Poems of Kadya Molodowsky* (Detroit: Wayne State University Press, 1999); and Leah Schoolnik, *A House with Seven Windows: Short Stories* (Syracuse, NY: Syracuse University Press, 2006), originally published in Yiddish as *A shtub mit zibn fenster* (New York: Farlag Matones, 1957).

83 Quoted in Joseph Berger, "How Yiddish Scholars are Rescuing Women's Novels from Obscurity."

84 Kadya Molodowsky, *A Jewish Refugee in New York: Rivke Zilberg's Journal*, trans. Anita Norich (Bloomington: Indiana University Press, 2019), 4. Further page citations to this work appear parenthetically in the text. The passage quoted here is remarkable for the challenges it posed for the translator. Norich writes, citing Molodowsky's play on words: "A shreklekher vort iz dos 'flikhtling.' Dos vort kumt mistome fun farflukht zayn" (Molodowsky), notes that the play between "flikhtling" ["refugee"] and "farflukht" ["cursed"] did not work in English. As a solution to this problem, Norich created a play between words: "What a horrible word: refugee. The word is a curse. It probably comes from refuse, garbage" (Molodowsky, trans. Norich, 4). Norich notes that she hoped that this would be recognized by American readers as a play on Emma Lazarus' "The New Colossus" which is inscribed on the base of the Statue of Liberty: "Give me your tired, your poor, / Your huddled masses yearning to breathe free, / The wretched refuse of your teeming shore." See Lizy Mostowski, "Teaching Guide to Kadya Molodovsky's *A Jewish Refugee in New York*, trans. Anita Norich," *In geveb: A Journal of Yiddish Studies*, April 2021, ingeveb.org/pedagogy/teaching-guide-kadya-molodovsky.

85 Rachel Rubinstein, "Review of *A Jewish Refugee in New York: Rivke Zilberg's Journal* by Kadya Molodowsky, Translated by Anita Norich," *In geveb: A Journal of Yiddish Studies*, October 2019, ingeveb.org/articles/review-of-a-jewish-refugee-in-new-york.

86 Allison Schachter, *Women Writing Jewish Modernity: 1919–1939* (Evanston, IL: Northwestern University Press, 2022), 4.

87 Weiman-Kelman, *Queer Expectations*, xxiii.

88 Schachter, quoting Shachar Pinsker, 26. See also 179n35. It is important to note that Schachter's scholarly project is closely linked to her translation work, having recently translated Fradl Shtok's short stories with Jordan Finkin.

89 Schachter, 174.

90 Schachter, 166.

Bibliography

Baskin, Judith R., ed. *Women of the Word: Jewish Women and Jewish Writing*. Detroit: Wayne State University Press, 1994.

Bassin, Morris, ed. *Antologye: Finf hundert yor yidishe poezye*. New York: Farlag yidish bukh, 1917.

Benjamin, Mara. "On the Uses of Academic Privilege (@theTable: 'Manthologies')." *FSR: Feminist Studies in Religion* (blog), May 27, 2019. www.fsrinc.org/on-the-uses-of-academic-privilege-thetable-manthologies/.

Berger, Joseph. "How Yiddish Scholars Are Rescuing Women's Novels from Obscurity." *New York Times*, February 6, 2022. www.nytimes.com/2022/02/06/books/yiddish-women-novels-fiction.html.

Blanksteyn, Chana. *Fear and Other Stories*. Translated by Anita Norich. Detroit: Wayne State University Press, 2022.

Burstin, Hinda Ena. "Still Waiting for Tomorrow: Lily Bes and Her Contemporaries in the 1920s." In Horowitz, *Women Writers*, 26–50.

Cammy, Justin. Introduction to *The Canvas and Other Stories*, by Salomea Perl, xi–xxiii. Translated by Ruth Murphy. Teaneck, NJ: Ben Yehuda Press, 2021.

Caplan, Debra. "Forgotten Playwright: Kadya Molodowsky and the Yiddish Theater." In Horowitz, *Women Writers*, 180–94.

"Celebrating Yiddish Women Writers." Yiddish Book Center. Accessed February 2, 2023. www.yiddishbookcenter.org/language-literature-culture/yiddish-literature/celebrating-yiddish-women-writers.

Chametzky, Jules, John Felstiner, Hilene Flanzbaum, and Kathryn Hellerstein, eds. *Jewish American Literature: A Norton Anthology*. New York: W. W. Norton, 2000.

Cohen, Madeline. "The Feminine Ending: On Women's Writing in Yiddish, Now Available in English." *Los Angeles Review of Books*, April 10, 2020. lareviewofbooks.org/article/the-feminine-ending-on-womens-writing-in-yiddish-now-available-in-english/.

Dropkin, Celia. *The Acrobat: Selected Poems of Celia Dropkin*. Translated and edited by Faith Jones, Jennifer Kronovet, and Samuel Solomon. Berkeley, CA: Small Press Distribution, 2014.

Forman, Frieda, Ethel Raicus, Sarah Silberstein Swartz, and Margie Wolfe, eds. *Found Treasures: Stories by Yiddish Women Writers*. Toronto: Second Story Press, 1994.

Garrett, Leah. *Young Lions: How Jewish Americans Reinvented the American War Novel*. Evanston, IL: Northwestern University Press, 2015.

Glaser, Amelia, and David Weintraub, eds. *Proletpen: America's Rebel Yiddish Poets*. Madison: University of Wisconsin Press, 2005.

Glatshteyn, Yankev, A. Leyeles, and Nokhem-Borekh Minkoff, eds. *In zikh: A zamlung introspective lider*. New York: M. N. Mayzel, 1920.

Glikl. *Glikl: Memoirs 1691–1719*. Edited by Chava Turniansky. Translated by Sara Friedman. Waltham, MA: Brandeis University Press, 2019.

Grinberg, Ronnie. "Neither 'Sissy' Boy nor Patrician Man: New York Intellectuals and the Construction of American Jewish Masculinity." *American Jewish History* 98, no. 3 (2014): 127–51.

Harshav, Benjamin. *The Meaning of Yiddish*. Stanford, CA: Stanford University Press, 1999.

Harshav, Benjamin, and Barbara Harshav. *American Yiddish Poetry: A Bilingual Anthology*. Berkeley: University of California Press, 1986.

Hellerstein, Kathryn. "Kadya Molodowsky." *The Shalvi/Hyman Encyclopedia of Jewish Women*. Jewish Women's Archive, December 31, 1999. jwa.org/encyclopedia/article/molodowsky-kadya.

———. *A Question of Tradition: Women Poets in Yiddish, 1586–1987*. Stanford, CA: Stanford University Press, 2014.

Horowitz, Rosemary. "A Review of Yiddish Women Writers in English-Language Anthologies." In Horowitz, *Women Writers*, 11–25.

———, ed. *Women Writers of Yiddish Literature: Critical Essays*. Jefferson, NC: McFarland, 2015.

Howe, Irving, and Eliezer Greenberg. *A Treasury of Yiddish Stories*. New York: Penguin, 1953.

———. *World of Our Fathers*. New York: Schocken Books, 1976.

Imhoff, Sarah. *Masculinity and the Making of American Judaism*. Bloomington: Indiana University Press, 2017.

Jelen, Sheila. *Salvage Poetics: Post-Holocaust American Jewish Folk Ethnographies*. Detroit: Wayne State University Press, 2020.

Jones, Faith. "The Bridge of Translation," *Bridges: A Jewish Feminist Journal* 14, no. 2 (Autumn 2009): 1–5.

———. "*Diary of a Lonely Girl*: A Queer Reading." *In geveb: A Journal of Yiddish Studies* (October 2020). ingeveb.org/articles/diary-of-a-lonely-girl-a-queer-reading.

Karpilove, Miriam. *Diary of a Lonely Girl, or The Battle against Free Love*. Translated and with an introduction by Jessica Kirzane. Syracuse, NY: Syracuse University Press, 2020.

Katz, Dovid. "Introduction: The Days of Proletpen in American Yiddish Poetry." In Glaser and Weintraub, *Proletpen*, 3–29.

Kellman, Ellen. "Miriam Karpilove." *The Shalvi/Hyman Encyclopedia of Jewish Women*. Jewish Women's Archive, June 23, 2021. jwa.org/encyclopedia/article/karpilove-miriam.

Kensky, Eitan, and Saul Noam Zaritt. "A Peacock's Dream: Introducing *In geveb*." *In geveb: A Journal of Yiddish Studies* (August 2015). ingeveb.org/blog/introducing-in-geveb-a-journal-of-yiddish-studies.

Kirshenblatt-Gimblett, Barbara. Introduction to *Life Is with People: The Culture of the Shtetl*, by Mark Zborowski and Elizabeth Herzog, ix–xlviii. New York: Schocken Books, 1995.

Kirzane, Jessica. Introduction to *Diary of a Lonely Girl, or The Battle against Free Love*, by Miriam Karpilove. Translated by Jessica Kirzane. Syracuse, NY: Syracuse University Press.

Klingenstein, Suzanne. *Enlarging America: The Cultural Work of Jewish Literary Scholars, 1930–1990*. Syracuse, NY: Syracuse University Press, 1998.

Klepfisz, Irene. "Queens of Contradiction: A Feminist Introduction to Yiddish Women Writers." In Forman et al., *Found Treasures*, 21–62.

Korman, Ezra, ed. *Yidishe dikhterins: Antologye*. Chicago: L. M. Stein, 1928.

Krutikov, Mikhael. "New York in American Yiddish Prose." In Wirth-Nesher, *Cambridge History*, 396–412.

Landau, Zishe, ed. *Antologye di yidishe dikhtung in amerike biz yor 1919*. New York: Yidish, 1919.

Leftwich, Joseph. *The Golden Peacock: A Worldwide Treasury of Yiddish Poetry*. London: Robert Anscombe, 1939.

Lempl, Blume. *Oedipus in Brooklyn and Other Stories by Blume Lempl*. Translated and edited by Ellen Cassedy and Yermiyahu Taub. Simsbury, CT: Mandel Vilar Press, 2016.

Leyeles, A. Glantz. "Kultur un di froy." *Di fraye arbeter shtime*, October 30, 1915.

Margolin, Anna. *Drunk from the Bitter Truth: The Poems of Anna Margolin*. Translated and edited by Shirley Kumove. Albany: State University of New York Press, 2005.

Mash, Yenta. *On the Landing: Stories by Yenta Mash*. Translated and edited by Ellen Cassedy. DeKalb: Northern Illinois University Press, 2018.

Molodowsky, Kadya. *A House with Seven Windows: Short Stories*. Translated by Leah Schoolnik. Syracuse, NY: Syracuse University Press, 2006.

———. *A Jewish Refugee in New York: Rivke Zilberg's Journal*. Translated by Anita Norich. Bloomington: Indiana University Press, 2019.

———. *Kheshvandike nekht*. Vilnius, 1927.

———. *Paper Bridges: Selected Poems of Kadya Molodowsky*. Translated and edited by Kathryn Hellerstein. Detroit: Wayne State University Press, 1999.

Mostowski, Lizy. "Teaching Guide to Kadya Molodovsky's *A Jewish Refugee in New York*. Trans. Anita Norich." *In geveb: A Journal of Yiddish Studies* (April 2021). ingeveb.org/pedagogy/teaching-guide-kadya-molodovsky.

New York Public Library. "Yiddish Women in Translation," *NYPL Blog*, August 17, 2020. www.nypl.org/blog/2020/08/17/other-words-yiddish-women-translation-month.

Niger [Charney], Shmuel. *Di yidishe literatur un di lezerin*. Vilna: Drukeray vilner farlag, 1919.

Niger [Charney], Shmuel, and Jacob Shatsky, eds. *Leksikon fun der nayer yidisher literatur*. New York: Alveltlekhn yidishn kultur-kongres, 1956.

Norich, Anita. Introduction to *A Jewish Refugee in New York: Rivke Zilberg's Journal*, by Kadya Molodowsky, vii–xxiv. Translated by Anita Norich. Bloomington: Indiana University Press, 2019.

———. "Kadya Molodovsky: A Woman Novelist Rediscovered." *Pakntreger*, no. 76, Winter 2017. www.yiddishbookcenter.org/language-literature-culture/pakn-treger/kadya-molodovsky-woman-novelist-rediscovered.

———. "The Poetics and Politics of Translation." In Wirth-Nesher, *Cambridge History*, 488–501.

———. "Translating and Teaching Yiddish Prose by Women." *In geveb: A Journal of Yiddish Studies* (April 2020). ingeveb.org/blog/translating-and-teaching-yiddish-prose-by-women.

———. "Women Writers in Yiddish Literature with Anita Norich and Karolina Szymaniak (in Yiddish)." YIVO Institute for Jewish Research, Yiddish Civilization Lecture Series. YouTube, July 22, 2021. www.youtube.com/watch?v=p2p_gt0EBIQ.

———. *Writing in Tongues: Translating Yiddish in the Twentieth Century*. Seattle: University of Washington Press, 2014.

Novershtern, Avrom. "Yiddish American Poetry." In Wirth-Nesher, *Cambridge History*, 202–22.
———. "Yiddish Women Writers (Part 1)." YIVO Institute for Jewish Research Yiddish Civilization Lecture Series. YouTube, July 12, 2021. www.youtube.com/watch?v=3wl81swZO2A.
———. "Yiddish Women Writers (Part 2)." YIVO Institute for Jewish Research Yiddish Civilization Lecture Series. YouTube, July 19, 2021. www.youtube.com/watch?v=66iydt6dzg0.
Ozick, Cynthia. "Envy, Or Yiddish in America," *Commentary*, November 1969. www.commentary.org/articles/cynthia-ozick/envy-or-yiddish-in-america-a-novella/.
Perl, Salomea. *The Canvas and Other Stories*. Translated by Ruth Murphy. Teaneck, NJ: Ben Yehuda Press, 2021.
Prell, Riv-Ellen. *Fighting to Become Americans: Assimilation and the Trouble between Jewish Women and Jewish Men*. New York: Beacon Press, 2000.
Rosenfarb, Chava. *Confessions of a Yiddish Writer and Other Essays*. Translated by Goldie Morgentaler. Montreal: McGill-Queen's University Press, 2019.
Rubinstein, Rachel. "Review of *A Jewish Refugee in New York: Rivke Zilberg's Journal* by Kadya Molodovsky, Translated by Anita Norich." *In geveb: A Journal of Yiddish Studies* (October 2019). ingeveb.org/articles/review-of-a-jewish-refugee-in-new-york.
Schachter, Allison. *Women Writing Jewish Modernity: 1919–1939*. Evanston, IL: Northwestern University Press, 2022.
Schwarz, Leo. *The Jewish Caravan*. London: Arthur Baker, 1935.
Seidman, Naomi. *A Marriage Made in Heaven: The Sexual Politics of Hebrew and Yiddish*. Berkeley: University of California Press, 1997.
Shandler, Jeffrey. "Anthologizing the Vernacular: Collections of Yiddish Literature in English Translation." In Stern, *Anthology in Jewish Literature*, 304–23.
Shtok, Fradl. *From the Jewish Provinces: Selected Stories*. Translated by Jordan Finkin and Allison Schachter. Evanston, IL: Northwestern University Press, 2022.
Sinkoff, Nancy. "The World of Sara Levy." Digital Yiddish Theatre Project, April 2019. web.uwm.edu/yiddish-stage/saralevy.
Sokoloff, Naomi B., Anne Lapidus Lerner, and Anita Norich, eds. *Gender and Text in Modern Hebrew and Yiddish Literature*. New York: Jewish Theological Seminary of America, 1992.

Spiller, Robert E., Willard Thorp, Thomas Herbert Johnson, Henry Seidel Canby, and Richard M. Ludwig. *Literary History of the United States*. New York: Macmillan, 1948.

Stern, David, ed. *The Anthology in Jewish Literature*. New York: Oxford University Press, 2004.

Vaybertaytsh. Episode 54, hosted by Sosye (Sandra) Fox and featuring Faith Jones, Jessica Kirzane, and Ayelet Brinn, July 19, 2021. www.vaybertaytsh.com/episodes/2021/7/18/episode-54-re-yiddish-women-writers-hjhes.

Weiman-Kelman, Zohar. *Queer Expectations: A Genealogy of Jewish Women's Poetry*. Albany: State University of New York Press, 2018.

Wirth-Nesher, Hana, ed. *The Cambridge History of Jewish American Literature*. Cambridge: Cambridge University Press, 2016.

Zborowski, Mark, and Elizabeth Herzog. *Life Is with People: The Culture of the Shtetl*. New York: Schocken Books, 1995.

Zierler, Wendy I. "The Caravan Returns: Jewish American Literary Anthologies 1935–2010." In Wirth-Nesher, *Cambridge History*, 470–87.

Zipperstein, Steven. "Underground Man: The Curious Case of Zborowski and the Writing of a Modern Jewish Classic." *Jewish Review of Books*, Summer 2010. jewishreviewofbooks.com/articles/275/underground-man-the-curious-case-of-mark-zborowski-and-the-writing-of-a-modern-jewish-classic/.

5

THE POETICS OF CONVERSATION

Adrienne Rich's and Audre Lorde's Uses of Voice

Alex Ullman

> **Adrienne Rich:** We are always reading poetry that is inhabited by other people's voices. And by our own voices which are not really our own voices anymore . . .
> **Audre Lorde:** Or an older voice, an older self.
> **Adrienne Rich:** And then there is something that I call the "Poetry Voice," which is, you know . . . *that voice* . . . I think that the "Poetry Voice" for me is a white male voice . . . I don't think it's *the* "Poetry Voice," but it's something with capital letters that we've been taught to listen for.
>
> —Adrienne Rich and Audre Lorde, "Poets in Conversation" (1981)

On December 5, 1981, Adrienne Rich and Audre Lorde gave a reading at Hunter College as a benefit for the Astraea Foundation, a then four-year-old philanthropic organization that supported female artists. The reading was advertised as "Poets in Conversation," and it began with Lorde clarifying how this event was to be different from other poetry readings: "This is really conversation with poems . . . rather than readings with conversation in between."[1] Lorde's comment aptly described the loose reading order of the first half of the event: she and Rich traded back and forth, Lorde reading from *The Black Unicorn* (1978) and Rich from *A Wild Patience*

Has Taken Me This Far (1981), framing their poems with commentary but also allowing their poems to speak to each other. In the second half of the event, dedicated to sharing newer work in progress, Rich again clarified the uniqueness of the format: "[W]e are trying through a different kind of format . . . to change some of the mental sets with which people come into a poetry reading."[2]

If one of the main "mental sets" of the mainstream poetry reading of the late twentieth century was that a poet reads a "sequence of voiced poems interspersed with a little bit of lecture" to a silent audience, then the framing of the event as a "conversation" was an attempt to disrupt this ritualized format and the kinds of consciousness that format typically affords.[3] In reviewing the event, Black feminist writer and then WBAI radio host Donna Allegra described the poets' success in disrupting this ritual—how, in a room "filled largely by women from the feminist community," the two poets "didn't hold to the stand-and-read format, where the audience applauds and stays seated in place. These poets explored with us."[4] Allegra's comments imply that the audience, too, felt like part of the conversation. In listening to the Astraea event recording—produced by the Lesbian Herstory Archives and housed in their online archives—we might ask: how did Rich and Lorde make the audience feel like part of the conversation?

As the comments in the epigraph suggest, Lorde and Rich's resistance to the normative poetry reading extended into its very sound. When Rich read the phrase "*that voice*" in the context of framing her poem "Sources," she performed what this stereotypical "Poetry Voice" sounded like to her: she spoke louder and moved from her conversational register to a comically elevated one, raising her vocal pitch on the word "voice" and extending the word's sibilance far enough to elicit uproarious laughter from the audience. The vocal event is not sustained long enough to suggest that Rich was imitating what Marit MacArthur calls "monotonous incantation," another perceived "Poetry Voice" so common to late twentieth-century poetry readings.[5] But the meaning of Rich's vocal shift is clear: she was playing on the performativity of gender—or the construction of authoritative masculinity—in front of an audience primed for the deconstruction of gendered conventions. Her laughter and the subsequent laughter of the audience indicate that both she and they have some ironic distance from the trappings of "Poetry Voice." Departing from Lorde's comment about hearing one's past self, Rich went on

to narrate a version of what feminist sound studies scholars today have called "nonconsensual listening": how she had been taught to "listen for" this particular sound of poetic delivery as a form of gendered control.[6] In this moment, Rich used her embodied voice to index a dominant style of speaking, to mediate the stylistic and affective distance between herself and that (perceived "white male") poetic style, as well as to bridge the distance between herself, Lorde, and her audience.

This chapter closely listens to a few other moments at the Astraea event in which Rich and Lorde engaged both poetic and embodied notions of speaking and listening to negotiate gendered, sexual, racial, and ethnic identity in front of a public audience, using what I call a "poetics of conversation." Rich and Lorde are two of the most recognized lesbian feminists of the latter half of the twentieth century, and there's no paucity of criticism on the "dialogism" of their poetry.[7] But these Bakhtinian readings often elide the fact of, and the affective power of, their embodied voices. Though there are several recordings of Rich and Lorde reading poems and essays together, the Astraea event is the only recorded example of them attempting to work out publicly—to perform—what they were discussing privately about the meaning of the poetry reading. In what follows, I pay particular attention to the modes of address within their poems but also the multiple registers in which they performed their poems aloud. Using unpublished letters and previously unstudied recordings from the archives, I argue that Lorde and Rich's live performance—and its afterlife as recorded sound—established a feminist, queer counterpublic that challenged inherited notions of lyric and prophetic voice.

For scholars of Jewish American women's literature and culture, the Astraea recording is of some historical importance: it is the first time that Rich spoke openly about her Jewish identity at a public reading, and it documents the only extant draft of "Sources"—the oft-cited companion poem to her essay "Split at the Root"—that differs substantially from its eventual publication.[8] But the "poetics of conversation" that Rich and Lorde perform also offers, I argue, an aesthetic and ethical alternative to narratives of interracial relation as typically told by scholars of Jewish American literature. Prior to at least 1998, the scholarly field of "Black-Jewish relations" focused on literatures of the 1960s and was arguably a "story told by Jewish scholars" about how this particular form of relation "provides the key to America's multicultural future (and past)."[9] Though Keith Feldman has

powerfully argued that the field continues to "domesticate" global conceptions of race into a US-centric "liberal pluralist ethnic relations paradigm," the past twenty years has seen the field expand widely to include modernist texts, women's literature, Caribbean contexts, and work by and about mixed-race Jews.[10] What a close listening of the 1981 Astraea event recording offers us is a chance to return to a crucial moment in the feminist movement when these two poets engaged in "conversation" but with a critical ear for the all-too-quick metaphorization of that term. In resisting the flattening of conversation into any power-free notion of free speech or historical cliché about the failures of Black-Jewish dialogue, the recording invites questions not just about what was said but how it sounded: the very material of performance.

"An Intimacy Rigged with Terrors"

By the time of the 1981 Astraea event, the relationship between Rich and Lorde had become iconic in the world of radical feminism, though the event represented a midpoint in their nearly twenty-five years of friendship. When Lorde and Rich met at City College of New York in 1968, Rich had quit her job at Columbia to teach in the SEEK (Search for Education, Elevation, and Knowledge) program, while Lorde was working as a librarian, soon to become a teacher in the program herself.[11] Rich would later describe this time as mutually supportive: "For most of those years, we exchanged drafts of poems, criticized and helped to sustain each other's work."[12] In the early 1970s, they began to share the stage, most famously when Rich accepted the National Book Award for *Diving into the Wreck* in 1974 on behalf of Lorde, Alice Walker, and herself as an act of solidarity and protest against a white, patriarchal institution.[13] Soon they appeared together in various forms and forums, including public readings, anthologies, feminist periodicals, academic panels, and even the 1977 recorded album *A Sign / I Was Not Alone* (along with Joan Larkin and Honor Moore). The 1970s also saw an increasing aesthetic resonance between their work, specifically around the thematics of silence, lesbian desire, bodily disability, and bearing witness.[14] Even though Rich would move to Montague, Massachusetts, in 1978 with her partner, the writer Michelle Cliff, her relationship with Lorde grew more intimate. They were

both in interracial relationships, and frequently the letters between them were addressed both to each other and to each other's partners.

Yet it was an "intimacy rigged with terrors," as Rich would suggest in "Hunger," a poem written and dedicated to Lorde in 1974.[15] As tensions were on the rise between white, Black, and Jewish women in the feminist movement more generally, Rich became white feminism's most vocal critic about the movement's stance on race and white privilege, a position Lorde deeply influenced.[16] The tension between the two emerged poignantly after Lorde resigned as poetry editor from the feminist periodical *Chrysalis* magazine in early 1979 and Rich refused to disavow relationships with white editors that Lorde found objectionable.[17] Their letters from the late 1970s bear traces of these tensions. On November 22, 1979, for example, Rich responded to a particularly difficult letter from Lorde to express how "there's a kind of pain I feel when you become impatient with me because I cannot and will not become your voice, your surrogate, in all this."[18] But their relationship continued to grow with and beyond these tensions, and the Astraea event capped perhaps their busiest and most collaborative year.[19]

In his 2018 book *Black Power, Jewish Politics*, historian Mark Dollinger argues against the well-worn historical claim that the Black and Jewish political alliance fell apart by the end of the 1960s. Both groups, he says, *did* fall apart—in the sense that they left behind a politics of cooperation and pluralism—but the influence of the Black Power movement also allowed both communities to grow into concomitant, albeit different, forms of "identity politics."[20] For Dollinger, the animating question of the Jewish turn toward "identity politics" was: "Is it good for the Jews?"[21] As is typical of "Black-Jewish relations" scholarship that centers on the pages of *Commentary* and the halls of the Religious Action Center, women are largely absent from Dollinger's story, especially queer feminist writers.[22] This elision risks a confusion of terms. The "identity politics" of the 1960s is not the same kind of "identity politics" circulating in the radical lesbian feminist movements of the 1970s and '80s.[23] Dollinger is right to claim that a more "intersectional" approach toward coalition building served as a "bonding agent for communities of color,"[24] but post-'60s feminism was also defined by various forms of intraracial conflict and cross-cultural contact between Jewish and Black lesbian feminists as well. The years between 1979 and 1984 were particularly tense, as evidenced by the publication of

Judy Simmons's "Minority" (1979), a poem that directly compared Black and Jewish oppression;[25] a series of heated workshops among Black, Jewish, and Jewish women of color at the Northeastern Women's Studies Association meeting in 1981; June Jordan's fiery condemnation of Rich's silence about Palestinian oppression in *WomaNews* in 1982; and a tense exchange between Alice Walker and Letty Cottin Pogrebin in *Ms.* magazine that same year.

One important text documenting these interracial conversations was *Yours in Struggle: Three Feminist Perspectives on Anti-Semitism and Racism* (1984) by Minnie Pratt, Barbara Smith, and Ellie Bulkin. The animating question of this text—in which three lesbian women writers meditate on the history of the two titular "-isms" in relation to their own lives—is not "Is it good for the Jews?" but "Who am I?" This latter question was one of Lorde's and Rich's central, poetic questions; their relationship was at least partially defined by the public, private, and poetic interrogation of their different answers to that question. As Claudia Rankine recently put it, "Lorde never stopped saying to [Rich]: 'Your particular concerns might not be my particular concerns,' and they built a friendship around that dialogue, and performed it in public for the rest of us."[26] Their fame, however, tended to cover up the numerous differences between them, especially during the 1980s, when Rich began to identify publicly as a secular Jew and Lorde with the transnational Black diaspora. As Rich explains in the 1996 film about Lorde's life, *A Litany for Survival*: "We were seen as this duo, a white woman and a Black woman, who were friends, who were both lesbians, who were apparently getting along quite well ... we really had to struggle against that kind of reification."[27]

How did they struggle against that kind of "reification"?[28] Marion Rust argues that they resisted it through the "open letter," a form of intimate publicity that foregrounded anger between them as a productive force against racism.[29] SaraEllen Strongman suggests that the personal letters clarify the difficult affective work that went into maintaining a specifically "non-romantic" interracial relationship.[30] And Danica Savonick claims that both poets sought to redistribute power into the hands of students through literary language, though their pedagogies were crucially distinct.[31] But Rich and Lorde were also thinking about how the poetry reading tended to reify their differences, as this undated letter from Rich—probably from 1978—suggests: "We've talked, in the past,

about poetry readings, audience responses, knee-jerk applause and standing ovations and that kind of thing, and the uneasiness it has given each of us . . . I wonder . . . whether you have any further thoughts on all that."[32] Because the correspondence in Rich's archive is closed to the public until 2050, it is not clear whether or how Lorde responded. Yet the recording of the Astraea event suggests that the poetry reading—not unlike their open letters, the private letters, and their pedagogical styles—was another crucial site for resisting the reification of their identities into iconic celebrities, as well as the reification of "conversation" into meaningless political cliché or poetic trope.

"Real Conversation"

The December 1981 Astraea event coincided with a year of cultural fascination with social and aesthetic forms of "conversation." Director Louis Malle's *My Dinner with Andre* served up casual talk between friends as its main course; *Bomb* magazine debuted with the explicit aim of foregrounding conversations between artists; and Erving Goffman published *Forms of Talk*, a sociolinguist study of the rituals and interactional patterns undergirding everyday speech. In the first chapter of Goffman's text, he defines conversation loosely as "an equivalent of talk or spoken encounter."[33] But there are some types of "talk" and "spoken encounter" that aren't conversational, like public lectures: "When talk comes from the podium, what does the hearing is an audience, not a set of fellow conversationalists."[34] For Goffman, being in conversation means to be part of an immediate linguistic encounter and to participate in what is being said. The podium, it seems, gets in the way of these conversational dynamics. Did the podium get in the way at the Astraea event? Yes and no. Beyond the question-and-answer session, there is no direct spoken interaction between the poets and the audience. But as Donna Allegra suggested in her review of the event, there were crucial *affective* connections forged, and Lorde and Rich used a conversational pattern I call "shifting the frame" to mediate the affective distance between themselves and their audiences.

An example of this pattern occurred early in the event, when Lorde says: "We of course, both Adrienne and myself, are doing this for ourselves . . . and we're doing it also in public because we believe that . . . what happens

in real conversation, as opposed to the false patterns sometimes that we indulge in ... [has] application beyond our own work."[35] In distinguishing between the "real conversation" at the Astraea event and "false patterns," Lorde pointed to how the poetry reading enacted a public version of what she elsewhere calls the "intimacy of scrutiny," or the collaborative process of closely examining difference and shared feeling.[36] This framing was Lorde's particular variation on a perennial theme of the feminist movement: the braiding of the personal and the political. Suggesting to the audience that what they were witnessing was both very intimate and very public was one rhetorical way in which Lorde shifts the frame around her own speech.[37] But then Rich reframed Lorde's comments by calling attention to the optics of the event:

> As I stand here ... the podiums, podii ... are rather distant from each other ... and there's ... a kind of statement that they're making, because this is a public occasion, and ... it feels important for me to identity here a kind of "setup" that I feel the need to struggle against as a white woman in my life, which has to do with letting our relationships with women of color stand in for a kind of day to day work ... there is a kind of agenda ... of subtle racism, that would like us to substitute personal relationships for difficult political work[38]

Here, Rich elicited raucous laughter from the crowd in grappling with how to pluralize the word "podium," but the linguistic difficulty is emblematic of the event's difficulty: she called attention to how the framing of the event risked reifying their relationship by turning the audience's attention toward how the present was staged, not just visually, but racially. This moment—one among many—when the poets framed how the audience should perceive their conversation, is what linguistic anthropologists call "metapragmatic": it regiments how other utterances should be received and understood. This meta-conversation about "conversation"—in which one poet will make a comment about what their conversation is doing and the other will reframe it—is another crucial example of shifting the frame.[39] While for Goffman the podium inhibits conversation, for Rich and Lorde the podium became a topic of it.

Conversation was a signal term for Rich and Lorde's poetics at the turn of the 1980s, one that emerged, for example, in an interview of

Lorde conducted by Rich in 1979 but later published in *Signs* in 1981, shortly before the Astraea event. In it, Lorde described how she hears Rich's voice while she writes, and this conversation about voice leads to a particular tense interaction, a moment Marion Rust calls the "one place in the published interview where Rich gets angry."[40] When Rich questioned the perception of herself as a symbolic "white voice," the threat of the reification seemed to come not from outside their relationship but from within it:

> **Audre Lorde:** Adrienne, in my journals I have a lot of pieces of conversations that I'm having with you in my head. I'll be having a conversation with you and I'll put it in my journal because stereotypically or symbolically these conversations occur in a space of black woman/white woman, where it's beyond Adrienne and Audre, almost as if we're two voices.
>
> **AR:** You mean the conversations you have in your head and your journal, or the conversations we're having on this earth?[41]

Lorde then recalled an earlier moment when Rich questioned her perceptions and Rich became defensive, saying, "I've had great resistance to some of your perceptions. They can be very painful to me."[42] Attempting to face this wave of anger, defensiveness, or guilt, Rich said the key questions for her now are: "How do I use this? What do I do about it?" Lorde echoes with a quote from her poem "Need": "How much of this pain / can I use?"

I want to attend to how the question of "voice" ("almost as if we're two voices"[43]) inaugurated a heated moment of disagreement between them, while the question of poetry's "use" afforded a resolution to the conflict without reifying those differences. A similar dynamic emerges at the Astraea event: Lorde and Rich performed their poems with very distinct voices and performance styles but consistently returned to the question of poetry's "use." This shift between "voice" and "use" had at least three purposes, I believe: to politicize apolitical notions of conversation, to thwart monological conventions of the normative poetry reading, and to resist the reception of their voices into any singular notion of "white," "Black" or "Jewish voice." In what follows, I examine how the poets explored the metaphor and material of the voice in the public performance of their poetry. Though I consider their performances separately, this mutual

dance—between their different uses of voice and their contentions over poetry's use—underlies their poetics of conversation.

"Conversation-ed Out"

The first poem Lorde read at the Astraea event is "A Litany for Survival." She framed the poem as useful in the sense that it inflected her struggle with cancer, an example of how she can "slant into that wall of fear and come back with something" (Lorde and Rich 1981d, 22:34).[44] Lorde then used her embodied voice to dramatize this particular use of poetry. As I have argued elsewhere, Lorde had numerous vocal techniques for performing her poetry aloud, and the Astraea recording makes them memorably audible.[45] "Litany" begins with a littoral image ("For those of us who live at the shoreline"), and she read these lines in her unadorned, matter-of-fact register: a mode of delivery that sounds much like a slower version of her conversational speaking voice. But in the second stanza, she began to switch between different registers to communicate—sonically—her present engagement with a past fear:

> For those of us
> who were imprinted with fear
> like a faint line in the center of our foreheads
> learning to be afraid with our mother's milk[46]

On the word "fear" in the second line and again "afraid" in the third, Lorde invoked her incantatory, chromatic register: over a gradual decreasing pitch across the line, the frequency oscillates between descending and rising, yet that rise is slightly lower in pitch than the previous word ("fear" is slightly higher than "faint line"). With her shift in vocal register, Lorde infused into this line an affective intensity that sonically communicates the visual image of fear being imprinted on one's forehead. If one of the "uses" of poetry is to "slant into" fear, she used shifts in vocal register to sonically perform such "slanting."

Lorde's biographer Alexis De Veaux writes that the popularity of "Litany" in the late 1970s and '80s stemmed from how the poet "shifted to a more intimate voice, replacing the pronouns 'you' and 'your' with 'we' and

'our.'"[47] In De Veaux's perceptive analysis lies an important tension: while "Litany" marks a move from the second to the first person, it also marks a move from the singular to the plural. How does a poem become more "intimate" as it becomes more collective? This question goes to the heart of the history of lyric poetry, a genre often contested on the grounds of shifting modes of address.[48] The "anthem"-like quality of Lorde's "Litany" challenged both high cultural norms and solipsistic conventions of lyric voice, drawing her audience intersubjectively into the roles of speaker and addressee. But Lorde also had performative means of merging intimacy and publicity. Having confessionally framed the poem around her experience of cancer and then heard the applause of her performance risk a unitary celebration of *her*, she directly asked the audience at the Astraea event to stop clapping because "it feels not part of our conversation or the kind of thread that I'm trying to follow through, or that we're trying to follow through between us."[49] Lorde often attempted to control the applause from her audience, but it was a way to encourage the audience to engage affectively with what they were hearing: to turn them into active listeners rather than mere passive audience members who simply clap at what pleases them.[50] Notice also how the conversational format of the evening is metaphorized as a kind of cloth—"our conversation or the kind of thread . . ."—one that is interwoven between the audience's clapping and the performers' speech. By moving between the multiple registers of her voice and calling attention to the hands of her hearers, Lorde crafted a conversational poetics that sought a social and embodied immediacy with her listening audience, not a transcendent identification that is typical of a readerly encounter with lyric.

Lorde also performed "Sequelae," her next poem at the Astraea reading, in multiple registers, but with different effects. "Sequelae" is a more unsettling poem than "Litany": if the listener is to feel inspired by "Litany"—as if they too are part of the "we"—"Sequelae" situates the listener at the threshold of the past and the present, the demotic and the otherworldly. The poem begins with a prophetic and sexual image ("Because a burning sword notches both of my doorposts"), which Lorde read mostly in her unadorned register—as if this shuttling between the biblical, the erotic, and the domestic is an everyday occurrence. But when the stanza moves into its most surreal content, her voice dropped into a slow incantation in which each tone on the last word of each line decreases by a half-step in a chromatic voice leading:

> while I battle the shapes of you
> wearing old ghosts of me
> hating you for being
> black and not woman
> hating you for being white
> and not me[51]

In the final stanza of the poem, Lorde recapitulates but inverts this language ("I battle old ghosts of you / wearing shapes of me") and, like the poem's opening, tinges the prophetic with the erotic:

> growing dark secrets
> out from between her thighs
> and night comes into me like a fever
> my hands grip a flaming sword that screams[52]

Though Lorde's early poem "Coal" is her most explicit riff on the prophet Isaiah, her mixing of biblically inflected language with eroticism in "Sequelae" reminds us that female sexuality always lies at the root of prophetic poetry.[53] At the poem's most violent and erotic moments—as when she responds to police brutality in "Power" or erotic desire in "Meet"— Lorde reads not just in the incantatory register but also with a pronounced vibrato. In this reading of "Sequelae" at the Astraea event, her pitch wavers on words like "thighs" and "me," at once emphasizing not only the connection between voice and body but also the instability of any stable sense of self and other.

Lorde initially framed "Sequelae" at the event as a Du Boisian investigation into her multiple selves, "knowing that much of me is both Black and white."[54] The dissolution of any stable speaker and addressee *and* the shift in register dramatized this warring of two selves. Yet while "double consciousness" is the framework for the poem before Lorde reads it, "conversation" becomes the crucial analytic after she reads it: "[I]it really gets to me still, the voice and the power . . . the questions that I came to in that poem . . . the poem itself . . . feels almost conversation-ed out, it's as if that conversation has gone over and over . . . and yet, by the same token, the way my heart is beating as I read it, tells me that it is a process that happened [and] as I said, it can happen again."[55] Conversation was

not just a format for the poetry reading but an embodied practice of speaking and listening to oneself: a mode of reading aloud *that makes your heart beat*. To listen to Lorde perform at the Astraea event, I argue, is to take seriously the idea that she is having a conversation with herself through the dramatic alteration of pitch. But this conversation was never completely solipsistic. Rich replied to this comment about the documentary uses of poetry with "it's never over," and Lorde countered with hesitant disagreement: her current poetic interests, she says, are "different, but on some level, they are not."[56] This interaction between Rich and Lorde embedded a private conversation that Lorde had been having with herself through her poetry into the present conversation between Rich and Lorde, but not in a way that flattened the difference into sameness or offered immediate consent to another's reframing. For these poets, at this moment in 1981, conversation was a polyvocal poetic form for inextricable from its role as a social form for exploring difference and disagreement publicly.

"That Voice"

As the epigraph to this essay attests, Rich also used the multiple registers of her voice to explore the "poetics of conversation," most notably in the second half of the event when she read preliminary drafts from her poem "Sources."[57] It is worth noting, however, that the dominant vocal register that Rich used to speak about "Sources" is not the same as the one in which she read the poem. Like Lorde, Rich typically read her poems with a slower speed than her conversational speaking voice, frequently punctuated by pauses; unlike Lorde, Rich usually read her poems in a single—what Marit MacArthur might call "formal"—style, even if she is well known to include various experimental forms of address throughout her poetic oeuvre.[58] But to listen to Rich perform "Sources" at the 1981 Astraea is not just to consider the relation between Lorde and Rich's speaking and performing styles but also to historicize Rich's voice over the arc of her nearly sixty years performing her poetry out loud for live audiences.

When it was eventually published in 1984, "Sources" was one of Rich's longest free verse poems with over 350 lines separated into eighteen different sections. It continues a long poetic conversation Rich had been having

with herself since at least 1955 about the origins and the lived experience of her Jewishness.[59] But, more overtly than any other poem to date, "Sources" explores Rich's relationship to her Jewish father's assimilation, her former Jewish husband's suicide, her experiences growing up in the shadow of the Holocaust, and her evolving views on Zionism. At the Astraea event, Rich directly connected the "question of voice in this poem" to her upbringing in Baltimore, where she was compelled to mask certain parts of her identity, including her vocal identity:

> My father was a Jew, my mother was not and I didn't know what to do with that, I was raised as a Christian. But all of this being part of the struggle against amnesia, the struggle to reclaim memory, the struggle to reclaim strands of the past which had been denied me, in part, in the effort to make me into that achieving young, white, middle class American Christian woman that I was supposed to be, without a southern accent preferably. . . . I think that this poem ["Sources"] bears the marks of a lot of struggle with all of that.[60]

What becomes perceptible in this conversational (and confessional) framing of "Sources" is a value Rich shares with Lorde: the use of poetry to decolonize and reclaim one's perceptions. Yet the conversation never lets that shared value reify into sameness: the conditions that made the work of decolonization difficult for Rich—namely, her father's assimilation and a hegemonic Christian culture—were much different than Lorde's.

It is well known that, unlike Lorde, Rich was strongly influenced in her early years by a white masculine tradition within American and British poetry, long before she became an icon of the lesbian feminist movement.[61] Biographer Hilary Holladay writes that Rich's background as a skilled pianist gave her a comfort onstage from her early career and that after watching Dylan Thomas perform at Harvard as an undergraduate, she cultivated both an "incantatory" and a "melodic voice"—affectations that would mark her many public readings to come.[62] But what do the adjectives "incantatory" and "melodic" sound like? The first available recording of Rich reading aloud is a 1951 recording from a reading she gave at Harvard on the occasion of winning the Yale Younger Poets Prize for her first book, *A Change of World* (1951). In the recording of her poem "Aunt Jennifer's Tigers" at this 1951 event, her reading voice sounds uncannily

like that "Poetry Voice" she parodied thirty years later at the Astraea event. The first stanza ("Aunt Jennifer's tigers prance across a screen, / Bright topaz denizens of a world of green") thematically riffs on Blakean imagery, but the register she used indexes the declamatory, Thomasian style.[63] The dactyls and the iambs oscillate from the beginning to the ends of each line, and her bravado moved with them—each stress goes up in pitch, followed by a lengthy pronunciation of the final word with a subsequent fall in pitch. Thus, the "Poetry Voice" that she claimed she had been taught to "listen for" at the Astraea event in 1981 is one she also had a deep history of performing.

"Sources," as performed at the 1981 Astraea event, frames the question of Jewishness as never separate from other aspects of her identity, including her southern vocal identity and her embeddedness in the culture of a perceived, masculine "Poet Voice." But how did "Sources" sound when she performed a draft of it in conversation with Lorde in 1981? The first section of the poem begins with a speaker returning to a Vermont landscape she had not visited in "sixteen years," as the first line reports. She encounters a series of names she sees printed on the houses, remembers a dead fox she once saw, and then further meditates on the scenery:

Clark, Pierce, Stone. Gossier. No names of mine.

The vixen I met at twilight on Route 5
south of Lake Willoughby: long dead. She was an omen.
to me, surviving, herding her cubs
in the silvery bend of the road
in nineteen sixty five.

Shapes of things: so much the same
they feel like eternal forms: the house and barn
on the rise above May Pond; the brow of Pisgah[64]

The lines are swirling with personal and historical memory: the "vixen" recalls her 1968 poem "Abnegation," in which the fox first appears as a metaphor for the Scottish Covenanters who settled in New England in the late seventeenth century, self-proclaimed "chosen people" in "the New Israel" of early America. Rich "re-visions" the fox in "Sources," for

it now represents an "omen" of having to mother her own children after her husband's suicide in 1970, and it becomes a metaphor later in the poem for Jews who strategize in the face of antisemitism.[65] The reference to "May Pond" also invokes her personal relationship with Lorde, as Rich would often invite Lorde and her partner Frances Clayton to stay in the Vermont summer house that she used to share with her former husband.[66] But Rich's embodied performance at the Astraea event also sounds deeply personal in this initial section, starkly contrasting not only with the "Poetry Voice" she imitates in the confessional framing of the poem but also with Lorde's multiregister, vibrato laden performance at the same event. The monotone delivery, the slow speaking rate, and the extended pauses—especially between "Willoughby" and "long dead"—vocally convey both distance and contemplation. If anything, the Astraea recording suggests how much less affected—or more conversational—Rich's voice had become since that earlier 1951 recording, although the Astraea reading voice is no less performative or affecting. Rich's reading voice at Astraea was much closer in pitch and timbre to the voice she used to converse with Lorde on stage.

"Sources," as critic Mary Strine has suggested, may represent a shift away from the "confrontational emphasis . . . of [Rich's] earlier work," but as the poem becomes more conversational in theme and form, the speaker's voice also becomes much *less* passive and observational.[67] The voice of section 2 of "Sources" asserts itself directly ("I refuse to become a seeker for cures") even as it becomes more introspective ("Old things, diffuse, unnamed, lie strong across my heart").[68] And in section 3, the speaker's voice fragments under the pressure of this inwardness, yielding a conversational typography—of italics and midline caesura—that reflects what Rich called, in a 1976 interview with Elly Bulkin, the "lesbian rhythms" of contemporary poetics.[69] A nineteenth-century theory of poetry as "utterance overheard" has long reified Hegelian theories of lyric that emphasize solitude and internally consistent forms of subjectivity.[70] But in "Sources," a poeticized overhearing causes subjectivity and history to break open:

> *From where?* the voice asks coldly
> This is the voice in cold morning air
> that pierces dreams. *From where does your strength come?*

Old things . . .
> *From where does your strength come, you Southern Jew?*
> *split at the root, raised in a castle of air?*

> Yes. I have expected this. I have known for years
> the question was coming. *From where*[71]

Who's speaking here? Is it that "older voice, older self" that Lorde suggested necessarily haunts poetry? Is it the voice of Psalm 121, in which the speaker "looks up at the mountains" and asks "From where will my help come?"[72] In either reading, the voice is challenging the speaker to listen more actively. Being a more active listener does not necessarily mean talking back to this voice—she never responds to "*From where?*" with "*from here.*" Instead, listening actively means hearing the very sound, even the temperature, of that voice. Rich frames how the voice should be heard and felt, situating the utterance with a dialogue tag ("the voice asks coldly"), describing its effect on atmospheric conditions ("This is the voice in cold morning air"), and reflecting on its power to cause a pause-filled, inward turn ("Yes. I have expected this"). The phrase "From where" repeats four more times over the course of the section, until the next section, in which the question changes slightly:

> With whom do you believe your lot is cast?
> *From where does your strength come?*

> I think somehow, somewhere
> every poem of mine must repeat those questions

> which are not the same. There is a whom, a where
> that is not chosen that is given and sometimes falsely given

> in the beginning we grasp whatever we can
> to survive.[73]

The "question of voice" in this poem has now become two questions that point in two different directions. To invoke a cliché of diaspora studies: while the question of "*From where*" points backward toward roots, the

question of "*With whom*" looks toward routes. The effect of repeating this question "*From where?*" until it splits is the dramatization of the speaker's transformation from a passive observer into an active listener, one that hears not only the difference between the questions but also the layers of history that map, as she describes it earlier at the Astraea event, a complex "geography of soul."[74]

Rich's poeticization of listening resists the reification of identity into any unitary, "falsely given" sense of self, but she also used her embodied voice to explore this aesthetic and ethical territory when performing this part of "Sources" at the Astraea event. In voicing that first "*From where?*" Rich elevated the pitch on the last stressed syllable of the iamb, just as she did when she first described "*that voice*" of the white male poets. That is, Rich read the italicized voice with the same pitch pattern and declamatory style of that "Poetry Voice" she so feared would possess her in the writing of this poem. She also aspirated "wh" at the beginning of the word "where" so that it sounds like "hwhere," signifying a lingering southernness in her embodied voice, one that she used selectively throughout the Astraea event and the rest of her performance career.[75] In both evoking the bravado of the archetypical white male poet and temporarily emphasizing the southern accent that she was so often encouraged to suppress—in reading her poem in at least two different vocal registers—Rich acoustically performed the split nature of her identity that her poem famously explores. In the performance of "Sources," then, Rich's voice resonates with the multiregister performance style of Lorde, though Rich's registers sound very different than Lorde's.

After Rich finished reading from "Sources," Lorde said she wishes she could "keep listening," and Rich launched into a description of the particular use of the poem: "As you said, [a poem can be] like the shard in the earth with the inscription and [I] pull it out again . . . when I needed contact with some power from myself that I had temporarily lost track of: No. [Sources] isn't that, and this poem, as it exists, could never be that for me."[76] As she goes on to explain, the use of poetry Rich wanted to attend to in the reading of a draft of "Sources" were the provisional and the unpublished, the kind that is never finished, perhaps not even read in public or ever published. Lorde jumped in to disagree: "It's useful not just to you as a record for you, it's useful to all of us to in that sense, not just in this dialogue, but as a work." Rich effectively said, "Well, not quite." In the

Signs interview, we saw how the conversation about Rich's "white voice" inaugurated a heated moment of disagreement between them after which a shift toward thinking about poetry's "use" was a way to move the conversation forward without resolving in agreement. But in the Astraea event recording, one can hear how the two—in conversing about poetry's uses and in using multiple registers of their own voices—explored the acoustic and affective space of disagreement without flattening their differences. Though Rich wasn't sure of it at the time, the existence of the recording forty years later suggests that Lorde was at least partially correct: the reading is useful "not just in this dialogue, but as a work." The recording documents the genesis of one of Rich's most conversational poems to date, but also the aesthetic and social labor that is conversation.

Prophetic Voice

"No other kind of language in [Rich's] poems can do as much as conversation," writes critic Nick Halpern in a study of the prophetic voice of Rich's poetry. "Conversation can be valued so intensely [for her] because it is, apart from everything else, a way of being useful."[77] But what happens when "conversation" itself becomes abstracted from particularities of experience, histories of power, and the materiality of embodied performance? Studies of Black and Jewish culture that take seriously these questions often tell a history of appropriation. And rightly so. As Jennifer Glaser has shown in her reading of postwar Jewish American fiction (following the influential work of Michael Rogin on Hollywood film), racial ventriloquism and transracial identification were literary tactics for Jewish writers to "disavow their whiteness (and, with it, their white privilege)."[78] At least since 1955, the history of Rich's engagement with blackness begins with this appropriative history.[79] But by the time of the Astraea event in 1981, Rich was thinking extensively about the possibilities and dangers of speaking for or on behalf of other women, and her relationship with Lorde was crucial to re-visioning the legacy of Blackness in her work.[80] In that same 1979 letter in which she "refused" to become Lorde's "voice," Rich also says that she "cannot afford ever to stop asking [her]self, How am I using Audre's blackness?"[81] Because these questions of how racial privilege and appropriation function in poetry are always on the table for

Rich and Lorde—they are a *frequent* topic of conversation—the Astraea event provides a case study for thinking about how it wasn't ventriloquism ("speaking for"), nor representation ("speaking on behalf of"), but conversation ("speaking alongside" or "with") that afforded them a framework for publicly resisting the reification of their identities, their voices, and their relationship.

Rich's essay "Split at the Root" makes it clear that the Black civil rights movement in general and James Baldwin's writing in specific urged her to investigate the silenced Jewishness in her own life. And Lorde in turn invoked Jewish experience to explore her own relationship to racial formation, both domestically and abroad. Any reader of even the first fifty pages of Alexis De Veaux's biography knows that Lorde was surrounded by Jews, both lovers and leftists. In her early poetry and in her biomythography, *Zami*, Lorde recognizes that both white Jews and Black people are the object of white ire, but in wildly uneven ways.[82] In her essay "Notes from a Trip to Russia" (1976), Lorde implies that Soviet attitudes toward Russian Jews would offer insight into their attitudes toward American racism.[83] As she began to travel to Germany more often in the eighties, Lorde translated her anti-racist politics to a German audience by speaking about Jewishness.[84] As one of the century's foremost thinkers on the relationship among gender, sexuality, and diasporic identity, as well as an international activist who understood the difference between antisemitism and anti-Zionism, Lorde was a sympathetic ear for Rich as the latter struggled to decolonize her own perceptions and think through her relationship to Jewishness in the early 1980s. Because Lorde was a powerful interlocutor and a sympathetic, yet critical, listener, the 1981 conversation between Rich and Lorde becomes another diasporic space in which Rich publicly claims her Jewish identity through the reading of "Sources."

Listening to Lorde and Rich negotiate the meaning of a poem through embodied conversation suggests that the "prophetic" is a crucial analytic by which to interpret their performance practice. In the Jewish biblical tradition, prophetic poetry is crucially "fictive": a literary and emotional technology for approximating what God's voice would sound like *if* we could hear it.[85] While the psalms and prophetic prose of the biblical texts emphasized the relationship between God and an individual, prophetic poetry historically emphasized the triad of god-prophet-people: it is deeply connected to the historic experience of speaking to a live audience.[86] In the

African American poetic tradition, it is not (just) the voice of God but the silenced voice of enslaved people that poetic language often mediates.[87] Both Lorde and Rich have frequently been thought of as "prophetic poets," though the application of this term focuses on the monitory function of their work and tends to obscure how embodied performance lies at the center of both ancient and contemporary prophetic poetry.[88] Listening to Lorde's and Rich's recorded voices requires that we pay attention to how the hearing and speaking of written words construct another level of "fictive" meaning, one created between the page and the stage. This performative notion of "prophecy" sets their work both with and against a more political prophetic tradition, both in the Black and Jewish traditions, which doesn't emphasize poetic language per se but instead social justice. Cornel West defines the Black prophetic tradition most clearly as "an infectious and invigorating way of life and struggle. Its telling signs are ethical witness (including maybe martyrdom for some), moral consistency, and political activism."[89] Lorde and Rich's performance history reminds us of the performative aspect of West's definition, that the very speaking of certain words is meant to inspire and effect the change that the content of the utterance promises.

It is not only the speaking of the words but also their afterlife as recorded sound that constitute what I would describe as Lorde and Rich's queer, feminist counterpublic. Against transcendent notions of lyric and Habermasian rational-critical "dialogue," queer counterpublics have a prophetic function in that they seek to "establish a world in which embodied sociability, affect, and play have a more defining role."[90] The Astraea recording documents Lorde and Rich speaking to a very specific public, but because it also exists as an aural object available on the internet, it "commits itself in principle to the possible participation of any stranger."[91] The poetics of conversation continue to resonate through this counterpublic with every critical listening: conversation unfolds in Donna Allegra's review, it replays over the feminist airwaves in the 1980s, it is restaged at a 2012 marathon reading of Lorde's and Rich's work at the Lesbian Herstory Archives, and it (hopefully) resounds in the very words of this essay.[92] By continuing to listen with an emergent counterpublic, we de-reify how we think about conversation as an aesthetic and social form, especially as that form appears in the field of Jewish American literature. The Astraea event is not a typical case study for the history of "Black-Jewish relations,"

and not just because Lorde and Rich do not talk about their relationship using that framework. Unlike in rote dialogues emblematizing Black-Jewish relations, for Lorde and Rich the question of method—how to have a conversation—is never hidden behind the question of value—whom that conversation serves and what it disguises. Rich and Lorde never shied away from exploring what Rebecca Pierce has recently called "the sorts of things that . . . make these [Black and Jewish] relationships hard": bodily disability, colonization, police brutality, white supremacy, and Christian hegemony.[93] These two poets used embodied performance to resist the reification of "conversation" into cliché by poeticizing it, dramatizing its very everydayness and yet lifting that everydayness into a crucial fictive realm through the performance of polyvocal poems. As a result, the conversation served as a performative space for documenting not only how structures of power affect diasporic life at the level of the senses but also how poetry functions as a method of reorienting the senses and a mode of prophesying worlds otherwise. And by virtue of it being recorded by the Lesbian Herstory Archives, the afterlife of the Astraea recording offers us a crucial tool by which to de-reify the constant banalization of the term "conversation" into a disembodied and mythologized notion of free speech in our own time. The recording invites us not only to embrace Rich's call to "re-vision" the past but to "re-sound" it: "the act of [listening] back, to [hear] with fresh [ears], to enter an old [recording] from a new critical direction."[94] What would it mean to hear forward? What would it mean to enter every conversation we have with another person with this level of poetic aliveness?

Notes

Thank you to the Audre Lorde Literary Trust and the Adrienne Rich Literary Estate for permission to quote from unpublished personal correspondence. The letters cited in this article are part of the Audre Lorde Papers at the Spelman College Archives. Many thanks to archivist Holly Smith at Spelman for her generosity of time and spirit in curating the materials for my research. I also want to acknowledge the labor of the Lesbian Herstory Archives archivists, who generously invited me into the space and offered a quiet place to work. The lines from "Sources." Copyright © 2016 by the Adrienne Rich Literary Trust.

Copyright © 1986 by Adrienne Rich, the lines from "Hunger." Copyright © 2016 by the Adrienne Rich Literary Trust. Copyright © 1978 by W. W. Norton & Company, Inc., from *Collected Poems: 1950–2012* by Adrienne Rich. Used by permission of W. W. Norton & Company, Inc. "A Litany for Survival." Copyright © 1978 by Audre Lorde, "Sequelae." Copyright © 1978 by Audre Lorde, from *The Collected Poems of Audre Lorde* by Audre Lorde. Used by permission of W. W. Norton & Company, Inc.

1 Audre Lorde and Adrienne Rich, *Astraea Benefit*, "Conversation with Poems" (tape 1 of 2, side 1). Lesbian Herstory Archives Audio Visual Collections, December 5, 1981, herstories.prattinfoschool.nyc/omeka/exhibits/show/audre-lorde/item/52.
2 Audre Lorde and Adrienne Rich, *Astraea Benefit*, "Conversation with Poems" (tape 2 of 2, side 1), 15:34, Lesbian Herstory Archives Audio Visual Collections, December 5, 1981, herstories.prattinfoschool.nyc/omeka/exhibits/show/audre-lorde/item/52.
3 Lesley Wheeler, *Voicing American Poetry: Sound and Performance from the 1920s to the Present* (Ithaca, NY: Cornell University Press, 2008).
4 Donna Allegra, "Lorde and Rich Fuel Spirits & Astraea," *WomaNews* 3, no. 2 (1982): 13.
5 Marit J. MacArthur, "Monotony, the Churches of Poetry Reading, and Sound Studies," *PMLA* 131, no. 1 (2016): 44.
6 Rebecca Lentjes, Amy E. Alterman, and Whitney Arey, "'The Ripping Apart of Silence': Sonic Patriarchy and Anti-Abortion Harassment," *Resonance* 1, no. 4 (2020): 424, https://doi.org/10.1525/res.2020.1.4.422.
7 Citing Bakhtinian dialogical theory, Mary Strine argues that Rich utilized polyvocality as "re-visionist" strategy, employing the voice of the spokeswoman, making public the private dialogue one has with oneself, and dramatizing the variegated social fabric. Strine, "The Politics of Asking Women's Questions: Voice and Value in the Poetry of Adrienne Rich," *Text and Performance Quarterly* 9, no. 1 (1989): 30–35. Mae Henderson reads Lorde's thematic engagement with the "other in ourselves" as heteroglossic. Henderson, "Speaking in Tongues: Dialogics, Dialectics, and the Black Woman Writer's Literary Tradition," in *African American Literary Theory: A Reader*, ed. Winston Napier (New York: New York University Press, 2000), 350.
8 Brooke Lober in "Adrienne Rich's 'Politics of Location,' US Jewish Feminism, and the Question of Palestine," *Women's Studies: An Interdisciplinary Journal* 46, no. 5–8 (2017): 663, has described the essay "Split at the Root" as Rich's first "extended meditation on Jewishness," but the Astraea

recording makes clear that the drafting of "Sources" preceded the drafting of "Split at the Root."
9 Rachel Rubinstein, "Textualizing Black-Jewish Relations," *Prooftexts* 22, no. 3 (Fall 2002): 400. Rubinstein is most explicitly referring to a third wave of "Black-Jewish relations" studies that includes E. Miller Budick, *Blacks and Jews in Literary Conversation* (New York: Cambridge University Press, 1998) and Adam Zachary Newton, *Facing Black and Jew: Literature as Public Space in Twentieth-Century America* (New York: Cambridge University Press, 1999).
10 Keith P. Feldman, *A Shadow over Palestine: The Imperial Life of Race in America*. (Minneapolis: University of Minnesota Press, 2015), 11. For Caribbean contexts, see Sarah Phillips Casteel, *Calypso Jews: Jewishness in the Caribbean Literary Imagination* (New York: Columbia University Press, 2016). For modernist and feminist contexts, see Lori Harrison-Kahan, *The White Negress: Literature, Minstrelsy, and the Black-Jewish Imaginary* (New Brunswick, NJ: Rutgers University Press, 2011). For mixed-race analysis, see Eli Bromberg, "'A Little More Jewish, Please': Black and Jewish Secularity and Invisibility in Fran Ross's Oreo," *Studies in American Jewish Literature* 38, no. 1 (2019): 23; and Rebecca Pierce, "Jews of Color and the Policing of White Space," *Jewish Currents*, May 29, 2020, jewishcurrents.org/jews-of-color-and-the-policing-of-white-space.
11 The SEEK program provided "students not only with free tuition and free books, but also a stipend that addressed the material conditions of students' complicated lives beyond the classroom." Danica Savonick, "Insurgent Knowledge: The Poetics and Pedagogy of Toni Cade Bambara, June Jordan, Audre Lorde, and Adrienne Rich in the Era of Open Admissions" (PhD diss., City University of New York, 2018), 14, CUNY Graduate Center Dissertations, Theses, and Capstone Projects, academicworks.cuny.edu/gc_etds/2604.
12 Audre Lorde, *The Cancer Journals*, special ed. (San Francisco: Aunt Lute Books, 1997), 101.
13 For the most thorough and recent history of the event, see Hilary Holladay, "When Adrienne Rich Refused the National Book Award." *Literary Hub*, November 23, 2020, lithub.com/when-adrienne-rich-refused-the-national-book-award/.
14 There is a minor critical history of Lorde and Rich's relationship buried in reviews of feminist magazines between the 1970s and '80s. See Judith McDaniel's review of Adrienne Rich's *The Dream of a Common Language*, where McDaniel reads Rich's poem "Hunger" as a kind of allegory of their relationship's political meaning McDaniel, "To Be of Use: Politics and

Vision in Adrienne Rich's Poetry," *Sinister Wisdom* 7 (Fall 1978): 92–99. In a 1983 article, Cathy Carruthers distinguishes between Rich's and Lorde's poetry on the basis of their reliance on different mythic system but argues that their works, along with those of Olga Broumas and Judy Grahn, constitute a new, eschatological turn in lesbian poetry. Carruthers, "Re-vision of the Muse: Adrienne Rich, Audre Lorde, Judy Grahn, Olga Broumas," *Hudson Review* 36 (1983): 294, https://doi.org/10.2307/3856702. Linda Alcoff's "Cultural Feminism versus Post-structuralism: The Identity Crisis in Feminist Theory," *Signs: Journal of Women in Culture and Society* 13, no. 3 (1988): 405–36, famously places Rich and Lorde on two different sides of cultural feminism, positioning Rich as the essentialist and Lorde as the antiessentialist. Linda Garber powerfully debunked Alcoff's dichotomy, considering Rich and Lorde distinctly while still arguing that they share a deep concern with the aestheticization of silence. Garber, *Identity Poetics: Race, Class, and the Lesbian-Feminist Roots of Queer Theory*, Between Men, between Women: Lesbian and Gay Studies (New York: Columbia University Press, 2012), 139–42.

15 Adrienne Rich, "Hunger," in *Collected Poems: 1950–2012* (New York: W. W. Norton, 2016), 451.

16 Alexis De Veaux, *Warrior Poet: A Biography of Audre Lorde* (New York: W. W. Norton, 2004), 187.

17 Hilary Holladay, *The Power of Adrienne Rich* (New York: Penguin, 2020), 322; Hilary Holladay, "When Adrienne Rich Refused the National Book Award." *Literary Hub*, November 23, 2020. lithub.com/when-adrienne-rich-refused-the-national-book-award/; and De Veaux, *Warrior Poet*, 238. Lorde had long been frustrated with the disorganization at *Chrysalis*, especially with Kristen Grimsted. But after repeatedly undermining her editorial decisions in ways she believed to be silencing writers of color and herself, *Chrysalis* became emblematic for her—along with June Jordan and Pat Parker—of the racism intrinsic to white liberal institutions. See SaraEllen Strongman, "'Creating Justice between Us': Audre Lorde's Theory of the Erotic as Coalitional Politics in the Women's Movement," *Feminist Theory* 19, no. 1 (2017): 51; and De Veaux, *Warrior Poet*, 258.

18 Adrienne Rich, "Letter to Audre Lorde," Box 4, Folder 1.1.106 (Correspondents), 1979. Audre Lorde Papers, Spelman College, Atlanta.

19 On March 7–9, they traveled to St. Croix for a conference organized by Gloria Joseph (De Veaux, *Warrior Poet*, 285–89); on May 9, 1981, they both read at the Arlington Street Church in Boston to celebrate the publication of *The Lesbian Poetry Anthology* (Anna M. Warrock, "Lesbian Poetry: A New

Vision," *Sojourner*, July 1981, 25); they gave keynote speeches in June at the National Women's Studies Association (NWSA); and they both read at the Women's Experimental Theater in New York City, albeit at different times (Clare Coss, Sandra Segal, Audre Lorde, and Eileen Zalisk, *The Velvet Sledgehammer* [recording of December 12, 1980, poetry reading by Audre Lorde], Pacifica Radio Archives, Los Angeles, 1980, https://avplayer.lib.berkeley.edu/Pacifica/991035425189706532).

20 Black Power, Dollinger concludes, "proved quite good for the Jews" in that it offered various Jewish communities a model for pursuing a political platform based on their own "ethnic particularity." Marc Dollinger, *Black Power, Jewish Politics: Reinventing the Alliance in the 1960s*, Brandeis Series in American Jewish History, Culture, and Life (Waltham, MA: Brandeis University Press, 2018), 140, https://doi.org/10.2307/j.ctv102bfs2.

21 Norman Podhoretz, "Is It Good for the Jews?" *Commentary*, February 1972.

22 In *Black Power, Jewish Politics*, Dollinger does give us a history of Judge Justine Wise Polier's activism with AJCongress (32), and he acknowledges that Jewish opposition to affirmative action was largely blinkered by its elision of Jewish women (67). But his own analysis suffers from such elision: Dollinger only offers two pages on feminism in the 1970s (129–31).

23 Most famously articulated in the 1977 Combahee River Collective Statement, the "identity politics" of Black lesbian feminists in the late 1970s largely resisted separatism and offered a theoretical and practical tool for organizing and thinking beyond the logic of a shared, common oppression. Lorde and Rich were a generation older than lesbian feminist groups like the Combahee Collective and Di Vilde Chayes, and yet they influenced these groups: Lorde's "politics of difference" helped shape the future of intersectional thinking (Jack Turner, "Audre Lorde's Politics of Difference," in African American Political Thought: A Collected History, ed. Melvin L. Rogers and Jack Turner [Chicago: University of Chicago Press], 2020, 567–69, https://doi.org/10.7208/chicago/9780226726076.001.0001), and Rich's emerging "politics of location" modeled what it was like for a white Jewish lesbian woman to name—and aestheticize—her own particularities (Adrienne Rich, "Notes toward a Politics of Location," in *Blood, Bread, and Poetry: Selected Prose* [New York: W. W. Norton, 1986], 210–31).

24 Dollinger, *Black Power, Jewish Politics*, 185.

25 Simmons poem features the lines: "mine is not a People of the Book/taxed / but acknowledged; their distinctiveness is / not yet a dignity; their Holocaust is lower case." Judy Simmons, "Minority," *Conditions* 5 (Autumn 1979): 93.

26 Mina Kim, dir., *Poet Claudia Rankine's Book "Just Us" Seeks Out "True Conversation" about Race*, 15:30, KQED, September 10, 2020, www.kqed.org/forum/2010101879621/poet-claudia-rankines-book-just-us-seeks-out-true-conversation-about-race.

27 Ada Gay Griffin, Michelle Parkerson, and Audre Lorde, dirs., *A Litany for Survival: The Life and Work of Audre Lorde* (videorecording), 52:24, Third World Newsreel, New York, 1998.

28 The term "reification" bears the mark of Rich's interest in Marxist thinking in the late 1980s early '90s, but it helpfully describes the numerous ways in which a complex set of social relations and identitarian affiliations that existed within and between the two poets were made into an understandable, even sellable commodity for public consumption. Such reification took many forms, perhaps most often through the tokenization of Lorde, where her inclusion in feminist spaces was perceived as a way for white women to check the box of diversity on their attendance lists. Moreover, Rich often perceived her name as being used as a way to legitimize Lorde's career and fought openly against such legitimization by association. Marion Rust, "Making Emends: Adrienne Rich, Audre Lorde, Anne Bradstreet," *American Literature* 88, no. 1 (2016): 96. The term also helpfully moves between abstract and the concrete, as well as individualist and structural, critiques of political economy. Anita Chari writes, "The concept of reification . . . refers to the very process of becoming material and 'thingly' . . . Reification, [Lukács] argued, is above all an unengaged, spectatorial stance that individuals take toward the social world and toward their own practices." Anita Chari, *A Political Economy of the Senses: Neoliberalism, Reification, Critique* (New York: Columbia University Press, 2015), 5. The movement between abstract and concrete, individual and structural notions of voice are what I'm most interested in: if de-reification is to make visible the social processes by which commodities form, it also means to hear the social processes at work behind the "thingification" of conversation.

29 Marion Rust, "Making Emends: Adrienne Rich, Audre Lorde, Anne Bradstreet," *American Literature* 88, no. 1 (2016): 94–95.

30 SaraEllen Strongman, "'Creating Justice between Us': Audre Lorde's Theory of the Erotic as Coalitional Politics in the Women's Movement," *Feminist Theory* 19, no. 1 (2017). One crucial quote from Lorde's November 1979 letter to Rich is "What are the demands and pitfalls of an open and close and direct relationship between a black woman and white woman who are not lovers?" Audre Lorde, "Letter to Adrienne Rich," Box 4,

Folder 1.1.004 (Letters written by Audre Lorde [?] May 10, 1992), 1979, Audre Lorde Papers, Spelman College, Atlanta.
31 Savonick, "Insurgent Knowledge," 57, 94.
32 Adrienne Rich, "Letter to Audre Lorde," Box 4, Folder 1.1.105 (Correspondents), n.d., Audre Lorde Papers, Spelman College, Atlanta. I date this letter to late 1978 as it refers to *The Black Unicorn* (1978) as Lorde's latest book of poems and to Lorde's cancer operation "last year," which may refer to Lorde's surgery in November 1977. More than a decade later, in a letter dated December 18, 1990, Rich wrote to Lorde that the "poetry reading is not just a communal sharing of art but an act of teaching.... Does that mean that poetry is reduced to pedagogy? Of course not. What we are 'teaching' is not information but a different kind of knowledge, sensual, dark and erotic as you said in 'Poetry Is Not A Luxury'" (Adrienne Rich, "Letter to Audre Lorde," Box 4, Folder 1.1.108 [Correspondents], 1990, Audre Lorde Papers, Spelman College, Atlanta). Rich was constantly resisting the claim that her political poetry was "didactic." Both she and Lorde were practicing teachers, who constantly thought deeply about how teaching was an embodied, transformative, and dangerous experience. The poetry reading was thus, for Rich, a form of teaching in this more nuanced understanding.
33 Erving Goffman, *Forms of Talk* (Philadelphia: University of Pennsylvania Press, 1981), 14.
34 Goffman, 137.
35 Lorde and Rich, *Astraea Benefit* (tape 1 of 2, side 1), 7:18, herstories.prattinfoschool.nyc/omeka/exhibits/show/audre-lorde/item/52.
36 Audre Lorde, "Poet as Teacher—Human as Poet—Teacher as Human," in *I Am Your Sister: Collected and Unpublished Writings of Audre Lorde*, ed. Rudolph P. Byrd, Johnnetta B. Cole, and Beverly Guy-Sheftall, Transgressing Boundaries (Oxford: Oxford University Press, 2009), 183.
37 This sort of statement that is immediately qualified reflects a rhetorical technique that Lorde often used in her prosaic works that Lester Olson refers to as "shifting subjectivities." Olson sees this happening in her 1981 NWSA speech on "the uses of anger," where Lorde "articulates a shift in the second person of an address, wherein the auditors or readers occupy one kind of role initially and then, drawing on what is remembered or learned from that position, are repositioned subsequently into a different role that is harder for them to recognize or occupy, but that might possess some transforming power." Olson, "Anger among Allies: Audre Lorde's 1981 Keynote Admonishing the National Women's Studies Association," *Quarterly Journal of Speech* 97, no. 2 (2011): 296.

38 Lorde and Rich, *Astraea Benefit* (tape 1 of 2, side 1), 14:24, herstories.prattinfoschool.nyc/omeka/exhibits/show/audre-lorde/item/52.
39 Rust, "Making Emends," 111. This happens again when Lorde dramatically shifts the framing of the event, calling attention to the embodied presence of the sign language interpreter, Susan Freundlich. Rich, then, begins telling a story about reading Chinese ideograms at Audre Lorde's kitchen table. Though the anecdote problematically elides Chinese with deafness through the category of the nonverbal, part of the affective power of the moment stems from shifting the frame: how Rich enfolds a scene from Audre Lorde's kitchen into the context of the public poetry reading.
40 The letters between Rich and Lorde reveal that, beyond this interview, the published interview was itself generic reification of the difficult and painful process of conversation and publication. Lorde writes in her November 1979 letter: "One of the reasons it was so hard was because in the spring [of 1979], you had said to me that you wanted to write something about my work. The next thing I knew it was an interview. So what it felt like was, when it came down to it, you did what all the other white girls do, stick a mic in my face and say talk." Lorde, "Letter to Adrienne Rich," 1979.
41 Audre Lorde and Adrienne Rich, "An Interview with Audre Lorde," *Signs: Journal of Women in Culture and Society* 6, no. 4 (1981): 731.
42 Lorde and Rich, 732 and 733.
43 Lorde and Rich, 731.
44 Lorde and Rich, *Astraea Benefit* (tape 2 of 2, side 1), 22:34, herstories.prattinfoschool.nyc/omeka/exhibits/show/audre-lorde/item/49. Lorde reads four entire poems at the Astraea event: "A Litany for Survival," "Sequelae," "Power," and "Meet." She speaks about her poem "After Images" and reads selections from her in-progress poem "Outlines."
45 Alex Ullman, "Audre Lorde, Sound Theorist: Register, Silence, Vibrato, Timbre," *PMLA* (forthcoming).
46 Audre Lorde, "Litany," in *The Collected Poems of Audre Lorde* (New York: W. W. Norton, 1997), 255.
47 De Veaux, *Warrior Poet*, 206.
48 Virginia Walker Jackson and Yopie Prins, *The Lyric Theory Reader: A Critical Anthology* (Baltimore: Johns Hopkins University Press, 2014), 3.
49 Lorde and Rich, *Astraea Benefit* (tape 2 of 2, side 1), 26:06, herstories.prattinfoschool.nyc/omeka/exhibits/show/audre-lorde/item/49.
50 Ullman, "Audre Lorde."
51 Audre Lorde, "Sequelae," in *Collected Poems*, 249.
52 Lorde, 249.

214 Alex Ullman

53 Throughout Isaiah, for instance, the act of giving birth is metaphorized for God's speaking voice ("I have been silent a very long time . . . like a woman in labor I now shriek" [Isaiah 42:14]). Idols should also be smashed at a distance comparable to the one kept from the menstruant woman ("You shall scatter them like a woman in her uncleanness" [Isaiah 30:22]).

54 Lorde and Rich, *Astraea Benefit* (tape 1 of 2, side 1), 27:20, herstories.prattinfoschool.nyc/omeka/exhibits/show/audre-lorde/item/52.

55 Audre Lorde and Adrienne Rich, *Astraea Benefit*, "Conversation with Poems" (tape 1 of 2, side 2), 1:44, Lesbian Herstory Archives Audio Visual Collections, December 5, 1981, herstories.prattinfoschool.nyc/omeka/exhibits/show/audre-lorde/item/52.

56 Lorde and Rich, *Astraea Benefit* (tape 1 of 2, side 2), 2:36, herstories.prattinfoschool.nyc/omeka/exhibits/show/audre-lorde/item/52.

57 In the first half of the event, Rich reads three poems from *A Wild Patience*: "Transit"; Self-Hatred and "Particularity" (both from a larger poem titled "Turning the Wheel"); and "For Memory."

58 MacArthur and colleagues write that in a study of over one hundred poets' performance styles, "[w]e would expect poets who read in a more Formal style to have predictable rhythm and speak relatively slowly, with fairly regular pauses." Marit J. MacArthur, Georgia Zellou, and Lee M. Miller, "Beyond Poet Voice: Sampling the (Non-) Performance Styles of 100 American Poets," Journal of Cultural Analytics 3, no. 1 (April 18, 2018): 28, culturalanalytics.org/article/11039-beyond-poet-voice-sampling-the-non-performance-styles-of-100-american-poets. For a recent investigation into forms of address in Rich's work, see Talia Shalev, "Adrienne Rich's 'Collaborations': Re-vision as Durational Address," *Women's Studies* 46, no. 7 (2017): 646–62.

59 Rich's earliest collected poem dealing with Jewish themes is "The Jewish New Year" (1955) and her 1960 poem "Readings of History" (1960) is where she described herself for the first time, in the fifth section titled "The Mirror," as "Split at the root, neither Gentile nor Jew, / Yankee nor Rebel." Zohar Weiman-Kelman has also persuasively reread Rich's 1968 translations of the Yiddish poet Kadya Malodowsky through queer temporality theory, arguing that both Rich and Malodowsky questioned normative notions of Jewish continuity and belonging. Weiman-Kelman, *Queer Expectations: A Genealogy of Jewish Women's Poetry*. SUNY series in Contemporary Jewish Literature and Culture (Albany: State University of New York Press, 2018), 1–22.

60 Lorde and Rich, *Astraea Benefit* (tape 2 of 2, side1), 27:17, herstories.prattinfoschool.nyc/omeka/exhibits/show/audre-lorde/item/49. Rich's

later essay "Split at the Root" (1982) describes in even more detail—beyond the suppression of a southern accent—how her father's internalized self-hatred of his Jewishness was mapped onto her voice:

> I am in a play-reading at school, of *The Merchant of Venice*.... I am the only Jewish girl in the class and I am playing Portia. As always, I read my part aloud for my father the night before, and he tells me to convey, with my voice, more scorn and contempt with the word "Jew": "Therefore, Jew ..." I have to say the word out [*sic*], and say it loudly. I was encouraged to pretend to be a non-Jewish child acting a non-Jewish character who has to speak the word "Jew" emphatically. (Adrienne Rich, "Split at the Root," in *Nice Jewish Girls: A Lesbian Anthology*, ed. Evelyn Torton Beck [Watertown, MA: Persephone Press, 1982], 70)

61 Auden's introduction to *A Change of World* (1951) is usually cited as the most overt link to this tradition; see Aidan Wasley's *The Age of Auden: Postwar Poetry and the American Scene* (Princeton, NJ: Princeton University Press, 2011), 147, for an insightful analysis of how Auden comes to stand in for the poetic tradition itself in Rich's work. If Auden famously said, in his rejection of utilitarian theories of art, that "poetry does nothing," the Astraea event was a strong riposte to this modernist sentiment on the axes of politics and performance.
62 Holladay, *Power of Adrienne Rich*, 87.
63 Adrienne Rich, "Aunt Jennifer's Tigers," PennSound, 1951, media.sas.upenn.edu/pennsound/authors/Rich/Rich-Adrienne_2_Aunt-Jennifers-Tigers_Woodberry-Poetry-Room-Reading_1951.mp3.
64 Adrienne Rich, "Sources," in *Collected Poems*, 573.
65 As Talia Shalev writes, "re-vision" has become a "keyword" in Rich criticism. Shalev, "Adrienne Rich's 'Collaborations': Re-vision as Durational Address," *Women's Studies* 46, no. 7 (2017): 647. The original use of "re-vision" stems from Rich's influential 1971 essay "When We Dead Awaken: Writing as Re-vision," where she defines it as "the act of looking back, of seeing with fresh eyes, of entering an old text from a new critical direction." Rich, "When We Dead Awaken," in *On Lies, Secrets, and Silence: Selected Prose, 1966–1978* (New York: W. W. Norton, 1979), 35. On the latter point, see section 5: "my kin / the Jews of Vicksburg or Birmingham / whose lives must have been strategies no less / than the vixen's on Route 5" (Rich, "Sources," 576). At the Astraea event, she reads "Atlanta" instead of "Birmingham," the former city being the original settling place of her

Hungarian grandfather, Samuel Reich. Holladay, *Power of Adrienne Rich*, 11.

66 In a letter from August 15, 1979, she described how Lorde's visits established a "profound continuity" for her with the Vermont landscape, especially after her husband's suicide. Adrienne Rich, "Letter to Audre Lorde," Box 4, Folder 1.1.105 (Correspondents), 1979, Audre Lorde Papers, Spelman College, Atlanta. And on August 2, 1981, Rich wrote to Lorde, after a short visit in Vermont one evening, that she and her partner, Michelle Cliff, "drove home like wildfire with one stop at Fairlee Diner—I almost immediately went into my study & started rereading old poems abt VT—then started writing a new one—it is very long & strange & scares me—but I know, I KNOW it is saying the stuff I have to say—May Pond is in it—when there's a first draft I'll send you a copy." Adrienne Rich, "Letter to Audre Lorde," Box 4, Folder 1.1.107 (Correspondents), 1981, Audre Lorde Papers, Spelman College, Atlanta. Attached to the letter is a postcard from the Shelbourne Museum in Vermont, which features a painting titled *The Garden of Eden* by Erastus Salisbury Field depicting an interpolation of the biblical scene with New England foliage and landscape: an aesthetic akin to the opening stanza of "Sources."

67 Strine, "Politics of Asking," 33.

68 Rich, "Sources," in *Collected Poems*, 573.

69 Poems with lesbian rhythms are, for Rich, "[t]hese long-line poems, very open, very loose, yet very dynamically charged . . . where the poem interrupts itself, where there are two voices against each other in the poem or maybe three or the poet's own voice against her voice, which echoes the kind of splitting and fragmentation women have lived in, the sense of being almost a battleground for different parts of the self. This is something I haven't seen before in poetry." Elly Bulkin, "An Interview with Adrienne Rich (Part 2)," *Conditions*, October 1977, 55.

70 Jackson and Prins, *Lyric Theory Reader*, 456.

71 Rich, "Sources," in *Collected Poems*, 574.

72 Robert Alter, *The Hebrew Bible: A Translation with Commentary*, vol. 3, *Writings* (New York: W. W. Norton, 2019), 292.

73 Rich, "Sources," in *Collected Poems*, 575.

74 Lorde and Rich, *Astraea Benefit* (tape 1 of 2, side 2), 5:05, herstories .prattinfoschool.nyc/omeka/exhibits/show/audre-lorde/item/52.

75 As noted in *The Atlas of North American English*, "In the middle of the twentieth century, the distinction between /hw/ and /w/ in *whale* vs. *wail*," for instance, "was maintained by most American speakers." But by the end of the twentieth century, "the distinction is made only by a scattering of

speakers, mainly concentrated in southern states." William Labov, Sharon Ash, and Charles Boberg, *The Atlas of North American English: Phonetics, Phonology and Sound Change* (Berlin: De Guyter Mouton, 2008), 50. When Rich performs "For Memory" earlier that night at the event—a poem that features the lines "and form whom? To what?"—she doesn't aspirate the first syllables of those two words.

76 Audre Lorde and Adrienne Rich, *Astraea Benefit, "Conversation with Poems"* (tape 1 of 2, side 2). Lesbian Herstory Archives Audio Visual Collections, December 5, 1981, herstories.prattinfoschool.nyc/omeka/exhibits/show/audre-lorde/item/52.

77 Nick Halpern, *Everyday and Prophetic: The Poetry of Lowell, Ammons, Merrill, and Rich* (Madison: University of Wisconsin Press, 2003), 220.

78 Jennifer Glaser, *Borrowed Voices: Writing and Racial Ventriloquism in the Jewish American Imagination* (New Brunswick, NJ: Rutgers University Press, 2016), 4.

79 Rich herself noted that her 1955 poem "The Diamond Cutters" had "[drawn], quite ignorantly, on the long tradition of domination . . . the enforced and exploited labor of actual Africans in actual diamond mines." Adrienne Rich, "The Diamond Cutters," in *The Fact of a Doorframe: Selected Poems, 1950–2001*, new ed. (New York: W. W. Norton, 2002), 329. As late as 1971, in the peroration of her famous essay "When We Dead Awaken: Writing as Re-vision," she testifies that she dreamed that she "was asked to read [her] poetry at a mass women's meeting, but when [she] began to read, what came out were the lyrics of a blues song." Rich, *On Lies*, 48. By the late 1970s, Rich was powerfully owning this appropriative legacy: in a footnote to the essay's reprinting in 1979, she writes "A.R., 1978: When I dreamed that dream, was I wholly ignorant of the tradition of Bessie Smith and other women's blues lyrics which transcended victimization to sing of resistance and independence?"

80 In "When We Dead Awaken" (1971), for example, she condemns more appropriative, patriarchal notions of speaking "for," whereas in "Vesuvius at Home: The Power of Emily Dickinson" (1975) she praises the ability to speak for those "who . . . are less conscious of what they are living through" (Rich, *On Lies*, 181). See Lorde's "Sexism: An American Disease in Blackface" for a critique of representative notions of "speaking for" other women.

81 Rich, "Letter to Audre Lorde," Box 4, Folder 1.1.106 (Correspondents), 1979.

82 In chapter 8 of *Zami*, Lorde tells a story of how her landlord committed suicide ostensibly because he had learned he had to rent to Black people. In a sudden juxtaposition at the end of the paragraph, Lorde writes, "He had

been Jewish; I was Black. That made us both fair game for the cruel curiosity of my pre-adolescent classmates." Audre Lorde, *Zami, a New Spelling of My Name* (Berkeley, CA: Crossing Press, 1982), 59.

83 Audre Lorde, "Notes from a Trip to Russia," in *Sister Outsider: Essays and Speeches* (Berkeley, CA: Crossing Press, 2007), 30.

84 In several essays and speeches, Jews function as an exception to the incommensurability of Black and white experience. See Lorde, "Age, Race, Class, and Sex," in *Sister Outsider*, 118, and her lecture in Dahlem on May 31, 1984, produced in Audre Lorde, Mayra A. Rodríguez Castro, and Dagmar Schultz, *Audre Lorde: Dream of Europe: Selected Seminars and Interviews: 1984–1992* (Chicago: Kenning Editions, 2020), 102. In *Warrior Poet*, De Veaux writes that after her first trips to Germany Lorde left feeling committed to helping non-Jewish women and German Jewish lesbians play a role in the battle against antisemitism (345), and her poem "This Urn Contains Earth from German Concentration Camps" is her only poetic attempt to think through the memorialization of Jewish death in the German context. Perhaps the most telling evidence, however, about her thoughts about the Holocaust appear in diary entry from February 1, 1981: "I am thinking of Anne Frank . . . her father kept more than 60% of her diary secret until after his death—all the parts about her conflicts with her mother and her becoming a woman—her sexuality which he said was too private. I wonder if it embarrassed him too much—why should her womanhood be so much more private than her death at the hands of German butchers?" Audre Lorde, "Journal 24 (1981)," Series 2, 002.5 (Journals), n.d., Audre Lorde Papers, Spelman College, Atlanta.

85 Robert Alter, *The Art of Biblical Poetry*, 2nd ed. (New York: Basic Books, 2011), 141.

86 Alter, 140.

87 Meta DuEwa Jones, *The Muse Is Music: Jazz Poetry from the Harlem Renaissance to Spoken Word*, New Black Studies Series (Urbana: University of Illinois Press, 2011), 3.

88 For Lorde and the monitory aspects of prophecy, see Flávia Santos de Araújo, "'Blessed within My Selves': The Prophetic Visions of Our Lorde," *Wagadu: A Journal of Transnational Women's and Gender Studies* 20 (2019): 8–31. In the continental English literary tradition, the Romantic Age marked a turn when the source of the prophetic utterance was no longer external (from God) but internal, within the psyche. Thus the romantic prophetic turn was an inward one, one that humanized the prophetic mode. Coleridge famously distinguished between poetry and prophecy by suggesting that while poetry was aimed at pleasure, it would be "not less irrational than strange to assert

that pleasure and not truth was the immediate object of the prophet." Dan Miron, *The Prophetic Mode in Modern Hebrew Poetry* (Milford, CT: Toby Press 2010), 137. Certainly, for Lorde and Rich, there was no clear distinction between pleasure and truth. Moreover, their politics deeply questioned the separation of the external and the internal. External forces—like ideology, capitalism, sexism—are ideologies that take on almost supernatural force in their poetry and haunt both the psyche and the body.

89 Cornel West, *Democracy Matters* (New York: Penguin, 2004), 215.
90 Michael Warner, *Publics and Counterpublics* (New York: Zone Books, 2002), 122.
91 Warner, 113.
92 To hear a version of the Astraea event replayed over the airwaves, see Donna Allegra, producer, *The Velvet Sledgehammer* [production reel of Adrienne Rich and Audre Lorde in conversation], Pacifica Radio, Los Angeles, 1982, avplayer.lib.berkeley.edu/Pacifica/991035425189706532. For information about the marathon reading event, see Harriet Staff, "Audre Lorde & Adrienne Rich Marathon Reading by Harriet Staff," Poetry Foundation, February 1, 2023, www.poetryfoundation.org/. https://www.poetryfoundation.org/harriet-books/2012/11/audre-lorde-adrienne-rich-marathon-reading.
93 "You People," *On the Nose* podcast, *Jewish Currents*, February 9, 2023, jewishcurrents.org/you-people.
94 See note 65 above for Rich's original passage in which she defines "re-vision."

Bibliography

Alcoff, Linda. "Cultural Feminism versus Post-structuralism: The Identity Crisis in Feminist Theory." *Signs: Journal of Women in Culture and Society* 13, no. 3 (1988): 405.

Allegra, Donna. "Lorde and Rich Fuel Spirits & Astraea." *WomaNews* 3, no. 2 (1982): 13.

———, producer. *The Velvet Sledgehammer* [production reel of Adrienne Rich and Audre Lorde in conversation]. Pacifica Radio Archives, Los Angeles, 1982. avplayer.lib.berkeley.edu/Pacifica/991035425189706532.

Alter, Robert. *The Art of Biblical Poetry*. 2nd ed. New York: Basic Books, 2011.

———. *The Hebrew Bible: A Translation with Commentary*. Vol. 3, *Writings*. New York: W. W. Norton, 2019.

Araújo, Flávia Santos de. "'Blessed within My Selves': The Prophetic Visions of Our Lorde." *Wagadu: A Journal of Transnational Women's and Gender Studies* 20 (2019): 8–31.

Bromberg, Eli. "'A Little More Jewish, Please': Black and Jewish Secularity and Invisibility in Fran Ross's Oreo." *Studies in American Jewish Literature* 38, no. 1 (2019): 23–46.

Budick, E. Miller. *Blacks and Jews in Literary Conversation*. New York: Cambridge University Press, 1998.

Bulkin, Elly. "An Interview with Adrienne Rich (Part 2)." *Conditions*, October 1977, 53–66.

Bulkin, Elly, Barbara Smith, and Minnie Bruce Pratt. *Yours in Struggle: Three Feminist Perspectives on Anti-Semitism and Racism*. 2nd ed. Ithaca, NY: Firebrand Books, 1988.

Carruthers, Mary J. "Re-vision of the Muse: Adrienne Rich, Audre Lorde, Judy Grahn, Olga Broumas," *Hudson Review* 36 (1983): 293–322. https://doi.org/10.2307/3856702.

Casteel, Sarah Phillips. *Calypso Jews: Jewishness in the Caribbean Literary Imagination*. New York: Columbia University Press, 2016.

Chari, Anita. *A Political Economy of the Senses: Neoliberalism, Reification, Critique*. New York: Columbia University Press, 2015.

Coss, Clare, Sandra Segal, Audre Lorde, and Eileen Zalisk. *The Velvet Sledgehammer* [recording of December 12, 1980, poetry reading by Audre Lorde]. Pacifica Radio Archives, Los Angeles, 1980. avplayer.lib.berkeley.edu/Pacifica/991036501229706532.

De Veaux, Alexis. *Warrior Poet: A Biography of Audre Lorde*. New York: W. W. Norton, 2004.

Dollinger, Marc. *Black Power, Jewish Politics: Reinventing the Alliance in the 1960s*. Brandeis Series in American Jewish History, Culture, and Life. Waltham, MA: Brandeis University Press, 2018. https://doi.org/10.2307/j.ctv102bfs2.

Feldman, Keith P. *A Shadow over Palestine: The Imperial Life of Race in America*. Minneapolis: University of Minnesota Press, 2015.

Garber, Linda. *Identity Poetics: Race, Class, and the Lesbian-Feminist Roots of Queer Theory*. Between Men, between Women: Lesbian and Gay Studies. New York: Columbia University Press, 2012.

Glaser, Jennifer. *Borrowed Voices: Writing and Racial Ventriloquism in the Jewish American Imagination*. New Brunswick, NJ: Rutgers University Press, 2016.

Goffman, Erving. *Forms of Talk*. Philadelphia: University of Pennsylvania Press, 1981.

Griffin, Ada Gay, Michelle Parkerson, and Audre Lorde, dirs. *A Litany for Survival: The Life and Work of Audre Lorde*. Video recording. New York: Third World Newsreel, 1998.

Halpern, Nick. *Everyday and Prophetic: The Poetry of Lowell, Ammons, Merrill, and Rich*. Madison: University of Wisconsin Press, 2003.

Harrison-Kahan, Lori. *The White Negress: Literature, Minstrelsy, and the Black-Jewish Imaginary*. New Brunswick, NJ: Rutgers University Press, 2011.

Henderson, Mae Gwendolyn. "Speaking in Tongues: Dialogics, Dialectics, and the Black Woman Writer's Literary Tradition." In *African American Literary Theory: A Reader*, edited by Winston Napier, 348–68. New York: New York University Press, 2000.

Holladay, Hilary. *The Power of Adrienne Rich*. New York: Penguin, 2020.

———. "When Adrienne Rich Refused the National Book Award." *Literary Hub*, November 23, 2020. lithub.com/when-adrienne-rich-refused-the-national-book-award/.

Jackson, Virginia Walker, and Yopie Prins. *The Lyric Theory Reader: A Critical Anthology*. Baltimore: Johns Hopkins University Press, 2014.

Jones, Meta DuEwa. *The Muse Is Music: Jazz Poetry from the Harlem Renaissance to Spoken Word*. New Black Studies Series. Urbana: University of Illinois Press, 2011.

Kim, Mina, dir. *Poet Claudia Rankine's Book "Just Us" Seeks Out "True Conversation" about Race*. KQED, September 10, 2020. www.kqed.org/forum/2010101879621/poet-claudia-rankines-book-just-us-seeks-out-true-conversation-about-race.

Labov, William, Sharon Ash, and Charles Boberg. *The Atlas of North American English: Phonetics, Phonology and Sound Change*. Berlin: De Gruyter Mouton, 2008.

Lentjes, Rebecca, Amy E. Alterman, and Whitney Arey. "'The Ripping Apart of Silence': Sonic Patriarchy and Anti-Abortion Harassment." *Resonance* 1, no. 4 (2020): 422–42. https://doi.org/10.1525/res.2020.1.4.422.

Lober, Brooke. "Adrienne Rich's 'Politics of Location,' US Jewish Feminism, and the Question of Palestine." *Women's Studies: An Interdisciplinary Journal* 46, no. 5–8 (2017): 663–83.

Lorde, Audre. *The Cancer Journals*. Special ed. San Francisco: Aunt Lute Books, 1997.

———. *The Collected Poems of Audre Lorde*. New York: W. W. Norton, 1997.

———. "Letter to Adrienne Rich." Box 4, Folder 1.1.004 (Letters written by Audre Lorde [?]—May 10, 1992), 1979. Audre Lorde Papers, Spelman College, Atlanta.

———. "Poet as Teacher—Human as Poet—Teacher as Human." In *I Am Your Sister: Collected and Unpublished Writings of Audre Lorde*, edited by Rudolph P. Byrd, Johnnetta B. Cole, and Beverly Guy-Sheftall, 182–83. Transgressing Boundaries. Oxford: Oxford University Press, 2009.

———. *Sister Outsider: Essays and Speeches*. Berkeley, CA: Crossing Press, 2007.

———. *Zami, a New Spelling of My Name*. Berkeley, CA: Crossing Press, 1982.

———. "Journal 24 (1981)." Series 2, 002.5 (Journals), n.d. Audre Lorde Papers, Spelman College, Atlanta.

Lorde, Audre, and Adrienne Rich. *Astraea Benefit, "Conversation with Poems"* (tape 1 of 2, side 1). Lesbian Herstory Archives Audio Visual Collections, December 5, 1981. herstories.prattinfoschool.nyc/omeka/exhibits/show/audre-lorde/item/52.

———. *Astraea Benefit, "Conversation with Poems"* (tape 1 of 2, side 2). Lesbian Herstory Archives Audio Visual Collections, December 5, 1981. herstories.prattinfoschool.nyc/omeka/exhibits/show/audre-lorde/item/52.

———. *Astraea Benefit, "Conversation with Poems"* (tape 2 of 2, side 1). Lesbian Herstory Archives Audio Visual Collections, December 5, 1981. herstories.prattinfoschool.nyc/omeka/exhibits/show/audre-lorde/item/49.

———. *Astraea Benefit, "Conversation with Poems"* (tape 2 of 2, side 2). Lesbian Herstory Archives Audio Visual Collections, December 5, 1981. herstories.prattinfoschool.nyc/omeka/exhibits/show/audre-lorde/item/49.

———. "An Interview with Audre Lorde." *Signs: Journal of Women in Culture and Society* 6, no. 4 (1981): 713–36.

Lorde, Audre, Mayra A. Rodríguez Castro, and Dagmar Schultz. *Audre Lorde: Dream of Europe: Selected Seminars and Interviews: 1984–1992*. Chicago: Kenning Editions, 2020.

MacArthur, Marit J. "Monotony, the Churches of Poetry Reading, and Sound Studies." *PMLA* 131, no. 1 (2016): 38–63.

MacArthur, Marit J., Georgia Zellou, and Lee M. Miller. "Beyond Poet Voice: Sampling the (Non-) Performance Styles of 100 American Poets." *Journal of Cultural Analytics* 3, no. 1 (April 18, 2018): 1–71. culturalanalytics.org/

article/11039-beyond-poet-voice-sampling-the-non-performance-styles-of-100-american-poets.

McDaniel, Judith. "To Be of Use: Politics and Vision in Adrienne Rich's Poetry." *Sinister Wisdom* 7 (Fall 1978): 92–99.

Miron, Dan. *The Prophetic Mode in Modern Hebrew Poetry*. Milford, CT: Toby Press, 2010.

Newton, Adam Zachary. *Facing Black and Jew: Literature as Public Space in Twentieth-Century America*. New York: Cambridge University Press, 2004.

Olson, Lester. "Anger among Allies: Audre Lorde's 1981 Keynote Admonishing the National Women's Studies Association." *Quarterly Journal of Speech* 97, no. 3 (2011): 283–308.

Pierce, Rebecca. "Jews of Color and the Policing of White Space." *Jewish Currents*, May 29, 2020. jewishcurrents.org/jews-of-color-and-the-policing-of-white-space.

Podhoretz, Norman. 1972. "Is It Good for the Jews?" *Commentary*, February 1972.

Rich, Adrienne. "Aunt Jennifer's Tigers." PennSound, 1951. media.sas.upenn.edu/pennsound/authors/Rich/Rich-Adrienne_2_Aunt-Jennifers-Tigers_Woodberry-Poetry-Room-Reading_1951.mp3.

———. *Collected Poems: 1950–2012*. New York: W. W. Norton, 2016.

———. *The Fact of a Doorframe: Selected Poems, 1950–2001*. New ed. New York: W. W. Norton, 2002.

———. "Letter to Audre Lorde." Box 4, Folder 1.1.105 (Correspondents), 1979. Audre Lorde Papers, Spelman College, Atlanta.

———. "Letter to Audre Lorde." Box 4, Folder 1.1.105 (Correspondents), n.d. Audre Lorde Papers, Spelman College, Atlanta.

———. "Letter to Audre Lorde." Box 4, Folder 1.1.106 (Correspondents), 1979. Audre Lorde Papers, Spelman College, Atlanta.

———. "Letter to Audre Lorde." Box 4, Folder 1.1.107 (Correspondents), 1981. Audre Lorde Papers, Spelman College, Atlanta.

———. "Letter to Audre Lorde." Box 4, Folder 1.1.108 (Correspondents), 1990. Audre Lorde Papers, Spelman College, Atlanta.

———. "Notes toward a Politics of Location." In *Blood, Bread, and Poetry: Selected Prose*, 210–31. New York: W. W. Norton, 1986.

———. *On Lies, Secrets, and Silence: Selected Prose, 1966–1978*. New York: W. W. Norton, 1979.

———. "Split at the Root." In *Nice Jewish Girls: A Lesbian Anthology*, edited by Evelyn Torton Beck, 67–84. Watertown, MA: Persephone Press, 1982.

Rubinstein, Rachel. "Textualizing Black-Jewish Relations." *Prooftexts* 22, no. 3 (Fall 2002): 392–402.

Rust, Marion. "Making Emends: Adrienne Rich, Audre Lorde, Anne Bradstreet." *American Literature* 88, no. 1 (2016): 93–125.

Savonick, Danica. "Insurgent Knowledge: The Poetics and Pedagogy of Toni Cade Bambara, June Jordan, Audre Lorde, and Adrienne Rich in the Era of Open Admissions." PhD diss., City University of New York, 2018. CUNY Graduate Center Dissertations, Theses, and Capstone Projects. academicworks.cuny.edu/gc_etds/2604.

Shalev, Talia. "Adrienne Rich's 'Collaborations': Re-vision as Durational Address." *Women's Studies* 46, no. 7 (2017): 646–62.

Simmons, Judy. "Minority." *Conditions* 5 (Autumn 1979): 93.

Staff, Harriet. "Audre Lorde & Adrienne Rich Marathon Reading by Harriet Staff." Poetry Foundation, February 1, 2023. www.poetryfoundation.org/. https://www.poetryfoundation.org/harriet-books/2012/11/audre-lorde-adrienne-rich-marathon-reading.

Strine, Mary S. "The Politics of Asking Women's Questions: Voice and Value in the Poetry of Adrienne Rich." *Text and Performance Quarterly* 9, no. 1 (1989): 24–41.

Strongman, SaraEllen. "'Creating Justice between Us': Audre Lorde's Theory of the Erotic as Coalitional Politics in the Women's Movement." *Feminist Theory* 19, no. 1 (2017).

Sundquist, Eric J. *Strangers in the Land: Blacks, Jews, Post-Holocaust America*. Cambridge, MA: Harvard University Press, 2005.

Turner, Jack. 2020. "Audre Lorde's Politics of Difference." In *African American Political Thought: A Collected History*, edited by Melvin L. Rogers and Jack Turner, 563–92. Chicago: University of Chicago Press. https://doi.org/10.7208/chicago/9780226726076.001.0001.

Ullman, Alex. "Audre Lorde, Sound Theorist: Register, Silence, Vibrato, Timbre." *PMLA* (forthcoming).

Warner, Michael. *Publics and Counterpublics*. New York: Zone Books, 2002.

Warrock, Anna M. "Lesbian Poetry: A New Vision." *Sojourner*, July 1981, 25.

Wasley, Aidan. *The Age of Auden: Postwar Poetry and the American Scene*. Princeton, NJ: Princeton University Press, 2011.

Weiman-Kelman, Zohar. *Queer Expectations: A Genealogy of Jewish Women's Poetry*. SUNY series in Contemporary Jewish Literature and Culture. Albany: State University of New York Press, 2018.

West, Cornel. *Democracy Matters*. New York: Penguin, 2004.

Wheeler, Lesley. *Voicing American Poetry: Sound and Performance from the 1920s to the Present*. Ithaca, NY: Cornell University Press, 2008.

"You People." *On the Nose* podcast. *Jewish Currents*, February 9, 2023. jewishcurrents.org/you-people.

6

RECEPTION AFTER #METOO

The Cases of Susan Taubes and Erica Jong

Josh Lambert

Not much about #MeToo was new in 2017. The slogan itself was coined by the activist Tarana Burke in 2006, and many of the most prominent allegations of abuse that have been central to the widespread discussion of #MeToo since 2017 concerned events from the past that had already been discussed as rumors for years, sometimes for decades.[1] One might say, then, that #MeToo in 2017 was a movement concerned with *reception*: in addition to its call for women to speak out and share stories of abuse for the first time, at its very center has been an insistence on a set of narratives being retold and reinterpreted, with new emphases, new audiences, and new expectations about how these audiences should respond.

That kind of rereading of older stories in new ways is, of course, deeply familiar to literary scholars: when applied to particular kinds of narratives and texts, such rereading could be said to be one of the core practices of literary studies. More specifically, the subfield of Reception Studies concerns itself with tracking the changing ways that narratives and texts have been understood and appreciated over time—and, like the #MeToo movement, Reception Studies can be understood as partly embedded in, or at least entangled with, the history of feminism.[2] Ika Willis, surveying the history of reception, emphasizes the role of second-wave feminist literary critics in "fram[ing] reading, rereading, and rewriting as important acts of political resistance," and projects like Tillie Olsen's *Silences* (1978) and Joanna Russ's *How to Suppress Women's Writing* (1983) exemplify how renewed attention

to writing produced by women has inspired explorations of the contingent and often distressing histories of literary practices and institutions.[3]

I do not by any means wish to suggest an equivalence between studies of literary reception, efforts to recover neglected literary work by women, and the efforts undertaken under the banner of the #MeToo movement to bring perpetrators of sexual misconduct to justice, but I do see value in the application of the emphases of #MeToo to rereading and reevaluating literary works. Feminist literary scholars had been attending to representations of sexual assault long before the #MeToo movement, of course, for example in Kate Millett's extraordinarily influential *Sexual Politics* (1970).[4] Such pioneering works notwithstanding, contemporary scholars, including Janet Badia and Mary K. Holland, have recently presented their reception studies explicitly in response to #MeToo.[5] In this chapter, I discuss two cases in which novelists, writing in the late 1960s and early 1970s, centered misogyny and sexual abuse in their books, demonstrating how the threat and reality of abuse and assault impose limits on women's lives and careers. These novels by Jewish women, which represent Jewish women's experiences in the mid-twentieth century—Susan Taubes's *Divorcing* (1969) and Erica Jong's *Fear of Flying* (1974)—are fascinating and complex literary works, not by any means reducible to a single issue or concern, but what particularly motivates this chapter is the way that these novels' receptions have largely ignored their representations of sexual abuse and assault.

Susan Taubes's *Divorcing*

Susan Taubes's *Divorcing*, her only novel published within her lifetime, was first published by Random House at the beginning of November 1969. Taubes was a Hungarian-born US scholar of religion and culture, who had written a dissertation at Harvard on Simone Weil and had published a handful of book and theater reviews and short stories before *Divorcing*. The novel centers on a character named Sophie Blind and the collapse of Sophie's marriage to a charismatic, feckless rabbi and scholar, Ezra Blind.

Sophie is a brilliant intellectual, who has "studied philosophy, epistemology, published papers on the problem of verification," while also raising three children.[6] Among its other concerns, the novel offers a powerful sense of what marriage to an intellectual man could offer to a woman

like Sophie in the midcentury United States, given the limits placed on women's opportunities by patriarchy in that time and place. As Sophie understands it, her marriage sets the conditions of possibility for her social experience:

> She did not forget . . . that she was Ezra's wife sitting in company; that it was under this cover that she could be anywhere or nowhere, anyone or no one. . . . Even when Sophie couldn't bear Ezra, she loved the marriage. It was a many-layered shroud whose weight she relished. To carry it eased, simplified entering a room full of people, it justified her presence in the room. There it was, a costume ready-made for public occasions. Ezra's wife; this was the answer to anyone who wanted to know her. She was the woman Ezra Blind had married. It had weight and power: like an impermeable cloak it warded off the inevitable swarm of prying, talky, argumentative, interrogating people. The shroud served to receive the obligatory marks and tags, it absorbed unavoidable stains, its fabric wrinkled and stretched obligingly. It saved her skin. How not cherish a garment so serviceable? (45)

While it may well be an exaggeration, in this passage Sophie's marriage is described as granting her considerable benefits, including making her social interactions easier and protecting her from the judgment of others, that "inevitable swarm of prying, talky, argumentative, interrogating people." If it truly allowed her to "be anywhere or nowhere, anyone or no one," as the passage indicates, marriage would be very powerful indeed. This captures the appeal, if not the reality, of marriage for female intellectuals in the United States in the middle of the twentieth century: in a system that tightly constrained women's opportunities, having a male partner promised to open opportunities, whether directly or indirectly, and sometimes it actually did.[7]

At the same time, this passage indicates that the social benefits of marriage for Sophie exist irrespective of the experience of spending time with a particular husband, noting that there are times "when Sophie couldn't bear Ezra." Ezra cheats on Sophie regularly and openly, manipulates and exploits her, and, most damagingly, refuses to divorce her when she requests it. Complaining that a divorce would be "economically unfeasible" (39), refusing to grant Sophie's request for a divorce "unless

[she had] someone else to marry [her]" (34), and at one point, in one of the novel's phantasmagoric passages, proclaiming that "Sophie Blind remains [his] wife till the Messiah comes" (129), Ezra denies Sophie what she explicitly, repeatedly demands. While Sophie simply and straightforwardly tells him, "I don't want to be married to you" (31), he seems incapable of treating this as a reasonable request made by a rational person:

> As for breaking the marriage, he did not take that seriously, of course, he never took that seriously, he says sternly, and with bitterness and superiority now; takes off his coat, his galoshes, and continues. A responsible man, under great strain, a reasonable man, a patient man, speaking to a woman undeserving of his patience, an irresponsible, childish woman, seething with spite and vindictiveness, driven by impossible dreams, lacking all sense of reality; a woman he once loved, against whose folly he must now protect the home, the family. A man cursed to perform this grim duty. (32)

A few pages later, Ezra addresses Sophie directly: "You have no reason to want a divorce. You just want to break the marriage. Why? Are you evil? Are you bent on my destruction?" (34). "So that's what you are. A bitch," Ezra says, thinking, "It's a psychiatrist she needs. Or a lover, or a beating. Beat her blue" (39). When Sophie says, "The thought of being married to you drives me insane," Ezra replies: "Then see an analyst. I have no more time to waste on these discussions. We have more important things to talk about" (34). Gaslighting Sophie unceasingly, Ezra projects a sense of himself as "responsible" and "reasonable" and his wife as "lacking all sense of reality," a "childish," "evil" "bitch" "bent on destruction" who deserves a "beating," and whose sexuality he expects to serve his desires and fantasies.

Notwithstanding his pose as "patient" and "reasonable," Ezra admits, without apology, that he "fool[s] around with other women" (41), among whom is a seventeen-year-old girl who was babysitting his children and whom he "deflower[s]" (132), though he meanwhile insists that Sophie remains "the only woman [he] ever loved" (41). Eventually, in a phantasmagoric trial sequence, Sophie, already dead, demands her divorce from a rabbinical court and, after a series of testimonies (by Sophie's father, women with whom Ezra has had affairs, and others), the rabbis declare that "[h]er divorce is granted, whether she is alive or dead." Lying in

her coffin, she "is presented with a Bill of Divorce" (135). As plentiful as harrowing accounts of marriage have been throughout world literature, Taubes's novel distinguishes itself with the vividness and intensity of its representation of marriage as a painful, even fatal, trap.

The first section of the novel offers poignant, detailed descriptions of exactly how it feels for Sophie to live inside that trap. In one passage, parallel to the one quoted above in which marriage is figured as a garment, the narrator indicates that Sophie's husband chooses what clothes she can and can't wear. He buys her "heavy silver jewelry" and makes her "dress in black," while denying her the one piece of clothing she "always dreamed of having," "a white nightgown, long and soft," saying "she looked better naked" (10). Whereas she wants a garment because it feels a particular way ("soft"), her husband's interest is in how she looks. That's one example of how her husband vitiates her autonomy, and over and over, in moving passages, the novel demonstrates how the domestic demands on Sophie make it impossible for her to do the work she wants to do, or even to manage household tasks:

> She can't, she's exhausted. She can't, she must unpack. She can't, she has fifty letters to write. No, she can't, she must work on her book; she can't tell them what it's about. She must sleep. She must really write those letters. To Ezra. Can't. Business letters. Can't. To her lover in New York. Can't. Finish unpacking. Can't. Can't sleep. Can't work. (19)

> Almost time to fetch the children and she hasn't even made the beds. Can't face thinking about what to serve for dinner. The effort of putting on her shoes is too much. (30)

Sophie's husband is "mostly away," showing up "unexpectedly," and Sophie knows when he does appear "there [will] be a row" (15). When her situation fills her with rage and she strikes out violently, her resistance is rendered meaningless: she is, from her husband's perspective, "only a woman, throwing her weight on him, fists pounding mostly wall, air, mattress ... Just a woman, and now increasingly molten, pliable, fluid with rage; his own beloved wife, he knew what to do with her, and in nine months there was a baby" (13). In other words, her anger does nothing except mark her as sexually available ("molten, pliable"), which leads nowhere for Sophie

except to an increase in her maternal and domestic responsibilities. And as much as Sophie recognizes her husband's villainy, she turns her harshest judgment on herself, reflecting that "however much she blamed Ezra for his foolishness, it was herself she blamed more strongly and endlessly for being defeated by Ezra's foolishness" (48). In other words, she is denied even the minor relief of being able to feel that her suffering is someone else's fault.

In presenting this harsh picture of marriage, Taubes resists, or at least registers objections to, a patriarchal system that radically constrains women's opportunities. The novel offers up many examples of that system in action, from Sophie's father who opines that "a woman's success as a wife depends entirely on how she has resolved her oedipal conflicts" (134), to a family cook who tells Sophie, during her childhood, "If you were a good girl they wouldn't make up stories like that about you" (194). That line, blaming Sophie for the way she is treated, recalls the novel's description of Sophie's grandmother, as "[a] true goddess, who could inspire a man to adore without permitting him to rape" (92). This ironically reflects a patriarchal ideology that insists that most women do, somehow, permit men to rape them. At one point in the trial sequence, Sophie, arguing on her own behalf, makes clear how stupid and hateful she finds the misogynistic standards of religious Judaism: "Go ahead, you dodoes, and condemn me for eating fried octopus, cock sucking, animal worship. I touched the mezuzah when I was menstruating, put that down. I confess to all your charges. . . . Now feed me to the dogs as is your custom" (127). In this satiric account of rabbinic authority, the sins evoked are mostly real (unkosher food, animal worship, and the impurity of menstruating women all being genuine concerns in traditional rabbinic Judaism), and if the punishment is hyperbolic (it is not actually a "custom" in Judaism to feed sinners to dogs), it reflects Sophie's refusal to accept as natural or reasonable the religiously sanctioned misogyny that has contributed to her immiseration.

Relatively little of this intense, complex representation of a Jewish woman's suffering in marriage was described by the book's first reviewers. There were two key phases in this novel's initial reception. The first brief phase consists of the reviews we can presume to have been written (if not in all cases published) before November 6, 1969. These include reviews in the *Los Angeles Times*, the *New York Times Book Review*, and the *Chicago Tribune*. In these reviews, Taubes was complimented for "writ[ing]

beautifully" and for her "obvious seriousness and intelligence" and "exceptional literary talent." Sections of the novel were called "tremendously skillful and moving," with one review headlined, "An Arresting Novel of Inner Feeling." These early reviews compared Taubes's work, affirmatively, to that of James Joyce and Doris Lessing.[8] The reviewers did express disappointment with various aspects of the book, in the very conventional way that book reviews almost always do, and Hugh Kenner's review in the *New York Times Book Review* notably trotted out misogynistic clichés, remarking that the book did not transcend "the with-it cat's cradling of lady novelists."[9] But even Kenner's antagonistic review conceded that parts of *Divorcing*—particularly, the final third, which flashes back to Sophie's childhood in Budapest, lapsing for long stretches into a more conventionally realist mode—were "tantalizing and coherent."

Remarkably, though, while the novel's title and contents focus on Sophie's marriage and its dissolution, these first reviews have surprisingly little to say about the character of Ezra Blind. The *Chicago Tribune* reviewer calls Ezra a "highly effusive, unlikeable Judaic scholar" and notes that divorce "is a tremendous relief for [Sophie], but it is also a disassociating experience that badly threatens her perceptions of current reality."[10] The *Los Angeles Times* review does not mention Ezra at all, and describes the divorce, neutrally, as "a process, a continuation of relationships."[11] Kenner, in the *New York Times Book Review*, notes that Sophie "can't stand her husband, whom she rarely sees any more anyhow," but by way of explanation of why she feels that way says only that he is "a brute" and "impossible." Most revealingly, Kenner objects that it is implausible that Ezra has held academic positions in the United States, Europe, and Israel.[12] This reflects the degree to which Kenner, at least, had neither knowledge of nor interest in Susan Taubes's life experiences—as she and Jacob Taubes had, by this time, lived in all of the places mentioned in *Divorcing*, mostly thanks to his employment. In other words, these first reviews of the novel do not devote any sustained attention to the novel's fictional husband, to the marriage as an abusive or horribly unpleasant one, or to Susan Taubes's life.

The second phase of reviews and discussions of the novel include those published after November 6, 1969, when Taubes died by suicide. These typically refer to Taubes's death as linked to the book in one way or another. A wire story that appeared in many newspapers noted that she died "just a month after publication of her novel, *Divorcing*."[13] An article in

a New Jersey newspaper, the *Record*, implied causation with its headline: "Novel Panned, Author Suicide."[14] The *Detroit Free Press* called the author's death a "sad footnote" to the novel.[15] Like the first reviews, though, these articles also do not have anything meaningful to say about the character of Ezra Blind or about Susan Taubes's ex-husband. The *Detroit Free Press* refers to Ezra as "a wandering scholar." The wire service story on Taubes's death does not refer to Ezra or Jacob Taubes at all, and the *Record* story notes only that Susan Taubes's "former husband is a university professor in West Germany." Far from offering any kind of commentary on either the Taubeses' marriage or Susan Taubes's fictional representation of a marriage in *Divorcing*, these articles do not even mention the name of Taubes's ex-husband or note that Susan Taubes was survived by the three children of that marriage. (Given the regularity with which women were identified with their husbands or even ex-husbands in the press in obituaries, news stories, and reviews in this period, it does not seem plausible that these omissions stemmed from a desire to protect or respect Susan Taubes's artistic autonomy.)

Little discussion of the novel seems to have been published after those first few articles at the end of 1969 and beginning of 1970, and the most recent phase of the reception of Susan Taubes's *Divorcing* has taken place in the wake of the #MeToo movement, following the publication of a new edition of the novel by New York Review Books Press on October 27, 2020. The reception of that new edition could be said to begin with David Rieff's introduction to the volume. Rieff remarks that his mother, Susan Sontag, "always thought that the proximate cause of Taubes's suicide was the bad reviews the novel received." Rieff acknowledges, without criticizing his mother too harshly, that this probably wasn't fair (he remarks that it is unclear "whether [Sontag's belief] was true or not in the most immediate sense").[16] Rieff also discusses the character of Ezra Blind in some detail, asserting that "Ezra was [modeled] on Jacob Taubes." Indeed, Rieff writes, "For those who remember Jacob Taubes, or have read the many recollections that have been written about him, the portrait of Ezra is an uncannily accurate description of him in all of his charm, intelligence, cruelty, and priapism. The man who would later write boastingly to a friend, 'I am impossible,' was just that and worse, especially toward women." Rieff acknowledges his family's friendship with the Taubes family, and it is understandable that this passage remains strategically vague. With critical

distance, one might ask what it means that Jacob Taubes's behavior consisted, in part, of "cruelty" and "priapism," and that he was "worse" than "impossible . . . especially toward women"?[17] To what degree are Ezra's particular sins modeled on Jacob Taubes's? Does Rieff have evidence that Jacob Taubes was, like Ezra, a serial sexual harasser of students and colleagues? Or that he sexually assaulted minors, once or regularly? Or that he gaslit and attacked his wife until she could not bear to live? Given the contents of *Divorcing*, all of these possibilities are opened by Rieff's comment that the character of Ezra is an "uncannily accurate description of" Jacob Taubes—though none of them can be confirmed without evidence.

The reviews of the new edition do not seem to have taken up such questions, even though most of them followed Rieff's lead in accepting a connection between Susan Taubes's fiction and her life; one called it "a semi-autobiographical novel."[18] Very few of these reviews devote attention to Ezra's abusive behavior, though. Reviews in *Publishers' Weekly*, the *Nation*, and the *New York Times* say very little, going only a little further than the first and second wave of reviews, mentioning Jacob Taubes by name (for instance, noting that Ezra "resembles Jacob Taubes"[19]) if not devoting much attention to what this might mean about Taubes's behavior. Quoting Benjamin Moser's biography of Susan Sontag, Jess Bergman's review in *Jewish Currents* remarks that the relationship of Susan and Jacob Taubes "had fallen bitterly apart due to . . . the couple's 'unorthodox sexual arrangements,'" then quotes Babette Babich's description of Jacob as "an inveterate womanizer."[20] The review seems to steer deliberately away from any statement that could be understood as placing the blame on Jacob Taubes for the divorce, and by using the term "womanizer" it treats euphemistically the possibility that Jacob Taubes was a sexual predator. Similarly, Becca Rothfeld's review describes Jacob Taubes "an infamous philanderer who had affairs with many women."[21] In the *Paris Review*, Dustin Illingworth quotes Rieff on Ezra's resemblance to Jacob Taubes, adding that Ezra is "unctuous, carnal, brilliant, despicable" and noting that "his pettiness and bullying are indexed with excruciating clarity," which perhaps begins to hint at what the novel might tell us about Jacob Taubes.

To be clear, I have not interviewed Taubes's former students, searched the archives of the university where he was employed for records of complaints, or found other sources of evidence that would allow me to make more precise statements about Jacob Taubes's behavior during his

lifetime.[22] Nor would I expect a book reviewer, paid little or nothing to write a thousand words on a recently reissued novel, to do that kind of forensic work. And we need to exercise caution in reading a roman à clef as representing reality in a straightforward way, even while acknowledging the utility of such works of putative fiction for making claims that might otherwise be much less acceptable to audiences.[23] Still, with all this in mind, I would like to suggest that among everything else it accomplishes, Susan Taubes's *Divorcing* proposes that such questions about Jacob Taubes might be worth asking—and notwithstanding the way it has been read, the novel seems to have been proposing that since 1969.

At the same time, I acknowledge that some readers, for understandable ethical, philosophical, or pragmatic reasons, may resist the suggestion that we should read a book that Taubes published as a novel primarily, or at all, as offering information on the conduct of any real people. Doing so might mean tripping on the line between fiction and autobiography and, more disturbingly, reproducing a pernicious, long-standing tendency in which women's fiction has been read, unsympathetically, as overly or merely factual. In her review, Bergman laments that Susan Taubes "is rarely discussed except in connection with her famous friend [Sontag] or ex-husband," and this is a pattern that my own reading does not do enough to resist.[24] One could argue that most of the novel's value, for most of its actual and potential readers, will be found in the generalizable account it offers of how spousal abuse feels by those who experience it. When Rothfeld notes that the character of Ezra is "recognizably pathetic and paternalistic, a specimen eminently familiar to any woman in even the remote orbit of a university," she suggests more generally the value of fiction that presents portraits not of specific real-life people but rather the kind of stylized "specimens" that reflect larger, recognizable social phenomena.[25] I intend my own contribution to the reception of *Divorcing* here as a complement to such readings of the novel.

Erica Jong's *Fear of Flying*

In contrast to Taubes's *Divorcing*, which never sold an enormous number of copies, Erica Jong's *Fear of Flying* is one of the most widely circulated American novels of the early 1970s. A comic novel of psychoanalysis and

Bildung, Fear of Flying describes the childhood and young adulthood of a poet named Isadora Wing, and it has sold a reported twenty million copies. The daunting task of considering this popular novel's reception over time is made easier thanks to the work of Charlotte Templin, who argues in *Feminism and the Politics of Literary Reputation: The Example of Erica Jong* (1995) that in general "the response to [Jong's] novels is inseparable from the social reception and construction of feminism." Examining the initial reception of *Fear of Flying* that took place in the early 1970s, Templin surveys the reviewers who "do not share the [feminist] ideology of Jong's novel and thus find it ideological," the "male reviewers . . . troubled by the brave new world the feminists are advocating," and reviews by "women who implicitly identify themselves as feminists" whose responses to the novel "center on Isadora's vocational aspirations" and "find meaningful and important Jong's depiction of a woman's inner life."[26]

In the decades after its publication, *Fear of Flying* has continued to circulate and to be appraised by many critics and essayists, as well as revisited by Jong herself. Surveying reception between the novel's first publication and the early 1990s, Templin highlights some feminist scholars and writers who view the novel positively, like Susan Rubin Suleiman, who in *Subversive Intent: Gender, Politics, and the Avant-Garde* (1990), credits Jong with having presented "a self-conscious reversal of stereotypes," even while admitting *Fear of Flying* is not, for her, "a great feminist novel." But Templin also acknowledges the degree to which many feminist critics, including Gayle Green and Rita Felski, regard the novel as a paradigmatic failure. Summarizing these responses, Templin wonders whether "present-day feminists [are] embarrassed by Jong." While more than two decades have passed since Templin's study was published, my impression is that the patterns Templin observed in the reception of the novel have largely persisted, and the largest new development in studies of the reception of Jong's work has been a decided increase in attention to Jewishness.[27]

What interests me in the history of the novel's reception is how rarely critics or scholars, Templin included, have responded to *Fear of Flying* in a way that seems obvious after the discussions of #MeToo in 2017: as a novel remarkable for the way it describes sexual assault.[28] At least, reading the novel this way seemed obvious to me and to a group of undergraduate students who participated in a seminar I taught in the fall of 2018, when

we read (or reread) *Fear of Flying* together. In a few excellent seminar papers, these students focused on the sections of the novel where Isadora is the victim of what the students recognized, unambiguously, as potential or actual sexual assaults: when her lover Adrian gropes her, when her brother-in-law Pierre creeps into her bed uninvited, and when, in the final pages of the novel, a stranger on a train puts his "hand . . . between [her] legs and [tries] to hold [her] down forcibly."[29] To these students, and to me, it seems quite clear that in each case, Isadora is not asked for, and does not give, affirmative consent—and that Jong takes pains to make sure her readers *notice* the absence of that consent and how distressing and unpleasant this makes the experiences. When Isadora's brother-in-law Pierre insists that she have sex with him, for example, despite her repeated refusals, eventually "pushing [her] down on the pillow" and "offer[ing] his erect penis to [her] mouth," Isadora feels guilty and blames herself ("Was I a prude?"), and when she tells her sisters about the experience, they tell her that he has tried the same thing with them but that they feel "he's pretty harmless" (243–44). Another section of the novel goes even further than this in describing Isadora's experience of sexual violence: when Isadora describes the "sexual myths of the fifties" that she was raised to believe, the first is that "[t]here is no such thing as rape. Nobody can rape a woman unless she consents at the last minute" (195). This description of 1950s culture is presented as ironic prelude to a scene in which Isadora's first husband is described as brutally raping her, "banging away at [her] like an ax murderer" while she is "crying and pleading" (201–2).

Even the novel's famous "Zipless Fuck," in its original formulation in the book's first pages, can be read as reflecting Jong's awareness that the dynamics of consent and the threat of sexual assault pose a serious, perhaps insuperable, obstacle to the liberatory potential of unbridled, fantastic sexuality for cisgendered, heterosexual women in the 1970s United States.[30] In the fantasy, as Isadora describes it, a male soldier acts decisively—he "begins to wind rubber fingers around and under the soft flesh of [a woman's] thigh" and then his "fingers are sliding between her thighs and they are parting her thighs . . . and they are sliding up under her garters into the damp unpantied place between her legs" (13)—while the woman, a "widow," is described only, repeatedly, as "star[ing] out the window," "continu[ing] staring at each olive tree," "continu[ing] to stare at the olive trees," never as enjoying or participating in or consenting, verbally

or otherwise, to sex (13). While Isadora insists that "[t]he zipless fuck is absolutely pure" and specifically that in this fantasy "[t]here is no power game," and "[t]he man is not 'taking' and the woman is not 'giving,'" her remark that "there is no talk at *all*" (14) seems as if it might acknowledge the degree to which the woman in the fantasy is entirely objectified. Indeed, after having sex with her, the soldier "stares after her as if he were Adam wondering what to name her" (14). As one student, Rachel Linfield, recognized, this equates Isadora with an animal (which most legal and ethical codes suggest cannot consent to sexual activity with a human).[31] Reading the original fantasy in light of its rewriting at the end of the novel, Linfield summed up that "because Isadora encounters the violent reality of a zipless fuck which vitiates her ability to consent ... the reader understands that Jong renounces the zipless fuck as ideal."[32]

Attending to the novel's representation of sexual fantasy and reality in this way, we can understand *Fear of Flying* as a fiction committed to representing Isabella's strategies of resistance and survival in an environment made hostile by misogyny and rape culture. Near the end of the chapter that describes in detail Isabella's rape by her husband in the 1950s, and shows how that rape was legitimated and protected by the sexual ideologies of the time, she reflects on her own writing practice: "How can I know what I think unless I see what I write? My writing is the submarine or spaceship which takes me to the unknown worlds within my head" (210). While analogizing her poems to "vehicles" (210) in this way might be understood in several different ways, it is worth noting that unlike other conveyances, the specific ones Isabella mentions here transport people into extraordinarily hostile environments that immediately, lethally suffocate unprotected humans. Isabella's vision of her own writing, with all of its humor, literary allusions, and remarkably honest representations of women's joyful and painful experiences, is of a technology that not only propels her to fascinating and vital places but also protects her from the threats those environments present.

This kind of reading of Jong's fiction would align it more closely than scholars have suggested to this point with the work of contemporary (white and mostly Jewish) second-wave feminists whose attitudes toward heterosexual sex ranged from skeptical to horrified and who sought out strategies for resistance to patriarchal norms. To take one example, Betty Friedan's *The Feminine Mystique* presented women's hopes for sexual fulfillment and

their reliance on sexual "phantasy"—the kind of hopes voiced and fantasies entertained by Isadora in *Fear of Flying*—as misguided and pernicious: "Instead of filling the promise of infinite orgiastic bliss, sex in the America of the feminine mystique is becoming a strangely joyless national compulsion, if not a contemptuous mockery."[33] One could easily imagine Isadora, in her disillusionment at the end of the novel ("There was no longer anything romantic about strangers on trains" [303]), saying almost exactly the same thing. Isadora might not go so far as Susan Brownmiller does when she insists in *Against Our Will* (which would appear in 1975) that rape "is nothing more or less than a conscious process of intimidation by which all men keep all women in a state of fear," but Jong's protagonist wishes, in her disillusionment, that she "were one of those wise women who carry aerosol cans of Mace or study karate" (302)—that is, women who are prepared, at all times, to defend themselves with physical force.[34] That Isadora's adventures in *Fear of Flying* echo Friedan and Brownmiller in this regard should be entirely unsurprising given that the novel, according to one critic, is "a primer of second wave feminism."[35]

It should be said that the reading that these students offered of Jong's novel, as centered on sexual assault, rape, and consent, wasn't entirely unprecedented. One critic, Sabine Sielke, in *Reading Rape* (2001), has argued that "Jong's novel makes all too clear what holds women captive: fictions of gender in which women do not survive and female sexuality is a no-no, a nuisance, or a construct of male fantasies" and that "the main point" of Jong's novel "is not to exorcise these fictions and phantoms . . . but to acknowledge them as what they are: fictions and phantoms that take part in constituting our sense of the real."[36] Even more striking is the fact that Jong herself seems to have been annoyed that no one had read the novel carefully enough to understand its skeptical attitude toward sex as liberation in the first place. In 1989, in a very short piece in *Ms.*, Jong noted that "the zipless fuck—even in *Fear of Flying*—was always better as a dream" and that "Isadora, at the end of the book, rejects the reality in order to keep the fantasy green." Suggesting that readers haven't understood that because "apparently, some people didn't read" to the end, Jong insists that she "never *advocated* the zipless fuck" but "merely *chronicled* it." Indeed, Jong goes on, "My generation is disillusioned with sex as a social panacea" and concludes by declaring that "a careful rereading of the novel shows that free love was never so very free at all." Still, in this piece, Jong,

despite her reputation for writing explicitly about everything, isn't quite explicit about the threat of sexual assault as one of the reasons why sex is "never so very free." The closest she gets to making that point is to say that "[s]ex is too volatile and overwhelming a force to use indiscriminately. When we use it indiscriminately, it is dulled and tarnished. When we use it indiscriminately, it takes its revenge by using us indiscriminately." The shift of agency in this sentence—endowing sex with the capacity to take revenge and use people—might be read as evoking the threat of sexual assault, but it would be easy to read it otherwise too.[37] And it is disheartening to note that the subheadline given to Jong's piece by the editors of *Ms.*—one that I have difficulty believing was chosen by the author herself—was "A Sexual Libertine Recants." This likely reflects an editor's refusal to take Jong at her word, because if one accepts Jong's claim that her first, famous novel showed that "free love was never so very free at all," in what sense was she ever actually "a sexual libertine," and how is her pointing out that her work has been persistently misread an act of "recant[ing]"? This would seem to indicate the resistance to taking seriously the novel's message about sex as described unambiguously by its author.

Indeed, readings of the novel that attend to its representation of sexual assault, like Sielke's, or even just reflect Jong's understanding of the novel as critiquing and showing the negative consequences of "free love," have been few and far between. Such perspectives have gone unmentioned even in thoughtful reconsiderations of the novel as recently as in the early 2010s. In 2013, on the novel's fortieth anniversary, the critic Liesl Schillinger reconsidered *Fear of Flying*, interviewing a range of feminist authors and editors for an extensive piece in the *New York Times*. While Schillinger herself and some of her interviewees did at least gesture toward the way the novel had been consistently misunderstood—one novelist, Lucinda Rosenfeld, rightly notes that "'Fear of Flying' was not a celebration of casual sex, it was completely misread"—none mention sexual assault, rape, or the issue of consent.[38] The general awareness that the #MeToo movement raised in 2017 makes it possible to believe that as the novel's fiftieth anniversary approaches, conversations about and readings of *Fear of Flying* might begin with an understanding that the book presents, in narrative form, a skepticism of sexual liberation and a sensitivity to the role of sexual violence in women's lives characteristic of other second-wave feminist writers like Friedan and Brownmiller.

Explaining (Non-)Reception

Although critics and scholars have mostly, until now, not offered readings of these two novels that center their representations of sexual assault and abuse, one index of the successes of the #MeToo movement is the fact that it does not feel necessary for me to argue too strenuously here on behalf of such readings. On the contrary, my impression is that just about any reasonable student or reader who revisits these novels or picks them up for the first time now or in the near future will almost certainly recognize, probably even more attentively and with more sophistication than I have been able to do here, how these two works represent the experiences of highly educated white women under patriarchy in the mid-twentieth-century United States, a moment in which the appalling commonness of sexual assault and spousal abuse contrasted with meaningful advances in feminist thought and women's rights.

If that's true, it seems that the more productive literary historical question that I can treat by way of conclusion here is the following: How can we understand these novels being read, over several decades, *without* explicit attention to issues around sexual assault and abuse, by feminist and nonfeminist critics alike? On a simple level, we can answer that these were decades in which sexual harassment and abuse were not just tolerated or condoned but encouraged by US culture in general, so they may not have seemed out of place or remarkable in novels like Taubes's and Jong's. Moreover, as Leigh Gilmore argues in *Tainted Witness*, this was a time when women in the United States (and elsewhere) were not accepted as reliable narrators of their own experiences and their testimony could be "discredited by a host of means meant to taint it: to contaminate by doubt, stigmatize through association with gender and race, and dishonor through shame, such that not only the testimony but the person herself is smeared."[39] While building a highly convincing case for the necessity and value of "literary witness," Gilmore acknowledges how frequently it has been insisted that "autobiographical fiction is a less than adequate means" of producing and sharing testimony.[40] The reception of *Divorcing* and *Fear of Flying* seems to be further evidence of that tendency.

Another, related explanation of the reception of these novels has to do with the way that US libel law inclines reviewers and critics to shy away from explicitly discussing the moments when novelists' representations

might be suggesting that real people have committed crimes or unethical acts.[41] While they were alive, Jacob Taubes and Jong's first husband, Michael Werthman, might have had the basis for libel suits against any critics who speculated about their conduct on the basis of those fictions; publishing such speculations meant opening oneself up to an extensive, expensive, and time-consuming legal battle. Especially if one has had firsthand experience with the kind of legal reviews of manuscripts that became increasingly common in the postwar decades and have become de rigueur now, it is difficult not to read the euphemistic tiptoeing around issues of abuse and assault in reviews of novels like Taubes's and Jong's as exemplifying, whether consciously or not, the so-called chilling effect of libel laws. It is much safer and easier to signal correspondences between fiction and real people subtly or suggestively, allowing oneself deniability, and to whisper about rather than publish one's suspicions and insider knowledge.

However it may be explained, the reception of these novels suggests that even when women were brave and talented enough to write powerful, revealing stories that reveal the depredations of sexual abuse and assault in the 1960s and 1970s *and* lucky enough to have those stories published to acclaim, their readers were very unlikely to receive the stories, as I would argue they deserved to be received, as protests against abuses and assault. As deeply insufficient as #MeToo might seem from our perspectives now, one can hope that what it *has* accomplished—in these specific cases, making a reading of *Fear of Flying* as centered on sexual assault obvious and raising questions about spousal abuse in *Divorcing* that have previously gone unasked—suggests at least the possibility of more just and meaningful responses to the ongoing epidemic of sexual assault and abuse in our lifetimes.

Notes

1 On #MeToo before 2017, see Tarana Burke, *Unbound: My Story and the Birth of the Me Too Movement* (New York: Flatiron/Oprah, 2021). In the field of Jewish studies, Keren McGinity has explained how encountering #MeToo in 2017 led to her to share a story about an incident of sexual misconduct from several years earlier. McGinity, "Why It Was So Hard to Say #MeToo and What I Learned when I Finally Did," *AJS Perspectives* (Spring 2019): 20–22.

2 Ika Willis, *Reception* (London: Routledge, 2018).
3 Willis, 25.
4 For a historical survey of this work by literary scholars and feminist activists, see Heather Hewitt and Mary K. Holland, "Introduction: Literary Studies as Literary Activism," in *#MeToo and Literary Studies: Reading, Writing, and Teaching about Sexual Violence and Rape Culture*, edited by Mary K. Holland and Heather Hewett (New York: Bloomsbury, 2021), 1–27.
5 Janet Badia, "'Dismissed, Trivialized, Misread': Re-examining the Reception of Women's Literature through the #MeToo Movement," in Holland and Hewett, *#MeToo and Literary Studies*, 31–42; and Mary K. Holland, "Quite Possibly the Last Essay I Need to Write about David Foster Wallace," in Holland and Hewett, *#MeToo and Literary Studies*, 113–31.
6 Susan Taubes, *Divorcing* (New York: Random House, 1969), 3. Further page citations from this novel appear parenthetically in the text.
7 On these dynamics, see Josh Lambert, *The Literary Mafia: Jews, Publishing, and Postwar American Literature* (New Haven, CT: Yale University Press, 2022), 96–129.
8 Sara Blackburn, "Interesting Patient," *Chicago Tribune Book Review*, November 16, 1969, 6; and Murrah Gattis, "Arresting Novel of Inner Feeling," *Los Angeles Times*, November 2, 1969, C55.
9 Hugh Kenner, "Divorcing," *New York Times Book Review*, November 2, 1969, BR4.
10 Blackburn, "Interesting Patient," 6.
11 Gattis, "Arresting Novel," C55.
12 Kenner, "Divorcing," BR4.
13 See, for example, "Writer Susan Taubes Ends Life by Walking into Sea," *Times Recorder* (Zanesville, OH), November 9, 1969, 6.
14 "Novel Panned, Author Suicide," *Record* (Hackensack, NJ), November 9, 1969, 3.
15 Bobby Mather, "'Divorcing' Sad Footnote," *Detroit Free Press*, November 30, 1969, 23.
16 David Rieff, "Anguish and Suffering in Susan Taubes' *Divorcing*," *Literary Hub*, November 20, 2020, lithub.com/david-rieff-on-anguish-and-suffering-in-susan-taubess-divorcing/.
17 Jacob Taubes described himself as "impossible" in a letter to Arthur Cohen, republished in the *Jewish Review of Books* in 2017. As Jerry Z. Muller notes while introducing that letter, "[O]stensibly this is only a remark about his peripatetic life" and not an admission of anything broader. In fact, read in the context of the letter itself, it seems worth noting that what Jacob Taubes

seems to mean when he says he is "impossible" is that he cannot be blamed for not bringing his address book with him on a trip; it seems quite easy to read it not to be Jacob Taubes taking responsibility for his actions, or apologizing for them, but on the contrary, disclaiming responsibility. See Muller, "I Am Impossible: An Exchange between Jacob Taubes and Arthur A. Cohen," *Jewish Review of Books*, Summer 2017, jewishreviewofbooks.com/articles/2672/i-am-impossible-an-exchange-between-jacob-taubes-and-arthur-a-cohen/.

18 Jennifer Schaffer-Goddard, "The Unspoken Corners: Susan Taubes's *Divorcing*," *Nation*, December 2, 2020, www.thenation.com/article/culture/susan-taubes-divorcing-review/.

19 John Williams, "A Skeptical Heroine, Unconvinced by Religion, Romance or Psychoanalysis," *New York Times*, December 1, 2020, www.nytimes.com/2020/12/01/books/review-divorcing-susan-taubes.html.

20 Jess Bergman, "A Compendium of Severance," *Jewish Currents*, October 27, 2020, jewishcurrents.org/a-compendium-of-severance.

21 Becca Rothfeld, "The Fiercely Despairing Fiction of Susan Taubes," *New Republic*, October 16, 2020, newrepublic.com/article/159812/fiercely-despairing-fiction-susan-taubes-book-review.

22 Jerry Z. Muller's biography of Jacob Taubes, *Professor of Apocalypse* (Princeton, NJ: Princeton University Press, 2022), which was published after most of my research for this chapter was completed, treats events represented in *Divorcing* as evidence for Jacob Taubes's real-life behavior. For example, Muller remarks on Jacob's "deflowering of the babysitter," citing *Divorcing* as his only source (292). Muller also draws on interviews and other sources to catalog Jacob Taubes's sexual relationships, noting that he "took a certain pleasure in destroying marriages" of people he knew (299).

23 See Lambert, *Literary Mafia*, 102–5.

24 Bergman, "Compendium of Severance."

25 Rothfeld, "The Fiercely Despairing Fiction of Susan Taubes," *New Republic*, October 16, 2020, newrepublic.com/article/159812/fiercely-despairing-fiction-susan-taubes-book-review.

26 Charlotte Templin, *Feminism and the Politics of Literary Reputation: The Example of Erica Jong* (Lawrence: University Press of Kansas, 1995), 11, 46, 57.

27 Suleiman quoted in Templin, 173; Templin, 178. In 2001, Tobin Belzer responded to and updated Templin's work, focusing on the novel's reception (or the lack thereof) as a work of Jewish literature. Notably, Belzer ends her article with the question, "What are the implications of the widespread popularity of a novel like *Fear of Flying*, which is filled with misogynistic and anti-Semitic images?" Belzer, "Written in and

Read out: Why Erica Jong's *Fear of Flying* Was Not Considered 'Jewish Writing,'" in *"Lost on the Map of the World": Jewish-American Women's Quest for Home in Essays and Memoirs, 1890–Present*, ed. Phillipa Kafka (New York: Peter Lang, 2001), 153. For another update to Templin's work, likewise focused on the perception of Jong as a Jewish author, see Mark H. Gelber, "Reception and Jewish Literature: The Case of Erica Jong and *Inventing Memory*," in *Identität und Gedächtnis in der jüdischen Literatur nach 1945*, ed. Dieter Lamping (Berlin: Erich Schmidt Verlag, 2003), 145–55.

28 As one example of how the novel has been considered thoughtfully, at length, with no reference to rape or sexual assault, see Ann R. Shapiro, "The Flight of Lilith: Modern Jewish American Feminist Literature," *Studies in American Jewish Literature* 29 (2010): 68–79, which devotes several pages to a reading of *Fear of Flying* as "a feminist breakthrough" (71). While Shapiro notes that the novel attends "to the suffering inflicted upon women . . . by all men" (72) and that "the irony of Isadora's efforts at sexual liberation is that she never feels liberated" (73), and surveys Isadora's marriages and experiences, she never mentions rape or sexual violence.

 I count myself among these critics. Looking back at my book *American Jewish Fiction*, JPS Guide (Philadelphia: Jewish Publication Society, 2009), I give myself credit for noting that Isadora attends to "all the woes of being a woman in a patriarchal world" and "recounts the traumas of her life to date," and for insisting that "Jong's aim is not simple titillation" while noting the "uncanny realism, even pragmatism" of "Jong's descriptions of sex and relationships" (103–4). But if I were to revise that description of the novel now, I would mention, explicitly, Jong's attention to sexual assault, as I do in my entry "Erica Jong," *The Shalvi/Hyman Encyclopedia of Jewish Women*, June 23, 1021, jwa.org/encyclopedia/article/jong-erica.

29 Erica Jong, *Fear of Flying* (New York: New American Library/Signet, 1974), 302. Further page citations from this novel appear parenthetically in the text.

30 Such a reading has more than once been explicitly raised as a possibility and then dismissed. In an article published in 2009, Timothy Aubry acknowledges that the "[t]he man [in the fantasy] initiates the sexual contact with a presumption that could qualify his overture as sexual harassment," but Aubry quickly dismisses that way of thinking of the interaction, suggesting that the woman's seeming passivity is misleading and that it in fact suggests she is "secretly orchestrating the affair"—a reading of a woman's passivity as implying consent and responsibility for a sexual act that strikes me as deeply disturbing. Aubry, "Erica Jong's Textual Bulimia: *Fear of Flying* and the Politics of Middlebrow Consumption," *Journal of Popular*

Culture 42, no. 3 (2009): 424. Writing in 2015 in an explicitly feminist context, Jay Hood notes that "the encounter can easily be read as an act of public rape" but "yet" decides to read it not that way, but rather in relation to psychoanalysis and discourse, "as a fantasy of the possibilities of desire outside of the confines of marriage," "a model of a potentially unachievable ideal" (160). Jay Hood, "Desire and Fantasy in Erica Jong's *Fear of Flying*," in *This Book Is an Action: Feminist Print Culture and Activist Aesthetics* (Bloomington: University of Illinois Press, 2015), 151–52.

31 Rachel Linfield, "The Zipless Fuck and the Illusion of Consent" (essay submitted for the course American Jews and Sexual Freedom, Princeton University, December 3, 2018). Linfield also notes that "some Biblical commentators suggest that Adam first slept with the animals, and then God gave him dominion over them," suggesting the complex dynamics of gender and nonhuman animals in the Torah that Jong seems to have been able to pick up on, perhaps intuitively. See Rashi on Genesis 2:23, and for a study of the reception of Rashi's gloss on this verse, see Eric Lawee, "From Sepharad to Ashkenaz: A Case Study in the Rashi Supercommentary Tradition," *AJS Review* 30, no. 2 (2006): 393–425.

32 Linfield, "Zipless Fuck," 5.

33 Betty Friedan, *The Feminine Mystique* (New York: W. W. Norton, 2001), 310.

34 Susan Brownmiller, *Against Our Will: Men, Women, and Rape* (New York: Bantam, 1985), 5.

35 Shapiro, "Flight of Lilith," 72.

36 Sabine Sielke, *Reading Rape: The Rhetoric of Sexual Violence in American Literature and Culture, 1790–1990* (Princeton, NJ: Princeton University Press, 2002), 167.

37 Erica Jong, "Ziplash: A Sexual Libertine Recants," *Ms.*, May 1989, 49.

38 Liesl Schillinger, "A Woman's Fantasy in a Modern Reality," *New York Times*, December 18, 2013, www.nytimes.com/2013/12/19/fashion/Fear-of-Flying-Erica-Jong.html.

39 Leigh Gilmore, *Tainted Witness: Why We Doubt What Women Say about Their Lives* (New York: Columbia University Press, 2017), 2. Thanks to Lori Harrison-Kahan for drawing my attention to the relevance of Gilmore's work to this project.

40 Gilmore, 154.

41 Legal commentators in the United States have been remarking since the 1980s, and into the new millennium, that "defamation law is woefully inconsistent and unclear in its treatment of fiction," which results "in 'a serious chilling effect on the publication of realistic novels,'" as well as forcing "publishers and distributors to spend extra time and resources

subjecting creators of fictional works to comprehensive clearance procedures." Mark Arnot, "When Is Fiction Just Fiction? Applying Heightened Threshold Tests to Defamation in Fiction," *Fordham Law Review* 76, no. 3 (2007): 1853–1904.

Bibliography

Arnot, Mark. "When Is Fiction Just Fiction? Applying Heightened Threshold Tests to Defamation in Fiction." *Fordham Law Review* 76, no. 3 (2007): 1853–1904.

Aubry, Timothy. "Erica Jong's Textual Bulimia: *Fear of Flying* and the Politics of Middlebrow Consumption." *Journal of Popular Culture* 42, no. 3 (2009): 419–41.

Badia, Janet. "'Dismissed, Trivialized, Misread': Re-examining the Reception of Women's Literature through the #MeToo Movement." In Holland and Hewitt, *#MeToo and Literary Studies*, 31–42.

Belzer, Tobin. "Written in and Read out: Why Erica Jong's *Fear of Flying* Was Not Considered 'Jewish Writing.'" In *"Lost on the Map of the World": Jewish-American Women's Quest for Home in Essays and Memoirs, 1890–Present*, edited by Phillipa Kafka, 139–53. New York: Peter Lang, 2001.

Bergman, Jess. "A Compendium of Severance." *Jewish Currents*, October 27, 2020. jewishcurrents.org/a-compendium-of-severance.

Blackburn, Sara. "Interesting Patient." *Chicago Tribune Book Review*, November 16, 1969.

Brownmiller, Susan. *Against Our Will: Men, Women, and Rape*. New York: Bantam, 1985. Originally published 1975.

Burke, Tarana. *Unbound: My Story and the Birth of the Me Too Movement*. New York: Flatiron/Oprah, 2021.

Friedan, Betty. *The Feminine Mystique*. New York: W. W. Norton, 2001. Originally published 1963.

Gattis, Murrah. "Arresting Novel of Inner Feeling." *Los Angeles Times*, November 2, 1969.

Gelber, Mark H. "Reception and Jewish Literature: The Case of Erica Jong and *Inventing Memory*." In *Identität und Gedächtnis in der jüdischen Literatur nach 1945*, edited by Dieter Lamping, 145–55. Berlin: Erich Schmidt Verlag, 2003.

Gilmore, Leigh. *Tainted Witness: Why We Doubt What Women Say about Their Lives.* New York: Columbia University Press, 2017.

Hewitt, Heather, and Mary K. Holland, "Introduction: Literary Studies as Literary Activism." In Holland and Hewitt, *#MeToo and Literary Studies,* 1–30.

Holland, Mary K. "Quite Possibly the Last Essay I Need to Write about David Foster Wallace." In Holland and Hewitt, *#MeToo and Literary Studies,* 113–31.

Holland, Mary K., and Heather Hewett, eds. *#MeToo and Literary Studies: Reading, Writing, and Teaching about Sexual Violence and Rape Culture.* New York: Bloomsbury, 2021.

Hood, Jay. "Desire and Fantasy in Erica Jong's *Fear of Flying.*" In *This Book Is an Action: Feminist Print Culture and Activist Aesthetics,* edited by Jaime Harker and Cecilia Konchar Farr, 149–62. Bloomington: University of Illinois Press, 2015.

Jong, Erica. *Fear of Flying.* New York: New American Library/Signet, 1974.

———. "Ziplash: A Sexual Libertine Recants." *Ms.,* May 1989.

Kenner, Hugh. "Divorcing." *New York Times Book Review,* November 2, 1969.

Lambert, Josh. *American Jewish Fiction.* A JPS Guide. Philadelphia: Jewish Publication Society, 2009.

———. "Erica Jong." *The Shalvi/Hyman Encyclopedia of Jewish Women.* Jewish Women's Archive, June 23, 2021. jwa.org/encyclopedia/article/jong-erica.

———. *The Literary Mafia: Jews, Publishing, and Postwar American Literature.* New Haven, CT: Yale University Press, 2022.

Lawee, Eric. "From Sepharad to Ashkenaz: A Case Study in the Rashi Supercommentary Tradition." *AJS Review,* 30, no. 2 (2006): 393–425.

Linfield, Rachel. "The Zipless Fuck and the Illusion of Consent." Essay submitted for the course American Jews and Sexual Freedom. Princeton University, December 3, 2018.

Mather, Bobby. "'Divorcing' Sad Footnote." *Detroit Free Press,* November 30, 1969.

McGinity, Keren R. "Why It Was So Hard to Say #MeToo and What I Learned when I Finally Did." *AJS Perspectives* (Spring 2019): 20–22.

Muller, Jerry Z. "'I Am Impossible': An Exchange between Jacob Taubes and Arthur A. Cohen." *Jewish Review of Books,* Summer 2017. jewishreviewofbooks.com/articles/2672/i-am-impossible-an-exchange-between-jacob-taubes-and-arthur-a-cohen/.

———. *Professor of Apocalypse: The Many Lives of Jacob Taubes*. Princeton: Princeton University Press, 2022.

"Novel Panned, Author Suicide." *Record* (Hackensack, NJ), November 9, 1969.

Olsen, Tillie. *Silences*. New York: Delacorte Press / Seymour Lawrence, 1978.

Rieff, David. "Anguish and Suffering in Susan Taubes' *Divorcing*." *Literary Hub*, November 20, 2020. lithub.com/david-rieff-on-anguish-and-suffering-in-susan-taubess-divorcing/.

Rothfeld, Becca. "The Fiercely Despairing Fiction of Susan Taubes." *New Republic*, October 16, 2020. newrepublic.com/article/159812/fiercely-despairing-fiction-susan-taubes-book-review.

Russ, Joanna. *How to Suppress Women's Writing*. Austin: University of Texas Press, 1983.

Schafer-Goddard, Jennifer. "The Unspoken Corners: Susan Taubes's *Divorcing*." *Nation*, December 2, 2020. www.thenation.com/article/culture/susan-taubes-divorcing-review/.

Schillinger, Liesl. "A Woman's Fantasy in a Modern Reality." *New York Times*, December 18, 2013. www.nytimes.com/2013/12/19/fashion/Fear-of-Flying-Erica-Jong.html.

Shapiro, Ann R. "The Flight of Lilith: Modern Jewish American Feminist Literature." *Studies in American Jewish Literature* 29 (2010): 68–79.

Sielke, Sabine. *Reading Rape: The Rhetoric of Sexual Violence in American Literature and Culture, 1790–1990*. Princeton, NJ: Princeton University Press, 2002.

Taubes, Susan. *Divorcing*. New York: Random House, 1969.

Templin, Charlotte. *Feminism and the Politics of Literary Reputation: The Example of Erica Jong*. Lawrence: University Press of Kansas, 1995.

Williams, John. "A Skeptical Heroine, Unconvinced by Religion, Romance or Psychoanalysis." *New York Times*, December 1, 2020, www.nytimes.com/2020/12/01/books/review-divorcing-susan-taubes.html.

Willis, Ika. *Reception*. London: Routledge, 2018.

"Writer Susan Taubes Ends Life by Walking into Sea." *Times Recorder* (Zanesville, OH), November 9, 1969.

7

"KIKE ART"

Chris Kraus's Bad Jewishness and Artworld Hustles

Annie Atura Bushnell

> You were the greatest Cowboy. And Sylvère and me, with our two-bit artworld hustles, projects, conversation skills—well, we were Kikes. You made me ready to recant on 15 years spent studying wit and difficulty in New York. I'd become a hag. And you were beautiful. Let the desert burn it out.[1]

In Chris Kraus's 1997 cult novel *I Love Dick*, the autofictional narrator, Chris, describes herself not only as the "Dumb Cunt" but also as a "Kike"—and as someone who makes an ambivalent political home for herself in both terms through telling "the Dumb Cunt's Tale" (27–28).[2] The role of "greatest Cowboy" is played by Dick, a cultural critic and professor. Chris's romantic adventure with Dick begins innocently enough: she and her husband, Sylvère, have dinner with him. Dick invites the couple back to his place and shows them some of his "hopelessly naive" video art (21). No literal sex is had that fateful night, just a "Conceptual Fuck," but Chris becomes obsessed with Dick, and she begins to write him letters that explore her self-consciously embarrassing and inappropriate infatuation, as if her sexual fixation were performance art and it were her role as a critic to provide an account thereof (23–24). Chris's letters to Dick make up the majority of the epistolary novel—they intermingle with diary entries and essays, a few letters from Sylvère, and (spoiler alert) one letter back from Dick at the novel's end.

Sylvère Lotringer was the name of Kraus's real-life husband at the time of *I Love Dick*'s publication, and Dick was swiftly outed in *New York* magazine as Dick Hebdige, then a professor of art and media studies at UC Santa Barbara. Kraus insists that the events described in the book are true and factual—"It all happened. . . . There would be no book if it hadn't happened"[3]—and critics have eagerly claimed the text as a pioneering example of autotheory.[4] Dick metonymically stands trial for the patriarchy—just as the "dick" does in some of the feminist theory to which Kraus responds—but he does so mostly in absentia: Chris writes to Dick, "I guess in a sense I've killed you. You've become Dear Diary" (90). Dick is the mere occasion for Chris's performance, the conjured, mythical audience (smart, well read, intimate, and always top of mind) that gives her a reason to write. In the end, Dick proves to be entirely beside the point. While Sylvère eggs Chris on as she writes letter after letter to Dick, Dick is cold, condescending, and suspicious. The real-life Hebdige objected to Kraus's book project and sent her a cease-and-desist letter in an attempt to halt its publication.[5] Yet Dick's withdrawal only seems to open more space for Chris's flourishing. In an interview, Kraus refers to Dick as a "transitional object,"[6] and over the course of the book, Dick comes to embody and to make available everything from which Chris feels excluded.

In her romantic pursuit of a non-Jewish man, as in her creative endeavors, Chris draws power from an imagined lineage of fearsome Jewish women artists. She likens herself to the hip Jewish women in the New York art scene who allegedly lured Jim Morrison to his untimely death with "their exotic drugs, their wild parties, mindfuck demonology. . . . The Witches are why Jim died of an overdose in the bathtub of a Paris hotel" (196). Chris writes, "Realize, D, that I am one of those Crazed Kike Witches and I understand your fear" (196). Yet Chris's identity as a "Crazed Kike Witch" is complicated by her ostensible willingness to surrender to the conspicuously phallic Dick, to "recant" on the heresy and to "[l]et the desert burn it out" (147). Her abjection as a femme in love with a hypermasculine jerk is doubled by the abjection of being a Jewish woman who finds herself imbricated in—and fascinated by—a deep history of settler colonialism and genocide encoded by the American cowboy, an American cowboy who can "burn . . . out" Chris's identification with "wit and difficulty." Dick gives Chris a complicated kind of access not only to masculinity and art world prestige but also, and relatedly, to

the homogenizing, dispossessing American whiteness of the cowboy.[7] It may be no coincidence that Kraus's alter ego in the years that she danced in "hustle bars" was named "Sally West."[8] Playing with the possibility of pleasurable self-annihilation—as a feminist, as a Jew—allows Chris to appreciate what exactly it is that Dick should fear.

The back cover of *I Love Dick* heralds the text as a "manifesto for a new kind of feminism." Indeed, it has emerged as the kind of book that—like Betty Friedan's *The Feminine Mystique*—readers are quick to describe as life changing. In their oft-quoted foreword to *I Love Dick*, the poet and writer Eileen Myles goes so far as to claim that Kraus's book has redeemed "work by women or about women," a corpus that, Myles admits, has disappointed time and time again:

> [E]ven as the female was trying to be an artist, she wound up pregnant, desperate, waiting on some man. A Marxist guy, perhaps. When would this end. Remarkably, it has, right here in this book. . . . Chris, marching boldly into self-abasement and self-advertisement, not being uncannily drawn there, sighing or kicking and screaming, but walking straight in, was exactly the ticket that solidified and dignified the pathos of her life's romantic voyage. (13–14)

Myles's stunning prefatory claim is not only that *I Love Dick* manages to escape the sordid fate of books "by women or about women," but that Kraus's devil-may-care spirit of "self-advertisement" has disrupted all of women's literary history: "[I]t has [ended], right here in this book."[9] The drama of this claim reflects the very spirit of self-advertisement that, with a nod to Norman Mailer's *Advertisements for Myself*, Myles is describing as essential to the novel's arresting immediacy. Yet it also rehashes a trope of second-wave feminism, positioning a white Jewish woman as the herald of a new era.[10]

As a paradigm-shifting feminist text by a white Jewish woman, *I Love Dick* is not often read as a book about race. Indeed, the Jewishness of the text seems to be subsumed under the sign of feminism. And yet, Chris tells Dick / the reader explicitly, and many times over, that her abjection is tied to her identity as a "kike" and that her enthrallment with Dick's difference is racialized as well as gendered. If we take seriously Kraus's insistence that we recognize her as both a "kike" *and* a "witch" (does "Crazed Kike

Witches" use kike as an adjective or a noun?), we would do well to ask what Kraus takes "kike" to mean, what social failures it names—and why those failures are, for Kraus, so critical to own. Myles does acknowledge, in passing, Kraus's "kike" identity in contouring the defiance and abjection that animates *I Love Dick*: "She's turned female abjection inside out and aimed it at a man.... As if [Chris], a hag, a kike, a poet, a failed filmmaker, a former go-go dancer—an intellectual, a wife, as if she had the right to go right up to the end of the book and *live* having felt all that" (15). As a "kike"—and as a wife!—Chris must imagine into being her own right to "live having felt all that." Why is Jewishness so important to this project of politicized survival?

Unlike her then-husband Lotringer, who survived the Holocaust under a borrowed name in occupied France, Kraus did not grow up consciously in fear of antisemitism. When Kraus was a child, her parents did not discuss her father's Jewish background.[11] They attended an Episcopalian church in the Bronx, "an oasis of order and beauty" that befitted Kraus's sense of Episcopalianism as "an aspirational religion."[12] The family moved from the Bronx to Connecticut when Kraus was five, then to New Zealand when she was fourteen. Only after graduating from university and moving back to New York at twenty-one did Kraus "meet these long lost relatives who were the Glassmans and the Heinemanns. And it's like, 'Oh, we're Jewish.'"[13] Kraus's story is decidedly different from the familiar narrative of the Jewish radical who grew up with an internalized sense of outsiderness that is cited as the source of intellect and critical thinking. And yet, as an adult, Kraus's Jewishness becomes an important part of her identity as an artist. "Kike" identity becomes a crucial way of navigating art worlds in which Jewish networks are a matter of survival and in which Jewishness serves as a marker both of exclusion and belonging.

By exploring the racialized dimensions of Chris's abjection, we can better understand Kraus's oeuvre as a complicated meditation on Jewish financial privilege and precarity. These themes have been taken up by many of the young Jewish feminist comics who dominate contemporary TV. In its celebration of prolonged adolescence[14] and economic insecurity, *I Love Dick* is a crucial precursor to what Rebecca Wanzo terms the "Precarious-Girl Comedy."[15] Exemplified by 2010s TV shows by the likes of Lena Dunham and Rachel Bloom, these shows have been enthusiastically received by viewers and critics alike, and they have attracted the

attention of Jewish studies' scholars who point to them as evidence of the enduring role of Jewishness in navigating questions of whiteness, class, sexuality, and gender in US culture. Indeed, it may be that *I Love Dick* was an attractive candidate for optioning as a TV show because the book so compellingly anticipated the 2010s shows discussed by Wanzo. As Kraus wrote in the *Guardian*, *I Love Dick* was much better received upon its rerelease in 2006 than it was upon its original publication: "Women, by then, had utterly rejected the unspoken rule of feminine discretion. In a milieu of female blogs and third-wave feminism, *I Love Dick* was seen as prescient."[16] Kraus's protagonists share features of the troped figure Hannah Schwadron terms the "Sexy Jewess," although *I Love Dick* predates most of the dance, performance art, and TV Schwadron examines in her study. Schwadron's Sexy Jewess is a figure of perpetual suggestion and critique: "The aftermath of American assimilation and women's liberation, her funny, sexy power navigates aging territories with new scripts. Oscillating as she does between ethnic difference and race privilege, emboldened femininity and its failures, her antics embody positions that she remains forever in-between."[17] Kraus is worth revisiting, k-word and all, as a matriarch of comic feminist precarity—one whose Jewishness is avowedly critical to her ability to remain, at least in the world of her text-performances, "forever in-between."

This chapter focuses on two aspects of "kike"-dom that Kraus introduces in the passage with which I opened: the aesthetics of "wit and difficulty" and the economics of "two-bit artworld hustles." The first describes a self-defeating or even perverse artistic impulse that Kraus explores in a chapter of *I Love Dick* titled "Kike Art." The second indexes the economic precarity that pervades so much of Kraus's work, and which comes into focus in Kraus's description of artists' funding structures in her 2017 literary biography *After Kathy Acker*. These texts cut a figure of the Jewish feminist parasite who, like the "kike witches" of Jim Morrison lore who supposedly led an all-American white boy astray, refuse to pretend that the circulation of sex and capital can be separated from the circulation of art and ideas.[18] "Difficulty" and "hustle" define a feminist "kike" who strains to find her place in the art establishment, even an art establishment full of fellow Jews. These two facets of Jewish abjection—which, as I will show, reverberate across Kraus's work, from her writing debut in 1997 to the 2018 essay collection *Social Practices*—allow us to see Kraus's formulation

of the kike as more than a sloppy analogy to the cunt, more than a pussy that grabs back. They demand that we read Kraus's work as an intervention not just in feminist theory or the politics of life-writing but as a materialist critique of a US art world profoundly shaped by Jewish funders, tastemakers, and artists, as well as by antisemitic resistance to the same.

Bad Jewishness

Like the early 1990s Riot Grrrl punk movement, which is often identified as quintessentially third-wave feminist and which made ample use of words such as "cunt," "bitch," "dyke," and "slut," *I Love Dick* revels in reappropriating insult.[19] Chris reclaims and resignifies what it means to love dick and, in an interesting riposte to (and expression of) heteropessimism, even toys with understanding femme desire as a mode of queerness: "My entire state of being's changed because I've become my sexuality: female, straight, wanting to love men, be fucked. Is there a way of living with this like a gay person, proudly?" (202). Rather than contesting the idea that she is boy crazy, self-obsessed, or crass, Chris forces us to remain in that moment of interpellation until we recognize ourselves, too, as stickily interpellated by the categories we try to affix to her.

Although Kraus's work has been the subject of a spate of scholarship in recent years, especially since *I Love Dick* was rereleased in 2015 and adapted into a TV series by Sarah Gubbins and Joey Soloway in 2016,[20] the persistence of unabashed antisemitic cliché in Kraus's work—and Kraus's Jewishness generally—receives little to no critical attention. Perhaps this is because her use of "kike" seems, on its face, to be invested in reinscribing familiar tropes rather than challenging them.[21] Where Kraus's embrace of misogynistic tropes is seen as central to her political project, the antisemitic tropes go unremarked upon, and *I Love Dick* is hailed as a groundbreaking feminist text and not an intervention in, or continuation of, Jewish literary history.

In a 2016 essay in the *Los Angeles Review of Books*, Rebecca Sonkin asks why Kraus's oeuvre, which makes no secret of Kraus's Jewishness and which "pulse[s] to a striking degree with Jewish themes," has not been studied as Jewish literature.[22] Sonkin is particularly interested in Kraus's use of the racial slur: "Most startling is the universal neglect of Kraus's brazen

and prolific use of the k-word. . . . It is a phenomenon that strikes me as falling somewhere along a spectrum of an aversion to confronting material that is controversial, even uncool in certain realms, and an oversight that is by turns lazy and dangerous among an adoring readership." In part, Sonkin blames the critical silence about Jewishness in Kraus's work on her use of the word "kike": "By employing the dirtiest language around the dirty subject of antisemitism, Kraus has shut down the discussion rather than open it up."[23] Whatever is to blame for the absence of critical discussion, Sonkin's call for an analysis of Kraus's work as Jewish literature has gone unanswered in the seven years since her article's publication. Kraus's abjection continues to be framed as a feminist—never Jewish—intervention in the ever-expanding scholarship, even as the Jewishness of white feminist figureheads in the United States has received ongoing academic and popular attention.[24,25]

While Sonkin is right to point out that Kraus's work writes with and against various Jewish American literary traditions, her claim that Jewish critics are squeamish around the k-word seems out of touch with the contemporary field of Jewish studies. The opposite would seem to be the case: the field is especially attracted to political difficulty, as the proliferation of scholarship on Holocaust humor, antisemitism, racial boundary traversal, and obscenity makes plain.[26] Nor does it seem appropriate to discipline Kraus's use of "the dirtiest language" exclusively as it applies to Jewishness. Why should "kike" be sacrosanct in a text so thoroughly invested in trash identities, a text that relishes the cunt and the bimbo? Indeed, one might read Kraus's self-identification as a kike as an undertheorized extension of the same iconoclastic impulse to recuperate the "witch," "cunt," and "monster." Sonkin's reading is even less generous, suggesting that the use of "kike" is a vapid, wannabe-punk move drained of political meaning: "Kraus never manages to locate a source of truth or hilarity beyond the shock value. Shock value for its own sake seems too juvenile an objective for an artist of Kraus's caliber. And draining the ugliness of the pejorative through usage seems too unoriginal." Shock value and desensitization have their limitations, to be sure—but is there a third way?

It is worth noting that "kike" seems to have more currency in contemporary mainstream US culture as a tool of antiracist critique than as a straight racial slur. Feminist comics have moved toward recuperations of the "Jewess" in recent years; in her introduction to the special issue

"The Modern Jewess in Image and Text" in *Shofar*, Keren Rosa Hammerschlag glosses a moment in the millennial comedy series *Broad City* by noting, "While 'Jewess' is used as a positive term of self-identification, 'Jew' is an insult."[27] Just as "Jewess" has reentered the popular lexicon due in no small part to the influence of *Broad City*, "kike" has been revived in popular media by Jewish millennials like the rapper Lil Dicky who, with explicit reference to Black hip-hop culture, lay claim to racial otherness.[28] The use of "kike" in *I Love Dick* recalls the use of "dirty Jew," which, Josh Lambert notes, "was more likely to crop up in the writing of liberals and anti-anti-Semites as a mark of the racism of bigots than in the writing of anti-Semites themselves."[29]

The question of why literary critics fail to read Kraus's work as Jewish, even when her writing insistently and aggressively lays claim to Jewishness, is at its heart a question about what constitutes Jewish legibility. Whom do we think of as Jewish, and why? Whose Jewishness is relevant? Thanks in part to Kraus's intervention, questions around women's subjectivity in art have entered the realm of the familiar, even the overdone: Why can't women sacrifice men's privacy for the sake of art? Why can't women's sex lives be intellectual? Why are navel-gazing and autobiography considered petty and solipsistic in women's writing when they have featured so prominently in men's? The prominence of autofictional writers like Elena Ferrante, Rachel Cusk, and Sheila Heti demonstrate how the tide has turned on these questions, which in 1997 were still controversial; Elizabeth Wurtzel's memoir *Prozac Nation* (1994) came out just a few years before *I Love Dick* and was roundly criticized for its supposed narcissism (and, not incidentally, for the JAP-iness of its heroine).

Like *Prozac Nation*, which has been credited with pioneering the disability memoir,[30] *I Love Dick* is notable insofar as it writes toward new genres and epistemologies rather than making a case for inclusion in an extant canon. In keeping with the spirit of this collection on matrilineage, *I Love Dick* stakes out its own intellectual genealogy, lavishing critical attention on the life and work of other Jewish women artists: Chris insists that artists as diverse in medium and approach as Hannah Wilke, Simone Weil, Jane Bowles, Kathy Acker, and Eleanor Antin merit the reader's attention. The artists Kraus invokes, while often Jewish, are not the usual suspects of the Jewish American "golden age," but a motley crew of European literary theorists and feminist artists, queer poets and punk rockers.

Chris writes in *I Love Dick* that she is more moved by these women artists than she is by Dick: "Reading Jane Bowles' letters makes me angrier and sadder than anything to do with you," she writes him (182).[31] Matrilineal genealogies of intellectual influence animate other works of Kraus's, too, including her 1996 film *Gravity & Grace*, a creative engagement with Simone Weil that Kraus has credited with deepening her connection to her own Jewishness.[32] While the introduction of this volume highlights how some Jewish women writers invoke the hegemonic, masculinist canon of the "golden age" to contextualize their work and shore up their own authorial credentials, Kraus, for her part, studiously avoids doing so.[33] It may be that Kraus's illegibility as a Jewish writer is a symptom of this very choice, to establish an alternate pantheon of loners and misfits who, like Jane Bowles, never achieved mainstream recognition and "hardly found anybody to agree with [them]" (182) in their own lifetimes. Kraus enters into conversation with a Jewish American canon of her own, this one defined more by hustle and difficulty than by institutional recognition and racial legibility.

If Kraus's interlocutors are not well known for their Jewishness, it bears mentioning, too, that they are rarely unproblematically feminist. Chris herself is not entirely at ease with feminism as an institution: "I was difficult and unadorable and a Bad Feminist to boot," she admits (87). As we learn, Chris's lack of patience for feminist policing is informed by her understanding of Jewishness. In one of the essays in *I Love Dick*, Chris notes that while Jewish men are sometimes denigrated or excluded for being Jews, they are not simultaneously accused of being *bad* Jews in the way that feminists are disavowed for being "bad feminists" even as they are dismissed for being feminist. Chris writes, "'I have long since resolved to be a Jew . . . I regard that as more important than my art,' R. B. Kitaj and Arnold Schoenberg declared. Hannah Wilke said: 'Feminism in a larger sense is intrinsically more important to me than art.' No one ever called these men bad Jews" (216). The comparison highlights how indelible the men's claim to Jewishness seems to be, and how comparably tenuous is Kraus's (and Wilke's). Perhaps, then, Chris's self-anointing as a kike is also a laying claim to men's agency in using Jewishness just as they please. Kraus—and the genealogy she charts—have helped solidify an alternative troping of the Jewish feminist as a Bad Feminist—one whose feminism, like her Jewishness, is defined by its discomfiture *and* its indelibility.

By using the gendered word "kike," and by leaning so heavily into antisemitic clichés that are typically ascribed to men, Kraus is also writing her way into a male Jewishness—one that valorizes hustle and difficulty while recognizing the unchosen economic conditions that necessitate them—without reinscribing the masculinist canon. The very gendering of "kike" suggests the primacy of the Jewish man in the cultural imagination of Jewishness. "Kike" has historically referred not just to a Jewish man but to one who is characterized by cheap or dishonest sales: the OED defines the "kike" as "spec. one who sells or manufactures poor-quality goods."[34] In this sense, the word is not so unlike "Jew," with derogatory uses, including, in verb form, "to cheat by sharp business practice"—a definition of "jew" in lower case that an editor of the Oxford Dictionary fought to retain even as late as 1973[35] and which sparked a Scrabble firestorm in 1994.[36] For Kraus, the confrontational use of "kike"—especially in writing about art—is a tool for insisting on racial identity as always also a matter of economic positioning, even and especially in an art world that thrives on mystification.

Kraus's autofictional personae artfully bring together antisemitic and misogynistic tropes: the middleman and the whore, the landlord and the bimbo, the financial manager and the hag. By leaning into the identities of the "kike" *and* the "witch," Kraus does three things: (1) she theorizes the interrelatedness of antisemitic and misogynistic systems of abjection; (2) she offers an intersectional intervention into the gendering and racialization of the terms, challenging the assumption that the kikes are men and the bimbos are white; and (3) she demonstrates that each trope, gendered or racialized, names as an essentially economic condition. These abjected identities capture the dizziness of Chris's compromised position as a (Bad) Feminist and a (Bad) Jew: rhetorics of exile and dispossession bump up against the imperative for capital accumulation. Kraus's protagonists are scrappy but downwardly mobile, disdainful of capitalism but obsessed with making money. Chris is arguably as enthralled with capital as she is with Dick, and in both cases she stands accused of exploitation.

Kraus also claps back at the obsessive attention given to the Jewish mother and the JAP as models for stereotypical Jewish femininity. Both, to be sure, revolve around a resentful dependency on men—but both play into a patriarchal (and Jewish) reproductive fantasy that Kraus gleefully eschews. Like Kathy Acker before her and Sheila Heti after,[37] Chris in *I Love Dick* writes from the avowed position of middle-aged childlessness: "Chris and

Sylvère had no children, three abortions, and they'd been shuttling between low-rent rural slums on both coasts for the past two years in order to put money into Chris' film."[38] This picture of downward mobility subverts the reproductive and accumulative aspirations of hegemonic Jewish futurity, offering something of a materialist inversion of the materialistic Jewish American Princess. If, as Riv-Ellen Prell writes in *Fighting to Become Americans*, Jewish women have borne the brunt of Jewish male anxiety about American assimilation, it is notable that Kraus embraces not the antisemitic tropes associated with women (in Prell's work: the ghetto girl, the wife, the mother, the JAP) but those associated specifically, and in deeper historical context, with men (the landlord, the middleman, the manager).[39] While tropes of Jewish female difference served, through the 1980s, as an emblem of middle-class white assimilation, Chris's abjection indexes profound anxieties about the perceived disappearance of a social safety net.

"Too Literary, Too Baudrillardian": Apologizing for Kike Art

In a chapter of *I Love Dick* titled "Kike Art," Chris meditates on the work of the Jewish painter R. B. Kitaj. As one would expect given the raucously self-obsessed style of *I Love Dick*, Chris's discussion of Kitaj calls her back time and again to the meanings of her own art (as a Jew, and as a woman, and as a Jewish woman obsessed with a callous, laconic, non-Jewish man). Chris remarks on Kitaj's compulsion to interpret his own work:

> It amused me that Kitaj has wrapped himself around the idea of creating "exegesis" for his art, writing texts to parallel each painting. "Exegesis": the crazy person's search for proof that they're not crazy. "Exegesis" is the word I used in trying to explain myself to you. Did I tell you, Dick, I'm thinking of calling all these letters *The Cowboy and the Kike*? (187)

This passage outs the epistolary project as a whole—largely concerned as it is with gender—as equally if not primarily an exploration of Jewishness. The alternate title, "*The Cowboy and the Kike*," loses the first person of *I Love Dick* and with it the gleeful and universal implication of the book's readers,

especially femme ones, in Chris's desire. Instead, it suggests a process that is arguably more historically specific: the erotics of Jewish racialization.

The jumping-off point for "Kike Art" is a retrospective of Kitaj's paintings at the Metropolitan Museum of Art. Kraus diagnoses the show's attitude towards Kitaj, and indeed the reception of his work writ large, as implicitly antisemitic: "[H]is work has been called a lot of things that Jews are called: 'abstruse, pretentious'; 'shallow, fake and narcissistic'; 'hermetic, dry and boorish'; 'difficult, obscure, slick and grade f.' Too much in dialogue with writing and ideas to be a painter, he's been called 'a quirky bibliophile . . . altogether too poetic and allusive . . . a little too literary for his own good'" (186). These dismissive reviews speak to Chris on multiple levels: the condescension ("too literary for his own good") and euphemism ("difficulty")—together with the skepticism about the worth of education for uppity kinds who will make the wrong use of it—gleam with misogyny and antisemitism alike. As both a woman and a Jew, Chris is doubly susceptible to the kinds of accusations leveled against Kitaj. In Chris's estimation, Kitaj undercuts his own art—and his mythologized status as an artist like the inscrutable Dick—by saying too much about it. Kraus identifies with Kitaj because he, too, suffers from exegetical mania, from intellectual overproduction.

If the neurotic form of the autoexegesis resonates with Chris's own "kike art," so too does the accusation of "difficulty" and the racialized freakishness that "difficulty" encodes. As we learn, the curators of the Kitaj exhibition "introduc[e] us to the artist as an admirable freak" (187); their biographical wall text "is telling us that while it may be impossible to love the artist or his work we must admire him" (188). Like Kitaj, Chris the failed filmmaker stands accused of being "abstruse, pretentious" and "difficult, obscure," an artist to be admired but not loved. Chris is simultaneously determined to make herself understood—like Kitaj and his textual exegeses—and committed to being the "difficult and unadorable" woman she is, too "difficult" for a facile understanding. Chris oscillates frenetically between the competing desires to be loved and admired, to be understood and to resist too easy an understanding. The genre-bending form of *I Love Dick*, which zigzags between sexual fantasies and cultural criticism, registers this tension. For Chris, it is a point of pride to straddle abstraction and hard material facts ("It all happened"), masculinized academia and the feminized reproductive labor that makes it possible. This is the work

of "autotheory," an emergent genre Kraus helped consolidate, and Chris's analogy to Kitaj suggests that, for her, the genre is bound up with anxieties around Jewishness. In the "Kike Art" chapter, we come to understand that Chris's capacity to be many things at once, to think and work in different registers, is also a matter of race: "Kitaj the slippery Kike is never just one thing and so people think he's tricking them" (187).

The idea that the narrator is "tricking" us because she has multiple critical registers, luring us in with a love story and shifting gears to critical theory, is introduced in a conversation Chris has with Sylvère early in the novel. Chris has embraced the devolution of her sexy narrative into a series of admirable-but-unlovable "literary" letters. But she does so over the objections of Sylvère, Chris's first reader: "Sylvère, who's typing this, says this letter lacks a point. What *reaction* am I looking for? He thinks this letter is too literary, too Baudrillardian. He says I'm squashing out all the trembly little things he found so touching. It's not the Dumb Cunt Exegesis he expected" (28). Sylvère the kinky typist seems to be winking here, goading Chris to cuckold him intellectually in much the same way he goads her to cuckold him sexually when Chris confesses her infatuation with Dick. After all, it is precisely Kraus's Baudrillardian sensibility that makes it possible for *I Love Dick* (and other Native Agents texts) to be published by Lotringer's press, Semiotext(e)—a press that made a name for itself publishing translations of Baudrillard. Like the accusation that Kitaj is "too literary for his own good," Sylvère's suggestion that Chris's writing is "too literary, too Baudrillardian" is not only silencing (restoring Chris to the position of the "Dumb Cunt") but also a kind of gaslighting, since Chris *must* be literary and Baudrillardian in order to be published by his press.[40]

Chris, then, is subject to a double bind. Like Kitaj, she *must* perform intellectualism in order to be taken seriously, and yet that very intellectualism spoils the art, "squash[ing] out all the trembly little things." Chris, who states her quixotic quest as a need to "explain [herself] to" Dick, feels herself becoming a parody of pathological Jewish overexertion, of exegetical excess. Like Kitaj, Chris strives to be her own best scholar.[41] To an extent, these efforts are doomed to failure: Kitaj's attempts at exegesis only "amused" Chris, much as Dick dismisses Chris's letters as a "game."[42] But while Chris likens her performance to Kitaj's failed attempts to garner critical respect, she also suggests that *I Love Dick* may have succeeded where Kitaj, or more specifically Kitaj's painting *If Not, Not*, fails. "I think

Kitaj's vision of the subconscious is mushier than both Chicken Marengo reheated on the second day and the little scene I wrote for you about cooking it," she writes, with some satisfaction (200). And when Myles describes *I Love Dick* in their foreword as an "entirely ghastly, cunty exegesis," they do so with great admiration for the form (15). The Kitaj chapter makes plain that Chris identifies her exegetical urge not just with the overdisclosure of the "cunty" but also with the sweaty hustle of the "kike"—while also making clear that Chris will play with and embody, but not simply repeat, Kitaj's mistake.

Perhaps Chris succeeds where Kitaj fails because her "kike art" never loses its connection to an embodied femme desire. The intellectual hyperactivity of "kike art" connects to Chris's sexual frenzy; as she glosses it, "I think desire isn't lack, it's surplus energy—a claustrophobia inside your skin—" (239). Kraus sees women's lust as productive, not just digressive. So too does she use the chapter "Kike Art" to challenge the idea that overexplaining reveals simple "lack," even if that overexplaining, like Chris's desire, *is* gloriously abject. To engage in autoexegesis is to cast oneself as the "crazy person" searching for "proof that they're not crazy." And yet, just as it would be gaslighting to accuse Kraus of being "too literary," so would it be unfair to suggest that Kitaj—and the kike artists like Chris for whom he stands—ever had the option to cultivate an air of aloofness and mystery, as Dick does.[43] Chris writes of Kitaj, "After years of fucked-up readings of his work, he was forced to write his own" (188).

One of the motivations for creating "kike art"—art that comes with its own overeager manual for reading—may indeed be that the artist might otherwise not be interpreted properly or recognized at all. Chris asks, "Did anybody ask me my ideas about Kitaj? Does it matter what they are? It's not like I've been invited, paid to speak. There isn't much that I take seriously and since I'm frivolous and female most people think I'm pretty dumb. They don't realize I'm a kike" (191). On one hand, this deployment of "kike" seems to caveat "frivolous and female": problematically, the kike is positioned above the rest of the "pretty dumb" females, such that Chris *should* be "invited, paid to speak." (This use also invokes the gendering of "kike": Chris's association with a Jewishly abjected *masculinity* is an automatic step up from being an abjected femme.) In another reading, however, Chris is pointing to her capacity to pass not just as a vapid, disposable plus-one, but as a non-Jew: "They don't realize I'm a kike." In

another moment in the "Kike Art" chapter, Chris writes, "I didn't really know I was a kike 'til I was 21 and met my relatives when I moved back to New York.[44] . . . Perhaps my parents, who both attended Christian church, were just trying to protect me" (200). In her prolific use of the k-word, then, Chris is leaning into an identity that has been denied her, and one moreover that she must claim aloud, and constantly, in order to benefit from its conceptual and political possibilities.

Chris's autoexegetical mode—and her ambivalence about that mode—may reflect her uncertainty about whether she is read as Jewish. This reading is supported by the connection Chris draws between Sylvère and Kitaj: "In Paris in the '50s, upwardly mobile ghetto Jews like Sylvère Lotringer suffered a terrible dinner party dilemma: whether to announce the fact that they were Jews to offset possible racial slurs and jokes and be accused of arrogantly 'flaunting it;' or say nothing and be accused of deviously 'hiding it'" (187). The possibility of being misread forces the Jewish artist either to insist on their Jewishness at every turn or to risk seeming as though they are "hiding it." The double bind produced by the instability of Jews' racial positioning, which connects to the text's overarching aesthetic of precarity, may lie at the heart of Kraus's strategy of, to use Myles's terms, "walking straight in[to]" an over-troped identification with Jewishness (14).

"Who's Independent?": Funding *I Love Dick*

Sonkin describes Kraus's biography as bifurcated along lines of class—and Jewish—respectability: "A bad girl of the first order, she purportedly danced topless and gave blow jobs in the bathroom of Max's Kansas City in an effort to score free coke and earn cash to fund her performance art. Later, she executed the definitive good-Jew deed by marrying a Holocaust survivor, the holy grail of the contemporary Jewish *mensch*."[45] In fact, *I Love Dick* allows us to see the continuity between these two forms of labor as the "bad girl" and the "good Jew."[46] Indeed, Kraus draws attention to the fact that the topless dancing was enmeshed with Jewishness in other ways as well: she writes in the 2007 essay "Trick" that she "worked in the hustle bars owned by 'the Jewish Mafia' in the late 1970s, early '80s."[47] Kraus's oeuvre takes an interest in the material realities of living as an artist: her work asks, in compellingly visceral ways, what you have to do—and whom you

have to know, serve, and please—to make it in the art world. Kraus's commitment to honest assessments of financing art, and to frank portrayals of sex work as a means of financial independence for young artists, is never more than a step or two away from questions about Jewishness—Jewish stereotypes, Jewish money, Jewish networks. That commitment to financial demystification is also one of the crucial continuities between Kraus and her predecessor, the punk experimental writer Kathy Acker, who similarly discusses her experiences as a young Jewish sex worker in her autofiction.[48] It is essential to both writers' feminist politics to make visible the difficulties of financing art, especially as a woman, and an experimental artist to boot. "Why does everybody think that women are debasing themselves when we expose the conditions of our own debasement?" Chris asks in *I Love Dick* (211).[49]

In *I Love Dick*, as in others of Kraus's autofictional novels, the protagonist's self-conscious parasitism—as a dependent wife, an academic plus-one, a manager, and a landlord—is inextricable from the Jewish themes of the book. Parasitism is essential to Kraus's formulation of the kike, and the theme of parasitism carries through Kraus's work and speaks to her fascination with Kathy Acker. In *The Play in the System*, Anna Watkins Fisher theorizes parasitism as a strategic response to "the waning sense of agency in a moment when the political tools on hand appear co-opted in advance" and suggests parasitism as an alternative to the "gestures of transgression and refusal inherited from twentieth-century avant-garde aesthetics and revolutionary politics."[50] Fisher offers Kraus as a case study in feminist parasitism, arguing that the form of the novel amounts to a "viral accumulation" that "stalk[s], and eventually overwhelm[s], the male hosts."[51] By writing and writing into the gaping void that is Dick, Chris becomes a swarm of a person, a manic pixie nightmare that beleaguers Dick and insistently, even quixotically, refuses his privileged "right" to privacy. Fisher's account clarifies the formal stakes of Kraus's project in *I Love Dick*, which is not just epistolary but lopsidedly so: Dick rarely responds to Chris's letters at all, and only once in print. Yet Fisher does not connect the parasitic form she identifies with Kraus's express interest in Jewishness, including only a passing reference—elsewhere in the book—to the antisemitic trope of the Jewish parasite and to the ways in which the figure "connotes an excess or supplement."[52]

Chris is quite clear throughout *I Love Dick* that she depends financially on her husband, Sylvère. She describes herself as a "failed filmmaker," and Kraus has explained, "The book was more than anything an attempt to analyze the social conditions surrounding my personal failure."[53] *Aliens & Anorexia*, Kraus's sophomore text, dwells at length on the circumstances that gave rise to *I Love Dick*: Kraus hemorrhaged money pursuing what turned out to be a film that people did not want to watch (*Gravity & Grace*, which takes as its intertext the eponymous work by Simone Weil), while the fallout from that harrowing disappointment became a book people did very much want to read.[54] Indeed, Kraus characterizes the "personal failure" of her film in abjectly Jewish terms: Chris finds herself flattening into an antisemitic trope as she makes sordid and self-defeating attempts to buy status with money. In *Aliens & Anorexia*, Chris goes to a film festival at which her screening is scheduled for an inopportune time, and at which she is invited to none of the parties—which is a big deal because, as "everybody knows, the parties are the most important thing of all."[55] When Chris tries to insist on a better screen time with the festival coordinator, she becomes hyperaware of herself as a grubby cliché: "No matter how much Gordon Laird [the coordinator] hated me, how insignificant, absurd my presence was, I was a New York Jew, entitled to seek value for my money."[56] And indeed, Laird takes her money, which makes the outcome all the more pitiful: only twelve people attend the screening, the "most notable" of whom "was the director of the Boston Jewish Women's Film Festival, who later took the time to write a personal rejection."[57] The Jewish connection—especially the Jewish *feminist* connection—is Chris's last best hope, and even the Jews won't have her. Remarkably, the very possibility of being excluded from such a space has been fantasized: in the 1990s, there was a Boston Jewish Film Festival and a Boston International Festival of Women's Cinema but no festival devoted specifically to Jewish women's film.[58]

In *I Love Dick*, Chris's financial stability is predicated on her marriage to a Jewish man who has a certain degree of status and earning potential—and on a marriage that is potentially jeopardized by the extramarital passions, erotic and intellectual, that instigate the book. Chris's situation is ideologically fraught:

> Bill Horrigan, Media Curator at the Wexner, asked me how I "really" managed to support myself. I was picking up the restaurant check and

driving a new car and obviously this cover story about an art school teaching job fooled no one. "It's simple," I told him. "I take money from Sylvère." Was Bill bothered that such a marginal sexless hag as me wasn't living in the street? . . .

"Sylvère and I are Marxists," I told Bill Horrigan. "He takes money from the people who won't give me money and gives it to me." Money's abstract and our culture's distribution of it is based on values I reject and it occurred to me that I was suffering from the dizziness of contradictions. (86–87)

Chris's use of a "cover story" suggests some degree of embarrassment about this arrangement, and although Chris's first "simple" response—that she "take money from Sylvère"—frames her as a financial agent brazenly playing the system, she goes on to explain that "*[h]e* takes money . . . and *gives* it to me" (emphasis mine). While on one hand Chris insists that the arrangement is ideological ("Sylvère and I are Marxists"), on the other she recognizes that she is "suffering from the dizziness of contradictions" as she "pick[s] up the restaurant check and driv[es] a new car."

Even in these relatively comfortable circumstances, Chris is acutely aware of her financial precarity and experiences it as potentially fatal. After she and Dick have sex, Chris careens into a queer genealogy of loss:

But how could I explain? "It's just—" I started, foraging through fifteen years of living in New York, the arbitrariness of art careers, or were they really arbitrary? Who gets to speak and why? David Rattray's book sold only about 500 copies and now he's dead. Penny Arcade's original and real and Karen Finley's fake and who's more famous? Ted Berrigan died of poverty and Jim Brodey was evicted, started living in the park before he died of AIDS. Artists without medical insurance who'd killed themselves at the beginning of the onset so they wouldn't be a burden to their friends . . . the ones who moved me most mostly lived and died like dogs unless like me they compromised. (164)

Later, Chris tries to impress the necessity of "compromise" on Dick directly: she writes, "Be glad you're in a California art school but don't forget you live by compromise and contradiction cause those who don't just die like dogs" (240).[59] Chris insists that she must either "live by compromise and

contradiction" or "die" and seems to have a degree of survivor's guilt about the choice she continues to make. While Dick must be *told* not to forget this brutal reality, Kraus is flatly unable to.

Fisher recognizes *I Love Dick* as a host-parasite romance in which Sylvère, nearly twenty years Chris's senior, plays the patron-prey: "[Chris] has a place in the worlds of art and academia only insofar as he provides it."[60] Chris's place on the margins of Sylvère's intellectual empire is in a way what frees her to make a mess of things, to "[walk] straight in[to]" a love triangle that the men find embarrassing and even, in Hebdige's case, legally actionable. Chris writes in the third person to convey a droll sense of alienation from her economic dependency, a dependency that does not align with her radical politics (or does it?):

> Chris, a diehard feminist who often saw herself as spinning on a great Elizabethan Wheel of Fortune, smiled to think that in order to continue making work she would have to be supported by her husband. "Who's independent?" Isabelle Huppert's pimp demanded, spanking her in the backseat of a car in *Sauve Qui Peut*. "The maid? The bureaucrat? The banker? No!" Yeah. In late capitalism, was anyone truly free? (32)

That is: sex work is work like any other, and capitalism makes us all into whores. And yet some of us are being spanked in the backseat of a car, and others are the pimps doing the spanking, delivering sanctimonious Marxist lessons all the while. Later, Dick acts much like Huppert's pimp, appropriating Marxist language to defend his blatant cruelty. When Dick kicks Chris out of bed immediately after sex, Chris objects, "You don't have to be so militantly callous." Dick responds, "So militantly mean? . . . So militantly against mystification?" (163). This recourse to the language of mystification is also, of course, a mechanism of mystification. Chris is at once aware that no one is truly "independent" and that some of us get to make that very claim while others of us, crucially, do not: as Chris notes, "WHO GETS TO SPEAK AND WHY? . . . IS THE ONLY QUESTION" (191).

While the plot of *I Love Dick* seems at first to revolve around Dick, who elicits the passion, it is Sylvère, Chris's Jewish husband, who solicits Chris's letters to Dick, and Sylvère and Chris's shared financial exploits

demand Chris's careful management and exegesis as surely as their erotic ones do. Unable to make money from her own art, Chris comes to occupy the maligned role of the Jewish manager, the exploitative middleman, "milking money from Sylvère's growing reputation, setting ever-higher fees. Would the German money and the $2,000 from Vienna be enough to pay her lab bill in Toronto? No. They'd better hit up Dieter for per diem. Et cetera" (33). The "et cetera" registers Chris's embarrassment about these wheelings and dealings. Chris knows that the funds she extracts must be sufficient to support both of them, because Chris's situation is causing the precarity in the first place: "So long as Chris continued making independent films," she states plainly, "they'd always be juggling money, thousands here and thousands there" (32). Chris's artistic pursuits are not only uncompensated—they are a devastating financial liability that commits her to a life of "milking money" from Sylvère's fans, "mostly young white men drawn to the more 'transgressive' elements of modernism" who "were often rude to Chris" (33). Fisher connects Chris's abjected financial condition to her emotional one: "A self-described financial and emotional drain on her husband's resources, she is emotive excess, spilling over the boundaries of institutional permissiveness granted to Sylvère with his subversive Ivy League deconstructive critical cachet."[61] But just as the apparent "excess" of her emotions is actually an essential expression of the men's—Chris describes herself "thrown into the weird position" of the "Dumb Cunt, a factory of emotions evoked by all the men" (27)—so does her parasitical identification as a financial "drain" unfold itself as an abjected essential of the nuptial economy, the Derridean supplement. Chris conceptualizes Dick, too, as a job: after Chris and Dick at last have physical sex, Chris thinks to herself, "[L]oving you'd become a full-time job and I wasn't ready to be unemployed" (162).[62]

Chris's role as Sylvère's avaricious manager is as ambivalent and enmeshed as her role as Dick's devotee: in both cases, she is avenging structural inequity while binding herself ever more tightly to the inequitable system. If Chris cannot be paid her worth, then she will have to inflate Sylvère's and extract her due; if Dick's cultural criticism is more highly valued than hers, then she will have to write her way into his intellectual space (and use his real name, if only his first name, in her book). Hitherto a filmmaker and editor, Kraus reinvents herself as a writer, triangulated by Dick's and Sylvère's prestige in the publishing world as surely as she is by their

sexual desire. A sort of reputational parasitism is essential to what Myles terms the "self-advertisement" of the novel. Not only Chris the character but also Kraus the author insist, in the text of the book as in the publicity around it, that the scandal is real: Dick is a real high-profile cultural critic, and his and Sylvère's epistolary voices are their own. Rather than deny her dependency on the men's reputational currency, Chris milks it. (The real-life culmination of this parasitical dynamic of self-advertisement may be found in an obituary of Sylvère Lotringer in the *Guardian*, subtitled "Critic and writer who launched postmodern French theory in the US but became better known for his role in his wife's memoir I Love Dick.")

Due in part to the meteoric success of *I Love Dick*, Kraus has a formidable intellectual career of her own. And yet the para-academic world she enters is figured as halting and unsustainable—not only because its pay must be supplemented by moneymaking ventures like landlording (as I discuss below), but also because it is marked as a sort of consolation prize. In a 2022 collection titled *Pathetic Literature*, in which Myles anthologizes an excerpt from *I Love Dick*,[63] Myles explains that in the 1990s (when *I Love Dick* was written and published) men had started producing "Pathetic Masculinity" work that appropriated feminist tropes: "[G]ood men and bad men and especially sad men made a terrific living in there whereas women more likely reaped the pathetic jouissance of community and later academic jobs."[64] Indeed, Myles describes their own enmeshment in this academic system of "pathetic jouissance," how they "taught a Pathetic Literature seminar at UCSD in 2006. . . . We even had a pathetic conference. It was a late-night event, scantily attended. Chris Kraus came."[65] This Kraus is Dick's abjected double, surviving on the para-academic compromise of a California art school, but deprived any real pretense of status.

While sex work is perhaps the classic instance of women's supposed "debasement" through paid labor, *I Love Dick* gestures toward modes of art financing beyond sex work. These jobs, too, raise insistent questions around dignity and self-determination. Like dancing topless, Chris's work as a landlord presents her as a hustler—but this time as one who falls squarely in the realm of antisemitic male tropes rather than misogynistic ones.[66] Early in *I Love Dick*, we learn that "Chris spent time buying or acquiring long-term leases to three apartments and two houses which they kept rented at a profit while holing up in rural slums. She kept Sylvère apprised of the status of their mortgages, taxes, rental income and repair bills" (32).

Although this is clearly Chris's project, the responsibility to report back to Sylvère, and the relegation of the couple to the "rural slums," makes apparent the contingencies and costs of the "profit." Kraus describes landlording much as she describes other "two-bit artworld hustles"—as an exercise in power that marks one's powerlessness.

Many of Kraus's books make something of a joke of how Jewish "power" looks on the ground. In *Torpor*, the protagonist, Sylvie, explains the personal cost of renting out her and her husband Jerome's "unhappy homes to happy couples who could afford to pay top dollar": "It was a profitable scheme, but consequently, the pair are homeless."[67] In *Aliens & Anorexia*, the strange reversal of power in which the landlords live in the "slums" while they rent other properties for profit appears in a nightmarish scene in which a confidante turned tormenter "convinced the cast and crew whose salaries Sylvère and I were paying that we were heartless money-grubbing Jews and monsters."[68] Chris is kicked out of her own car because it is determined to be a "production vehicle," and "Sylvère and I cruised the outer reaches of the Bronx in search of cheap hotels so that . . . [their tormenters] could be alone and run up long distance bills in our apartment."[69] This is a history of antisemitism burlesqued in miniature, the "money-grubbing Jews" left penniless and exiled from their homes.

In more recent interviews, Kraus has given her real-life work as a landlord a more agentive cast. A *Guardian* interview notes that the protagonist of Kraus's *Torpor*, Sylvie, is a landlord, and Kraus uses the opportunity to explain her own choice to go into property management: "I chose early on not to pursue full-time teaching, and property management has been a means of supporting myself."[70] In her interview of Kraus for the *Believer*, Sheila Heti suggests that landlording could be especially suitable for an artist: "I want to ask you [Kraus] if you have real estate advice—because I think it's ingenious to try to make money in a separate realm from your creative work, as you've done. Not only because it makes sense on a financial level, but because you absorb a world that you wouldn't otherwise absorb." Kraus responds, "At one point, instead of getting a tenure-track job, I decided to make real estate investments and operate these properties as lower-income, affordable housing. Buying and fixing, and then renting and managing, was a way of engaging with a population completely outside the culture industry. Kind of like in gay culture, where hookups are a

way of escaping your class."[71] Kraus is at pains elsewhere, too, to emphasize that her work as a landlord does not reinscribe class boundaries so much as transgress them: "My real estate work has always been property management, not speculation . . . I've never flipped houses—I think it's sociopathic."[72]

The likening of property management to gay hookups that serve as "a way of escaping your class" brings the sense of cultural, if not financial, parasitism into sharp relief, even as its appropriation of the utopic politics of cruising claims to do the opposite. Myka Tucker-Abramson reads the same *Believer* interview as emblematic of how Kraus "effac[es] the fundamentally parasitic relationship of landlordism." For Tucker-Abramson, Kraus's oeuvre offers "one of the most remarkable and sustained literary exemplars and evaluations of the entanglements of art and real estate"; she argues that Kraus's works are both autofiction and road novels, and in the latter genre "enact art's role in the ramped-up and wide-ranging processes that Harvey called 'accumulation by dispossession.'"[73] Tucker-Abramson's rich analysis misses the crucial racialized coding of this labor in the context of Kraus's self-identification as a kike. If Kraus's work juxtaposes the Marxist commitments of autotheory with the settler colonialism of the road novel, it must also be said that it troubles the categories of "The Cowboy and the Kike": her protagonists' Jewishness, like their landlordism, is identified at once with dispossessing and being dispossessed.

"I'd Love to Fuck the Whole Family": Jewish Family Money in *After Kathy Acker*

It is against the backdrop of this pervasive interest in the material realities of art-making and the ubiquity of exploitation that Kraus explores intra-Jewish networks of support for artists. The material conditions subtending US art culture have been, Kraus has argued, significantly impacted by the shifting terrain of Jewish wealth in the United States. In an October 2017 interview with Juliet Jacques, Kraus is asked about her portrayal of 1970s New York in *After Kathy Acker*. She responds:

> Everybody was Jewish, right. All the names of [Acker's] friends, associates, agents, editors, they're all Jewish names, New York in the '70s.

> And, you know, most of them sort of have private means. They all have kind of little trust funds or kind of family money in one way or another. And I realized, it was like, it was the end of the Jewish mercantile class in New York, those were the years that those family businesses were selling out to conglomerates, and basically it was like the end of the Jewish mercantile class that made conceptual art possible. Why does nobody talk about that?[74]

The "little trust funds or family money," Kraus argues, are essential to the blossoming of "conceptual art"—a blossoming that coincided with the last gasp of the "Jewish mercantile class." Kraus does not hazard this hypothesis about the 1970s art world quite so explicitly in *After Kathy Acker* as she does in the interview about the book. The closest she comes is to note that "[t]hroughout the first part of her life, virtually all the names of Acker's husbands, lovers and friends, mentors and art world associates are Jewish. In mid-twentieth-century New York, Jews were the culture industry's dominant force."[75] Acker's professional world is Jewish, Kraus observes, and so are her backers. Kraus consistently presents the 1970s New York art world (an implicitly Jewish one, as she signals elsewhere) as intimate, if not incestuous: "The New York art world was still small: a series of Venn diagrams in which everyone was related, if not by marriage or blood, then by friendship and sex. Everyone knew everyone then."[76]

Kraus goes on to lament in the interview "how snobby and exclusionary" the art world of 1970s New York really was: "I arrive from New Zealand like at the very tail end of that era, at the end of the '70s, and it was not like that at all for me, coming from the outside. I mean I found it like a very kind of snobby and kind of ironclad, airtight scene where you were either in or you were out."[77] Kraus does not make explicit the connection between these two points—that conceptual art was financed by "the end of the Jewish mercantile class" and that the art scene was "airtight"—but one suggests itself: if the art world was dominated by Jewish family money, it should be of little surprise that it would be "snobby and exclusionary." While the historical legitimacy of Kraus's claims are beyond the scope of this chapter, the argument offers another mode of understanding the financial precarity that pervades Kraus's oeuvre as a historically situated *Jewish* precarity: according to Kraus, Jews (patrons, friends, associates, family, lovers) were the funders of the experimental

art world, the way *into* the art world—and yet, in Kraus's understanding, Jews were already on the way out, already spending down their trust funds, when she arrived on the scene.

Kraus's conviction that Jews were *the* dominant cultural forces of 1970s New York—and her hunch that the avant-garde was funded by Jewish "family money"—speaks to Josh Lambert's research in *The Literary Mafia*, which explores the myth advanced by Jews and non-Jews alike that Jews controlled the publishing industry, as well as the world of literary fellowships and prizes, in the 1960s and '70s. Lambert details the institutional history of Jewish enfranchisement in the publishing industry, describing the publishing world of that era as an "ethnic niche" for Jews that acted in accordance with certain homophilous logics, but not "*simply* and *straightforwardly* (or *predictably*)" so.[78] Kraus's unapolegetic claim that "Jews were the culture industry's dominant force" recalls, like many of the tropes already named here, antisemitic clichés about Jewish power, and, yet like many antisemitic clichés, it encodes a curious romanticization of that power.

Kraus, like Acker, is a self-styled outsider artist who is nevertheless inside of a Jewishly dominated art network. Beginning in the late 1980s, Kraus served as an editor at Semiotext(e), the publishing house that Lotringer had started as a journal in 1973. In 1990, she started the Native Agents series at Semiotext(e) and became its editor. The imprint describes itself as "an 'antidote' to Semiotext(e)'s male-dominated, primarily French Foreign Agents series" that set out "to explore American voices and issues of subjectivity, with an emphasis on women and queer experience."[79] To be sure, an imprint of an independent press is not big money, and yet it is obvious how Kraus, like Acker, benefited from a Jewish network of "friends, associates, agents, editors." Acker herself is a part of this network. Kraus's and Acker's personal and professional lives (and afterlives) are deeply interconnected, and Kraus makes no great secret of this fact: in *I Love Dick*, Chris comes across a note from Acker in one of Sylvère's books: "To Sylvère, The Best Fuck In The World (At Least To My Knowledge) Love, Kathy Acker" (177). Kraus wields power over Acker's legacy not only as her biographer but also as her editor; as the editor of Native Agents, Kraus oversaw the publication of Acker's *Hannibal Lecter, My Father* in 1991. Both Kraus and Acker are enmeshed in a system of Jewish patronage and mutual reputation building, a system of relations, "if not by marriage or blood, then by friendship and sex."

Like many of her peers, Acker benefited at various points in her life from family money, although she wrote frequently about how it was denied her (eventually, she inherited half of her grandmother's sizable estate). Kraus describes Acker's upbringing in a wealthy German Jewish family as emphatically respectable, with all the raced and classed expectations that attend respectability. Even Acker's first marriage to Bob Acker, a Jewish man she had met at Brandeis and who would go on to become an attorney, was met with disapproval by her family because he was lower middle class and Polish rather than rich and Austrian, like Kathy.[80] In her writing, Acker describes being abandoned by her natal family in her hour of need, and when they refused her money to treat her pelvic inflammatory disease, Kraus writes, "She felt truly poor for the first time, and completely alone."[81]

In the biography of Acker, as in her autotheory, Kraus does her best to chart the many ways that art is financed, gently contesting the veracity of Acker's automythology without dismissing its symbolic importance. Kraus writes, "Like most human communication, Acker's account of her life fluctuates between rigorous honesty and self-serving white lies"—but "the lies weren't literal lies, but more a system of magical thought."[82] In one section, Kraus investigates Acker's claim that the father of her then boyfriend, the experimental composer Peter Gordon, served as her "patron" when she was writing her first book:

> Far from being a patron, [Gordon's father] was a writer himself, supporting his family by working for Voice of America and writing scripts. Nevertheless, Acker seems to have been determined to cast her boyfriend's dad as a patron and, by extension—even more gratifyingly—as a substitute father. . . . Still, her real patron was Peter Gordon himself: "I shared whatever I had with her, and we scraped and struggled for money." . . . [T]he myth she devised of the Gordon family's financial support during those months gave her the confidence boost that helped her to finish the book. *I'd love to fuck the whole family*, she wrote.[83]

Acker's fantasy that Gordon's father had signed on both as a daddy and a patron exemplifies the "magical thought" that Kraus points to as essential to Acker's capacity to sustain herself. Acker was notorious for embellishing and outright falsifying, but Kraus insists that Acker had to lie in order

to create a position from which to write. Acker's reinvention of Gordon's father as a patron allows her to construct a second kind of Jewish family, one that rewards her for her rebellion and artistry rather than for belonging and obedience.

Acker's literary career made a spectacle of rejecting the bourgeois norms with which she had been raised, and even as a teenager she was reluctant to affiliate with Jewish institutions: Kraus suggestively writes that "Brandeis, known at the time as 'Jew U,' wasn't her first choice of school."[84] Yet Kraus's account indicates that Acker depended, for money as for artistic community, on a closed circuit of Jewish artists, cotravelers, and benefactors. Gordon's father stands in for the right kind of Jew, the Jew whose patronage is a mark of power rather than infantilization; it is with elation, not horror, that Acker entertains the prospect of "fuck[ing] the whole family." The second, surrogate family, the mythological art patron, offers the *right* kind of Jewishness, one that redeems Jewish money from its banality and bourgeois privilege.

Both Acker and Kraus—or really Acker as a sort of mythological guide for Kraus—offer economic dependency as a crucial literary-political stance, one that tangles with the paradoxically empowered femme abjection that is more commonly recognized as Kraus's aesthetic and political contribution. For Kraus to theorize economic dependency through the lens of the kike is to confront a Jewish establishment that is both competitive and redistributive, punishing and nurturing. Acker's mythologization of the Gordon family illustrates this conflicted picture of Jewishness, with Gordon's father playing the generous, appreciative patron who stands opposite the stinginess of the natal home. The story of Gordon's family money is instructive because it contours a kike identity that Acker—and Kraus—are eager to reclaim, mythologizing a division between the Jewish family as the bastion of the avant-garde and the Jewish family as the assimilationist oppressor.

Conclusion: "My New Imaginary Reader"

The trope of the kike supports Kraus in reframing the problematic (and racially freighted) work of landlording, investing, and nepotistic patronage as the essential material work of the artist, much like the figures of the bimbo and the hag support her in theorizing femme silence and aggression.

The figure of the kike may be neurotic and money obsessed, but s/he is also scrappy, experimental, and intellectual, a master of the "two-bit art hustle" for which Kraus has abiding respect. As a self-professed "bad feminist," Kraus refuses the salvific liberalism of a certain white feminism, and she similarly embraces a kind of bad Jewishness, a kike-dom, that reframes hustling as punk. Animating tropes around the intimate relationship between Jewish capital accumulation and Jewish restlessness and insecurity,[85] Kraus describes herself not only as a landlord but also a "nomad"[86] living in perennial "exile."[87] In so doing, Kraus refuses to let go of the tired and embarrassing clichés about Jewish money just as she refuses to ignore the misogynistic tropes through which people read her femme desire. Instead, her text raises questions about economic realities of the US Jewish community, questions that are all too material.

Toward the conclusion of the "Kike Art" chapter, Chris finds herself settling into a home of sorts, a new life of "independent poverty":

> Sylvère's in California for a week and I am writing you from 7th Street and Avenue C, where I am living in the independent poverty I've believed since I was 12 to be my birthright. I don't have to spend my days thinking about money, or dream about it multiplying overnight. I don't have to work at menial degrading jobs (if you're a girl menial always turns out to be degrading) or pretend to believe in my career in the third-rate world of experimental film. After building up my husband's academic/cultural career and investing all his money I have enough to live on so long as I don't spend too much. And luckily my husband is a very reasonable man. (192)

Through invoking the Jewish age of bat mitzvah (which often takes place at twelve for girls) and suggestively using the term "birthright," Kraus codes this position of "independent poverty" as a latter-day form of Jewish emancipation. But it is a financial freedom that bears everywhere the marks of financial dependency, of the social networks that enabled it and to which it remains in thrall. A modest flow of capital allows Chris not to "spend [her] days thinking about money," and yet her letters return again and again to those very thoughts, especially as she meditates on Kitaj as a Jew; and Chris does not "have to work at menial degrading jobs" but only because she has worked the clichéd Jewish roles of agent, controlling wife,

and financial manager, "building up [her] husband's academic/cultural career and investing all his money." Sylvère and his network are the capital to be invested, and the suggestion is that he may yet be called on for discreet financial support, even if he and Chris remain separated: "[L]uckily my husband is a very reasonable man."

This position of not-so-independent "independent poverty" is one of simultaneous privilege and precarity, the delicate balance of which appears to be as essential to Chris's artistic productivity as a happily "incestuous" Jewish community that accords privileges it is always on the verge of losing or withdrawing. In *After Kathy Acker*, Kraus describes Acker waiting in line for food stamps and chatting with others in line about "impending doom" in 1975 New York. Kraus writes, "Acker, apparently, saw no correlation between the catastrophic municipal debt and a well-educated twenty-eight-year-old Jewish white girl availing herself of social welfare services . . . but at the time, nobody did. Throughout the 1970s, welfare, unemployment insurance, and disability SSI were the de facto grants that funded most of New York's off-the-grid artistic enterprises."[88] This picture of financing for the 1970s art world, especially for young, "well-educated," and white Jewish women, seems on its face to contradict Kraus's claim elsewhere that it was Jewish family money that funded the avant-garde—although, as Acker's case makes clear, the two are not mutually exclusive. In calling out Acker for being a "well-educated twenty-eight-year-old Jewish white girl" but also saying that "at the time, nobody" would have objected, Kraus normalizes Acker's reliance on social services as "de facto grants."[89] Not all of Acker's contemporaries were as friendly in their assessment; Kraus quotes the feminist conceptual artist Martha Rosler, who was married to Len Neufield when he and Acker became lovers, describing Acker as "a familiar form—she'd been to Brandeis, she was a Brandeis type, you know? Sleek and clean. Jewish and smart and self-confident, but also vulnerable. Her persona was about being the victim—a kid from the Upper East Side pretending to be a waitress down on her luck."[90]

As Kraus's artistic legacy is carried forward, will abjection, Jewish or otherwise, remain at the center of the narrative? What will readers see in *I Love Dick*? In Joey Soloway's 2018 memoir, *She Wants It*, Soloway picks up *I Love Dick* for the first time and encounters the name of their future lover, Eileen Myles, in the byline of the introduction. (Soloway, a Jewish

American writer and director best known for *Transparent*, would later adapt *I Love Dick* into the Amazon Prime TV series.) Soloway falls in love with Myles's voice, writing,

> I wondered what it would feel like to be in love with Eileen and what it would mean if this hero with the gigantic mind could be my new imaginary reader for everything I would ever write again. My artist's voice could become a devotional act instead of a money-making one. What would it mean to fall in love with the mind you are writing for as you are becoming yourself? Even imagining that she might never love me back felt desperate but good. This new feeling of risk with women felt like something opening instead of something doomed.[91]

While Kraus's "imaginary reader" is Dick, Soloway's is Myles—and the effect is not the "impending doom" of Acker's 1975 New York but "something opening instead of something doomed." While Kraus falls in love with Dick at her directorial nadir, in a position of intense financial precarity, Soloway is at the height of their success as the director of the television show *Transparent*, fantasizing about writing as "a devotional act *instead of a moneymaking one*" (emphasis mine). Precipitated by a literal encounter with *I Love Dick*, and by Myles's claim in the foreword that Kraus has ended the servile heterosexuality of women's literary history, the giddily optimistic scene of two women in love[92] offers a stark counterpoint to Kraus's text, which culminates in a breakup first with Sylvère and finally with Dick. While Kraus commits life and limb to the project of demystifying the "devotional" quality of art and reinvesting in the "moneymaking" clarity of the kike, Soloway turns toward a trans politics of ecstasy, transforming the monomania of *I Love Dick* into a television series that lingers on women's and nonbinary people's pleasures. In thinking about Kraus as a pivotal (and overlooked) precursor to the Sexy Jewess trope and to the comic precarity that pervades contemporary representations of millennial and Zoomer Jewish women, it is worth considering how markers of Jewishness—especially in the US art world—will be transformed once more by radical reconfigurations of gender.

Notes

1 Chris Kraus, *I Love Dick* (Los Angeles: Semiotext(e), 2006; originally published 1997), 147. Further page citations from this novel appear parenthetically in the text.
2 Later, Sylvère Lotringer points out that Dick himself, and not just Chris, is treated as the "Dumb Cunt"—by Chris and Sylvère: "Remember the introduction that we wrote for him? In a sense Dick isn't necessary. He has more to say by not saying anything and maybe he's aware of it. We've been treating Dick like a dumb cunt. Why should he like it? By not calling he's playing right into his role" (59). Arguably, the cowboy—like Dick and dick—becomes abjected in its own right, a hyper-gendered symbol of white-dad masculinity that is laughably unselfconscious and politically backward.
3 Elaine Blair, "Chris Kraus, Female Antihero." *New Yorker*, November 14, 2016, www.newyorker.com/magazine/2016/11/21/chris-kraus-female-antihero.
4 Rebecca Van Laer, "Just Admit It, You Wrote a Memoir." *Electric Literature*, July 29, 2019, electricliterature.com/just-admit-it-you-wrote-a-memoir/. Kraus describes the term "autotheory" as needless—hasn't women's writing always theorized about personal experience?
5 Blair, "Chris Kraus."
6 Giovanni Intra, "A Fusion of Gossip with Theory," *artnet*, accessed May 29, 2020, www.artnet.com/magazine_pre2000/index/intra/intra11-13-97.asp.
7 This infectious if outmoded whiteness is captured in a letter from Sylvère: "[T]hen you came, the rambling man, with all these expatriate philosophies that we've outgrown ourselves over the past 20 years. This is really not our problem, Dick. You're leading a ghost town life, infecting everyone who comes near you with a ghost disease. Take it back, Dick. We don't need it" (Kraus, *I Love Dick*, 35).
8 Chris Kraus, "Trick," in *Social Practices* (South Pasadena, CA: Semiotext(e), 2018), 18.
9 Sheila Heti makes strong claims about the form-breaking quality of the work as well: "I know there was a time before I read Chris Kraus's *I Love Dick* (in fact that time was only five years ago), but it's hard to imagine; some works of art do this to you. They tear down so many assumptions of what the form can handle (in this case, what the form of a novel can handle) that there is no way to recreate your mind before you encountered them." Sheila Heti, "An Interview with Chris Kraus," *Believer*, September 1, 2013, www.thebeliever.net/an-interview-with-chris-kraus/.

10 For more on the close identification of Jewish women with the second wave, see, for example, Joyce Antler, *Radical Jewish Feminism: Voices from the Women's Liberation Movement* (New York: New York University Press, 2020); Joyce Antler, *The Journey Home: Jewish Women and the American Century* (New York: Free Press, 2010); and Matthew Frye Jacobson, *Roots Too: White Ethnic Revival in Post-Civil Rights America* (Cambridge, MA: Harvard University Press), chapter 6.

11 "Chris Kraus," interview, *ARQ*, October 2, 2017, thisisarq.com/read/chris-kraus.

12 She goes on to add, "Definitely an Anglophile religion. Also, kind of a smug religion." "Chris Kraus."

13 "Chris Kraus."

14 Kraus describes her prolonged adolescence as a matter of principle and pride: "The ideals of your adolescence can be left behind in the dust. I was able to maintain my adolescence for a very long time, probably into late middle age, by basing my life around the things that are most important to me: writing, art, literature, culture, communicating." "Chris Kraus."

15 Rebecca Wanzo, "Precarious-Girl Comedy: Issa Rae, Lena Dunham, and Abjection Aesthetics," *Camera Obscura* 31, no. 2(92) (September 1, 2016): 27–59, https://read.dukeupress.edu/camera-obscura/article-abstract/31/2%20(92)/27/97584/Precarious-Girl-Comedy-Issa-Rae-Lena-Dunham-and. Jonathan Branfman expands on this work in his theorization of the "Jewy-Screwy Leading Lady," emblematized by Rachel Bloom's *Crazy Ex-Girlfriend*. See his "Jewy/Screwy Leading Lady: *Crazy Ex-Girlfriend* and the Critique of Rom-Com Femininity," *Journal of Modern Jewish Studies* 19, no. 1 (2020): 71–92.

16 Chris Kraus, "Chris Kraus: 'I Love Dick Happened in Real Life, but It's Not a Memoir.'" *Guardian*, May 17, 2016. www.theguardian.com/books/2016/may/17/chris-kraus-i-love-dick-happened-in-real-life-but-its-not-a-memoir.

17 Hannah Schwadron, *The Case of the Sexy Jewess: Dance, Gender, and Jewish Joke-Work in US Pop Culture* (Oxford: Oxford University Press, 2018).

18 Thank you to Alex Ullman for pointing out that this connection is also made by the original quote: "Two bit artworld hustles" is followed by "conversation skills." In *After Kathy Acker: A Literary Biography* (South Pasadena: Semiotext(e), 2017), Kraus writes, "Typical of Jewish comedy, most of Acker's burlesque family routines center around money, hubris, and sex" (181)—and the same can be said of Chris's own "routines" with Sylvère.

19 Famously, Kathleen Hanna of the Riot Grrrl bands Bikini Kill and Le Tigra wrote "slut" on her stomach in lipstick to perform as early as 1992.

20 See the following pieces published just since 2019, none of which comment on Kraus's Jewishness: Abram Foley, *The Editor Function: Literary Publishing in Post-War America* (Minneapolis: University of Minnesota Press, 2021); Camilla Schwartz and Rita Felski, "Gender, Love and Recognition in *I Love Dick* and *The Other Woman*," *European Journal of Women's Studies* 29, no. 1 (2022): 92–106, https://doi-org.stanford.idm.oclc.org/10.1177/1350506821995911; Margret Grebowicz and Zachary Low Reyna, "The Animality of Simone Weil: *I Love Dick* and a Nonhuman Politics of the Impersonal," *Minnesota Review* 97 (2021): 77–94, Project MUSE, muse.jhu.edu/article/842596; Lauren Fournier, *Autotheory as Feminist Practice in Art, Writing, and Criticism* (Cambridge, MA: MIT Press), https://doi.org/10.7551/mitpress/13573.001.0001; Lauren Fournier, "Becoming Post-Hysteric: Chris Kraus's Deterritorializing of French Post-Structuralism," *Angelaki* 26, no. 6 (2021): 86–110; Myka Tucker-Abramson, "Cruising the Real Estate of Empire: Chris Kraus's Road Novels," *Contemporary Literature* 62 (1): 67–96; and A. Rigaud, "Chris Kraus' Auto-Fictional Strategies of Failure," *Revue française d'études américaines*, 163, 46–58. https://doi-org.stanford.idm.oclc.org/10.3917/rfea.163.0046.

21 Note that Chris is as quick to apply antisemitic slurs to her husband, Sylvère as she is to own them herself. In one scene that feels pointedly cruel given Sylvère's survival of the Holocaust, Chris is moving some of their stuff into storage bins: "For 15 dollars more they could've had Bin #14, an ample 10×12, but Sylvère won't hear of it, these unnecessary expenses. *I'm very organized!* he cries (just as concentration camp survivors boasted about their ability to 'organize' a smuggled egg or contraband potato). He keeps re-visioning how to stack the floor lamps, mattresses, 300 pounds of books and Chris is screaming at him, sagging under the weight of all this shit, (*You Cheap Jew!*) as she drags junk out of Bin #26 to the hall and back again" (71).

22 Sonkin summarizes some of the ways in which Kraus's work announces itself as Jewish (or, to make Sonkin's use of Jewish more specific, Ashkenazi and US born). Sonkin writes, "Despite a childhood spent outside the Jewish mainstream, Kraus has mastered all of its tropes." Sonkin positions Kraus as (yet another!) "female Jewish schlemiel, an awkward and unlucky person—insecure, emotionally hungry, self-obsessed—for whom things never turn out right." Her femme abjection, then, is hardly new, to Sonkin; it merely refits the Jewish literary position of postwar power to a woman in the 1990s. Her pursuit of messy sex is a part of this story: "She's absconded with the male chutzpah of the pursuit, hazarding self-abasement in order to fulfill her desires." Rebecca Sonkin, "Chris Kraus and the K-Word," *Los*

Angeles Review of Books, August 5, 2016, lareviewofbooks.org/article/chris-kraus-k-word/.
23. Sonkin hopes that Joey Soloway's 2016 adaptation of *I Love Dick* can help correct the error. Sonkin's hope for the show does not exactly come to pass; unlike *Transparent*, *I Love Dick* presents Jewishness under erasure.
24. Kraus notes in an article in the *Guardian*, "Almost invariably, reviewers praise the book for its embrace of 'feminine abjection,' although I see it more as comedy. The years that I spent living and then writing *I Love Dick* were exhilarating. They laid the groundwork for all my future writing." ("Chris Kraus: 'I Love Dick Happened in Real Life, but It's Not a Memoir.'")
25. See, for example, Antler, *Radical Jewish Feminism*; Hasia R. Diner, Shira Kohn, and Rachel Kranson, eds., *A Jewish Feminine Mystique? Jewish Women in Postwar America* (New Brunswick, NJ: Rutgers University Press); and the TV series *Mrs. America*.
26. Kraus—like her antecedent, Kathy Acker—belongs to a tradition of twentieth-century Jewish American obscenity that Josh Lambert has described in *Unclean Lips* as "meaningful and useful, even necessary, to some American Jews." Lambert, *Unclean Lips: Obscenity, Jews, and American Culture* (New York: New York University Press, 2014), 19.
27. Keren Rosa Hammerschlag, "'Your Favourite Jewish Girl Apart from Your Mum': Introducing the Modern Jewess in Image and Text," *Shofar: An Interdisciplinary Journal of Jewish Studies* 39, no. 3 (2021): 2.
28. See Lil Dicky's 2013 song "All K," in which the hook includes the lines "Yea I'm Jewish, so I'm praying das yo boo cuz I'mma take her / Dinner at the crib, feedin kobe like a Laker / You know what it is, I'm a mafuckan K-I-K-E . . . You can find a cracker getting paid like a seder." It concludes with the signoff "Yeah, I'm saying If they can say the N word I sure as fuck can say kike / Do something about it, pussy." The song received media attention after it was flagged as age restricted due to its use of the slur.
29. Lambert, *Unclean Lips*, 248.
30. Patricia Grisafi, "Elizabeth Wurtzel and the Feminist Disability Memoir," *LA Review of Books*, February 14, 2020, lareviewofbooks.org/article/elizabeth-wurtzel-and-the-feminist-disability-memoir/.
31. Kraus goes on to describe Bowles as "difficult" and to remind herself once more of the indelibility of her racialization: "Because she was just so brilliant and she was willing to take a crack at it—telling the truth about her difficult and contradictory life. And because she got it right. Even though, like the artist Hannah Wilke, she hardly found anybody to agree with her in her own lifetime. You're the Cowboy, I'm the Kike. Steadfast and true, slippery and devious. We aren't anything but our circumstances.

Why is it men become essentialists, especially in middle age?" (Kraus, *I Love Dick*, 182).

32 "Chris Kraus."

33 Because women interlocutors are the norm rather than the exception, Kraus cultivates literary worlds in which women's work is intrinsically valuable and not only insofar as women offer a feminist corrective to male-dominated institutions: "Dear Dick, I'm wondering why every act that narrated female lived experience in the '70s has been read only as 'collaborative' and 'feminist.' The Zurich Dadaists worked together too but they were geniuses and they had names" (Kraus, *I Love Dick*, 150).

34 The early citations (from the turn of the century) that the OED offers make this economic association blatant: 1903, "A friendly Indian from Syracuse, who had a fit-'em-quick hand-me-down some kike had unloaded on him"; 1907, "If the dealer would aim to sustain the maker in his fight against both the 'Kike' and price-cutter of more pretentious character, there would not only be less complaint as to quality of his goods, but more remunerative sales"; 1907, "We can give you kike goods and kike methods if you want them, but we like the square way best"; 1909, "It is a common practice to purchase samples from a leading firm and allow the 'kike' manufacturer to copy at a lower price." The gendering is apparent too: 1901, "What 'uptown lady' would tolerate an 'East Side kike'?"

"Kike" also appears in Abraham Cahan's 1917 novel *The Rise of David Levinsky* (New York: Penguin, 1993). After becoming rich, a madame-like hag named Mrs. Kalch introduces David to some eligible women of dubious repute: "After introducing me to two of the girls and causing them to introduce me to the other two, she said: 'And now go for him, young ladies! You know who Mr. Levinsky is, don't you? It isn't some kike. It's David Levinsky, the cloak-manufacturer. Don't miss your chance. Try to catch him" (407). That is, David could be confused for a kike, but his high economic status has priced him out of the term.

35 "Disputed Entry on 'Jew' Upheld by Editor of Oxford Dictionary," *New York Times*, June 12, 1973, www.nytimes.com/1973/06/12/archives/disputed-entry-on-jew-upheldby-editor-of-oxford-dictionary.html.

36 The Anti-Defamation League got involved and advocated for over one hundred offensive words (including "kike") to be struck from the Scrabble dictionary. Amy E. Schwartz, "Correct across the Board," *Washington Post*, June 8, 1994, www.washingtonpost.com/archive/opinions/1994/06/08/correct-across-the-board/6d3eaae0-19d7-40aa-bf3a-2103fdfb3113/.

37 Kraus and Heti have had a number of speaking engagements together and expressed admiration for one another's writing. Kraus wrote a review of

Heti's *How Should a Person Be?* in the *Los Angeles Review of Books* that highlights aspects of the book that might feel familiar to readers of *I Love Dick*: "In this book, she channels all of her gifts—as a playwright, philosopher, a Jewish stand-up comedian, a writer of precise lyrical prose, and a great blow-job artist—towards her efforts to answer the titular question, which, in the spirit of that same dialectic, is at once coy and profoundly serious." In the same review, Kraus also connects Heti to Acker; "Heti's use of real art-world names, real events, real conversations and correspondence, owes a large debt to the work of the late Kathy Acker, which, due to our short cultural memory, might be obscured by the tedious arguments for and against the 'generational narcissism' of social media. Like Acker, she is a brilliant, original thinker and an engaging writer." Chris Kraus, "What Women Say to One Another: Sheila Heti's 'How Should a Person Be?'" *Los Angeles Review of Books*, June 18, 2012, lareviewofbooks.org/article/what-women-say-to-one-another-sheila-hetis-how-should-a-person-be/. In a later interview, Kraus has acknowledged her own work as an influence on Heti; when asked, "How have you seen your work have an impact on your readers?" Kraus responds, "I've just got to say Sheila Heti does that so beautifully. Did you read *How Should a Person Be?* That is a classic" ("Chris Kraus.")

38 Eileen Myles remarks in the foreword to *I Love Dick* (Los Angeles: Semiotext(e), 2006), that Chris's age at the time of writing, thirty-nine, is a "female expiration date" (19).

39 Riv-Ellen Prell, *Fighting to Become Americans: Assimilation and the Trouble between Jewish Women and Jewish Men* (Boston: Beacon Press, 2000).

40 In the essay "This Is Chance" in *Social Practices*, Kraus describes a relationship to Baudrillard at the time of her writing *I Love Dick* that recalls her relationship with Sylvère: "I organized The Chance Event [featuring Baudrillard] for my own reasons. Is there anything that happens, ever, without a confluence of mutual self-interest? You are not American if you do not believe this. I'd left New York for Los Angeles the year before, after fifteen miserable years of trying to be an experimental filmmaker. I'd started writing letters that would turn into *I Love Dick*, my first novel. My goal then was to become famous in the art world. I was getting old and didn't want to become bitter. And I realized that making experimental films with large groups of women was not the best way to achieve this. Everyone likes famous men, I reasoned" (29).

41 In her 2018 essay collection *Social Practices*, Kraus opens with an acknowledgment: "Nearly all the pieces [in the collection] were commissioned, often for artist's catalogues or other publications. For a while, the art world

fashion seemed to be to drape an artist's work in any kind of text, so long as it did not explicitly discuss the work" (9). Kraus capitalized on the art world's hostility to precisely the kind of direct exegesis Kitaj conducted, writing that she suspected she was "somehow getting over on the gallerists and curators who hired me: being paid to explore my own ideas, sketch out stories, or expand my diary entries. . . . [These pieces] were written more *to* the work than about it" (9).

42 Chris responds to Dick's dismissal by thinking, "How could I make you understand the letters were the realest thing I'd ever done? By calling it a game you were negating all my feelings" (153).

43 In *I Love Dick*, Sylvère writes Dick, "The fact that you don't return messages turns your answerphone into a blank screen onto which we can project our fantasies" (29).

44 The quote also brings forward that Chris uses "kike" to describe a particular type of East Coast Jew.

45 Sonkin, "Chris Kraus and the K-Word."

46 In one scene, Chris imagines Dick as a client, even as she regales him with her theories about the Case Study and "American first-person fiction" and the Guatemalan Coca-Cola strike: "You were listening, eyes moving up and down between me and your wine glass on the table. I saw what I was saying register across your face . . . cryptically, ambiguously, shifting between curiosity and incredulity. Your face was like the faces of the lawyers in the topless bars when I started telling Buddhist fairy tales with my legs spread wide across the table" (Kraus, *I Love Dick*, 154).

47 Kraus, "Trick," in *Social Practices*, 17. She goes on to describe that "Mafia": "The Wild West was one of four or five places owned by Sy, Hy, and three other guys known as 'the Jewish Mafia.' In cheap white nylon button-down shirts, old, bald, with bellies hanging down over their belts, the wonders looked almost identical. Rotating between clubs to collect cash and check over the books, they otherwise kept a low profile" (19).

48 In *After Kathy Acker*, Kraus describes Acker's first self-published work as one that reimagines politics through sex work: "She knew then that the rhetoric of the New Left didn't begin to describe the existential situation in the United States as aptly as the dynamics of sex work. Her collaged text described her brief and partly self-willed season in hell in long, run-on sentences. She offered no explicit analysis of this situation. There were no explanations, confessions, apologies. She called the work Politics" (65).

49 Another formulation of this idea appears in Chris's citation of Simone Weil's *Gravity & Grace*: "It is impossible," Chris quotes Weil as saying, "to forgive whoever has done us harm if that harm has lowered us. We have to

think that it has not lowered us but revealed to us our true level" (Kraus, *I Love Dick*, 165). That is: there is a feminist power in *insisting* on the reality of one's abjection instead of mystifying it as a mere circumstance that has no bearing on one's essential value.
50 Anna Watkins Fisher, *The Play in the System: The Art of Parasitical Resistance* (Durham, NC: Duke University Press, 2020), 5.
51 Fisher, 31.
52 Fisher, 42.
53 Heti, "Interview with Chris Kraus."
54 It bears mentioning that *I Love Dick* was a sleeper hit; it received mixed reviews upon release, including some so mean and sexist as to prove precisely the urgency of Kraus's critique.
55 Chris Kraus, *Aliens & Anorexia* (South Pasadena, CA: Semiotext(e), 2000), 8.
56 Kraus, 9.
57 Kraus, 37.
58 On women's film festivals in Boston, see Loren King, "Inaugural Boston Women's Film Festival Arrives Soon," *Boston Globe*, September 13, 2018, www.bostonglobe.com/arts/movies/2018/09/13/inaugural-boston-women-film-festival-arrives-soon/vrBuQJNtzwUOT8nMtqafBP/story.html#:~:text=The%20Boston%20International%20Festival%20of,for%2011%20years%2C%20until%202003.
59 The acceptance of "contradictions" is also attached to Chris's identity as a "hag." "Before I got together with Sylvère I'd usually get dumped by guys as soon as they found someone else more feminine or bovine. 'She's not like you,' they'd say. 'She is a truly nice girl.' And it hurt 'cause what turned me on in sex was believing that they knew me, that I'd found somebody to understand. But now that I've become a hag, i.e., accepted all the contradictions of my life, there's nothing left to know. The only thing that moves me now is moving, finding out about another person (you)" (Kraus, *I Love Dick*, 54).
60 Fisher, *Play in the System*, 120.
61 Fisher, *Play in the System*, 121.
62 Dick won't have Chris's protestations: "But you don't know me!" he protests. "And you project this shit all over me, you kidnap me, you stalk me, invade me with your games, and I don't want it! I never asked for it! I think you're evil and psychotic!" (Kraus, *I Love Dick*, 163).
63 Notably, the excerpt includes the section of the book in which Chris and Dick finally do have sex—and Dick proceeds to unceremoniously reveal that he has "a Friend (you [Dick] somehow feminized the word) arriving for the weekend" (Kraus, 162).

64 Eileen Myles, *Pathetic Literature* (New York: Grove Press, 2023), xiv.
65 Myles, xx.
66 It is notable that Chris also uses "hustle" to describe her "old friend Suzan Cooper, a Crazed Kike Witch of the First Order." Chris writes, "Suzan always has several hustles running" (Kraus, *I Love Dick*, 197–98).
67 Chris Kraus, *Torpor* (New York: Semiotext(e), 2000), 21, 22.
68 Kraus, *Aliens & Anorexia*, 54.
69 Kraus, 54.
70 Rachel Cooke, "Novelist Chris Kraus: Who Hasn't Had an Affair?," *Guardian*, April 30, 2017, www.theguardian.com/books/2017/apr/30/chris-kraus-ive-never-had-much-talent-for-making-things-up-i-love-dick-interview.
71 Heti, "Interview with Chris Kraus."
72 Vicky Spratt, "Chris Kraus on the Enduring Relevance of 'I Love Dick' and Her New Book, a Biography of Kathy Acker," *Grazia*, October 16, 2017, graziadaily.co.uk/life/books/chris-kraus-love-dick-biography-kathy-acker/.
73 Tucker-Abramson, 71.
74 "After Kathy Acker: Chris Kraus and Juliet Jacques," interview, *London Review Bookshop Podcast*, October 31, 2017, open.spotify.com/episode/39IHzRkeJKUEmCEWo0dl02?si=WTgA8DhcQMqtSTstHRHJRA.
75 Kraus, *After Kathy Acker*, 181.
76 Kraus, 94.
77 "After Kathy Acker."
78 Lambert, *Literary Mafia*, 24, emphasis in original.
79 For MIT's description of the imprint, see mitpress.mit.edu/series/semiotexte-native-agents/#:~:text=The%20Native%20Agents%20series%20was,on%20women%20and%20queer%20experience.
80 "Until the marriage, her family still harbored hope that she'd find a rich husband. They were Upper East Side Austrian Jews. Bob Acker's parents were Polish Jews, and he'd grown up in lower middle-class Queens. Kathy Acker described herself as a German Jew. A hierarchy then still prevailed among New York Jews, descending from German to Austrian to Russian and Lithuanian, all the way down to the lowest-ranked Poles." Kraus, *After Kathy Acker*, 34.
81 Kraus, 54.
82 Kraus, 98, 14.
83 Kraus, 78–79.
84 Kraus, 35.
85 See Cathy Gelbin and Sander Gilman's *Cosmopolitanisms and the Jews* (Ann Arbor: University of Michigan Press, 2017): "Both cosmopolitanism and nomadism are clearly revealed as symbolic manifestations of the

antisemitic stereotype that associates Jews with capital. Over time, as we shall see, the related concept of the nomad gives way to that of the exile, the refugee, the D[isplaced] P[erson]. The association with capital also wanes but never quite vanishes" (1).

86 This, too, in curious kinship with and juxtaposition to Dick: Chris writes in I Love Dick, "Though we come from different places, we've both tried breaking up with our pasts. You're a cowboy; for ten years, I was a nomad in New York" (34). In her review of *After Kathy Acker*, Suzanne Moore uses the same language to describe Acker: "Was this what it was to be a female artist, I used to wonder. To be an outlaw, to be a nomad, to have a life of sexual adventure that some days looked like old-fashioned masochism and others like thrilling narcissism? I didn't know then and I don't know now, for she invented her own mythology." Moore, "Kathy Acker Showed It Takes Blood, Guts and Smarts to Be a Female Artist," *Guardian*, September 27, 2017, www.theguardian.com/commentisfree/2017/sep/27/kathy-acker-chris-kraus-female-artist-blood-guts-smarts.

87 In *I Love Dick*, Chris celebrates how smaller towns afford her more freedom: "Somehow this redneck town allows the possibility of a middle-aged New York City woman bouncing round a house alone more generously than Woodstock or East Hampton. It's a community of exiles anyway. No one asks me any questions 'cause there's no frame of reference to put the answers in" (122). Exile also structures a number of the essays in *Social Practices*.

88 Kraus, *After Kathy Acker*, 123.

89 Kraus writes in "Trick" about her own government hustles: After finding a job at a teaching college, "I taught under a false name with a false Social Security number so I could collect unemployment insurance under my actual name while I was teaching. Meanwhile, the college itself was defrauding the New York and federal government by enrolling fictitious low-income students, then billing for tuition grant reimbursement. The idea came straight out of Gogol's *Dead Souls*, one of the books I was teaching. Two years later the whole thing got busted." Kraus, "Trick," in *Social Practices*, 24.

90 Kraus, *After Kathy Acker*, 52.

91 Joey Soloway, *She Wants It: Desire, Power, and Toppling the Patriarchy* (New York: Crown Archetype, 2018), 118.

92 In the scene in question, Myles and Soloway identify as women; the memoir *She Wants It* is published under Soloway's deadname.

Bibliography

"After Kathy Acker: Chris Kraus and Juliet Jacques." Interview. *London Review Bookshop Podcast*, October 31, 2017, open.spotify.com/episode/39IHzRkeJKUEmCEWo0dl02?si=WTgA8DhcQMqtSTstHRHJRA.

Antler, Joyce. *Jewish Radical Feminism: Voices from the Women's Liberation Movement*. New York: New York University Press, 2020.

———. *The Journey Home: Jewish Women and the American Century*. New York: Free Press, 2010.

Blair, Elaine. "Chris Kraus, Female Antihero." *New Yorker*, November 14, 2016. www.newyorker.com/magazine/2016/11/21/chris-kraus-female-antihero.

Branfman, Jonathan. "Jewy/Screwy Leading Lady: *Crazy Ex-Girlfriend* and the Critique of Rom-Com Femininity." *Journal of Modern Jewish Studies* 19, no. 1 (2020): 71–92. https://doi.org/10.1080/14725886.2019.1703631.

Cahan, Abraham. *The Rise of David Levinsky*. New York: Penguin, 1993.

"Chris Kraus." Interview. *ARQ*, October 2, 2017, thisisarq.com/read/chris-kraus.

Cooke, Rachel. "Novelist Chris Kraus: 'Who Hasn't Had an Affair?,'" *Guardian*, April 30, 2017. www.theguardian.com/books/2017/apr/30/chris-kraus-ive-never-had-much-talent-for-making-things-up-i-love-dick-interview.

Diner, Hasia R., Shira Kohn, and Rachel Kranson, eds. *A Jewish Feminine Mystique? Jewish Women in Postwar America*. New Brunswick, NJ: Rutgers University Press, 2010.

"Disputed Entry on 'Jew' Upheld by Editor of Oxford Dictionary." *New York Times*, June 12, 1973. www.nytimes.com/1973/06/12/archives/disputed-entry-on-jew-upheldby-editor-of-oxford-dictionary.html.

Fisher, Anna Watkins. *The Play in the System: The Art of Parasitical Resistance*. Durham, NC: Duke University Press, 2020.

Foley, Abram. *The Editor Function: Literary Publishing in Post-War America*. Minneapolis: University of Minnesota Press, 2021.

Fournier, Lauren. *Autotheory as Feminist Practice in Art, Writing, and Criticism*. Cambridge, MA: MIT Press, 2021. https://doi.org/10.7551/mitpress/13573.001.0001.

———. "Becoming Post-Hysteric: Chris Kraus's Deterritorializing of French Post-Structuralism." *Angelaki*, 26, no. 6 (2021): 86–110.

Gelbin, Cathy S., and Sander L. Gilman. *Cosmopolitanisms and the Jews*. Ann Arbor: University of Michigan Press, 2017.

Grebowicz, Margret, and Zachary Low Reyna. "The Animality of Simone Weil: *I Love Dick* and a Nonhuman Politics of the Impersonal." *Minnesota Review* 97 (2021): 77–94. Project MUSE. Muse.jhu.edu/article/842596.

Grisafi, Patricia. "Elizabeth Wurtzel and the Feminist Disability Memoir." *Los Angeles Review of Books*, February 14, 2020. Lareviewofbooks.org/article/Elizabeth-wurtzel-and-the-feminist-disability-memoir/.

Hammerschlag, Keren Rosa. "'Your Favourite Jewish Girl Apart from Your Mum': Introducing the Modern Jewess in Image and Text." *Shofar: An Interdisciplinary Journal of Jewish Studies* 39, no. 3 (2021): 1–12.

Heti, Sheila. "An Interview with Chris Kraus." *Believer*, September 1, 2013, www.thebeliever.net/an-interview-with-chris-kraus/.

I Love Dick. Created by Joey Soloway and Sarah Gubbins, season 1, Amazon Prime Video, May 12, 2017.

Intra, Giovanni. "A Fusion of Gossip and Theory." *artnet*. Accessed May 29, 2023. www.artnet.com/magazine_pre2000/index/intra/intra11-13-97.asp.

Itzkovitz, Daniel. "Passing Like Me." *South Atlantic Quarterly* 98, no. 1–2 (1999): 35–57.

Jacobson, Matthew Frye. *Roots Too: White Ethnic Revival in Post-Civil Rights America*. Cambridge, MA: Harvard University Press, 2008.

Jeffries, Stuart. "Sylvère Lotringer Obituary." *Guardian*, December 19, 2021. www.theguardian.com/books/2021/dec/19/sylvere-lotringer-obituary#:~:text=It%20was%20the%20misfortune%2C%20or,memoir%20about%20her%20erotic%20obsession.

King, Loren. "Inaugural Boston Women's Film Festival Arrives Soon." *Boston Globe*, September 13, 2018. www.bostonglobe.com/arts/movies/2018/09/13/inaugural-boston-women-film-festival-arrives-soon/vrBuQJNtzwUOT8nMtqafBP/story.html#:~:text=The%20Boston%20International%20Festival%20of,for%2011%20years%2C%20until%202003.

Kraus, Chris. *After Kathy Acker: A Literary Biography*. New York: Penguin, 2017.

———. *Aliens & Anorexia*. South Pasadena, CA: Semiotext(e), 2000.

———. "Chris Kraus: 'I Love Dick Happened in Real Life, but It's Not a Memoir.'" *Guardian*, May 17, 2016. www.theguardian.com/books/2016/may/17/chris-kraus-i-love-dick-happened-in-real-life-but-its-not-a-memoir.

———. *I Love Dick*. Los Angeles: Semiotext(e), 2006. Originally published 1997.

———. *Social Practices*. South Pasadena, CA: Semiotext(e), 2018.

———. *Torpor*. New York: Semiotext(e), 2006.

———. "What Women Say to One Another: Sheila Heti's 'How Should a Person Be?'" *Los Angeles Review of Books*, June 18, 2012. lareviewofbooks.org/article/what-women-say-to-one-another-sheila-hetis-how-should-a-person-be/.

Lambert, Josh. *Literary Mafia: Jews, Publishing, and Postwar American Literature*. Yale University Press, 2022.

———. *Unclean Lips: Obscenity, Jews, and American Culture*. New York University Press, 2014.

Lassner, Phyllis. "The Modern Jewess and Her Wondering Jewish Identity." *Shofar: An Interdisciplinary Journal of Jewish Studies* 39, no. 3 (2021): 87–108.

Moore, Suzanne. "Kathy Acker Showed It Takes Blood, Guts and Smarts to Be a Female Artist." *Guardian*, September 27, 2017. www.theguardian.com/commentisfree/2017/sep/27/kathy-acker-chris-kraus-female-artist-blood-guts-smarts.

Muller, Jerry Z. *Capitalism and the Jews*. Princeton, NJ: Princeton University Press, 2011.

Myles, Eileen. Foreword to *I Love Dick*, by Chris Kraus. Los Angeles: Semiotext(e), 2006, 13–15.

———. *Pathetic Literature*. New York: Grove Press, 2023.

Prell, Riv-Ellen. *Fighting to Become Americans: Assimilation and the Trouble between Jewish Women and Jewish Men*. Boston: Beacon Press, 2000.

Rigaud, A. "Chris Kraus' Auto-Fictional Strategies of Failure." *Revue française d'études américaines* 163 (2020): 46–58. https://doi-org.stanford.idm.oclc.org/10.3917/rfea.163.0046.

Schwadron, Hannah. *The Case of the Sexy Jewess: Dance, Gender, and Jewish Joke-Work in US Pop Culture*. Oxford: Oxford University Press.

Schwartz, Amy E. "Correct across the Board." *Washington Post*, June 8, 1994. www.washingtonpost.com/archive/opinions/1994/06/08/correct-across-the-board/6d3eaae0-19d7-40aa-bf3a-2103fdfb3113/.

Schwartz, Camilla, and Rita Felski. "Gender, Love and Recognition in *I Love Dick* and *The Other Woman*." *European Journal of Women's Studies* 29, no. 1 (2022): 92–106, https://doi-org.stanford.idm.oclc.org/10.1177/1350506821995911.

Soloway, Joey. *She Wants It: Desire, Power, and Toppling the Patriarchy*. New York: Crown Archetype, 2018.

Sonkin, Rebecca. "Chris Kraus and the K-Word." *Los Angeles Review of Books*, August 5, 2016. lareviewofbooks.org/article/chris-kraus-k-word/.

Spratt, Vicky. "Chris Kraus on the Enduring Relevance of 'I Love Dick' and Her New Book, a Biography of Kathy Acker." *Grazia*, October 6, 2017. graziadaily.co.uk/life/books/chris-kraus-love-dick-biography-kathy-acker/.

Traub, Alex. "Sylvère Lotringer, Shape-Shifting Force of the Avant-Garde, Dies at 83." *New York Times*, November 22, 2021. www.nytimes.com/2021/11/22/books/sylvere-lotringer-dead.html?auth=register-email*ister=email.

Tucker-Abramson, Myka. "Cruising the Real Estate of Empire: Chris Kraus's Road Novels." *Contemporary Literature* 62, no. 1 (2021): 67–96.

Van Laer, Rebecca. "Just Admit It, You Wrote a Memoir." *Electric Literature*, July 29, 2019. electricliterature.com/just-admit-it-you-wrote-a-memoir/.

Wanzo, Rebecca. "Precarious-Girl Comedy: Issa Rae, Lena Dunham, and Abjection Aesthetics" 31, no. 2(92) (September 1, 2016). https://read.dukeupress.edu/camera-obscura/article-abstract/31/2%20(92)/27/97584/Precarious-Girl-Comedy-Issa-Rae-Lena-Dunham-and.

Wurtzel, Elizabeth. *Prozac Nation: Young and Depressed in America*. New York: Penguin, 2017.

8

THE MOTHER-GOLEM

Jewish, Queer, Feminist Writing about Disability

Jennifer Glaser

Artist Julie Weitz began her multiyear performance project *My Golem* in the aftermath of the "Unite the Right" white supremacist rally that overtook Charlottesville, Virginia, in 2017.[1] Like Rabbi Judah Loew ben Bezalel, the sixteenth-century rabbi who raises the golem in the most famous iteration of the monster tale, Weitz constructs her monster at a moment when Jews—and other marginalized groups—need protection. Weitz's golem is an ambiguously gendered and racialized figure covered in white clay with script across her forehead reading *emet*, or truth, in Hebrew.[2] Throughout her various performances of the figure, Weitz makes explicit the golem's connection to the monster's past incarnations and to the Jewish past more broadly. The golem of Weitz's imagination wears the stereotypical fur hat of a prewar shtetl dweller, complete with curly *payos* protruding from beneath, and communicates via the exaggerated gestures of a silent film star.

Despite this nostalgic nod to the early twentieth century, *My Golem* is a decidedly twenty-first-century project—feminist, queer, and citational. Unlike the lumpen golem of lore, Weitz's golem is a sinuous trickster figure, her white face and broad smile marking her as an uncanny clown. Weitz refers to her golem with feminine pronouns and draws attention to the contradictions of her embodiment as a female performer inhabiting the role of the usually male-identified golem by offsetting the fitted, white unitard she often wears with black leather arm straps that recall both

tefillin and bondage wear.³ In one of Weitz's performances, *My Golem, Her Tower* (2020), the golem sits at a pottery wheel and works to shape a phallic tower, a reference both to the Tower of Babel and to wider patriarchal structures that shape Jewish women's experiences. She works on the priapic tower with exaggerated fervor until it flops over into flaccidity. The golem's repeated failures at crafting a successful tower are a joke on male power and the inevitability of impotence. She assimilates the phallus's former potency as she rubs the tower's clay all over her face, mixing the brown substance with the white of her makeup in a burlesque of blackface and another nod to the golem's complicated gender and racial performances. In Weitz's work the golem represents bodily failure—and the potential power that comes with inhabiting and reclaiming a body that has been rendered other or abject due to its gender, race, or ability.

A number of critics have written about the history of the golem as a transnational and transhistorical symbol. Most notably, Maya Barzilai and Cathy Gelbin have explored the question of why the golem continues to maintain its power in Jewish and non-Jewish representations alike. By analyzing Melissa Broder's novel *Milk Fed* (2021) and Riva Lehrer's memoir *Golem Girl* (2020), I will argue that Jewish women writers are reinventing the golem for the twenty-first century. Their golem figure is not the hypermasculine golem of yore but rather a mother-golem who opens a portal into an archive of Jewish queer and feminist disability history and aesthetics. Like the fabled Rabbi Judah Ben Loew, Jewish women writers have harnessed the figure of the golem to serve the needs and preoccupations of their time.

Thinking through the Golem

In her influential *Golem: Modern Wars and Their Monsters* (2016), Barzilai brilliantly theorizes the Jewish monster as a primarily masculine "golem of war" who appears at moments of violence and crisis.⁴ She writes, "Performing an exaggerated form of male aggression—or else of male vulnerability in the case of the injured, living-dead soldier—the inherently indeterminate golem figure served writers and artists in varied cultural contexts to criticize the militarization of society but also give free reign to fantasies of (Jewish) revenge."⁵ Although Barzilai acknowledges that

"[f]emale golems do exist in both Jewish and Christian scriptural and literary sources," she sees this genealogy as less prevalent than that of "the golem of war, [who] persistently appears as a masculine being and, oftentimes, an object of female attention and attraction."[6]

While I agree with Barzilai's assertion that the golem has been used both to critique and embody militarism, I would argue that Jewish women writers, in particular, have been deeply invested in rewriting the golem as a female figure whose relationship to her creator resembles less the father-son dyad of rabbi and golem (not to mention Dr. Frankenstein and his monster) than that of mother and daughter, with all of the maternal relationship's attendant complications. These matriarchal creation stories provide a site for critiquing canonical, masculinist Jewish American literary narratives.

Recent fiction has summoned a number of female golems. In addition to Helene Wecker's *The Golem and the Jinni* (2013) and its sequel, *The Hidden Palace* (2021), which relate the story of a friendship between a female golem and a jinni in New York during the late nineteenth and early twentieth centuries, there is Emily Barton's *The Book of Esther* (2016), a fantasy novel featuring a crew of androgynous golems who help a woman warrior defeat a Holocaust-like threat to Jewish culture.[7] Further, Alice Hoffman's 2019 *The World That We Knew* focuses on the story of a young female golem figure who protects a Jewish child (and acts as her maternal proxy) when she is sent away by her mother in 1941 in order to avoid the rising threat of the Nazis.[8] Lesser known works by women and nonbinary authors—such as Myriad Augustine's short story about a nonbinary, disabled character and a golem, "Bellwoods Golem," and the queer romance novel *Kissing the Golem*—also feature the monster in new incarnations.[9] These recent texts, many of which were influenced by Cynthia Ozick's *The Puttermesser Papers* (1997), use a female golem to explore themes of gender, mothering, kinship, and queerness.[10] Even more strikingly, the female golem found in many works of contemporary women's memoir and fiction often explicitly engages with issues of embodiment, disability, and illness.

In her essay "Why Disability Studies Needs to Take Religion Seriously," Sarah Imhoff argues that the field of disability studies has avoided assessing the importance of religion despite its importance in the lives of many disabled people and the centrality of theology in representing and interpreting disability.[11] According to Imhoff, disability studies scholars

often portray religion in a negative light when they mention it at all. The disability studies critique of religion has been particularly harsh on Judaism. As Imhoff suggests, disability studies has traditionally regarded Judaism and the Judaic interpretation of disability as monolithic, reading all Jewish approaches to disability through the prism of the most egregious rabbinic and Old Testament perspectives on physical or psychological difference. Imhoff's argument—much of which centers on the case of queer, disabled Zionist writer and activist Jesse Sampter—is persuasive.[12]

However, while Imhoff is correct that disability studies scholars have often avoided or denigrated Judaism as a religion, Jewishness—as ethnic identity—has long been central to the discourse on disability, whether disability studies has acknowledged the connection to religious studies or not. Prominent theorists have studied the role of Jewish difference in formulations of eugenics in Anglo-America and, later, in Germany during the buildup to World War II. David Mitchell and Sharon Snyder's work on "the eugenic Atlantic" and Douglas Baynton's *Defectives in the Land: Disability and Immigration in the Age of Eugenics* are just two central works in disability studies that place Jewishness front and center.[13] Moreover, disability and Jewishness have been intertwined in the lives of many prominent disability activists in the post–Civil Rights Act (1964) wave of the disability rights movement that begat the fight for the Americans with Disabilities Act (1990). Judy Heumann and Arlene Meyerson, for instance, are Jewish American women whose parents raised them in the shadow of Hitler's purge of disabled children and adults before and during the Holocaust.[14]

Just as Judaism has remained a vexed category in disability studies, disability has not been an officially recognized category in Jewish studies until relatively recently. The 2022 scholarly meeting of the Association for Jewish studies was the first to offer a "disability" category—and the category was labeled as "experimental," denoting the provisional nature of the field in the wider discourse of Jewish studies. But Jewish studies and disability studies have much to gain from being in dialogue with each other. Disability studies theorists have traditionally focused on how Jews were seen by wider ableist movements, such as the early twentieth-century Anglo-American discourse on eugenics, while Jewish studies has primarily explored the construction of disability in Jewish legal and religious texts or—as in Sander Gilman's pioneering work—how antisemitic discourses

constructed the body of the Jew.[15] More recently, however, scholars working at the intersection of these discourses have begun the important work of grappling with how Jewish writers and thinkers represent *themselves* and their lived experiences of bodily difference.

While acknowledging the pivotal work of scholars such as Gilman, my analysis of Lehrer and Broder builds on the recent strain of scholarship that brings together disability theory and Jewish self-fashioning. Particularly influential is Natan Meir's *Stepchildren of the Shtetl: The Destitute, Disabled, and Mad of Jewish Eastern Europe, 1800–1939*, which, like Imhoff's work on Jesse Sampter, looks precisely at how disability functioned in Jews' own responses to modernity. He writes, "The internal Jewish discourse of modernization, progress, and integration required the creation of a despised Other to serve as a kind of doppelganger to be cast out or transformed utterly—until the realization that 'they' were 'us.'"[16] During the "modernist" period Meir covers, disability was often associated with "the crippled, pitiful Jews of the diaspora."[17] Disabled and outcast Jews were portrayed as dangerous to the new landscape of *Muskeljudentum* that Zionist Jews were attempting to develop at the same time that they came to stand in for all Eastern European Jews in a way that invoked nostalgia for an earlier, purportedly more primitive period of Jewish life.[18] The figures of the shtetl Meir explores are rendered other not only through their disabled status or their penury but also through the ways in which their otherness is linked to gender. As Michael Stanislawski notes in *Zionism and the Fin de Siècle* and Imhoff explores in her work on Jewish masculinity, the Zionist project cast the diaspora as feminine and weak in contrast to the masculine-identified strength of Jewish nationalism.[19]

The figure of the golem, long acknowledged as central to Jewish self-representation, provides a generative site for bringing together disability and gender. Although critics have noted the relationship between the golem and injury, as in Barzilai's exploration of war injury and the golem's recombinant form after World War I, they have not explicitly recognized the importance of the golem for disability studies and disabled self-representation. What makes the new spate of golem art—like that of Weitz, Lehrer, and Broder—so striking and resonant for disability studies is its move from seeing the golem as an object to a subject of representation, à la the work of Meir and Imhoff, as well as its melding of disability,

queerness, and race. As Gelbin has pointed out in *The Golem Returns: From German Romantic Literature to Global Jewish Culture, 1808–2008*, writers and artists have long associated the golem figure with bodily "deviance," particularly the perceived bodily difference of Jews.[20] Focusing on the role of German Jewish figures, such as Freud and Magnus Hirschfeld, in encouraging German modernity, Gelbin writes: "If their efforts helped to modernize broader German society and, with it, German Jewish life, anti-semitic discourses on the other hand increasingly fused older images of the Jew with the new scientifically based discourse of gender and sexual difference. The Jew thus became the symbol of the fin de siècle theme of decadence with its focus on racial, gender, and sexual deviance."[21] This combination of premodern antisemitism with "the new scientifically based discourse of gender and sexual difference" contributed to the popularity of the golem figure as a symbol of Jewish "decadence" and "deviance," an association that contemporary Jewish women writers have turned on its head. In the "unruly body" of the mother-golem, these writers have combined the perverse charge of the pejorative with the empowering discourses of feminism, disability studies, and queer theory to reclaim the monster and monstrosity itself.[22] Broder and Lehrer are not, of course, the first artists to harness the power of the monster to such ends. In "My Words to Victor Frankenstein above the Village of Chamounix," her performance art theorization of trans rage, for example, Susan Stryker uses Frankenstein's monster as a powerful, if ambivalent, metaphor for trans corporeality.[23] Other writers are drawn to the figure of the golem as a symbol of queerness. In an article titled "Could the Golem be the Ultimate Jewish Queer Symbol?," Michele Kirichanskaya writes, "As a Jewish reader and fan of the spectacular, I was drawn to this story [of the golem] because of the weight of its dimensions, seeing in it the same heroic legacy as I do in Jewish American Jack Kirby's creation of The Thing from the Fantastic Four. Yet upon closer analysis, I also began to see parallels that mirror my life as a queer person, being created by another person's hands, imprinted with the expectations that others drew upon my body, feared that I will become an independent entity beyond anyone's control."[24] Broder and Lehrer innovate by employing the metaphorical power of the monster to create a space for Jewishness, feminist and queer critique, and disability to come together.

Sex, Motherhood, and the Fat Golem in *Milk Fed*

The golem in Melissa Broder's *Milk Fed* (2021) is a complicated figure of eros and maternal love that brings together race, gender, and embodiment. Rachel, the protagonist of *Milk Fed*, is the daughter of a hypercritical mother who is particularly obsessed with her daughter's childhood chubbiness. Rachel's working-class Jewish grandparents were overweight and her mother sees Rachel's body as a reflection of all that she sought to leave behind when she left her own childhood home. As in Meir's reading of the response of many Jewish writers and thinkers to the marginalized bodies of disabled and poor Jews in the shtetl, Rachel's mother is preoccupied with displacing her racial and class anxieties onto the bodies of a perceived other and actively manufactures otherness in people who are dangerously close to her, like her parents—something Rachel herself does throughout *Milk Fed*. In response to her mother's intense criticism, Rachel restricts her calorie intake and develops an eating disorder. After she stops getting her period and grows lanugo (a downy fuzz) all over her body, she tells her mother she thinks she might be anorexic. Her mother replies, "Anorexics are much skinnier than you are. They look like concentration camp victims. They have to be hospitalized. You aren't anorexic."[25] This invocation of "concentration camp victims" proves only one instance of the joining of Jewishness to abject or deviant embodiment in *Milk Fed*.[26] When the loss of Rachel's period risks potential infertility, her mother finally takes notice. Rachel is sent to a nutritionist, who helps her gain a little bit of weight but never discourages her obsession with weight loss.

Years later, Rachel talks about her mother to her therapist, who replies that looking for validation from her mother is like "going to a hardware store for milk" (17). *Milk Fed* is about the futile quest for acceptance, the attempt to gain sustenance from patriarchal structures or standards—"the hardware store"—when what one really needs cannot be found there. Rachel "wished that [she] could procure, from nowhere, an incarnation of a mother [she] wanted. This interplay between hope and reality was also part of the mourning" (26). As part of the process of mourning for the mother she will never have, the therapist suggests that Rachel "detox" from her mother and engage in art therapy by building a model of herself from "Therapputicals Anti-Microbial Modeling Clay" (35). The therapist relates that she has "written down some words [Rachel] used to

describe her body... 'Amorphous.' 'Out of control.' 'Disgusting.' 'Exploding.'" (35). Forming her self-portrait out of clay, Rachel sculpts a massive woman with "an immense belly, huge tits," what the therapist describes as the kind of "out of control woman" Rachel usually fears herself becoming (36). Despite the joy she feels while constructing the woman, Rachel feels shame as soon as she completes the task, rushing to put the clay figure in the trunk of her car from which it quickly disappears.

The figure soon comes to life in the form of Miriam, an Orthodox Jewish woman whom Rachel meets at the local frozen yogurt business where she obsessively counts calories in the hopes of experiencing a little bit of pleasure without losing control. Miriam, whose family owns the store, is large and blonde, with pendulous breasts and a protruding belly. Rachel is preoccupied with Miriam's size, writing: "Above all, she is fat, undeniably fat, irrefutably fat. She wasn't thick, curvy, or chubby. She surpassed plump, she eclipsed heavy" (39). Moreover, to Rachel, a secular Jew, Miriam "looked both Jewish and not Jewish at the same time—but there was something distinctly Jewish about her, a shtetl essence that perhaps only a fellow Jew could detect" (39).[27] Like her mother before her, Rachel essentializes Jewishness and locates it firmly in a racialized Jewish other. The "shtetl essence" that is only detectable by a "fellow Jew" is central to Miriam's allure and to Rachel's fetishization of her. Miriam is everything that Rachel fears, and Rachel finds her incredibly attractive, becoming sexually obsessed with her as their friendship grows. Part of the tension in *Milk Fed* comes from the ambiguity inherent to Broder's approach. Is Broder's depiction of Miriam (which becomes more complex as the novel progresses) a subversive rewriting of Rothian objectification in which the sexualized and racialized fat body becomes not the other (the golem) but the self? Or, is Rachel's desire for Miriam a form of narcissism? Does Rachel ever see Miriam as a person rather than a metaphor or an object of desire (whether for sex or maternal embrace)?[28]

It is through the contrast between Miriam's fatness and Rachel's thinness, as well as their different negotiations of Jewishness, that Broder explores the link between disability and the golem.[29] Recent writing in disability studies has embraced fatness—and, to a more limited extent, eating disorders—as forms of embodiment that highlight the stigma of disability. The social model of disability as articulated by Susan Wendell argues that the medical model of disability focuses too much on

individual impairment and cure, rather than on the social conditions that turn an impairment into a disability.[30] April Herndon argues that "resistance to seeing fatness as a disability and fat people as a politicized group situates itself within medical epistemological frameworks that focus on the biology of individuals" rather than on the social landscape that makes fatness into a disability by refusing to accommodate or accept fat people or their bodies.[31]

After constructing the clay figure and meeting Miriam, Rachel's commitment to thinness and obsession with calorie counting are overwhelmed by her lust for Miriam. As Miriam encourages her to add toppings to her desserts and let them overrun the cup, Rachel worries about how her engagement with the fat woman is affecting her: "Was I becoming a frozen yogurt girl: soft, sloppy, melting?" (69). Her affection for Miriam's overflowing body and the creation and loss of the clay figure become connected in her mind. Fearful of the changes taking place in her life, she writes: "That night, I googled voodoo doll. I ended up on someone's Etsy page, featuring an array of ugly gingerbread-man-looking stuffed dolls—said to be handmade in Brooklyn" (70). It is not incidental that the clay figure becomes a "voodoo doll" in Rachel's mind, another body onto which to project her anxieties, as well as a marker of how these anxieties are racialized. As Michelle Y. Gordon notes, the media stoked white fears of the religious practice of vodun during the Reconstruction period in order to buttress claims about African American danger and deviance.[32] After looking up Jewish voodoo dolls and Jewish Frankensteins (the latter of which merely lead her to a biography of Mel Brooks), she ends up finding the story of the golem. She reads that it is an "animated anthropomorphic being found in Jewish folklore that is created magically from inanimate matter—usually clay or mud. The golem possesses infinite meanings, and can function as a metaphor for that which is sought in the life of the creator" (70). Gazing at the images, she notes, "In one picture the golem looked like King Kong. In another it looked like something of a hulk: the Jolly Green Giant or Andre the Giant. In no picture did the golem look like Miriam or me or a young me or the psychedelic woman I'd made or Dr. Mahjoub or even frozen yogurt" (70). The golem is the central "metaphor" through which Rachel—and her author, Broder—will explore eating disorders, queerness, and Jewishness. It is precisely the golem's ambiguity—its history as a revolving symbol—that makes it an

ideal vehicle for Jewish women writers' exploration of the valences of the gendered Jewish body and its categorical differences.

Various characters in *Milk Fed* play the role of the golem, as Broder's listing of frozen yogurt, therapist, "young me," "Miriam," and "the psychedelic woman I'd made" suggest. Broder's satirical and sexy bildungsroman plays with the idea of the indeterminacy of the golem and the power differential between master/mater and monster. At different points in the text, Miriam "mothers" Rachel; at other times, Rachel treats Miriam as the Galatea to her Pygmalion, remaking her in the image of her ideal woman. The choice to name both characters after biblical matriarchs emphasizes their roles as symbols of empowered Jewish femininity. The biblical Miriam, in particular, has become a feminist icon in contemporary Judaism, inspiring the addition of "Miriam's Cup" to the Passover table in order to highlight the role of women in the Exodus narrative and the often-neglected importance of Jewish women's stories in the religion as a whole.

Rachel buys Miriam bright red lipstick and imagines replacing her plain sunglasses with a chic new pair. She relates, "I wanted to 'improve her' like a project, make her more fashionable. It was not so much about goodwill as it was about my own fear" (117).[33] Miriam teaches and trains Rachel as well. On their first outing, which may or may not be a date, they go to a kosher Chinese restaurant, where Miriam's unfettered eating inflames Rachel and encourages her to consume as well. As Rachel's sexual interest in Miriam transforms into romantic love, Rachel muses, "I had thought that I was the sculptor and she was the golem. But now I considered that she might be the sculptor, the maestro, the creatrix, expanding and improving me, giving life to my dead parts, laughter to my breath. Maybe she was remaking me in her image. Maybe we were remaking each other" (151).

Miriam is not the only woman onto whom Rachel projects both sex and maternity. At the talent agency where she works, Rachel meets Ana, an older woman from whom she seeks maternal validation even as Ana becomes an object of Rachel's masturbatory fantasies. When Rachel first visits Miriam's home to observe the Sabbath, she fantasizes about making Miriam's mother her own. Later, Miriam visits Rachel in the makeshift room they have set up for her in the basement and relates the story of a fictional character, Esther, who wants to leave the place where she is born but ends up settling for staying home. This story enrages Rachel, who had

imagined that Miriam might consider leaving the comfort of her Orthodox Jewish life to date her. After Miriam leaves the room, Rachel masturbates. Instead of thinking about Miriam, as she often does, she "imagined another woman, one [she had] never seen before, who had the same body as Miriam but very dark hair." Her fantasy expands: "Yes, I would create a woman right there in the Schwebels' basement. Esther! I was going to fuck Esther!" (145). Rachel humps a pillow, imagining herself as "Rabbi Judah Loew ben Bezalel of that fucking pillow." She declares: "I was Adam, and that pillow was my rib, or whatever. From that pillow I would create my dream woman" (145). Later, while riding a stationary bicycle at the gym (one component of her punishing daily weight loss regime), Rachel fantasizes that the bike seat is her penis, what she dubs, recalling, again, the golem, her "Frankencock" (161). These Rothian interludes are brash and comical, but they also suggest the ways in which sex, maternal creation, and the golem intermix in *Milk Fed*. More notably, they provide Broder with a means of rewriting the often-masculinist script of Jewish American fiction. Broder's writing about sex throughout *Milk Fed* provides a queer corrective to the prose of Jewish patriarchs of the sex-writing genre, like Roth, Bellow, and Singer.[34]

For Broder, the use of the sexualized golem is a self-conscious means of joining her work to a genealogy of Jewish American literature, even as she upends it. Broder explicitly places herself in conversation with canonical Jewish American writers in *Milk Fed*. In an interview about the novel, she relates that "[all] my old Jewish faves primed [her] to tell the tale. *The Puttermesser Papers* by Cynthia Ozick, in which there is also a contemporary golem. *Goodbye, Columbus, Sabbath's Theater*, and *Portnoy's Complaint*, by Philip Roth, where the line between sex and a tuna salad sandwich dissipates. Pretty much everything by Isaac Bashevis Singer, but especially *Enemies: A Love Story, Shosha*, and *The Magician of Lublin*."[35] Broder's golem connects her not only to other works that explicitly treat the figure, such as *The Puttermesser Papers* (which she mentions) or *The Amazing Adventures of Kavalier and Clay* (which she does not) but also to a long history of Jewish writers who have reanimated iconic Jewish figures in their work—from Ozick's reimagining of the life of Bruno Schulz in *The Messiah of Stockholm* to both Philip Roth's and Nathan Englander's engagement with Anne Frank in their fiction.[36] Moreover, Broder's queer love story acts as a corrective to the usual heterosexual tendencies of the

golem narrative, which appear even in avowedly feminist fiction; Marge Piercy's *He, She and It* (1991), for instance, casts the golem as the steely love interest of the main character's daughter.[37] As Barzilai points out in her analysis of the cyberpunk novel, "[W]hile Piercy's narrative challenges the nature of Judaism and 'the boundaries of what is human,' her characters reproduce norms of heterosexual and monogamous relationships."[38] Broder's erotic imagination transgresses the boundaries of heterosexuality and monogamy, even as it plays with the boundaries between human and nonhuman, reality and fantasy.

When Rachel has sex with a man, the pretentious actor Jace, she compares him unfavorably to Miriam. Jace, who is represented by Rachel's company and stars in a popular television series about the undead, is the opposite of Miriam. If he is untouchably masculine, a zombie like the monsters on his show, she is a more vulnerable creature. Of Jace, says Rachel, "He was safe from judgment in his body, this naturally skinny, handsome actor. He had an armor to protect him from any consequences to his own hunger. In Miriam, it was different. She wore the fruits of her hunger on her body at all times" (107). Miriam's unwillingness to hide her hunger contrasts with Rachel's willingness to eat only in secret and symbolizes the queerness that Rachel wants desperately to keep at bay throughout *Milk Fed*. Although Rachel fantasizes about cutting her hair short and wearing more classically butch clothing, she feels constrained by the expectations of the older Jewish women around her (chiefly her mother but also her coworker) to maintain her performance of normative heterosexual femininity.

When Miriam and Rachel first have sex, Rachel likens the two women to shtetl matriarchs. While performing cunnilingus on Miriam, she is carried into a kind of Proustian reverie laced with shtetl nostalgia: "When I tasted her brine, I was hit with a sense of timelessness, as though this had all happened before, somewhere as far back as our ancestors in Russian or Lithuania or Poland or Moldova. We were two shtetl Jewish women reincarnated, two women who had known each other and been lovers in a past life" (217). This melding of racial essentialism and sex echoes Rachel's feelings upon first meeting Miriam and her "shtetl essence." It also suggests that fatness and Jewishness are intertwined in Rachel's imagination, allowing Miriam to function as a conduit to self-acceptance—of Rachel's Jewishness, her queerness, and her body.

Early on in the novel, when Rachel visits Miriam's house, she is worried that Miriam's family accepts her with open arms only because she, too, is Jewish. Later, it is Miriam's commitment to her Jewish family that drives the two women apart. Rachel visits Miriam's house for Shabbat after the two have started dating. Miriam's mother begins to suspect the romantic relationship between the women and becomes increasingly antagonistic to Rachel. The visit culminates in a fight about Israel in which it becomes clear that Israel, too, functions as a golem in the Jewish imaginary: a bulwark against antisemitism and a potent creation myth for Jewish exceptionalism even as it tends to backfire on the Jewish community that first imagined it. Miriam's brother fights in the IDF and the Schwebels have an uncomplicated love for the Jewish nation-state. When Rachel questions their devotion and refers to Israel's relationship to Palestine as an "occupation," the Schwebels call her self-hating and ask her to leave their home, in another move that recalls Roth's writing, this time about intra-Jewish conflict about Israel in *Operation Shylock* (1993).[39] After leaving Miriam's parents' home, Rachel wonders: "What did it mean to love a version of something that might not really exist—not as you saw it? Did this negate the love? Was the love still real?" (235). In this rendering, Israel, like Miriam and like Rachel's ideal of mother-love, is a hollow idol.[40] Later, after a brief reconciliation, Miriam leaves Rachel for good and conforms to her family's ideals about marriage and family; when Rachel encounters her in the street years later, Miriam is pushing a baby carriage and wearing a beret to cover her hair in the Orthodox fashion. While the vision of Israel as golem maps onto the "golem of war" that Barzilai notes in her assessment of twentieth-century golem imagery, Miriam as golem and her refusal to leave her home behind complicate the picture and make us think about the golem as an always already failed figure, one whose ideals are ultimately unrealizable even as they are impossible not to pursue.

As *Milk Fed* proceeds, the line between reality and fantasy grows fainter for Rachel. She begins to dream more and more of Rabbi Bezalel and questions him about how "real" her relationship with Miriam is. The rabbi responds, "Real, shmeal . . . Do you think anyone knows? A mother loves how she sees her child. A people love their myth of a homeland. You love your Miriam" (269). The rabbi's use of the phrase "your Miriam" emphasizes the shifting nature of the golem as a figure that possesses and is possessed, as well as the blurry line between creator and creation that makes

these monsters so dangerous. After Miriam and Rachel break up, and Miriam becomes a mother, Rachel, again, sees the rabbi in a dream. There, he reminds her that "the word golem, in English, means shapeless mass. But, in Hebrew, it means unfinished substance" (288). At the end of *Milk Fed*, Rachel is left "unfinished," a metacommentary on the power of art to free, even as it constrains. In the last lines of the novel, Rachel asks "the rabbi where [she] could find him if [she] needed his wisdom. He reminded [her] that [she] was his creator" (288). Rachel's creation of the golem (both in her therapist's office and in her relationship with Miriam) thus transcends its origin in distorted thinking to become a fable about the possibility of the queer, feminist imagination to shape one's identity and life.

Monsters as Metaphors, Metaphors as Maters in Riva Lehrer's *Golem Girl*

In Riva Lehrer's memoir, *Golem Girl* (2020), as in *Milk Fed*, the golem becomes a metaphor for the power of Jewish women writers to create a figure that speaks to the particularity of queer, feminist experience. The transformation of the golem (and the self) from object to subject of representation is central to Lehrer's memoir.[41] Lehrer structures her narrative of growing up with spina bifida in postwar Cincinnati (and, later, Chicago) via the metaphor of the golem. She opens *Golem Girl* by relating her love for the film *Frankenstein*. When the monster first came on-screen, she writes, "I knew he was real, because we were the same—everything that made him a monster made me one, too. We had more in common than scars and shoes. *Frankenstein* is the story of a disabled child and his parent. It is also the story of a Golem" (xiii).[42] She goes on to list a number of other golem figures, including the character of "Gollum" in J. R. R. Tolkien's Middle-earth fantasy series, before acknowledging that "[w]hile these are not all golems exactly, every creature is made of inanimate material that is shaped and awakened by the will of the master (and nearly every story is of a master—not a mater—a male who attempts to attain the generative power of the female body)" (xiv). Although Lehrer draws from these examples of golems who are "shaped and awakened by the will of the master," her own work rewrites the golem to focus on the mother-daughter relationship. Her defining relationship throughout the memoir

Figure 8.1. A self-portrait of Riva Lehrer with a tattoo of her mother on her arm. Riva Lehrer. Used by permission.

is with her mother, Carole, a brilliant, frustrated woman who advocates for her daughter even as she often overpowers her.

Chapter 1 of *Golem Girl*, "Carole's Story: It's Alive," frames Riva Lehrer's birth through her mother's experience of it, as if Carole were simultaneously the author of her daughter's life and a viewer of its monster movie excesses.[43] According to Lehrer, Carole told her daughter's origin story frequently throughout Lehrer's childhood as a means of shaping her own traumatic experience, expressing pride in her child, and also, like Scheherazade, extending her daughter's survival. When Lehrer was born in

1958, children with spina bifida were largely viewed as destined for death. "[D]octors foretold that I would be a 'vegetable,' a thing without volition or self-awareness," Lehrer writes. "Children like me were saved without purpose, at least not any purpose we could call our own" (xv). It is only through her mother's advocacy that young Riva survives. Prior to her pregnancy, Carole had worked as a researcher at Cincinnati Children's Hospital assisting Joseph Warkany, the scientist who had "established the field of teratology in America ('teratology,' from the Greek '*teratos*,' or monster, is the medical term for the study of birth defects)" (8). This experience as a researcher, along with her own indomitable instincts, help Carole advocate for her child's medical and psychological health.

Lehrer was hospitalized for most of the first two years of her life, undergoing dozens of surgeries and surviving many brushes with death. Carole repeatedly narrates those difficult years for young Riva as she grows: "The dramatic thread that wound through her stories was that she nearly lost me, not only to death, but to life in an institution" (17). Carole argues with the countless social workers who, as was commonplace at the time, contend that a child with Lehrer's severe disabilities would be better off in an institution than at home.[44] Lehrer relates that her mother finally prepared her for escape from the space of the hospital when she was two. At Grand Rounds, the many doctors who regularly surrounded Riva were met by the little girl and her mother, each bedecked in finery and prepared to make their case that young Riva was well enough to go home. Carole teaches Riva the names of the many drugs she takes and has her recite them in front of the doctors. "Maybe," Lehrer writes, "they were onto us—but, even so, something shifted that day in Grand Rounds. The social workers evaporated and the doctors began to discuss how to care for me at home" (20). This performance of extraordinary precocity and determination was a mutual triumph. Lehrer relates, "We were a team. Pirate mommy and parrot daughter, puppeteer and marionette. My stage mother didn't give me lessons in piano, or dancing, or horseback riding. She taught me to be seen. Visibility was our Basic Scales, First Position, Stay in the Saddle. It was survival" (20). The ambivalence of Lehrer's description—Carole as a "stage mother" and "puppeteer" but also the person who teaches her "to be seen"—characterizes the pair's relationship throughout *Golem Girl*.[45] Both Riva and Carole come to take on the "monstrous" qualities of the golem at various points in the narrative (20). To Lehrer, the master can be as monstrous as its creation.

Carole's and Riva's relationship is often likened to that between the golem and his master, as well as to a variety of other monsters and their creators. Lehrer wonders if her mother felt guilty about having given birth to a child with disabilities. She writes that "'[m]onstrous' children were blamed on mothers via an ancient concept known as 'maternal imprinting' . . . A fetus could be imprinted by something its mother saw. Women were warned against looking at disturbing sights if they were pregnant or trying to conceive" (14).[46] Riva believes that she survived not only because of her mother's intelligence (emotional and otherwise) but also due to her mother's "dark" past—the three miscarriages that led up to the birth of her first child. "After such loss," she writes, "how could she give up a living child?" (21). Like the writer Mary Shelley, who had suffered both a miscarriage and the death of a child by the time she published *Frankenstein*, Carole was deeply invested in her creation, according to Lehrer. These losses, Lehrer contends, are at the center of Carole's artistic approach to Riva's (and her own) life, as well as to Shelley's power as a writer.[47] Lehrer writes: "Could *Frankenstein* have been written by anyone but a mother who had lost child after child? A woman for whom the line between life and death had smudged?" (21). Lehrer suggests that Carole might not have been able to advocate for and author Riva's life without her history of fertility loss.

Lehrer often blurs the lines between her own and her mother's bodies. She relates of her life as a fetus: "The amnion—the inner layer of the placental wall—had adhered to the baby's skin and formed swathes like mummy's bandages. These had affixed the baby to Carole's uterus, as if her body was trying to keep the child inside her maternal fortress. As if preparing dressings for the surgeries that lay ahead. As if knowing that mother and child would never be much good at separation" (8). Throughout *Golem Girl*, Lehrer and her mother's attempts to separate are often vexed—until Carole becomes addicted to pain medication due to her own health problems and eventually commits suicide, devastating the still-young Riva and making her feel responsible for the death of her "creator."

The desire to keep Riva alive at all costs is also linked to her family's Jewishness. In the aftermath of Hitler's euthanizing of the disabled, Lehrer asserts, Jewish families were especially sensitive to the difficulties faced by children who would have been victims of Nazi eugenics. Despite continuing advances in the treatment of spina bifida, Lehrer points out that the condition is still perceived through a eugenic lens by many thinkers, such

as Peter Singer, who has argued that children with spina bifida have lives that are not worth living.[48] Throughout *Golem Girl*, Lehrer is interested in understanding her golem-ness through the pathologizing medical discourse of writers such as Singer. As Lehrer points out, she is a golem not only because of her relationship with her mother-creator but also because of her dependence on the ministrations of surgeons who sew her back together and on the broader medical field that keeps her alive. When Lehrer was born, little was known about spina bifida and 90 percent of children with the condition died before their second birthday. Lehrer was lucky enough to meet a young surgeon who performed a series of risky procedures on her at birth. Like the golem of myth, Lehrer is a liminal figure—"a mass, a body with irregular borders," a "body... built by human hands" (xv) that is given shape by the surgeon. Lehrer writes: "The shape of my body was pared away according to normal outlines, but this normalcy didn't last very long. My body insisted on aberrance" (xv).

Lehrer's condition also obscured her genital sex at birth, an indeterminacy that Lehrer emphasizes in *Golem Girl*. When she is born, the lower half of her body is "encased" in "adhesions" that make it difficult to tell whether she is male or female (8). This indeterminacy is mapped onto the liminality of the golem as well as Lehrer's queerness. Lehrer writes that she has not embraced "they/them" pronouns, despite her feeling of existing between genders, because her femininity is hard won, gained despite those who saw her disability as disqualifying her for womanhood. The narrative of her birth not only aligns Lehrer's disability with her gender queerness but also echoes the "pervasive cultural desexualization of disabled women's bodies" and the projection of deviance onto the sexuality of disabled women.[49]

In Lehrer's hands, the golem poses fundamental questions about agency and self-determination that resonate with experiences of disability. The golem becomes a figure useful for thinking both about the relationship Lehrer has with her mother, with society at large, and with the doctors who reconstruct her body more than forty-three times over the course of her lifetime. Lehrer writes:

> Golems are built in order to serve a specific purpose. Adam, it is said, was built for the glory of God. The Golem of Prague was built to save the Jews from a pogrom. Frankenstein's monster was built for the

glory of his maker, and for the glory of science itself. These Golems were not created for their own sake. None given purposes of their own, or futures under their control. Golems are permitted to exist only if they conform to the wishes of their masters. When a Golem determines its own purpose—let's call it hubris—it is almost always destroyed. The Golem must stay unconscious of its own existence in order to remain a receptacle of divine will. (xiv)

Despite this sense that the golem is defined by the will of its master/mater, the story of *Golem Girl* overturns the power dynamics of the monster-master dynamic. "Yet every tale tells us: it is in the nature of a Golem to wake up," Lehrer writes. "To search for the path from being an *It* to an *I*" (xv).

Lehrer embraces her subjecthood through her art and her gradual embrace of disabled community. Her talent as a visual artist is recognized from a young age, and as an adult Lehrer becomes a celebrated portraitist. She is famous for her paintings of other disabled artists and activists, many of whom collaborate with Lehrer on their images. The power of finding community in her disabled identity echoes the sense of belonging she felt as a small child at the Condon School for the Handicapped, a progressive elementary school where she could be "a Golem among Golems. A monster in a school for the strange where normal was whatever was real for us" (115). This sense of belonging is not something that Riva often experiences in the normative world, even as she becomes part of the queer community. At the Michigan Womyn's Festival, when other queer women take off their shirts, Lehrer's discomfort with her body makes her keep hers on: "[S]till a Golem," she writes (219).

Lehrer ends *Golem Girl* by retelling the golem narrative in both written and visual form in sections labeled "Golem I" and "Golem II." In "Golem I," Lehrer retells the traditional sixteenth-century version of the golem of Prague featuring Rabbi Bezalel, often known as "the Maharal." This portion of the golem story is told from the perspective of the rabbi, who marvels at and eventually comes to fear his creation. In "Golem II," Lehrer herself is the golem. She describes and includes a reproduction of one of her self-portraits, *Portrait of the Artist as a Young Golem*, painted for her Circle Stories project in 1997. The self-portrait is a diptych meant to be hung with a blank space between the two paintings: "The top painting: the head of a woman in her thirties. She wears a pair of silver spectacles

and a dyke-style braided tail. Her forehead is emblazoned with pink keloid letters spelling אמת" (366). Like the golem of Prague, Lehrer's image is animated by the Hebrew word for "truth." But, for Lehrer, the word is written in keloid scars recalling those she has all over her body. The bottom portrait shows a pair of heavy, orthopedic shoes (which Lehrer laments wearing throughout *Golem Girl*) planted in mud and surrounded by grass. "But the center of her body isn't there," Lehrer writes. "The part of the body that connects head to feet—the explanation—is a mystery" (366). The absence of Lehrer's body might be read as an erasure of her disability, but it also functions to emphasize her indeterminacy and liminality, as well as the collaborative process of meaning-making she foregrounds in her artistic process. Lehrer's art relies increasingly on encouraging its disabled subjects to participate in the art-making. The gap between head and feet also draws attention to the ways in which, as Lehrer puts it, "[h]er painted mouth mocks her insistence at calling herself, a queer, crippled Jew with peculiar shoes, a dreadful, grievous monster" (366). The reader is left to draw the conclusion that there is beauty in the reclaimed monstrosity of Lehrer's portrait and in Lehrer herself.

Still, following these words, Lehrer writes (and, later, revises) her epilogue to suggest the ways in which, in her words, "monstrum monstrare," monsters "reveal" (369). In light of the coronavirus pandemic, which began between the completion and publication of *Golem Girl*, disability became, not for the first time, "the great billboard of human truth," pointing out the ways in which American culture continues to function along deeply ableist and eugenicist lines (369). To Lehrer, disabled "monsters" aid the wider culture in seeing its fault lines. "Sometimes a monster is the one who saves us," she observes (371).

Lehrer is not the first writer to use the figure of the monster as a metaphor for disability or disease—or to point out the ways in which disability as metaphor illuminates the pitfalls of ideas of normalcy and ability.[50] Stephen Crane's 1898 novella, *The Monster*, is considered one of the central texts in literary studies of disability because of the questions it poses about the interweaving of disability, race, and embodiment in modernity.[51] Monster imagery has been used to express anxiety not only about deviant forms of embodiment but also about the spread of diseases and their treatment. A number of writers, including Susan Sontag, have considered the connection between vampire imagery and representations of tuberculosis. In *On*

Immunity, Eula Biss points out that critics of inoculation have historically used the vampire as a trope both for the spread of disease and the dangers of the vaccine needle.[52] Recent media stories have invoked the zombie as a metaphor for the Covid-19 pandemic.[53]

Lehrer differs from these authors in using the golem not simply to represent disability but to represent her own experience of it—a move continuous with the reclamation of pejorative terms and metaphors in queer and disability cultures. As Eli Clare points out in *Exile and Pride*, naming remains a complicated practice for most marginalized communities, and "crip" and "queer" are alternately embraced and rejected by those in queer and disabled communities.[54] Nonetheless, for some, the reclamation of terms such as "crip" and, perhaps, for Lehrer, "monster," can be empowering. In Ellen Samuels's writing about what she calls "crip time," she uses both zombie and vampire metaphors to evoke her experience of disability.[55] These metaphors do not evacuate the content of Samuels's experience, as Mitchell and Snyder claim many disability metaphors do, but instead provide a vehicle for self-expression.[56]

The golem's utility for metaphorizing disability is apparent for Lehrer. She writes that "in Golem stories, the monster is often disabled. Speechless and somnambulistic, a marionette acting on dreams and animal instincts. In Yiddish, one meaning of goylem is 'lummox'; to quote the scholar Michael Chemers, from God's perspective, all humans are disabled" (xv).[57] In *Golem Girl*, the golem becomes the key to humanizing disability from a queer, feminist perspective, even as it challenges timeworn notions of the human.

In Broder's *Milk Fed* and Lehrer's *Golem Girl*, the golem becomes a means of meditating on the power of Jewish American women writers to play with and rewrite patriarchal scripts about sexuality, gender, ability, and authorship itself. Despite differences in genre, Broder and Lehrer are both decidedly the creators of their own golem narratives rather than figures in another person's story. If the golem has long functioned as a kind of chronotope for understanding important nodal points in modern Jewish identity, *Golem Girl* and *Milk Fed* provide us with a new way of looking at Jewish difference. Jewish studies and disability studies have long maintained a wary relationship, but queer, feminist disability studies—and Broder's and Lehrer's queer, Jewish, feminist writing—illuminate the potential for a mutually sustaining connection between the two fields.

Notes

1. Julie Weitz, *My Golem*, 2017–22, accessed August 16, 2020, www.julieweitz.com/artwork#mygolemartworks.
2. Although the golem is androgynous and plays with gender, Weitz uses the pronoun "she" through *My Golem*.
3. Hannah Schwadron addresses the golem as dominatrix at more length in her "Redressing Power through Hasidic Drag: Julie Weitz in *My Golem as the Great Dominatrix*," *Shofar* 39, no. 3 (Winter 2021): 181–209, https://doi.org/10.1353/sho.2021.0032.
4. Maya Barzilai, *Golem: Modern Wars and Their Monsters* (New York: New York University Press, 2016), 5.
5. Barzilai, 14.
6. Barzilai, 14.
7. Helene Wecker, *The Golem and the Jinni* (New York: Harper, 2013); Helene Wecker, *The Hidden Palace* (New York: Harper, 2021); and Emily Barton, *The Book of Esther* (New York: Random House, 2016).
8. Alice Hoffman, *The World That We Knew* (London: Scribner UK, 2019).
9. Myriad Augustine, "The Bellwoods Golem," in *Nothing Without Us*, ed. Cait Gordon and Talia Johnson (New York: Renaissance, 2019), 9–19; and Danielle Summers, *Kissing the Golem* (New York: Tulabella Ruby Press, 2015).
10. Cynthia Ozick, *The Puttermesser Papers* (New York: Atlantic, 1997). *The Puttermesser Papers* tells—in a series of semisatirical vignettes—the story of Ruth Puttermesser, who creates a golem-daughter for herself out of clay. Ozick would not necessarily have seen herself as the progenitor of this particular genealogy. Timothy Parrish in "Creation's Covenant: The Art of Cynthia Ozick," *Texas Studies in Literature and Language* 43, no. 4 (Winter 2001): 440–64, persuasively argues that the question of literature as idolatry, rather than gender, was at the heart of her work in *The Puttermesser Papers*.
11. Sarah Imhoff, "Why Disability Studies Needs to Take Religion Seriously," *Religions* 8, no. 9 (September 2017), https://doi.org/10.3390/rel8090186.
12. Imhoff has recently published a book-length exploration of Sampter's life. Sarah Imhoff, *The Lives of Jesse Sampter: Queer, Disabled, Zionist* (Durham, NC: Duke University Press, 2022).
13. David Mitchell and Sharon Snyder, "The Eugenic Atlantic: Race, Disability, and the Making of an International Eugenic Science, 1800–1945," *Disability & Society* 18, no. 7 (2003): 843–64, https://doi.org/10.1080/0968759032000127281; and Douglas Baynton, *Defectives in the Land:*

Disability and Immigration in the Age of Eugenics (Chicago: University of Chicago Press, 2016).

14 A number of the people featured in the recent documentary *Crip Camp*—about the summer camp for disabled teenagers that brought together many of those who would later form the core of the disability activist community in the U.S.—are Jewish and some, like Heumann, are the children of refugees from Nazi-occupied Europe.

15 Sander Gilman, *The Jew's Body* (New York: Routledge, 1991).

16 Natan Meir, *Stepchildren of the Shtetl: The Destitute, Disabled, and Mad of Jewish Eastern Europe, 1800–1939*, (Palo Alto, CA: Stanford University Press, 2020), 3.

17 Meir, 1.

18 Meir is talking not just about disability but also about marginalized Jews more generally, such as those in the poorhouse. This melding of class and ability recalls Susan Schweik's *The Ugly Laws* (New York: New York University Press, 2009), which looks at the ways in which laws against beggars, many of whom were also disabled, worked to construct disability in the American context.

19 Michael Stanislawski, *Zionism and the Fin de Siècle: Cosmopolitanism and Nationalism from Nordau to Jabotinsky* (Berkeley: University of California Press, 2001); and Sarah Imhoff, *Masculinity and the Making of American Judaism* (Bloomington: Indiana University Press, 2017).

20 Cathy Gelbin, *The Golem Returns: From German Romantic Literature to Global Jewish Culture, 1808–2008* (Ann Arbor: University of Michigan Press, 2010).

21 Gelbin, 75.

22 The term "unruly" to refer to bodies that exist outside the expectations of the normative is common within disability studies and related discourses, such as fat studies. Susannah Mintz used the term as the title for her anthology *Unruly Bodies: Life Writing by Women with Disabilities* (Chapel Hill: University of North Carolina Press, 2007). Writer Roxane Gay used "unruly bodies" as the name for a short-lived magazine, as well as an essay that discussed her experiences as a fat woman. The "unruly" body exists in contrast to the "docile" body that Michel Foucault describes as one "that may be subjected, used, transformed and improved." Foucault, *Discipline and Punish: The Birth of the Prison* (Paris: Gallimard, 1975), 136.

23 Susan Stryker, "My Words to Victor Frankenstein above the Village of Chamounix," *GLQ* 1, no. 3 (1994): 237–54. Stryker begins her piece on Frankenstein's monster and the trans body by acknowledging that a

number of feminist critics have already associated Shelley's *Frankenstein* with transness in a pejorative sense. The "transsexual" is the Other of their particular brand of feminist criticism. Stryker writes: "Might I suggest that Daly, Raymond and others of their ilk similarly construct the transsexual as their own particular golem?" (238).

24 Michele Kirichanskaya, "Could the Golem Be the Ultimate Queer Symbol?," *Hey Alma*, June 21, 2021, www.heyalma.com/could-the-golem-be-the-ultimate-jewish-queer-symbol.

25 Melissa Broder, *Milk Fed* (New York: Scribner, 2021), 8. Further page citations from this novel appear parenthetically in the text.

26 The title of the novel is also perhaps an allusion to one of the most famous works of Holocaust literature, Paul Celan's "Death Fugue." Given that Broder began her career as a poet, it is difficult not to see an invocation of "Death Fugue" in her title and the ambivalent maternal figures at its heart. One of Celan's many poems to explore the Holocaust and its aftermath, "Death Fugue" begins with the lines: "Black milk of morning we drink you evenings." Celan, "Death Fugue," trans. Pierre Joris, Poets.org, accessed May 15, 2023, poets.org/poem/death-fugue.

27 Broder often critiques the nostalgia that Miriam engenders in Rachel, even as she celebrates its contrast to Rachel's mother's secular iciness.

28 Here there are notable similarities to Broder's first novel, *The Pisces* (New York: Hogarth, 2018), which also explores desire, objectification, and the limits of the human when her protagonist falls in love with a mer-man.

29 The contrast between Rachel and Miriam is also, seemingly, a reference to Mary Gaitskill's dark fairy tale, *Two Girls, Fat and Thin* (New York: Penguin, 1991).

30 Susan Wendell, "The Social Construction of Disability," *The Rejected Body: Feminist Philosophical Reflections on Disability* (New York: Routledge, 1996).

31 April Herndon, "Disparate but Disabled: Fat Embodiment and Disability Studies," *NWSA Journal* 14, no. 3 (Fall 2002): 123. Not all fat studies scholars feel the same about the equation of fatness with disability. Anna Kirkland points out some of the complications of the analogy between fatness and disability for fat politics in her look at fatness as what she calls a "managed" category of identity in "What's at Stake in Fatness as a Disability?," *Disability Studies Quarterly* 26, no. 1 (Winter 2006). https://doi.org/10.18061/dsq.v26i1.648.

32 Michelle Y. Gordon, "'Midnight Scenes and Orgies': Public Narratives of Voodoo in New Orleans and Nineteenth-Century Discourses of White Supremacy," *American Quarterly* 64, no. 4 (December 2012): 767–86.

33 Broder, 117.

34 Broder is certainly not the first Jewish American woman writer to engage with (and, perhaps, subvert) Roth's sex writing. Erica Jong's *Fear of Flying* (New York: Hold, Rinehart & Winston, 1973) is in clear conversation with *Portnoy's Complaint* (1969), among other canonical Jewish texts of the period. However, Broder's novel innovates in its embrace of queer sexuality and its insistence on Jewish women as both subject and object of desire.

35 J. A. Tyler, "Hybrid Interview with Melissa Broder," *Craft Literary*, May 11, 2021, www.craftliterary.com/2021/05/11/hybrid-interview-melissa-broder/.

36 Other Jewish American novels written in tribute to earlier Jewish iconic figures include Jonathan Safran Foer's experimental *Tree of Codes* (London: Visual Editions, 2010); and Jay Cantor's *Great Neck: A Novel* (New York: Vintage Books, 2003).

37 Marge Piercy, *He, She and It* (New York: Knopf, 1991).

38 Barzilai, *Golem*, 213.

39 Philip Roth, *Operation Shylock* (New York: Simon & Schuster, 1993).

40 At one point, Rachel says, "I'd carve her in stone, if I could really sculpt. I'd make all kinds of Miriam idols and worship each one of them" (266).

41 Riva Lehrer, *Golem Girl* (New York: Virago, 2020). Page citations from this memoir appear parenthetically in the text.

42 Lehrer capitalizes "golem" throughout *Golem Girl* as if to emphasize his overlap with monsters such as Frankenstein's.

43 The subsequent two chapters also feature "Carole's Story" headings.

44 In "The Mountain," a chapter in *Exile and Pride* (Durham: Duke University Press, 1999), the disability studies scholar and activist Eli Clare notes that the space of the institution haunts most people with disabilities and encourages them to feel that they must become "supercrips" (disabled people who can do extraordinary things, like climb mountains or run in marathons) in order to remain outside the institution or nursing home.

45 Not incidentally, in *At 54*, one of her many self-portraits, Lehrer depicts herself as both puppet and puppeteer, pulling elongated strings that attach to various places on her body and clothing.

46 Lehrer, 14. For more on the history of this discourse, see Rachel Adams's work on "maternal impressions" in *Sideshow U.S.A.: Freaks and the American Cultural Imagination* (Chicago: University of Chicago Press, 2001).

47 Throughout *Golem Girl*, Carole is portrayed as a frustrated creative, constrained by the expectations of womanhood in the 1950s.

48 Peter Singer, *Practical Ethics* (Cambridge University Press, 1979).

49 Robert McRuer and Anna Mollow, introduction to *Sex and Disability*, ed. Robert McRuer and Anna Mollow (Durham, NC: Duke University Press, 2012), 28.

50 Exploring the pitfalls and possibilities of disease as metaphor is central to Susan Sontag's work, for instance.
51 Stephen Crane, *The Monster and Other Stories* (New York: Harper, 1898). Susan Schweik makes the monster central to one of the chapters in her remarkable book on "ugly laws" in American culture, literary and otherwise. Schweik, *Ugly Laws*.
52 Eula Biss, *On Immunity* (Minneapolis: Graywolf Press, 2014).
53 See, for example, Steven Gavazzi, "Zombie Phrase 'Don't Waste a Crisis' Doesn't Work with Covid-19," *Forbes*, May 5, 2020. Daniel V. Drezner, "What I Learned about the Coronavirus World from Watching Zombie Flicks," *Foreign Policy*, April 11, 2020; and Jonathan Charteris-Black, *Metaphors of Coronavirus: Invisible Enemy or Zombie Apocalypse?* (New York: Palgrave Macmillan, 2021).
54 Eli Clare, "Freaks and Queers," in *Exile and Pride*.
55 Ellen Samuels, "Six Ways of Looking at Crip Time," *Disability Studies Quarterly* 37, no. 3 (Summer 2017), https://doi.org/10.18061/dsq.v37i3.
56 David Mitchell and Sharon Snyder, *Narrative Prosthesis* (Ann Arbor: University of Michigan Press, 2001).
57 As Barzilai points out in *Golem*, "Though it exhibits extraordinary strength, its lack of intelligence and inability to speak mark the golem as inferior to the human being. From here, the Yiddish term *goylem* figuratively came to denote an idiot, fool, or clumsy fellow" (3).

Bibliography

Adams, Rachel. *Sideshow U.S.A.: Freaks and the American Cultural Imagination*. Chicago: University of Chicago Press, 2001.
Augustine, Myriad. "The Bellwood Golem." In *Nothing Without Us*, edited by Cait Gordon and Talia Johnson, 9–19. New York: Renaissance, 2019.
Barton, Emily. *The Book of Esther*. New York: Random House, 2016.
Barzilai, Maya. *Golem: Modern Wars and Their Monsters*. New York: New York University Press, 2016.
Baynton, Douglas. *Defectives in the Land: Disability and Immigration in the Age of Eugenics*. Chicago: University of Chicago Press, 2016.
Biss, Eula. *On Immunity*. Minneapolis: Graywolf Press, 2014.
Broder, Melissa. *Milk Fed*. New York: Scribner, 2021.
———. *The Pisces: A Novel*. New York: Hogarth, 2018.

Cantor, Jay. *Great Neck: A Novel*. New York: Vintage Books, 2003.
Celan, Paul. "Death Fugue." Trans. Pierre Joris. Poets.org. Accessed May 15, 2023. poets.org/poem/death-fugue.
Chabon, Michael. *The Amazing Adventures of Kavalier and Clay*. New York: Random House, 2000.
Charteris-Black, Jonathan. *Metaphors of Coronavirus: Invisible Enemy or Zombie Apocalypse?* New York: Palgrave Macmillan, 2021.
Clare, Eli. *Exile and Pride: Disability, Queerness, and Liberation*. Durham, NC: Duke University Press, 1999.
Crane, Stephen. *The Monster and Other Stories*. New York: Harper, 1898.
Drezner, Daniel V. "What I Learned about the Coronavirus World from Watching Zombie Flicks," *Foreign Policy*, April 11, 2020.
Foer, Jonathan Safran. *Tree of Codes*. London: Visual Editions, 2010.
Foucault, Michel. *Discipline and Punish: The Birth of the Prison*. Paris: Gallimard, 1975.
Gaitskill, Mary. *Two Girls, Fat and Thin*. New York: Penguin, 1991.
Gavazzi, Steven. "Zombie Phrase 'Don't Waste a Crisis' Doesn't Work with Covid-19," *Forbes*, May 5, 2020.
Gelbin, Cathy. *The Golem Returns: From German Romantic Literature to Global Jewish Culture, 1808–2008*. Ann Arbor: University of Michigan Press, 2010.
Gilman, Sander. *The Jew's Body*. New York: Routledge, 1991.
Gordon, Michelle Y. "'Midnight Scenes and Orgies': Public Narratives of Voodoo in New Orleans and Nineteenth-Century Discourses of White Supremacy." *American Quarterly* 64, no. 4 (December 2012): 767–86.
Herndon, April. "Disparate but Disabled: Fat Embodiment and Disability Studies." *NWSA Journal* 14, no. 3 (Fall 2002): 120–37.
Hoffman, Alice. *The World That We Knew*. London: Scribner UK, 2019.
Imhoff, Sarah. *The Lives of Jesse Sampter: Queer, Disabled, Zionist*. Durham, NC: Duke University Press, 2022.
———. *Masculinity and the Making of American Judaism*. Bloomington: Indian University Press, 2017.
———. "Why Disability Studies Needs to Take Religion Seriously." *Religions* 8, no. 9 (September 2017). https://doi.org/10.3390/rel8090186.
Jong, Erica. *Fear of Flying*. New York: Holt, Rinehart & Winston, 1973.
Kirichanskaya, Michele. "Could the Golem Be the Ultimate Queer Symbol?" *Hey Alma*, June 21, 2021. www.heyalma.com/could-the-golem-be-the-ultimate-jewish-queer-symbol.

Kirkland, Anna. "What's at Stake in Fatness as a Disability?," *Disability Studies Quarterly* 26, no. 1 (Winter 2006). https://doi.org/10.18061/dsq.v26i1.648.

Lehrer, Riva. *Golem Girl*. New York: Virago, 2020.

McRuer, Robert, and Anna Mollow, eds. *Sex and Disability*. Durham: Duke University Press, 2021.

Meir, Natan. *Stepchildren of the Shtetl: The Destitute, Disabled, and Mad of Jewish Eastern Europe, 1800–1939*. Palo Alto, CA: Stanford University Press, 2020.

Mintz, Susannah. *Unruly Bodies: Life Writing by Women with Disabilities*. Chapel Hill: University of North Carolina Press, 2007.

Mitchell, David, and Sharon Snyder. "The Eugenic Atlantic: Race, Disability, and the Making of an International Eugenic Science, 1800–1945." *Disability & Society* 18, no. 7 (2003): 843–64. https://doi.org/10.1080/0968759032000127281.

———. *Narrative Prosthesis*. Ann Arbor: University of Michigan Press, 2001.

Ozick, Cynthia. *The Messiah of Stockholm*. New York: Vintage Books, 1987.

———. *The Puttermesser Papers*. New York: Atlantic, 1997.

Parrish, Timothy. "Creation's Covenant: The Art of Cynthia Ozick." *Texas Studies in Literature and Language* 43, no. 4 (Winter 2001): 440–64.

Piercy, Marge. *He, She and It*. New York: Knopf, 1991.

Roth, Philip. *The Ghost Writer*. New York: Farrar, Straus & Giroux, 1979.

———. *Operation Shylock*. New York: Simon & Schuster, 1993.

———. *Portnoy's Complaint*. New York: Random House, 1969.

Samuels, Ellen. "Six Ways of Looking at Crip Time." *Disability Studies Quarterly* 37, no. 3 (Summer 2017). https://doi.org/10.18061/dsq.v37i3.

Schwadron, Hannah. "Redressing Power through Hasidic Drag: Julie Weitz in *My Golem as the Great Dominatrix*." *Shofar* 39, no. 3 (Winter 2021): 181–209. https://doi.org/10.1353/sho.2021.0032.

Schweik, Susan. *The Ugly Laws*. New York: New York University Press, 2009.

Singer, Peter. *Practical Ethics*. Cambridge: Cambridge University Press, 1979.

Sontag, Susan. *AIDS and Its Metaphors*. New York: Farrar, Straus & Giroux, 1989.

———. *Illness as Metaphor*. New York: Farrar, Straus & Giroux, 1978.

Stanislawski, Michael. *Zionism and the Fin de Siècle: Cosmopolitanism and Nationalism from Nordau to Jabotinsky*. Berkeley: University of California Press, 2001.

Stryker, Susan. "My Words to Victor Frankenstein above the Village of Chamounix: Performing Transgender Rage." *GLQ* 1, no. 3 (1994): 237–54.

Summers, Danielle. *Kissing the Golem*. New York: Tulabella Ruby Press, 2015.
Tyler, J. A. "Hybrid Interview with Melissa Broder." *Craft Literary*, May 11, 2021. www.craftliterary.com/2021/05/11/hybrid-interview-melissa-broder/.
Wecker, Helene. *The Golem and the Jinni*. New York: Harper, 2013.
———. *The Hidden Palace*. New York, Harper, 2021.
Wendell, Susan. "The Social Construction of Disability." *The Rejected Body: Feminist Philosophical Reflections on Disability*. New York: Routledge, 1996.
Weitz, Julie. *My Golem*. 2017–22. Accessed August 16, 2023. www.julieweitz.com/artwork#/mygolemartworks/.

9

INTERCONNECTED LOSSES

Grief Made Visible in Roz Chast's
Can't We Talk about Something More Pleasant?

Tahneer Oksman

Halfway through cartoonist Roz Chast's best-selling 2014 visual memoir, *Can't We Talk about Something More Pleasant?*, she presents a simple, three-paneled comic titled "Here's what I used to think happened at 'the end'" (148).[1] The first box pictures a frail woman comfortably nestled in bed, her arms outstretched over the bedspread. "One day, old Mrs. McGillicuddy felt unwell, and she took to her bed," the top of the image reads. The second panel zeroes in on the figure as her head tilts to the side, her tongue hangs aloof, and her now-gnarled hands wildly grope at the covers around her. "She stayed there for, oh, about three or four weeks, growing weaker day by day." Even in this transformed, deteriorated state, Mrs. McGillicuddy seems strangely composed, as though her decline, captured in this frozen still, were nothing more than a fleeting moment of discomfort. Finally, we see a gravestone settled in a patch of grass in the third and closing panel ("R.I.P. OLD MRS. McGILLICUDDY"). Overhead, a narrative encompassing a broader time frame than that of the scene itself nonetheless boils that final part of the story into a short, spare account: "One night, she developed something called a 'death rattle,' and soon after that, she died. The end."

This mordant, darkly amusing template contradicts everything Chast strives to relay in her 228-plus page memoir.[2] Her work refutes this simplifying mythology by recasting, and expanding, the storyline contained within and between these simple panels. Dedicated to her parents, George

and Elizabeth, both born in 1912 and having graduated college into the Depression, the book recounts Chast's active involvement in their end of lives, opening, after a brief introduction, with a chapter titled "The Beginning of the End" and closing with "The End." Indeed, the book is structured around and primarily engaged with the caretaking role provided by Chast, an only child who left home for college at age sixteen and returned thirty-plus years later, however grudgingly, to the nuclear family fold.[3] As the narrative text sprawled beneath that three-paneled comic about Mrs. McGillicuddy explains, "What I was starting to understand was that the middle panel was a lot more painful, humiliating, long-lasting, complicated, and hideously expensive. My parents had been in pretty good health for their age—they did not have heart disease, diabetes, or cancer—but the reality was that at 95, their minds and bodies were falling apart" (148).

Here and at various points throughout, Chast presents her memoir as a candid counternarrative to mainstream versions of the (North American) end-of-life story.[4] Over the course of the book, she endeavors to put down on the page all of the usually unspoken—and unseen—aspects of the final stages of life, from the perspective of a caregiver working, for the most part, alone. The obstacles she depicts include everything from the many costs of care to the endless choices to be made by her and her parents. As communication among the three is often strained, and as her parents find their mental faculties impaired, figuring out what they want and need becomes increasingly difficult. Chast also seeks to demythologize the mental and physical breakdowns of bodies in deep crisis, from failing organ functions to the forfeiture of mental acuity, or what her mother at one point movingly describes as the feeling that "my brains are melting" (172). The work of caretaking becomes entwined with, and profoundly shaped by, the work of bearing witness and of grieving.

The book tells the story of these events of caregiving in the past through the bereaved daughter's point of view, as she looks back after her parents' deaths. Chast's narration often turns to meditations on her relationships with her parents over time, particularly her more complicated, ambivalent interactions with her often-domineering mother. An unusual textual hybrid, the work incorporates photographs, illustrations, handwritten prose, cartoons, and comics of various lengths—everything from snapshots preceding and threading through her childhood to the final years and even moments of her parents' lives, and beyond.[5] The tone of

the book regularly fluctuates, too, and ranges across a spectrum—from earnestness to lightheartedness, cynical humor to the unilaterally somber, especially toward the conclusion. The associative, variegated, and uneven texture of the storyline includes regular interruptions, asides, and anecdotes out of sync with the chronological framework proposed in the table of contents; much of the richness of the book derives from moments not obviously connected with the goal of conveying a sustained and cohesive caregiving experience.[6] The original memoir, in fact, ends with an emphasis on Chast's dreams about her parents after their deaths and her sense that she has yet to "completely give up this desire to make it right with my mother," an inclination more directly connected to grieving than to caregiving (227).

In this chapter, I read *Can't We Talk about Something More Pleasant?* for what it reveals about experiences of grief and mourning. This approach goes somewhat against the grain of most critical work published so far on Chast's book, which interprets the text as chiefly about a caregiving experience, hence aimed for other current or future caregivers or care receivers.[7] Though the memoir does not explicitly call attention to itself as a text with grief at the focus, foregrounding this aspect of the book has much to teach us about what I have come to think of as grief's interconnective nature. That is, reading *Can't We Talk about Something More Pleasant?* as a "grief memoir"—or a memoir in which "grieving is *the* defining reality—the heart of the text"—exposes, in complicated but revealing ways, how every individual experience of loss, in this case the loss of beloved family members (parents), is chained to other experiences of loss, both individual and communal.[8] This interconnective component of grief is a characteristic often underemphasized in professional discussions of grief, as well as in conversations about literary, artistic, and cultural representations of grief. The latter especially tend to focus either on individual or communal experiences of loss and grief, but not as often on the relationship between different experiences, how they build on and shape one another.[9]

Reading Chast's work through the lens of grief also, and correspondingly, exposes the Jewish themes underlying the narrative—another critically underemphasized feature of Chast's book and of her oeuvre more generally. Jewishness emerges as a site from which to trace and recognize the interconnected nature of grief and grieving, even as its irregular appearance marks this relational interconnectedness as a source of

fluctuation and hesitancy. By reading for grief, we can uncover some of the less explicit, yet still evocative, characteristics of Chast's formally and thematically unconventional text. This approach does not take away from rightful recognitions of Chast's work as an important contribution to caregiving narratives. Instead, such a tactic reinforces a more expansive understanding of grief as an experience that is quite often interlinked with memories of caregiving as well as other events both directly and indirectly tied to the individual or individuals being closely mourned. In this way, autobiographical representations of grief like Chast's memoir help show how grief might best be understood as a process of assembly, "a response to the fracturing that occurs in especially forceful ways following the loss of a person with whom one has been sharing a life" or, as in Chast's case, with whom one has shared a most formative time in her life.[10] Finally, this chapter focuses on Chast's text as an exceptionally generative case study offering a model of how reading for grief can yield unanticipated networks and linkages. Grief chains become more clearly visible through the compound formats and registers offered in Chast's hybrid text, as readers are given various simultaneous tracks to trace, compare, and contrast.

Haunting Silences, Crushing Disclosures

Chast's book is framed around the slow illnesses and eventual deaths of her late-age parents. From its outset the memoir establishes the ways in which the loss of an individual loved one impacts, and is impacted by, a network of losses within, and inevitably also outside of, the family circle.[11] In the six-page introduction that opens the book (a prelude to "The Beginning of the End"), in the earliest instance of Chast's first-person narrative voice bordering the ensuing image/text, the narrator announces, "It was against my parents' principles to talk about death" (4). As we learn from the get-go, the family story passed on to a young Chast—a story, as readers soon learn, deeply informed by such refusals and withholdings and now revisited by the daughter in her grief—is the impetus for this book. It is the foundation on which the now grown-up Chast will present her own revision or "critique."[12] As autobiography scholar Nancy K. Miller writes in *Bequest and Betrayal: Memoirs of a Parent's Death*, "A parent's history is a life narrative against which the memoirist ceaselessly shapes and reshapes

the past and tries to live in the present."[13] Chast's text can consequently be understood not only as a counterstory to a suppressed, communal cultural narrative—a straightforward look at what it means to be, in our narrator's words, "moving into the part of old age that was scarier, harder to talk about, and not part of this culture" (20)—but must also be recognized as a counternarrative to her family story, the one most forcefully transmitted to her by her mother.

In contrast to their many silences, Chast's parents were willing to divulge the ghastly details of some of the troubles they, their Russian immigrant parents, and their "Old World" grandparents had been through. In a twelve-panel comic, Chast documents what was passed on to her of her family history, with an emphasis on the traumas often vividly, and orally, delivered (6). Compressed into a single page, these disclosures, in conjunction with her parents' earlier withholdings, are framed as having been made to compensate for other silences. Thus, as she explains on this page, while she may have heard plenty while growing up about "the Depression, World War II, and the Holocaust, in which they'd both lost family," other subjects remained off limits. This comic is particularly noteworthy for how crammed it looks, with each text-heavy box retelling its own compressed traumatic event. If, just two pages ago, we learned about Chast's parents' unwillingness to discuss death, here is evidence directly to the contrary—almost excessively so. Three panels of the comic, unevenly placed throughout, are packed only with words set against bright watercolor-filled backgrounds, with no illustrated accompaniment at all, as though to emphasize the staggering effect of these stories. In contrast with the equally crushing silences that emerge in other contexts, the paratactic construction of this narrative text, punctuated with semicolons, colons, dashes, and ellipses, gives an overall sense of the overwhelming amount of information transferred from parents to daughter.

This page conveys not just general, brutal facts about the obstacles Chast's grandparents and great-grandparents faced, like the cholera pandemic or poverty. There are also gruesome, unexpected details and colorful particulars sprinkled throughout. So, for example, in one panel Chast relates the story of how her paternal grandmother's father's "throat got cut 'from ear to ear' in a forest by 'bandits.'" Note the quotation marks within the already relayed narrative, reminding readers of the indelible nature of some of the more evocative phrases and words, recalled verbatim. The

image included within the panel box below this narrative text depicts a man, his eyes wide open, surrounded by two caricatures of bandits. Each one sports a striped shirt, a short dark cap, and a five o'clock shadow. Most prominently, bright strokes of blood suspended in air surround the dying man—more marks than seem warranted to portray the basic order of events. The visual embellishments become Chast's way of matching, in pictures, her parents'—most likely just her mother's—turns of phrase. It's a kind of collaboration between mother and daughter, an assembly in which Chast both complements and critiques her mother's oral/verbal register with her own trademark visual/textual accompaniments. Her counter-narrative is as much tribute as commentary on what has been passed on to her, and how.

Chast's illustrations graphically elaborate on what cannot, in a sense, be exaggerated, since these horrible events are so difficult to imagine in the first place when they have not been experienced firsthand. The silences surrounding these piercing narrative tidbits alongside the mother's hyperbolic turns of phrase convey the difficult reality of these histories in a way that feels surreal, far from a knowable, or known, reality. The effect is also partly comedic—a kind of inverted *dayenu*-inflected litany of horrors, opening with an older generation's familiar invocation: "You don't know how good you have it!" / "You don't know what trouble is!"[14] There is, too, finally, a set of overarching unposed questions that haunts the entire text, just as it haunts every grief experience, which has to do with meaning-making and finding reasons why: Why antisemitism, why poverty, why illness? Also, why death at all?

Chast emphasizes that these stories had been passed on to her since she was a little girl. She does this not only verbally ("I had heard the stories my whole life," the second panel begins) but also through the inclusion of a lavishly cartoonish depiction of herself as a young girl on the second to last line of panels. In the image, she has chin-length blonde hair and wears glasses. We recognize from these telltale markers that this is the protagonist pictured on the cover of the book, though here a small bow in her hair and the purple suspenders she is wearing signal her young age. In the illustration, young Roz's eyes and mouth are set wide open in surprise and shock. Above, we are given more details of her family story, in this case her paternal grandmother's cesarean section, with her mother's exact words set off in quotation marks: "a horrible ordeal which involved, according to

my mother, 'opening her up from her neck to her you-know-what.'" The daughter is clearly being given information that she is not ready for, that she does not yet know how to absorb. Even more striking is how the young Roz's expression in this panel almost identically matches her expression just three pages earlier, in a very different and later-in-life context, when she faces her parents' refusals to speak about their end-of-life wishes (3). Both excessive telling and active withholding of information seem to have the same disturbing effect on the protagonist, whatever her age: shock, paralysis, and disbelief.

The book's comedic title comes directly from a conversation depicted in an earlier eight-panel comic. An adult Roz faces her parents on an old couch, a recurrent visual trope that winds through the book, including on its cover, and signals isolation and solitude as a central aspect of the unfolding domestic drama.[15] Now, as well as at various points in the text, she joins her parents on that couch, and in this opening recollection she demands they speak to her about "THINGS." As she tells them, "I have no idea what you guys want!" In this fourth panel, in response to their silent shrugs, her persona buzzes with angst and anxiety.[16] In contrast, her parents sit across from her, appearing clueless and benumbed, arms identically folded across their chests. Crucially, this comic is placed directly across the page from a reproduction of an idyllic black-and-white photograph of the small nuclear family of three, taken from the time when Chast was still a young child.[17] The three of them look uncharacteristically carefree and content in the photograph, each smiling, the daughter leaning into her mother. Her parents' refusals to address, or even acknowledge, their own declines as they age are the clear driving forces behind this conversation and the ensuing composition of the text as a whole. Challenging the dominant family story—frozen in the frame of this family photograph—thus means putting forth competing versions, in Chast's own hand and voice.[18] It means conveying everything that had been passed along, for better and for worse, and finding ways to represent all that had been withheld or distorted.

In Search of Due Cause

In addition to refusing discussions of their own impending deaths, her parents also declined to address other topics closer to home. Chast isolates her disclosure of these additional familial taboos to two facing pages, thereby linking them (4–5). First, her parents refused to discuss religion, and particularly their Jewish identities ("I'm Jewish. Daddy is Jewish. You're Jewish. End of story," her mother's alter ego declares in an opening panel); second, they would not discuss the particulars of an incident that had become a crucial aspect of what Chast describes as "family lore" (4, 5). That is, they would not talk about the death of a one-day-old baby girl who would have been Chast's older sister (5). This loss happened almost fifteen years before Chast herself was born. Chast tells this story over the course of a single page covered mostly in handwritten prose, with the detail at the bottom of the page of a drawn tiny baby enfolded in an amniotic shape, which is colored in a light blue. Her parents were unwilling, as she tells it, to offer up many details about what her mother referred to, tellingly, as "that mess." Chast mentions, however, that her aunt had once told her the baby was buried somewhere. At the time of composing the memoir, Chast does not know where.

The details that her parents *are* willing to offer up about this early tragedy mainly focus on depicting the scene around which the event unfolded. As the story had been told to Roz, her mother was six and a half months pregnant in 1940 when she got up on a step stool to change a lightbulb; her father, ever the anxious bystander, was too fearful to do it himself. One month later, Chast's mother delivered a baby girl who died the day after she was born. Despite the gravity of the events conveyed, otherwise innocuous interactions with everyday objects—the lightbulb, the step stool—play a central role in how her parents relay this sequence of events. In Chast's retelling of it, though, she insists on the medical cause of "placenta previa" as the likelier driving force behind her sister's death. As she writes just above the drawing of the baby, "It had nothing to do with reaching for a lightbulb, even though whenever I heard the story of my almost-sister, 'reaching' definitely took some of the blame. I heard this story frequently."

Chast coalesces the brief account repeatedly told to her into a single narrative in which all the unresolved questions become tangled up

with her own, and her aunt's, retroactive clarifications. The rejection of her parents' version of the story hinges on a detail about a single object, that "lightbulb," a word repeated three times in this brief retelling. As in her parents' recounting, objects become undeniably central throughout Chast's narrative—just recall that early mention of "THINGS." They are depicted as both literal causes and emblematic representations of the many struggles and exertions that Chast as caregiver and griever witnesses and endures, of the many matters piling up in her parents' apartment over the forty years that they lived in it, which she will have to take care of once they depart. Indeed, as the saga of aging and caretaking that ends in death very often begins at home, or in the midst of some kind of household space, it is no surprise how often domestic spaces and everyday objects play a role in many such texts about aging, death, and grief.[19] In Chast's memoir, we witness the governing role that objects play not only in caretaking and later grieving but also as part of "family lore," the mythology that Chast at times borrows from and at other times resists. It is a mythology that lends to objects an almost animistic, often capriciously animate status. In the case of her parents' version of this story of her sister's death, objects offer a causal link to help explain a past traumatic event: the lightbulb went out so her mother got a step stool and reached to change it; next, the baby died. Telling the story in this way also means the baby's death was prompted by a decision the mother made. By this logic, the death was preventable.

This spotlighted fallacious sense of causality (*post hoc, ergo propter hoc*) opens a memoir that concludes with the recognition of unresolved conflict between mother and daughter, even after the mother's death. Given the prominence of the lightbulb story in the memoir's introduction, the opening narrative is an important backdrop to understanding the difficult relationship Chast describes as having had with her mother. Throughout, the narrator depicts her mother as a domineering personality, prone to inexplicable, sudden outbursts. The story of her mother's primal loss, together with the stories of her ancestral traumas, posits a cause—however tenuously drawn and deficiently developed—for what the narrator finds otherwise frustrating and inexplicable. Indeed, in a *New York Times* article about the book, reviewer Alex Witchel subscribes to the idea that this narrative is key to the story that follows. Writing of the baby's death, she explains, "Self-recrimination and grief visited Elizabeth for the rest of her life, as they did her husband and daughter. There's

a certain place in hell-on-earth for children who follow a deceased sibling: Chast was the blank slate for her father's crippling fears and for her mother's rage."[20] Yet there is no direct evidence corroborating these connections to be found in the remainder of the book, especially since Chast's sister is not mentioned thereafter. Upon closer inspection, then, this causal reading of Chast's sister's death as the root cause of the Chast family dynamic highlights the faulty logic in both readings—the one in which the death of the baby sister is at the center of Chast's relationship with her mother and Chast's mother's own "reaching" story. The two seem like counterparts to one another. We might also add that Chast's father's anxieties are already apparent, at the beginning of this very story, in his inexplicable fear of changing a lightbulb, a detail that further highlights this faulty causality.

This early story is told within the context of other, earlier family tragedies, from pogroms to poverty, which are not explained away and which are therefore difficult to label as foreseeable, or as following a readily comprehensible sequence of causality (why antisemitism? why poverty?). Because of its proximity to the other inexplicable family history, the reaching story is easier to recognize as part of a larger pattern of illogical reasoning, often tied to everyday objects, that Chast is often both taken in by and writing/drawing against. Her parents regularly search for concrete explanations and a semblance of control in the domestic and local environments which they and their daughter inhabit. In this way, some unhappy situations, often choices made around the use, or misuse, of particular objects, are told as though preventable. It's an illogical blueprint that Chast continually subscribes to even as she often resists it—the question of *why* the bad, tragic things happen. So, for example, throughout the book she highlights, often to comedic effect, the ways in which, even as her parents were insistently silent on certain particulars—the particulars of their own impending deaths or of their own brushes with death—they concurrently seemed to be almost always worrying about and referencing death.[21] On one page, for instance, she depicts "The Wheel of Doom, surrounded by 'cautionary' tales of my childhood." It's a full-page cartoon in which a wheel—modeled after *Wheel of Fortune*—is surrounded by a cadre of scenarios that might lead to various terrible consequences: "death" "deafness" "death" "blindness, then death" and "death" (29). The anecdotes, often featuring someone close but not too close ("friend's husband," "friend's son," "friend"), litter

the frame around the circle. They include: "Friend who traveled too much: jaundice"; "Guy who almost died after playing oboe"; "A headache, then dead"; "A rash, then dead."

Here, then, is a formula passed on to Chast by her parents: objects as agents and related individual decisions on the use or misuse of those objects as the sole drivers of individual destinies. Chast attempts to counteract this formula in many ways, as when she pokes fun at this flawed reasoning, turning her parents' anxieties into the butt of jokes, and/or adds her own annotations to her parents' narratives. At the same time, Chast incorporates animate objects into her own storylines, much as her parents do. In scenes preceding bad news about to be received, vibrant drawings of a ringing telephone ("R-R-RING!!!") nearly jump off the page.[22] The aforementioned couch comes to stand in for the domestic dramas that Chast sometimes chooses to hide from, and sometimes gets trapped in, as if the couch were a desert island on which she is marooned.[23] Indeed, one might note the attention and care that Chast's comics oeuvre as a whole gives to objects as symbols and proxies of gloom and doom but also curiosity and joy.[24]

Chast's counternarrative thus in a way often subscribes to her mother's specious outlook, even to the detriment of her own project's goals: transparency, directness, a desire to tell things as they are and to avoid—or simply expose—her parents' faulty logic. We might think of these moments of replication and accordance with her parents' ways of seeing the world as flashes of her own "magical thinking," a term made famous, in its relation to grief, by Joan Didion's 2005 memoir about the sudden death of her husband, *The Year of Magical Thinking*. Speaking of her mindset immediately following his death, Didion writes of how, even as the news spread, "I was myself in no way prepared to accept this news as final: there was a level on which I believed that what had happened remained reversible."[25] Following the loss of her parents, in expressing her experiences of grieving Chast at times borrows their false logic, itself a remnant from their own close encounters with grief and loss as well as a familial history of traumatic events. Most compellingly, the detail of the step stool, the one her mother climbed onto and reached from—the ostensible catalyst for the sister's death—comes up at another crucial, perhaps *the* crucial, turning point in the memoir.

336 Tahneer Oksman

"YOU ARE HERE / SUCK IT UP"

In early chapters of the book, Chast describes her parents' advancement into their nineties, recalling how guilty she felt that she rarely visited them in the previous decade, after she'd moved from Manhattan to Connecticut to raise her young children (11–12). Though she begins to visit them more often in 2001 and notes the increasingly unkempt nature of an apartment her mother had once kept spotless, only after her mother takes a bad fall does the daughter's version of their end-of-life story take off. After "the fall," as Chast titles chapter 5, the narrator's life becomes, once more, inextricably tied to her parents, as she comes to recognize that they have lost the ability to live independently (51). The chapter includes the reproduction of a typed thirty-two-line lyric poem written by Chast's mother, who recalls what has just happened as she recovers in bed (53). In sum, she had been retrieving an item from what Chast describes earlier as her parents' "crazy closet," a space filled with a motley of outdated, "decrepit" items (45). The *thing* her mother had gone to retrieve was a certificate recalled in a recent phone conversation with her daughter. So it was that another climb on a ladder, this one prompted by something Roz herself said, led to another devastating outcome.

In this post facto collaboration with her mother, Chast frames the poem in her trademarked curvy line colored over with watercolor. She annotates her mother's poem with illustrations, enclosed beside those typed words within the space of the large frame. Drawings of a ladder—depicted, in fact, with only three short steps to the top, like a step stool—stand out. The ladder is pictured twice in Chast's illustration, as though for emphasis. It is the inanimate object that will now propel Chast into *her* grief as she confronts the eventual loss of her parents. In a kind of role reversal—in this case, an event portrayed via a logical fallacy echoing her mother's—Chast narrates herself as the catalyst of her mother's fall instead of the mother's reaching killing the baby daughter.[26] In this case, too, as Chast pictures it, her father stands idly—and very anxiously—beside the climbing mother. Chast has visualized the story of the step stool and the dead sister that her parents had, however sketchily, passed along to her. Crucially, Chast does not illustrate her parents, or the climb, in that one-page earlier recounting of the story, a formal detail that even more powerfully links that moment to this one, as though it is only here that the original account reaches its

full expression. The daughter's grief is thus inextricably chained to, and shaped by, her parents' earlier, underexpressed grief. She has established due cause for her parents' declines even as we know, even as she knows, that their late-life deaths were unavoidable, that death itself is unavoidable.

It is not only Chast's parents who potentially grieve this lost sister. Having a sister, particularly in this time of her life, would have altered Chast's experience in relation to this narrative of caring for her aging parents.[27] At the very least, she would not have been trapped, alone, facing her parents on the couch. "YOU ARE HERE / SUCK IT UP," reads a rectangular panel hanging over a drawing of Chast lodged between her parents on a couch even before her mother's second crucial fall (36). The three of them sit with their hands on their laps, morosely staring into space. "I didn't see a way out," Chast narrates above the image. Her sister, of course, would have been, at least potentially, a way beyond the confines of this narrow framework. Even though the story of her sister's death is never again directly referenced in the pages of the book as it was originally published, her absence haunts the text, informing the many scenes in which Chast finds herself increasingly alienated and all alone in her position of caring for her late-life parents.

As Chast makes clear in the first chapter, which turns back to set the stage of her childhood, the two characteristics that most clearly informed her early life included the fact of her being an only child and her parents being "a lot older than other kids' parents" (10). Though Chast does not directly reference Jewishness here, in interviews she has spoken of her Jewish identity as similarly contributing to a sense of being an outsider in childhood and beyond. In a 2006 interview with Arthur J. Magida, at a time when Chast was still living the story of the book, she spoke at length about her complicated relationship to Jewishness.[28] Her parents had briefly sent her to a Bible class, and they belonged to a synagogue for a short time. But Chast mainly recalled her parents' hesitation about religion: "It was a combination of lack of interest and lack of commitment to give me any kind of Jewish education. I don't think they liked anything about religion."[29] She had gone to a public school in Brooklyn that was predominantly Jewish, though, and so her lack of engagement in Jewish activities—like Hebrew school—largely contributed to her sense of feeling like an outsider Jew in addition to her blonde hair and not obviously Jewish-sounding name (115). As Chast summarizes, "I had a very isolated

childhood in many, many, *many* ways"—and that isolation stemmed from a variety of factors that all seemed to converge in her indeterminate relationship to her Jewish identity (emphasis hers). Indeed, in an interview for the Jewish Book Council following the publication of her memoir, Chast stated the case more directly: "On some deep level, I identify as a Jew. I don't know exactly what that means. Maybe feeling a little bit like an outsider. And that no matter how much I assimilate, there will always be something about me that will not fit in."[30]

As a cartoonist at the *New Yorker*, Chast has had a long relationship with not fitting in, with breaking the status quo, even as she has by now become a staple of the magazine's cartoon portfolio.[31] Her sense of outsiderness is thus a result of a confluence of elements, not least her style and the substance of her cartoons, which often have a kind of "insider" appeal to them.[32] Though, crucially, they do not generally trade in overt Jewish references, the tropes and themes that repeatedly surface in Chast's work about anxious New Yorkers or struggling suburban moms are deeply connected with what we tend to think of as Jewish American humor (neurotic, ironic, self-deprecating, quirky). Chast's sense of outsiderness is also connected to her original difficulties breaking into a male-dominated cartooning profession. In fact, when she first sent her work to the *New Yorker*, she signed her cartoons "R. Chast" in order to camouflage her gender.[33] In a 2011 interview with the *Comics Journal*, Chast spoke of how when she first started selling her cartoons there, she was the only woman in the room as well as the youngest person.[34] Chast's style—comprising "crumbly yet accurate lines," as David Remnick has described it—ran counter to most of the contributions that populated the magazine when she started, and arguably her work continues to stand out in this way. Chast was also unusual in "breaking the frame and conventions of the gag cartoon."[35] A 2019 profile of Chast mentions how she was "one of the first cartoonists not only to always come up with her own ideas but to use her own lettering to explain her points."[36] Whereas most cartoonists at the time followed a standard cartoon-caption formula, Chast's earliest pieces were a complete rethinking of the shape and mechanics of cartooning.

This quirky independence reinforced Chast's outsider status over time, and some critics bristled against it.[37] Chast recalled, for example, that one of her early editors, Lee Lorenz, had been asked whether "he [Lorenz] owed [Chast's] family money" after he started publishing her work in the

New Yorker.[38] Chast's style, like that of many contemporary women cartoonists, goes against the grain of what many consider skilled or expert drawing. Instead, her work often juxtaposes abstraction with figuration, the characters and backdrops expressively cartoonish. Yet the nonconformist nature of her work—in form, theme, and structure—is at the heart of the family story that she seeks to explore in the book: that sense of being an outsider, even among the already outsiders, yet still finding connections and associations. In Chast's creation of various counternarratives across her works, there are always threads of influence to be found, enduring, if complicated, communal and familial ties.

Indeed, within her memoir, Chast fits herself back into her family story, even as she reshapes that story to better suit her own perspective. In this way, she composes a version of what it means to belong to, and in, her parents' story. It is a story that, for her and them both, traces various forms of uncomfortable and uncertain, but also inescapable and meaningful, connections, not least the Jewish ones. Like death (and its accessory, grief), Jewishness becomes a realm of acknowledged influence that is unfixed in substance, effect, and significance. That is to say, voicing, or visualizing, otherwise unspoken or unreliably expressed *things* leads, in Chast's work, not to fixed ideations or conclusions but to openness and possibility. Thus, notably, at the very end of the book the narrator recasts the two parental taboos—Jewishness and death—at the heart of her parents' story. In her epilogue, she depicts her parents' cremains, which she has stored in two large pouches at the bottom of her closet (fig. 9.1).[39] She includes a full-page image of this closet, the pouches camouflaged and set one atop the other in a sea of brightly colored hanging and folded clothing, rows of women's shoes and boots, a smattering of purses, a sewing machine, and even some stray art supplies. Instead of finding ways to insert herself into her parents' lives and stories, as she has had to do since the beginning of their declines and even further back, she now integrates these pouches into elements of her life, her domestic sphere. As the book ends, she notes the disquieting nature of this arrangement.

"Maybe when I completely give up this desire to make it right with my mother," she writes, "I'll know what to do with their cremains. Or, maybe not" (227). This lack of a permanent home for the cremains, a circumstance directly tethered to Chast's lack of closure in regard to her mother's death and her ambivalent grief connect this narrative ending to the page

> On the floor of my closet, along with shoes, old photo albums, wrapping paper, a sewing machine, a shelf of sleep t-shirts, an iron, a carton of my kids' childhood artwork, and some other miscellaneous stuff, are two special boxes.
>
> One holds my father's cremains. The other holds my mother's.

Figure 9.1. A page from the original "Epilogue" of Roz Chast's *Can't We Talk about Something More Pleasant?* Used by permission.

early on in the memoir in which she recounts the death of her baby sister. There, she writes of her sister, "She is buried in a cemetery (my aunt told me), but I don't know which one" (5). There is an unsettled, and unsettling, quality to both of these stories, the story of her sister's death and now the story of her parents' deaths, especially her mother's, as though one brush with a difficult loss led to another. Here Chast acknowledges her ambivalence to the various threads of grieving and ungrieving exposed in her unfolding story.

Epilogues; or, What Cremains

Chast's book, as it was originally printed, ends there. But amazingly, several years after the memoir came out, she published a follow-up two-page comic in *The New Yorker*. Also titled "Epilogue" (an echo of the original "Epilogue," which featured the cremains-in-closet image), this short piece recounts how a fan of Chast's work had read her original memoir and attempted to locate the gravesite of Chast's "parents' first baby."[40] Like a character from a Chast cartoon come to life, the fan reassures the cartoonist in an email message "that she wasn't bats—that she was merely curious." With this stranger's help, not only is Chast now able to locate the cemetery in Queens where her sister is buried, she finds that her mother's parents, too, are buried there. In a panel at the bottom of the first page, she includes a reproduced photograph of the gravesite of her maternal grandparents, Harry Buchman and Mollie Buchman, their headstones etched with their names in both Hebrew and English. In a panel beside the gravestones, Chast pictures the two bags of ashes in her parents' closet. This time, though, Chast draws her persona standing beside the closet, looking in, with the bags distinguished from the rest of the items cluttering the same space. They are the only colored-in items pictured (one red, one blue), and they stand against a sketchy gray background. This twinning image—with the parents' bagged cremains as two focal points—mirrors the grandparents' gravestones, set side by side in the previous panel. Soon, parents and grandparents will be reunited, and in a Jewish cemetery, no less.

On the following page of the comic, Chast describes how she and her adult son eventually took a trip to the cemetery, found "the precise place where [her] sister was buried," and set down stones on the unmarked gravesite, one stone from each of them. Beside the narrative text recounting this experience, Chast illustrates two stones lying in the green grass, one slightly larger than the other. The image recalls the two pouches of cremains sitting at the bottom of her closet as they are depicted earlier in this new "Epilogue," and it also mimics the twinning of the grandparents' headstones. "Jews don't put flowers on graves. Just stones," Chast annotates in the corner of this drawn panel, an explanation marked by two asterisk symbols. It is the most explicit mention of Jewishness in relation to this story since the narrator of the originally published book disclosed her

parents' explicit rejection of the topic on the page facing her description of the death of her sister.

This new epilogue, which, in later printings came to replace the book's original one, concludes on a Jewish note that also ends up being a note of seeming resolution, of tying up loose ends. The words "It was time to say goodbye" hover over the new resting place Chast has chosen for her parents. There is a photograph of a tall niche wall in which their cremains will be housed. As she explains in narration, the wall will overlook the site of her sister's remains. It is high from the ground, and a tall, aluminum ladder rests against it. "A workman drove me out to the niche wall," Chast writes. "I carried the bag on my lap. We were joined by a group of workmen at the wall. One of them climbed a ladder, opened the niche, and, one by one, placed my parents' ashes inside. Then he resealed it and climbed back down" (231).

As I have argued elsewhere with Laura Limonic, often in times of grappling with death and grief, otherwise nonpracticing Jews turn or return, if briefly, to Jewish ritual and practice.[41] Chast's second epilogue is a narrative of grief that in fact brings readers back into the "present" moment of Chast's continued life, the journey that endures after her parents' deaths and the circulation of the book she has written about that experience. It concludes not only with a Jewish ritual performed in the family, a final visit to her sister's gravesite with her son to place memorial stones. But it also culminates in a storyline catalyzed by a stranger's gentle intrusion into Chast's family story, and another stranger's safe and sound climb down a ladder to assist the daughter in this final act on behalf of her parents. These additions emphasize the ways in which the relational nature at the heart of each individual experience of grief can also extend ever outward—there is always the potential for an ever-widening circle. In this sense, both versions of the book end on an uncertain note, the second with an uncertainty that points to the potential for connection and inclusion stemming from Chast's sharing of her story.

Ultimately, both versions of Chast's memoir address and celebrate the ways in which grievers can be held, even and especially in silence, by the individuals and communities that surround them. This is perhaps most evident in a series of images that Chast draws towards the end of the memoir, a series that one might say enacts the silent witnessing that Chast's entire memoir both draws on and invites. Between the moment

Chast announces her mother's death in the memoir and the original "Epilogue" (labeled "Postscript" in the later version), she includes a series of sketches of her mother on her deathbed over the course of twelve pages (211–22). The sketches are drawn in black ink on cream paper, reproduced and framed within the white pages of the book. The spare, haunting illustrations include almost no accompanying notes or words except for dates scribbled and occasional plain observations ("intense frowning"; "my mother"). The images stand out as uncharacteristic in a book otherwise brimming with evocative and playful layers of commentary, sound, color, and observation. These images are, instead, lapses into silence, moments of witness.

If the rest of Chast's memoir is visibly and topically connected with her vibrant *New Yorker* cartoons (some even direct republications), these pages are a segment out of time and also out of character. In the "stripped down vulnerability of individual drawings," Chast allows herself to attend singularly to the presence of her dying, then dead, mother.[42] She grieves, and we, readers, are invited to attend to her in the span of her grief. In these closing pages, Chast in a sense yields to the atmospheric silence, her parents' silence, that earlier held her in its grip. But she has revised the quality of that silence to one of careful attention, of narrowing in, even when it would be easier to look away.

"The capacity to give one's attention to a sufferer is a very rare and difficult thing; it is almost a miracle; it *is* a miracle," Simone Weil once wrote.[43] These silent illustrations are a reminder that every story about grief, about the dying and the dead, is in fact also a story about people still alive in the world. As painful as it is, grieving happens in life, through life, and in that way it has the potential to return us to life, to others. As Chast observed in an interview about her memoir, "I think especially with my parents, I wanted to remember who they were. I wanted to remember all of it."[44] In writing and drawing her life with her parents as well as their deaths and after, Chast reenacts many of the joyful and painful moments. But her remembering on the page also connects her to an audience bearing witness along with her, to strangers with the potential to shape and be shaped by her grief.

Notes

1 The book was an undeniable success: it won a 2014 Kirkus Prize, was a finalist for the 2014 National Book Awards, was a #1 *New York Times* bestseller, won a 2014 National Book Critics Circle Award, won the 2014 Books for a Better Life Award, and won the 2015 Reuben Award from the National Cartoonists Society. All parenthetical page citations in the text correspond with the 2019 edition of the book, which includes an added epilogue.
2 As in any work of memoir, the individuals presented therein are versions of people in real life (personas, or alter egos). Throughout, I will use "Chast" or "Roz Chast" to refer to author and narrator, sometimes interchangeably, and I will use "Roz" only when emphasizing Chast's alter ego within the comics.
3 In fact, Chast moved back in with her parents after graduating college in 1977 and was living there when she first approached the *New Yorker* (Roz Chast, "Roz Chast," interview with Richard Gehr, *Comics Journal*, June 14, 2011, www.tcj.com/roz-chast/). But this brief return to live at home as a twenty-something searching for work is skipped over in the memoir.
4 Interestingly, Mrs. McGillicuddy was the name of the title character's mother on the television show *I Love Lucy*, a detail that connects this sequence to Chast's childhood and popular culture more broadly. Chast also uses the name to signal a generic stand in for "any person," as in her cartoon *Average Joes*, which features, among others, "Joe McGillicuddy."
5 The formal flexibility found in Chast's memoir can be at least partially attributed to her *New Yorker* work, as she explained in a 2011 interview with *Comics Journal*: "*The New Yorker* has let me explore different formats, whether it's a page or a single panel, and that's very important to me" (Chast, "Roz Chast"). When asked directly in 2014 about her formal choices for the book, she explained, "It was a very organic process. I used whatever form fit the content best" (Roz Chast, "Interview: Roz Chast," interview with Tahneer Oksman, Jewish Book Council, August 13, 2014, www.jewishbookcouncil.org/pb-daily/interview-roz-chast).
6 For a discussion on graphic caregiving memoirs, including an overview of the ethical issues involved in the representation of such relationships, see Amelia DeFalco, "Graphic Somatography: Life Writing, Comics, and the Ethics of Care," *Journal of Medical Humanities* 36 (2016): 223–40.
7 For example, narrative theorist James Phelan sees Chast's central "contribution" as aimed at "the understanding of the many facets of end-of-life experiences for patients and their families by unpacking significant details of her exploration of her experiences." Phelan, "Local Fictionality within

Global Nonfiction: Roz Chast's *Can't We Talk about Something More Pleasant?*" *ENTHYMEMA* 16 (2016): 18. Life-writing scholar Kathleen Venema, too, reads Chast's memoir in an essay exploring four "graphic caregiving memoirs" in the context of contemporary discourses on aging. Venema, "Remembering Forgetting: Graphic Lives at the End of the Line," *a/b: Auto/Biography Studies* 33, no. 3 (2018): 662. Venema mentions a "kinship" between the works she explores and the genre of grief memoirs, but her focus is mainly on representations of caregiving and aging. Mainstream journalistic responses to the book, too, emphasize its representations of caregiving. Here is cultural critic Eric Liebetrau writing about the memoir for the National Book Critics Circle's website: "In her revelatory, pitch-perfect and—yes—often-hilarious graphic memoir of that time, she masterfully captures the kaleidoscopic array of emotions involved in the caregiving for her 90-something parents." Liebetrau, "Eric Liebetrau on Roz Chast's *Can't We Talk about Something More Pleasant*," National Book Critics Circle, February 26, 2015, www.bookcritics.org/2015/02/26/eric-liebetrau-on-roz-chasts-cant-we-talk-about-something-more-pleasant/. And Terry Gross, introducing Chast's memoir for her 2014 *Fresh Air* interview, said: "The book is funny, heartbreaking and unflinching in dealing with her parents' stubbornness and denial as they became frail and increasingly unable to care for themselves, and her own feelings of guilt that no matter what she did, she wasn't doing enough." Roz Chast, "A Cartoonist's Funny, Heartbreaking Take on Caring for Aging Parents," interview with Terry Gross [transcript], Fresh Air, National Public Radio, May 8, 2014, www.npr.org/transcripts/310725572.

8 Kathleen Fowler, "'So New, So New': Art and Heart in Women's Grief Memoirs," *Women's Studies* 36, no. 7 (October 2007): 527, emphasis in original. Fowler here works to distinguish grief memoirs from other "literary treatments of grief," but this work of categorization is complicated. Other closely related and often overlapping subgenres include somatographies, illness narratives, thanatographies, disability narratives, and so on.

9 For example, in *Reading Autobiography: A Guide for Interpreting Life Narratives*, 2nd ed. (Minneapolis: University of Minnesota Press, 2010), in a chapter in which the authors "survey some emergent forms that have recently gained prominence," autobiography scholars Sidonie Smith and Julia Watson include a classification, "Narratives of Grief, Mourning, and Reparation" (128, 138–41). They further break down this overarching category into "narratives of witness" and "narratives of mourning," distinguishing the former as often linked to activism as well as "collective vulnerability

and communal loss" (139). Smith and Watson note, however, that the distinction is "slippery" (140).
10 Tahneer Oksman, "Assembling a Shared Life in Anders Nilsen's *Don't Go Where I Can't Follow*," in *PathoGraphics: Narrative, Aesthetics, Contention, Community*, ed. Susan Merrill Squier and Iremele Marei Krüger-Fürhoff (University Park: Pennsylvania State University Press, 2020), 24.
11 We can contrast this narrative of dual losses, for instance, with most books that fall in the grief memoir genre and focus instead on a single instance of loss, even when other losses or deaths co-occur in the time frame of the narrative or throughout the duration of its composition. Most famously, one might think of Joan Didion's *The Year of Magical Thinking* (New York: Vintage, 2005), which is an especially poignant example for how it withholds most information about Didion's daughter, who was in an induced coma at the time the book opens and whose death coincided with Didion's writing of this memoir about the death of her husband. Quintana's death was left unmentioned—though it became the subject of a second, separate book, *Blue Nights* (New York: Knopf, 2011). Conversely, Jesmyn Ward's *Men We Reaped* (New York: Bloomsbury, 2013) is an unusually structured memoir recounting the death of five Black men that Ward had known in various capacities, including her brother and cousin, and brings together their stories by exposing how racism impacted each of their stories. Ward's work, in this case, exemplifies another instance of a text unusually attuned to the interconnected nature of loss and grief.
12 "Critique" comes from Rachel Cusk, in her essay "Lions on Leashes," in which she describes how children grow up first as characters in "the family story" narrated by their parents and, later, as active critics. I quote it at length here for its marked correspondence with the framework established by Chast's narrator:

> Until adolescence, parents by and large control the family story. The children are the subject of this story, sure enough, the generators of its interest or charm, but they remain, as it were, characters. . . . But it is perhaps unwise to treasure this story too closely or believe in it too much, for at some point the growing child will pick it up and turn it over in his hands like some dispassionate reviewer composing a cold-hearted analysis of an overhyped novel. The shock of critique is the first, faint sign of the coming conflict . . . (Cusk, "Lions on Leashes," in *Coventry: Essays* [New York: Farrar, Straus & Giroux, 2019], 90–91)

13 Nancy K. Miller, *Bequest and Betrayal: Memoirs of a Parent's Death* (Bloomington: Indiana University Press, 2000), 5.

14 The second phrase is the one actually uttered by Chast's mother, sitting beside her father, in the first panel of this comic (6).

15 The couch was enough of a touchstone that an April 14–October 16, 2016, exhibition related to Chast's New York City work at the Museum of the City of New York, *Roz Chast: Cartoon Memoirs*, featured an actual teal two-seater couch as a centerpiece. Visitors could sit on the couch and pose for photographs.

16 The anxious energy is indicated here, as in many Chast cartoons, not only by the character's facial expression—wide eyes, open mouth—and the words set on the page, underlined, bolded, and including unruly punctuation. It is also signaled by the curvy lines emanating off the character's hands. Known in comics as "emanata," these nonmimetic lines signal, often through exaggeration, what a character is feeling or thinking.

17 In it, Chast holds a copy of *The Story of Babar*—a harbinger of what's to come: Chast's illustration career and the death of a mother.

18 Countering the official family story, the one endorsed by the most powerful family members, by building on and responding to family photographs and albums is a practice that has been powerfully taken up by artists like Jo Spence and Nan Goldin, among others. See Oksman, "Mourning the Family Album," *a/b: Auto/Biography Studies* 24, no 2 (Winter 2009): 235–38.

19 See Henry Jenkins, for instance, who includes in his book *Comics and Stuff* a chapter on the role of objects in relation to grief in Chast's memoir as well as in Joyce Farmer's *Special Exits* (2014), a memoir about her parents' final years. As Jenkins writes of these two books, "Grief for a lost parent is displaced onto sorting and letting go of their material traces. I am interested in how sorting and culling are performed formally, in terms of these graphic memoirs' narrative and visual strategies, but also conceptually, as the authors make sense of these life processes." Jenkins, "Sorting, Culling, Hoarding, and Cleaning: Joyce Farmer's *Special Exits* and Roz Chast's *Can't We Talk about Something More Pleasant?*," in *Comics and Stuff* (New York: New York University Press, 2020), 261. Jenkins centers in particular on Chapter 10 of Chast's memoir, "The Old Apartment" (106–23), which focuses on Chast's documentation of clearing out all of the stuff in her parents' apartment.

20 Alex Witchel, "Drawn from Life," *New York Times*, May 30, 2014, https://www.nytimes.com/2014/06/01/books/review/roz-chasts-cant-we-talk-about-something-more-pleasant.html.

21 We see this fixation on anxiety and death as a beloved characteristic of many of Chast's well-known *New Yorker* cartoons. See Linda A. Morris, "Roz Chast: From Whimsy to Transgression," in *Transgressive Humor of American Women Writers*, ed. S. Fuchs Abrams (New York: Palgrave, 2017), 186–87.

22 For some stand out examples, see pp. 17, 44–45, 59, and 139. Note how in each case the wavy lines (emanata) drawn around the telephone and the stand-alone sound word indicating the phone's ringing ("R-R-RING!!!") accentuate the phone itself as an active presence, or what Bill Brown describes as "active matter." Brown, *Other Things* (Chicago: University of Chicago Press, 2015), 2.

23 For images of the couch as a deserted island, on which Chast is stranded with her parents, or Chast's parents are stranded together in old age, see, in addition to the book's cover, pp. 3, 16, 27, and 36. For the couch (or, in its singular iteration, the armchair) as a place of hiding from reality, see pp. 97, 139, and 177.

24 Chast's first published *New Yorker* cartoon, from July 3, 1978, was called "Little Things" and consisted of neologisms written beside made up, odd shapes. Her first *New Yorker* cover, published August 4, 1986, also featured "things": a man in a lab coat stands with a pointer leveled at a chart mapping out various adaptations of how ice cream is served (a cone; a sundae; a sandwich; a milkshake; etc.).

25 Didion, *Year of Magical Thinking*, 32. For an insightful reading of how magical thinking figures in modernity in relation to grieving, see Roger Luckhurst, "Reflections on Joan Didion's *The Year of Magical Thinking*," *New Formations* 67 (Summer 2009): 91–100.

26 Interestingly, in a 2014 interview with Chast, Terry Gross, in referring to the mother's late-life fall, calls the ladder a "stepstool," a slip that evidences this easy association between the two stories (Chast, "Cartoonist's Funny, Heartbreaking Take").

27 Even if only as a fantasy, of course, as one never knows how individual children will—or will be able to—respond to their aging parents' needs, or how siblings' life courses will affect one another.

28 Her parents were both ninety-two at the time of the interview; her father died in 2007 at age ninety-five, and her mother died in 2009 at age ninety-seven.

29 Roz Chast, "I Was Like a Spy. Like a Closet Jew," in *Opening the Doors of Wonder: Reflections on Religious Rites of Passage*, ed. Arthur J. Magida (Berkeley: University of California Press, 2006), 116.

30 Chast, "Interview: Roz Chast."

31 David Remnick, "Introduction: Little Things," in *Theories of Everything: Selected, Collected, Health-Inspected Cartoons, 1978–2006*, by Roz Chast (New York: Bloomsbury, 2006), n.p.
32 Liza Donnelly, Funny Ladies: The New Yorker's Greatest Women Cartoonists and Their Cartoons (New York: Prometheus Books, 2005), 141.
33 Donnelly, 133.
34 Chast, "Roz Chast."
35 Remnick, n.p.
36 Adam Gopnik, "Scenes from the Life of Roz Chast," *New Yorker*, December 23, 2019, www.newyorker.com/magazine/2019/12/30/scenes-from-the-life-of-roz-chast.
37 Some continue to do so even today. Take, for example, a comment from G. Thomas Couser, who connects Chast's style with cartoonist Sarah Leavitt, creator of *Tangles: A Story about Alzheimer's, My Mother, and Me* (2010). Leavitt's style is spare and looks visually unpracticed—indeed she has referred to it herself as "scruffy" (Leavitt, "Images of Healing and Learning," *American Medical Association Journal of Ethics* 16, no. 8 [August 2014]: 653). Couser, in "Is There A Body in This Text? Embodiment in Graphic Somatography," *a/b: Auto/Biography Studies* 33, no. 2 (2018), describes Levitt's style as "sterile and sanitary," explaining, "I would like to see more in the way of distinguishing detail. For me, Leavitt's style is a bit too delicate and, well, sketchy to have real power" (363). Couser then goes on, in a footnote, to compare Chast's style with Leavitt's, explaining his "reservations" about Chast's memoir: "There is a disjunction between her characteristic style and her subjects—and the genre of graphic somatography" (372). As I have argued elsewhere, such critical responses are regularly attributed to visually expressive and experimental forms and styles composed by women, and should be examined more closely for their gendered implications. See Tahneer Oksman, *"How Come Boys Get to Keep Their Noses?": Women and Jewish American Identity in Contemporary Graphic Memoirs* (New York: Columbia University Press, 2016), 16–17. On readers' hostility to Chast's work, see also Donnelly, *Funny Ladies*, 135–37.
38 Chast, "Roz Chast."
39 Chast brought up the Jewish backdrop to this final scene in the book in a 2016 lecture at the Museum of the City of New York, telling the audience, "Cremation isn't common in Judaism but it's becoming more common" (Roz Chast, "Can't We Talk about Something More Pleasant?"). Cremation is taboo in certain observant communities and has a complicated role and import for Jews. See, for example, Adam S. Ferziger, "Ashes to Outcasts: Cremation, Jewish Law, and Identity in Early Twentieth-Century

Germany," *AJS Review* 36, no. 1 (April 2012): 71–102, for some background and historical context, particularly regarding early twentieth-century Jewish burial practices with regard to cremation.

40 Roz Chast, "Epilogue," *New Yorker*, July 25, 2016, www.newyorker.com/magazine/2016/07/25/epilogue-by-roz-chast. In the 2019 edition of the book, the new epilogue, which is unpaginated, starts after p. 228.

41 Laura Limonic and Tahneer Oksman, "Introduction: Contemplating Death," in "What's Jewish about Death?," ed. Laura Limonic and Tahneer Oksman, special issue, *Shofar: An Interdisciplinary Journal of Jewish Studies* 39, no. 1 (Spring 2021): 1–20.

42 Roberta Smith, "Drawing: A Cure for the January Blahs," *New York Times*, January 20, 2022, www.nytimes.com/2022/01/20/arts/design/drawing-center-art-galleries-shear.html.

43 Simone Weil, "Reflections on the Right Use of School Studies with a View to the Love of God," in The Simone Weil Reader: A Legendary Spiritual Odyssey of Our Time, edited by George A. Panichas (Philadelphia: David McKay, 1977), 49.

44 Roz Chast, "Readers Relate to New Yorker Cartoonist Roz Chast's Personal Book on Aging Parents." Interview with Jeffrey Brown [transcript]. *PBS News Hour*, PBS, December 26, 2014, www.pbs.org/newshour/show/readers-relate-new-yorker-cartoonist-roz-chasts-personal-book-aging-parents.

Bibliography

Brown, Bill. *Other Things*. Chicago: University of Chicago Press, 2015.

Chast, Roz. *Can't We Talk about Something More Pleasant?* New York: Bloomsbury, 2019.

———. "Can't We Talk about Something More Pleasant?" Lecture. Museum of the City of New York, September 27, 2016.

———. "A Cartoonist's Funny, Heartbreaking Take on Caring for Aging Parents." Interview with Terry Gross [transcript]. *Fresh Air*, National Public Radio, May 8, 2014. www.npr.org/transcripts/310725572.

———. "Epilogue." *New Yorker*, July 25, 2016. www.newyorker.com/magazine/2016/07/25/epilogue-by-roz-chast.

———. "Interview: Roz Chast." Interview with Tahneer Oksman. Jewish Book Council, August 13, 2014. www.jewishbookcouncil.org/pb-daily/interview-roz-chast.

———. "I Was Like a Spy. Like a Closet Jew." In *Opening the Doors of Wonder: Reflections on Religious Rites of Passage*, edited by Arthur J. Magida, 112–19. Berkeley: University of California Press, 2006.

———. "Readers Relate to New Yorker Cartoonist Roz Chast's Personal Book on Aging Parents." Interview with Jeffrey Brown [transcript]. *PBS News Hour*, PBS, December 26, 2014. www.pbs.org/newshour/show/readers-relate-new-yorker-cartoonist-roz-chasts-personal-book-aging-parents.

———. "Roz Chast." Interview with Richard Gehr. *Comics Journal*. June 14, 2011. www.tcj.com/roz-chast/.

Couser, G. Thomas. "Is There a Body in This Text? Embodiment in Graphic Somatography." *a/b: Auto/Biography Studies* 33, no. 2 (2018): 347–73.

Cusk, Rachel. "Lions on Leashes." In *Coventry: Essays*, 88–107. New York: Farrar, Straus & Giroux, 2019.

DeFalco, Amelia. "Graphic Somatography: Life Writing, Comics, and the Ethics of Care." *Journal of Medical Humanities* 37 (2016): 223–40.

Didion, Joan. *Blue Nights*. New York: Knopf, 2011.

———. *The Year of Magical Thinking*. New York: Vintage, 2005.

Donnelly, Liza. *Funny Ladies: The New Yorker's Greatest Women Cartoonists and Their Cartoons*. New York: Prometheus Books, 2005.

Ferziger, Adam S. "Ashes to Outcasts: Cremation, Jewish Law, and Identity in Early Twentieth-Century Germany." *AJS Review* 36, no. 1 (April 2012): 71–102.

Fowler, Kathleen. "'So New, So New': Art and Heart in Women's Grief Memoirs." *Women's Studies* 36, no. 7 (October 2007): 525–49.

Gopnik, Adam. "Scenes from the Life of Roz Chast." *New Yorker*, December 23, 2019. www.newyorker.com/magazine/2019/12/30/scenes-from-the-life-of-roz-chast.

Jenkins, Henry. "Sorting, Culling, Hoarding, and Cleaning: Joyce Farmer's *Special Exits* and Roz Chast's *Can't We Talk about Something More Pleasant?*" In *Comics and Stuff*, 259–92. New York: New York University Press, 2020.

Leavitt, Sarah. "Images of Healing and Learning." *American Medical Association Journal of Ethics* 16, no. 8 (August 2014): 652–55.

Liebetrau, Eric. "Eric Liebetrau on Roz Chast's *Can't We Talk about Something More Pleasant*." National Book Critics Circle, February 26, 2015. www.bookcritics.org/2015/02/26/eric-liebetrau-on-roz-chasts-cant-we-talk-about-something-more-pleasant/.

Limonic, Laura, and Tahneer Oksman. "Introduction: Contemplating Death." In "What's Jewish about Death?," edited by Laura Limonic and Tahneer Oksman, special issue, *Shofar: An Interdisciplinary Journal of Jewish Studies* 39, no. 1 (Spring 2021): 1–20.

Luckhurst, Roger. "Reflections on Joan Didion's *The Year of Magical Thinking*." *New Formations* 67 (Summer 2009): 91–100.

Miller, Nancy K. *Bequest and Betrayal: Memoirs of a Parent's Death*. Bloomington: Indiana University Press, 2000.

Morris, Linda A. "Roz Chast: From Whimsy to Transgression." In *Transgressive Humor of American Women Writers*, edited by S. Fuchs Abrams, 175–201. New York: Palgrave, 2017.

Oksman, Tahneer. "Assembling a Shared Life in Anders Nilsen's *Don't Go Where I Can't Follow*." In *PathoGraphics: Narrative, Aesthetics, Contention, Community*, edited by Susan Merrill Squier and Iremele Marei Krüger-Fürhoff, 23–38. University Park: Pennsylvania State University Press, 2020.

———. *"How Come Boys Get to Keep Their Noses?": Women and Jewish American Identity in Contemporary Graphic Memoirs*. New York: Columbia University Press, 2016.

———. "Mourning the Family Album." *a/b: Auto/Biography Studies* 24, no. 2 (Winter 2009): 235–48.

Phelan, James. "Local Fictionality within Global Nonfiction: Roz Chast's *Can't We Talk about Something More Pleasant?*" *ENTHYMEMA* 16 (2016): 18–31.

Remnick, David. "Introduction: Little Things." In *Theories of Everything: Selected, Collected, Health-Inspected Cartoons, 1978–2006*, by Roz Chast, n.p. New York: Bloomsbury, 2006.

Roz Chast: Cartoon Memoirs. Museum of the City of New York, April 14–October 16, 2016, New York.

Smith, Roberta. "Drawing: A Cure for the January Blahs." *New York Times*, January 20, 2022. www.nytimes.com/2022/01/20/arts/design/drawing-center-art-galleries-shear.html.

Smith, Sidonie, and Julia Watson. *Reading Autobiography: A Guide for Interpreting Life Narratives*, 2nd ed. Minneapolis: University of Minnesota Press, 2010.

Venema, Kathleen. "Remembering Forgetting: Graphic Lives at the End of the Line." *a/b: Auto/Biography Studies* 33, no. 3 (2018): 661–84.

Ward, Jesmyn. *Men We Reaped*. New York: Bloomsbury, 2013.

Weil, Simone. "Reflections on the Right Use of School Studies with a View to the Love of God." In *The Simone Weil Reader: A Legendary Spiritual Odyssey of Our Time*. Edited by George A. Panichas, 44–52. Philadelphia: David McKay, 1977.

Witchel, Alex. "Drawn from Life." *New York Times*, May 30, 2014. https://www.nytimes.com/2014/06/01/books/review/roz-chasts-cant-we-talk-about-something-more-pleasant.html.

10

MIZRAHI JEWISH WOMEN WRITERS IN AMERICA

A Conversation

Karen E. H. Skinazi

You mean you're Jewish? And you don't know about gefilte fish? ... What kind of Jew are you?

—Joyce Zonana, *Dream Homes: From Cairo to Katrina, an Exile's Journey* (2008)

In Jessica Soffer's novel *Tomorrow There Will Be Apricots* (2013), Victoria and Joseph, Iraqi immigrants to the United States, learn to speak English, eat Pop-Tarts, and mark their lives using events with American significance, like where they were the day JFK was shot. "Even in our home, on quiet evenings alone on our couch, we insisted on being Americans," Victoria relates, explaining, "We made latkes for Hannukah."[1] In the United States, Victoria and Joseph are free to be Jewish; in Iraq, Victoria's father was hanged for it. Still, they make not *sambousak* or *zengoula*, the Iraqi dishes popular on the holiday, but rather latkes, the favored fare from Eastern Europe. Both latkes and *zengoula* are Jewish foods, but only one seems to fit into the new national setting. Ashkenazi, as far as Victoria can tell, is American; Mizrahi is not.[2]

Mizrahim—Jews from the Middle East and North Africa—comprise half the Jewish population of Israel and are significant contributors to cultural, political, and literary life there.[3] In the United States, however, the

Jewish population is primarily European; it was from Eastern Europe that Jews came in large numbers during the great waves of immigration in the late nineteenth through early twentieth century and in the years after the Holocaust.[4] Mizrahim in the United States are a minority within a minority. So, for the most part, Victoria is not wrong: in America, Jewish food is typically chicken soup and matzah balls, not *fuul medames*; the Jewish language is Yiddish, not Ladino; the "Old Country" refers to Poland or Russia, not Iran. These monolithic assumptions about Jewishness do not mean that Mizrahim are or have been absent in the United States; more commonly, they have gone unnoticed.[5]

Literature has played a significant role in popularizing Ashkenazi Jewish culture in the United States. The explosion of Ashkenazi American writing at the turn of the twentieth century began a trend of Jewish writing that continued through the next generation and then the next. Although literary concerns evolved—from themes of immigration and assimilation to the Holocaust and its aftermath, for example—the Jewishness portrayed remained rooted in similar religious, cultural, linguistic, and culinary traditions. Non-Ashkenazi literature was subsumed by the dominant canon.[6] Yet in recent years, as the emerging body of Mizrahi literature demonstrates—along with new scholarship, including the groundbreaking 2016 book *Sephardi and Mizrahi Jews in America*, edited by Saba Soomekh—there has been a growing recognition that other important Jewish American histories and stories need to be told.

Until the last decade of the twentieth century, the only (somewhat) influential Mizrahi American writer was Jacqueline Shohet Kahanoff, an Iraqi Egyptian Jewish woman who resided in the United States for several years and published short stories and a novel in the 1940s and '50s.[7] Recent years have witnessed a sea change in Jewish publishing. In 1991, Gina Nahai wrote her debut novel, *Cry of the Peacock*, a multigenerational saga that unfolds over the course of two hundred years of Iranian Jewish history. Soon after, André Aciman published *Out of Egypt* (1994), a memoir describing his Egyptian Jewish family members—wealthy, cosmopolitan, and superior, by their reckoning, to Ashkenazi Jews. His depiction served as a direct rebuttal to the racializing and orientalizing of Mizrahim, who are often depicted and treated as inferior—poor, backward, and illiterate—by Israeli as well as by diasporic Ashkenazi Jewry.

Today, Nahai's and Aciman's oeuvres are part of a burgeoning genre of Mizrahi American literature.[8] Significantly, Mizrahi writing complicates

ideas about "Jewish American literature." For instance, Ashkenazi literature traditionally foregrounded the United States as a promised land, a desired lover, a fresh beginning, while for Mizrahi writers, the country often serves as the place of exile. "We've been [in Iran] two thousand years," says a Jewish character in Dalia Sofer's *Man of My Time* (2020); even her Muslim boyfriend refers to Jews as "[Queen] Esther's children," suggesting widespread recognition of Jews' place in Iranian national history.[9] Similarly, Gina Nahai writes in "Becoming American":

> Perhaps the greatest collective loss for the Mizrahi Jews of the Middle East is that of home and country—once, in 586 BCE, when they were brought as slaves into Babylon, and again, in modern times, when they were driven out of what they rightly believed was their native land. . . . In 583 BCE, when Cyrus encouraged the Jews to return to Jerusalem and rebuild their temple, about half chose to stay in Persia instead. Twenty-five hundred years later, when Arab Muslim governments expelled their Jewish citizens, they lost their homeland all over again.[10]

This sentiment can also be found in Tobie Nathan's *A Land Like You* (2020), when the Egyptian Jews lament that "we were there with the Pharaohs, then with the Persians, the Babylonians, the Greeks, the Romans; and when the Arabs arrived, we were still there . . . and also with the Turks, the Ottomans. . . . We are indigenous, like the ibis, like the water-buffalo calves, like the kites."[11] Once in America, memoirist Lucette Lagnado writes in *The Man in the White Sharkskin Suit* (2007), her father "preferred being an old Egyptian to a new American. He had, in short, no desire whatsoever to assimilate."[12] Coming to the United States is rarely represented as a triumph for the characters of Mizrahi literature.

This literature not only writes Mizrahim and Mizrahi experiences (back) into Jewish American culture and history, but also women into the male-dominated narratives from their countries of origin. Mizrahi American literature is a genre dominated by women writers: among them, Gini Alhadeff, Lucette Lagnado, Roya Hakakian, Farideh Goldin, Jean Naggar, Colette Rossant, Dalia Sofer, Joyce Zonana, Corie Adjmi, and Jessica Soffer. *The Flying Camel* (2003), a book of essays edited by Loolwa Khazzoom, also comprises women's writing.[13] In her introduction, Khazzoom describes finding and trying on her Iraqi

grandmother's abayah only to realize she has already been wearing a full-body veil: "The traditional veil, it seemed, not only covered the bodies of the Khazzoom women; it also permeated our souls."[14] Khazzoom explains that the women of her family are typical of Jewish women of North African and Middle Eastern descent, who "continue to live in the shadows of metaphoric veils."[15] *The Flying Camel* is one of a number of literary attempts to bring those women out of the shadows. In *Dream Homes*, Zonana describes how her family hoped she "would marry an Egyptian Jewish man, keeping house for him and raising children who would themselves marry other Egyptian Jews," and declares, "I cherished another ideal: the life of a writer, an artist, an independent woman."[16]

Over the last two decades, Mizrahi women have been writing stories that look back over the centuries, tell of rituals passed down from mother to daughter, revive lost languages, delve into regional Jewish cuisine, examine gendered relationships, consider Muslim-Jewish relations and Jewish-Jewish relations, assess the losses and gains of immigration and assimilation, challenge patriarchal inheritances, and offer sharp insights into the politics of their home nations. They also explore the experience of being both Mizrahi and American.

To capture some of the diversity of Mizrahi American women's writing, I chose to interview writers of fiction and memoir whose families hailed from (and whose writing speaks to) three different countries: Iran, Egypt, and Iraq. On December 2, 2021, I spoke to Dalia Sofer, Joyce Zonana, and Jessica Soffer. Dalia, who teaches at City College in New York, is a well-known writer, having established her career with *The Septembers of Shiraz* (2007), which was made into a 2015 film starring Salma Hayek and Adrien Brody. Her second novel, *Man of My Time*, came out in 2020. Both books focus on Iranians during and in the aftermath of the Iranian Revolution. Joyce, a recently retired professor of English who taught at the Borough of Manhattan Community College, CUNY, wrote *Dream Homes* (2008), a memoir about growing up as an Egyptian Jewish woman in the United States. She also published scholarship on other Egyptian Jewish writers and translated *Ce pay qui te ressemble* [*A Land Like You*] (2015/2020) by Tobie Nathan. Finally, Jessica Soffer, who teaches at Connecticut College, is the author of *Tomorrow There Will Be Apricots* (2013), a novel about an Iraqi Jewish couple and a young American woman. The transcript of the interview that follows has been condensed and edited for clarity.

Karen: I want to start by talking about the fact that so much of what is considered Jewish culture in America is often really Ashkenazi or Eastern European: the literature, the food, the history. I think your novels and memoir pushed against this notion of what Jewishness is. Was it important to you to write about these heritages that are lesser known in American culture and American Jewish culture?

Joyce: I very specifically and explicitly and consciously worked to insert a non-Ashkenazi story into American Jewish discourse. When I was growing up, reading whatever I read, I very clearly felt that I was excluded from it.

And when I was writing my book back in the 1990s (it came out in 2008, but I was working on it in the '90s), I couldn't find anything about Egyptian Jewish experience. It was before André Aciman's book [*Out of Egypt*] came out, and suddenly there was this big splash of attention on this other story.

But before that, I wasn't aware of much. And so, I really felt I wanted and needed to get it out there.

Karen: I remember when I read Aciman's memoir, it was also a big deal to me, though I felt like he put a lot of emphasis on the Europeanness of his family, which somewhat undercuts the North African difference.

Joyce: I felt the same way. Absolutely. So, when his book came out, it was even more motivation for me to write mine. I didn't feel like a book like mine had been done yet, even if something about Egyptian Jews had been done.

Karen: Jessica, you look at two different sets of Jewish traditions in your novel. You include the story of a woman raised in an Ashkenazi household, we presume (because Ashkenazi always seems to be the default!), as well as an Iraqi Jewish couple in the novel.

Jessica: Yes, that's right, and it's very personal. It's very much autobiographical.

I was raised with a father who was an Iraqi Jew and very much Sephardic and came from a highly religious background. His father was a scribe. My last name, *sofer* [spelled Soffer], means "scribe." My mother's family, on the other hand, was distinctly New York Jewish. There were no real rituals, I would say, other than lox. So I didn't come to the novel from a scholarly perspective but rather a personal perspective, just trying to tell the story of my two

backgrounds, which I felt in certain ways, were both . . . "ending" sounds a bit too dramatic, but the Iraqi Jews were just becoming fewer and fewer, and it felt like my father's story was one that I really wanted to tell. That kind of particular Ashkenazi Jewish, New York, Upper West Side Jewishness was also of a time and felt like it was sort of shifting—not ending, but shifting. And so, that's how the story came to be. I also looked for Iraqi Jewish literature, as Joyce did with Egyptian Jewish literature, and I had a really hard time finding any.

Then my father became very sick very early on in my writing process. All the kinds of authoritative details I thought I would get, I ended up not being able to get.

Karen: Dalia, I know you came to the US from Iran when you were young. Was it important to you to tell the story of Iranian Jews? Also, I was struck by that relationship in *The Septembers of Shiraz* between the Iranian immigrant and the Hasidic family, which I thought nicely showcased the awareness that there are two different narratives rubbing up against each other, the lesser-known and the better-known narrative. So, I wondered if you could tell me a little about the motivations behind your choices.

Dalia: Yes, I came when I was eleven, and like Jessica, whose name has the same roots as mine, my father is also from Iraq, so I'm familiar with the Baghdadi story. I think there are now five Jews left in Iraq, which is really horrible. But, in terms of the book, I would say that it emerged from a personal space. It's fictional, only a lot of it was inspired by events that happened to me and my family.

As I wrote it, I wasn't thinking about whether we need an Iranian Jewish novel in this space. I was exploring Jewishness or the idea of religion as something that both binds people and divides them. Isaac, the father, is in prison. He's a secular man who is integrated in Iranian society, but he's imprisoned in part for being Jewish. He's accused of being a Zionist spy, which is completely absurd in the context of his life. Meanwhile, his son is welcomed in New York by a Hasidic family, but there's a limit to their kindness; in the end, it's clear that he's not one of them.

I was exploring the ways that religion can unite and also divide. I was also interested in the idea of Jewishness as something that's

inherited, something that one carries in one's body and one's psyche, a collective memory of Jews past. One is always reminded that one is Jewish, regardless of how one chooses to live.

Karen: In terms of the collective memory of Jews past, your character of Minoo Levy in *Man of My Time* insists on staying in Iran when the Jews are fleeing because, she says, after 2000 years of Jews in Iran, "someone must persevere."[17] She is also arguably the most insightful character in the book!

Dalia: The Jewish population for the most part was doing very well under the shah, and not many supported the revolution. But some did. There was a Jewish society called the Society of Jewish Iranian Intellectuals—they were part of the revolution. There was also a Jewish hospital called Sapir that treated a lot of the demonstrators who were wounded, whereas other hospitals were turning them away or turning them in. The scholar Lior Sternfeld has written a lot about this. Also important is the fact that Iranian Jews have been there since the sixth century BCE, since the time of Cyrus, and they've had a continuous presence until now. It's a very ancient community, like the Iraqi Jews. I wanted to slip that in because that's another aspect of Iranian history. Finally, through Minoo's character, I was also expressing my own anxiety about the vanishing—or potential vanishing—of this community. Even though there are a few thousand Jews left in Iran, the community is not what it used to be. And the fact that I, myself, am among those who left—although as child I didn't make the choice—is something that I'm very conflicted about.

Karen: Your character Minoo is actually a good segue into the question I wanted to ask next about gender. You all approach gender in different ways. Dalia in particular, I think you are a bit of a standout in that both of your books, particularly *Man of My Time*, are very invested in a male consciousness, right? Minoo is an exception in the story. We really have so much of the narrative through Hamid's perspective. And Isaac, arguably, is at the heart of *The Septembers of Shiraz*. On the other hand, Jessica, in your book, you present three generations of women, and their experiences and ways of thinking and anxieties are gendered in so many ways. Joyce, you describe the way that in your family's culture, a woman's role was to create a warm and welcoming sanctuary for her men. You also write at

length about how you were called *aroosa*, Arabic for bride, when you were just a little girl, suggesting the goal in life for a girl is to marry.

Joyce: I would say that I was pretty consciously foregrounding questions of gender. The book is about my search for myself, my struggle to have my own life in the United States. Growing up in a family that was still behaving as if they were in Egypt and with expectations for me as a woman to simply step into my mother's role—not just being gracious and hostessing or something like that, caring for men—but it was much, much more than that. It was really not having a life, basically not having an independent life. And here I was growing up in the United States in the 1950s and '60s, being influenced by feminism, being eager to become a full-fledged person.

From a very early age, I wanted to be a writer, and that was completely not part of the story that my family had for me. So the book is very much about that. I struggled to claim an identity for myself within the context of the culture that I was raised in and to find a way to be a modern, independent woman but also remaining connected to that culture. That's what I was struggling with in my life and trying to write about in my book.

Karen: When you talk about making the stuffed grape leaves for your department at work, you describe the labor involved and say that you'll never do it again. So you perform for us in your writing that conflict between your heritage, your being taught that women should be cooking and caring for others, and at the same time, your determination to be independent. After all, the grape leaves are for your colleagues. The path you've chosen is *not* to be an *aroosa*.

Joyce: Yes—should I be writing an academic article, or should I be stuffing grape leaves? What's the right thing? The answer is both, I think. When I was first working on the book, the working title that I had was "Aroosa." I didn't keep the name, but that whole question of being a bride or not being a bride was very much what I was thinking about.

Jessica: I think I am typically inspired more by character than by gender. I'm also drawn to characters with trauma of different levels—of either working through trauma or actively *not* working through trauma.

All the characters in *Apricots* are linked by some level of trauma. And some of that trauma is due to gender. So the kind of trauma innate to women, the expectations of women, of being a mother, of being a *good* mother, of being a particular kind of mother—either gets passed down or actively not passed down, but it's something that we're sort of all quite conscious of. The female characters in *Apricots* are all linked by that kind of trauma. I don't want to say female trauma but, more specifically, the trauma of being a mother or being a daughter.

I think the question that really runs through the book, and as it relates to gender, is how does that trauma get inherited and passed down the genetic line? But equally, too, I think that all the characters in *Apricots*, male as well, suffer from trauma. For instance, there's a male protagonist named Joseph, and he, too, has to deal with an immense amount of trauma because of being shunned by his motherland for exactly who he is.

Karen: In terms of your mothers, Jessica, they're not just *not* maternal, but we might actually call them *anti*-maternal, right? The resistance to being maternal is so strong, so overpowering, that I think it's like a slap in the face when you read it.

Jessica: That really has been a struggle with the response to *Apricots*. There were a lot of people that were really sort of repelled by that kind of mothering. They couldn't understand it. They couldn't imagine it.

That depiction, in certain ways, is autobiographical. My own mother was incredible, is incredible, but her mother, because of her trauma, was distinctly horrible as a mother—and shouldn't have been a mother. But a lot of the women in my life have really struggled with this idea of motherhood.

And, interestingly as a newish mother, I can't imagine writing *Apricots* now, for a lot of reasons. The particular traumas in *Apricots*—it's not that I don't understand them but rather that I no longer relate to them in the immediate way that I once did. And I think trying to get inside of them now would be—to continue the theme of trauma—traumatic.

It's an interesting thing about these books that we write. They really have a time, at least for me.

Karen: Tell me, Dalia, what made you decide to put men so much at the heart of your books?

Dalia: It's strange, but I've always felt more comfortable writing from the point of view of male characters. And I've been trying to figure that out. In the first book, I think it's the character of Isaac, really, who is the protagonist, and that character is very much based on my father. What happened to my father was such a seminal event in my life, and I think that in some ways I merged with him at that time. There was this constant quest to understand what he went through and how his life unraveled before him. So having a male protagonist in that book makes sense to me.

Now, Hamid, the protagonist [of *Man of My Time*], is so unusual in so many ways. He came to me as a voice really. I heard him very clearly, and he was very insistent. Different books come from different places. And that one came with a very strong voice—and I went with it.

I am more comfortable writing male characters, but that isn't to say I'm not interested in exploring other aspects of gender, especially how women contend with patriarchy. In the first book, for example, Isaac's wife Farnaz is perhaps not a fully realized person, but that's because she has been so stifled throughout her own life.

For example, she had a beautiful voice as a young woman, but she wasn't allowed to sing (by her father), in public at least. So she marries Isaac and becomes imprisoned in this life that she herself insisted on, which is very based on material things, things that aren't satisfying her in a fundamental way. That is the culture that made her. She's a bit frustrating because she's frustrated.

In *Man of My Time*, I think the women have more agency. There is Minoo; there is Hamid's wife; and there's Hamid's daughter. I think that's also a generational question, as these women are all from subsequent generations.

Gender is something that I want to keep on exploring, especially in terms of my relationship with it as a writer.

Karen: Do you all see your work as speaking to a broader immigrant experience?

Jessica: I feel that I learned really quickly after publishing a book that intention with a book is entirely irrelevant. I work with people now

who are working on novels, and sometimes people will come to it with this idea of what it is they want to get across. I was talking to a woman yesterday, and she's really concerned with sense of self, and she kept insisting on this idea of sense of self. Finally, I had to say, "You just have to let go of that, and whatever it is that you end up writing will be perceived in whatever way it is perceived. And it's entirely not up to you." But, of course, the beauty of literature is the way that we can imagine ourselves in someone else's shoes.

I feel like there are at once two things at play: there's the first bit, which is that intention equals exactly nothing; and then there's the other bit, which is that there's so much opportunity in literature to be part of something, to be part of a world that you would never be a part of.

Joyce: I would say that my story absolutely fits into the larger category of immigrant narratives, and more that broader category than within Jewish narratives. I have gotten responses from people saying, "I saw myself in your story." These people were from completely different backgrounds, some not even immigrant, though many were immigrants.

The book was published in a series of Jewish women's writing; that's the imprint it came out under. So I guess that's what it is, but I never thought about it so much that way.

Karen: What about you, Dalia? I did a search of reviews of *Man of My Time*, and apart from my own review, I didn't see anything specific about the book in terms of its Jewishness.

Dalia: Well, that's because it's not really about anything Jewish. But I agree completely that you don't decide what happens to the book. However, as I see it, my novels are not entirely immigrant stories, because in both books the principal story takes place in Tehran. That's the nucleus of both books, and whatever happens in America is an offshoot of what's happening in Tehran.

I haven't quite made the shift to being here. I'm still very much attached to that principal story. I don't think of the characters who are in America as immigrants necessarily because immigration to me has a kind of agency associated with it.

If you think of the word *immigrare* in Latin, it means "to move into"; there's something positive about it, or at least active. I think of

my characters in America as characters *in exile*; they're people who don't have a home, which suggests a very different state of mind.

In terms of reception: the first book had a Jewish reception as well as a non-Jewish reception, and they were completely different.

Non-Jewish readers just understood it as a novel about a man and about a family unravelling in an unraveling society. But a lot of the Jewish readers zoomed in on the Jewish aspect, like it was a Jewish persecution story. It wasn't. They were comparing it to the Holocaust, which is completely erroneous. In fact, I went out of my way to put my character Isaac in a communal prison, where he's imprisoned with all kinds of people—Muslims, Marxists, Armenians—to really point out the fact that this is not a Jewish persecution story. But it was read in this way.

Again, you can't help how a book will be read; still, that was sort of surprising to me.

Karen: Two of you write extensively about food in your books and include recipes for your readers. Joyce, you link the art of cooking to that of writing: "For several years now," you write, after detailing the process of making stuffed grape leaves, "I have been piecing together this memoir, assembling the fragments of my story and the story of my family, attempting to roll them together into tidy packets, letting them simmer in the juice of my imagination."[18] Jessica, throughout *Tomorrow There Will Be Apricots*, we not only learn about the lives of three generations of foodies, but more significantly, food becomes a metaphor for almost every thought, character, and action. It seems to me that food links the generations and allows you to offer a truly sensuous experience for your readers as you render the smells, tastes, and textures of traditional foods; it also works as an emotional experience. Could you tell me about what *you* see as the role of food in your writing?

Do you want to start us off, Jessica? After all, there's food right in your title.

Jessica: It's funny, the other option for my title was "Day of Honey," which was gobbled up by someone else who published just before me. So it's interesting that there was food language in both potential titles.

I teach a food writing class, and one of the first things that we do is we talk about our first memories, and it's probably unsurprising

that nine out of ten people's first memory is tied up with food. So of course food is sort of the most . . . *the most*. At least for me! A lot of religion fell away when my dad came to the US because it was too painful to revisit religion in the way that it had been engaged with when he was in Iraq. When he came to the US, food became, culturally, his religion. So there was so much about maintaining these recipes that had been in his family for many years.

My strongest memories are from being at my aunt's house, my dad's sister's house, in Roslyn, Long Island, and eating the delicious food of their culture. It just felt like if I were going to write about his culture, I would have to write about it through food. In certain ways, it's the easiest writing that I know. When I write about food, it's really, really natural.

As a first-time novelist, it just happened. This next book has very little food overtly, but it's never, never not about food!

Joyce: I don't know why food played such a big role in my book. Certainly, it played a big role in my life. My mother was an extraordinary cook, and we did have these amazing Egyptian feasts. Food—and language—were for them the primary ways of staying connected to their culture, to their lives in Egypt.

My relationship with food was a conflicted one because when I was growing up, I refused to learn how to cook. I didn't want to cook because cooking would mean living a life like my mother's, and I didn't want to live that life.

There was this crazy irony: when I was in my twenties, I got hired to write a cookbook. I was in New York, and I was working for the men who wrote the Underground Gourmet column in *New York* magazine. I was typing the column for them. Then they suggested that I do a cookbook of recipes from New York restaurants they had reviewed.

I resisted doing it because I didn't want to be spending my time cooking. At the same time, it was an opportunity to write a book. So I did it, and it turned out to be an incredible, terrific experience for me. I walked around New York talking to all kinds of immigrant chefs from all different countries, and that's how I learned how to cook. I learned how to cook from them and learned to love cooking from that. So that entered into my memoir. As for the recipes at the

end of the book . . . I did not want them there. The publisher wanted the recipes in the book. I thought it was a silly idea. I thought it was trivial. I thought it was taking away from the seriousness of the book and that it was making it sort of folkloric, so I didn't want to do that. They persuaded me to do it, and I'm happy enough that that's the way the book ended up. I now turn to the book for the recipes because they're my mother's recipes, and I forget them. So I open up the book, and I make them. Also, I know people have enjoyed that aspect of the book, and I'm okay with it, but it wasn't my idea at all, at all. It was my idea to talk about the role of food and cooking in my life but not to do it that way.

Karen: There are a lot of books that end with recipes. Like Jessica's! And other books about Egyptian Jewry, like Colette Rossant's *Apricots on the Nile* [subtitled *A Memoir with Recipes*].

Joyce: It was a moment when such books were coming out, and so they thought they would capitalize on it.

Karen: Shall we end with what stories you hope to tell next?

Dalia: I'm working on something that isn't buttressed by a place of origin. I'm trying to enter a space of absence, be in the presence of exile, and explore what that means.

At some point I hope to tackle that whole Iraqi thread that I've read about and heard so much about through my father. But that perhaps is in the distant future.

Karen: Jessica, you've just finished a draft of something.

Jessica: I've always been really interested in craft and . . . I don't know if I want to say alternative styles, but I love weird books. I've always really liked stylistically strange books. I wrote one previously, and I couldn't make it work. I spent six years on it, and I could never make it work.

This one is a bit more traditional and therefore, hopefully, a bit more publishable. I don't know. But it's funny. I no longer feel I would even be able to write a traditional novel anymore. So, looking at *Apricots*, it's surprising. I don't know how I did it. And yet these things happen.

Karen: Joyce? Is there fiction in your future?

Joyce: I don't know. I always thought perhaps one day there would be, but so far there hasn't been. Mostly now I'm interested in translation,

and I'm very interested in translating Arab Jewish writing that has not come into English consciousness. So right now, I'm working on a Moroccan Jewish writer, Edmond El Maleh, who is really extraordinary and very highly regarded in Morocco, but none of his books have been translated.

There are more books, more Egyptian Jewish books that were written in French that I think need to be in English. There's a vast field of stuff out there, and I feel like it's part of my mission to try to bring it into broader circulation.

Dalia: Joyce, are you translating books that were originally written in French or in Arabic and then translated into French?

Joyce: These are books that were written in French. There's a whole field of books written in Arabic that remain to be translated, particularly some Iraqi writers. It's very slow getting them into English. There are also many Mizrahi books in Hebrew that need to be translated into English. But back to the issue of Ashkenormativity—it's everywhere. It's everywhere. In the publishing industry, it's really hard to get these other voices represented.

Part of what I was trying to do in my book was not just to tell my story but also to tell my family's story and to *learn* my family's story. They had not really told it to me, because there was that silence that is so common in families that have been torn away from their culture. So I also saw myself as documenting that history and bringing that history into play in the world.

Notes

1 Jessica Soffer, *Tomorrow There Will Be Apricots* (London: Windmill Books, 2013), 25.
2 Soffer's description of learning to partake in Ashkenazi culture in the United States has a long echo. In 1910, Moise Gadol, who founded the first American Ladino weekly newspaper, *La America*, published for his Sephardic compatriots a helpful guide titled *Livro de embezar las linguas ingleza i yudish* (The book for learning the English and Yiddish languages).
3 Like all such catchall terms, "Mizrahi," "Sephardi," and "Ashkenazi" are imprecise and historically unstable. The former two terms serve most

fruitfully in contradistinction to the latter term. See Saba Soomekh, ed., *Sephardi and Mizrahi Jews in America* (West Lafayette, IN: Purdue University Press, 2016), ix–x; and Devin S. Naar, "'Sephardim since Birth': Reconfiguring Jewish Identity in America," in Soomekh, *Sephardi and Mizrahi*, 75–104. For an in-depth study of Israeli Mizrahi literature, see Gil Hochberg, *In Spite of Partition: Jews, Arabs, and the Limits of Separatist Imagination*. Princeton, NJ: Princeton University Press, 2007.

4 Though they primarily came from Eastern Europe during this time, Jews also came from Syria, Turkey, and the Balkans, and Bryan Kirschen writes about the "booming" Judeo-Spanish printing press in New York City and, to a lesser degree, Los Angeles, in the early twentieth century. Kirschen, "Diglossic Distribution among Judeo-Spanish-Speaking Sephardim in the United States," in Soomekh, *Sephardi and Mizrahi*, 25.

5 Of course, Sephardic Jews have a long history in the United States, and resonances of the early Sephardic immigrant populations abound. In Rhode Island, for example, one can visit the oldest synagogue in the United States, the Spanish and Portuguese Touro Synagogue, built in the mid-eighteenth century. Moreover, the words of the most famous Sephardic American, Emma Lazarus, a nineteenth-century poet descended from Portuguese Jews, are inscribed on the pedestal of the Statue of Liberty.

6 See Dalia Kandiyoti, "What Is the 'Jewish' in 'Jewish American Literature'?," *Studies in American Jewish Literature* 31, no. 1 (2012): 48–60.

7 Kahanoff was finally given her due as an important writer only in 2022, when the *New York Times* included her in Overlooked No More, its "series of obituaries about remarkable people whose deaths, beginning in 1851, went unreported in the *Times*." "Jacqueline Shohet Kahanoff, Writer of Levantine Identity," *New York Times*, April 16, 2022.

8 Neither Nahai's nor Aciman's first books touched American soil, but that geographical remoteness would disappear from later works. In addition to his memoir, Aciman has written several novels, including *Call Me by Your Name* (New York: Farrar, Straus & Giroux, 2007), a story of intimacy between two Jewish men (one Italian, one American). In *Harvard Square* (New York: W. W. Norton, 2013), Aciman again pairs two men, this time two Arabs in the United States (one Jewish, one Muslim) to act as unusual narrative doppelgängers. On the latter, see Joyce Zonana, "'Entra Omri: You Are My Life': Embracing the Arab Self in Andre Aciman's *Harvard Square*," *Studies in American Jewish Literature* 35, no. 1 (2016): 35–51. Zonana also does an excellent job of demonstrating the way that Aciman's articulation of "Jewish" is coded male (36–37).

9 Dalia Sofer, *Man of My Time* (New York: Farrar, Straus & Giroux, 2020), 168, 99. For a Jewish reading of *Man of My Time*, see Skinazi, "'We've Been Here for Two Thousand Years.': Dalia Sofer's Novel of Post-revolutionary Iran," *Jewish Journal*, December 3, 2021.
10 Gina Nahai, "Becoming American," in Soomekh, *Sephardi and Mizrahi*, 135.
11 Tobie Nathan, *A Land Like You*, trans. Joyce Zonana (London: Seagull Books, 2020), 343. Nathan is French, but by translating his work and publishing her translation with University of Chicago Press, Zonana brings the novel into the American context.
12 Lucette Lagnado, *The Man in the White Sharkskin Suit* (New York: HarperCollins, 2007), 207.
13 Khazzoom is the founder of the Jewish Multicultural Project, an organization dedicated to working with Jewish institutions to raise awareness about Jewish diversity.
14 Loolwa Khazzoom, ed., *The Flying Camel: Essays on Identity by Women of North African and Middle Eastern Jewish Heritage* (New York: Seal Press, 2003), x.
15 Khazzoom, xi.
16 Joyce Zonana, *Dream Homes: From Cairo to Katrina, an Exile's Journey* (New York: Feminist Press, 2008), 125.
17 Sofer, *Man of My Time*, 168.
18 Zonana, *Dream Homes*, 26.

Bibliography

Aciman, André. *Call Me by Your Name*. New York: Farrar, Straus & Giroux, 2007.

———. *Harvard Square*. New York: W. W. Norton, 2013.

———. *Out of Egypt: A Memoir*. New York: Picador, 1994.

Ben-Ur, Aviva. *Sephardic Jews in America: A Diasporic History*. New York: New York University Press, 2009.

Hochberg, Gil Z. *In Spite of Partition: Jews, Arabs, and the Limits of Separatist Imagination*. Princeton, NJ: Princeton University Press, 2007.

Kandiyoti, Dalia. "What Is the 'Jewish' in 'Jewish American Literature'?" *Studies in American Jewish Literature* 31, no. 1 (2012): 48–60.

Khazzoom, Loolwa, ed. *The Flying Camel: Essays on Identity by Women of North African and Middle Eastern Jewish Heritage*. New York: Seal Press, 2003.

Kirschen, Bryan. "Diglossic Distribution among Judeo-Spanish-Speaking Sephardim in the United States." In Soomekh, *Sephardi and Mizrahi*, 25–52.

Lagnado, Lucette. *The Arrogant Years: One Girl's Search for Her Lost Youth, from Cairo to Brooklyn*. New York: Ecco, 2012.

———. *The Man in the White Sharkskin Suit: A Jewish Family's Exodus from Old Cairo to New World*. New York: HarperCollins, 2007.

Nahai, Gina B. "Becoming American." In Soomekh, *Sephardi and Mizrahi*, 131–40.

———. *Caspian Rain*. San Francisco: MacAdam/Cage, 2008.

———. *The Cry of the Peacock*. New York: Crown, 1992.

———. *The Luminous Heart of Jonah S*. Brooklyn, NY: Akashic Books, 2014.

———. *Moonlight on the Avenue of Faith*. New York: Washington Square Press, 2000.

Nathan, Tobie. *A Land Like You*. Trans. Joyce Zonana. London: Seagull Books, 2020.

Naar, Devin S. "'Sephardim since Birth': Reconfiguring Jewish Identity in America." In Soomekh, *Sephardi and Mizrahi*, 74–105.

Nechin, Eitan. "Overlooked No More: Jacqueline Shohet Kahanoff, Writer of Levantine Identity." *New York Times*, April 16, 2022.

Rossant, Colette. *Apricots on the Nile: A Memoir with Recipes*. New York: Bloomsbury, 2001.

Shohat, Ella. "Dislocated Identities: Reflections of an Arab Jew." *Movement Research* 5 (1991/2): 8.

Shohet, Jacqueline. *Jacob's Ladder*. London: Harville, 1951.

Skinazi, Karen E. H. "'We've Been Here for Two Thousand Years': Dalia Sofer's Novel of Post-revolutionary Iran." *Jewish Journal*, December 3, 2021.

Sofer, Dalia. *Man of My Time*. New York: Farrar, Straus & Giroux, 2020.

———. *The Septembers of Shiraz*. New York: Picador, 2007.

Soffer, Jessica. *Tomorrow There Will Be Apricots*. London: Windmill Books, 2013.

Soomekh, Saba, ed. *Sephardi and Mizrahi Jews in America*. West Lafayette, IN: Purdue University Press, 2016.

Starr, Deborah and Sasson Somekh, eds. *Mongrels or Marvels: The Levantine Writings of Jacqueline Shohet Kahanoff*. Stanford, CA: Stanford, 2011.

Zonana, Joyce. *Dream Homes: From Cairo to Katrina, an Exile's Journey.* New York: Feminist Press, 2008.

———. "'*Entra Omri,* You Are My Life': Embracing the Arab Self in André Aciman's *Harvard Square.*" *Studies in American Jewish Literature* 35, no. 1 (2016): 35–51.

CONTRIBUTORS

Annie Atura Bushnell is the executive director of academic programs at the Center for Comparative Studies in Race & Ethnicity at Stanford University. Her work has recently appeared in the *Journal of the American Psychoanalytic Association* and *Studies in American Jewish Literature*.

Jennifer Glaser is an associate professor of English and affiliate faculty in Women's, Gender, and Sexuality Studies and Judaic Studies at the University of Cincinnati. She is the author of *Borrowed Voices: Writing and Racial Ventriloquism in the Jewish American Imagination* and book review editor of *Studies in American Jewish Literature*. She has published work in *PMLA*, *MELUS*, *ImageText*, the *Los Angeles Review of Books*, the *New York Times*, the *Forward*, *Miracle Monocle*, and an anthology of essays from Random House.

Lori Harrison-Kahan is a professor in the Department of English at Boston College. She is the author of *The White Negress: Literature, Minstrelsy, and the Black-Jewish Imaginary* and editor of *The Superwoman and Other Writings by Miriam Michelson*. She coedited a reissue of Emma Wolf's 1900 novel, *Heirs of Yesterday*, and the Penguin Classics edition of Elizabeth Garver Jordan's writings titled *The Case of Lizzie Borden and Other Writings: Tales of a Newspaper Woman*.

Jessica Kirzane is an assistant instructional professor in Yiddish at the University of Chicago. She is the editor in chief of *In geveb: A Journal of Yiddish Studies* and translator of three works by Yiddish author Miriam Karpilove: *Diary of a Lonely Girl, or The Battle against Free Love*; *Judith: A Tale of Love and Woe*; and *A Provincial Newspaper and Other Stories*.

Josh Lambert is the Sophia Moses Robison Associate Professor of Jewish Studies and English and director of the Jewish Studies Program at Wellesley College. He is the author of the books *Unclean Lips* and *The Literary Mafia* and coeditor of *How Yiddish Changed America and How America Changed Yiddish*. His book reviews and essays have appeared recently in the *New York Times Book Review*, *Jewish Currents*, and *Lilith*.

Tahneer Oksman is an associate professor in the Department of Writing, Literature, and Language, with a joint appointment in the Department of Communication and Media Arts, at Marymount Manhattan College in New York City. She is author of *"How Come Boys Get to Keep Their Noses?": Women and Jewish American Identity in Contemporary Graphic Memoirs* and coeditor of *The Comics of Julie Doucet and Gabrielle Bell: A Place Inside Yourself* as well as *Feminists Reclaim Mentorship: An Anthology*. Her writing on memoir and graphic novels and comics has been published in the *Believer*, the *Comics Journal*, the *Guardian*, *Los Angeles Review of Books*, NPR, *Paper Brigade*, *Public Books*, and the *Washington Post*. Currently she is writing a book about grief memoirs and why people read and write them.

Rachel Rubinstein is a professor and dean of the School of Arts and Sciences at Springfield College. She is the author of *Members of the Tribe: Native America in the Jewish Imagination* and coeditor of *Arguing the Modern Jewish Canon: Essays on Literature and Culture* and *Teaching Jewish American Literature*. Her book reviews, translations, and essays have appeared most recently in *AJS Review*, *In geveb*, and in the volumes *Caribbean-Jewish Crossings: Atlantic Literature and Theory* and *Jews Across the Americas: A Sourcebook, 1492–Present*.

Karen E. H. Skinazi is a senior lecturer at the University of Bristol. She is the author of *Women of Valor: Orthodox Jewish Troll Fighters, Crime Writers, and Rock Stars in Contemporary Literature and Culture* and the editor of a special issue of *Shofar* on the art and feminism of Orthodox and Haredi Jewish women. She also published a critical edition of the 1916 novel, *Marion: The Story of an Artist's Model*, by the first Asian North American novelist, Winnifred Eaton (Onoto Watanna). Her current research examines the productive interface between contemporary Muslim and Jewish women's lives, literature, and activism.

Alex Ullman is a graduate student in the Department of English at the University of California Berkeley and a 2023–24 Dissertation Fellow at Berkeley's Townsend Center for the Humanities.

Ashley Walters is an assistant professor of Jewish studies at the College of Charleston and director of the Pearlstine/Lipov Center for Southern Jewish Culture. She is currently working on a monograph titled "Intimate Radicals: East European Jewish Women and Progressive American Desires."

INDEX

Note: Page numbers appearing in *italics* refer to photographs.

Aarons, Victoria, 10
abortion, 49–50, 261
Aciman, André, 356, 359, 370n8
Acker, Bob, 276, 289n80
Acker, Kathy, 258–59, 266, 275–76, 279, 285n37, 287n48, 289n80, 290n86. See also *After Kathy Acker* (Kraus)
adolescence, prolonged, 254, 282n14
African American themes: in *Black Souls*, 79–88; in "The Shoe Pinches Mr. Samuels," 90–91, 93–94
After Kathy Acker (Kraus), 273–77, 279, 282n18
Aftermath (Burrill), 81
"Age of Sophistication," 113
Alcoff, Linda, 208n14
Aleichem, Sholom, 151, 156
Aliens & Anorexia (Kraus), 267, 272
Allan, Lewis (Abel Meeropol), 100n48
Allegra, Donna, 186, 191, 205
"All K" (Lil Dicky), 284n28
allyship: and *Black Souls*, 73–89; and "The Shoe Pinches Mr. Samuels," 89–95. See also Lorde, Audre; Rich, Adrienne
alternative literary genealogies, 167–68, 251–80. See also matrilineage
American Dirt (Cummins), 71
American Mercury, 115–16

American Yiddish Poetry: A Bilingual Anthology (Harshav and Harshav), 174n55
Anderson, Marian, 82
Angoff, Charles, 154
anti-Blackness, 74, 86, 89, 93, 94, 95, 103n70, 104n77, 204
anti-lynching literature: *Black Souls*, 73–89; Jewish-authored, 99n24; reception of, 98n23; sexual violence in, 74, 80, 90, 91, 102n66, 103n67; "The Shoe Pinches Mr. Samuels," 89–95
Antin, Eleanor, 258–59
Antin, Mary, 10–11, 37
antisemitism, 6, 11, 12, 13, 30, 115, 135n21, 200, 204, 218n83, 256, 257, 261, 266, 267, 271, 275, 289n85, 298–99, 300, 307, 330, 334; German Jewish prejudice against Eastern European Jews, 122–24; and January 6 Capitol insurrection, 95, 104n77; Kitaj's art as antisemitic, 262; and Kraus's formative years, 254; in Kraus's works, 260, 283n21; and lynching in "The Shoe Pinches Mr. Samuels," 92–94; in Progressive Era, 44–45; recent events charged by, 95
anti-suffrage movement, 6, 39, 75

Antologye di yidishe dikhtung in amerike biz yor 1919 (Landau), 170n18
Antologye: Finf hundert yor yidishe poezye (Bassin), 170n18
appropriation, 71–73; and *Black Souls*, 73–89; in *The Diary of a Shirtwaist Striker*, 42; and Rich's engagement with blackness, 203–4, 217nn79–80; and "The Shoe Pinches Mr. Samuels," 89–95
art, financing, 265–77, 279
Asch, Sholem, 172n30
Ashkenormativity, 14, 57n10, 75–76, 356, 359, 369
Astraea Foundation, 185. See also "Poets in Conversation" reading
Aubry, Timothy, 246n30
Auden, W. H., 215n61
"Aunt Jennifer's Tigers" (Rich), 198–99
autofiction, 4, 13, 251, 258, 260, 266, 273
autotheory, 252, 262–63, 273, 281n4
Avery, Evelyn, 8

Babich, Babette, 235
bad Jewishness, 256–61
Bailey, Blake, 3
Baldwin, James, 204
Bantha, Martha, 117
Barnard College: founding of, 73, 75; integration of, 82
Barzilai, Maya, 296–97, 299, 306, 307, 320n57
Bassin, Morris, 170n18
Baudrillard, Jean, 263, 286n40
Belzer, Tobin, 245n27
Benjamin, Mara, 171n29
Ben-Ur, Aviva, 75
Berger, Joseph, 175n62
Bergman, Jess, 235, 236
"Best Husbands, The" (Spitzer), 119–20
biography, 3, 4, 7, 13, 18n3, 97n12, 174n56, 204, 235, 245n22, 255, 265, 276, 303

birth control movement, 48–49, 62n61
Biss, Eula, 314–15
Black and Jewish political alliance, 189–90. See also Lorde, Audre; Rich, Adrienne
Black-Jewish relations, 71–95, 187–88. See also Lorde, Audre; Rich, Adrienne
Blackness: appropriation and Rich's engagement with, 203–4; historical linkages between Jewishness and, 78–79, 80–81; white women's engagement with, 185–225. See also allyship; anti-lynching literature; appropriation; reception
Black Power movement, 189, 210n20
Black prophetic tradition, 205
Black soldiers, 80–81
Black Souls (Meyer), 73–89, 101n50, 101n52, 103n70
Black Unicorn, The (Lorde), 185–86. See also "Poets in Conversation" reading
Bornstein, George, 52
Bornstein, Kate, 17
Botshon, Lisa, 126, 127
Bowles, Jane, 258–59, 284n31
Bread Givers (Yezierska), 122
breakthrough narrative, 4–5, 12. See also *Divorcing* (Taubes); *Fear of Flying* (Jong)
Broder, Melissa, 300. See also *Milk Fed* (Broder)
Brodesser-Akner, Taffy, 2, 17n2
Broner, E. M., 2
Browder, Laura, 63n72
Brown, Bill, 348n22
Brownmiller, Susan, 240
Buchman, Harry, 341
Buchman, Mollie, 341
Bulkin, Ellie, 190
Burke, Tarana, 227
Burrill, Mary Powell, 81, 83
Burstein, Janet, 8
Burstin, Hinde, 152
Butler, Judith, 17

Cahan, Abraham, 285n34
canonicity, in Yiddish literature, 147–48
Can't We Talk about Something More Pleasant? (Chast), 325–28; ambivalence to grieving in, 339–40; anxious energy in, 331, 347n16; Chast's grief connected to parents' grief in, 336–37; and Chast's outsider status, 337–39; epilogue to, 341–43; format of, 344n5; omissions and disclosures of author's parents in, 328–35; reception of, 344n1, 344–45n7
Cardozo, Benjamin, 76
care work, 6–7, 11, 49, 50, 310, 326–28, 333, 344nn6–7
Carney, Mabel, 101n53
Carruthers, Cathy, 208n14
Celan, Paul, 318n26
Chapman, John, 85
Chari, Anita, 211n28
Charney, Shmuel, 152
Chast, Roz: early works published in *New Yorker*, 348n24; outsider status of, 337–39. See also *Can't We Talk about Something More Pleasant?* (Chast)
child labor, 33, 47, 48, 49
childlessness, 260–61
children's literature, 14, 16
Chrysalis, 189, 209n17
civil rights, 81–82, 94, 204. See also golem
Civil War, 7, 78, 79
Clare, Eli, 315, 319n44
Cohen, Madeline, 159, 160
Coleridge, Samuel Taylor, 218n87
colonial Sephardim, 97n13
colorism, 78–79
Combahee River Collective, 210n23
comedy, 111, 162, 186, 254–55, 257, 258, 280, 284n24, 285n37, 305, 330, 331, 334
comic novel, 13, 236–37
Conley, Jim, 94

contraception, 48–49, 62n61
conversation: cultural fascination with, 191; between Mizrahi Jewish women writers, 355–69; Rich and Lorde's meta-conversation about, 192, 213nn39–40; as signal term for Rich and Lorde's poetics, 192–93. See also "Poets in Conversation" reading
Cosella Wayne (Wilburn), 8
cosmopolitanism, 113, 289n85
counterpublics, queer, 205
Couser, G. Thomas, 349n37
Crane, Stephen, 314
cremation, 349n39
"crip time," 315
Crisis, The (periodical), 73, 80, 85, 89, 101n52
Crumb, Aline Kominsky, 13
Cry of the Peacock (Nahai), 356
"cult of domesticity," 35, 121
Cummins, Jeanine, 71
Cusk, Rachel, 258, 346n12
"Cycle of Manhattan, A" (Winslow), 116

Davis, Rebecca Harding, 36
Davis, Vanessa, 13
"Death Fugue" (Celan), 318n26
De Veaux, Alexis, 194–95, 218n83
Dewey, John, 54
Diamant, Anita, 2
"Diamond Cutters, The" (Rich), 217n79
Diary of a Lonely Girl (Karpilove), 160–64, 167, 177n78
Diary of a Shirtwaist Striker, The (Malkiel), 29–31, 38–46
Didion, Joan, 335, 346n11
Diner, Hasia, 94
disability: class and, 317n18; in *Golem Girl*, 309–15; in Jewish studies, 298–99; metaphors, 315
disability studies, 297–98; fatness in, 302–3, 318n31; importance of golem for, 299–300

dissent, 6–10, 17, 54. *See also* rebellion; resistance, of Jewish women
Divorcing (Taubes), 228–36, 242
"Di yidishe literature un di lezerin" (Charney), 152
Dollinger, Mark, 189, 210n20, 210n22
Dolly Sisters, The (Spitzer and Larkin), 126, 127, 140n86
drama, 11, 73, 80, 82–83, 85, 94, 98n24, 127–28, 134, 150
Dream Homes (Zonana), 358, 359, 362
Dropkin, Celia, 170n18, 174n55
Du Bois, W. E. B., 83, 85, 88–89, 100n45, 101n50
Dudley, John, 59n33
Dunbar-Nelson, Alice, 80–81, 83, 90
Dunham, Lena, 2, 254

Eastern European Jews: contrast between Spitzer and, 114–15, 127; German Jewish prejudice against, 122–24; as immigrants, 7, 14, 122–24, 356; and Jewish American manthology, 153–54; and Jewish women's proletariat fiction, 29–31, 33–35, 38, 44, 45, 46, 51, 57nn10–11; Zionist Jews as stand in for, 299. *See also* Ashkenormativity
Egyptian Jews, 356, 357, 358, 359, 362, 367–68
entertainment industry: in *A Hungry Young Lady*, 129–32; and women's employment, 135n4
epistolary novels, 160–68. *See also I Love Dick* (Kraus)
ethnicity: eschewing of, in Spitzer works, 121–28, 133; in Ferber's works, 134; interethnic communities, 31; interethnic recognition, 52; Jewishness as, 298; and Jews in publishing industry, 275; social status and perception of, 141n100; Spitzer's self-presentation as emerging from, 114, 117; in Yezierska's works, 134, 141n100

ethnic studies, 9, 10
ethnoracial displacement, in Jewish women's proletariat fiction, 31–32, 53–55, 57n11. *See also Diary of a Shirtwaist Striker, The* (Malkiel); *Woman Who Wouldn't, The* (Stokes)
"eugenic Atlantic, the," 298, 315n13
eugenics, 48, 298, 311–12

family trauma, disclosed in *Can't We Talk about Something More Pleasant?*, 329–35
Farmer, Joyce, 347n19
fatness: in disability studies, 302–3, 318n31; in *Milk Fed*, 302, 306
Fear of Flying (Jong), 236–42, 246n28, 246n30, 319n34
Feinberg, Leslie, 17
Feldman, Keith, 187–88
Felski, Rita, 237
Feminine Mystique, The (Friedan), 239–40
feminism: and *Black Souls*, 75; *I Love Dick* as manifesto for new kind of, 253; intersectional, 4, 75, 189, 210n23; Kraus on, 259; and reception of *Fear of Flying*, 237, 239–40; reinterpretation of Yiddish literature, 169n9; in *Who Would Be Free*, 121–28
feminist, 6, 13, 30, 38, 75, 121–28, 161, 210n23, 237, 239, 244n4, 253, 256, 259–60, 269, 285n33
Ferber, Edna, 72, 133–34
Ferrante, Elena, 258
Fields, W. C., 111, *112*
financing art, 265–77, 279
Finck, Liana, 15–17
Fink, Leon, 51
Finkin, Jordan, 156
Fishbein, Leslie, 127
Fisher, Anna Watkins, 266, 270
Fisher, Harrison, 138n35
Fleishman Is in Trouble (2022), 14, 17n2
Flying Camel, The (Khazzoom), 357–58

food: in *Milk Fed*, 301, 302; in Mizrahi Jewish women's works, 366–68
Forms of Talk (Goffman), 191
Foucault, Michel, 317n22
Found Treasures: Stories by Yiddish Women Writers (Forman et al.), 158
Fowler, Kathleen, 345n8
Frank, Anne, 218n83
Frank, Leo, 93–94
Frankel, Jonathan, 34
Frankenstein (Shelley), 308, 317n23
Freedman, Jonathan, 72
free love, 161, 162–64
Freud, Sigmund, 300
Friedan, Betty, 239–40
Friedberg, Beyle, 176n69

Gadol, Moise, 369n2
Garber, Linda, 208n14
Gay, Roxane, 317n22
Gelbin, Cathy, 289n85, 296, 300
gender inequality: in *The Diary of a Shirtwaist Striker*, 40–41, 42–43; and historical context of *The Woman Who Wouldn't*, 47; Malkiel and, 39; and marriage, 51; Stokes and, 51; and Yiddish literature, 147–49, 151–53, 154, 155–56, 157
gender norms: rebellion against, in *Diary of a Lonely Girl*, 163–64; rebellion against, in *A Hungry Young Lady*, 128–32; rebellion against, in *Who Would Be Free*, 121–28; spurned by Jewish immigrant women, 32; and writing in industrial America, 59n33
genealogies: alternative literary, 167–68, 251–80; matrilineal, 6–10, 258, 259
German Jews: Acker as, 276, 289n80; and modernization of German society, 300; in Spitzer's early magazine fiction, 115–21; in Spitzer's works, 122–24
ghetto fiction, 31, 32, 37, 123, 125, 127, 134

Gilman, Sander, 289n85
Gilmore, Leigh, 242
Ginsburg, Ruth Bader, 6
Girls (2017), 2
Glaser, Jennifer, 72, 203
Glatshteyn, Yankev, 157, 170n18
Glenn, Susan, 34
Glikl of Hameln, 161
Glück, Louise, 18n8
God: Katherine's faith in, in *The Woman Who Wouldn't*, 52–53; in *Let There Be Light*, 15–16. *See also* prophetic poetry
"God of Mercy" (Molodowsky), 157, 164, 174n54
Goffman, Erving, 191, 192
Goldberg, Isaac, 172n30
Golden Peacock, The (Leftwich), 154
Goldstein, Benjamin, 94
golem: and disability studies, 299–300; female, in recent fiction, 297; in *Golem Girl*, 308–15; in *Milk Fed*, 301–8; reinvention of, by Jewish women writers, 296–97; as symbol of Jewish decadence and deviance, 300; as transnational and transhistorical symbol, 296
Golem Girl (Lehrer), 308–15
Goodbye, Columbus (Roth), 305
Gordon, Michelle Y., 303
Gordon, Peter, 276–77
Grant, Madison, 44
graphic narrative, 1, 4, 13, 15, 21n21, 344nn6–7, 347n19, 349n37
Gravity & Grace (1996), 259, 267, 287n49
Greatest Moments in a Girl's Life, The (Fisher), 138n35
Green, Gayle, 237
Greenberg, Eliezer, 153–54, 155, 156
Greenwich Village, 48, 51, 115, 121, 124, 125, 126
Gregory, Montgomery, 88

grief and grief memoirs, 327–28, 332–35, 345n8, 346n11, 347n19. See also *Can't We Talk about Something More Pleasant?* (Chast)
Grimké, Angelina Weld, 80, 83, 90, 103n68
Grimsted, Kristen, 209n17
Gross, Terry, 344n7, 348n26

Hadassah-Brandeis Institute's Conversations Series, 15
Halliday, Lisa, 17n3
Halpern, Nick, 203
Hammerschlag, Keren Rosa, 257–58
Hammill, Faye, 113, 114, 117
Hanna, Kathleen, 282n19
Hapgood, Hutchins, 37
Haredi, 15
Harlem Renaissance, 81
Harris, Kamala, 7
Harrison-Kahan, Lori, 37, 141n100
Harshav, Barbara, 174n55
Harshav, Benjamin, 174n55
Harvey, Paul, 44
Haskalah, 151, 157
He, She and It (Piercy), 306
Hebdige, Dick, 252
Hebrew, 14, 150, 167, 295, 308, 314, 369
Hefner, Brooks E., 140n76
Heifetz-Tussman, Malka, 174n55
Hellerstein, Kathryn, 150, 151, 152–53, 164, 175n59
Herndon, April, 303
Heti, Sheila, 258, 272, 281n9, 285n37
Heumann, Judy, 298
highbrow modern writing, 133
Hill, Abram, 101n52
Hirschfeld, Magnus, 300
Holiday, Billie, 100n48
Holladay, Hilary, 198
Holmes, John Haynes, 86–87
Holocaust, 198, 218n83, 254, 283n21, 298, 329, 366

Holocaust literature, 22n23, 257, 318n26
Hood, Jay, 246n30
Horn, Dara, 2
Horowitz, Rosemary, 158
Howe, Irving, 153–54, 155, 156–57, 164, 174nn53–54
How Should a Person Be? (Heti), 285n37
Hughes, Langston, 81
Hungry Hearts (film, 1922), 127
Hungry Hearts (Yezierska), 126–27
Hungry Young Lady, A (Spitzer), 128–32, 140n88
Hurst, Fannie, 72, 82
Hurston, Zora Neale, 82, 83–84

I Am a Woman—and a Jew (Stern), 55
identity politics, 71, 189–90, 210n23
Illingworth, Dustin, 235
I Love Dick (2016 adaptation), 284n23
I Love Dick (Kraus): as feminist text, 253; and financing art, 265–73; form-breaking quality of, 253, 281n9; genre of, 284n24; and Kraus's bad Jewishness, 256–61; Kraus's "independent poverty" in, 278–79; race in, 253–54; reception of, 255, 267, 288n54; scholarship on, 256–57, 258; themes and influence of, 254–55
Imhoff, Sarah, 297–98, 299
"independent poverty," 278–79
In geveb: A Journal of Yiddish Studies, 159–60, 176n68
intergenerational trauma, 15, 74, 329, 333
intermarriage, 8, 55, 117–18, 120, 135n14, 137n32
interracial relations, 21n21, 54, 82, 85, 86, 100n48, 187, 188–89, 190
intersectional feminism, 4, 75, 189, 210n23
In zikh: A zamlung introspective lider (Glatshteyn et al.), 170n18
Iranian Jews, 356, 357, 358, 360–61
Iraqi Jews, 355, 358, 359–60, 367

Irish immigrants, in *The Woman Who Wouldn't*, 51–52
Israel: as golem in *Milk Fed*, 307; Mizrahim in, 355
Italian immigrants, in *The Diary of a Shirtwaist Striker*, 45–46
It's Been Fun (Meyer), 76, 80, 88, 101nn52–53

Jazz Singer, The (1927), 72
Jenkins, Henry, 347n19
"Jewess," 6, 76, 79, 255, 257–58
Jewish American literature: audience of, 15; breakthrough narrative regarding, 4–5; "golden age" of, 1, 5, 10, 12, 18n5, 258, 259; new developments in, 9–10; reframed as matrilineal, 7; representations of racial others in, 32, 72, 73, 258 (see also *Black Souls* [Meyer]; "Shoe Pinches Mr. Samuels, The" [Meyer]); scholarship on, 8–10, 14–15, 20n15, 52, 54–55, 63n72, 72, 88, 95, 127, 141n100, 187–88. *See also* Yiddish literature
Jewish identity: of Chast, 337–39; of Kraus, 253–54
Jewish immigrants: antisemitism against, 44–45, 122–24; challenges facing, 33; Eastern European Jews as, 7, 14, 122–24, 356; in *A Jewish Refugee in New York*, 165–66; and labor organizing, 34; working conditions of, 33–34
Jewish modernity, rewriting, from women's perspectives, 167–68
Jewishness: advancement of teleological narrative of American, 5; as aligned with whiteness, 72, 73; bad, 256–61; as central to discourse on disability, 298; Chast's complicated relationship to, 337–39; displaced by Jewish women authors, 31, 32, 45; and grief in *Can't We Talk about Something More Pleasant?*, 327–28; historical linkages between Blackness and, 78–79, 80–81; intertwining of femininity and middlebrow and, 12; Meyer's relationship to, 75; in race and ethnic studies, 9; refusal to discuss, in *Can't We Talk about Something More Pleasant?*, 332; relationship between Americanness and, 76

Jewish parental figures: in *After Kathy Acker*, 277; in *The Diary of a Shirtwaist Striker*, 40–41, 42; in *I Love Dick*, 265; and rebellion in *Who Would Be Free*, 121–22; and Spitzer's critique of marriage in Reform Jewish community, 118–19; in Spitzer's works, 117; in *The Woman Who Wouldn't*, 50, 52–53. *See also Can't We Talk about Something More Pleasant?* (Chast); motherhood
Jewish power, 272, 275
Jewish prophetic tradition, 204–5
Jewish publishing industry, 37–38
Jewish Refugee in New York, A (Molodowsky), 160–61, 164–67, 178n84
Jewish studies, 256–57; canonization of, 5; decolonizing, 4; disability in, 298–99, 315; and #MeToo movement, 243n1; non-Ashkenazi experiences within, 75; and "Precarious-Girl Comedy," 254–55
Jewish women: Asian American, writers, 21n21; engagement with Blackness, 71–109; and feminist activism, 13; influence on literary culture, 4; interest in social issues, 11; participation in elite magazine culture, 16n20, 133–34; political engagement of, 6–10, 34–35, 53–54. *See also* allyship; anti-lynching literature; appropriation; reception
Jewish Women's Archive (JWA), 15, 63n72

Jewish Women's Archive Book Talks, 15
Jewish women's literature: allusive gestures in, 2; Ashkenormativity of, 14; audience of, 15; contribution to Holocaust literature, 22n23; interracial partnerships in, 21n21; and middlebrow designation, 12; new directions in, 13; recovery efforts surrounding, 7–8; role and contributions to Jewish American literary history, 3, 4–5; scholarship on, 8–10, 14–15. *See also* Jewish women's proletariat fiction; Mizrahi Jewish women writers
Jewish women's proletariat fiction, 30; ethnoracial displacement in, 31–32, 53–55, 57n11; reception of, 32. *See also Diary of a Shirtwaist Striker, The* (Malkiel); *Woman Who Wouldn't, The* (Stokes)
Jewish women writers, new generation of, 32–33. *See also* Mizrahi Jewish women writers
Johnson, Georgia Douglas, 103n67
Johnson, James Weldon, 84–85, 86, 101n50
Jolson, Al, 72
Jones, Faith, 149, 159, 162, 164
Jong, Erica, 236–42. See also *Fear of Flying* (Jong)
Jordan, June, 190
journalism, 36, 37, 38, 47, 59n33, 90, 111, *112*, 113, 135n4, 344n7

Kadish, Rachel, 2
Kahanoff, Jacqueline Shohet, 356, 370n7
Kaplan, Carla, 82–83, 88
Karpilove, Miriam, 161. See also *Diary of a Lonely Girl* (Karpilove)
Katz, Dovid, 155–56
Kenner, Hugh, 233
Kessler-Harris, Alice, 34–35
Keyser, Catherine, 113

Khazzoom, Loolwa, 357–58, 371n13
Kheshvandike nekht (Molodowsky), 171n21
"kike," 253–60, 264–65, 277–78, 284n28, 285n34
"kike art," 261–65
Kincaid, Jamaica, 16
Kirichanskaya, Michele, 300
Kirschen, Bryan, 370n4
Kirzane, Jessica, 160, 161, 162. See also *Diary of a Lonely Girl* (Karpilove)
Kitaj, R. B., 259, 261, 262–64, 265, 286n41
Kleeberg, Minna Cohen, 7
Klepfisz, Irena, 151, 153, 154
Korman, Ezra, 151–53, 171n19
Kramer, Michael, 128
Kraus, Chris, 251–56; artistic legacy of, 279–80; and bad Jewishness, 256–61; on financing art, 272–73; Heti's relationship with, 285n37; on *I Love Dick*, 284n24; on Kitaj's interpreting of his own work, 261; on prolonged adolescence, 282n14; on relationship with Baudrillard, 286n40; "Trick," 290n89; upbringing and identity of, 254. See also *After Kathy Acker* (Kraus); *I Love Dick* (Kraus)
Krauss, Nicole, 2
Kremer, S. Lillian, 8
Krutikov, Mikhail, 174n57
"Kultur un di froy" (Leyeles), 152

labor organizing: and American naturalism, 36–37; in *The Diary of a Shirtwaist Striker*, 38–46; Jewish immigrants' involvement in, 34; Jewish women's activism in, 35; Malkiel's activism in, 38–39; Shirtwaist Strike (1909) (The Uprising of 20,000), 29–31, 36; Stokes and, 47; in *The Woman Who Wouldn't*, 49
Ladino, 14, 356, 369n2
Lagnado, Lucette, 357

Lambert, Josh, 37, 258, 275, 284n26
Landau, Zishe, 170n18
Land Like You, A (Nathan), 357, 358, 371n11
landlording, 272–73
Lang, Jessica, 9
Lant, Antonia, 135n4
Larkin, John Francis, 126. See also *Dolly Sisters, The* (Spitzer and Larkin)
Lasch, Christopher, 54
Laykhtsin und fremelay (Wolfssohn), 170n13
Lazarus, Emma, 7, 76, 97n12, 178, 370n5
Leavitt, Sarah, 349n37
lectures, 147–48, 191–92, 268n3, 349n39
Leftwich, Joseph, 154, 172n36
Lehrer, Riva, 300. See also *Golem Girl* (Lehrer)
Leksikon fun der nayer yidisher literatur (Charney and Shatsky), 152
Lemlich, Clara, 29
Lena Finkle's Magic Barrel (Ulinich), 1, 5
Let There Be Light (Finck), 15–17
Levering Lewis, David, 103n74
Levin, Meyer, 154
Leyeles, A., 152, 170n18, 171n25
Libicki, Miriam, 13
Lichtenstein, Diane, 8
Liebetrau, Eric, 344n7
Liebowitz, Samuel, 94
Light, Alison, 132
Lil Dicky, 258, 284n28
Lilith, in *Let There Be Light*, 16–17
Lilith magazine, 15
Limonic, Laura, 342
Linfield, Rachel, 239, 247n31
"Lintsheray" ("A Lynching") (Opatoshu), 43, 99n24, 102n57, 102n66
"Litany for Survival, A" (Lorde), 194–95
Literary History of the United States (Spiller et al.), 155, 173n43
literary patriarchs, love-hate relationship with, 2–3

"Lives of Others, The" (Russo), 71–72
Lober, Brooke, 207n8
Locke, Alain, 85
Loos, Anita, 132
Lorde, Audre, 185–88; exploration of voice in "Poets in Conversation" reading, 193–97, 203–6; frustration with *Chrysalis*, 209n17; on Holocaust, 218n83; influence of, 210n23; Rich's relationship with, 188–91, 208n14, 211n28, 216n66; shifting subjectivities in works of, 212n37; and "shifting the frame" conversational pattern, 191–94
Lorenz, Lee, 338–39
Lotringer, Sylvère, 252, 271, 283n21, 286n40
Lower East Side, 34, 37, 47, 125
lynching, 42–43, 90–91, 93–94. See also anti-lynching literature
"Lynching, A" (Opatoshu), 43, 99n24, 102n57, 102n66

MacArthur, Marit, 186, 197, 214n58
Malamud, Bernard, 1
Malkiel, Theresa Serber, 29–31, 36, 38–39. See also *Diary of a Shirtwaist Striker, The* (Malkiel)
Malodowsky, Kadya, 214n59
Man of My Time (Sofer), 357, 358, 361, 364, 365
"mansplaining," 162, 177n74
"manthology," 153–58, 171n29
Margolin, Anna, 174n56
marriage: in *Diary of a Lonely Girl*, 163–64; in *The Diary of a Shirtwaist Striker*, 43; in *Divorcing*, 228–35; in *A Jewish Refugee in New York*, 166; Spitzer's critique of, in Reform Jewish community, 117–18; in Spitzer's early magazine fiction, 118–20; in *The Woman Who Wouldn't*, 50–51
matrilineage, 6–10, 258, 259. See also alternative literary genealogies

McGinity, Keren, 243n1
McGraw, Eliza, 134
Meeropol, Abel (Lewis Allan), 100n48
Meir, Natan, 299, 317n18
Melnick, Jeffrey, 93
memoir, 13, 14, 15, 21n21, 37, 38, 56n5, 58n22, 62n60, 63n72, 114, 153, 158, 159, 161, 258, 271, 279, 281n4, 297, 308, 319n41, 325, 326, 327, 328, 332, 333, 335, 338, 339, 340, 341, 342, 343, 344nn2-3, 344n5, 344n7, 345n8, 346n11, 347n19, 349n37, 356, 357, 358, 359, 366, 367-68
Menken, Adah Isaacs, 7
Men We Reaped (Ward), 346n11
metaphors, monsters as, in *Golem Girl*, 308-15
#MeToo movement, 140n88, 227-28, 234-35, 237-38, 241. See also reception
Meyer, Alfred, 81
Meyer, Annie Nathan, 72-79, 83-89, 100n45, 101n50, 101n53. See also *Black Souls* (Meyer); "Shoe Pinches Mr. Samuels, The" (Meyer)
Meyerson, Arlene, 298
Michels, Tony, 34
Michelson, Miriam, 20n16
middlebrow writing, 11-12, 20n17, 115-16, 117, 118-21, 132-34. See also Spitzer, Marian
Milk Fed (Broder), 301-8, 315, 319n34
Miller, Nancy K., 328-29
Miller, Nina, 124-25
Millet, Kate, 228
Mine Eyes Have Seen (Dunbar-Nelson), 80-81
Minkoff, Nokhem-Borekh, 170n18
"Minority" (Simmons), 189-90, 210n25
minority within a minority, 75, 76, 97n11, 356
Mintz, Susannah, 317n22
Miriam, 304

misogyny, 2, 3, 11, 12-13, 17n2, 115, 130, 131, 228, 232-33, 239, 245n27, 256, 260, 262, 271, 278
Mitchell, David, 298, 315n13
Mitchell, Koritha, 80, 81
Mizrahi Jewish women writers, 355-69
Moïse, Penina, 7
Molodowsky, Kadya, 157, 164, 174n54. See also *Jewish Refugee in New York, A* (Molodowsky)
Monster, The (Crane), 314
Moore, Suzanne, 290n86
Morrison, Jim, 252, 255
Moser, Benjamin, 235
motherhood: and *Can't We Talk about Something More Pleasant?*, 330-31, 332, 333, 334, 335, 336, 339; in *Golem Girl*, 308-11; in *Milk Fed*, 301-8; in Mizrahi Jewish women's works, 362, 363, 367; in *Who Would Be Free*, 124; in *The Woman Who Wouldn't*, 50-51; and working-class women, 35, 53. See also Jewish parental figures
Muller, Jerry Z., 244n17, 245n22
Musterverk fun der yidisher literatur (Rozhansky), 153
My Golem (Weitz), 295-96
My Golem, Her Tower (Weitz), 296
Myles, Eileen, 253, 271, 279-80, 286n38, 290n92
mystification, 269

NAACP, 73, 80, 81, 84, 85, 89
Nahai, Gina, 356, 357, 370n8
Nathan, Annie Augusta (Florance), 76, 78
Nathan, Maud, 75
Nathan, Robert Weeks, 76
Nathan, Simon, 77
Nathan, Tobie, 357, 358, 371n11
nativism, 44-46, 55
naturalism, 36-37
Neufield, Len, 279

"New Colossus, The" (Lazarus), 7, 76, 178n84
Newman, Rabbi Louis, 124
New York, 7, 29, 38, 47, 48, 73, 75, 76, 77, 82, 84, 93, 111, 112, 113, 114, 115, 118, 148, 151, 160–68, 170n18, 188, 254, 264, 267, 268, 273–74, 275, 279, 286n40, 290nn86–87, 297, 338, 359–60, 367, 370n4
New Yorker, 338–39, 341, 344n2, 344n5, 348n24
nomadism, 278, 289nn85–86
nonbinary gender identity, 15, 297
Norich, Anita, 147, 148–49, 153, 155, 159, 164–65, 172n35, 176nn68–69, 178n84. See also *Jewish Refugee in New York, A* (Molodowsky)
"Notes from a Trip to Russia" (Lorde), 204
Novershtern, Avrom, 147–48, 157, 174n56

objects: as agents, 335, 348n22; linked to past traumatic events, 332–35; in relation to grief, 347n19
"off the derech" narrative, 22n23
Old Sephardim, 97n13
Old Yiddish literature, 150, 169n9
Olsen, Tillie, 227–28
Olson, Lester, 212n37
Opatoshu, Joseph, 43, 99n24, 102n57, 102n66
Orleck, Annelise, 35
Orthodox Judaism, 5, 10, 163, 302, 307
Ostriker, Alicia, 22n23
Out of Egypt (Aciman), 356, 359
Ovington, Mary White, 86
Ozick, Cynthia, 22n23, 174n53, 305, 316n10

Pappenheim, Bertha, 161
parasitism, 266–67, 269, 270–71, 273
Parker, Dorothy, 115, 132, 133–34, 137n26

patriarchy, 2, 3, 5, 16, 33, 35, 40, 41, 49, 73, 122, 157, 188, 228–35, 239, 242, 246n28, 252, 260–61, 264, 295–96, 301, 305, 315, 357, 358, 364
perinatal death, in *Can't We Talk about Something More Pleasant?*, 332–34
Perkins, Kathy A., 73, 75, 86, 98n23, 100n48, 103n70
Phagan, Mary, 93
Phelan, James, 344n7
Phelps Stokes, James Graham, 47, 51, 52
Pierce, Rebecca, 206
Piercy, Marge, 22n23, 306
poetics of conversation, 187, 197, 205. *See also* Lorde, Audre; Rich, Adrienne
poetry: Lorde and Rich on use of, 193–94, 203; performance styles in reading, 214n58; Rich on, as form of teaching, 212n32; women and Jewish American, 7, 18n8; Yiddish, 158, 170n18. *See also* "Poets in Conversation" reading
"Poets in Conversation" reading, 185–88; exploration of voice in, 193–206; and "shifting the frame" conversational pattern, 191–94. *See also* Lorde, Audre; Rich, Adrienne
Polier, Justine Wise, 210n22
Polland, Annie, 33
Portnoy's Complaint (Roth), 305
poverty: experienced by Stokes, 47, 48; independent, 278–79; in *The Woman Who Wouldn't*, 49–51. See also *Diary of a Shirtwaist Striker, The* (Malkiel)
power, Jewish, 5, 93, 272, 275, 277, 308, 315
Pratt, Minnie, 190
"Precarious-Girl Comedy," 254–55
Prell, Riv-Ellen, 261
proletariat fiction, 31. *See also* Jewish women's proletariat fiction
prolonged adolescence, 254, 282n14
property management, 272–73

prophetic poetry, 195–96, 203–6, 214n53, 218n87
protest literature, 11, 73, 80, 82, 94, 101n48
Prozac Nation (Wurtzel), 258
publishing industry, Jewish control of, 275
Puttermesser Papers, The (Ozick), 305, 316n10

queer counterpublics, 205
Queer Expectations: A Genealogy of Jewish Women's Poetry (Weiman-Kelman), 167
queerness: and challenge to category of "woman," 17; and *Diary of a Lonely Girl*, 164; embraced by Jewish women writers, 13; golem as symbol of, 13, 300, 302–8; in *I Love Dick*, 256, 268; of Lehrer, 312, 313; and Lorde and Rich's feminist counterpublic, 187, 205; and reclamation of pejorative terms and metaphors, 315; seminars, lectures, and discussions on, 148

race: in *I Love Dick*, 253–54, 263; Jews in American racial hierarchy, 78–79, 289n80; and religion in *The Diary of a Shirtwaist Striker*, 43–45. *See also* allyship; anti-lynching literature; appropriation
Rachel (Grimké), 80, 103n68
racial slurs, 253–54, 255–56, 257–58, 259–60, 264–65, 277–78, 284n28, 285n34
racism. *See* anti-Blackness; antisemitism
Rankine, Claudia, 190
rape. *See* sexual abuse and assault
Rascoe, Burton, 113
rebellion: in *A Hungry Young Lady*, 128–32; in *Who Would Be Free*, 121–28. *See also* dissent; resistance, of Jewish women

reception, 11–12, 227–28, 242–43; of *Black Souls*, 87–88, 101n52; of *Divorcing*, 228–36; of *Fear of Flying*, 236–42, 246n28, 246n30; of Kitaj's work, 262; and #MeToo movement, 140n88; of Sofer's work, 366; of women's labor literature, 32
Reception studies, 227–28
Red Scare, 54
Reform Judaism, 8, 116, 117, 118, 121, 123, 124, 125, 128, 141n100, 151; confirmation in, 121, 127–28
reification, 190–91, 192, 193, 202, 206, 211n28
relationality, 4, 13, 78, 89
religion: disability studies' critique of, 297–98; Malkiel on, 52; and race in *The Diary of a Shirtwaist Striker*, 43–45; refusal to discuss, in *Can't We Talk about Something More Pleasant?*, 332, 337; Stokes on, 52; in *The Woman Who Wouldn't*, 52–53
Remnick, David, 338
rereading, 227–28
resistance, of Jewish women, 6–10. *See also* dissent; rebellion
Rich, Adrienne, 185–88; engagement with Blackness, 203–4, 217nn79–80; exploration of voice in "Poets in Conversation" reading, 197–206; influence of, 210n23; Lorde's relationship with, 188–91, 208n14, 211n28, 216n66; on poems with lesbian rhythms, 216n69; on poetry as form of teaching, 212n32; poetry dealing with Jewish themes, 214n59; prophetic voice of poetry of, 203–6; and "shifting the frame" conversational pattern, 191–94; "Split at the Root," 204, 214n60
Rieff, David, 234–35
Riis, Jacob, 37
Riot Grrrl punk movement, 256

"Rise and Fall of Florrie Weissman, The" (Spitzer), 120–21
Rise of American Jewish Literature, The (Levin and Angoff), 154
Rise of David Levinsky, The (Cahan), 285n34
Rosenfeld, Lucinda, 241
Rosler, Martha, 279
Roth, Philip, 1, 2–3, 17n2, 305, 319n34
Rothfeld, Becca, 235, 236
Rozhansky, Shmuel, 153
Russ, Joanna, 227–28
Russo, Richard, 71–72
Rust, Marion, 190, 193

Sabbath's Theater (Roth), 305
Salome of the Tenements (Yezierska), 54, 135n14
Sampter, Jesse, 298, 299, 316n12
Samuels, Ellen, 315
Savonick, Danica, 190
Schachter, Allison, 156, 167–68
Schillinger, Liesl, 241
Schoenberg, Arnold, 259
Schor, Esther, 7
Schorsch, Jonathan, 78–79
Schreier, Benjamin, 18
Schwadron, Hannah, 255
Schwarz, Leo, 172n30
Schweik, Susan, 317n18, 320n51
Scottsboro trial, 94
SEEK (Search for Education, Elevation, and Knowledge) program, 188, 208n11
Seidman, Naomi, 150, 151, 169n9
Seixas, Grace, 77
Seixas, Rabbi Gershom Mendes, 76–77
Semiotext(e), 275
Sentinel, The (periodical), 73, 89
Sephardic Jews, 75–79, 97n13, 98nn15–16, 370n5
Septembers of Shiraz, The (Sofer), 358, 360–61, 364

"Sequelae" (Lorde), 195–96
sex and sexual agency: in *Divorcing*, 229, 230, 231; in *I Love Dick*, 251, 256, 263, 268; in *Milk Fed*, 301–8; and religion, 53; of working-class women, 49–50
sexual abuse and assault: and anti-lynching literature, 74, 80, 90, 91, 102n66, 103n67; in *Diary of a Lonely Girl*, 163; in *Divorcing*, 232; in *Fear of Flying*, 237–41, 246n28, 246n30; in *A Hungry Young Lady*, 130–31, 140n88; #MeToo movement, 140n88, 227–28, 234–35, 237–38, 241; and reception of *Fear of Flying* and *Divorcing*, 242–43; and Scottsboro trial, 94
sexual harassment, 13, 33, 131, 242
sex work, 41, 265–66, 269, 271, 287n48
"Sexy Jewess," 255. *See also* "Jewess"
Sforim, Mendele Moykher, 151
Shalvi/Hyman Encyclopedia of Jewish Women, The, 15
Shapiro, Ann R., 246n28
Shatsky, Jacob, 152
Shirtwaist Strike (1909) (The Uprising of 20,000), 29–31, 36. See also *Diary of a Shirtwaist Striker, The* (Malkiel)
"Shoe Pinches Mr. Samuels, The" (Meyer), 72–73, 87, 89–95, 103n70
Shriver, Lionel, 71
Sielke, Sabine, 240
Simmons, Judy, 189–90, 210n25
Singer, Isaac Bashevis, 157, 305
Singer, Peter, 311–12
Singer, Rabbi Jacob, 124
Sinkoff, Nancy, 170n13
"Six Greatest Moments, The" (Spitzer), 118–19, 123, 129, 138n35
slavery, 78
Smart Set, 20n16, 115–16
Smith, Barbara, 190
Smith, Sidonie, 345n9
Snyder, Sharon, 298, 315n13
socialism, 39, 47–48

Socialist Party of America (SP), 38–39, 47, 54
social mobility: in *A Hungry Young Lady*, 128–32; as impetus for lynching, 90–91; and marriage in Spitzer's "The Six Greatest Moments," 118–19; sophistication as means of, 133; in Winslow's versus Spitzer's works, 116–17
social services, and financing art, 279
social "types," in Spitzer's works, 117
Sofer, Dalia, 357, 358, 360–61, 364, 365–66, 368
Soffer, Jessica, 355, 358, 359–60, 361, 362–63, 364–65, 366–67, 368, 369n2
Solomon, Anna, 2
Soloway, Joey, 279–80, 290n92
Sonkin, Rebecca, 256–57, 265, 283n22, 284n23
Sontag, Susan, 234, 235, 236, 314
sophistication, 114, 133
"Sources" (Rich), 187, 197–98, 199–202, 204
Soviet immigrant writers, 1, 5
Soyer, Daniel, 33
Special Exits (Farmer), 347n19
Spiller, Robert Ernest, 155, 173n43
spina bifida, 310–15
Spitzer, Marian: background and career of, 112–15, 135n12; early magazine fiction of, 115–21; interviews W. C. Fields, 111, *112*; rebellion in *A Hungry Young Lady*, 128–32; rebellion in *Who Would Be Free*, 121–28; relationship with Thompson, 118, 137n33; and scholarship on middlebrow writing, 132–34; writing style of, 114
"Split at the Root" (Rich), 204, 214n60
Stanislawski, Michael, 299
Stansell, Christine, 51
Stephens, Judith L., 73, 75, 86, 98n23, 100n48, 103n70
Stern, Elizabeth, 55, 63n72

Stokes, Rose Pastor, 31, 47, 49, 51, 52, 54, 62n61. See also *Woman Who Wouldn't, The* (Stokes)
"Strange Fruit" (Holiday), 100n48
Strange Fruit: Plays on Lynching by American Women (Perkins and Stephens), 73, 75, 86, 98n23, 100n48
Strine, Mary, 200, 207n7
Strongman, SaraEllen, 190
Stryker, Susan, 300, 317n23
suffrage movement, 75
suicide, 49–50, 198, 200, 216n66, 217n82, 233–34, 311
Suleiman, Susan Rubin, 237
Szymaniak, Karolina, 147, 148

Taubes, Jacob, 233, 234, 235–36, 243, 244n17, 245n22
Taubes, Susan, 228–36, 242
television series, 14–15, 254–55, 256, 280
Templin, Charlotte, 237
Thompson, Harlan, 114, 118, 120, 137n33
Tomorrow There Will Be Apricots (Soffer), 355, 358, 361–62, 363, 366–67, 368
Torpor (Kraus), 272
translation of Yiddish women writers, 147–48; historical overview of, 153–58; impact of, 160–68; recent wave of feminist, 158–60. See also Yiddish literature
transness, 15, 317n23
Transparent (2014), 14, 280
traumas: in *Black Souls*, 74; collective, of Irish and Jewish diasporas, 52; disclosed in *Can't We Talk about Something More Pleasant?*, 329–35; in *Fear of Flying*, 246n28; and gender in Mizrahi Jewish women's works, 362–63; in *Golem Girl*, 309–10; labor struggles and, 33; in *Mine Eyes Have Seen*, 80–81. See also #MeToo movement; sexual abuse and assault

Treasury of Yiddish Stories, A (Howe and Greenberg), 153–54, 156, 164
Triangle Shirtwaist Factory Fire, 34, 46
"Trick" (Kraus), 290n89
Truth, Sojourner, 42
Tucker-Abramson, Myka, 273

Uffen, Ellen Serlen, 8
Ugly Laws, The (Schweik), 317n18, 320n51
Ulinich, Anya, 1–2, 5
Ulinover, Miriam, 171n19
universalism, 31, 34, 38
"unruly bodies," 317n22
Uprising of 20,000, The (Shirtwaist Strike) (1909), 29–31, 36. See also *Diary of a Shirtwaist Striker, The* (Malkiel)

vampire imagery, 314–15
"vamp" / seductress, 130
Venema, Kathleen, 344n7
Vermont, 216n66
Villard, Oswald Garrison, 86
voice: in Lorde and Rich's poetic performances, 193–206; prophetic, 203–6

Wanzo, Rebecca, 254, 255
Ward, Erik K., 95
Ward, Jesmyn, 346n11
Warwick, Diana, 125
Wasson, Kirsten, 63n72
Watson, Julia, 345n9
Watt, Stephen, 52
Weil, Simone, 258–59, 287n49, 343
Weiman-Kelman, Zohar, 167, 214n59
Weitz, Julie, 295–96
Wells, Ida B., 86, 90
Wendell, Susan, 302
Werthman, Michael, 243
West, Cornel, 205

Western Sephardim, 97n13
Wharton, Edith, 136n21
White, Walter, 86
whiteness: and Ashkenormativity, 75; centering of, in labor movement and American proletarian literature, 32, 53–54; and Jews in American racial hierarchy, 78–79, 289n80; "The Shoe Pinches Mr. Samuels" and Jewish, 89–95; Spitzer's assimilability into, 114–15, 127–28, 133; Yezierska's rejection of, 135n14
white supremacy, 74, 87. *See also* antilynching literature; lynching
Who Would Be Free (Spitzer), 121–28
Wilburn, Cora, 8
Wild Patience Has Taken Me This Far, A (Rich), 185–86. *See also* "Poets in Conversation" reading
Wilke, Hannah, 258–59
Willis, Ika, 227–28
Winslow, Thyra Samter, 20n16, 116, 133–34, 137n24
Wirth-Nesher, Hana, 10
witch, in Kraus's works, 260
Witchel, Alex, 333–34
Wolf, Emma, 8, 20n16
Wolfssohn, Aaron Halle, 170n13
Wolitzer, Meg, 2
Woman Who Wouldn't, The (Stokes), 31, 47–53
Women's National Committee, 39
women's suffrage, 39, 75
working-class fiction, erasure of Jewish subjectivities in, 37–38. *See also Diary of a Shirtwaist Striker, The* (Malkiel); *Woman Who Wouldn't, The* (Stokes)
World of Our Fathers (Howe), 157
World War I, 54
World War II, 298, 329
Wurtzel, Elizabeth, 258

Yakubovitsh, Rosa, 171n19
Year of Magical Thinking, The (Didion), 335, 346n11
Yezierska, Anzia: *Bread Givers*, 122; contrast between Spitzer and, 126–27, 128, 133, 140n76; contribution to American literary realism, 37; *Hungry Hearts*, 126–27; and Jewish women's rejection of assimilation, 32–33, 55, 128; as prioritizing Jewish women's voices, 139n69; rejection of whiteness, 115, 127, 135n14; *Salome of the Tenements*, 54, 135n14
"Yiddish American Poetry" (Novershtern), 157
Yiddish Book Center's Translation Fellowship, 159–60
Yiddish language, 150, 151
Yiddish literature: debates concerning canonicity in, 147–48; feminist reinterpretation of, 169n9; women as writers and readers of, 149–53, 170n18, 171n19, 174n57. *See also* translation of Yiddish women writers
Yidishe dikhterins: Antologye (Korman), 151–53
Yours in Struggle (Pratt et al.), 190

Zangwill, Israel, 37
Zierler, Wendy, 154
Zikhroynes (Glikl of Hamln), 161
Zionism, 299
"zipless fuck," 238–39, 240, 247n31
Zipperstein, Steven, 153
Zonana, Joyce, 355, 358–59, 361–62, 365, 367–69, 370n8, 371n11